THE MAKING OF
ISLAMIC ART

Edinburgh Studies in Islamic Art
Series Editor: Professor Robert Hillenbrand
Advisory Editors: Bernard O'Kane and Scott Redford

edinburghuniversitypress.com/series/esii

THE MAKING OF ISLAMIC ART

STUDIES IN HONOUR OF SHEILA BLAIR AND JONATHAN BLOOM

EDITED BY ROBERT HILLENBRAND

EDINBURGH
University Press

Edinburgh University Press is one of the leading university presses in the UK. We publish academic books and journals in our selected subject areas across the humanities and social sciences, combining cutting-edge scholarship with high editorial and production values to produce academic works of lasting importance. For more information visit our website: edinburghuniversitypress.com

Edinburgh University Press Ltd
The Tun – Holyrood Road
12 (2f) Jackson's Entry
Edinburgh EH8 8PJ

Typeset in Trump Medieval by
Servis Filmsetting Ltd, Stockport, Cheshire,
and printed and bound in Great Britain

A CIP record for this book is available from the British Library

ISBN 978 1 4744 3429 4 (hardback)
ISBN 978 1 4744 3430 0 (webready PDF)
ISBN 978 1 4744 3431 7 (epub)

Published with the support of the University of Edinburgh Scholarly Publishing Initiatives Fund.

Contents

Figures

The Contributors

Catherine B. Asher is Professor Emerita, Department of Art History, University of Minnesota.

Barbara Finster is Professor of Islamic Art and Archaeology (emerita) at the University of Bamberg.

Carole Hillenbrand is a Professorial Fellow at the School of History of the University of St Andrews and Professor Emerita at Edinburgh University.

Robert Hillenbrand is a Professorial Fellow at the School of Art History of the University of St Andrews and Professorial Fellow and Professor Emeritus at the University of Edinburgh.

Linda Komaroff is Curator of Islamic Art and Department Head, Art of the Middle East, at the Los Angeles County Museum of Art.

Marcus Milwright is Professor of Islamic Art and Archaeology in the Department of Art History and Visual Studies at the University of Victoria, BC, Canada.

Lawrence Nees is Professor in the Department of Art History and H. Fletcher Brown Chair of Humanities at the University of Delaware.

Alison Ohta is Director of the Royal Asiatic Society for Great Britain and Ireland.

Bernard O'Kane is Professor of Islamic Art and Architecture, The American University in Cairo.

Simon O'Meara is Lecturer in the History of Architecture and Archaeology of the Islamic Middle East at SOAS, University of London.

Laura E. Parodi currently teaches at the University of Genoa, Italy.

Cheryl Porter is Director of the Montefiascone Conservation Project, Italy and consultant to the Conservation Department at the Library of Alexandria, Egypt.

Venetia Porter is Curator of Islamic and Contemporary Middle East Art at the British Museum and Honorary Research Fellow at the Courtauld Institute of Art.

Marianna Shreve Simpson is Research Associate, Schoenberg Institute for Manuscript Studies, University of Pennsylvania.

Nancy Steinhardt is Professor of East Asian Art and Curator of Chinese Art at the University of Pennsylvania.

Wheeler M. Thackston is retired Professor of the Practice in Persian and Other Near Eastern Languages at Harvard University.

Kjeld von Folsach is Director of the David Collection, Copenhagen.

Oliver Watson is Emeritus Professor of Islamic Art at the University of Oxford.

Series Editor's Foreword

Edinburgh Studies in Islamic Art is a venture that offers readers easy access to the most up-to-date research across the whole range of Islamic art. Building on the long and distinguished tradition of Edinburgh University Press in publishing books on the Islamic world, it is a forum for studies that, while closely focused, also open wide horizons. Books in the series concentrate in an accessible way, and – this is important – in clear, plain English devoid of technical jargon, on the art of a single century, dynasty or geographical area; on the meaning of works of art; on a given medium in a restricted time frame; or on analyses of key works in their wider contexts. A balance is maintained as far as possible between successive titles, so that various parts of the Islamic world and various media, periods and approaches are represented.

Books in the series are academic monographs or composite volumes of intellectual distinction that mark a significant advance in the field. While they are naturally aimed at an advanced and graduate academic audience, a complementary target readership is the worldwide community of specialists in Islamic art – professionals who work in universities, research institutes, auction houses and museums – as well as that elusive character, the interested general reader.

Professor Robert Hillenbrand

Preface and Acknowledgements

Sheila Blair and Jonathan Bloom, whose friendship Carole and I have enjoyed for many years, have both contributed very generously over the years to the Festschriften of other scholars, including my own, so it is a particular pleasure to be able to return the compliment, and moreover to welcome its appearance in the series *Edinburgh Studies in Islamic Art* which I have edited for over a decade, and to which both of them have also contributed a title. The range and depth of the contributions to this volume offer another kind of compliment, this time to the wide horizons which these two scholars have opened for their colleagues in the course of their spectacularly productive careers as researchers. It is quite plain that their example has been inspirational. It is a tribute to them that every one of these chapters reflects some aspect or other of their own interests as expressed in their publications. Hence the frequent references to 'B&B' in the footnotes and bibliographies of the chapters in this book.

A special word of thanks goes to the contributors. It is they who have made this book. Many are based in the United States and Britain, but Denmark, Egypt, Germany and Italy are also represented. Some of them have generously devoted time that they did not have to prepare their chapters, as a gesture of friendship and respect to Sheila and Jonathan; others have chosen to build on work done by the very scholars whom they honour, and yet others, responding to the challenge set by these two eminent scholars that their Festschrift should celebrate what they themselves have termed 'thinginess', have dug deep to unearth something appropriate that they would not otherwise have explored. That word 'thinginess' is not in the lexicon just yet, but its meaning is clear. The field of Islamic art these days has no shortage of theorists, and there have been many attempts – not always happy ones – to make research into the world of Islamic art fit the Procrustean bed of theories generated by Western scholars for Western culture in its many expressions. Sheila and Jonathan

future. Sheila and Jonathan have also seen to it that each conference
has yielded short-term fellowships to enable scholars young and old
from all over the Islamic world and the West to network at these
events.

For decades now, they have engaged, from their base in the rural
tranquillity of New Hampshire, with Islamic art on a global scale,
and they have managed to mould the development of that field for
generations to come. The catalyst for this was their joint appoint-
ment in the early 1990s as editors for the articles on Islamic art for
The Dictionary of Art, an extraordinarily ambitious enterprise by
Grove that in 1996 resulted in thirty-four volumes and was the first
such venture to engage seriously with the art of all cultures from
across the planet. They rose to the intellectual challenge, commis-
sioning scores of articles, many of them on hitherto neglected mate-
rial, and when they could not persuade authors to tackle some really
out-of-the-way subject, they wrote the article themselves. Together,
then, they became the instrument whereby Islamic art finally came
of age. Often they chose up-and-coming scholars rather than the
great and the good of the field. They subdivided fields and media
chronologically and regionally. They brought content into sharper
focus than ever before. Such was their success that in 2009 Grove
brought out three substantial volumes, suitably enlarged with much
new material, entitled *The Grove Encyclopaedia of Islamic Art and
Architecture*, under their editorship. This is now the go-to source for
basic information on all aspects of Islamic art.

The impact of this prolonged editorial experience on their scholar-
ship can scarcely be overrated. The labour of improving defective
articles, of ferreting out subjects on which nobody had ever written
a word, of checking sloppy bibliographies, increased not just their
information base but also their stature as scholars, and their vis-
ibility, exponentially. Not for them the tunnel vision that is so often
the price that prolonged specialisation exacts. Their thorough sense
of context, painfully acquired over decades, gives them a sixth sense
of the appropriate answer in disputes about provenance, date and
style. It enables them to make connections, often across vast tracts
of space and time, that elude many of their peers.

They both have a marked practical side – they like to know how
things were made and how they work, and it is no accident that,
when asked what they wanted to choose as the theme for this
Festschrift, they hit on 'thinginess' – their word. It is intended, I
think, as an antidote to 'theory', which when properly used can of
course enrich the understanding of Islamic as of Western art, but
which in the wrong hands can easily deteriorate, in Basil Robinson's
words, into 'the charge of the bold jargoneers'. They do not waste
words. Neither Jonathan nor Sheila could ever be dismissed as liter-
alists, but they have a healthy respect for facts. So whenever possible
(for example, in picture captions) they give details of measurements,

dates, techniques. They learn about weaving or bookbinding and have a go at such crafts themselves. They illustrate Gandhi's maxim: 'learn every day as if you were going to live forever'.

It is particularly appropriate that this Festschrift should be published by Edinburgh University Press, which has published one book after another by them, both as free-standing titles and as part of its series *Edinburgh Studies in Islamic Art*. Moreover, Jonathan, in his capacity as a member of the editorial board for this series, has given years of sterling service to it, and his sage and incisive advice has been invaluable.

But their life is not all work and no play. Jonathan is a fabulously inventive and omni-competent cook, gardener, pianist and handyman. Sheila knows how to relax with solitaire, a bracing swim in a nearby woodland lake, a long walk with the dog. They are devoted parents to Felicity and Olly. And both Sheila and Jonathan have big hearts that express themselves in wonderfully warm hospitality which has given much joy over many decades to numerous friends and colleagues. Long may they prosper as people and as scholars!

Robert Hillenbrand
February 2020

CHAPTER ONE

Old Mosques: Destroyed, Lost and Transformed in Twentieth- and Twenty-first-century India

Catherine B. Asher

IN INDIA TODAY, literature suggesting widespread Muslim icono-clasm has found considerable popularity. To cite just one example, the Hindu nationalist Sita Ram Goel's *What Happened to Hindu Temples* claims that over 2,000 mosques rest on the foundations of earlier Hindu temples.[1] While scholarly opinion has argued against these statistics, stereotypical thinking about Islam, Muslims and temple destruction has escalated increasingly from the mid-nine-teenth century through to the twenty-first century.[2] The word used to define these attitudes is Hindutva, a termed coined in the early 1920s, and it has become synonymous with Hindu nationalism or an India meant for Hindus. While Hindutva's antagonism can be directed against any non-Hindu religion found in India, it is most often used in anti-Muslim contexts. Given this sentiment, I ask what is its impact on India's built landscape from the mid-nineteenth century to the present? More specifically I ask what happened to India's mosques since the Rebellion of 1857, when the tide officially turned against South Asia's Muslims, up to the present, as Hindu contempt for Muslims is on the rise. I suggest that several rather different tra-jectories transpired. In their extremes, one is rooted in destruction, but others surprisingly are based on reuse with minimal destruction and little reconstruction. In order to understand these approaches, examining political events since 1857 and the subsequent impact of Hindutva help contextualise these approaches.

By the year 1700, much of the Indian subcontinent was dominated by the Mughals, a Muslim dynasty that ruled from 1526 until its official demise in 1858. The events of 1857, formerly known as the Indian Mutiny and now often termed the Indian Rebellion or Uprising of 1857, spelled the death knell for the Mughals and any preferential treatment of its Muslim subjects. A variety of reasons led to this revolt of Indian soldiers against British forces, which resulted in the end of Mughal rule and its replacement by the British Raj.

This uprising was given reluctant support by Bahadur Shah II, the last Mughal ruler, who was tried for treason and exiled to Rangoon, where he died in 1862. While Indians belonging to multiple ethnic and religious groups were involved in this unsuccessful revolt, it was Muslims who most felt the repercussions of British ire. In the British mind, the support for the rebellion, given by the Mughal king even though it was coerced, was seen as tantamount to disloyalty on the part of all Indian Muslims. So too it was buildings constructed by Muslims that were destroyed more than those of any other group. From the mid-nineteenth century until the present, Muslims and Muslim architecture bore the brunt of the antagonism first expressed in 1857. That animosity morphed in various forms. By the 1920s the term Hindutva, a strident form of Hindu nationalism, gave rise to an increasing sense of anti-Muslim sentiment throughout India. In this chapter I address the impact of India's anti-Muslim sentiment on the built landscape from the mid-nineteenth century up to the present.

While the British were victors in the Rebellion of 1857, they were shocked by Indian disloyalty and harboured fears of other uprisings, especially by Muslims.[3] Initially all Indians were expelled from Delhi's walled city, but Hindus were allowed to return in 1858. Muslims were detained for another year and then often were not given access to their former homes unless they could prove they had no role in the Rebellion of 1857. In the parts of India where the rebellion transpired, large structures with enclosure walls were either completely destroyed or partially dismantled so Indians could not use them as barricades against the British.[4] Since the Mughals, as the rulers of north India, had been the dominant patrons, it was their buildings that predominately were ruined or altered. For example, a Mughal palace pavilion in the Jaunpur fort was destroyed, much to the dismay of Alexander Cunningham, the first director of the newly established Archaeological Survey of India.[5] Luckily a drawing of it survives. The imperial Mughal fort and palace in Delhi, popularly known as the Red Fort, is almost incomprehensible today since the British removed all the original walls that separated one portion of the palace from another.[6] Today the visitor simply sees isolated pavilions that appear to have no relation to one another.

Mosques, especially those in Delhi, were the most affected structures. Only the smallest ones were used as houses of prayer. For over two years Muslims had no access to Delhi's large seventeenth-century Jami mosque, built by Shah Jahan, used then as a barracks for British soldiers. One British official who didn't believe mosques should ever be returned to Delhi's Muslims wrote, 'Let us [the British] keep them as tokens of our displeasure towards the blinded fanatics.'[7] Other mosques were sold to the highest bidder, which now inevitably was a newly moneyed Hindu. For example, a rich Hindu banker, Lala Chunna Mal, purchased Delhi's seventeenth-century Fatehpuri mosque. The Mughal Zinat al-Masajid mosque was trans-

formed into a bakery and others into hospitals. The congregational mosque in Agra that had been provided by Shah Jahan's daughter, Jahan Ara, is still missing its entrance wall on the east, thus giving it an odd appearance.[8] Others, such as the Akbarabadi mosque, built by one of wives of Shah Jahan, famed for his construction of the Taj Mahal among many other Muslim-built structures, were demolished for what was claimed to be security reasons. Concessions, however, were made to Hindus by allowing their temples to remain. By the 1860s almost all the land and buildings of what only a few years earlier had been an elite Muslim city were in the hands of Hindus. Many Muslims had become squatters on the city's outskirts as they were denied access to their former homes and mosques.

Delhi remained a fairly desolate city into the early twentieth century, while Calcutta, far to the east, was the capital of the newly proclaimed empire of the Raj. But in 1911, King George V, during his official visit to India in his role as emperor, announced, much to amazement of those present, that the capital would be shifted from Calcutta to Delhi. To seal his pronouncement, King George placed the foundation stone for the new capital north of Mughal Delhi, although in the end the new capital was constructed to the south of the old city.[9] World War I delayed the building of the new city, which was planned by Edwin Lutyens and Herbert Baker. Inaugurated in 1931, the city covered land that was relatively unoccupied in the nineteenth and early twentieth centuries, but it had been the capitals of the earlier sultans of Delhi as well the first several Mughal rulers. This area was dotted with buildings and graveyards. The idea was to keep important monuments as anchors, to subsume lesser ones of some interest into gardens or parks, but to either actively destroy or let nature take its course on the remaining structures. Thus, major monuments such as Humayun's tomb, the Purana Qila and its mosque, Safdar Jang's tomb and the tombs of the Lodi rulers were placed under the protection of the Archaeological Survey of India.

Lutyens designed his new capital so that its main avenue was aligned to the east with the Purana Qila, linking Mughal Delhi with the Raj's new capital.[10] The mausoleum garden complex of Safdar Jang's tomb marked the south end of Lutyen's New Delhi. The tombs of the Sayyid and Lodi sultans were transformed into a public park designed by Lady Willingdon and are today known as Lodi Gardens. Other structures had less fortuitous futures. For example, an important *dargah*, in India a term referring specifically to a Muslim saint's shrine, was deemed by the new capital's designers to be an acceptable part of the city, but its attached extensive and messy graveyard was not.[11] While most of the demolition of small sultanate and Mughal structures caused no particular stir, the intended demolition of this graveyard is a case where the authorities misgauged local sentiment, setting off contentious confrontations between government officials and citizen groups. In the case of this particular graveyard the will of

government agencies prevailed over local sentiment. As populations grew and land was needed for housing, Muslim graveyards that had sprung up around saints' shrines and Mughal tombs were razed.

The year 1947 marked South Asian independence from British colonial rule. Along with the joy of freedom came the anguish of Partition, when British India, now independent, was divided into two states, Pakistan and India. Massive numbers of Hindus fled what was now Pakistan into India, and similar numbers of Muslims streamed into Pakistan largely from north India. The resulting violence and bloodshed were phenomenal. Large-scale Mughal monuments were used as refugee camps. For example, the Purana Qila, an early Mughal period fort, was used as a holding cell, first for Muslims leaving for Pakistan and then displaced Hindus coming from what was now Pakistan.[12] The fort became an enormous squalid camp, and its spectacular mosque was used as a school, one of the more benevolent transformations for a house of prayer.

Partition was a major force dividing Hindus and Muslims and leading to a rise of anti-Muslim sentiment among India's Hindus. While the government of India claims that Hindutva only defines a style of living,[13] critics recognise a religious component to the term. A blatant manifestation of Hindutva is found in the writings of P. N. Oak (1917–2007), who founded the Institute for the Rewriting of Indian History in 1964. This institute was dedicated to the notion that traditional historians have completely misrepresented Indian history. One scholar terms Oak a 'mythistorian', for much of his study is based not on fact but unsubstantiated sound-alikes between English and Sanskrit words.[14] In the opinion of Oak, Westminster Abbey, the Ka'ba and the Vatican, among other monuments including the Taj Mahal, are all of Hindu origin.[15] Largely in the 1960s and into the 1980s, but with many reprints still available, Oak penned books with titles such as *The Taj Mahal is a Temple Palace* and *Great Britain was Hindu Land*. You, the reader, are probably laughing by now, but Oak's popularity and influence is no laughing matter. His books on the Taj Mahal are, for example, easily available on the Internet, and appeal to the majority of Indians who subscribe in some form or another to Hindutva. Many, I would argue, have no idea of how influenced they are by concepts of Hindutva. Oak petitioned the Indian Supreme Court to officially acknowledge that the Taj Mahal is a Hindu structure, not a Muslim tomb. In 2000 the court rejected his petition, but all the same his ideas still carry popular appeal.

Oak's basic premise is that much culture is Hindu in origin, including culture in East Asia and South East Asia. Thus, by extension, mosques in India sit on land that is rightfully Hindu. Other writers who also subscribe to Hindutva ideology, such as Goel, mentioned earlier in this chapter, claim that the land was not only Hindu but also that many mosques replaced temples that were torn down by Muslim zealots. This brings us to 6 December 1992, when a Mughal

mosque, built by Mir Baqi, a high-ranking noble in the court of the Mughal emperor Babur, was demolished by Hindu fundamentalists.

The mosque, known today as the Babri Masjid, was completed in 1528–9, in Ayodhya. Historically the mosque was important, for it dated to Babur's reign, although stylistically it adhered to a single-aisled mosque type associated with the previous Afghan Lodi dynasty. While Ayodhya was long associated with the birthplace of the Hindu god, Rama, it was not until the nineteenth century, when the British introduced new laws concerning land ownership, that the various Hindu deities suddenly had specific birth spots within sites, not general ones. The land on which the Babri Masjid sat was designated Rama's birth site. By the mid-nineteenth century a group of Hindus had claimed the land and built a small temple near the mosque.[16] For about the next 100 years minor lawsuits over the site's ownership surfaced, but a major incident transpired in 1949, when an image of the deity Rama was installed inside the mosque. At this point the structure was locked by government order and no one was allowed to enter. This led to more lawsuits in the following decades, seeking legal designation of the site as either a temple or mosque. In 1984 a local judge ordered that the Babri Masjid be unlocked so Hindus could worship there, but Muslims were still not allowed to enter the mosque. By 1987 both Hindu and Muslim groups were demanding rights to the mosque. Hindus wanted to liberate the site and build a Rama temple on it, while Muslims wished to pray inside the mosque. By 1990 tensions escalated further, especially when the leader of the right-wing BJP party, L. K. Advani, commenced a Ram Yatra, that is, a chariot procession, from Somnath in western India, the site of a temple destroyed in the eleventh century by Mahmud of Ghazni, to the Babri Masjid in Ayodhya. Advani crossed northern India in this month-long procession in a motorised chariot, presenting himself as a political leader who personified Rama. He actually costumed himself as this Hindu deity holding a bow and arrow, attributes of the god, Rama. Advani's procession further stimulated Hindu fundamentalists to seize control of the Babri Masjid, and by 1991 high-level government officials belonging to right-wing Hindu groups secretly were planning the mosque's destruction.

In preparation for the mosque's demolition, young men were recruited and trained to ascend high structures using grappling hooks and ropes. In addition, they were supplied with equipment for demolition, including bombs. One man arrested during the destruction carried twenty-eight sticks of dynamite, indicating that the attackers were so determined to dismantle the mosque that the loss of human life was not a major concern. The leaders, using tactics associated with terrorist organisations, did not reveal the goal of this training until the day before the mosque was to be demolished. The men were divided into groups of ten, each with a specific task, explaining in hindsight how the mosque was destroyed so rapidly. As is well

known, the police were compliant, allowing the men to ascend the mosque and proceed with their violent attack on it.

The demolition of the Babri Masjid had repercussions in India, Pakistan, Bangladesh and the Middle East, as riots were triggered. In Pakistan and Bangladesh the violence was directed against Hindus, minorities in those countries. In Bombay, where the largest number of deaths occurred, the riots were planned by an ultra right-wing Hindu group, and it was mostly Muslims who suffered.

The success of the Babri Masjid's destruction has led to a heightened sense that mosques and other Muslim buildings believed to be on the site of a former Hindu temple can be returned to their original function. I provide a few examples I recently encountered of Muslim buildings transformed into temples.

To the north of Delhi is Hisar, a city founded in the fourteenth century by a sultan as a fortified military enclave, enclosing multiple structures. This includes a former palace pavilion that I was told at the site was to be used as a government museum for archaeological finds, but instead was transformed into a temple. The central zone of the palace's back wall that would have been intended as a seat of honour or throne niche for the fort's supervisor has been transformed into the inner chamber of a Jain temple (Figure 1.1). In spite of my persistent questioning I was unable to learn how this sleight of hand occurred. However, I was told that originally the building was a

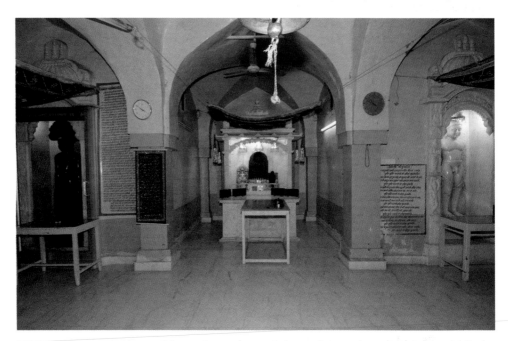

Figure 1.1 *Interior of a Tughluq palace now transformed into a Jain temple; original palace, fourteenth century; temple, 2007 to present, Hisar, Punjab, India.*
Photo © Catherine B. Asher.

temple and Muslims took it for themselves. In the minds of the
current occupants they were simply reclaiming what was rightfully
theirs.

This notion of legitimately reclaiming a building which some
believe was originally a temple is seen also at Daulatabad, a massive
fortress in the Deccan. This fort initially was built under a Hindu
dynasty, but by the late thirteenth century had fallen into the hands
of various Muslim houses. In 1318 a large mosque was added to the
fort under the auspices of the ruling Tughluq sultan.[17] The prayer
chamber's pillars of differing sizes and shapes suggest that they were
reused from earlier buildings. While scholars have claimed they are
salvaged from earlier temples, there are no images or any evidence of
excised images on them, suggesting that they could have come from
any building type, not necessarily a religious one.

In 1949 an image of Bharat Mata, Mother India, then a newly
invented goddess and a symbol of Indian nationalism, was installed
in the central *mihrab* (Figure 1.2). While Bharat Mata was and
remains a popular image on posters, this was only the second temple
dedicated to her.[18] In spite of concerted efforts, I have not yet come
across any mention of how the mosque was transformed into a Bharat
Mata temple, but given the political situation during this period,
the following is likely what transpired. Daulatabad was part of the
independent princely state of Hyderabad that in late 1949 was forced
to become part of the newly formed nation state of India. For several
years before and just after Hyderabad was incorporated into India,
there was a great deal of violence against Muslims there. Moreover,
close control over archaeological sites such as Daulatabad was a low
priority given the ensuing chaos. It thus would have been relatively
easy for right-wing Hindu nationalists to establish a temple to Bharat
Mata, a goddess dedicated to Hindu nationalism, under the guise of
Indian nationalism.

Daulatabad, built by a Hindu king but taken by Muslim rulers,
was in 1949 designated once again as Hindu with the installation
of this goddess. By 1949 the ground swell of Hindutva was visibly
growing. Hindu deities in that year were installed in mosques not
only in Daulatabad but also in Ayodhya. Only a year earlier Gandhi
had been assassinated by a militant follower of Hindutva.

Why did the Archaeological Survey of India allow a newly estab-
lished temple to remain inside Daulatabad's historical mosque? This
is not the norm at other Islamic sites protected by the Archaeological
Survey. But here at Daulatabad signage indicates that this structure
is a Bharat Mata temple, not a mosque. It was suggested to me that
this transformation was done by court order; however, I was not able
to verify this.[19] I did contact various officials. Only one responded
stating, 'The idol of Bharat Mata denotes Hindu–Muslim unity as
all Indians are sons and daughters of our mother land. It cannot be
seen and should not be seen in the context of [a] Hindu temple.'[20]

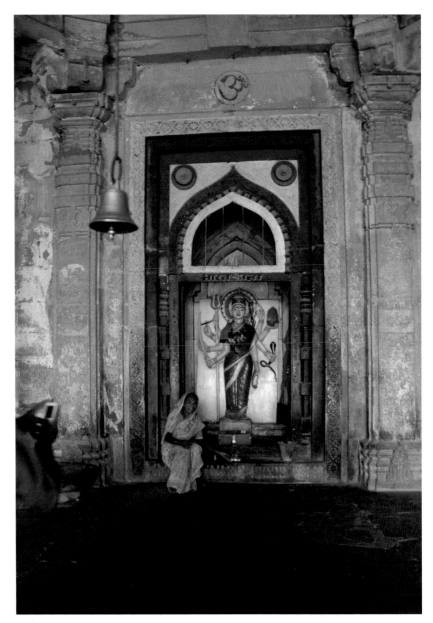

Figure 1.2 *Image of Bharat Mata (Mother India) installed in the* mihrab *of a Tughluq mosque; original mosque, fourteenth century; Bharat Mata, 1949, Daulatabad, Maharashtra, India. Photo © Catherine B. Asher.*

But, I ask, how can Muslims accept anthropomorphic imagery in a mosque? How can the image of Bharat Mata be anything but Hindu? The officer's response appears to reflect Hindutva ideology, though perhaps he was not aware of that.

Mohit Manohar, a graduate student at Yale, recently brought to

my attention a former tomb on top of the Daulatabad fort that has been transformed into a Ganesh temple. How and when this happened, I do not know, but again this change must have been made with the knowledge of the Archaeological Survey of India since all of Daulatabad is under their protection. In this case, there can be no claim that the tomb was once a temple, for it was completely built of new masonry, not reused materials.

With this apparent disregard for the historical character of these monuments, it seemed that the future of Indian mosques was dim. Indeed, events transpiring from the mid-nineteenth century in northern India would appear to underscore this notion. After Independence, Delhi's Muslim population dwindled and former Muslim neighbourhoods were now inhabited largely by immigrant Hindu and Sikh families. The Hindu and Sikh residents of former Muslim neighbourhoods built new settlements, known as colonies, that encroached on old tombs and mosques, which were seen as a nuisance, not structures that had any historical value. Until 1958 schoolchildren had to answer compulsory questions on Delhi's monuments, but with the abolition of this requirement younger persons who entered the government bureaucracy had little knowledge of Delhi's historic visual landscape.[21]

However, a second scenario, this one confined to the Indian states of Haryana and Punjab, is seemingly more hopeful. To the north and west of Delhi is Punjab, now divided into two states, Haryana and Punjab. This area once had a large Muslim population, but today it is very small. The homes these Muslims left behind at Partition were occupied by Hindus and Sikhs coming from Pakistan, but their mosques and tombs had little value for these non-Muslim newcomers. Some of the most significant saints' tombs are still actively visited, mostly by Hindus, and are cared for by a paid attendant, usually a Muslim whose family remained in India.[22]

Mosques, however, are a somewhat different story. As I drove through Haryana and Punjab, first in the early 1980s and then much more recently, I noted from the exterior many domed single aisled mosques (Figure 1.3); however, once I went inside I saw evidence of one or two different religious traditions. Most of these former mosques had been transformed into gurdwaras while fewer, it appears, had been recast as Hindu temples.[23] I even found one mosque in Farrukhnagar (Dt. Gurgaon, Haryana) that is now used as both a gurdwara and Hindu temple. To what extent did the Hindus and Sikhs who took over these old mosques, transforming them to their own needs, obliterate indications of a former Muslim presence? Images published on the Internet suggest that the original décor in many instances remained until just a few years ago, but my recent visit to some of these former mosques indicates that fresh uniformly applied paint has obliterated the original multi-coloured scroll and floral detail of most interior domes.[24]

Figure 1.3 *Jami' mosque, now used as a* gurdwara; *mosque, early seventeenth century;* gurdwara, *after 1947 to 2001; by 2017 it was once again used as a* gurdwara, *Sri Hargobindpur, Punjab, India. Photo © Catherine B. Asher.*

In some cases the original décor remains. The small former mosque in Dhamuli (Dt. Jalandhar, Punjab), now used as a gurdwara, has the Muslim creed still boldly visible on the structure's facade (Figure 1.4).[25] Another notable mosque also now used as a Sikh gurdwara remains in the town of Meham (Dt. Rohtak, Haryana). From the exterior this structure, with its cusped arches and stucco ornament, looks like a typical late eighteenth- or early nineteenth-century mosque (Figure 1.5). The *trompe l'œil* work on the interior suggests that it is a nineteenth-century product, although inscriptions on its exterior bear dates of the sixteenth and seventeenth centuries. There is also a portion of the central *mihrab* that appears to date to the sultanate period, all suggesting that this mosque has been rebuilt several times.

What is remarkable is how its current Sikh custodians have left most of the interior untouched, for its walls are covered with Urdu and Arabic inscriptions rendered elegantly in *nasta'liq* script (Figure 1.6). This is very different from the *gurmukhi* script of Punjabi in which the Sikh Holy Book, the Guru Granth, is written. It also differs from *nagari*, that is the script in which Hindi is written and appears ubiquitously in this part of India.[26] Paint is readily available, so had the new Sikh occupants wished to erase signs of former Muslim presence they easily could have done so. In a land where hostility, if

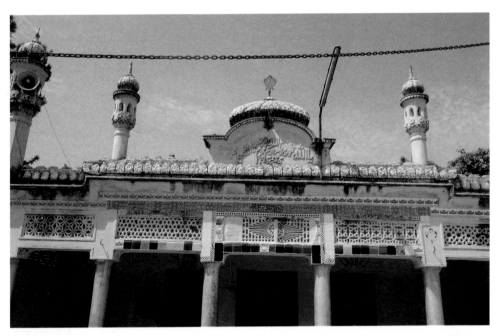

Figure 1.4 *Mosque, now used as a* gurdwara; *mosque, 1 Muharram 1365/
5–6 December 1945;* gurdwara, *after 1947 to present, Dhamuli, Punjab, India.
Photo © Catherine B. Asher.*

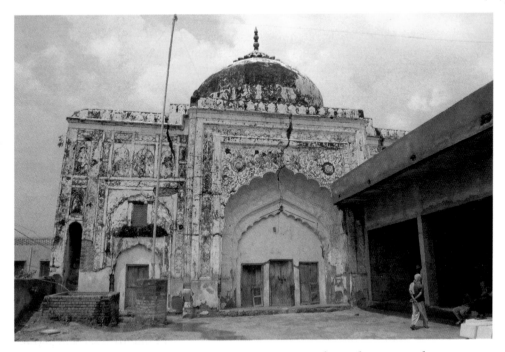

Figure 1.5 *Mosque, now used as a* gurdwara; *mosque, eighteenth–nineteenth century;*
gurdwara *after 1947 to present, Meham, Haryana, India. Photo © Catherine B. Asher.*

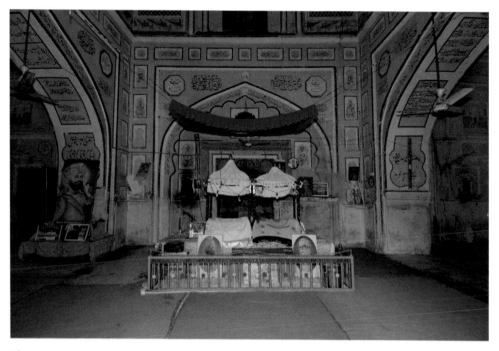

Figure 1.6 *Interior, mosque now used as a* gurdwara; *mosque, eighteenth–nineteenth century;* gurdwara *after 1947 to present, Meham, Haryana, India. Photo © Catherine B. Asher.*

not violence, among religious communities is all too common, this sign of a seeming acceptance of the past is refreshing. When I first went into this gurdwara I was somewhat hesitant to ask them why they had maintained all the original inscriptions and décor. After visiting the building a number of times, however, I was told that they very much appreciated the historical nature of the gurdwara, but when adequate funds are acquired they would build a new one.

While dozens of former mosques in Haryana and Punjab have been converted to gurdwaras and temples, there are two structures that stand out, each unique in its own manner. One is a highly unusual mosque built for poor Muslims in Sarwarpur (Dt. Ludhiana, Punjab) on the foundations of a mosque destroyed during Partition.[27] The entire project was funded by a wealthy Sikh businessman originally from Sarwarpur, now living in the UK. The majority of the labour was carried out by members of the local Sikh community. In the Sikh tradition physical labour for a temple or religious structure is considered to be service to God. This project, completed in 2010, joined the ranks of about twenty other mosques that had been rebuilt in Punjab, according to a local religious official with whom I spoke.

The second is the mosque in Sri Hargobindpur (Dt. Gurdaspur, Punjab) that was converted into a gurdwara and then, after much exchange of official documents, handed back to the Muslim com-

munity in 2001 (Figure 1.3). Religious historian Anna Bigelow has written about this mosque, its origins, its transformation to a gurdwara and then its reestablishment as a mosque.[28] Her essays gained attention and were quoted at length in publications across Punjab.[29] According to tradition, this mosque was built in the early seventeenth century by the sixth Sikh Guru, Sri Hargobind, for the local Muslim community. In 1947 the vast majority of the Muslims in Sri Hargobind left for Pakistan and, as the mosque stood empty, it was over time converted to a gurdwara. In 1997 conservation of the building began uncovering layers of paint and restoring the original inscriptions and floral décor. By 2001 the work was complete and a formal agreement was signed by representatives of the Punjab Waqf Board and the Sikhs who had been tending the mosque/gurdwara. At this point the structure was handed over to the Muslims and was once again used for *namaz* (prayer). Having read about this remarkable act of goodwill on the part of the Sikh community, I was eager to visit the mosque. The village of Sri Hargobinpur is well known, so reaching it was not difficult. However, as I entered the mosque's courtyard, I was dismayed to see a towering standard bearing the Sikh pennant and even more disappointed once I entered the building to see the Guru Granth in front of what was once a *mihrab* now embellished with a poster depicting the guru Sri Hargobind (Figure 1.7).

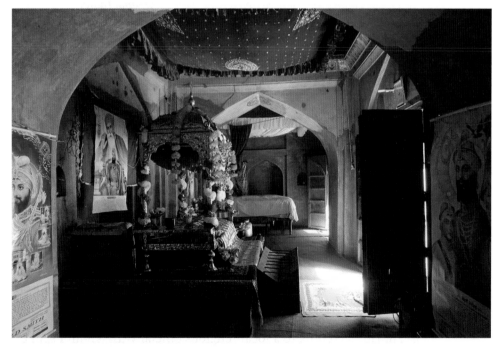

Figure 1.7 *Interior, Jami' mosque, now used as a* gurdwara; *mosque, early seventeenth century; gurdwara after 1947 to 2001; by 2017 it was once again used as a gurdwara, Sri Hargobindpur, Punjab, India. Photo © Catherine B. Asher.*

The goodwill had failed. Why? Perhaps because after 1947 there were virtually no Muslims left to care for the mosque and to uphold the agreement between the Sikhs and the Waqf Board.

Notes

1. Sita Ram Goel, *Hindu Temples, What Happened to Them*, rev. ed., 2 vols (New Delhi, 1998).
2. Cynthia Talbot, 'Inscribing the other, inscribing the self: Hindu-Muslim identities in pre-colonial India', *Comparative Studies in Society and History* 37.4 (1995), pp. 692–722; Richard M. Eaton, 'Temple desecration and Indo-Muslim states', in D. Gilmartin and B. B. Lawrence (eds), *Beyond Turk and Hindu: Rethinking Religious Identities in Islamicate South Asia* (Gainsville, 2000), pp. 246–81.
3. For this material, see Narayani Gupta, *Delhi between Two Empires, 1803–1931: Society, Government and Urban Growth* (Delhi, 1981), pp. 20–5.
4. Gupta, *Delhi between Two Empires*, pp. 27–32.
5. Catherine B. Asher, 'Sub-imperial palaces: power and authority in Mughal India', *Ars Orientalis* 23 (1993), pp. 284, 298, fig. 8.
6. Gupta, *Delhi between Two Empires*, p. 28; For before and after plans, see Mrinalini Rajagopalan, *Building Histories: The Archival and Affective Lives of Five Monuments in Modern Delhi* (Chicago, 2016), pl. 3.
7. See Gupta, *Delhi between Two Empires*, p. 27 for this quote and most of the following material in this paragraph.
8. Ebba Koch, *Mughal Architecture: An Outline of Its History and Development (1526–1858)* (Munich, 1991), p. 118.
9. Robert Grant Irving, *Indian Summer: Lutyens, Baker, and Imperial Delhi* (New Haven, 1981), pp. 50–2.
10. For the city's layout, see Irving, *Indian Summer*, pp. 53–90.
11. Rajagopalan, *Building Histories*, pp. 59–85.
12. Aditi Chandra, 'Potential of the "un-exchangeable monument": Delhi's Purana Qila, in the time of Partition, c. 1947–63', *International Journal of Islamic Architecture* 2.1 (2012), pp. 201–23.
13. Namit Saxena, 'Supreme Court's tryst with secularism and Hindutva,' *Economic and Political Weekly*, 2 May 2015, available at <http://www-lexisnexis com.ezp2.lib.umn.edu/hottopics/lnacademic/?verb=sr&csi =365197&sr=HEADLINE(Supreme+Court%27s+Tryst+with+Secularis m+and+Hindutva)%2BAND%2BDATE%2BIS%2B2015> (last accessed 20 July 2017).
14. Srinivas Aravamudan, *Guru English: South Asian Religion in a Cosmopolitan Language* (Princeton, 2006), pp. 34–6. See also Koenraad Elst, 'The incurable Hindu fondness for P. N. Oak', available at <http://koenraadelst.blogspot.com/2010/06/incurable-hindu-fondness-for-pn-oak.html> (last accessed 15 June 2016).
15. For example, P. N. Oak, *The Taj Mahal is a Temple Palace* (New Delhi, 1974) and his *Vedic World Heritage* (New Delhi, 1984).
16. For these events, see Manmohan Singh Liberhan, *A Report on Demolition of Structure at Ayodhya of Ram Janambhoomi Babri Masjid on 6th December, 1992: Commission of Inquiry Report of The Liberhan Ayodhya Commission of Inquiry, 2009* (Delhi, 2010); available at <http://docs.indiatimes.com/liberhan/liberhan.pdf> (last accessed 7 September 2020).

17. M. S. Mate and T. V. Pathy (eds), *Daulatabad (A Report on the Archaeological Investigations)* (Pune, 1992), pp. 9–11; Richard M. Eaton and Phillip B. Wagoner, *Power, Memory, Architecture: Contested Sites on India's Deccan Plateau, 1300–1600* (New Delhi, 2014), pp. 42–4.

18. The first Bharat Mata temple was dedicated in 1936 on the Kashi Vidyapeeth campus in Varanasi.

19. I thank Mohit Manohar for this suggestion.

20. This was written to me in an email of 5 November 2014 by an officer of the Archaeological Survey of India.

21. Narayani Gupta, 'Concern, indifference, controversy: reflections on 50 years of "conservation" in Delhi', in V. Dupont, E. Tarlo and D. Vidal (eds), *Delhi: Urban Space and Human Destinies* (New Delhi 2000), p. 15.

22. Some of these shrines maintain their Muslim identity, for example the Dargah of Shaikh Muhammad Turk Narnauli in Narnaul (Haryana) and the Rauza of Shah Nimatallah in Hisar (Haryana), while others such as the shrine of Lakh Baba in Kalanaur (Punjab) are recognised as having Muslim origins but are also venerated as a Sikh shrine. The mosque at Raja Taal (Punjab) has been turned into a gurdwara, but the graves are recognised as Muslim.

23. In addition to those structures discussed in this chapter, former mosques are now temples in Hisar and Sonepat (both Haryana), while those in Sirhind (Punjab) and Gidderanwali (Punjab) among others are now gurdwaras. Many other mosques are featured on the Facebook page 'Save the Mosques of India', available at <https://www.facebook.com/SaveTheMosquesOfIndia/> (last accessed 15 May 2017).

24. This is the case at the Badi Masjid at Sonepat now used as a Durga temple and the former mosque now called the Sita Ram temple at Farrukhnagar that is used as both a temple and gurdwara; at the Guru ki Maseet in Sri Hargobindpur (Punjab), traces of original paint still remain. One notable exception is the mosque, now used as a gurdwara, in Talinia (Dt. Fatehgarh Sahib, Punjab), where polychrome still outlines the net vaulting. I thank Dr Vandana Sinha for an image of its interior.

25. This is the mosque, now gurdwara, in Dhamuli (Dt. Jalandhar, Punjab). I thank Riyaz Latif for reading the date of this much over-painted inscription.

26. This mosque is in Haryana where Hindi written in *nagari* script is used; in Punjab where some other mosques in this chapter are located, Punjabi is spoken, which is written in *gurmukhi* script.

27. Available at <https://www.thenational.ae/world/asia/sikhs-rebuild-mosque-destroyed-during-partition-1.581831> (last accessed 28 September 2017).

28. Anna Bigelow, 'Guru ki Maseet', *Muslim India* 19.220 (2001), and 'Sri Hargobindpur: the Guru's secular city', *The Tribune* (Punjab), 24 June 2001; 'Unifying structures, structuring unity: negotiating the sharing of the Guru's mosque', *Radical History Review* 99 (2007), pp. 158–72.

29. The most accessible is available at <https://www.sikhiwiki.org/index.php/Guru_ki_maseet> (last accessed 12 May 2017).

Bibliography

Aravamudan, Srinivas, *Guru English: South Asian Religion in a Cosmopolitan Language* (Princeton, 2006).

Asher, Catherine B., 'Sub-imperial palaces: power and authority in Mughal India', *Ars Orientalis* 23 (1993), pp. 281–302.

Bigelow, Anna, 'Guru ki Maseet', *Muslim India* 19.220 (2001).

Bigelow, Anna, 'Sri Hargobindpur: the Guru's secular city', *The Tribune* (Punjab) (24 June 2001).

Bigelow, Anna, 'Unifying structures, structuring unity: negotiating the sharing of the Guru's Mosque', *Radical History Review* 99 (2007), pp. 158–72.

Chandra, Aditi, 'Potential of the "un-exchangeable monument": Delhi's Purana Qila, in the time of Partition, c. 1947–63', *International Journal of Islamic Architecture* 2.1 (2012), pp. 201–23.

Eaton, Richard M., 'Temple desecration and Indo-Muslim states', in D. Gilmartin and B. B. Lawrence (eds), *Beyond Turk and Hindu: Rethinking Religious Identities in Islamicate South Asia* (Gainsville, 2000), pp. 246–81.

Eaton, Richard M. and Phillip B. Wagoner, *Power, Memory, Architecture: Contested Sites on India's Deccan Plateau, 1300–1600* (New Delhi, 2014).

Elst, Koenraad, 'The incurable Hindu fondness for P. N. Oak', 23 June 2010, <http://koenraadelst.blogspot.com/2010/06/incurable-hindu-fondness-for-pn-oak.html> (last accessed 15 June 2016).

Facebook, 'Save the Mosques of India', <https://www.facebook.com/SaveTheMosquesOfIndia/> (last accessed 15 May 2017).

Goel, Sita Ram, *Hindu Temples, What Happened to Them*, rev. ed., 2 vols (New Delhi, 1998).

Gupta, Narayani, *Delhi between Two Empires, 1803–1931: Society, Government and Urban Growth* (Delhi, 1981).

Gupta, Narayani, 'Concern, indifference, controversy: reflections on 50 years of "conservation" in Delhi', in V. Dupont, E. Tarlo and D. Vidal (eds), *Delhi: Urban Space and Human Destinies* (New Delhi, 2000), pp. 157–71.

Irving, Robert Grant, *Indian Summer: Lutyens, Baker, and Imperial Delhi* (New Haven, 1981).

Koch, Ebba, *Mughal Architecture: An Outline of Its History and Development (1526–1858)* (Munich, 1991).

Liberhan, Manmohan Singh, *A Report on Demolition of Structure at Ayodhya of Ram Janambhoomi Babri Masjid on 6th December, 1992: Commission of Inquiry Report of The Liberhan Ayodhya Commission of Inquiry, 2009* (Delhi, 2010), <http://docs.indiatimes.com/liberhan/liberhan.pdf> (last accessed 7 September 2020).

Mate, M. S. and T. V. Pathy (eds), *Daulatabad (A Report on the Archaeological Investigations)* (Pune, 1992).

Oak, P. N., *The Taj Mahal is a Temple Palace* (New Delhi, 1974).

Oak, P. N., *Vedic World Heritage* (New Delhi, 1984).

Rahman, Shaikh Azizur, 'Sikhs rebuild mosque destroyed during Partition', *The National*, 6 July 2010, <https://www.thenational.ae/world/asia/sikhs-rebuild-mosque-destroyed-during-partition-1.581831> (last accessed 28 September 2017).

Rajagopalan, Mrinalini, *Building Histories: The Archival and Affective Lives of Five Monuments in Modern Delhi* (Chicago, 2016).

Saxena, Namit, 'Supreme Court's tryst with secularism and Hindutva', *Economic and Political Weekly*, 2 May 2015, <http://www-lexisnexis com.ezp2.lib.umn.edu/hottopics/lnacademic/?verb=sr&csi=365197&sr= HEADLINE(Supreme+Court%27s+Tryst+with+Secularism+and+Hindut va)%2BAND%2BDATE%2BIS%2B2015> (last accessed 20 July 2017).

Sikhi Wiki, 'Guru ki Maseet', <https://www.sikhiwiki.org/index.php/ Guru_ki_maseet> (last accessed 12 May 2017).

Talbot, Cynthia, 'Inscribing the other, inscribing the self: Hindu-Muslim identities in pre-colonial India', *Comparative Studies in Society and History* 37.4 (1995), pp. 692–722.

CHAPTER TWO

The 'Arraf Mosque in Dhu Jibla

Barbara Finster

THE MASJID 'ARRAF ('Arraf mosque) is located at the centre of the old city of Dhu Jibla, Yemen, not far from the Great Mosque built by Sayyida Arwa bint Ahmad, wife of King al-Mukarram b. 'Ali as-Sulayhi (459/1067–484/1091 or 477/1084), around 484/1087. It is a specimen of the small cubic mosque type that is widespread in Yemen. It measures 6 × 6 m (Figure 2.1). Constructed of relatively small stone blocks, it was comprehensively restored at an unknown time.

The south-west façade with the entrance, and also the east façade, were each given a new arch (Figure 2.2). It is likely that the upper blind arcade in stucco on the *qibla* wall also dates from this restoration. Small window openings on the west wall, and perhaps also on the east wall, were originally framed with blind arches as the walls rose. This lofty building is crowned by stucco crenellations at the centre and the corners. The monument in its present state has a hall on its western side, and also truly sumptuous ablution facilities provided with wash-basins.

An epigraphic panel over the *mihrab* records that the mosque was built in the month of Dhu'l-Qa'da 474/March 1082 by Sultan As'ad b. 'Arraf b. Muhammad b. Ibrahim. The Sulayhid king al-Mukarram Ahmad b. 'Ali had

ĜIBLA, ʿARRÂF MOSCHEE

AUFGEN. F. ZARRINGHALAM U. Z. MADANI
ĜEZ. U. Z.DRUCK ĜEZ. Z. MADANI X.86

0 1 2 3 4 5 10 m.

Figure 2.1 *Masjid 'Arraf, plan. Courtesy of Zitla Madani and Feridun Zarrin.*

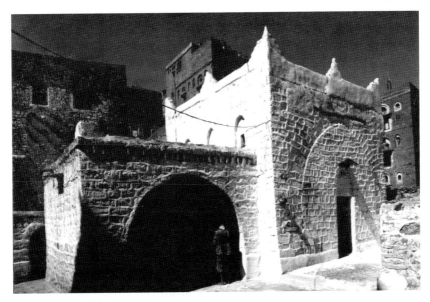

Figure 2.2 *Masjid 'Arraf, view from the south-west 1.*
Photo: Barbara Grunewald DAI.

appointed him governor of Zabid.[1] Given the difficult political situation in the Tihama, and especially Zabid, with its constantly changing conditions of governance, the question of how long As'ad b. 'Arraf was actually able to remain in Zabid remains open. Nevertheless, he seems to have played an important role in the exercise of Sulayhid rule, and he was later confirmed in his post by the queen, Arwa bint Ahmad.[2]

The city of Dhu Jibla was at that time a relatively new foundation. It had been founded only in 457–8/1065 by 'Abdallah b. Muhammad al-Sulayhi on the orders of his brother, King 'Ali b. Muhammad al-Sulayhi.[3] However, Dhu Jibla became the seat of government only when Sayyida Arwa bint Ahmad went there in 480/1087 in order to take over the affairs of state on behalf of her husband al-Mukarram Ahmad b. 'Ali. On the death of al-Mukarram in 484/1091 [or perhaps in 477/1084] Sayyida Arwa bint Ahmad took over the sovereignty of the Sulayhids, and, with the support of a relative, took on the task of mission (da'wa) for her under-age son.[4] She transformed the Dar al-'Izz, which had been built at the time that the city was founded, into a mosque, in which she was buried in 532/1138. However, the second Dar al-'Izz, which al-Mukarram had ordered to be built in 479/1086 or 481/1088 – a beautiful walled precinct with gardens – was left untouched.[5]

This means that the Masjid 'Arraf was erected some years before the new mosque. At the time of its construction Dhu Jibla was not yet the official seat of government and the new Great Mosque of Arwa bint Ahmad was not yet built.

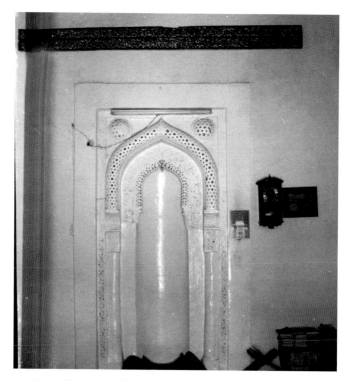

Figure 2.3 *Masjid 'Arraf*, mihrab *1. Photo: Barbara Grunewald DAI.*

The noteworthy features of the Masjid 'Arraf include the *mihrab*, the epigraphic panel above it, and the ceiling, which is made up of original coffers and bands of inscriptions. In comparison to the dimensions of the plan (6 × 6 m), the chamber is very high: 5.5 m. The proportions of the *mihrab* correspond to this height; it was subsequently enclosed by a wide and perhaps later frame.

The *mihrab* itself comprises a blind arch set on engaged columns with block capitals and abacus (Figure 2.3). The arches are stilted and open out energetically, ending in a pointed apex. The blind arch is framed by a torus moulding of lattice type formed of tiny openwork stars and emerging from a stylised vessel. The spandrels are filled with openwork hemispheres. The inner arched niche itself is lined with a screen made up of arcuated intersecting tendrils which open up to form trefoils. The inscribed band which marks the profile of the inner arch has been rendered illegible by being covered in oil paint, and the same masking effect can be noted on the block-like capitals of the engaged columns. It is probable that these bear tendril motifs. A narrow frame with undulating and intersecting tendrils encloses the whole.

The *mihrab*, in its simple but elegant linear design, scrolling ornament and what might be termed 'garlands', is one of the earliest to survive in Yemen. The form of the arcades recalls the mosque of

al-Hakim in Cairo (1003),[6] though one cannot recognise this as a direct model.

The so-called 'garlands' and tendrils, that climb up in arched form over the engaged columns, illustrate an ancient motif that appears here for the first time in Yemen, and was later to become popular.[7] In Egypt only the *mihrab* of al-Afdal Shahanshah (487/1094) in the mosque of Ibn Tulun has a screen-like woven arch treated in a sculptural manner; yet this does not rest on the columns that support the *mihrab* arch, but rather encloses the framing inscription band.[8]

The *mihrab* set up in the mosque of Sayyida Arwa bint Ahmad in Dhu Jibla underwent – some years later – an extension, in that the outer blind arch with its 'garland' decoration suggested a niche form. The *mihrab* consists of two niches, one inside the other, which are executed with lush richness. The woven 'garlands', so to speak, embroidered with floral stars, rise out of hemispherical glass vases over the imposts of the engaged columns carrying the outer arch. Not only are all the vaulted surfaces, columns, borders and frames covered with tendrils, but also the accentuation of the arches and the insertion of sculpturally executed triangles into the spandrels result in a distinctive articulation of the entire composition.[9]

So far the earliest known *mihrab* in Yemen is to be found in the mosque of Dhu Ashraq (410/1019), but this has been seriously denatured as a result of modern additions. The niche itself, with a threefold profiled pointed arch, is heightened by a lofty, slightly stilted round arch. Interlaced patterns cover the tympana. The star in the centre of the lower tympanon is particularly striking but was probably added later.[10]

The coffered ceiling

In the original form of the Masjid 'Arraf, a coffered ceiling decorated with stars created of tendrils spanned its interior space (Figure 2.4). The eight-pointed stellar blossoms, carved in wood, are grouped around eight globes which have retained their original gilding, and out of which heart-shaped tendrils grow. A second tendril encircles each globe, intersecting with the first tendril and reaching outwards in star formation with its palmette tips. Unfortunately, the remains of the original colour, which can be glimpsed under the whitewash, are scarcely visible, but it is possible that additional decorative motifs filled the background.

The idea of creating star forms out of tendrils in this way was new in Yemen. It was only in 519/1126 that there appeared in the Masjid 'Abbas in Asnaf/Khaulan a star ceiling with glittering golden stars formed of tendrils, which in its richness and inventiveness put all other coffered ceilings in the shade.[11]

In its present state, as already noted, the ceiling of the Masjid 'Arraf is put together with decorative strips and fragments of

Figure 2.4 *Masjid 'Arraf, coffered ceiling 1.*
Photo: Barbara Grunewald DAI.

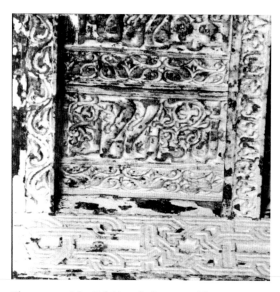

Figure 2.5 *Masjid 'Arraf, decorated beams 1.*
Photo: Barbara Grunewald DAI.

epigraphic bands, which originally encircled the walls underneath the ceiling. Embossed interlaced bands decorated the underside of the beams with alternating stellar and circular forms, while the transverse strips bore mobile, deeply undercut, undulating tendrils or had an arched frieze whose apices were each decorated with a trefoil (Figure 2.5). Strips with a frieze of deeply worked lotus palmettes marked the lower border of the epigraphic bands. The lotus leaves, which turn into palmettes, spread out generously, and join up with the neighbouring leaf, enclosing at their centres a three-leaved blossom. These alternate with two-leaved palmette forms whose leaves droop down on either side. This creates a closed band that extends to two registers and is enclosed, mobile and full of variations. In the deeper parts one can detect traces of light blue, and one may assume that originally the leaves too had some kind of colouring. A console frieze of rolled-up leaves which is still *in situ* originally supported the epigraphic band.

Inscribed panel over the *mihrab*

Text:

In the name of God, the Merciful, the Compassionate: a mosque that was founded upon god-fearing from the first day is worthier for thee to stand in; therein are men who love to cleanse themselves; and God loves those who cleanse themselves [Q.9:109].[12] There

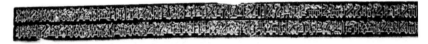

Figure 2.6a *Masjid 'Arraf, epigraphic panel over the* mihrab *in full.*
Photo: Barbara Grunewald DAI.

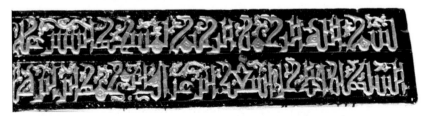

Figure 2.6b *Masjid 'Arraf, epigraphic panel over the* mihrab, *detail*
showing the bismillah. *Photo: Barbara Grunewald DAI.*

ordered the completion of this mosque the exalted Sultan al-As'ad
b. 'Arraf b. Muhammad b. Ibrahim b. Isma'il b. Qa'id (?) al-Himyari,
may God grant him success for that which he has done well, in the
month of Dhu'l-Qa'da of the year 474 AH [April 1082], in the city
of Dhu Jibla, may God protect it.

The letters in 'floriated Kufic' unfold on a ground line so that short
descenders or tails are possible while the shafts rise energetically
upwards. A line marks the border of the descenders. The shafts
expand in the upper register and end in two points, for example in
lam-alif. *Nun, ha'* or *mim* can end in tendrils with tiny leaves. *Waw*
has a central spike, while *'ayn* is treated like a soaring blossom. It is
noticeable that *ha'* takes a right-angled form comprising two linked
arches which draw together in the centre; *mim* is a complete circle
with a pointed centre and a crowning tendril. The *lam-alif* ligature
joins the two letters with a double crossbar, or they are linked at
their base by a downward-pointing triangle. Moreover, both initial
and terminal letters are apt to join up with the neighbouring word,
though *ibn* is elevated and is placed in stepped fashion between two
words. Additional tendrils and little leaves fill possible gaps, thereby
ensuring a harmonious and aesthetically balanced image.

Epigraphic panels on the ceiling

As already noted, in its present state the ceiling is made up of frag-
ments of the original inscription band that formerly encircled the
chamber. The text includes Sura 1 (the Fatiha), Sura 2:255 (the
Throne Verse), Sura 31:2–5 (of which only verse 5 is legible) and Sura
48:2. Since only fragments of the text can be recognised it remains
uncertain how much of the Fatiha or of the Throne Verse were
quoted.

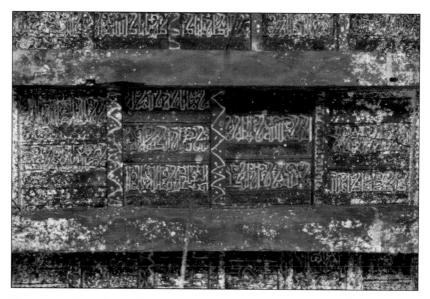

Figure 2.7 *Masjid 'Arraf, inscribed bands 1. Photo: Barbara Grunewald DAI.*

Sura 31:2–5:

> Those are the signs of the Wise Book
> for a guidance and a mercy to the good-doers
> who perform the prayer, and pay the alms,
> and have sure faith in the Hereafter.
> Those are upon guidance from their Lord; those are the prosperers.

Sura 48:2:

> that God may forgive thee and thy former and thy latter sins, and
> complete His blessings upon thee, and guide thee on a straight path.

Two epigraphic styles can be recognised. Some panels correspond roughly to the script over the *mihrab*, partially enriched by unusually voluptuous tendrils, while most of the panels have letters with long and supple shafts. Often, they do not respect the baseline or the lower border; delicate tendrils fill the interstitial spaces. The letters have a flattened base and operate almost as bands made out of letters that have been stretched to conform to that shape. In general, they are not as carefully organised as the compact script over the *mihrab*, but they have a corresponding liveliness.

The model for this spatially lively script wreathed in tendrils – floriated Kufic – could be sought in Fatimid inscriptions, notably the letters in the inscriptions of the mosque of al-Hakim in Cairo.[13] In favour of this hypothesis is the fact that al-Mukarram was a

da'i (missionary) and that his governors, the sultans, were assuredly Isma'ilis. So a political connection cannot be excluded. But the main point is that in Yemen in the early eleventh century floriated Kufic was in use. The first known example of this is the tombstone of Husain b. Qasim, a descendant of Hasan b. 'Ali b. Abu Talib, in the courtyard of the mosque of Dhamar, dated 394/1003–4. Although the letters are densely packed, tendrils are nevertheless inserted between the lines of the inscription as filler motifs. Letter endings morph with a reversed S into palmettes and even medial letters are ornamented. In rather archaic fashion mim is plumped out with a quatrefoil. In general, the inscription cannot be appreciated as an integrated whole and cannot really qualify as a beautiful example of floriated Kufic.[14] And yet the inscription – also chiselled in stone – on the façade of the mosque of Dhu Ashraq and dated 410/1019, a mosque which is attributed to Husain b. Salama (983–1012), is clear and distinct. The letters of the inscription on the façade of the prayer chamber of this mosque display the typical waw with a central spike, kaf and nun with a swan's neck, and 'ayn opening into a palmette. Only a few tendrils are introduced as infill between the letters, which are in any case closely set together.[15]

Incomparably more beautiful than these lines worked in stone is, however, the script on a wooden strip on the qibla wall of the Asha'ir mosque in Zabid, which was also founded by Husain b. Salama, in 407/1016–17 (Figure 2.8). According to Ibn al-Daib'a this strip is of teakwood.[16] It is a pity that now the text breaks off after the Qur'anic quotation, but the missing passage has been recorded by 'Abd al-Rahman al-Hadrami, and stated that the order to erect the structure was given by Husain b. Salama. However, it was completed only in the month of Rabi'a I 425/January 1034, after the death of Husain in 402–3/1011–12.[17]

The text gives Sura 9:18

> Only he shall inhabit God's places of worship who believes in God and the Last Day, and performs the prayer, and pays the alms, and fears none but God alone; it may be that those will be among the guided.

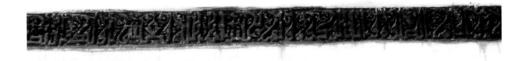

Figure 2.8 *Asha'ir mosque, Zabid, epigraphic panel 1. Photo: Barbara Grunewald DAI.*

The script makes lavish use of swan-necked forms marked by narrow upright shafts, split at the top, the spiked *waw* which blossoms out above, and the leafy tendrils which grow out of a *mim* in a richly decorative way. The letters themselves are relatively broad; their upper surfaces are rounded and grow out from the baseline. In spite of the forest of tendrils, the well-shaped letters stand proud of the deeper background from which they emerge. The lively terminal letters can morph into a palmette or tendril; the terminal *ha'* of Allah ends in a triple palmette. *Alif-lam* can be triply knotted, while *jim-dal* can be plaited, as in the word *masajid*. Tendrils with five-leaved palmettes and side-shoots cover all the remaining empty spaces in the upper zone and in the interstitial areas. Groups of words are clearly deline-ated, and sometimes they create their own formal composition, for example by means of the diagonal bevelling of the shafts or by making them parallel with each other. The script has a rounded and mobile quality which is different from that of the Masjid 'Arraf, and this may have something to do with the use of wood and the lack of colour.

Inscriptions from the time of the caliph al-Hakim, for example the epigraphic panel on the wooden doors of 1010, indicate that Fatimid models must have been decisive and inspirational.[18] The epigraphic panel in the Masjid al-'Umari in Qus, datable to the eleventh century, is similar in many respects. Even though the letters are placed close together, they are lifted well above the ground from which they rise; little room is left for tendrils and palmettes.[19]

Husain b. Salama was a Nubian *mamluk* of the Ziyadi amir Abu'l-Jaish Ishaq b. Ibrahim, who ruled in Zabid from 291/903–371/981.[20] After the amir's death he reigned for the amir's under-age son 'Abdallah from 373/983 to 402/3/1012, and it is certain that, like the Ziyadi rulers, he was a Sunni. He was known for his philanthropy, and for his building of mosques and of way-stations along the pil-grimage route from the Hadramaut to Mecca.[21]

It seems that Husain b. Salama valued Fatimid art. The proof for this lies *inter alia* in the carved beam ends in the naves of the sanctu-ary of the Great Mosque in Zabid which he built in 393/1002 in place of the first mosque founded in 205/820. These serve to this day as supports for the transverse beams of the flat wooden ceiling and are decorated for the most part with ornament of the 'second bevelled' style of Samarra.[22]

Thus, floriated Kufic was used in Yemen in the early eleventh century and was important not only for Shi'ite but also for Sunni mosques.[23] Nor should one exclude the possibility, as already sug-gested, that the patron of the Masjid 'Arraf, Sultan As'ad b. 'Arraf, deliberately chose this style of script, which was widespread in the Fatimid domains, in order to establish his close relationship with the Fatimid caliphate.

A few years later Sayyida Arwa bint Ahmad also availed herself of this type of script, albeit with variations and refinements, in her

own mosque, in a framing strip for the *mihrab*. The contoured letters with their elegantly sinuous endings create a network of tendrils and can be clearly recognised as words distinctly separated from each other, without any additional ornament.

The Masjid 'Abbas in Asnaf/Khaulan was built in 519/1126 and, quite apart from its gilded coffered ceiling, it is also decorated with many individually distinct epigraphic bands. The great frieze that runs right round the walls immediately beneath the ceiling marks a further variant of floriated Kufic. The rigid letters here are accomplished set pieces. What is noteworthy is the new arrangement which controls the entire inscription frieze. The lofty shafts whose tips intermittently turn towards each other, or are clipped, serve to bracket the rows of letters and thus organise the movement of the epigraphic band.[24]

Conclusion

In spite of its modest dimensions, the Masjid 'Arraf in Dhu Jibla stands out by virtue of its richness and the quality of its fittings. There is a notably sculptural quality discernible in the undulating tendrils on the inner side of the ceiling beams, while below the epigraphic bands appears a richly varied lotus and palmette frieze. The stars formed of tendrils that fill the coffers of the ceiling are exceeded in quality only by the stars in the Masjid 'Abbas/Asnaf. The stucco-work of the *mihrab* niche, now made unrecognisable by the application of oil paint, display the first examples of the 'garland' arch, emerging from stylised vessels, encountered so far in Yemen. Perhaps, indeed, this is the first time that a *mihrab* niche took this form. The epigraphic panel over the *mihrab* is especially impressive in the balanced arrangement of its letters.

The identity of the craftsmen who erected the Masjid 'Arraf in Dhu Jibla remains an open question. The names of craftsmen, such as remain from this period, occur on the façade of the mosque of Dhu Ashraq and on the *mihrab* in the Masjid Abbas/Asnaf and seem to be Yemenis.[25] It is possible that As'ad b. 'Arraf could have employed craftsmen from Egypt and elsewhere and these men might have brought with them new forms of artistic expression. The relatively sculptural execution of the undulating tendrils is, so far as one can judge at present, unusual in the Yemeni art of this period. Nor does the lotus-palmette frieze belong in the repertory of Yemeni ornament, and it is also possible that the *mihrab* was an innovation, unless indeed the first Great Mosque in Dhu Jibla provided the model for it. The form of this *mihrab* – the framing of the niche with a blind arch and the dissolution of the surface by lattice ornament – was then transmitted to the mosques constructed by Zaydi Shi'ites. It attained its classical expression in the mosque of Zafar Dhibin (before 614/1217) and maintained itself for a long time thereafter.[26]

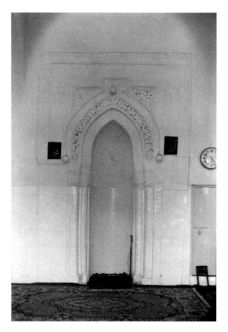

Figure 2.9 *Janad mosque,* mihrab *1.*
Photo: Barbara Grunewald DAI.

The simpler *mihrab* niche, like the one in the Masjid 'Arraf, recurs – this time provided with an additional quatrefoil – in the *mihrab* of the Great Mosque of Dhamar.[27] This monument is perhaps to be dated to the twelfth to thirteenth century and also served a Shi'ite congregation. On the other hand, the *mihrab* of the Great Mosque of Janad, a variant of this model and executed wholly in the spirit of Sulayhid art, was plainly commissioned by the Ayyubid Atabeg Saif al-Din Sunqur (598/1201/2–607/8/1210). Inscriptions on the capitals testify that this is the work of 'Abdallah b. Abi'l-Faraj who completed his work in Rajab 613/1216. While the organisation of the *mihrab* entirely corresponds to traditional forms, the decoration of the *mihrab* hood and the cursive script both announce the arrival of a new style (Figure 2.9).[28]

In the following centuries the religious architecture of the Sunni Rasulid dynasty deliberately developed new, even 'modern' forms in a programmatic way which differentiated their work from the strongly conservative style of religious architecture favoured by earlier Shi'ite and Zaidi patrons. The architecture of the latter was characterised, as already noted, by inscriptions in floriated Kufic and by richly conceived forms of the *mihrab* with perforated stucco ornament. The Masjid 'Arraf in Dhu Jibla is an early example of this style.

Notes

1. The mosque was measured and photographed in October 1987. The survey team comprised Zitla Madani and Feridun Zarrin (architects) and Barbara Grunewald (photographer). I want to express my gratitude to Robert Hillenbrand for kindly translating the article and to Ahmad Wahby for reading the inscriptions. Husain ibn Faid Allah al-Hamdani, *As-Sulaihiyun wa'l-harakat al-fatimiya fi'l-Yaman (min sanat 268 ila sanat 626 h)* (Cairo, 1887/8), p. 151, n. 1; Henry C. Kay, *'Umara: Yaman, Its Early Medieval History by Najm ad-Din 'Imarah al-Hakami, also the Abridged History of Its Dynasties by Ibn Khaldun and an Account of the Karmathians of Yaman by Abu 'Abd Allah Baha ad-Din al-*

Janadi, (Farnborough, 1892; repr. 1968) p. 38. According to Christian Robin, in *La Mosquée al-'Abbas et l'Histoire du Yemen* (Damascus, 1999), p. 30, n. 47, some shaikhs of the tribes took the title of sultan.

2. 'Ali b. Muhammad al-Sulayhi (429/1037–454/1063) conquered Zabid in 454/1063, but in 459/1067, while he was on the pilgrimage, he was attacked and killed by the sons of the previous ruler of Zabid, Amir Najah. Thus, the Tihama again managed to escape from Fatimid control, even though al-Mukarram succeeded in again occupying the city for a time (Husain 'Abdallah al-'Amri, 'As-Sulaihiyun 429–492', in *Encyclopedia of Yemen* (Beirut, 1992), p. 573; Heinz Halm, *Die Kalifen von Kairo, Die Fatimiden in Ägypten, 973–1074* (Munich, 2003), p. 339).

3. Al-Hamdani, *As-Sulayhiyun*, pp. 136, n. 1, 148; Kay, *'Umara*, p. 40; 'Abd a-Rahman ibn Ali al- Daib'a, *Bughyat al-mustafid fi tarikh Madinat Zabid* (San'a', 1979), p. 50.

4. Yahya Ibn al-Husain, *Ghayat al-amani fi akhbar al-qutr al-Yamani* (Cairo, 1968), pp. 271, 274; 'Abd al-Rahman ibn 'Ali al-Daib'a, *Kitab Qurrat al-'uyun bi-akhbar al-Yaman al-maimum* (Beirut, 1988), p. 189 ('death of al-Mukarram'); al-'Amri (here only Sayyida bint Ahmad), p. 574; Kay, *'Umara*, p. 40; Robin, *al-'Abbas*, p. 39. According to al-Hamdani, it was the amir al-Mukarram who transferred his formal residence in 479/1086 from San'a' to Dhu Jibla (al-Hamdani, *As-Sulaihiyun*, p. 136, n. 1); according to Kay, *'Umara*, p. 41, this was in the year 481/1088.

5. Al-Hamdani, pp. 136, n. 1 and p. 137; Kay, *'Umara*, p. 41.

6. K. A. C. Creswell, *The Muslim Architecture of Egypt, Vol. I: Ikhshids and Fatimids* A.D. *939–1171* (Oxford, 1952; repr. New York, 1978), pl. 31d, fig. 41b.

7. This motif goes back all the way to a classical and late antique type of portal decoration, which finds sculptural expression at Qasr al-Hair al-Gharbi and is found in a religious context in *mihrab* arches, for example in the mosque of Na'in (tenth century; see Arthur Upham Pope and Phyllis Ackerman (eds), *A Survey of Persian Art from Prehistoric Times to the Present* (Oxford and London, 1938–9; repr. Tehran, 1967), vol. 8, pl. 269.

8. Jonathan Bloom, *Arts of the City Victorious* (New Haven, 2007), pp. 137–8 and fig. 103.

9. *ABADY* (Mainz, 1982) vol. I, Taf. 93.

10. *ABADY*, vol. I, pl. 88a; according to Solange Ory, *De l'Or du Sultan à la Lumière d'Allah, La Mosquée al-'Abbas à Asnaf (Yémen)* (Damascus, 1999), p. 251, the *mihrab* of the Masjid 'Abbas/Asnaf of 519/1126 is the oldest dated *mihrab* in Yemen. The star design in the niche of the *mihrab*, which carries a particular meaning, is also found in the Masjid 'Abbas/Asnaf and in the Qubbat 'Arraf in Wusab (Ory, *L'Or*, p. 242; Barbara Finster, *Qubbat 'Arraf in der Provinz Wusab al-'Ali/Jemen* (Berlin, 2016), fig. 13.

11. Ory, *L'Or*, pp. 114 and 129; *ABADY*, vol. III, pls 62–5. In the coffers of the mosque of Dhu Ashraq, wreaths of palmettes, but not stars made up of tendrils, create a circle around a central six-leaved blossom. It was common practice to have geometrically constructed eight-pointed stars, as can be seen, for example, in the mosque of Sayyida Arwa bint Ahmad in Dhu Jibla or in the mosque in Ibb (*ABADY*, vol. I, pls 96 and 99).

12. Arthur J. Arberry, *The Qur'an Interpreted* (London, (1964), p. 192.

13. Bloom, *City Victorious*, fig, 47; Sheila Blair, 'Floriated Kufic and the

Fatimids', in M. Barrucand (ed.), *L'Égypte Fatimide son art et son histoire* (Paris, 1991), pp. 107–16.

14. *ABADY*, vol. III, pl. 35.
15. *ABADY*, vol. I, pl. 90.
16. Al-Daib'a, *Bughyat*, p. 41; 'Abd ar-Rahman ibn 'Abd Allah al-Hadrami, *Zabid, masajiduha wa madarisuha al-'ilmiyya fi'l-tarikh* (Damascus, 2000), p. 55.
17. Al-Hadrami, *Zabid*, p. 55, al-Daib'a *Bughyat*, p. 46: 'and that which is in the inscription (*tiraz*) that is located in the front part of the Masjid al-Asha'ir and concerns the date of its completion, this was installed only after the death of Husain. And God knows best'. The date of the death of Husain b. Salama is disputed; according to al-'Amri, it took place in 403/1012 (*As-Sulaihiyun*, p. 179).
18. Bloom, *City Victorious*, fig. 37.
19. Marianne Barrucand (ed.), *Trésors fatimides du Caire* (Paris, 1998), p. 152. The letters themselves are smoothed flat rather than rounded and thus have a stiffer appearance. *Mim* has the typical circle at the centre, crowned by a palmette, while *'ayn* takes floral form in the shape of an inverted U (*Trésors*, no. 93). Gaston Wiet dates the panel, on the basis of a historical tradition, to the year 473/1080 (Gaston Wiet, 'Deux Inscriptions coufiques de Kous', *Bulletin de l'Institut d'Égypte* XVII (1936), pp. 31–7).
20. Al-'Amri, *As-Sulaihiyun*, pp. 178–9.
21. 'He built the Masjid al-Asha'ir there [in Zabid], the Great Mosque, the Mu'adh mosque at the beginning of the *wadi* under the mountain, and the Inqaza mosque in the lower *wadi* on the sea-coast.' There is also a reference to the Great Mosque of Haly [Halya?], the Masjid al-Ribat in Abyan, which was the most beautiful and spacious of these mosques: al-Daib'a, *Bughyat*, p. 41.
22. Al-Hadrami, *Zabid*, p. 47; al-Daib'a, *Bughyat*, p. 41. Hitherto the only known work of art in Yemen to illustrate the 'second bevelled style' was a *minbar* in the Great Mosque of Dhamar (*ABADY*, vol. III, pls 38 and 39). Presumably this *minbar* was an import.
23. 'Thus it is clear that styles of script evolved independently of political changes'(Blair, 'Floriated Kufic', p. 113).
24. Ory, *L'Or*, p. 204.
25. *ABADY*, vol. I, p. 227; Ory, *L'Or*, pp. 245–6.
26. *ABADY*, vol. I, pl. 110. The mosque of Huth probably had an arch of sculptural type (*ABADY*, vol. I, pl. 104).
27. *ABADY*, vol. III, pl. 33b.
28. Saif ad-Din Sunqur who reigned as Atabeg (598/1201/2–607/8/1210) for the minor son of Tughtegin ibn Ayyub (577/1182–593/1197), restored large sections of the Great Mosque in Janad after its destruction by al-Mahdi b. 'Ali al-Mahdi in 558/1163 (al-Daib'a, *Kitab Qurrat*, p. 289; Paolo M. Costa, 'The mosque of al-Janad', in R. L. Bidwell and G. R. Smith (eds), *Arabian and Islamic Studies* (London, 1983) p.44). The *mihrab* with its stilted pointed arch, its perforated 'garlands' emerging from vases, and its sculpturally modelled spandrels, could also date from the time of Sayyida Arwa bint Ahmad.

Bibliography

ABADY (*Archäologische Berichte aus dem Yemen*), Vol. I (Mainz, 1982), Vol. III (Mainz, 1987).

Al-'Amri, Husain 'Abdallah, '*As-Sulaihiyun 429–492*', in A. J. 'Afif *et al.* (eds), *The Encyclopedia of Yemen*, Vols 1 and 2 (Beirut, 1412/1992), pp. 573–4.

Arberry, Arthur J., *The Koran Interpreted* (London, 1964 (first published 1955)).

Barrucand, Marianne (ed.), *Trésors fatimides du Caire*, Exposition, Catalogue (Paris 1998).

Blair, Sheila, 'Floriated Kufic and the Fatimids', in M. Barrucand (ed.), *L'Égypte Fatimide son art et son histoire*, Actes du colloque organisé à Paris les 28, 29 et 30 mai 1998 (Paris, 1999), pp. 107–16.

Blair, Sheila, *Islamic Inscriptions* (Edinburgh, 1998).

Bloom, Jonathan, *Arts of the City Victorious* (New Haven, 2007).

Costa, Paolo M., 'The mosque of al-Janad', in R. L. Leonard and G. R. Smith (eds), *Arabian and Islamic Studies: Articles Presented to R. B. Serjeant on the Occasion of His Retirement from the Sir Thomas Adams's Chair of Arabic at the University of Cambridge* (London, 1983), pp. 43–67.

Creswell, K. A. C., *The Muslim Architecture of Egypt, Vol. I: Ikhshids and Fatimids* A.D. *939–1171* (Oxford, 1952; repr. New York, 1978).

Al-Daib'a, 'Abd ar-Rahman ibn 'Ali, *Bughyat al-mustafid fi ta'rikh Madinat Zabid*, ed. 'A. M. al-Hibshi (San'a', 1979).

Al-Daib'a, 'Abd ar-Rahman ibn 'Ali, *Kitab Qurrat al-'uyun bi-akhbar al-Yaman al-maimun*, ed. M. al-Akw'a al-Hiwali (Beirut, 1409/1988, 2nd ed.).

Finster, Barbara mit einem Beitrag von Ahmed Wahby, *Qubbat 'Arraf in der Provinz Wusab al-'Ali/ Jemen*, Zeitschrift für Orient-Archäologie Bd. 9 (Berlin, 2016), pp. 243–64.

Flury, Samuel, *Die Ornamente der Hakim- und Ashar-Moschee, Materialien zur Geschichte der älteren Kunst des Islam* (Heidelberg, 1912).

Al-Hadrami, 'Abd ar-Rahman ibn 'Abd Allah, *Zabid, masajiduha wa madarisuha al-'ilmiyya fi'l-ta'rikh* (Damascus, 2000).

Halm, Heinz, *Die Kalifen von Kairo, Die Fatimiden in Ägypten 973–1074* (Munich, 2003).

Al-Hamdani, Husain ibn Faid Allah, *As-Sulaihiyun wa'l-harakat al- fatimiya fi'l-Yaman (min sanat 268 ila sanat 626 h)* (Cairo, 1305/1887-8).

Herzfeld, Ernst, *Der Wandschmuck der Bauten von Samarra und seine Ornamentik, Die Ausgrabungen von Samarra/Erster Band* (Berlin, 1923).

Kay, Henry C., '*Umara: Yaman, Its Early Medieval History by Najm ad-Din 'Omarah al-Hakami, also the abridged History of its Dynasties by Ibn Khaldun as an Account of the Karmathians of Yaman by Abu 'Abd Allah Baha ad-Din al-Janadi* (Farnborough, 1892; repr. 1968).

Al-Maqhafi, Ibrahim Ahmad (ed.), *Mu'jam al-buldan wa'l-qaba'il al-Yamaniya* (San'a', 1988).

Ory, Solange (ed.), *De l'Or du Sultan à la Lumière d'Allah, La Mosquée al-'Abbas à Asnaf (Yémen)* (Damascus, 1999).

Pope, Arthur Upham and Phyllis Ackerman (eds), *A Survey of Persian Art from Prehistoric Times to the Present*, Vol. VIII (Oxford and London, 1938–9; repr. Tehran, 1967).

Robin, Christian, 'La Mosquée al-'Abbas et l'Histoire du Yemen', in S. Ory (ed.), *De l'Or du Sultan à la Lumière d'Allah, La Mosquée al-'Abbas à Asnaf (Yémen)* (Damascus, 1999) pp. 23–40.

Wiet, Gaston, 'Deux Inscriptions coufiques de Kous', *Bulletin de l'Institut d'Égypte* XVII (1936), pp. 31–7.

Yahya ibn al-Husain ibn al-Qasim, *Ghayat al-amani fi akhbar al-qutr al-Yamani*, ed. S. 'Abd al-Fattah 'Ashur (Cairo, 1968).

CHAPTER THREE

Monumentality *en Miniature*: On Two Dome-shaped Carpet Weights – *mir-i farsh*

Kjeld von Folsach

IT IS NOT always an easy task to write an essay for a Festschrift. The written word should preferably live up to the standard set by the people to be honoured, something that is naturally almost impossible in this case. When the recipients are furthermore such good old friends as Sheila Blair and Jonathan Bloom, it would actually be more tempting to say thanks for all the good times, to dwell on memories, and to write anecdotes about these two energetic individuals instead of presenting an arid account of some kind.

But back to the straight and narrow. When Babur laid the foundation for the Mughal Empire in northern India following the battle at Panipat in 1526, five sultanates in the Deccan in Central India – Bidar, Bijapur, Ahmadnagar, Berar and Golconda – had been established more or less simultaneously in the wake of the disintegration of the Bahmanid state.

In the course of the seventeenth century, the southern sultanates were slowly but surely swallowed up by their increasingly dominant neighbour to the north, but previously, two artistic traditions had emerged that despite many similarities also had their own expression in architecture, painting and decorative art.

The two relatively modest works of art that will be discussed here (Figures 3.1 and 3.2) come from these two regions.

Figure 3.1 *Carpet weight, black basalt, H: 27.6; W: 12.8; D: 12.8 cm, India, Deccan, c. 1650, The David Collection 1/2016. Photo: Pernille Klemp.*

Figure 3.2 *Carpet weight, white marble inlaid with carnelian, lapis lazuli, green glass and a yellow, amber-like material, H: 9.8; W: 9.9; D: 9.9 cm, India, Mughal, c. 1650, The David Collection 12/2012. Photo: Pernille Klemp.*

They are two carpet weights (*mir-i farsh*), objects that could be used in both a secular and a religious context. Their function was first and foremost to keep thin carpets or covers in place in a specific position, and consequently the designation 'weights for floor coverings or tomb covers' might be more suitable, though less idiomatic, than carpet weights.

The designation *mir-i farsh*

In modern scholarship, carpet weights of this kind are often referred to using the Persian designation *mir-i farsh*. Strangely enough, the term cannot be found in any Persian dictionary, and it may have been coined in Europe, or more likely in India.[1] It is uncertain when it emerged, and the earliest use of the designation that I have been able to find in the David Collection's library comes from India, where in 1969 Moreshwar G. Dikshit wrote 'Mir Pharash' about a carpet weight made of glass.[2] The term is, however, most probably older.

Dikshit did not translate the concept, but Mark Zebrowski did in a shorter article from 1982. He wrote '*mir-i farsh*, or "slaves of the carpet"'.[3] This translation was repeated in Zebrowski's important and seminal book *Gold, Silver & Bronze from Mughal India* from 1997,[4] and it was used repeatedly thereafter in innumerable catalogues of collections, exhibitions and galleries.

In 1985 Vishakha Desai added a little detail, not to the translation, but to the concept. He described a large carpet weight of bidri metal and almost in keeping with Zebrowski's usage called it '*Mir-e-farsh* (literally "slaves of carpet")'. Desai further noted that the concept

mir-e-farsh covers not only individual carpet weights, but also 'posts for low beds'.[5] This latter meaning of the term does not seem to have been commonly used since, and in any case, carpet weights are the focus here.

In his 2011 book about bidri ware, Jagdish Mittal introduced a variation on the now common translation, writing 'slaves of the floor',[6] a translation that was adopted by Ramaswami and Sing in 2015.[7]

Logically, one could wonder how often richly decorated carpet weights placed on top of a textile could be considered its slaves – that is, have a subordinate, subservient function. Naturally one could make the case that they serve the textile by keeping it in place. But actually, the Persian word *mir* does not mean 'slave'; it means quite the opposite: 'master'. Without knowing when the expression *mir-i farsh* was coined, the translation for this group of objects should in the future in any case be corrected to 'master of the carpet'.[8]

Function, form and materials

As noted, carpet weights are intended to keep thin textiles in place so that they do not flutter in the wind. In the hot Indian climate, it was common to cover stone terraces, and also thick woollen pile carpets, with light summer carpets or floor coverings of cotton that could be richly decorated with embroidery or printed patterns. Pieces of this kind have been preserved and are found on countless miniatures from India, and to a lesser extent also from Iran. Considering the fairly large number of carpet weights and even larger number of miniatures from the Indian subcontinent that show individuals or groups seated on carpets of this kind atop platforms in gardens, on terraces, and also indoors, there are surprisingly few miniatures that show carpet weights in use. Despite persistent searches, I have been able to find only a few, and none of them is from the Mughal court or the courts in the Deccan. The material comes from Bikaner, Malwa and the Hills and dates to the late seventeenth and eighteenth centuries.[9]

It was consequently rather surprising to find miniatures with carpet weights from Safavid Iran. Two were painted by Ali Quli Jabbadar in the second half of the seventeenth century and presumably show Shah Sulaiman (r. 1666–94).[10] In both cases, the carpet weights keep a light summer carpet in place on a much larger pile carpet, and the carpet weights seem to be the same: hemispherical with a little knob. They are presumably made of gold and set with four rows of precious stones, perhaps rubies and emeralds. Nearly a century later, in a manuscript about Nadir Shah from 1757, we find related golden carpet weights.[11] All these carpet weights could look like the work of Indian goldsmiths and could certainly be gifts from India or, in Nadir Shah's case, war booty. Carpet weights seem to be largely an Indian phenomenon and none have, as far as I know, been

published that can with certainty be attributed to Iran, or for that matter any of the other large nations in the world of Islam.

The use of carpet weights discussed so far belongs to the secular sphere and should be seen first and foremost in connection with Indian (and Persian) court culture. But they were used and are used this very day in a religious context as well, keeping textiles of different kinds in place on the tombs of both holy men and princes. Mark Zebrowski wrote:

> In one northern Deccani shrine, I saw innumerable *mir-i farsh* in a great variety of materials, shapes and sizes. Arranged in no particular order, although they were always on a straight line along the edge of the tomb cloth, they formed rows of miniature domes in *bidri*, brass, bronze, marble and crystal, symbols of the shaykh's power and popularity.[12]

I have personally seen carpet weights used in this way in the tombs of the Nizams in the Mecca mosque in Hyderabad (Figure 3.3) and in the mausoleum of Jahan Begum in Ainapur in Bijapur. All of the carpet weights were quite simple and made of marble and their shape did not differ markedly from the form of those found in secular depictions.

By far the majority of carpet weights that have been preserved demonstrate the same basic shape, despite their differences: a top section that is easy to grip with a single hand and a base that gives the piece weight and stability. The uppermost part is most often shaped like a sphere or a dome with a more or less architectural

Figure 3.3 *Carpet weights used at the tombs of the Nizams in the Mecca mosque, Hyderabad. Photo: Peter Wandel.*

design and is decorated to some extent, but might also take the shape of a flower bud or flower in bloom – an iris, for example.[13]

In most cases, the base is square, but it can also be polygonal or circular. Its height in relation to the 'dome' varies, but it generally seems like a fairly low pedestal for it. It is practical to be able to move a carpet weight with one hand, and most weights are in fact around 10 cm high, with a base of the same depth and width. Both somewhat smaller and larger pieces are also found, and a few, like the David Collection's basalt carpet weight (Figure 3.1), which measures nearly 28 cm, are actually so big and heavy that it is difficult to lift them with one hand.

A certain mass is naturally necessary if a carpet weight is to fulfil its mission: to keep fluttering textiles in place in the wind, whether they lie on a terrace or rest on a tomb. Heavy materials would consequently be generally preferable to light ones.

The most common carpet weights formerly and currently in use are made of various types of stone, a material that could also stand up to India's often humid climate and a material whose price could range from low for modest, simple types (Figure 3.3) to high for more elaborate ones. The two carpet weights described here are of marble and basalt, but others are of alabaster and rock crystal.[14] In principle, all types of stone can be used, and jade, which is so highly prized in India, could be an obvious material, though I do not know of any examples. Their value can naturally be increased by carving the material and embellishing it with intricate forms; they can be inlaid with semi-precious stones (*pietra dura*) or with gold and precious stones.

Metal is another obvious choice. Carpet weights made of the blackish-grey bidri alloy seem to be most common, and they can be found in many institutions.[15] Like so many other items made of bidri, they are most often inlaid with silver, but also with brass, to achieve a richer colouristic effect. There are also silver-plated[16] and gilded copper or bronze carpet weights, and there is even a set inlaid with enamel – an unusual choice.[17] Carpet weights made of precious metals would conceivably be used at court, and the museum in Mehrangarh Fort in Jodhpur has a set of four made of silver with traces of their original gilding.[18] The carpet weights found on the miniatures from the Persian court mentioned above (see notes 10 and 11) seem to be made of gold inlaid with precious stones, something that could be expected in this context, but they could naturally also be made of less expensive silver gilt, copper or bronze.

Carpet weights made of porcelain have also survived: Chinese export goods intended for the Indian and perhaps Persian market. In 1990, a private Indian collector offered the David Collection four seventeenth–eighteenth-century carpet weights c. 10 cm high with a floral decoration painted in blue under the glaze and highlighted with gold over the glaze. Another carpet weight, c. 14 cm high, with

Kangxi *famille verte* decoration has moreover been published with an Indian provenance.[19] There was apparently also a local Middle Eastern production of ceramic carpet weights. The Victoria and Albert Museum has one with a green glaze – domed with a circular base – made of fritware and attributed to seventeenth–eighteenth-century Iran, described in the museum's database as possible export ware to India.[20]

Like porcelain, glass was also used as a material for carpet weights. In his *History of Indian Glass*, Moreshwar Dikshit mentions a glass carpet weight in Bharat Kala Bhavan in Varanasi. The account unfortunately seems to be lacking measurements and a description, but the carpet weight appears to have been cast in the usual domed shape on a square base with a cut scale pattern.[21] Another carpet weight of glass is in the David Collection.[22] Its shape is a stylised version of the one mentioned above, but the technique is completely different. It has a dark-green body with marvered decoration in the form of more or less stylised flowers in largely yellow glass, but with details in red and white glass and traces of gilding.

These materials – stone, metal, porcelain and glass – are all heavy when they are solid, but other materials can also be used if they have an inner core of metal or heavy East Indian wood, for example. This is presumably the case with a set of four 18 cm-high carpet weights found at the museum in Mehrangarh Fort in Jodhpur.[23] These elegant carpet weights are of the domed type, but the dome is shaped like a large closed flower bud, its individual petals made up of pink camel bone attached to the base material with little metal pins. Under the flower bud are green sepals and below them is a square base in white and pink with four green leaves at the corners – all made of camel bone. The museum has dated them to the early eighteenth century.

And now to the two stone carpet weights in the David Collection. Although one is made of black stone and the other of white, and although they have different shapes and sizes, both are of the domed type that to some extent is based on contemporary, local architecture.

The larger and most unusual of the two is 1/2016, which is made of black basalt (Figure 3.1). This stone is found in abundance in the Deccan and has been used extensively in the region for architecture: tombs, and so on. Together with a related but smaller piece that is 25.5 cm high, it was published by Marika Sadar in *Sultans of Deccan India*.[24] The surface is highly polished, but in the course of time has been scarred by knocks and blows. The dome exhibits small traces of gold, and it might originally have been partly decorated with this precious material. There are no traces of inlays, but intricate mother-of-pearl inlays in black basalt can be seen on a doorframe in the Rangin Mahal in Bidar – a more sombre pendant to the contemporary, colourful *pietra dura* decorations in Delhi and Agra.[25]

The bulbous dome is topped by a low knob. On the lowermost incurving part, the dome is surrounded by a border of 'sepals' in

two variations, not unlike the ones seen on a young fruit. Under the sepal frieze are two more bands, narrow and wide, between which is a beaded border. As is true of many other carpet weights, the dome rests on a base. This piece is quite unusual, however, since a section was inserted between the dome and the very simple square base. The intermediary section is designed almost like a table, with four wide, curved legs between which four leaves are suspended. Right under the square 'tabletop' are three little leaves on each side and under the centre, the domed structure is extended with a solid cylinder that runs down into the base itself.

Related curved legs or feet are also found on seventeenth-century Deccan basalt cenotaphs, for example in the royal necropolis in Golconda, in the Ibrahim Rauza in Bijapur, and in Jahan Begum's mausoleum in Ainapur in Bijapur.[26] They are also found on a monumental scale in some of Ibrahim Rauza's column bases.[27] Also in Bijapur are domed structures on the Ibrahim Rauza and Gol Gunbad that bear a striking resemblance to the uppermost part of the carpet weight (Figure 3.4).

The colour and form of the carpet weight thus largely reflect those of tomb architecture and other funerary structures from the Deccan, and especially from Bijapur, in the first half of the seventeenth century. Moreover, since it is heavy and quite impracticable for daily use, it is reasonable to suggest that it was found in a religious context and that it kept a tomb cover in place permanently on one of the region's many graves of princes or saints.

In contrast to the black basalt carpet weight from the Deccan, the second piece is made of white marble and richly inlaid using the *pietra dura* technique, with nuances of orange carnelian, blue lapis lazuli, two shades of green glass, and a yellow, amber-like material (Figure 3.2). This quite classical carpet weight can be divided with regard to both shape and decoration into three parts: a slightly flattened, spherical dome, a concave neck with a narrow vertical lower section, and a low, square base. The white marble is highly polished and the *pietra dura* decoration is inlaid in chiselled holes 2–4 mm deep that in many places have a white or coloured plaster-like bedding material and the remains of metal foil that enhance the transparent carnelian and green glass.[28]

At the top of the dome is an inlaid flower head with eight petals. It is divided into eight segments of green 'stems' that emerge from the ornamental decoration on the neck and end in the points of the petals of the topmost flower. The vertical tendrils taper elegantly as they rise. Several of the tendrils are intact, which unless they were made with a type of enamel technique is difficult to explain since they follow the curved form of the dome. Between the tendrils in the eight segments are two different plant compositions that alternate, each of which emerges from a little mound of carnelian at the bottom of the dome, something that is also found on reliefs on the exterior

Figure 3.4 *Detail from Gol Gunbad, Bijapur (1626–56).*
Photo: Kjeld von Folsach.

of the Taj Mahal, on many other contemporary monuments, and on
different kinds of decorative art.[29] Both refined types of plant have
a central green stem from which the leaves emerge symmetrically,
and each has four imaginary flowers with quite a naturalistic look
composed of different nuances of carnelian, glass and lapis lazuli.
The detail is so fine that four of the flowers have stamens of glass and
carnelian. The neck is decorated with an elaborate garland of flowers
and leaves in glass, carnelian, lapis lazuli, and a badly decomposed
yellow, amber-like material. There are little circles of carnelian on

the neck's narrow vertical sides. There is leaf ornamentation of glass and carnelian on the upper part of the base, and on the sides is a more geometric floral and leaf decoration in glass, carnelian and lapis lazuli between two horizontal lines of green glass. Much of the inlay material has unfortunately disappeared, but the colouristic effect is still sumptuous.

Under the influence of the Italian tradition, the *pietra dura* technique was introduced in India under Jahangir, but reached its absolute zenith during the reign of Shah Jahan (1628–58).[30] It was called *parchin kari* and was used extensively on a number of the period's architectural masterpieces, such as the Taj Mahal (1632–54), the Divan-i-'Amm, and the Divan-i-Khass in the Red Fort in Delhi. As is true of the carpet weight, it is the delicate meeting between the sensuous, highly polished surface of the white marble and the coloured, often transparent inlaying materials that attracts our attention. Combined with quite a naturalistic rendering of plants that is also typical of art under Shah Jahan, an aesthetic elegance was achieved that slowly became rigid and stylised in the second half of the seventeenth century under his son Aurangzeb.

In Mark Zebrowski's view, the carpet weight in the David Collection is 'one of the very finest surviving objects from Shah Jahan's reign', and he compares its decorations to those found on the architecture of the day, while another carpet weight in the Virginia Museum of Fine Arts in Richmond is described and dated by Stephen Markel as follows: 'The slight stiffness of the flowers suggests a date somewhat later than the reign of Shah Jahan.'[31] The two carpet weights are actually rather similar, although the inlaid materials are different: marble and alabaster. The piece in the David Collection, however, has gold leaf under the inlays and its decoration is slightly richer and more complex than those on the piece in Richmond. The symmetrical form of the motifs was undoubtedly chosen because of their small size and the fact that they are part of a decorative repeated pattern. Even on the cenotaphs in the Taj Mahal, only a few of the very largest flowering plants are built up asymmetrically, and when they are repeated in friezes, they are identical, although they might be reversed.[32] Dating the marble carpet weight in the David Collection to the middle of the seventeenth century does not seem unreasonable, although a later date cannot be definitively dismissed. Since its heyday in the seventeenth century, the *pietra dura* technique has never died out in India, and a visitor to Agra today can see that different kinds of souvenirs are still made of white marble inlaid with semi-precious stones and other coloured materials.

Other carpet weights of marble with *pietra dura* inlays have been published. Their execution is, however, simpler than that of the two in Copenhagen and Richmond. One is in the al-Sabah Collection in Kuwait and has been attributed by Fridrich Spuhler to the eighteenth

century.[33] Another was published by Simon Ray and dated to c. 1700, and a set of four was sold by Christie's and dated to the nineteenth century.[34] All of them are variations on the classical, domed carpet weight.

We can conclude that carpet weights – *mir-i farsh* – cannot be viewed semantically, at least, as the slaves of the carpet or tomb cover, but rather as its masters.

Both of the two carpet weights described here to some extent reflect the architecture in the regions and periods in which they were created with regard to form, material and decoration.

One carpet weight is monumental, monochrome, fairly simple, yet simultaneously sculptural, while the other is little, handy, and exceptional for its colour and elegant decoration rather than for its shape. It is a matter of personal taste whether one prefers one or the other.

Notes

1. I would like to thank Will Kwiatkowski for examining the concept in Persian literature. I would also like to thank Martha Gaber Abrahamsen for translating my text.
2. Moreshwar G. Dikshit, *History of Indian Glass* (Bombay, 1969), pl. XXIX C.
3. Mark Zebrowski, 'Bidri: metalware from the Islamic courts of India', *Art East: A Review of Islamic and Asiatic Art* 1 (1982), p. 29.
4. Mark Zebrowski, *Gold, Silver & Bronze from Mughal India* (London, 1997), p. 131.
5. Vishakha N. Desai, *Life at Court: Art for India's Rulers, 16th–19th Centuries* (Boston, 1985), p. 137. Desai is undoubtedly thinking of cot legs (*palang-pae*) in sets of four of the type illustrated in Krishna Lal, *National Museum Collection: Bidri Ware* (New Delhi, 1990), pp. 115–16. They are generally higher than carpet weights and have a different function. See also Sotheby's London, 3 October 2012, lot 208.
6. Jagdish Mittal, *Bidri Ware and Damascene Work in Jagdish and Kamla Museum of Indian Art* (Hyderabad, 2011), p. 124.
7. Preeti Bahadur Ramaswami and Kavita Singh (eds), *Nauras: The Many Arts of the Deccan* (New Delhi, 2015), p. 179.
8. As I looked for pictures of carpet weights, I found an article by Hadi Maktabi in which he actually, without further comment, translated the term: '*mir-i farsh* (roughly, lord of the carpet)'. See Hadi Maktabi, 'Under the Peacock Throne: carpets, felts, and silks in Persian painting, 1736–1834', *Muqarnas* 26 (2009), p. 324.
9. John Guy and Jorrit Britschgi, *Wonder of the Age: Master Painters of India 1100–1900* (New York, 2011), p. 54; Sam Fogg, *Indian Paintings and Manuscripts* (London, 1999), pp. 66–7; and Brijinder N. Goswamy, *Nala and Damayanti: A Great Series of Paintings and an Old Indian Romance* (New Delhi, 2015), pp. 90–1 and 134–5.
10. Oleg F. Akimushkin, *The St. Petersburg Muraqqa* (Lugano, 1994), pp. 89–90.
11. Maktabi, 'Under the Peacock Throne', figs 9 and 12.
12. Zebrowski, *Gold, Silver & Bronze*, p. 131.

Figure 4.2 *Cavalry pursuit: the forces of Mahmud of Ghazna feign flight from the Ghurids (Rashid al-Din, World History, Edinburgh University Library, Ms. Arab 20, f. 129b).*

in the sources, it is still not always easy to ascertain what the differences are between them. The chronicler Sibt b. al-Jawzi (d. 1256) mentions the presence of '*al-Turcoman wa'-l atrak*' (Turcomans and Turks) in his account of the events of the 1060s.[10] These are identified as two distinct groups. He is critical of the Turcomans, the majority of whom were keen on pillaging; according to him, they did all kinds of foul and forbidden things and they had taken complete possession of Syria. But he does not mention any involvement by the '*atrak*' (Turks) in these misdeeds; this term probably refers to the Turkish slave soldiers in the sultans' armies. Another chronicler, Ibn al-Qalanisi, seems to be writing about another category of Turk whom he calls *kafir Turk* (infidel Turk). But he does not explain who they were. He writes in his account of the year 532/1137–8, when Byzantine cavalry were in the environs of Aleppo, 'some "*kafir*" Turks took refuge in Aleppo to escape them and to warn the people of Aleppo that the Greeks (were there)'.[11] Inevitably biased but still valuable evidence about the Turks is provided by Eastern Christian chroniclers. Michael the Syrian (d. 1199) writes that the people of Edessa said of the Turks: 'Behold a new and barbarous nation pours forth … (they) have the faces of men and the hearts of dogs. O Christians, take heed!'[12] Later on in his chronicle, he has a more positive or pragmatic approach: 'Those towards the west, the middle of the inhabitable earth, their journey was in the kingdom of the Arabs. They united (with the Arabs), adhered to their faith and embraced (it).'[13]

How did Muslim sources portray the nomadic Turks?

The nomadic Turks (Turcomans) had endured unremittingly hard lives for millennia. Their most striking characteristic was mobility. This was the key to their survival. It was by their mobility that they could attack the enemy, plunder and then depart at great speed. Their mobility was not confined to warriors alone; it entailed movement of men, women, livestock, tents and baggage wagons. Their military strength lay in their mounted archers, who discharged their arrows at a distance and avoided direct encounters with the enemy. Already in the ninth century the Arabic writer al-Jahiz praised the Turkish horseman, saying:

> The Turk has four eyes, two at the front and two at the back of his head. They have taught their horsemen to carry two or three bows and strings to match them. And the Turk has with him on his raid all that he needs for himself, his armour, his beast, and the harness of his beast.[14]

The nomads' dress contrasted forcibly with that of the settled Muslims. The Turcomans wore furs or shapeless sack-like cloth

Figure 4.3 *Parthian shot from a fifteenth-century Persian manuscript. Istanbul, Topkapı Sarayı Müzesi H.2153.*

Figure 4.4 *Two women in conversation (after İpşiroğlu,* Bozkir Rüzgâri Siyah Kalem *(Istanbul, 1985), pl. 34).*

garments. Both sexes wore trousers. Their lack of hygiene must have shocked the Muslim Arabs. The men commonly wore their hair down to their waists and greased it with rancid butter. Indeed, one Eastern Christian source, Matthew of Edessa, mentions that the Seljuq army could be smelt at a distance of three days' travel. The basis of the nomadic economy was a combination of pastoralism and raiding. The Turcomans' major food supply came from their herds. Their wealth and status were usually assessed by how many horses they owned. The sedentary Muslim populations were disgusted when they saw what the Turcomans ate: wolves, foxes, dogs, mice, rats and snakes. The eleventh-century Arab writer Ibn Hassul says: 'They consume only meat, even if it is dripping blood or filthy, and they do not wish for anything else.'[15]

During the pre-Seljuq period Arabic and Persian geographers had

written about the Turkish nomads in salacious detail, providing accounts that mixed fact and fantasy. The anonymous author of the late tenth-century Persian work entitled *Hudud al-'alam*, for example, wrote of the nomadic Turks: 'These people have the nature of wild beasts and have rough faces and scanty hair. They are lawless and merciless.'[16] In the tenth century Ibn al-Faqih mentions the type of details about the nomadic Turks which probably helped to formulate stereotypical views of the Turks in general in the minds of later Muslims. He writes that the Turks are the most skilled bowmen and are very courageous and strong. But he also mentions many lurid details about Turcoman customs: 'They have sexual intercourse with every creature they meet, be it a woman, a boy or an animal.'[17]

The infiltration of the Seljuq Turks into Syria and the Jazira

The coming of nomadic Turkish tribes into Syria in the eleventh and twelfth centuries was an extension of their movements from Central Asia into Iran and Iraq and especially the invasions led by the Seljuq family. As already mentioned, by the early twelfth century the Levant was in disarray. The Seljuq dynasty that had ruled the eastern Islamic world since 1055 was no longer as strong or as centralised as it had been. Weaknesses inherent in the Seljuq system of government – which was based on the divisive principle of family rule – had become more obvious and debilitating since the deaths in quick succession of the mighty Seljuq vizier Nizam al-Mulk and the Seljuq sultan Malikshah in 1092. Petty scions of the Seljuq family, whose power was concentrated in such key cities as Damascus and Aleppo, were being replaced or controlled by ambitious Turkish military barons who served as their *atabeg*s and then took power themselves.

How the Turkish military barons ruled

Ibn al-Azraq, a twelfth-century chronicler from the Jazira, describes the plight of the citizens of Mayyafariqin before its conquest by the Turcoman military leader Il-Ghazi in 512/1118. He writes in some detail about the state of devastation in the city:

> The people were in great distress because of billeting in their homes. Most of the city was ruined because of constant changes of régime and overlord. Those who conquered them treated them unjustly, tyrannised and mulcted them, because they knew that they themselves would not endure and their rule would not last ... The soldiers who had no homes began living in it (the city) and setting up tents in the ruins of the city because most of the city was devastated and the roads were terrorised by robbers and highwaymen.[18]

However, Ibn al-Azraq is at pains to praise the nature of Il-Ghazi's rule in Mayyafariqin:

'He showed justice and kindness to the inhabitants ... From the moment that he assumed power, the roads and the countryside became safe. The robbers fled and the villages flourished. Mayyafariqin began to prosper and he ruled the people very well.'[19] But this lavish praise should be treated with caution. Ibn al-Azraq worked as a scribe for the Artuqid family. He knew on which side his bread was buttered.

Two key Turkish rulers in Syria: how Islamised were they?

a) Il-Ghazi (d. 1122), the ruler of Mardin, Mayyafariqin and Aleppo (for a short while)

How important was jihad for a Turkish military baron, such as Il-Ghazi, in Syria and the Jazira in the early Crusading period? Certainly this concept had been well known in tenth-century Syria where the Hamdanid Shi'ite dynasty waged jihad on the Byzantine/Muslim frontier. Grandiose jihad sermons were preached by Ibn Nubata (d. 374/984–5) in the Jazira[20] and the Arabic poet al-Mutanabbi praised the Hamdanid ruler, Sayf al-Dawla, for his promotion of jihad.[21]

But generally amongst the sedentary Muslim populations of the eleventh and early twelfth centuries, they probably remembered the words of al-Jahiz: 'The Turk does not fight for religion nor for the interpretation of Scripture ... nor for defence of the home nor for wealth, but only for plunder.'[22] Ibn al-Qalanisi (d. 1160) the chronicler of Damascus, likened Il-Ghazi's Turcomans to birds and beasts of prey: 'lions seeking their prey and gerfalcons hovering over their victims'.[23] In his view, therefore, although undoubtedly skilled fighters, they were motivated only by lust for booty. However, Il-Ghazi is mentioned as deliberately exploiting jihad propaganda with his Turcoman forces in 513/1119–20 before the Battle of the Field of Blood. While in Aleppo, which was being increasingly pressurised by the Crusader leader Roger of Antioch, Il-Ghazi found himself immersed in a feverish atmosphere of jihad and he came to realise that he could use this to boost the morale of his troops in the forthcoming battle. So, according to the account of Ibn al-'Adim, a *qadi* called Ibn Khashshab (d. 528/1133–4) preached jihad to the assembled Turcoman troops and Il-Ghazi made his amirs swear an oath 'to perform their duty courageously, to fight heroically, and not to retreat, even if they had to shed all their blood in the jihad'. Initially the Turcomans displayed indifference and even contempt; one of them cried out: 'Was it to obey this man with a turban that we left our country?' Later on, Ibn al-'Adim continues, Ibn al-Khashshab brought 'tears of ecstasy' to the eyes of the Turcomans who then went into battle and gained a glorious victory.[24] The caliph in Baghdad sent

Il-Ghazi a robe of honour. The narrative about Ibn al-Khashshab does, however, remain problematic. How could the assembled Turcoman troops of Il-Ghazi understand a jihad speech proclaimed in Arabic? It is much more likely that this grandiose speech was composed before or after the event rather than delivered on the spot.

Il-Ghazi apparently never again utilised the weapon of jihad propaganda in his later campaigns against the Crusaders. Nor did he follow up this military triumph; according to Usama b. Munqidh, this was due to Il-Ghazi's habit of excessive drinking of alcohol. After his victory over the Crusaders at the Battle of the Field of Blood in 1119, Usama writes that Il-Ghazi remained in a drunken state for twenty days.[25]

b) Tughtegin, the ruler of Damascus (1104–28)

The most important source for the life of Tughtegin is the town chronicle of Damascus written by Ibn al-Qalanisi (died 1160).[26] Despite his obvious bias towards his Turkish overlords and his convenient omissions and obfuscations of negative information – he would have been foolish to do otherwise – Ibn al-Qalanisi is a keen observer of events.

The name Tughtegin means Warrior Falcon. His full names were Abu Mansur Tughtegin b. 'Abdallah. His honorific titles, acquired whilst he was ruler of Damascus, were Zahir al-Din and Sayf al-Islam. Most often in the Islamic sources which recount his career he is simply mentioned as the Atabeg or Atabeg Tughtegin. Perhaps it is worth noting that Tughtegin's father is here called 'Abdallah. This could be an indication that he was a Muslim, thus showing that Tughtegin's family had converted to Islam at least one generation back, or that the name of his father was unknown. What's in a name? It is dangerous to speculate too much on the question of Tughtegin's personal name, but it is perhaps not too fanciful to suggest that this major Turkish leader in Syria deliberately chose to keep his Turkish name rather than using his Arabic titles; and he was generally known by it. The use of Tughtegin, a totemistic Turkish name, must have enhanced his reputation as an alien ruler, a steppe warrior whose not-so-distant ancestors had hailed from distant Central Asia. In due course, naturally, the inhabitants of Syria must have got used to the fact that their military warlords bore Turkish names.

Tughtegin had been a *mamluk* belonging to Tutush, son of the Seljuq sultan Alp Arslan. Tughtegin served as a military commander for his master who manumitted him, married him to Safwat al-Mulk, the mother of Duqaq, son of Tutush, and made him Duqaq's *atabeg*. After the death of Tutush, his son Duqaq took over Damascus, where Tughtegin joined him and became his *atabeg*. In 497/1104, Duqaq died and Tughtegin became the openly independent ruler of Damascus. Tughtegin's Muslim piety and beneficent rule are empha-

sised by Ibn al-Qalanisi in the following terms: 'He modelled his
conduct on the precepts of the Faith; he inspired fear in the lawless
and the evildoers, and was bountiful in excess in rewarding the loyal
and well-doing; all hearts were attached to his cause by his liberal-
ity.'[27] Thus, admittedly from the pen of the panegyrist of his dynasty,
Ibn al-Qalanisi, we see Tughtegin using a traditional combination
of ingratiation and coercion to consolidate his takeover of power.
His conduct is, however, also described as that of the pious Muslim
ruler who exercises *hisba* – the task of 'commanding the good and
prohibiting the bad'.

Legitimacy was a key preoccupation of the Turkish military com-
manders of Syria. Such men seized lands, but the mere possession of
territory was not sufficient for them; they needed Islamic legitimisa-
tion of their power by the caliph in Baghdad. Tughtegin pursued,
whenever he could, an aggressively expansionist policy not only
against the Franks but also against other petty Muslim rulers left in
the wake of Seljuq decline. When he died, medieval Arabic sources
present his achievements in the usual clichéd obituary notices. Ibn
al-Athir writes of Tughtegin: 'He was wise and generous. He raided
and waged jihad against the Franks frequently and ruled his subjects
well, eager to be just to them.'[28]

In turbulent times Tughtegin managed to rule Damascus with
an iron hand for twenty-four years and was a much respected and
feared opponent of the Crusaders. He can be seen as the major early
Turkish defender of Islam against the Crusaders. This judgement is
not based on his personal virtues or piety but on his sheer longevity,
persistence, tenacity and ability to stay in power. He outlived all the
Turkish military barons – Balak, Il-Ghazi and others – in the first
phase of Crusading activity in the Levant. Moreover, he managed
to die not at the hand of an assassin or on the battlefield but in his
own bed. Much of his success sprang from his firm commitment to
Syria. Seljuq offensives from further east were destined to fail since
they had no local Syrian support. Other early Muslim leaders such as
Il-Ghazi and, later on, Zengi, dabbled in politico-military struggles
in the Jazira or in Baghdad and dissipated their energies, much to the
advantage of the Crusaders. Tughtegin was a worthy precursor of
Nur al-Din in his concentration on Syria, and especially Damascus,
as his sphere of operation.

The survival of pre-Islamic shamanistic practices amongst the Turks in eleventh- and twelfth-century Syria

Turcoman society had long been shamanistic, and even after the con-
version of their tribal leaders to Sunni Islam, as dutifully proclaimed
in the Arabic and Persian sources, it is probable that the Turcomans
retained many of their basic shamanistic practices for many years
to come. For example, the Syriac Christian chronicler Bar Hebraeus

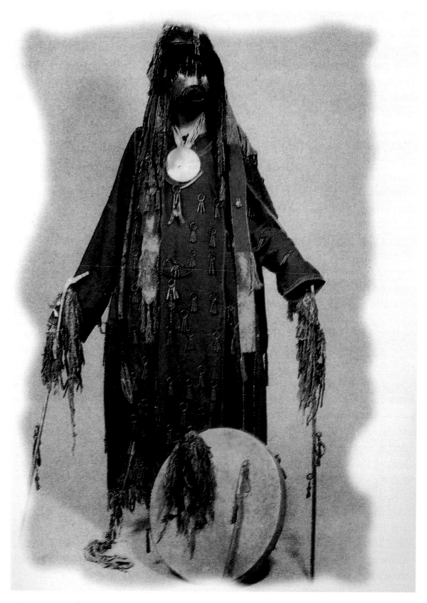

Figure 4.5 *Shaman (after Çandaroğlu et al., A Cultural Atlas of the Turkish World: The Pre-Islamic Period (Istanbul, 1997), p. 200).*

(d. 1286) writes that the first Seljuq sultan, Tughril, had the habit of sitting on an elevated throne opposite a splendid bow made of gold 'and he held in his hand two arrows which he played with'.[29] This detail has shamanistic resonances, since the bow and arrow were used for divination. Moreover, there is clear evidence of Turkish totemistic names in the sources; these names often refer to animals and birds.

A truly notorious event in the career of Tughtegin deserves special attention in this context: the death of Gervase de Basoches, the Crusader lord of Tiberias, in 501/1107–8. Versions of the story are given in a number of sources, both Muslim and Crusader. The account of Gervase's killing given by Albert of Aachen (d. 1120) is detailed and shocking. To his audience back home in Europe it might even have seemed amazing and almost unbelievable:

> Gervase was brought out in the middle of the town of Damascus, and after much mockery he was shot through by the Turks' arrows and gave up the ghost. Gervase, eminent knight, having died in this way, one of the most powerful of the Turks ordered his head to be cut off, and the skin of his head … to be pulled off and dried.[30]

Similar details can be found in the account of another Crusader author, Guibert of Nogent (d. 1124), who relates that Gervase was killed by arrows, and thereafter the crown of his head was removed and a cup was made from his skull.[31]

What of the Muslim accounts of this episode? Most of these go so far as to mention that Gervase was killed whilst he was Tughtegin's prisoner, but they generally gloss over certain macabre details. Clearly, stories similar to those told by Albert of Aachen and Guibert of Nogent must have been circulating in the Levant. They are eventually mentioned, in rather laconic but frank fashion, by the much later Muslim historian, Ibn al-Furat (d. 807/1405). He provides the gruesome detail that Tughtegin hollowed out Gervase's skull while he was still alive and drank from it:

> Tiberias remained in their (Crusader) hands until Tughtegin attacked the Count, the Lord of Tiberias, in Shawwal in the year 501. He hollowed out the skull of his head while he was still alive, and drank wine in it, while he was looking at him [sic]. He lived for an hour, then he died.[32]

Clearly this particular version of the story is sensationalist rather than accurate, though it does succeed in conjuring up, in vivid pictorial terms, an abominable spectacle. But what was behind this savage killing? It is worth remembering that the earliest known Turkic people, the Hsiung-Nu, as well as the non-Turkic Scythians, made drinking bowls from the skulls of prestigious fallen enemies. Wine would be poured into such a 'bowl' and then mixed with the blood of a sacrificial victim and stirred with a sword.

The Turkish ruler of Damascus, Nur al-Din Mahmud (d. 1176)

The accession of Nur al-Din as the ruler of Damascus in 1146 marked a turning point.[33] His personal name was Mahmud, a solidly Islamic

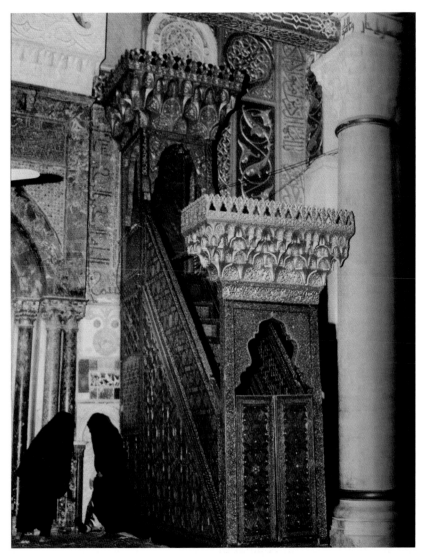

Figure 4.6 Minbar *of Nur al-Din, Jerusalem, Masjid al-Aqsa. Courtesy of Alistair Duncan.*

name. His predecessors often bore Islamic titles, but their personal names told a very different story – Tughril, Chaghri, Alp Arslan, Tutush, Atsiz, Duqaq, Buri, Berkyaruq, Tapan, Balak, Il-Ghazi, Tughtegin, Aq Sunqur, Zengi. Even the supreme Seljuq monarch, who reigned from 1065 to 1085, bore the name Sultan Malikshah, conjoining the royal titles of Turk, Arab and Persian in his cognomen, and making no reference to the Islamic faith. These names signal a marked loyalty to Turkic tradition at the expense of Islam. In contrast, Nur al-Din quickly established an enviable reputation for Islamic piety based on the celebrated asceticism of his private life,

his honouring of the Islamic *'ulama'*, his ambitious programme of erecting buildings such as mosques and madrasas to serve the Islamic faith, and his deliberate fostering of jihad ideology and propaganda. It was he who exemplified the transition from outsider to insider, from foreigner to native, from infidel to Muslim. His personal name says it all. And the sources make it clear that he was fluent in Arabic. He knew the Qur'an well and allegedly often engaged in theological conversations with Muslim scholars.

This sea-change in the behaviour of a Turkish warlord brought a concomitant change in his way of life. Nur al-Din made Damascus his capital. Those words sound unremarkable, but much of consequence flowed from that decision. It meant that he abandoned the aimless, peripatetic lifestyle that characterised, say, Il-Ghazi or his own father Zengi, with its backdrop of endless warfare. It meant that he put down roots. It meant that he gave up on nomadism. It meant that he threw in his lot with the settled population, almost all of whom lived in cities, towns and villages. And that meant that he adopted the norms and forms of their culture. There was no turning back. His commitment to Damascus expressed itself in the costly building programme he funded but also in his decision to strengthen its walls and gates. Nur al-Din, then, exemplified the increasing accommodation that characterised both sides of the linguistic and cultural divide in the later twelfth century, and with it an increasing mutual dependency on the part of Arab and Turk alike. Once again architecture provides a yardstick for social change, for one Turkish warlord after another followed the lead of Nur al-Din in erecting buildings that proclaimed their piety and memorialised their names while also serving the Muslim community to which they increasingly saw themselves as belonging.

Concluding remarks

The presence of the Turcomans was viewed as a necessary evil by the sedentary Muslim populations. The Seljuq leadership exercised control, sometimes precariously, over them. The Seljuqs also came to an understanding with the urban elites; the Seljuqs would provide military support and the cities would provide taxes and the bureaucratic expertise necessary to administer the Seljuq Empire. Despite the disruption to agriculture caused by the Turcomans, and their tendency to damage cities and monuments, Muslim writers valiantly made the best of a bad situation, for they saw that these nomads were here to stay.

There were, however, new aspects of Seljuq government that came from the shamanistic steppe heritage. The first two Seljuq sultans retained their Turkish totemistic names – Tughril, meaning 'falcon', and Alp Arslan, meaning 'hero lion'. Thereafter, most, but not all subsequent, Seljuq sultans were known by Muslim

names. Even so, the title 'Sultan of east and west' bestowed by the 'Abbasid caliph in Baghdad on the first Seljuq sultan Tughril in 1055 reflects the nomadic steppe concept of world dominion – a symbol of Turkish sovereignty, extending from where the sun rises to where it sets.

The Turkish symbol of a bow and arrow denotes sovereignty. Legend has it that the first Seljuq sultan Tughril is said to have placed a bow and arrow in the mosque of Byzantine Constantinople. The Seljuq Turkish institution of *atabeg*, usually denoting a powerful Turkish military commander whose duty it was to supervise the upbringing of young Seljuq princes, also came from steppe tradition. But when it was introduced into the Seljuq government it had dire consequences. The institution proved to be a serious centrifugal force, working against the centralised government model beloved of Nizam al-Mulk. After 1092 *atabeg*s seized power in their own right and this contributed to the disintegration of the Seljuq state.

Traditionally, the Seljuq Turkish elite are presented in the medieval Arabic and Persian sources as pious Sunni Muslims who had converted to Islam before their major invasions began. This portrayal of the Turks, who went on to govern the heartlands of the Islamic world for many centuries, is not surprising. Their Arab and Persian bureaucrats, court chroniclers and poets needed to put a brave face on political realities and to help to forge the necessary alliance between the military force of the Turks and the long-established prestige of the Sunni Arab and Persian religious classes. No doubt, over time, some of the Turkish sultans did indeed grow into the role accorded them by their chroniclers and court poets – namely, that of defenders of Sunni Islam and fighters of jihad against infidels and heretics. But that could not be said of the Turkish rulers of Syria and the Jazira up to 1146.

As an alien, invading military force, the Seljuq Turkish sultans generally adopted a publicly supportive and deferential stance towards the Sunni caliph in Baghdad, from whom they sought the key religious credentials that they craved. And the caliphs gave them grand robes and honorific titles. A major religious development was the establishment of a network of Sunni madrasas by high-ranking Seljuq administrators across the empire. Nizam al-Mulk set the example by funding and supervising at least ten such madrasas or religio-legal colleges; the principal one of these was in Baghdad. Thus, a reliable, well-trained class of Sunni religious scholars could promote orthodox Islam across the empire under the umbrella of the Seljuq state.

Stories about the Turks, such as the tragic end to the life of Gervase de Basoches, analysed above, were narrated to titillate and mock and were saturated with feelings of religious or cultural superiority on the part of Muslim and Crusader sources alike. To the Muslims, the

The Multiple Faces of Restoration in the Medieval Islamic Architecture of Central Asia

Robert Hillenbrand

THE TOPIC OF this chapter is a melancholy one, for it concerns what often passes for conservation and restoration in the medieval architecture of Iranshahr.[1] That term might be rendered as 'the Iranian world', whose fluid boundaries, ever-expanding and ever-contracting, encompassed over the millennia the area between Anatolia and India and between the Persian Gulf and northern Central Asia. The present chapter places particular emphasis on Central Asia, since this is where the main killing fields of 'restoring' medieval architecture are to be found. The replacement of the trained craftsman's hand by the soulless efficiency of the machine, a theme that preoccupied Ruskin 150 years ago,[2] is at the heart of this chapter.

Iran, especially since the Islamic Revolution, has a very much better record than its neighbours in preserving medieval architecture, though its record is not unblemished.[3] This is no accident. Iran has immeasurably better infrastructure in this field than they do, in that the country's various provinces each has an office and a team, many of them architects or engineers, charged with protecting and maintaining the local monuments. Obviously, over time these local teams get to know the buildings under their care very well indeed. These local offices maintain photographic records of the buildings under their care, have a growing archive of drawings at their disposal, and have the authority to conduct limited excavations, repairs, conservation and restoration. And above this network of local offices is the organisation responsible not only for the oversight and control of their activities but also for formulating policy. So there is a proper chain of command, with local work subject to inspection from the central office. And in Afghanistan too, despite the political turmoil it has endured over the last forty years, restoration projects are under way and specialists are being trained in the techniques of restoration.[4]

That said, it will be appropriate to draw on an occasional example from Iran in this chapter, as well as others from Anatolia and

Azerbaijan, to contextualise the focus on Central Asia. After all, the catchment area of the architecture to be considered here was very wide indeed. The discussion will be confined to buildings made of brick, since stone brings a rather different set of variables into play. But it is still worthy of record in passing that stone buildings in both Anatolia[5] and Azerbaijan[6] have been subjected to major abuse in recent decades at the hands of official bodies. The present jeremiad thus has truly wide implications. But it has been triggered by a very particular set of circumstances, and these need to be spelled out in detail before close analysis of individual buildings is attempted. So basically, this chapter will be in two parts: background and foreground. First the context, then the buildings themselves.

A brief introduction will suffice to set into the context of the Iranian world as defined above the whole issue of destruction, restoration and conservation – and it is important to note that sequence of diminishing degrees of damage. Next, this chapter will sketch the official attitudes to medieval Islamic architecture first in the Soviet period and then thereafter, as these made themselves felt in Central Asia. In so doing it will focus on the implications of two significant elements that impact on the medieval architectural heritage of the region: first, the vibrant nationalisms that have taken root there over the past generation, and second, the impact of large-scale tourism. Thereafter, the chapter will tackle in detail three specific ways in which buildings have been denatured by crass intrusions. These are the replacement of permanent by impermanent decoration; the loss of the original exterior surface or patina; and finally, over-restoration.

First, then, the general context. Much information has been gathered in the past few years on the destruction of the built heritage in Syria and Iraq as a result of armed conflict. Crac des Chevaliers, Aleppo, Palmyra and Mosul are among the most high-profile sites that have suffered collateral damage as the human tragedy of these war-torn countries unfolds and deepens.[7] The grandchildren of today's victims will not readily forgive those responsible for the wanton destruction of so much of a heritage admired and cherished by the rest of the world – for in a sense that heritage belongs to everyone. But such damage to a millennial heritage is dwarfed by what has been inflicted on medieval brick buildings over the past half-century or so from Anatolia to the borders of China in the name of restoration or conservation. And well before that, the built heritage of Islamic Central Asia suffered an orgy of destruction decreed by the Communist state, since it was considered to represent a backward and feudal society.[8]

The basic aim of conservation is not rocket science, although the techniques employed by its most expert practitioners can be complex and ingenious. Fundamentally, conservators seek to conserve, to stabilise, to arrest decay. They do not regard it as part of their job description to improve upon the original work, or to

second-guess the intentions of a medieval craftsman, or indeed to add anything to the original concept. If scaffolding, or indeed any other modern means of support, is needed to prop up a crumbling wall, well and good.

And if some physical barrier is required to stop people touching a monument and thus in the long run degrading it, that too is better than doing nothing. Even a plastic or Perspex shell, or a corrugated iron roof, however unsightly or ungainly they might look, have their place as instruments of protection for a threatened monument. Persepolis today, for example, is a far cry from the romantically deserted site that greeted generations of Western travellers from the seventeenth to the early twentieth centuries. But barriers and roofing protect what is left of this majestic structure from the weather and from people. In much the same way a plastic screen has been set up in front of the Ilkhanid sculpture of a dragon at Viar near Sultaniyya.[9] Part of the Natanz shrine has received similar protection,[10] as has a subsidiary *mihrab* in the Isfahan *jami'*. And near Taraz in remote Kazakhstan the fragile but highly decorated though roofless 'A'isha Bibi mausoleum, perhaps of twelfth-century date,[11] a museum of virtuoso terracotta ornament, was protected in the later twentieth century by being entirely encased by a transparent plastic shell. In none of these cases is the monument improved from the visitor's point of view, but at least it is safeguarded and one may hope that in future less clunky and more subtle and discreet methods of protection will be devised.[12] Many a site is ill-equipped to deal with the relentless hordes of tourists that visit it, each one of them bringing his or her miniscule quota of degradation and eventually destruction. And it is important to point out here that, for the most part, the Central Asian sites that have suffered the most grievous damage in the past thirty years have been, for the most part, individual isolated buildings.[13] They therefore offer a very different challenge than does the conservation or restoration of an entire urban heritage, as in the case of Cairo[14] or Delhi,[15] where the destruction of the medieval Islamic built heritage has attracted worldwide attention. In such cases, restoration projects can benefit from economies of scale. Not so in Central Asia to date.

Desperate times, then, require desperate measures. So long as the methods chosen for this protection are reversible, it is better to install them than to do nothing and let tourism take its course.

Here one may cite a very straightforward example of such rescue measures. When the Austrian scholar Ernst Diez first photographed the spectacular tomb tower known as the Gunbad-i Qabus, in north-western Iran, over a century ago, its appearance was truly alarming (Figure 5.1).[16] Brick robbers had nibbled away around its base until they were in imminent danger of losing their own lives if the building had collapsed. They knew what they were doing – this mausoleum has some of the finest and most unusual bricks in all of medieval

Iranian architecture, for example the asymmetrical wedge-shaped stretchers used at the lip of the roof.[17] The depredations of the brick robbers were made good within a generation by a rebuilding of the lost areas, thereby preserving this masterpiece for future generations. At the time the urgent priority was to stabilise a building threatened with collapse; the physical nature of the bricks used to achieve that aim was of secondary importance (Figure 5.2).

So this chapter is not intended as a shrill rant either against restoration in itself or against clunky but well-meaning efforts at conservation. There is also no need to quarrel with the dedicated modern craftsman who chips out tile mosaic in the time-honoured way, or who removes encrusted dirt from an inscription. It is with his boss, who directs the team, and who decrees destruction and rebuilding in line with his own personal vision of how the building should look. That person may have only the most limited and patchy knowledge of the architecture on which he is laying his clumsy hands; the fact that he is a native of the country does not give him some intuitive genetic understanding of its medieval architecture, let alone a licence to kill. This combination of ignorance, arrogance and national pride is lethal. One is reminded of Evelyn Waugh's damning verdict on Stephen Spender: 'To see him fumbling with our rich and delicate language is to experience all the horror of seeing a Sèvres vase in the hands of a chimpanzee.'[18]

It is perhaps the desire to rebuild a ruined monument instead of conserving it as a ruin that leads to the most pernicious results (Figures 5.3 and 5.4). This may be the place to recall a documentary made a few years ago, but well after the end of Soviet rule, about a so-called master craftsman, a local Uzbek, charged with 'restoring' the medieval monuments of Samarqand. To the accompaniment of an admiring voice-over narrative in English, this frankly propagandist piece documented the transformation of a fifteenth-century Timurid tiled façade, ruined but still magnificent in its subtle range of colours and designs, into a piece of kitsch worthy of a wealthy parvenu's bathroom: glossy, sparkling, spick and span, and as subtle as a fist in your face. To coin a word, it had been *qashangified*. This documentary ended with an extended sequence, shot from below, of this 'master craftsman' standing, with smugly folded arms and legs akimbo, before another Timurid building and appraising it – another lamb to the slaughter – while the narrator vaunted his unique skills in bringing a dying building back to vibrant life.[19] And indeed Samarqand, though still trading profitably on its storied name, is now to a depressing degree a modern capital of fake-medieval zombie architecture. The name remains. But what made the name matter has gone. So tourism in Central Asia is beginning to assume the proportions of a huge confidence trick.

The interpretation of a building conserved is full of possibilities. Successive visitors can reconstruct it in their minds, each one in a

different way, on the basis of what remains. It challenges the imagi-
nation. It makes your brain work. Above all, it still bears the imprint
of those who erected it. A building restored, on the other hand,
represents a single possibility fully realised. In that process, all other
possibilities are destroyed. You can take it or leave it. Furthermore,
it now bears the imprint of the modern restorer, which is in instant
conflict with that of the original builder. Obviously, one must make
an exception of restorations which are based on irrefutable evidence,
for example early photographs, of how the building formerly appeared.
The replacement of the robbed bricks at the Gunbad-i Qabus is one
such exception. But a full restoration of a building whose earlier
form cannot be reconstructed with any certainty is quite another
matter. No doubt we have all experienced something similar when a
book that we enjoyed, perhaps even loved, was adapted to the screen.
Have we not all felt the obscure dismay of seeing a much-loved
fictional character taking on a physical form totally at variance with
the version created by our own imagination?

It is now time to move to the situation in Central Asia before
and after Gorbachov's reforms. Before 1989, when the architectural
heritage of Central Asia was under Soviet control, conservation and
restoration were carried out relatively sparingly and with a light
touch. There are indeed exceptions – one such is the over-restoration
of Khiva (Figure 5.5), which drained the life, the very soul, from the
city's buildings so that a walk through its streets left one curiously
dejected. Somehow the excursion didn't do what it said on the tin. But
on the whole the Russians were content to leave well alone.[20] One
has only to leaf through the coloured plates in the Russian-language
coffee-table books on medieval Central Asian architecture produced
so copiously from the 1960s to the 1980s, and compare them with
the superlative photographic record produced much earlier by such
German scholars as, say, Friedrich Sarre[21] or Ernst Cohn-Wiener,[22] to
confirm this. It is, incidentally, a great pity that Arthur Upham Pope,
the ringmaster of numerous American expeditions to photograph
Iranian architecture in the 1930s, never got to Central Asia.

At all events, in the course of a century the Russians had built up
a solid body of scholarship based on hands-on knowledge of these
buildings,[23] with a concomitant well-established and smoothly func-
tioning academic infrastructure of universities, archaeological insti-
tutes and publishing outlets.[24] So there was abundant academic and
practical expertise on tap, plainly nurtured by admiration and respect
for these buildings – though that did not necessarily mean that basic
conservation measures were undertaken even for key buildings, as
in the case of the portal of the Gur-i Amir (Figure 5.6). It has to
be conceded, though, that the key players were overwhelmingly
Russian rather than Turcoman, Uzbek, Kazakh, Tajik or Kirghiz.
That did have a beneficial subsidiary effect, namely that the cultural
unity of this vast region in the middle ages, a unity independent of

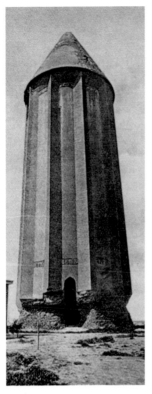

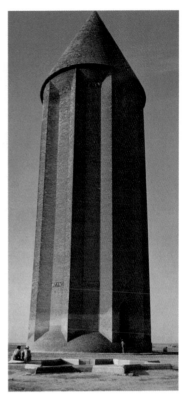

Figure 5.1 *Gunbad-i Qabus (after E. Diez,* Churasanische Baudenkmäler. *Band I (Berlin, 1918), pl. 4/1).*

Figure 5.2 *Gunbad-i Qabus (after H. and S. P. Seherr-Thoss,* Design and Color in Islamic Architecture *(Washington, DC, 1968), pl. 1).*

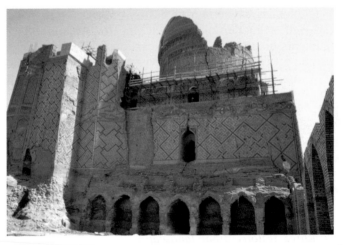

Figure 5.3 *Samarqand, mosque of Bibi Khanum, c. 1990. Courtesy of Sheila Blair and Jonathan Bloom.*

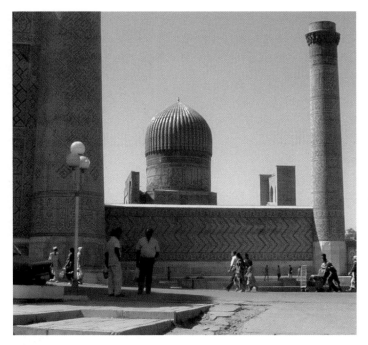

Figure 5.4 *Samarqand, mosque of Bibi Khanum, current state.*

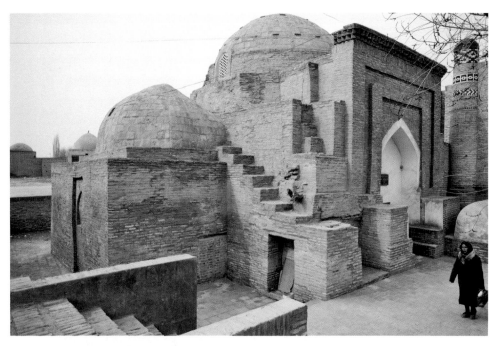

Figure 5.5 *Khiva, restored urban landscape.*

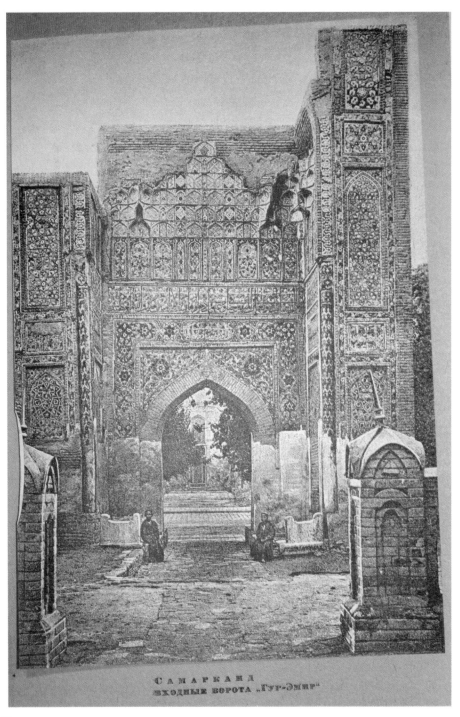

Figure 5.6 *Samarqand, Gur-i Amir, portal, archival photograph (after Ivan I. Umnyakov,* Arkhitekturniye pamyatniki Srednei Azii. Issledovaniye, remont, restavratsiya, *1920–1928 g.g. ([Tashkent, 1929]).*

the rise and fall of local dynasties or ethnic distinctions, was well understood.

Very few foreigners with expertise in medieval Islamic architecture got to visit Central Asia in the Soviet period, and those that did saw a tiny selection of the scores of important medieval buildings in the region. This was because almost every site outside a few major cities was out of bounds to foreigners. The very expensive and limited programme of tourism promoted, if that is the word, by Intourist, the government body charged with the draconian oversight of tourists to the Soviet Union, ensured that tourists, whether they liked it or not, obeyed a schedule drawn up by the central authorities, in which factories, collective farms and concerts of ethnic music jostled for precedence with medieval architectural masterpieces. Moreover, many Islamic buildings were given new functions with the tourist market in mind, as is evident from successive plans devised in 1965 and 1977 to redevelop the centre of Bukhara.[25] But even so the profoundly flawed Intourist system ensured that the numbers of foreign tourists remained low.

This changed dramatically with the disintegration of the Soviet Union. There followed a large-scale departure from Central Asia of many Russians with expertise on the architecture of the region, with a consequent weakening of their influence. Those that remained found themselves effectively demoted in the new order. Nature abhors a vacuum, so the necessary resources to deal with the monuments of the past on all levels, in terms of people and money alike, had to be found locally.

Moreover, the seismic political changes from the late 1980s onwards had unleashed a fervent nationalism that affected all the major new republics of Central Asia to some degree. This had its impact on medieval monuments too – on how they were regarded from political, social and economic angles. And not surprisingly, the nature of academic discourse on them also changed. The broad pan-Central Asian vision nurtured by Russian scholarship[26] gave way to a tunnel-visioned nationalism that purported to detect distinct ethnicities in the medieval architecture of the whole area. Modern boundaries were inflicted on areas which in medieval times knew nothing of them. High-profile monuments had their part to play in this; for example, the mausoleum of the twelfth-century Seljuq sultan Sanjar has become a Turcoman rather than a Central Asian monument, framed by camels and people in Turcoman costume on tourist brochures, and proudly displayed in all kinds of popular contexts (Figures 5.7a–d).[27] And all other medieval monuments within the modern political boundaries of Turkmenistan could also be so regarded.

There is perhaps no better proof of the significant role of monuments as symbols of nationhood and as a focus of ethnic and national pride than their use on banknotes. Every single one of the Central Asian republics uses its medieval Islamic monuments on

Figure 5.7b *Merv, mausoleum of Sultan Sanjar depicted on a 500 manat commemorative coin dated 2000. Available at: coinect.com (last accessed 10 October 2020).*

Figure 5.7a *Merv, dish towel with image of mausoleum of Sultan Sanjar, produced for Merv's cancelled 2500th anniversary jubilee, 2000. British Museum, collection of ephemera, ANE Reg. No. EPH.108.*

Figure 5.7c *Merv, silver 500 manat commemorative coin with 'portrait' of Sultan Sanjar, mausoleum of Sultan Sanjar, dated 2001 (after Richard J. Guy,* Uses for a Monumental Tomb: The Motives for Restoration and Interpretation at the Sultan Sanjar Mausoleum *(unpublished MA thesis, Cornell University, 2006), p. 56, fig. 13).*

Figure 5.7d *Merv, ceramic model of mausoleum of Sultan Sanjar sold as a souvenir, 2005 (after Richard J. Guy,* Uses for a Monumental Tomb: The Motives for Restoration and Interpretation at the Sultan Sanjar Mausoleum *(unpublished MA thesis, Cornell University, 2006), p. 58, fig. 16).*

its banknotes, thereby ensuring that virtually the entire population becomes familiar with the look of the building even if most people cannot identify it by name. Kyrgyzstan uses Uzgend and the tomb of the folk hero Manas; Kazakhstan features the shrine of Khwaja Ahmad Yasavi in Turkistan; Tajikistan displays the fortress (*hisar*) of Gissar; Turkmenistan presents the tomb of Sultan Sanjar, of course, but also the three major mausolea at Kunya (old) Urgench and the tomb at Mihna (Figures 5.8a–d); but it is Uzbekistan that easily outguns the opposition. Successive Uzbek banknotes bear images of the shrine of Ayyub in Bukhara, and of the Gur-i Amir, the mosque of Bibi Khanum, the Rigistan and the Shah-i Zinda, all in Samarqand. These are mainly low-denomination notes with a wide circulation – which ensures that the patriotic message is beamed loud and clear to virtually the entire population. Clearly buildings are being made to carry a weight of symbolic meaning: monuments have become metaphors. Postage stamps issued by the Central Asian republics occasionally serve the same purpose, but on a smaller scale; they do not have the daily visibility of banknotes. The political and propagandist dimensions of this practice are vividly highlighted by a truly maverick case, namely the appearance on a 100-somoni banknote from Tajikistan of the ninth- to tenth-century ruler Isma'il the Samanid, in *faux*-medieval costume and crown, placed side by side with his mausoleum in Bukhara, which is by far the most familiar and indeed iconic early medieval monument in Central Asia (Figure 5.8e). Clearly, the minor inconvenience that this monument happens to be located not in Tajikistan at all but in the neighbouring republic of Uzbekistan did not prevent its use on a banknote issued by Tajikistan. This particular piece of cultural theft places a new spin on the age-old conflict of Turk and Tajik – for the Samanids are traditionally associated with the revival of Persian culture in Central Asia from the ninth century onwards. It also highlights the competitive spirit which now infects the study of Central Asian architecture in the region itself.

I myself had a vivid experience of the practical implications of such thinking fifteen years ago when I attended a UNESCO conference in Ashgabat whose purpose was to consider proposals for placing selected Central Asian monuments on the list of World Heritage sites. That honour is a focus of eager, indeed frenzied, competition, for it is a priceless accolade, a gold standard of world-class quality that is internationally recognised. Its economic implications for tourism are of crucial importance. All five Central Asian republics sent delegations. To the best of my recollection, Turkmenistan, the host country, submitted four proposals; Tajikistan two; Kazakhstan and Kyrgyzstan, one apiece; and Uzbekistan, twenty-three. A more objective, or at any rate non-Uzbek, appraisal might have come up with six. This was a take-over bid in the making, an unmistakable claim to cultural pre-eminence.

Figure 5.8a Merv, mausoleum of Sultan Sanjar on banknote from Turkmenistan. Available at <https://justworldbanknotes.co.uk> (last accessed 10 October 2020).

Figure 5.8b Mihna, mausoleum of Shaikh Abu Sa'id Fadl Allah on banknote from Turkmenistan. Available at <nickynice.com> (last accessed 10 October 2020).

Figure 5.8c Urgench, so-called mausoleum of Fakhr al-Din Razi on banknote from Turkmenistan. Available at <https://justworldbanknotes.co.uk> (last accessed 10 October 2020).

Figure 5.8d Urgench, mausoleum of Tekesh on banknote from Turkmenistan. Available at <https://www.kazcoins.com> (last accessed 10 October 2020).

Figure 5.8e Tomb of the Samanids on banknote from Tajikistan. Available at <https://www.numiscollection.com> (last accessed 10 October 2020).

This anecdote leads quite naturally to perhaps the most fundamental change of all after 1989 so far as this chapter is concerned. It came in the area of tourism. Suddenly, all of Central Asia was thrown open to foreign tourists, and they came in droves. The new Central Asian republics did not seek to perpetuate the apparatus of Intourist, so ruinously costly to the foreigners compelled to use it, but freely opened their medieval buildings without restrictions to those who wanted to see them. Buildings that for many decades had been known only to those living nearby, and to specialists, suddenly began to attract visitors – and not just one or two, but coachloads of them. Now foreigners were no longer confined to the familiar quartet of Bukhara, Samarqand, Khiva and Tashkent, and they flocked to new destinations to make up for lost time. It quickly became apparent that this flood of tourists could be turned into a major source of revenue, and so it proved. Tourist literature and dedicated websites proliferated.

Obviously, the cachet of having a monument or group of monuments designated as a World Heritage Site was of crucial importance here. So government authorities stepped in. And suddenly monuments were being considered for their potential – forgive the mixed metaphor – as cash cows. That in turn brought their physical condition under scrutiny from people with no architectural or archaeological expertise whatever, but with a sleepless eye to the bottom line. That scrutiny was therefore ignorant, but it was also unfriendly and ruthlessly practical. Should a brochure aimed at encouraging foreign tourism be packed with pictures of decaying ruins? Would a tourist regard this mosque, that mausoleum, or some other madrasa as worthy of a visit and a photograph? If not, what could be done to make such tourists change their minds?

It is easy to see where all this must of necessity lead. The desire to make old buildings look presentable trumps the desire to take loving care of them. To some, it boils down to a stark choice: is it better for the monument to make money or to tear it down so that the land it occupies can be used for some other, more profitable purpose? And the Central Asian republics are not rich countries. They cannot afford elaborate measures of conservation even if they wanted to put them in place.[28] And they do not have the trained staff to carry out such large-scale projects of conservation. Indeed, in these countries it is often less a matter of failing to maintain international standards of excellence than of not having the least idea what those standards are. There are at present, it seems, no permanent state-funded institutions in Central Asia where aspiring conservationists can learn their craft. Regional publication outlets of international standing no longer exist.[29] So local scholars have to look elsewhere to publish their research. Enterprises like the long-running International Merv Project[30] or the French excavations in Uzbekistan[31] are isolated beacons of good practice. They show what can and should be done to

combine frontline research with a responsible attitude to conserving the subject of that research. And of course there have also been generations of local scholars who have laboured long and hard in very unfavourable conditions to work on and preserve their own medieval heritage, for example in Egypt,[32] Turkey,[33] India[34] or Iran.[35]

But it is not they who make the key decisions that have resulted in such calamitous transformations of medieval monuments. It is local, provincial and governmental authorities that have decreed these changes. They are behind the drive to spruce up these buildings, to make them look neat and tidy. And the tourists do not help. Some of them are discriminating, but the majority are not, and they tamely pile out of their coaches to photograph whatever monument is next on their itinerary. Their very presence in large numbers justifies the policy of prettification. And so the celebrated Tomb of the Samanids in Bukhara, which less than a century ago reared majestically and appropriately amidst the tumbled gravestones of an extensive cemetery (Figure 5.9),[36] now has a very different and thoroughly sanitised environment that testifies to a gross insensitivity to context on the part of those responsible. Clearly at some point in living memory (and certainly before 1966, when I first saw it) the decision was made to raze the surroundings, blot out all traces of the cemetery, plant some quick-growing trees and make the tomb the cynosure of a banal municipal park (Figure 5.10). For such tourist attractions, one feels it is only a matter of time before further changes in their immediate environment are decreed to make them civic amenities: provide parking lots for coaches and cars, perhaps add benches and tables for picnickers, and see to it that the makeshift souvenir stalls give way to full-scale tourist emporia, sanitary facilities, cafés and fast-food outlets. That is not an entirely fanciful prediction.[37]

To summarise, then, in the last few decades Islamic architecture in Central Asia, and not only there, has been increasingly threatened by an enemy very different from urban expansion, war or material damage from the environment, such as the destructive impact of water seepage,[38] often with a high proportion of salt. This eats away the very fabric of the building, including its decoration, and turns the bricks themselves to powder, as in the case of the portal of the Maghak-i 'Attari mosque in Bukhara.[39] This is a relatively new threat to these buildings, but it too is man-made. It is a direct consequence of the large-scale cultivation of cotton, with its concomitant need for huge quantities of water, in the command economy of Soviet times, with a consequent disastrous impact on the water table of the region. Cotton was certainly cultivated in Central Asia before the Arab conquest,[40] and Merv itself was famous for producing a heavy type of soft flannel unsuitable for clothing in early Islamic times,[41] but this industry, even in the early twentieth century,[42] was trifling in comparison with the mass production of the Soviet era.

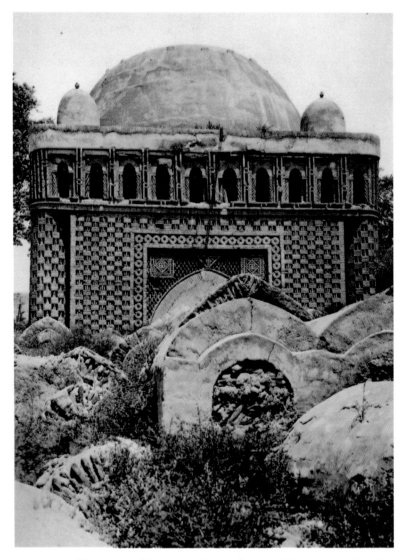

Figure 5.9 *Bukhara, so-called mausoleum of Isma'il the Samanid in the 1920s (after Ernst Cohn-Wiener,* Turan. Islamische Baukunst in Zentralasien *(Berlin, 1930), pl. 1).*

But a far greater threat to these medieval monuments is posed by a relatively new and thoroughly sinister enemy, namely state or official vandalism carried out in the interests of expanding the local tourist industry. The short-term fix, the liberal use of concrete, crass and ignorant interventions (such as restoring a four-centred arch as an ogee)[43] and a mania for tidying-up are the natural expressions of this vandalism.

It is now time to move from the general to the particular and to consider the specific case studies which comprise the second part of

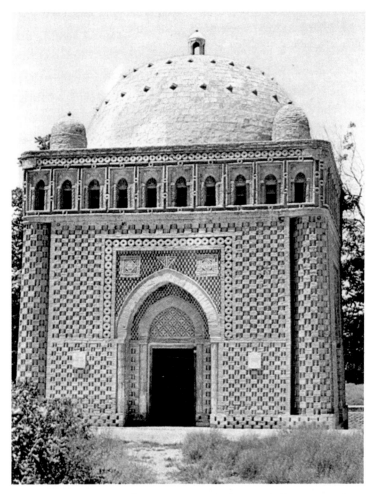

Figure 5.10 *Bukhara, so-called mausoleum of Isma'il the Samanid, setting in the 1960s (after J. Michael Rogers,* The Spread of Islam *(Oxford, 1976), p. 131).*

this chapter. It is worth looking in some detail at various aspects of the bad treatment meted out to medieval brick buildings by modern intrusions. That last term is more accurate than either 'conservation' or 'restoration', words that connote some expertise. So the rest of this chapter will focus, as noted earlier, on three major themes: first, the replacement of permanent by impermanent decoration; second, the loss of exterior surface or patina; and third, over-restoration. There are of course other aspects of this subject that deserve close attention, for example the use of inappropriate materials such as cement and cement-based mortar, but that is a broad topic that deserves more detailed investigation elsewhere.

And so to the first theme: the replacement of permanent by impermanent decoration. This is akin to plastering over the cracks

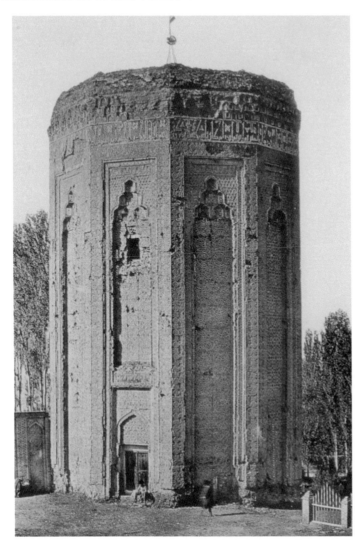

Figure 5.14 *Nakhchivan, mausoleum of Mu'mina Khatun, before restoration (after Friedrich Sarre,* Denkmäler Persischer Baukunst *(Berlin, 1901–10), pl. II).*

rather to display than to suggest' sums up the apparent intention of the restorers. The result – look at the deplorable tin roof – is a sharp, hard-edged, in-your-face cosmetic make-over, with the glazed tilework applied like lavish make-up. This goes beyond mere scrubbing-up; it is loud, insensitive restoration rather than conservation (Figure 5.15), and it is by no means an isolated case in the Republic of Azerbaijan.[50] A conserved piece of decoration focuses the eye; the neutral modern stabilising material around it acts like a foil. But the 'completion' of a passage of medieval decoration by modern work can blur the distinction between the two.

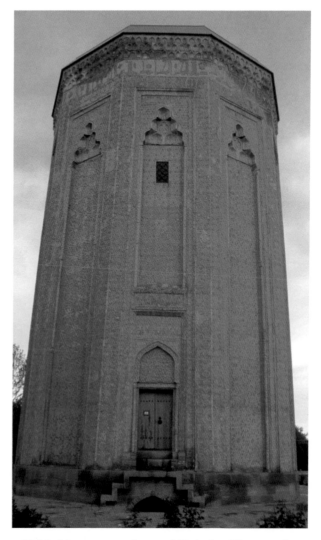

Figure 5.15 *Nakhchivan, mausoleum of Mu'mina Khatun, after restoration. Courtesy of Richard McClary.*

There is both a good and a bad way of tackling this problem. The good way is on display in the mosaics of the Great Mosque of Damascus, where a thin red line divides the modern Italian restoration from the 'original' Umayyad work.[51] That enables the viewer to make an instant distinction between 'old' and new, and indeed to compare them side by side. And it makes the modern additions reversible, for that thin red line tells the next generation of conservators precisely where they must concentrate their efforts. The bad way is to seek to disguise conservation, restoration or intrusion, no matter whether it applies to decoration or to basic structure, by not giving it any visual and quickly recognisable acknowledgement.

That way, old and new merge, which compromises the integrity of the monument. According to Marguerite van Berchem, this has been done to both the main Umayyad inscription at the Dome of the Rock and to the Barada panel in the Great Mosque of Damascus.[52]

One might ask what is to be done if it becomes necessary to repair a crumbling medieval brick wall. For even if a decayed area of a façade is replaced with hand-made bricks produced in a traditional manner, there is no way of ageing those bricks or of hiding the plain fact that they are new. So they will be an obvious blemish in the overall appearance of such a building. That price has to be paid if the building is not to collapse. This is emphatically not to suggest that it is a mistake to use them. On the contrary, it is much better, when carrying out conservation and restoration, to use just such bricks rather than machine-made ones. They will age much more gracefully. And the restorers should take care to match the colour of the new bricks as closely as possible to that of the old ones. But even so, some permanent method of distinguishing repair work from original work is required, perhaps by using a different colour, texture or thickness of mortar to indicate the boundary between old and new. That is a much better solution than not drawing attention to new work, or – worse still – making an entire old building look new.

It is common in Central Asia nowadays for buildings to be refaced or restored with a peculiarly ugly machine-made brick of a dispiriting muddy yellow colour.[53] This can be guaranteed not to fit with any earlier kind of brick, and to reduce its visual appeal to that of a suburban garage. There can even be something unintentionally comic in the harlequin motley of a restored façade in uncomfortably uneven colours. The clashing discordant tones of contrasting old and new brickwork now spoil the appearance of many a medieval Central Asian building, and not just the exterior either, as the *mihrab* area of the mosque of Talkhatan Baba in the Merv oasis shows.

Architectural historians do not use the vocabulary of numismatists, who make a distinction between the pristine condition of a coin when it leaves the mint, with its minter's sheen intact, and 'very fine', which is the condition of a coin that has seen minimal use. In some curious way, brick buildings work in the opposite direction: it is only with age and use that they acquire patina. Medieval bricklayers sometimes brushed a thin skim of plaster over a finished wall, and incised decorative plugs between the horizontally laid bricks (that is, the stretchers) with a sharp tool. In most buildings only a limited number of designs are used for these plugs, and so the craftsman profits from this repetition to develop a fine turn of speed and accuracy of execution (Figure 5.17, which shows the original appearance of the wall with the plaster layer intact – now lost to pressure washing and a chemical cleaner).[54] This technique would bring an entire wall to life, creating a dappled effect that introduces an unpredictably playful quality into the otherwise severe geometry

Figure 5.16 *Sivas, mortar decoration east of façade of tomb of 'Izz al-Din Kay Ka'us I, after restoration. Courtesy of Richard McClary.*

of a wall built in common bond, with the joint plugs serving as grace notes for the regular beat of whatever bond is used on the entire wall. They also showcase the bricklayer's skills as a sculptor. Their reduced scale is no barrier to this, for often they render complex compositions executed with a jeweller's finesse. But these subtleties are forever lost, and sharp colour contrasts blunted, once pressure washing and the sanding machine are brought into play. They iron out variety and replace it with a dull, lifeless conformity. Over-pointing, another common practice, changes the original proportions between bricks and mortar, as do new bricks (Figure 5.16).

Finally, what of over-restoration? It is here, above all, that Central Asian monuments have fallen on hard times and into the wrong hands. It is a matter of putting King Herod in charge of the kindergarten. In almost every case, these are not rescue restorations; the monument is not in danger of collapse; it merely offends the eye of some bureaucrat because it looks old and perhaps dilapidated.

Figure 5.17 *Sivas, hospital of 'Izz al-Din Kay Ka'us I, north* iwan *wall, original state. Courtesy of Richard McClary.*

Such restoration is not always obvious at first glance. Thus, in the portal arch of the 1187 mausoleum at Uzgend, a very stylish cursive inscription had lost its central portion when Cohn-Wiener photographed the building in 1925 (Figure 5.18).[55] When I saw the building almost sixty years later, however, that lost portion had magically re-appeared – except that it was no longer a text at all, but a series of fancy non-alphabetic arabesque flourishes that did duty for the missing text (Figure 5.19). Some modern craftsman was having himself a bit of fun. Here, then, 'restoration' was telling a bare-faced lie. Another example, bold as brass, can be seen at the

Figure 5.18 *Uzgend, mausoleum dated 1187, before restoration (after Ernst Cohn-Wiener,* Turan. Islamische Baukunst in Zentralasien *(Berlin, 1930), pl. XV).*

base of the gadrooned dome of the Yasavi shrine at Turkistan, where the merest fragments of the original inscription remains, drowned out by modern scrolling ornament, although old and new are clearly distinguished (Figure 5.20).

Typically, though, over-restoration affects more than mere ornament or even surface; it extends to the very form of the monument. I mentioned earlier the plastic shell that entombed the roofless mausoleum of 'A'isha Bibi when I visited it in 1983. No longer. The crumbling walls (Figure 5.21) that Soviet conservators had carefully

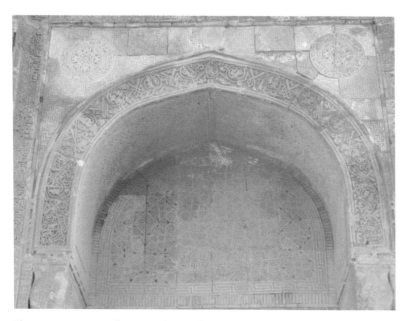

Figure 5.19 *Uzgend, mausoleum dated 1187, after restoration. Courtesy of Richard McClary.*

Figure 5.20 *Turkistan, mausoleum of Ahmad Yasavi, modern restoration at base of dome. Courtesy of Richard McClary.*

kept in place with strategic dabs of plaster and wooden supports have been whisked away. The plastic shell has gone, and some cowboy contractor has seen fit to crown the building with a dome of his own devising (Figure 5.22).[56] The monument now looks meretriciously solid and all sense of fragility has disappeared – one dare not ask at what cost to its authenticity. It has also acquired a fetching little lawn and a surrounding park. And this is no isolated case. Parts of the Bibi Khanum mosque in Samarqand are now substantially higher than they ever were in the Timurid period when it was built (Figures 5.23 and 5.24), and bear a coarse modern Uzbek zigzag motif of gigantic scale (Figure 5.4) that is a poor excuse for architectural decoration on a building famed precisely for its varied and subtle ornament in several media. The fashion of the time would have used sacred names in square Kufic for such cladding. Such changes often go hand in hand with modern materials – thus cement has done much to denature the portal of the Gök Medrese in Sivas, and its courtyard features a new concrete structure clumsily faced with random slabs of marble (Figure 5.25), and the bags that were stacked at the entrance told their own sinister story. The dignified cubic mass of the Shah Fadl mausoleum in Safid Buland, in Kyrgyzstan, has been saved from collapse by unsightly steel scaffolding inside and outside; one can only hope that the future of its spectacular stucco decoration is not in peril.

But beyond question, the most outrageous and high-profile case of over-restoration is that of the celebrated mausoleum of Sultan Sanjar, in Merv, datable to c. 1140 and formerly one of the masterpieces of medieval Islamic architecture (Figure 5.26).[57] The word 'restored' does not begin to describe what has happened to this unfortunate building. It has been puffed up, done over, and subjected to a complete cosmetic overhaul, pancake makeup and all. The brooding mass that the structure presented a century ago, the eloquent wreck of one of the most ambitious of all medieval mausolea, a key link in the chain that eventually leads to the Taj Mahal, is now only a memory. This restoration (Figure 5.27) is a present from the Turkish government to the Turkmen people – *timeo Turcos et dona ferentes*. A marble slab erected near the monument records this gift. A team of Turkish restorers worked from 2002 to 2004 to recreate this masterpiece in their own image of what it should look like, taking the most diabolical liberties in the process. I have walked, climbed and crawled over most of the monument in three successive visits before this work was fully underway and I have trouble in reconciling what I saw then with what I see now. It is plain that the conservation option was roundly rejected in favour of large-scale rebuilding and then, on top of that, an imaginative and arguably misconceived recreation of areas of the upper half of the mausoleum that had vanished centuries ago. The restorers chose to ignore the testimony of the traveller Yaqut, who saw the building in the 1220s and said that its blue dome was

Figure 5.21 *Taraz/Dzhambul, mausoleum of 'A'isha Bibi, before restoration (after Boris P. Denike,* Arkhitekturni Ornament Srednei Azii *(Moscow and Leningrad, 1939), pl. 95).*

visible a day's journey away,[58] so the outer dome is unglazed. Giving them the benefit of the doubt, the fact that there is no evidence of glazed brick at the site could justify this decision as cautionary.[59]

This dramatic change of appearance has been achieved at sore cost to the original brickwork. A comparison of pictures taken before and after the restoration indicates that the lower part of the outer dome – a huge mass of Seljuq brickwork – was removed and replaced with modern bricks so as to give the dome a visually consistent appearance. So, in plain language, it no longer looks its age; it looks as if it had been built yesterday.

But this is only the beginning. Before 2002 the building was an object lesson in the use of a double dome, as can be seen very plainly in an aerial view and as was equally obvious to anyone studying the upper parts of the structure. Now the outer surface of that inner dome is hidden – as of course it would be even in the most sensitive of restorations. And to put it mildly, there is room for argument about the accuracy of the profile of the outer dome which the Turkish team constructed. There are sufficient surviving large Seljuq domes – the south dome at Isfahan, the north dome in the same mosque, Barsiyan and Qazvin, all measured with extreme exactitude by Haeedeh Laleh,[60] as well as others such as Ardistan, Zavara, Rida'iyya, Gulpaygan and Burujird – to suggest that the reconstructed profile here is too acute, too pointed. There is no serious attempt to use the material evidence that survived the work of the 1980s to reconstruct the zone of transition in any convincing way. The presence of the main gallery is clear and seems

Figure 5.22 *Taraz/Dzhambul, mausoleum of 'A'isha Bibi, current state. Courtesy of Richard McClary.*

to be restored accurately as to form; but there is strong evidence of a second gallery above that of similar form to the one below. There is also convincing archaeological evidence for the curious ring of blind arches at the collar of the dome. Although this looks quite out of place above the mishmash of arches and openings below it, it might make visual sense above the geometrically formal upper gallery which close examination shows was there. These features – the stacked galleries and the ring of blind arches – are quite without

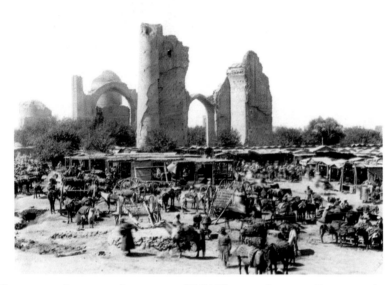

Figure 5.23 *Samarqand, mosque of Bibi Khanum in 1900. Courtesy of Sheila Blair and Jonathan Bloom.*

parallel in the medieval architecture of the Iranian world, and that fact alone makes accurate reconstruction of this unique building vitally important. As currently constructed, this fussy multitude of openings, taken in conjunction with the arcade below it and the main gallery arcade below that, results in mere clutter. The sheer quantity of perforations is counter-productive. And the contrast between the blind mass of plain brick surface in the lower half of the building and this agitated array of openings, like tiered gunports, is uncomfortable and unconvincing. Here again, surviving buildings do not justify this reconstruction. Several mausolea with single galleries are known, from the tomb of the Samanids to Sangbast, but all contrast the open arcaded gallery with the unbroken surface of the dome behind. If, as seems to be the case, there really was a full double gallery at Sanjar's mausoleum, it too could make the same architectonic sense against the bulk of the dome behind it, and arguably that ensemble would not be prejudiced by the ring of blind arches above it, hardly visible as they peeped over the top of the upper gallery. The fourteenth-century dome at Sultaniyya has a series of small arches at the base of the outer dome which serve to lighten its mass, but the point is that they were covered by the outer skin of the dome, and thus not visible. It may be that the architect of Sanjar's tomb was experimenting with a similar idea. If so, the Turkish restorers misunderstood his intention.

Either way, by its grotesque misinterpretation of the evidence on the ground, this reconstruction has denied us an insight into a probably unique development of several vital features of

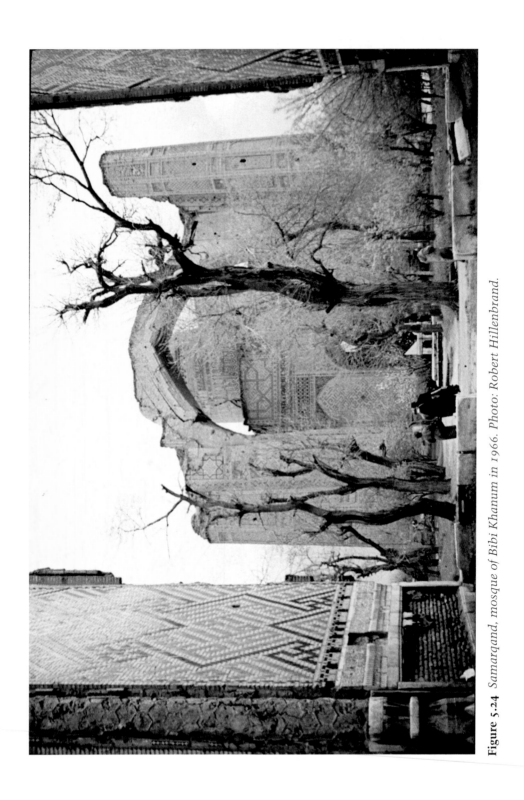

Figure 5.24 *Samarqand, mosque of Bibi Khanum in 1966. Photo: Robert Hillenbrand.*

Figure 5.25 *Sivas, Gök Medrese, courtyard. Courtesy of Richard McClary.*

contemporary architecture. And it has also denied us a beautiful and uniquely imposing monument – whether that is the pre-restoration ruin, or – if reconstruction was inevitable – a sensitive reflection of what the architect wanted us to experience.

It would be tempting to question the zigzag infill of the narrow blind niches in the gallery or to analyse what has been done to the interior of the mausoleum, but there is no need. It will suffice to note the bland pastel hues which decisively tone down the powerful sculptural impact formerly exerted by the outset ribbing which drew the eye to the centre of the inner dome and its oculus.

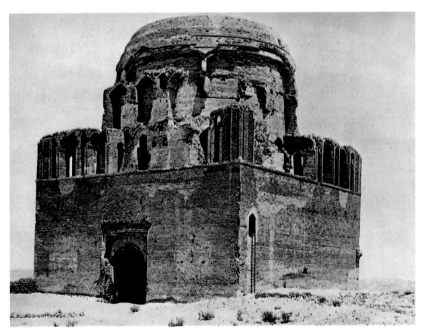

Figure 5.26 *Merv, mausoleum of Sultan Sanjar, before restoration (after Arthur Upham Pope and Phyllis Ackerman (eds),* A Survey of Persian Art from Prehistoric Times to the Present *(Oxford and London, 1938–9), pl. 282).*

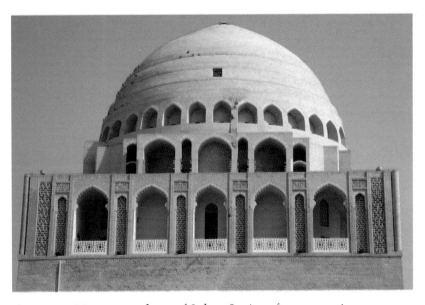

Figure 5.27 *Merv, mausoleum of Sultan Sanjar, after restoration.*

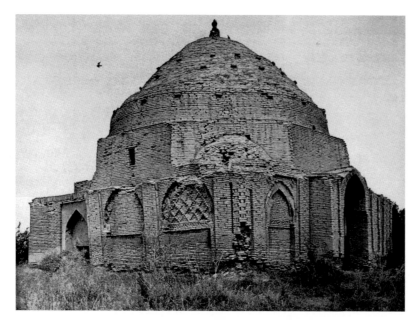

Figure 5.28 *Karkh, mausoleum of al-Muntasir in 1971 (after V. I. Pilyavskii*, Pamyatniki Arkhitekturi Turkmenistana *(Leningrad, 1974), p. 236).*

Let me end with a warning to the curious. One of the finest early Islamic buildings in Transoxiana was – let me stress the past tense – a mausoleum near Karkh in modern east Turkmenistan, popularly attributed to the Samanid ruler al-Muntasir and thus conventionally dated to c. 1007. For some reason, perhaps because of its relative remoteness, it had escaped detailed analysis in Soviet times, though Pilyavsky published some good photographs of it taken in 1971.[61] These showed it to be in fairly good condition (Figure 5.28). Eighteen years ago I visited Karkh with the most eager anticipation. On arrival I was dumbfounded. The building was there all right, but it was another building entirely (Figure 5.29). Through an interpreter, the site guard told a sorry tale. A few years back, the local supremo in charge of the area's flagging tourist industry had visited the monument and proclaimed it to be too damaged to be of interest to tourists. The idea that a building could grow old gracefully was clearly anathema to him. He had therefore decreed that it should be demolished to ground zero and rebuilt from scratch. This was done, and it is now

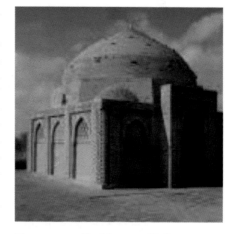

Figure 5.29 *Karkh, so-called mausoleum of al-Muntasir, Karkh, current state.*

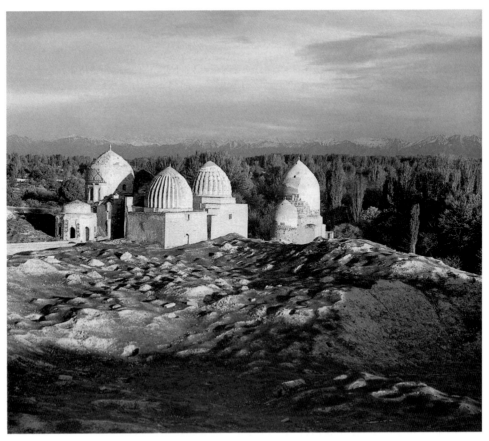

Figure 5.30 *Samarqand, Shah-i Zinda. Colour photograph taken by Prokodin Gorskii before the First World War.*

available to all and sundry in glorious technicolour. From a distance, this is a reasonable simulacrum of its medieval original. Clearly the rebuilders had decent photographs before them as they set about their task with machine-made bricks and modern mortar. But close up, this structure is a calamity. It has zero evidential value as a source of information on local medieval architecture. The wrecking ball has replaced the measuring tape. The respect shown to the medieval architecture of Central Asia under Russian rule, which is manifest early on in a wonderful colour image of the Shah-i Zinda, taken before the First World War by Prokudin Gorskii (Figure 5.30), is no more. And worst of all, this twenty-first-century monument at Karkh tells an impudent lie in a bid to bring in more tourists. At least the castles in Disneyland do not pretend to be the real thing.[62]

Notes

1. In deciding what contribution to offer to this Festschrift for two outstanding scholars of Islamic art and architecture, I settled on this chapter, not least because for them it will evoke happy recollections of many medieval Islamic buildings which they were able to visit and study at close quarters before modern restoration transformed them. I have also used some of the thousands of their photographs of which they so generously gave me copies. I hope that they will enjoy this trip down memory lane. Professor Bernard O'Kane kindly made some very useful suggestions for improvement. I am extremely grateful to Dr Richard McClary for doing the same, in addition to his comments on an earlier version of this chapter – some of which are incorporated in notes 3, 10, 21, 24, 26, 39, 50 and 52 – and for providing illustrations 13, 14, 15, 17, 19, 20, 21 and 25. Special thanks are also due to David Gye for his perceptive comments on several aspects of the mausoleum of Sultan Sanjar, a building on and in which the pair of us spent many happy hours and some alarming moments.
2. John Ruskin, *The Seven Lamps of Architecture. Lectures on Architecture and Painting: The Study of Architecture* (repr. Boston, 1900), pp. 55–8 and 162.
3. Formerly there was a panel of square Kufic text on the south-east facing upper facet of the exterior of the Natanz shrine, visible in Myron Smith's images (but too blurred in André Godard's) that has now been totally lost and replaced with simple intersecting lines of turquoise intarsia in the most recent restoration, showing that mistakes are also made in Iran.
4. See the admirably precise and comprehensive approach to the Shah-i Mashhad madrasa taken by Abdul Wassay Najimi, a conservation architect working in Kabul: 'The Ghurid madrasa and mausoleum of Shah-i Mashhad, Ghur, Afghanistan', *Iran* LIII (2015), pp. 143–69.
5. The victims include several caravanserais, of both major and minor importance.
6. Such as the khanqah of Shaikh Pir Husain al-Ghada'iri near the Pirsagaat River, whose earlier form – see Vera Kratchkovskaya, *Izraztsi Mavzoleya Pir-Khuseina* (Tbilisi, 1946), pls II, III and XXIX – is now unrecognisable under the modern rebuilding. See also Ishayahu Landa, 'New light on early Mongol Islamisation: the case of Arghun Aqa's family', *Journal of the Royal Asiatic Society*, Series 3, 28.1 (2018), pp. 84–6.
7. Richard P. McClary, 'Remembering the Imam Yahya ibn al-Qasim Mashhad in Mosul', *Iraq* LXXIX (2017), pp. 129–54. For a rare colour image of an inscribed panel from this tomb using glazed terracotta, plus a black and white image of its masterly cursive inscription in white marble against a black marble ground, see A. Souren Melikian-Chirvani, 'Paroles d'Or et de Turquoise', *L'Oeil* 228–9 (July–August 1974), pp. 42 and 44–5.
8. For the paradigmatic case of Bukhara, which had 360 mosques in 1917 but by 1940 was left with only thirty-five buildings (including four mosques) deemed worthy of preservation, see Richard P. McClary, *Medieval Monuments of Central Asia: Qarakhanid Architecture of the 11th and 12th Centuries* (Edinburgh, 2020), p. 3. For an exhaustive attempt to chronicle the changing vision of heritage professionals from the mid-1960s onwards, to rectify the earlier mistakes of the Soviet regime, to change the city's identity and to create what she terms a 'museum-ification'

of Bukhara's Islamic monuments, see Hanna Rutkouskaya, *Redefining Historical Bukhara: Professional Architectural Vision of the National Heritage in Late Soviet Uzbekistan (1965–1991)* (Masters dissertation, MIT, 2012). For further detail on Bukhara, see Mounira Azzout, 'The Soviet interpretation and preservation of the ancient heritage of Uzbekistan: the example of Bukhara', in A. Petruccioli (ed.), *Bukhara: The Myth and the Architecture* (Cambridge, MA, 1999), pp. 161–73. For a lengthy discussion of the pre-1917 local and imperial efforts to preserve the medieval architectural heritage of Central Asia, see Svetlana Gorshenina and Vera Tolz, 'Constructing heritage in early Soviet Central Asia: the politics of memory in a revolutionary context', *Ab Imperio* 4 (2016), pp. 77–115. But this entire discussion, larded though it is by learned footnotes, is vitiated by an echoing silence about the mass destruction of that heritage from 1917 to at least 1940 by the Soviet state. This lends the discussion (for example, on pp. 95–9) of the new regime's 'commitment' to the 'preservation' of the Islamic heritage in Central Asia a pervasive air of unreality. The basic fact, which the authors sedulously ignore, is that the regime destroyed almost all of the Islamic built heritage of Bukhara, and of other Central Asian cities, instead of attempting to preserve it. One of the reasons given for this eradication of the material past, which included the city's walls, was 'to let in more air'.

9. For a view of the site before this intervention, see Gianroberto Scarcia, 'The "vihar" of Qonqor-olong: preliminary report', *East and West* 25.1–2 (1975), fig. 9.

10. There are also plastic screens both inside the tomb and on the portal at Natanz to protect what little remains of the original tiles inside, and the new restored tilework outside on the portal.

11. An early scholarly reference to this mausoleum was by Boris Denike, *Arkhitekturnii Ornament Srednei Azii* (Moscow and Leningrad, 1939), pp. 100 and 102 and pls 95–8. For a truly magisterial account of it, see Monique Kervran, 'Un monument baroque dans les steppes du Kazakhstan: Le tombeau d'Örkina Khatun, princesse Chaghatay?', *Arts Asiatiques* 57 (2002), pp. 5–32, though her dating (late thirteenth century) can be contested. See too, for an earlier account of the building and its context, Robert Hillenbrand, 'The mausoleum of 'A'isha Bibi and the Central Asian tradition of funerary architecture', in *Annemarie Schimmel Festschrift. Essays Presented to Annemarie Schimmel on the Occasion of her Retirement from Harvard University by Her Colleagues, Students and Friends, Journal of Turkish Studies* 18, ed. M. E. Subtelny (Cambridge, MA, 1994), pp. 111–20. For the most recent study of this building, see McClary, *Medieval Monuments*, pp. 220–32. He suggests (p. 224) that the mausoleum 'was probably built before the middle of the twelfth century'.

12. For a vivid image of what has happened to the tomb of 'A'isha Bibi, see McClary, *Medieval Monuments*, fig. 6.19, which shows a thin red line superimposed on the photograph, revealing the sheer amount of modern restoration which effectively changes the character of the whole structure.

13. The removal of the admittedly unappealing concrete cover on the Kilij Arslan II kiosk in Konya and the total rebuilding of the upper section is, as Richard McClary notes (personal communication) 'a Las Vegas/ Disneyland model of worst practice'.

14. For an overview, see Hossam Mahdy, *Approaches to the Conservation*

of Islamic Cities: The Case of Cairo (Sharjah, 2016). He discusses (pp. 35–45) the attempts made over the centuries to conserve and restore four of the most important Cairene mosques, and this provides a historical context for the study as a whole.

15. Deborah Cherry, 'The afterlives of monuments', South Asian Studies 29.1 (2013), pp. 1–14; Nayanjot Lahiri, 'Commemorating and remembering 1857: the revolt in Delhi and its afterlife', World Archaeology 35.1 (2003), especially pp. 37–42. For a convenient overview, see Sam Dalrymple, 'Sweet decay: the destruction of art and architecture in Delhi', ISIS, 25 April 2018, available at: <https://isismagazine.org.uk/2018/04/the-destruction-of-art-and-architecture-in-delhi/> (last accessed 25 September 2019). For a more detailed assessment of the dangers to which the built heritage in India is currently exposed, see Om Prakash, 'Religious fundamentalism, public apathy and destruction of heritage structures in India: need for a public policy', South Asian Journal of Tourism and Heritage 4.2 (2011), pp. 206–15. See too Chapter 1 above.

16. Ernst Diez, Churasanische Baudenkmäler (Berlin, 1918), Taf. 4.

17. Alireza Anisi, Early Islamic Architecture in Iran, 637–1059 (unpublished PhD thesis, University of Edinburgh, 2008), pp. 222–3.

18. Donat Gallagher (ed.), The Essays, Articles and Reviews of Evelyn Waugh (Boston, 1984), p. 394.

19. I regret that I kept no record of the name or date of this documentary.

20. I am grateful to Richard McClary for the observation that one must take into account on the debit side the evidence of intervention at the shrine of Ahmad Yasavi, the Shah-i Zinda necropolis, the mosque of Bibi Khanum and the rebuilding of the Burana tower as well as the destruction of much of the urban fabric of Bukhara.

21. Friedrich Sarre, Denkmäler Persischer Baukunst (Berlin, 1901–10).

22. Ernst Cohn-Wiener, Turan. Islamische Baukunst in Zentralasien (Berlin, 1930).

23. See, for example, Ivan I. Umnyakov, Arkhitekturniye pamyatniki Srednei Azii. Issledovaniye, remont, restavratsiya, 1920–1928 g.g. (Tashkent, 1929).

24. For a conspectus of this literature, see K. Archibald C. Creswell, A Bibliography of the Architecture, Arts and Crafts of Islam (Cairo, 1961), cols 301–3 and 304–12; K. Archibald C. Creswell, A Bibliography of the Architecture, Arts and Crafts of Islam, Supplement 1 (Cairo, 1973), cols 58–81; John D. Pearson, Michael Meinecke and George T. Scanlon, A Bibliography of the Architecture, Arts and Crafts of Islam, Supplement II (Cairo, 1984), cols 98–112. While these three bibliographies do capture most of the important titles up to 1980, there are hundreds more from before and after that date that are not listed in them. Many of these are listed in Yuri Bregel, Bibliography of Islamic Central Asia, III (Bloomington, 1995).

25. Azzout, 'Soviet interpretation', p. 167.

26. But it must be conceded that there was still a very SSR-specific approach taken to architecture in the Soviet period, in order to augment the national delimitation process outlined by Stalin, although it does indeed grow exponentially after 1991. I am grateful to Richard McClary for the observation that there was substantial proto-nationalist competition and lack of cooperation between the different SSRs from 1932 onwards (see Gorshenina and Tolz 2016, p. 109).

27. For the sheer variety of symbols, kitsch and otherwise, which the tomb

of Sanjar has inspired in the past generation, see Richard J. Guy, *Uses for a Monumental Tomb: The Motives for Restoration and Interpretation at the Sultan Sanjar Mausoleum* (MA thesis, Cornell University, 2006), pp. 56–8, figs 12–17.

28. I am grateful to Richard McClary for the observation that the fact that Uzbekistan has tied its national identity so tightly to the mast of Timur, and by extension to what he built, is another reason why its government does not want to be represented by ruins, but by perfectly preserved monuments. This adds a political angle to the fiscal one.

29. A notable exception to this is IICAS (International Institute for Central Asian Studies) in Samarqand, which is under the aegis of UNESCO and does publish serious work by Central Asian scholars in English (and Russian) – as their website reveals. The Kazakhstan Archaeological Society also deserves notice in this connection.

30. For the early stages of this ambitious and ongoing project, see Georgina Herrmann, *Monuments of Merv: Traditional Buildings of the Karakum* (London, 1999), and the preliminary multi-author reports by herself and others in *Iran* XXXI (1993), 39–62; XXXIV (1996), 1–22; XXXV (1997), 1–33; XXXVI (1998), 53–75; and XXXVII (1999), 1–24. Nevertheless, there have been ill-judged local interventions in the monuments of the area. The project is currently overseen by Tim Williams of University College, London.

31. For the results of this project, see, for example, Yuri Karev, 'Qarakhanid wall paintings in the citadel of Samarqand: first report and preliminary observations', *Muqarnas* 22 (2005), pp. 45–84; Thérèse Bittar, 'La mosquée de Tchor Soutoun à Termez. Sa place dans l'architecture islamique', in Pierre Leriche and Vincent Fourniau (eds), *La Bactriane au carrefour des routes et des civilisations de l'Asie centrale: Termez et les villes de Bactriane-Tokharestan. Actes du colloque de Termez 1997* (Paris, 2001), vol. 1, pp. 392–6; and Pierre Leriche and Shakirdzhan/Chakirjan R. Pidaev, *Termez sur Oxus: cité-capitale d'Asie centrale* (Paris, 2008).

32. Such as the frequently anonymous contributors to the volumes of the Comité de Conservation des Monuments de l'Art arabe (see Creswell, *Bibliography*, cols 89–96).

33. Such as Halil Edhem, who worked in Anatolia from the 1890s (Wendy M. K. Shaw, 'Islamic arts in the Ottoman Imperial Museum, 1889–1923', *Ars Orientalis* XXX (2000)), pp. 55–68, pp. 60 and 68). He was a long-time collaborator of Max van Berchem, to whom he wrote a moving tribute (see Lucien Gautier, *Hommage à Max van Berchem* (Geneva, 1923), pp. 133–4; cf. ibid., p. 124, where Strzygowski describes the plan for a joint work on the art of the Seljuqs in Anatolia based on the fieldwork of van Berchem and Halil Edhem). See also Edhem's own ambitious book, *Kitabehler* (Istanbul, 1345/1927), published under the name Isma'il Haqqi.

34. In pre-Partition India there come to mind the names of Sayyid Ahmad Khan (who among much other work on the monuments of Delhi transcribed the inscriptions of the Qutb Minar in his book *Athar al-Sanadid* Lucknow, 1856), whose core text was rendered into French by Garcin de Tassy (see bibliography); and Sayyid Muhammad Latif, author of *Agra: Historical & Descriptive* (Calcutta, 1896) and of *Lahore: its History, Architectural Remains and Antiquities, with an Account of Its Modern Institutions, Inhabitants, Their Trade, Customs, etc.* (Lahore, 1892).

35. Here the publications of the Anjuman-i Athar-i Milli brought out in the

1960s and 70s are of major importance. Especially compendious are the two volumes devoted to Yazd (Iraj Afshar, *Yadgarha-yi Yazd* (Tehran, 1348–54/1969–75) and the indispensable and independently published study of the monuments of Isfahan by Lutfallah Hunarfar, *Ganjina-yi athar-i tarikhi-yi Isfahan* (Tehran, 1350/1977).

36. Cohn-Wiener, *Turan*, Taf. I.6

37. Richard McClary notes that the recent destruction of archaeological remains at the east end of the site of the Alhambra in Granada, to create a coach park to save tourists having to walk up the hill, shows that sometimes the West is not much more advanced in some respects.

38. For an example of the damage caused to the Ottoman sabil of Shahin Agha in Cairo, see Nabil A. Bader and Anwer F. Mahran, 'Restoration and preservation of artistic elements applied on Islamic architectural façade of Shahin Agha sebil, Cairo, Egypt', *International Journal of Conservation Science* 6.1 (2015), p. 67.

39. See McClary, *Medieval Monuments*, pp. 136–8 and figs 4.20 and 4.36 showing salt build-up and surface delamination on the portal of the Maghak-i 'Attari mosque in Bukhara. For a discussion of the methods to slow down this process, see Barbara Lubelli and Rob P. J. van Hees, 'Effectiveness of crystallization inhibitors in preventing salt damage in building materials', *Journal of Cultural Heritage* 8 (2007), pp. 223–34.

40. Richard W. Bulliet, *Cotton, Climate and Camels in Early Islamic Iran* (New York, 2009), p. 8.

41. Adam Mez, *The Renaissance of Islam*, trans. Salahuddin Khuda Bakhsh and David S. Margoliouth (Patna, 1937), p. 463.

42. Ibid.

43. For a similarly ill-considered alteration of a pointed to a rounded arch at Sivas, see Richard McClary, *Rum Seljuq Architecture, 1170–1220: The Patronage of Sultans* (Edinburgh, 2017), p. 116, fig. 4.23.

44. Jonathan M. Bloom, *The Minaret* (Edinburgh, 2013), p. 298.

45. This change was already in place in 1970. I am grateful to Bernard O'Kane for the suggestion that paint is hugely preferable to restoring the inscription in tilework, since the use of a different medium guarantees that one can still distinguish what is original. And when it fades, the inscription will look more like its pre-restoration state.

46. This inscription has attracted the attention of epigraphers for a century and more. See Max van Berchem, 'Die Inschriften der Grabtürme', in Diez, *Baudenkmäler*, pp. 107–9, followed by Ernst Herzfeld, 'Die Gumbadh-i 'Alawiyyan und die Baukunst der Ilkane in Iran', in Sir Thomas W. Arnold and R. A. Nicholson (eds), *A Volume of Oriental Studies Presented to Edward G. Browne on his 60th Birthday* (Cambridge, 1922), pp. 192–3; by Sheila S. Blair, 'The madrasa at Zuzan: Islamic architecture in eastern Iran on the eve of the Mongol invasion', *Muqarnas* 3 (1985), pp. 87 and 91 and, most recently, by Ishayahu Landa, 'Arghun Aqa's family', p. 89. He connects the mausoleum (whose tenant is still of disputed identity) with that of Arghun's daughter in Salmas, destroyed by earthquake in 1930 but whose inscription was read by Max van Berchem, 'Arabische Inschriften aus Armenien und Diyarbekr', in Carl F. Lehmann-Haupt, *Materialien zur älteren Geschichte Armeniens und Mesopotamiens* (Berlin, 1907), pp. 158–60.

47. This fragment has been penetratingly and extensively analysed by Richard McClary, to whom I owe pl. 16 (McClary, *Medieval Monuments*, pp. 238–40 and figs 6.54 and 6.35). It was photographed by

Lisa Golombek and published in Ludmilla I. Man'kovskaia, 'Towards the Study of Forms in Central Asian Architecture at the End of the Fourteenth Century: the Mausoleum of Khvaja Ahmad Yasavi', tr. Lisa Golombek, *Iran* XXIII (1985), p. 127 and pl. VIIb. I am grateful to Bernard O'Kane for reminding me of this publication.

48. Charles Dickens, *Dombey and Son* (repr. London, 1921), p. 1.

49. Enrico Fodde, 'Fired brick conservation in the Kyrgyz Silk Roads', *Journal of Architectural Conservation* 14.1 (2008), pp. 77–94, in which he describes in detail (see especially pp. 82–8) the methods used to conserve the brickwork of an eleventh-century mausoleum at Burana, the medieval Balasaghun. The same author has also reported on the problems of conserving mud brick structures: 'Structural faults in earthen archaeological sites in central Asia: analysis and repair methods', in Dina D'Ayala and Enrico Fodde (eds), *Structural Analysis of Historic Construction* (London, 2008), pp. 1415–22, with references to six related publications by Fodde on p. 1422. For an authoritative account of mud brick, see Eisa Esfanjary, *Persian Historic Landscapes: Interpreting and Managing Maibud over 6000 Years* (Edinburgh, 2017), pp. 19–213.

50. Other examples include the shrine of Pir Husain, famous for its lustre tiles, and the tomb tower at Barda'a; I thank Bernard O'Kane for the following reference: https://commons.wikimedia.org/wiki/File:Barda_TowerMausoleum_004_6789.jpg. The site of Karabaghlar, with its twin-minaret Ilkhanid portal, was still untouched in its tranquil and dignified old age when I visited it a few years ago, but it has now also suffered the rough hand of 'restoration'.

51. See Gérard Degeorge, *La Grande Mosquée des Omeyyades Damas* (Paris, 2010), p. 175, showing French 1930s re-setting.

52. Marguerite Gautier-van Berchem, 'The mosaics of the Dome of the Rock in Jerusalem and of the Great Mosque in Damascus', trans. Gaston A. Vetch, in K. A. C. Creswell, *Early Muslim Architecture: Umayyads* AD 622–750, Part 1 (Oxford, 1969), pp. 220 and, 324–5; cf., however, the doubts expressed by Robert W. Hamilton in 'Minarets, mihrabs and mosques' (a review of this book), *The Times Literary Supplement* (25 December 1970), p. 1518. One cannot avoid the suspicion that the accounts given by Marguerite Gautier-van Berchem of truly destructive 'repairs' to the Umayyad mosaics in Jerusalem and Damascus are simply vast exaggerations, as I myself have had occasion to confirm at close quarters by actually touching the Jerusalem mosaics. Cf. also the abundant and highly detailed visual evidence presented in Saïd Nuseibeh and Oleg Grabar, *The Dome of the Rock* (London, 1996) and Degeorge, *Grande Mosquée*.

53. As early as 1922 there was local opposition to the use of European bricks instead of old Central Asian ones (Gorshenina and Tolz, 'Constructing Heritage', p. 100).

54. Intact sections can still be seen in Natanz, and formerly, but now lost, in the north *iwan* of the Sivas hospital.

55. Cohn-Wiener, *Turan*, Taf. XV, top.

56. This was Nishan Ramatov; it cost $400,000 in 2002.

57. For a set of 211 archival and recent photographs that permit a series of detailed comparisons between the pre-restoration and post-restoration state of the building, see Georgina Herrmann, Helena Coffey and Stuart Laidlaw, *Monuments of Merv: A Scanned Archive of Photographs and Plans* (London, 2002), pp. 20–35. For succinct analyses of the building before its restoration by two experienced Russian architectural histori-

ans, see Galina A. Pugachenkova, *Puti Razvitiya arkhitekturni Iuznogo Turkmenistana pori rabovladeniya i feodalisma* (Moscow, 1958), pp. 315–28 and Sergei Chmelnizkij, 'Das Mausoleum des Sultans Sandschar in Merw', *Architectura. Zeitschrift für Geschichte der Baukunst. Journal of the History of Architecture* (1989), pp. 20–35 and Sergei Chmelnizkij, *Mezhdu Samanidami i Mongolami. Arkhitektura Srednei Azii XI – nachala XIII vv. Chast II* (Berlin and Riga, 1997), pp. 45–61.

58. Charles A. C. Barbier de Meynard, *Dictionnaire géographique, historique et littéraire de la Perse et des contrées adjacentes, extrait du Mo'djem el-Bouldan de Yaqout, et complété à l'aide de documents arabes et persans pour la plupart inédits* (Paris, 1861), p. 529.

59. Cf. David H. Gye and Robert Hillenbrand, 'Mausolea at Merv and Dehistan', *Iran* XXXIX (2001), pp. 53–4.

60. Haeedeh Laleh, *La Structure Fondamentale des Arcs dans l'Architecture Saldjukide de l'Iran* (PhD thesis, University of Paris, 1989), vol. III, figs 17, 41, 87 and 145 respectively.

61. Vladimir Pilyavsky, *Pamyatniki Arkhitekturi Turkmenistana* (Leningrad, 1974), pp. 236–40.

62. And the process continues unabated. I am grateful to Richard McClary for the following epitaph on Shahr-i Sabz: 'the recent destruction of almost the entire city of Shakhrisabz in order to leave the Aksaray and a couple of associated structures standing isolated and alone is perhaps the worst example of the same process that happened around the Samanid Mausoleum ... I only have images of immediately after the fact. The acres of new flower beds sparkle with the crushed fragments of Timurid tilework. A truly awful sight.'

Bibliography

Afshar, Iraj, *Yadgarha-yi Yazd*, 2 vols (Tehran, 1348–54/1969–75).

Ahmad Khan, Sayyid, *Athar al-Sanadid* (Lucknow, 1856); see also below, under Garcin de Tassy.

Anisi, Alireza, *Early Islamic Architecture in Iran, 637–1059* (PhD thesis, University of Edinburgh, 2008).

Azzout, Mounira, 'The Soviet interpretation and preservation of the ancient heritage of Uzbekistan: the example of Bukhara', in A. Petruccioli (ed.), *Bukhara: The Myth and the Architecture* (Cambridge, MA, 1999), pp. 161–73.

Bader, Nabil A. and Anwer F. Mahran, 'Restoration and preservation of artistic elements applied on Islamic architectural façade of Shahin Agha sebil, Cairo, Egypt', *International Journal of Conservation Science* 6.1 (2015), pp. 63–78.

Barbier de Meynard, Charles A. C., *Dictionnaire géographique, historique et littéraire de la Perse et des contrées adjacentes, extrait du Mo'djem el-Bouldan de Yaqout, et complété à l'aide de documents arabes et persans pour la plupart inédits* (Paris, 1861).

Bittar, Thérèse, 'La mosquée de Tchor Soutoun à Termez. Sa place dans l'architecture islamique', in Pierre Leriche and Vincent Fourniau (eds), *La Bactriane au carrefour des routes et des civilisations de l'Asie centrale: Termez et les villes de Bactriane-Tokharestan. Actes du colloque de Termez 1997*, Vol. 1 (Paris, 2001), pp. 392–6.

Blair, Sheila S., 'The madrasa at Zuzan: Islamic architecture in eastern Iran on the eve of the Mongol invasion', *Muqarnas* 3 (1985), pp. 75–91.

Bloom, Jonathan M., *The Minaret* (Edinburgh, 2013).

Bulliet, Richard W., *Cotton, Climate and Camels in Early Islamic Iran* (New York, 2009).

Cherry, Deborah, 'The afterlives of monuments', *South Asian Studies* 29.1 (2013), pp. 1–14.

Chmelnizkij, Sergei, 'Das Mausoleum des Sultans Sandschar in Merw', *Architectura. Zeitschrift für Geschichte der Baukunst. Journal of the History of Architecture* 19 (1989), pp. 20–35.

Chmelnizkij, Sergei, *Mezhdu Samanidami i Mongolami. Arkhitektura Srednei Azii XI – nachala XIII vv. Chast II* (Berlin and Riga, 1997).

Cohn-Wiener, Ernst, *Turan. Islamische Baukunst in Zentralasien* (Berlin, 1930).

Creswell, K. Archibald C., *A Bibliography of the Architecture, Arts and Crafts of Islam* (Cairo, 1961).

Creswell, K. Archibald C., *A Bibliography of the Architecture, Arts and Crafts of Islam, Supplement 1* (Cairo, 1973).

Dalrymple, Sam, 'Sweet decay: the destruction of art and architecture in Delhi', *ISIS*, 24 April 2018, <https://isismagazine.org.uk/2018/04/the-destruction-of-art-and-architecture-in-delhi/> (last accessed 25 September 2019).

Degeorge, Gérard, *La Grande Mosquée des Omeyyades Damas* (Paris, 2010).

Denike, Boris, *Arkhitekturnii Ornament Srednei Azii* (Moscow and Leningrad, 1939).

Dickens, Charles, *Dombey and Son* (repr. London, 1921).

Diez, Ernst, *Churasanische Baudenkmäler* (Berlin, 1918).

Edhem, Halil, *see* Haqqi, Isma'il.

Esfanjary, Eisa, *Persian Historic Landscapes: Interpreting and Managing Maibud over 6000 Years* (Edinburgh, 2017).

Fodde, Enrico, 'Fired brick conservation in the Kyrgyz Silk Roads', *Journal of Architectural Conservation* 14.1 (2008), pp. 77–94.

Fodde, Enrico, 'Structural faults in earthen archaeological sites in Central Asia: analysis and repair methods', in Dina D'Ayala and Enrico Fodde (eds), *Structural Analysis of Historic Construction* (London, 2008), pp. 1415–22.

Gallagher, Donat (ed.), *The Essays, Articles and Reviews of Evelyn Waugh* (Boston, 1984).

Garcin de Tassy, Joseph H. S. V., 'Description des monuments de Dehli en 1852, d'après le texte hindoustani de Sayyïd Ahmad Khan', *Journal Asiatique*, 5me série, XV, pp. 508–36; XVI, pp. 190–254, 392–451 and 521–43; and XVII, pp. 77–97 (1860–1).

Gautier-van Berchem, Marguerite, 'The mosaics of the Dome of the Rock in Jerusalem and of the Great Mosque in Damascus', trans. and revised by G. A. Vetch, in K. A. C. Creswell, *Early Muslim Architecture: Umayyads AD 622–750*, Part 1 (Oxford, 1969), pp. 215–372.

Gautier, Lucien, *Hommage à Max van Berchem* (Geneva, 1923).

Gorshenina, Svetlana and Vera Tolz, 'Constructing heritage in early Soviet Central Asia: the politics of memory in a revolutionary context', *Ab Imperio* 4 (2016), pp. 77–115.

Guy, Richard J., *Uses for a Monumental Tomb: The Motives for Restoration and Interpretation at the Sultan Sanjar Mausoleum* (MA thesis, Cornell University, 2006).

Gye, David H. and Robert Hillenbrand, 'Mausolea at Merv and Dehistan', *Iran* XXXIX (2001), pp. 53–4.

Hamilton, Robert W. 'Minarets, mihrabs and mosques', *The Times Literary Supplement* (25 December 1970), p. 1518.

CHAPTER SIX

A Damascus Room in Los Angeles

Linda Komaroff

UNLIKE FASHIONABLE RESIDENCES in early modern Europe, the homes of the well-to-do in Ottoman-era Damascus had very plain exteriors, hidden within which were elaborately decorated rooms that faced onto courtyards. Vintage photographs show the ornate stone courtyards replete with flowering plants, citrus trees and fountains, which provided a cooler living space during the hottest times of the year. In 1900, nearly 17,000 such courtyard homes still survived.[1] With the modernisation and growth of Damascus, many such historic homes were demolished, but occasionally their sumptuous interiors, mainly reception rooms, were spared. Several have found their way into museums not only in Damascus but also in Europe and the US, of which the best-known example, perhaps, is the one at the Metropolitan Museum of Art, dated 1119/1707.[2]

In 2014, after nearly two years of extensive study, the Los Angeles County Museum of Art (LACMA) acquired a relatively well-preserved Damascus room dated 1180/1766–7 (Figures 6.1–6.4). According to documents provided to the museum, it was dismantled intact from a courtyard home belonging to the El-Mourabeh family in the al-Bahsa quarter of Damascus, which was slated to be torn down to make way for a road. On that account, in 1978, its disassembled reception room was sold to a Lebanese art dealer who soon thereafter exported the room to Beirut, where it remained for over thirty years. Brought to London in 2010, the room first came to my attention in late 2011.[3] I saw the room in London in early 2012 and with the blessing and encouragement of LACMA's director, it was shipped to Los Angeles that summer.[4] No *in situ* photographs are said to survive.

In spite of its dismantled circumstance and the decades of accumulated dust and grime, the great appeal and importance of acquiring the room for LACMA had to do with its overall condition. Except for its panelled wood ceiling, which has not survived, the room is largely in its original state, with one of the best-preserved painted

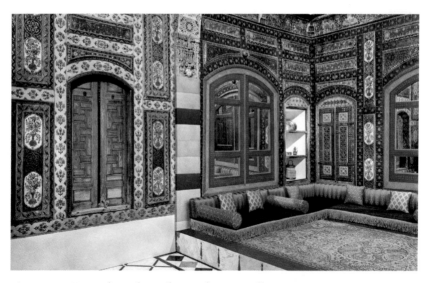

Figure 6.1 *View of south- and west-facing walls, Damascus Room, Syria, Damascus, 1180/1776–7, wood (poplar) with gesso relief, brass and tin leaf, glazes and paint, plaster with stone paste inlays, and multicoloured stones, M.2014.33. Conservation of the room was organised in partnership with the King Abdulaziz Center for World Culture; additional conservation support was provided by the Friends of Heritage Preservation. Photo © Museum Associates/LACMA.*

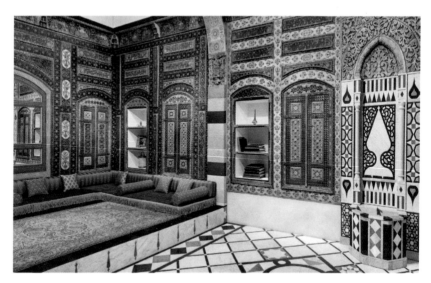

Figure 6.2 *View of west- and north-facing walls, Damascus Room, Syria, Damascus, 1180/1776–7, wood (poplar) with gesso relief, brass and tin leaf, glazes and paint, plaster with stone paste inlays, and multicoloured stones, M.2014.33. Conservation of the room was organised in partnership with the King Abdulaziz Center for World Culture; additional conservation support was provided by the Friends of Heritage Preservation. Photo © Museum Associates/LACMA.*

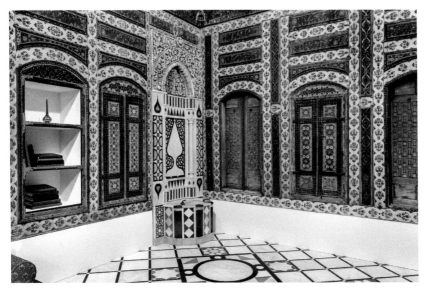

Figure 6.3 *View of north- and east-facing walls, Damascus Room, Syria, Damascus, 1180/1776–7, wood (poplar) with gesso relief, brass and tin leaf, glazes and paint, plaster with stone paste inlays, and multicoloured stones, M.2014.33. Conservation of the room was organised in partnership with the King Abdulaziz Center for World Culture; additional conservation support was provided by the Friends of Heritage Preservation. Photo © Museum Associates/LACMA.*

surfaces – including brilliant pinks, oranges, blues and greens – of any similar room of the period.[5] As is characteristic, it is composed of colourful stone floor tiles, painted and carved wood walls, elaborate cupboard doors and storage niches, a high arch of plaster voussoirs decorated with stone paste inlays, which served to divide the room into upper and lower sections separated by a single, tall step – and unusually, an intricately inlaid stone wall fountain with a carved and painted stone hood. Much of the painted wood surfaces are embellished with a particular type of relief decoration known in Arabic as *al-'ajami*, which is typical of the period. This technique produces raised designs of gypsum (mixed with glue), which are then covered with metal leaf, coloured glazes and matte paint. A calligraphic band of Arabic poetry circumscribes the upper register of the walls. The main floral decoration is likely based on textile designs, while the room's cornices incorporate detailed depictions of platters of fruit, nuts, and even baklava, which must have served to whet the appetites of visitors to the room as they awaited similar types of refreshment (Figure 6.5).

This chapter will address the recent and more distant history of this exceptional room and its remarkable journey from Damascus to Los Angeles. Now restored, the room projects a kind of grace, warmth and beauty, which is in keeping with its original function

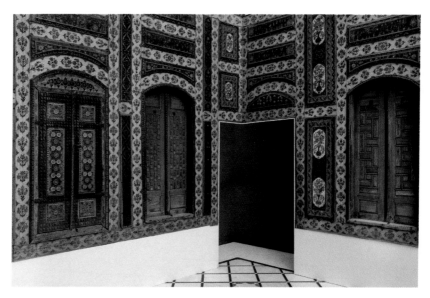

Figure 6.4 *View of east- and south-facing walls, Damascus Room, Syria, Damascus, 1180/1776–7, wood (poplar) with gesso relief, brass and tin leaf, glazes and paint, plaster with stone paste inlays, and multicoloured stones, M.2014.33. Conservation of the room was organised in partnership with the King Abdulaziz Center for World Culture; additional conservation support was provided by the Friends of Heritage Preservation. Photo © Museum Associates/LACMA.*

Figure 6.5 *Detail of cornice, Damascus Room, Syria, Damascus, 1180/1776–7, wood (poplar) with gesso relief, brass and tin leaf, glazes and paint, plaster with stone paste inlays, and multicoloured stones, M.2014.33. Conservation of the room was organised in partnership with the King Abdulaziz Center for World Culture; additional conservation support was provided by the Friends of Heritage Preservation. Photo © Museum Associates/LACMA.*

as a place for welcoming guests. It seems a fitting subject for a study in honour of Sheila and Jonathan, who have always been so generous with their friendship and in sharing their vast knowledge.

Although it was created more than 250 years ago, we know more about its recent, peripatetic past than its far longer history as a luxurious reception room in an affluent Damascene courtyard house. Fortunately, it is possible to gain an understanding of the original milieu of the room and some of the circumstances of its conception, design and manufacture from the large body of academic studies focusing on late Ottoman Damascus, especially its urban, architectural and social setting.

Eighteenth-century Damascus was home to 80,000–90,000 inhabitants, making it one of the largest cities in the Ottoman Empire, though it functioned as a provincial capital.[6] By the early 1700s, after two centuries of direct Ottoman rule, a local patrician family – the 'Azms – was granted the governorship of Damascus.[7] Members of this powerful clan governed for much of the period from 1725–83, an era that witnessed the rise of a new class of notables, whose wealth and influence were aligned with the city's role as a hub for international and especially regional commerce, and as a trade emporium for goods such as coffee, soap and textiles.[8] Damascus was also one of the gathering places for the Hajj caravan to Mecca.[9] Sponsored by the Ottoman leadership in Istanbul as a means of asserting temporal authority, the annual pilgrimage, under the command of the governor of Damascus, became a major commercial operation that was of local benefit.[10] It is therefore not unexpected that the eighteenth century, especially the second half, marks a key phase for the construction of homes for the newly affluent social elite,[11] their grand scale and splendid decoration inspired in part by the great Bayt al-'Azm, the governor's palace begun in 1749.[12] Not only rich merchants, but members of the military and the 'ulama' were among the middle and upper strata of eighteenth-century society able to commission large well-appointed homes in the rapidly expanding city.[13]

Already by the mid-eighteenth century, Damascus had extended well beyond the walls of the Old City and the precincts of the Umayyad Mosque and the Citadel at its western end.[14] South-west of the Citadel, the Ottomans had developed a new administrative centre in the later sixteenth century.[15] By the seventeenth century, a symmetrically planned residential district – the al-Bahsa quarter – had been laid out west of the Citadel, presumably to ease some of the congestion in the Old City.[16] Located on the edge of the westernmost quarters and facing the Barada River, al-Bahsa seems nonetheless to have been only sparsely developed until the mid-nineteenth century.[17] On that account, perhaps the al-Bahsa courtyard home to which the LACMA room belonged may have had a more generous layout; its mid-eighteenth-century setting certainly must have been more suburban than urban.[18]

We do not know the size of the home associated with the LACMA room nor do we know for whom it was built.[19] We do know that eighteenth-century Damascus was largely a city of homes and home-owners whose domestic lives eschewed the narrow, crowded streets by focusing inward instead on light-filled courtyards planted with trees and scented with the ubiquitous jasmine.[20] The plainness of the street façades of Damascene homes has often been remarked upon, as these gave little clue to what lay within; amplifying this sense of austerity, their exteriors were often coated in a whitewash of lime thickened with gum, something that appears to have been reserved for the homes of the wealthy.[21] Although most dwellings were fairly humble affairs, generally two storeys built of sun-dried brick reinforced by timber, more affluent residences had a first storey constructed of stone masonry and timber, with an upper storey of brick and timber.[22]

Surviving eighteenth-century buildings along with contemporaneous textual sources indicate that the residences of the well-to-do often contained two or more courtyards.[23] Such a home would have been divided in two main sections: a semi-public space with multiple rooms centred on an outer courtyard (*barrani*), and a more secluded inner courtyard and associated rooms intended for the family and special guests (*juwwani*).[24] Of the two, the inner courtyard was generally richer in its appointments and materials.[25] The courtyard provided the main point of axis within the home; each had a central fountain opposite which was an *iwan* – the barrel-vaulted, two-storeyed hall open to the courtyard, which functioned as a kind of warm-weather living room.[26] Homes of this type often had more than one reception room, sometimes one for each courtyard, while there might even have been two reception rooms sharing the same courtyard.[27]

It is not possible to determine whether the LACMA room, in its original architectural context, was the only or main reception room or was primarily reserved for more intimate family gatherings.[28] Nonetheless, the ample dimensions of the room, the skilfulness of its decoration and the costliness of its materials all suggest it came from a large and elite home. Its poplar wood panels, and marble, basalt and limestone for the walls and floor would have been pricey items even when sourced from nearby Damascus.[29] The poplar likely came from the fertile forested and agricultural belt known as the Ghouta, which surrounded Damascus;[30] the limestone and basalt also perhaps derived from the general vicinity of the city. Some of the marble – the black and red varieties – may have been quarried locally while the white stones were likely imported.[31]

Generally known as a *qa'a*, such a lavishly decorated reception room, which typically opened on to a courtyard, was used primarily in the winter months. Often, though not always, it was located on the north side of the courtyard to take best advantage of the warmth

of the winter sun.[32] The *qaʿa* was the centrepiece of the home, its opulent materials demonstrated the family's wealth and social status, while its colour palette and decorative motifs reflected contemporary tastes. As such, it served as a place for receiving and entertaining guests who, entering from the courtyard, would have removed their shoes in the lower section or *ʿataba*, a kind of antechamber. Once properly greeted by the host, the guests would have been invited to step up to the *tazar*, a raised square seating area, where comfortable cushions and refreshments awaited.[33] Seated in the elevated *tazar*, some rooms provided a view through the windows, as is the case with the LACMA room.[34] When seated, guests could also enjoy the Arabic inscriptions that were a key element in the decoration of the typical Damascus room; often taking the form of poetry, both religious and profane, such inscriptions were generally executed with care and occupied places of prominence, suggesting that they were meant to be read and appreciated.

Despite the lack of more specific information about its original setting, the LACMA room itself has something to say about its now lost architectural context and domestic history. The room measures roughly 6.1 x 4.6 metres, but it is not a true rectangle – rather it is more rhombic in form. This irregularity probably reflects the actual structural space for which the wood panels and floor were customised.[35] That the dimensions of the room indicate the original space with no wall sections missing is demonstrated by the inscription panels; these include a type of numbering system on the back from one to thirty without omissions, about which more will be said below. The four walls were created from dozens of individual wood panels of varying sizes joined together by a mortise-and-tenon technique to form a framework that originally was attached to the timber framing of the walls with long hand-wrought nails, some of which have survived.[36]

If we assume that the LACMA *qaʿa* once was located on the north side of the courtyard, based on the locations of in situ and related rooms of the second half of the eighteenth century, then the entrance doorway faced south.[37] The door would have opened inward to the right; perhaps the room was slightly higher than the courtyard, requiring a short step up, as a narrow section of the wood panelling immediately to the left inside the entranceway is especially worn as though those entering the room used this part of the wall to balance themselves.[38] Upon entering the *ʿataba*, on the south side, just west of the doorway, is a shuttered window (Figure 6.1) that also would have faced south onto the courtyard. Proceeding west, along the south wall, in the upper area or *tazar*, is a large niche (now covered) and a built-in shelf niche. On the west wall is a larger niche (also now covered) with a cupboard on either side (Figure 6.2). On the north side, west corner, is a built-in shelf niche with adjacent cupboard. In the north-east, back in the *ʿataba*, is another pairing of shelf niche

and cupboard, next to which is the wall fountain. Lastly, on the east wall, (Figure 6.3) is a cupboard with a pair of shuttered windows on either side; these windows presumably accessed some type of open area, perhaps a southern-facing *iwan*.[39] The south-east corner of the room was left undecorated up to the height of the doorway for the backswing of the door (Figure 6.4).[40]

In the *tazar*, the wood panels extend nearly to the floor[41] while in the lower section the wood panels achieve the identical height, so as to align at the top, leaving an undecorated area of about 59.5 cm to the floor. These plain sections of the walls in the *'ataba* were presumably covered with some form of whitewashed plaster or more likely marble, perhaps echoing the opus sectile designs of the wall fountain and stone floor and stair riser.[42] The wood panels are surmounted by six cornices: two pairs on the north and south sides, and longer solitary versions on the east and west. The cornices are decorated with *muqarnas*; a complete element at their centres and a half one at each end, so that the latter interlock to form a complete *muqarnas* in the four corners of the room. Just above the cornices, on all sides of the room, is a projecting wood shelf, the painted decoration facing downward;[43] later nineteenth and twentieth-century photographs indicate that these shelves, like the shelved niches below, were used for the display and storage of prized objects such as porcelain and other glazed ceramics.[44] The clerestory would have finished the upper walls; it was presumably covered with whitewashed plaster – and was likely pierced by windows.[45]

Rooms of this time, place and quality would have included a wood ceiling above the clerestory, decorated in a comparable manner to the walls below.[46] Although the LACMA ceiling has not survived, the elements of the arch that helped to support it are preserved. The LACMA arch, as provisionally reconstructed, is generated from fourteen pairs of solid cast-plaster blocks that feature coloured plaster inlays. Each pair represents a slightly different pattern. The plaster voussoirs spring from matching carved and glazed ceramic capitals depicting an elaborate cupola flanked by minarets, which in turn were likely supported by a stone pilaster, now reconstructed. Without an *in situ* photograph or description, there is no way of determining whether the arch elements represent a complete group – the same types of arch elements are known from *in situ* rooms and are illustrated in vintage photographs. Based on comparison with related rooms,[47] the number of voussoirs – twenty-eight – is about average and will determine our room's eventual ceiling height estimated at around 6.7 to 7.6 metres. The projected height of the ceiling enhances the generous proportions of the room and further suggests that it was once part of a large and well-appointed home.

Lastly, turning to the room's stone elements, the most significant is also the most problematic, namely the wall fountain. Although

we were able to determine that some sections of the fountain, such as the pair of inset columns and the red and black triangular and rectangular elements above and below its central decoration, are modern additions, the main constituent parts – including the striking opus sectile abstract design at the centre, the stone basin, and the carved and painted stone hood – are appropriate to and consonant with the late Ottoman period. The fact that the stone hood fits perfectly among the wood panels does not exclude the possibility that it, along with certain of the other stone elements, once may have formed part of a *masabb*, a tall wall niche often located opposite the entrance of the reception room. Wall fountains, though less common in Damascus rooms than freestanding ones, are, however, also sometimes found in the *'ataba*.[48]

The stone floor of the *'ataba* is a mixture of red-and-white marble opus sectile tiles and plain white marble tiles within a latticework design of black marble, centred on a pair of white medallions within black borders. At one end, like a carpet runner, is a harlequin design of red and black, with white and yellow stone tiles. It has been restored adjacent to the stair riser,[49] which is composed of white marble inset with red stone cut in the shape of a stoppered bottle with a fleur-de-lis at the bottom. The colour scheme and formal elements of the stair riser, floor and the eighteenth-century parts of the fountain suggest an overall cohesive design concept, one that is in keeping with later eighteenth-century courtyard homes.[50]

The fate of LACMA's room was of course bound up with the later history of its former home in al-Bahsa, the once quiet and sparsely populated neighbourhood west of the Old City along the Barada River. In the second half of the nineteenth century, the Ottoman directorate developed al-Bahsa and its environs as a new administrative centre focused on Marja Square.[51] This new urban core developed rapidly, and soon included the Court of Justice, Police Headquarters, the Post and Telegraph office and hotels, as well as residences for the affluent, which occupied a far smaller footprint than in the previous century.[52] Eventually, with the construction of an electric tramline, al-Bahsa was fully incorporated within the greater urban fabric of the city. The home to which the LACMA room belonged was now embedded within a more densely populated neighbourhood.[53] Perhaps, as elsewhere in Damascus in the late nineteenth and twentieth centuries, it was subdivided into apartments or parts of the home may even have been demolished or subsumed into an adjacent home.[54] That at least its *qa'a* remained in use is suggested by the evidence of the room's having been electrified, as remnants of old knob-and-tube wiring were discovered after its removal to LACMA. According to a verbal communication, the room had been given a stretched and painted canvas ceiling, probably to replace the original wood ceiling, which was likely destroyed by rain leaking

from the roof, to judge by the water damage to some of the cornices and other wood panels.[55] The room's survival until well into the twentieth century without major alteration also indicates that it continued to be appreciated by the homeowners.[56] Throughout the 1970s, al-Bahsa was subjected to relentless urban development; in 1978 the LACMA room was dismantled and the home to which it belonged was demolished. By 1983 al-Bahsa had been obliterated by the municipal authorities; its extramural location excluded it from the protection afforded by the two government agencies charged with safeguarding the Old City, which became a UNESCO World Heritage Site in 1979.[57]

From its arrival at LACMA on 13 August 2012, the room has been the subject of extensive documentation and a lavish amount of attention, of which the conservation-related aspects eventually will be published elsewhere.[58] The Los Angeles sojourn of the room, thus far, may be summarised as follows.

The Damascus room arrived at LACMA packed in twenty-four crates. As already indicated, we did not have an *in situ* photograph, although we were given a series of line drawings made long after the room had been dismantled. We were faced with the formidable task of establishing the general configuration of the original architectural ensemble, one lacking its ceiling as well as any elements that were integral to the structure of the room. In some respects, it was akin to assembling a jigsaw puzzle without the benefit of a picture on the box. As part of our preliminary study, we first inventoried all the components to ascertain what we had in order to consider the treatment of the diverse parts and the fabrication of a freestanding armature to which all the elements would eventually be attached so as to create an independent room.

Conservation work began full-throttle in spring 2014, by which time we had a general plan of action. The room was first reconstructed on a wood armature that was larger than the estimated actual dimensions so we could study the best way to join the different components and to understand how the upper and lower sections, stair riser and stone floor related to one another. During this time, conservation work was begun on the polychrome wood panels by carefully consolidating lifting or flaking paint, cleaning the painted surfaces and inpainting areas of loss. The room was reinstalled a second time on the wood armature now shrunk to the actual projected size of the room to determine the most accurate dimensions for the construction of the armature. The room was dismantled yet again, the stone elements were cleaned and reassembled and the entire structure was attached part by part to its custom-made armature of welded tubular aluminum frames for both walls and floors. In this way, we were able to realise our overall goal by early 2016: namely, to produce a modular three-dimensional structure in which the now-conserved major components could be assembled as a series

of interconnecting units to create a self-supporting room that could be disassembled for transport or storage.

Although we knew the paint pigments of the polychrome wood were unspoiled by multiple layers of varnish beneath the surface dirt, we were nonetheless unprepared for the sheer vivacity of the palette after cleaning, especially in the *'ataba*. There, the background colour of the panels was once pink, now faded in most areas, with floral designs of blue, yellow, white and bright orange.[59] In the *tazar*, the background is a brownish purple, with foliate motifs of pale green, yellow and orange. The niched shelves and cupboard doors demonstrate the same colour scheme of the *tazar*'s floral designs but with the addition of a well-preserved pink. Vertical and horizontal raised wood panels are attached to the wood-panelled superstructure in both upper and lower sections of the room. These, like the room's cornices, are decorated in the previously noted *'ajami* technique.[60] Here, tin and brass leaf, covered with transparent tinted glazes, were applied on top of raised decorations built up with gypsum, as, for example, in the flower and fruit-filled bowls on the cornices (for example, Figure 6.5). The virtuosity of the *'ajami* technique is reflected as well in the floral designs of the narrow vertical panels, which seem to simulate in paint and metal leaf the brilliantly colourful splendour of late Islamic silk textiles woven with metallic-wrapped threads.[61] Nevertheless, it is the matte-painted floral designs on pink or purple backgrounds that are most reminiscent of textiles.

The clusters of three blossoms, leaves and stems, often described as floral palmettes, in the *'ataba*, and the multi-petal single flowers with leaves and stem in the *tazar*, seem to mimic the designs of seventeenth- and eighteenth-century Safavid silk textiles and eighteenth-century and later Mughal cotton textiles, including block-printed examples.[62] Given the position of Damascus as a trade emporium, specialising in textiles, it is certainly possible that such luxury items were imported from Iran or India.[63] Whether of Safavid or Mughal inspiration, the polychrome wood panels are certainly reminiscent of a fabric-draped interior. Perhaps imported textiles, suggesting one important source of inspiration for eighteenth-century Damascene taste, may have influenced not only the designs but even the room's bright colour palette.

Like the raised floral-ornamented panels, the room's Arabic inscriptions are decorated in the *'ajami* technique. These thirty calligraphic panels circumscribe the room at a height just below the springing of the arch and are rendered in a once-golden *thulth* script (actually brass leaf) on a blue ground. The text comprises fifteen verses or *bayt*s, with a half verse or *misra'* in each panel; it is from the opening of an ode by the thirteenth-century Egyptian poet Sharaf al-Din Muhammad b. Sa'id al-Busiri (d. c. 694–6/1294–7). Known as the *Hamziyya*, it celebrates the birth of the Prophet Muhammad:

كَيْفَ تَرْقَى رُقَيَّكَ الْأَنْبِيَاءُ يَا سَمَاءً مَا طَاوَلَتْهَا سَمَاءُ

لَمْ يُسَاوُوكَ فِي عُلَاكَ وَ قَدْ حَالَ سَنّاً مِنْكَ دُونَهُمْ وَ سَنَاءُ

إِنَّمَا مَثَّلُوا صِفَاتِكَ لِلنَّاسِ كَمَا مَثَّلَ النُّجُومَ الْمَاءُ

أَنْتَ مِصْبَاحُ كُلِّ فَضْلٍ فَمَا تَصْدُرُ إِلَّا عَنْ ضَوْئِكَ الْأَضْوَاءُ

لَكَ ذَاتُ الْعُلُومِ مِنْ عَالِمِ الْغَيْبِ وَمِنْهَا لِآدَمَ الْأَسْمَاءُ

لَمْ تَزَلْ فِي ضَمَائِرِ الْكَوْنِ تُخْتَارُ لَكَ الْأُمَّهَاتُ وَ الْآبَاءُ

مَا مَضَتْ فَتْرَةٌ مِنَ الرُّسُلِ إِلَّا بَشَّرَتْ قَوْمَهَا بِكَ الْأَنْبِيَاءُ

تَتَبَاهَى بِكَ الْعُصُورُ وَ تَسْمُو بِكَ عَلْيَاءُ بَعْدَهَا عَلْيَاءُ

وَبَدَا لِلْوُجُودِ مِنْكَ كَرِيمٌ مِنْ كَرِيمٍ أَبَاؤُهُ كُرَمَاءُ

نَسَبٌ تَحْسَبُ الْعُلَا بِحِلَاهُ قَلَّدَتْهَا نُجُومَهَا الْجَوْزَاءُ

حَبَّذَا عِقْدُ سُؤْدَدٍ وَ فَخَارٍ أَنْتَ فِيهِ الْيَتِيمَةُ الْعَصْمَاءُ

وَ مُحَيَّا كَالشَّمْسِ مِنْكَ مُضِيءٌ أَسْفَرَتْ عَنْهُ لَيْلَةٌ غَرَّاءُ

لَيْلَةُ الْمَوْلِدِ الَّذِي كَانَ لِلدِّينِ سُرُورٌ بِيَوْمِهِ وَازْدِهَاءُ

وَتَوَالَتْ بُشْرَى الْهَوَاتِفِ أَنْ قَدْ وُلِدَ الْمُصْطَفَى وَ حَقَّ الْهَنَاءُ

فَهَنِيئاً بِهِ لِآمِنَةَ الْفَضْلُ الَّذِي شُرِّفَتْ [بِهِ] حَوَّاءُ [فِي] سَنَةَ 1180

1. How can the prophets ascend as far as you, O heaven with which no heaven can vie?

2. They cannot equal you in exaltedness, and your glory has eclipsed them.

3. They only represent your qualities to the people as water reflects the stars.

4. You are the shining vessel of every excellence, and lights emanate only from your light.

5. Yours is the storehouse of knowledge from him who knows the unseen, and among them are the names for Adam

6. Which remained in the minds of creatures to be chosen for you by mothers and fathers.

7. No apostolic age has ever passed without prophets giving the good news of you to their people.

8. The ages vie with each other for your sake as they rise to one height after another.

9. Noble after noble of your forefathers appeared on the stage of being.

10. A lineage adorned by exaltedness. For it Gemini made a necklace of its stars.

11. What a splendid necklace of pride and glory of which you are the central unmatched pearl!

12. Your countenance shining like the sun, lighting up a brilliant night.

13. The night of the birth meant happiness and pride for religion.

14. And good news came in rapid succession that the Chosen One had been born and congratulations were in order.

15. Then congratulating Amina (mother of the Prophet) on the superiority by which Eve was ennobled. [In the] year 1180 AH [1766–7].[64]

As previously noted, there is a numbering system on the back of the panels, which allowed for the correct ordering of the calligraphy during installation, perhaps by illiterate workmen. Each bears a series of slash-like black vertical lines of one to thirty strokes; this type of notation is characteristic of inscription panels in Damascus rooms.[65] Because no panels are missing from this sequence in the LACMA room, and by comparison with modern-day editions, it seems that certain lines from al-Busiri's poem were omitted intentionally from this already much-shortened version. Certainly sections of the lengthy poem were cut due to limitations of space but in this instance, perhaps, the excluded verses may have been less relevant or appealing to an eighteenth-century Damascene audience.[66] Al-Busiri's poetry, especially the *Hamziyya*, is frequently found preserved among the inscriptions of Damascus rooms while it seems to have been particularly popular in the Ottoman period.[67] Overall, the inscribed text is well written, suggesting that it was copied carefully and with forethought, though not necessarily by a professional calligrapher.[68] Since the verses begin on the centre wall of the *tazar*, and conclude with the dated inscription on the adjacent wall to the right, we can perhaps assume that literate visitors to the room would have recognised the poem, or gained a quick appreciation of the gist of the text before they were seated.

In bringing the room to LACMA, and even before beginning conservation work, we too had to consider the response of visitors as well as accessibility. Our curatorial objective was not to produce an absolute historical re-creation of an eighteenth-century Damascus room, especially as we had no way of knowing how the room looked in its original setting. Rather, we decided to create a period room that would capture the essence of such late Ottoman domestic interiors without entirely divorcing the room from either its more recent history or its new twenty-first-century museum context.[69]

We resolved early on to permit visitors direct access to the antechamber, to best enhance their experience. This allowed us to use as our entrance the original doorway opening combined with the adjacent area of the wall, now missing, that had been left undecorated for the door's backswing (Figure 6.4).[70] Because the room was not going to have a permanent location for its first years of exhibition, we determined to keep the window shutters closed, to cover the two large niches (to avoid addressing the issue of what, if anything, to place in these twin focal points), and to install only the lower elements of the tall arch. Eventually, we will re-install the window shutters opening outward, and incorporating the painted soffits for the window boxes, which are preserved.[71] The large niches were enclosed with re-creations of late Ottoman-appropriate mirrored doors, of a type often found in related rooms of a slightly later date.[72] Since the curved painted soffits of the niches have also survived we expect eventually to install them and to remove the mirrored doors.[73]

The room's tall arch was likely supported by a pair of stone pilasters, which would have been structurally integral to the home; we therefore recreated pilasters of alternating stones of black, yellowish and cream, in keeping with the *ablaq* style associated with Damascene homes of the period.[74] As indicated, for now we can only approximate the actual height of the room; the installation of all twenty-eight elements of the arch and the creation of the clerestory await a more permanent and appropriate space at LACMA.

In determining how to reconstruct the seating area of the *tazar*, we were guided by vintage photographs of other such rooms *in situ*, as well as by contemporaneous accounts, for instance, that of the British physician Alexander Russell, who lived in Syria for several years. Russell supplied this description of a reception room in his account of the city of Aleppo, first published in 1756:

> The divan is formed in the following manner. Across the upper end and along the sides of the room, is fixed a wooden platform four feet broad, and six inches high. Upon this are laid cotton mattresses exactly of the same breadth and over these a cover of broad cloth, trimmed with gold lace and fringes, hanging over the ground. A number of large oblong cushions, stuffed hard with cotton, and faced with flowered velvet, are then arranged on the platform close to the wall. The terraced floor in the middle, being first matted, is covered with the finest carpets of Persia and Turkey.[75]

For the LACMA room, we built low platforms for the flat cushions, which were made slightly smaller than those in Russell's narrative; the Ottomanising velvet and silk-and-gold-style fabrics used for the cushions and pillows were purchased in Istanbul, as was the classic Turkish-style carpet.[76] We decided to use an unpolished black stone for the floor, which we believe to be more period appropriate than the additional white marble tiles provided by the dealer. Lastly, since we felt the three shelf niches should not be left bare, we added *faux-leather* bound books, while objects of the type that might have been displayed on the shelves were selected from the museum's Islamic art collection for inclusion. Made in Turkey, Iran and North Africa as well as the Levant, these objects would reflect the cosmopolitan tastes and extensive resources of the elite owners of the room.

The reconstruction and restoration of the room is finished for now; the images illustrated here project the way it will one day look at LACMA, with its arch fully installed and its clerestory recreated.[77] It is remarkable that in spite of its kaleidoscope of colours and designs, the room is so visually cohesive and tranquil. For me, leaving it to be dismantled once again was very difficult; I can only imagine how much more difficult it was for the members of the El-Mourabeh family when they left it and their home in al-Bahsa for the last time in 1978, and how much more tragic still for recent refugees fleeing

their homes in Syria. Hopefully, the exhibition of the LACMA room will provide a small comfort and consolation for all the lost homes, while its serene and majestic beauty serves to remind us of what humanity can do at its best and what we all stand to lose at its worst.

Notes

1. Stefan Weber, *Damascus: Ottoman Modernity and Urban Transformation (1808–1918)*, 2 vols (Aarhus, 2009), vol. 1, p. 228 – the exact number was 16,832; in the 1990s, Weber surveyed around 600 homes, which he recorded in this monumental study, see vol. 2, p. 284 ff.

2. See Anke Scharrahs, *Damascene 'Ajami Rooms: Forgotten Jewels of Interior Design* (London, 2013), pp. 289–92, for a list of dated rooms, minus the LACMA room. On the room in the Metropolitan Museum specifically, see most recently Maryam D. Ekhtiar, Priscilla P. Soucek, Sheila R. Canby and Navina Najat Haidar (eds), *Masterpieces from the Department of Islamic Art in The Metropolitan Museum of Art* (New Haven, CT, 2011), pp. 333 ff.

3. According to the documents provided, the home belonged to the family of Mohamad Salim El-Mourabeh; it was located in the general vicinity of the intersection of present-day al-Naser and al-Jaberee Streets in what was then the al-Bahsa district. The disassembled reception room was sold to Mikhael Daher Haddad, and passed by descent to his son, Daher Haddad; the room was offered to LACMA by Daher Haddad through his New York partner, Robert Haber and Associates.

4. I remain grateful to Michael Govan for his support and encouragement in a project that has been one of the highlights of my curatorial career.

5. In contrast to the Metropolitan Museum room with its aged varnish layers, the LACMA room retains the bright colours that must have been typical of an eighteenth-century palette. For the condition of the painted surfaces of the Metropolitan Museum's room, see Mechthild Baumeister, Beth Edelstein, Adriana Rizzo, Arianna Gambirasi, Timothy Hayes, Roos and Julia Schultz, 'A splendid welcome to the "House of Praises, Glorious Deeds and Magnanimity"', in C. Rozeik, A. Roy and D. Saunders (eds), *Conservation and the Eastern Mediterranean* (London, 2010), pp. 126–33.

6. James Grehan, *Everyday Life and Consumer Culture in 18th-Century Damascus* (Seattle, 2007), p. 10.

7. The governorship of Damascus included administration of all of southern Syria, as well as the annual Hajj beginning in 1708; on the 'Azms, see Karl Barbir, *Ottoman Rule in Damascus, 1708–1758* (Princeton, 1980), especially pp. 60 ff. Also, see Linda Schatkowski Schilcher, *Families in Politics: Damascene Factions and Estates of the 18th and 19th Centuries* (Stuttgart, 1985), pp. 29–40 and 136–44.

8. For a good summary see, for example, Ross Burns, *Damascus: A History* (London, 2007), pp. 240 ff. Also, see Schatkowski Schilcher, *Families in Politics*, pp. 60 ff.; and Bruce Masters, *The Arabs of the Ottoman Empire, 1516–1918* (Cambridge, 2013), pp. 75 ff.

9. Cairo was the other main point of departure; see Venetia Porter (ed.), *Hajj: Journey to the Heart of Islam* (London, 2012), pp. 146 ff. for the most recent discussion.

10. See Barbir, *Ottoman Rule*, pp. 108 ff., but also Burns, *Damascus*, pp. 227–28.
11. See Grehan, *Everyday Life*, pp. 228 ff., on social elites and consumer culture. Somewhat differently, see Weber, *Damascus*, vol. 1, pp. 50–1, on the social elite of late Ottoman Damascus; also, see Schatkowski Schilcher, *Families in Politics*, pp. 107 ff., and Masters, *Arabs of the Ottoman Empire*, pp. 83 ff. See Scharrahs, *'Ajami Rooms*, especially pp. 289–91, for a list of dated extant homes or rooms or parts of rooms.
12. On the Bayt al-'Azam, perhaps better designated as As'ad Pasha Al-'Azm palace, see Weber, *Damascus*, vol. 2, pp. 451–2.
13. Weber, *Damascus*, vol. 1, pp. 50 and 230 ff.
14. For a brief summary of the long history of Islamic Damascus up to the Ottoman conquest in 1516, see Burns, *Damascus*, pp. 108 ff.
15. Weber, *Damascus*, vol. 1, p. 115.
16. Weber, *Damascus*, vol. 1, pp. 115, 361. Others date the establishment of al-Bahsa to the eighteenth century, see for example, 'Abd al-Razzaq Moaz, 'The urban fabric of an extramural quarter in 19th-century Damascus', in T. Phillip and B. Schäbler (eds), *The Syrian Land: Processes of Integration and Fragmentation: Bilad al-Sham from the 18th to the 20th Century* (Stuttgart, 1998), p. 169.
17. For a map of Damascus west of the Old City, see Brigid Keenan, *Damascus Hidden Treasures of the Old City* (New York, 2000), p. 73.
18. According to Weber, *Damascus*, vol. 1, pp. 361 ff., more compact terraced courtyard homes began to be built there in the mid-nineteenth century. Perhaps, by that time, the presumably more spacious courtyard home to which the mid-eighteenth-century LACMA room belonged was already something of an anomaly in the quarter.
19. There are a few important instances where the name of the commissioner of the home as well as some biographical information are preserved. See, for example, Peder Mortensen (ed.), *Bayt al-'Aqqad: The History and Restoration of a House in Old Damascus* (Aarhus, 2005), pp. 379 ff. and Weber, *Damascus*, vol. 1, pp. 253 ff.
20. Grehan, *Everyday Life*, pp. 157–8.
21. Grehan, *Everyday Life*, pp. 158–9.
22. Annie-Christine Daskalakis, *Damascus 18th- and 19th-Century Houses in the Ablaq-'Ajami Style of Decoration: Local and International Significance* (PhD thesis, New York University, 2004), pp. 5–6, summarises the structural building materials.
23. Grehan, *Everyday Life*, p. 160.
24. Here following Weber, *Damascus*, vol. 1, p. 232, who does not characterise the courtyards as being gender related.
25. Daskalakis, 'Damascus 18th- and 19th-century houses', p. 154.
26. See, for example, Weber, *Damascus*, vol. 1, pp. 230–6.
27. For example, the late eighteenth-century Bayt al-Hawraniyya, which had both a standard *qa'a* and a larger *qa'a* with a central *'ataba* and a trio of *tazars* in the inner courtyard; see Weber, *Damascus*, Vol. 1, pp. 233 ff. and Vol. 2, p. 523.
28. The decoration of the LACMA room is closely related to that of the *tazars* (there were three) of a much larger *qa'a* in the inner courtyard of the Bayt al-Hawraniyya, which has two dated inscriptions from 1204/1789 and 1206 /1791–2. See Weber, *Damascus*, vol. 1, fig. 223, and Scharrahs, *'Ajami Rooms*, figs 151, 152 and 154.
29. Grehan, *Everyday Life*, p. 159.

30. See Scharrahs, 'Ajami Rooms, p. 117. The thickness of the wood panels ranges from 2.3–2.7 cm, suggesting the craftsmen exercised great economy in their use of the wood. The wood was confirmed by LACMA conservators as poplar (*Populus tremula*).

31. See Annie-Christine Daskalakis Mathews, 'A room of "splendor and generosity" from Ottoman Damascus', *Metropolitan Museum Journal* 32 (1997), p. 116.

32. See Daskalakis, *Damascus 18th- and 19th-Century Houses*, pp. 161–2; also see Weber, *Damascus*, vol. 1, p. 236, and n. 696, where the author cites examples of reception rooms that were not built on the north side of the courtyard.

33. See Daskalakis, *Damascus 18th- and 19th-Century Houses*, p. 188, where the social significance of not being invited from 'ataba to tazar, or refusing the invitation, is discussed.

34. See Daskalakis, *Damascus 18th- and 19th-Century Houses*, p. 171.

35. Such asymmetry in the configuration of the space was not unusual; see Scharrahs, 'Ajami Rooms, p. 154, for other instances of irregularly shaped rooms.

36. See Scharrahs, 'Ajami Rooms, pp. 118–19. Much of the hardware in the room has survived as well, such as the pulls and hinges of the cupboards. The spigot from the fountain, however, is not original to the room.

37. See above n. 32. There was likely a small vestibule between the courtyard and the entrance to the room, which as presently reconstructed has a height of 203 cm.

38. Interestingly, diagonally opposite this worn area is a more damaged edge from closing the door, which probably fitted into a shallow niche in the wall.

39. The *iwan* most often seems to have been north facing to provide as much shade as possible. Bayt 'Ajami, from the eighteenth century with nineteenth-century modifications, has an *iwan* north of the courtyard with an adjacent *qa'a* on its west side; see Weber, *Damascus*, vol. 1, p. 310, fig. 381, and vol. 2, p. 357 (no. 576), and vol. 1, pp. 254–5, figs 269–71, for a home with two *iwans* on a courtyard.

40. Similarly in the Bayt al-'Aqqad, see Mortensen, *Bayt al-'Aqqad*, p. 61; also, see Scharrahs, 'Ajami Rooms, pp. 83–4 and fig. 92. The wooden door would have been left open most of the time, even in winter, so the sense of bareness that exists in this section today would have been mitigated by the door's decoration; see Daskalakas, *Damascus 18th- and 19th-Century Houses*, p. 170. The door to the LACMA room is preserved, although coated with multiple layers of white paint that have yet to be removed; it is comparable in technique, design and presumably original colour scheme to the window shutters on the south side of the room.

41. There are ladder-like but horizontal wood panels just above the floor of the *tazar* that may have been part of the superstructure for the *diwan* or platform for the cushions.

42. Dorothea Duda, 'Painted and lacquered woodwork in Arab houses of Damascus and Aleppo', in W. Watson (ed.) *Lacquerwork in Asia and Beyond: Colloquies on Art & Archaeology in Asia* 11 (London, 1982), p. 249, considers the marble socles to be commonplace; however, since so few are preserved in rooms with an 'ataba with wood panels that was not updated or restored, it is difficult to be definitive.

43. This board-like shelf is known as a *rafraf*; see Scharrahs, *'Ajami Rooms*, fig. 205, for a detail of the upper section of the wood panelling in the Bayt al-Shirazi, dated 1178/1764–5, which is very similar to that of the LACMA room in many details, including the decoration of the *rafraf*.

44. Weber, *Damascus*, vol. 1, p. 237. Following the purchase of the room, we were made aware that the Haddad family had a group of fourteenth–fifteenth-century Mamluk glazed ceramics that were said to have been displayed in the room.

45. See Keenan, *Hidden Treasures*, pp. 91 and 115 for *in situ* examples; also, see Daskalakis, *Damascus 18th- and 19th-Century Houses*, pp. 302–4.

46. See, for example, Scharrahs, *'Ajami Rooms*, pp. 68 ff.

47. Such as those in the Bayt al-Siba'i (dated 1187/1773–4) and the Bayt al-Hawraniyya (dated 1204/1789–90 and 1206/1791–2); we are grateful to Anke Scharrahs for sharing her images of the arches with us.

48. As in the Damascene interior in the Robert Mouawad Museum, Beirut, see Stefan Weber, 'Walls and ceilings', in J. Carswell (ed.), *The Future of the Past: The Robert Mouawad Private Museum* (Beirut, 2004), p. 254. They occur as well in related domestic architecture in Lebanon, as in the *qa'a* of Bayt al-Din. Such wall fountains may also be the invention of twentieth-century artisans such as Muhammad 'Ali al-Khayyat, who restored Bayt al-Din Palace in 1930. See Scharrahs, *'Ajami Rooms*, p. 285, n. 118, as well as Rami George Khouri, 'Room for tradition', *Aramco World*, May–June (1993), pp. 11–17.

49. We initially had placed it on the wall opposite, as reflected in some earlier photographs. Its current location seems more appropriate as it did not align very well with the doorway in its previous location.

50. The original pattern of the stone floor was unknown; no drawings were provided with which to reassemble the floor. We relied instead on the evidence of rooms preserved *in situ* in Damascus. Although we received enough marble (including modern marble) to provide flooring for both sections of the room, we elected to use only the best preserved of the pre-modern stone tiles for the antechamber, or *'ataba*, where fine-cut stones were more common.

51. Weber, *Damascus*, vol. 1, pp. 114 ff.

52. Weber, *Damascus*, vol. 1, pp. 114 ff. and 361 ff.

53. For a late nineteenth-century photograph identified as a street scene in al-Bahsa, see Keenan, *Hidden Treasures*, p. 40.

54. Weber, *Damascus*, vol. 1, pp. 227 ff.

55. As told to me by Mikhael Hadad, whose grandfather purchased the room in 1978. For reference to another canvas ceiling in a contemporaneous Damascene home, see Mortensen, *Bayt al-'Aqqad*, pp. 157–8.

56. For a sentimental and highly evocative account of life in a courtyard home in Damascus, between the two World Wars, see Siham Tergeman, *Daughter of Damascus* (Austin, TX, 1994).

57. Weber, *Damascus*, vol. 1, p. 227; see Faedah M. Totah, *Preserving the Old City of Damascus* (Syracuse, 2014), pp. xxvii–xxix and 229–30, on the roles of the Committee for the Protection of the Old City of Damascus (CPOC) and the Department of Antiquities for the Old City.

58. Also, see Linda Komaroff, *Beauty and Identity: Islamic Art from the Los Angeles County Museum of Art* (Los Angeles, 2016), pp. 26–30.

59. The pink is best-preserved on the south wall and in the south-east corner, which are the only areas of the *'ataba* that would not have received direct sunlight. The *'ataba* seems to have had a single layer

of varnish applied perhaps in the early twentieth century, which was largely removed by LACMA conservators.

60. Known in Europe by the Italian term *pastiglia*; see Scharrahs, '*Ajamai Rooms*, pp. 133–5.

61. Especially from Safavid Iran; see, for example, textiles decorated with a similar floral latticework design, in Deutsches Textilmuseum, *Persische Seiden des 16.-18. Jahrhunderts aus dem Besitz des Deutschen Textilmuseums Krefeld* (Krefeld, 1988), nos 87–9.

62. For a large group of Safavid textiles, see Deutsches Textilmuseum, *Persische Seiden*, pp. 72 ff. Later block-printed Iranian cottons also bear similar designs; see Jennifer Wearden and Patricia Baker, *Iranian Textiles* (London, 2010), pp. 170–1. For a small but representative group of Mughal cottons, see Christie's, *Arts & Textiles of the Islamic & Indian Worlds*, South Kensington, 22 April 2016, lots 450, 451, 454 and 455. Related designs occur among fancier Mughal textiles, see for example George Michell, *Mughal Style in the Art and Architecture of Islamic India* (Mumbai, 2007), p. 194 and cat. no. 40.

63. On the general trade in Iranian silks and Indian cottons, see Masters, *Arabs of the Ottoman Empire*, p. 77; see also Grehan, *Everyday Life*, p. 214, where the author suggests the market in imported Iranian silks severely declined after the 1740s. Damascus also was known for its own textile industry, though I am so far unaware of any extant Damascene textiles related to the LACMA room; see Schatkowski Schilcher, *Families in Politics*, pp. 71–5. The supposition that the overall décor of the room might have been the responsibility of a design team is an interesting one; see Scharrahs, '*Ajami Rooms*, pp. 154–6.

64. My special thanks to Wheeler Thackston, professor emeritus, Harvard University, for first identifying al-Busiri as the author of the room's inscription. I have here relied on Professor Thackston's translation.

65. See Scharrahs, '*Ajami Rooms*, p. 131.

66. The expunged text, four *bayt*s, references the destruction of the palace of Khosraw, ruler of the Persian Empire, as a precursor to the coming of Islam. The omitted text normally follows the fourteenth *bayt*. Cf. Sharaf al-Din Muhammad b. Sa'id al-Busiri, *Diwan al-Busiri* (Beirut, 2007), pp. 10 ff.

67. For example, a still further abridged version in the Bayt al-'Aqqad, see Mortensen, *Bayt al-'Aqqad*, pp. 313–14; also see Daskalakis, *Damascus 18th- and 19th-Century Houses*, pp. 376–8. In assessing the Ottoman-era literature manuscript records in the British Library catalogue, the one other poet whose works are referenced on the same order of magnitude is the renowned Abu al-Tayyib Ahmad ibn Husain al-Mutanabbi. I am grateful to Professor Dana Sajdi, Boston College, for this observation (written communication).

68. In some of the panels, the letters are more crowded at the end as though the copyist had not planned ahead, however, the *bayt* inscribed in two smaller cartouches above the hood of the fountain shows that the reduction in written surface was taken into account here. There are also minor discrepancies with the modern-day edition, as in the second *bayt*, where the line should have been broken in the middle of the word حَال.

69. Although many of the decisions were curator-driven, for the sake of any future curatorial narrative or enhanced state of knowledge, most of the conservation work is reversible.

70. See Baumeister *et al.*, 'A splendid welcome', for how the entrance was determined for the Metropolitan Museum room's reinstallation in 2011. We benefitted enormously from the Met's conservation project and are grateful for having had access to the room and its armature, as well as discussions with Mecka Baumeister and Beth Edelstein.

71. Scharrahs, 'Ajami Rooms, pp. 85–7 and fig. 143. In our eventual reconstruction, we will likely follow the example of the Metropolitan Museum, including perhaps the recreation of the window grills; see Ekhtiar *et al.*, *Masterpieces from the Department of Islamic Art*, pp. 333 ff. We hope to be able to align our south-facing window with an actual museum window in order to integrate the eighteenth-century room with twenty-first-century Los Angeles.

72. For example, in the Bayt Jacques Montluçon, Damascus dated 1204/1789–90. See Scharrahs, 'Ajami Rooms, fig. 96.

73. Similar curved soffits were likewise preserved in several other rooms, for example in a reception room in the north wing of the As'ad Pasha Al-'Azm, see Komaroff, *Beauty and Identity*, p. 23. Also, see Scharrahs, 'Ajami Rooms, pp. 91–2.

74. Daskalakis, *Damascus 18th- and 19th-Century Houses*, pp. 231 ff. We sought to duplicate the stone pilasters in a reception room in the north wing of the As'ad Pasha Al-'Azm; see Komaroff, *Beauty and Identity*, p. 23.

75. Alexander Russell, *The Natural History of Aleppo, and Parts Adjacent: Containing a Description of the City, and the Principal Natural Productions in Its Neighbourhood; Together with an Account of the Climate, Inhabitants, and Diseases* (London, 1756), p. 100.

76. My deepest appreciation, as always, to Hülya Karadeniz for her gracious assistance in this regard.

77. It is understood that the extensive time and enormous effort devoted to the room were apportioned among a large and devoted team of conservators. Foremost among them was John Hirx, LACMA's senior objects conservator; he was supported by other members of the LACMA conservation centre as well as a host of outside conservators who temporarily joined the team. We were especially fortunate to have had Anke Scharrahs both as an advisor on the room's polychrome wood, about which she knows more than anyone, and as a hands-on conservator.

Bibliography

Baumeister, Mechthild, Beth Edelstein, Adriana Rizzo, Arianna Gambirasi, Timothy Hayes, Roos and Julia Schultz, 'A splendid welcome to the "House of Praises, Glorious Deeds and Magnanimity"', in C. Rozeik, A. Roy and D. Saunders (eds), *Conservation and the Eastern Mediterranean* (London, 2010), pp. 126–33.

Barbir, Karl, *Ottoman Rule in Damascus, 1708–1758* (Princeton, 1980).

Burns, Ross, *Damascus: A History* (London, 2007).

Al-Busiri, Sharaf al-Din Muhammad b. Sa'id, *Diwan al-Busiri* (Beirut, 2007).

Christie's, *Arts & Textiles of the Islamic & Indian Worlds*, South Kensington, 22 April (London, 2016).

Daskalakis Mathews, Annie-Christine, 'A room of "splendor and generosity" from Ottoman Damascus', *Metropolitan Museum Journal* 32 (1997), pp. 111–39.

Daskalakis, Annie-Christine, *Damascus 18th- and 19th-Century Houses in the Ablaq-'Ajami Style of Decoration: Local and International Significance* (PhD thesis, New York University, 2004).

Deutschen Textilmuseums, Krefeld, *Persische Seiden des 16.-18. Jahrhunderts aus dem Besitz des Deutsches Textilmuseum Krefeld* (Krefeld).

Duda, Dorothea, 'Painted and lacquered woodwork in Arab houses of Damascus and Aleppo', in W. Watson (ed.), *Lacquerwork in Asia and Beyond: Colloquies on Art & Archaeology in Asia* 11 (London, 1982), pp. 247–66.

Ekhtiar, Maryam D., Priscilla P. Soucek, Sheila R. Canby and Navina Najat Haidar (eds), *Masterpieces from the Department of Islamic Art in The Metropolitan Museum of Art* (New Haven, CT, 2011).

Grehan, James, *Everyday Life and Consumer Culture in 18th-Century Damascus* (Seattle, 2007).

Keenan, Brigid, *Damascus Hidden Treasures of the Old City* (New York, 2000).

Khouri, Rami George, 'Room for tradition', *Aramco World*, May–June (1993), pp. 11–17.

Komaroff, Linda, *Beauty and Identity: Islamic Art from the Los Angeles County Museum of Art* (Los Angeles, 2016).

Masters, Bruce, *The Arabs of the Ottoman Empire, 1516–1918* (Cambridge, 2013).

Michell, George, *Mughal Style in the Art and Architecture of Islamic India* (Mumbai, 2007).

Moaz, 'Abd al-Razzaq, 'The urban fabric of an extramural quarter in 19th-century Damascus', in T. Phillip and B. Schäbler (eds), *The Syrian Land: Processes of Integration and Fragmentation: Bilad al-Sham from the 18th to the 20th Century* (Beiruter Texte und Studien) (Stuttgart, 1998), pp. 165–84.

Mortensen, Peder (ed.), *Bayt al-'Aqqad: The History and Restoration of a House in Old Damascus* (Aarhus, 2005).

Porter, Venetia (ed.), *Hajj: Journey to the Heart of Islam* (Cambridge and London, 2012).

Russell, Alexander, *The Natural History of Aleppo, and Parts Adjacent: Containing a Description of the City, and the Principal Natural Productions in Its Neighbourhood; Together with an Account of the Climate, Inhabitants, and Diseases* (London, 1756).

Scharrahs, Anke, *Damascene 'Ajami Rooms: Forgotten Jewels of Interior Design* (London, 2013).

Schatkowski Schilcher, Linda, *Families in Politics: Damascene Factions and Estates of the 18th and 19th Centuries* (Stuttgart, 1985).

Tergeman, Siham, *Daughter of Damascus* (Austin, TX, 1994).

Totah, Faedah M., *Preserving the Old City of Damascus* (Syracuse, 2014).

Wearden, Jennifer and Patricia Baker, *Iranian Textiles* (London, 2010).

Weber, Stefan, 'Walls and ceilings', in J. Carswell (ed.), *The Future of the Past: The Robert Mouawad Private Museum* (Beirut, 2004), pp. 242–65.

Weber, Stefan, *Damascus: Ottoman Modernity and Urban Transformation (1808–1918)*, 2 vols (Aarhus, 2009).

Rubbish, Recycling and Repair: Perspectives on the Portable Arts of the Islamic Middle East

Marcus Milwright

Abu Sa'id's maid was forbidden to throw out the rubbish. Instead, she had to collect it from all the apartments in the house and deposit it with his. Every so often, he would sit down, have her fetch basket-loads of garbage, and, one by one, sift through them.

It is obvious what happened to any odd dirhams, a purse with a few dinars or small change and pieces of jewellery he came across. Tufts of wool and strips of cloth were sold, once enough had been collected, to saddle-cloth makers. Rags were bought by the porcelain and china-ware merchants. Pomegranate peel fetched a price from the dyers and tanners and broken glass could be sold to the glass-blowers. Date stones were hawked to gazelle breeders and peach stones to nurseries. Nails and bits of metal were peddled to the blacksmiths and papyrus scraps went to the scroll makers. The pack-saddlers were the market for odd pieces of wood. Paper was used to seal jars, bones became kindling and broken pottery was resettled in new kilns. Lumps of brick and mortar were set aside for building. Pitch would be bought by the tar merchant. The rubbish basket was then shaken out and anything left over was burned in the stove. If there was enough clean clay and he was of a mind to make bricks for his own use or for sale then, in order to save on water, Abu Sa'id demanded that everyone in the building wash and shower over the clay and, when it was moist enough, had it moulded into a brick. 'The stranger to my canny ways can lay no claim to thrift', Abu Sa'id was fond of saying.[1]

THIS ENTERTAINING ACCOUNT comes from the *Kitab al-Bukhala'* (Book of Misers) by the famous Iraqi satirist, al-Jahiz (d. 868–9). The author layers detail upon detail to the point of absurdity, and yet, for the humour to succeed, the description of Abu Sa'id's activities has to contain a kernel of truth. The society in which al-Jahiz lived did indeed find ways to reuse broken objects, scraps of textile and

writing materials, and domestic refuse. There were few things that could not be recycled in some way, and the collection and use of discarded materials sometimes became specialised activities in their own right. Recycled materials were supplied to the practitioners of individual crafts, with other applications existing in the domestic environment or in agriculture. While these activities might seem at first rather marginal to the study of art history, or even to the discipline of archaeology, they are worthy of further consideration. The physical and aesthetic qualities of manufactured objects are affected by these practices of employing recycled materials. Evidence of reuse can be found in many aspects of Islamic material and visual culture from paper manufacture through to pyrotechnologies such as ceramics, metal and glass. The study of recycling and repairing can also increase our understanding of the economic dimensions of craft activities, and of the interactions between crafts in the urban settings of the Islamic world.

The first part of this chapter provides some general comments about the collection and exploitation of refuse, as well as of practices associated with the repair of broken objects in the medieval Middle East. The second part looks in more detail at the late nineteenth and early twentieth centuries, with particular attention paid to the region of Greater Syria.

Practices of recycling and mending prior to the modern period

While al-Jahiz depicts recycling as an activity occurring within the domestic environment, it is clear that there were individuals and groups who devoted themselves to hunting on the streets and city dumps for useful items that could be sold to artisans and others. The eighth epistle of the *Rasa'il Ikhwan al-Safa'* (Epistles of the Brethren of Purity) contains an interesting set of observations about the place of the crafts within the city. In one passage the text, probably written in the late ninth or tenth century, draws a distinction between the craft of the perfumer and that of the unenviable, but essential scavenger:

> As for the trade of scavenger, the harm resulting from their aban-
> doning it is grievous and universal to the people of the city. Thus,
> if the perfumers, the material of whose craft is the opposite of that
> of the scavengers, were to close their shops and markets for one
> month, the harm which would befall the people of the city would
> be less than that which would result if the scavengers were to
> cease their work for one week, for the city would be filled with
> refuse and ordure and filth and carrion, and with that which would
> plague the life of its people.[2]

Al-Maqrizi (d. 1442) is another writer who mentions the economic potential of objects found within refuse, though he does not refer

directly to the practitioners themselves.[3] While his claim that the pottery thrown away each day in Cairo was worth a thousand dinars must be regarded as hyperbole, there can be little doubt that cities were ideal locations for scavengers. The waste deposits at Fustat were exploited for *sibakh*, the fertiliser created through the decomposition of organic refuse. This practice of continually digging in Fustat has had an indirect effect on modern archaeology; the confused stratigraphy makes it difficult to establish precise dating for many of the excavated artifacts.[4]

Other types of recycling are recorded in medieval sources. For example, 'Abd al-Latif al-Baghdadi (d. 1231) discusses the exploitation of hemp textiles wound around ancient mummies. He claims that bedouin and farmers sought out caves containing mummies. The unwound textiles were employed 'for making dresses, or to sell to the manufacturers of paper, who use them in the making of paper for the grocers'.[5] While it is difficult to know whether 'Abd al-Latif al-Baghdadi's report should be taken literally, it is the case that recycled products – rope, cotton and linen rags, and paper itself – often featured as raw materials for paper production. This can still be seen in traditional paper-making practices in northern India.[6] Old documents could even be cut up and reused for other functions. One example is an autograph notebook by al-Maqrizi made from a parts of a diploma (*marsum*) issued by the Mamluk chancery some decades before.[7] Imported paper could also be adapted for use by Islamic scribes and painters. Jonathan Bloom discusses a manuscript produced in Tabriz in 1478 in which the Persian script is written on pale blue sheets decorated in gold with landscapes, birds and flowers. This paper was cut from two Chinese painted scrolls. Bloom observes that the paper would have been sized so to allow it to be inscribed with a reed pen.[8] Chinese paper was evidently a desirable product; the famous scribe, Ibn al-Bawwab (d. c. 1022), is reported to have accepted payment in the form of cut sheets of the stuff stored in a Baghdad library.[9]

Archaeologists working in the Middle East are the beneficiaries of the fact that throughout human history the vast majority of broken pots were discarded by their owners. Quite simply, broken pottery generally possessed no commercial value. There is evidence, however, for the mending of pottery (see below), and for the reuse of ceramic fragments. Sherds could be used to line the walls of cisterns, kilns and furnaces, while larger quantities of ceramic – sometimes in the form of complete vessels filled with sand – formed the foundation for military constructions or buildings.[10] Broken pottery could be ground up to create a temper (known as grog) for clays. This practice is attested in ethnographic studies, and evidence for the presence of grog has also been demonstrated in petrographic studies of medieval pottery from Jordan.[11] The abrasive quality of unglazed pottery made it suitable for cleaning. Ibn al-Ukhuwwa (d. 1329), in his book on

hisba (market law), recommends the combination of potsherds and potash (ushnan) for cleaning water jars (sing. kuz) and for scouring the copper pans used for making almond tart (zulabiyya).[12] Pottery could also be ground into a powder for use in equine medicine, while sherds from glazed vessels are mentioned by Ibn al-Nafis (d. 1288) in relation to ophthalmological procedures. Ibn al-Baitar (d. 1248) recommends ceramics as abrasives in the treatment of several skin diseases.[13]

Damaged metal and glass vessels were readily recyclable. Precious metal could be melted down to be struck as coin, particularly in times of financial crisis. Copper alloys (brass and bronze) were more likely to be collected as scrap.[14] A result of melting different copper alloys together was the creation of what are commonly known as quaternary alloys. These were often employed in the manufacture of cast objects.[15] The relatively high cost of producing glass from raw materials encouraged the reuse of broken pieces (cullet) and materials gathered from manufacturing sites. One can imagine that in many workshops unsuccessful broken vessels, moils and shards of glass were simply thrown back into the furnace to be remelted. These materials could also be sold for profit. The economic potential of this practice is well illustrated in the eleventh-century Serçe Limanı wreck. This trading vessel was found to contain baskets filled with cullet and glass waste that had probably come from the glass-making centres in Palestine.[16] The practice of reusing glass is also mentioned by Sir John Chardin (d. 1713) in his review of the craft in the towns and cities of Iran. His assessment is far from positive, noting that 'The Glass of *Chiras* is the finest in the Country; that of *Ispahan*, on the contrary, is the sorriest, because it is only Glass melted again; they make it commonly in Spring'.[17]

Chardin does, however, display admiration for one skill relating to the Persian glass industry. He writes:

> I ought not to forget to acquaint you with the *Persian* Art of Sowing Glass together very ingeniously, as I have hinted above; for providing the Pieces be not smaller than one's Nail, they sow them together with Wyre, and rub the seam all over with a white Lead, or with calcined Lime, mix'd with the White of Eggs, which hinders the Water from soaking thro.[18]

Many cities across the Middle East contained specialists who made their living from mending broken objects in glass and glazed ceramic. Ibn Battuta (d. 1368–9) even reports on a charitable bequest (waqfiyya) established in Damascus to pay the costs of mending broken Chinese glazed wares (sini).[19] Imported porcelain and green wares (celadon) were very expensive commodities in the Middle East prior to the nineteenth century (see below). Thus, costs involved in mending were more than offset by the value and rarity of such items.

Figure 7.1 *Unglazed and glazed pottery sherds with drilled holes,*
tenth–twelfth centuries, excavated from Tal Fukhkhar, Raqqa, Syria.
Photo courtesy of the Raqqa Ancient Industries Project,
University of Nottingham.

Istanbul had many specialists in this field: Evliya Çelebi (d. after
1682) claims there were ten workshops containing a total of twenty-
five craftsmen. The collection in the Topkapı Sarayı contains numer-
ous examples of repaired bowls and vases. Archival records indicate
that boxes of broken porcelain from the palace might be sold on the
open market.[20] The practice of drilling and wiring broken pottery
is confirmed by archaeological evidence,[21] and in ethnographic
observations of the *pathragar* (vessel mender) in twentieth-century
Uzbekistan and Afghanistan.[22] Intriguingly, drill holes and even wire
can sometimes be detected in unglazed or simple lead-glazed earth-
enwares from archaeological sites, indicating that high cost was not
the only determining factor in the decision to mend a given vessel
(Figures 7.1 and 7.2). Pieces of broken glazed ware could be put to
decorative uses, being set into architecture or even into the surfaces
of unglazed ceramic vessels (Figure 7.3).

In common with all other urban crafts, the mending of vessels was
overseen by the market inspector (*muhtasib*) through his deputies
(sing. *'arif*). The regulations imposed upon these artisans appear in
hisba manuals. The most detailed medieval account of the mending
of pottery is given by Ibn Bassam (fl. thirteenth–fourteenth century).
He notes that the *sha"abin al-biran* employed a variety of glues,
including a powder formed from the spleens (sing. *tihal*) of animals
and a mixture of crushed ceramic with either egg white or radish
oil (*zayt al-fujl*). The same author also prohibits the use of blood in

Ramallah, remarks that women were abandoning the practice of making handmade pottery:

> The bustling commercial petroleum industry has brought a lot of large waterproof metal boxes into the country, which are used for all sorts of things in households and [have] replaced the usual pottery in a perfect way. The plumber adapts this cheap metal for all sorts of home appliances.[37]

Additional factors noted by Einsler include the low price of imported glass and porcelain, and the decline in animal husbandry in rural Palestine. The latter was a relevant consideration because of the use of animal dung as fuel for firing handmade ceramics. Other types of imported metal containers were recycled in Jordan in the early twentieth century for decorative purposes. Crudely made, but brightly painted wooden cupboards were often given metal facings to the doors. These were made by beating flat the enamelled tins used for the sale of tea. Chinese pagodas are a common theme on the metal doors of cabinets of this type.[38]

Other types of packaging were also recycled. For example, Sir E. A. Wallis Budge (d. 1934) gives an intriguing account of a Christian scribe working in the village of Tal Qif, near Mosul. The man was copying a text by Bar Hebraeus (d. 1286). After remarking upon the scribe's mastery over script styles, Budge continues:

> In answer to my questions he told me that he bought his paper from the grocers in the bazâr who used it for wrapping up sugar. It was good, stout, rag-made paper manufactured in Russia, very rough on both sides, and in size small folio. Before use each sheet was laid on a smooth board and well rubbed and rolled with a small round bottle, like a whisky bottle, and under this treatment the paper became so beautifully smooth and shiny that the reed pen rarely spluttered. The scribe took a sheet of the paper and ruled dry lines on it with a metal stilus to mark the margins and the number of lines in the column of text to be written upon it, and having rubbed it with his bottle he sat down and wrote whilst we looked on.[39]

Notably, the scribe worked with a traditional reed pen despite the availability of imported steel nibs in the markets of the Middle East.[40] Opportunistic reuse of paper and card has been noted among the Qur'anic scribes operating in twentieth-century Nigeria.[41]

One last example of inventive reuse comes from the time of the First World War. Metalworkers in Damascus and Jerusalem took to decorating spent artillery shell cases (a practice commonly known as 'trench art'). These were often made into vases (Figure 7.4) and lidded boxes for tobacco or cigarettes (Figure 7.5). These objects

Figure 7.4 *Pair of artillery shell cases decorated with silver and copper inlay, Damascus or Cairo, c. 1918, collection of the author. Photo: Marcus Milwright.*

are ornamented in a variety of styles, with the finest combining elegant chased designs with inlay in silver and copper wire. Arabic inscriptions are usually written in *thuluth* script, suggesting a connection to 'Mamluk revival' metalwork produced in Egypt and Syria during the late nineteenth and early twentieth centuries.[42] Hebrew inscriptions appear on some examples. Most of these vases and pyxides were probably made for sale to soldiers, and notably some carry the dates marking the capture of Jerusalem (11 December 1917) and Damascus (1 October 1918) by the Egypt Expeditionary Force and its allies. One might speculate that metalworkers in Greater Syria melted down artillery shell cases in order to make cast or hammered objects. Recent metallographic testing of 'Mamluk revival' metalwork has shown no significant correlation in the alloys, however.[43]

A few general points can be made on the basis of this preliminary examination. Prior to the advent of widespread industrialisation, urban communities across the Middle East contained men and women who earned their livings sifting through rubbish heaps, searching streets for discarded items, collecting waste associated with other craft activities and mending damaged objects. Recycling and repair were also a feature of rural settlements, though these practices are seldom recorded in primary sources. That these activities were commonplace indicates that waste was kept to a relative minimum, and that there was a powerful incentive to render even the humblest materials into marketable commodities. More expensive media, such as broken glass and scrap metal, could even be traded internationally. The presence of spolia in Islamic architecture has been discussed extensively by other scholars.[44] In this context it can be noted that spolia were often employed in buildings near to their original locations (Figure 7.6), though there are also numerous instances of marble columns and other desirable architectural elements being transported over long distances.[45]

Two economic factors facilitated the practices of recycling and repair. First is the low value generally placed on human labour, even

Figure 7.5 *Lidded box made from two artillery shell cases, inlaid in Damascus, c. 1919, collection of Mr Murray Webb, Victoria, Canada. Photo: Marcus Milwright.*

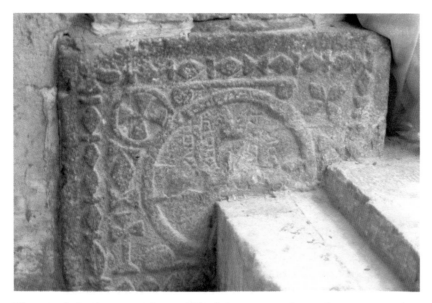

Figure 7.6 *Ancient carved stone block incorporated into the entrance of the Madrasa al-Halawiyya, Aleppo, 1149. Photo: Marcus Milwright.*

that of relatively skilled artisans.[46] Those engaged in the mending of objects appear to have been poorly paid. For example, ethnographic research in Afghanistan indicates that those engaged in this activity were among the least well-paid artisans in urban markets.[47] The second factor is the high cost of manufactured goods in relation to the earnings of the poorer sectors of society. The evidence from the late nineteenth and early twentieth centuries suggests some disruption in existing patterns of behaviour. Most important in this respect was the decline in the unit cost of many manufactured goods. While this reduction in prices did not eliminate all types of recycling and repair, there is evidence that many activities lost their economic imperative. These processes of change only intensified with the establishment of factories in the Middle East and the widespread introduction of commodities such as plastics and synthetic dyes. Traditional crafts were not extinguished as the result of these transformations, however, and forms of inventive recycling continue to occur across the Islamic world.

Notes

1. Abu 'Uthman 'Amr ibn Bahr al-Jahiz, *Avarice and the Avaricious (Kitab al-bukhala')*, trans. Jim Colville, The Kegan Paul Arabia Library 5 (London and New York, 1999), pp. 137–8.
2. From the eighth epistle of the first series of the *Rasa'il Ikhwan al-Safa'*. Translated in Bernard Lewis, 'An epistle on the manual crafts', *Islamic Culture* 17 (1943), pp. 149–50.
3. Taqi al-Din al-Maqrizi, *Kitab al-mawa'iz wa'l-i'tibar bi-dhikr al-khitat wa'l-athar* (Bulaq, 1853–5), vol. II, p. 95.
4. George Scanlon, 'Fustat expedition: preliminary report, 1965: Part I', *Journal of the American Research Center in Egypt* 4 (1965), p. 11. Scanlon notes that Aly Bahgat, who co-directed the earlier excavations of the site, funded his work by obtaining the concession to sell *sibakh* gathered from Fustat.
5. 'Abd al-Latif al-Baghdadi, *The Eastern Key: Kitab al-Ifadah wa'l-i'tibar of 'Abd al-Latif al-Baghdadi*, trans. Kamal Zand, John Videan and Ivy Videan (London, 1965), pp. 162 (Arabic), pp. 163 (English).
6. Alexandra Soteriou, *Gift of Emperors: Hand Papermaking in India* (Middletown, NJ and Chidambaram, India, 1999), pp. 104–9, 172–8.
7. Frédéric Bauden, 'The recovery of Mamluk chancery documents in an unsuspected place', in Michael Winter and Amalia Levanoni (eds), *The Mamluks in Egyptian and Syrian Politics and Society* (Leiden and Boston, 2004), pp. 59–76.
8. Jonathan Bloom, *Paper before Print: The History and Impact of Paper in the Islamic World* (New Haven and London, 2001), pp. 71–2.
9. David S. Rice, *The Unique Ibn al-Bawwab Manuscript in the Chester Beatty Library* (Dublin, 1955), pp. 7–8.
10. On these issues, see Marcus Milwright, 'Prologues and epilogues in Islamic ceramics: clays, repairs and secondary use', *Medieval Ceramics* 25 (2001), pp. 72–83. See also Marcus Milwright, 'Pottery in written sources of the Ayyubid–Mamluk period (c. 567–923/1171–1517)',

Bulletin of the School of Oriental and African Studies 62.3 (1999), pp. 504–18.

11. Birgit Mershen, 'Recent hand-made pottery from northern Jordan', *Berytus* 33 (1985), pp. 79–80; N. Abu Jaber and Z. Al Saa'd, 'Petrology of Middle Islamic pottery from Khirbat Faris, Jordan', *Levant* 32 (2000), pp. 182–3, table 1.

12. Ibn al-Ukhuwwa, *The Ma'alim al-qurba fi ahkam al-hisba of Diya' al-Din Muhammad ibn Muhammad al-Qurashi al-Shafi'i, known as Ibn al-Ukhuwwa*, ed. and trans. Reuben Levy, E. J. W. Gibb Memorial Trust (London, 1938), pp. 239 (Arabic), p. 112 (English). Also 'Abd al-Rahman b. Nasr al-Shayzari, *The Book of the Market Inspector: Nihayat al-rutba fi talab al-hisba* (Utmost Authority in the Pursuit of Hisba), trans. Ronald P. Buckley, *Journal of Semitic Studies Supplement* 9 (Oxford and New York, 1999), p. 50.

13. For references, see Milwright, 'Pottery in written sources', p. 512, nn. 69–70; 'Prologues and epilogues', p. 80.

14. On the recycling of scrap metal in mid twentieth-century Iran, see Hans Wulff, *The Traditional Crafts of Persia: Their Development, Technology, and Influence on Eastern and Western Civilizations* (Cambridge, MA, 1966), pp. 22–3, fig. 17.

15. On quaternary alloys, see James Allan, *Persian Metal Technology, 700–1300 AD* (London, 1979), pp. 45–6. For examples of quaternary alloy vessels, see James Allan, *Metalwork of the Islamic World: The Aron Collection* (London, 1986), cat. nos 1–3, 8, 9, 11, 13, 21, 22, 26, 27, 29–34, 36, 38, 41, 42.

16. Sheila Matthews and Berta Lledó, 'Raw glass and factory waste', in George Bass *et al.* (eds), *Serçe Limanı, Volume II: The Glass of an Eleventh-Century Shipwreck*, Ed Rachal Foundation Nautical Archaeology Series (College Station, TX, 2009), pp. 442–56.

17. Sir John Chardin, *Travels in Persia*, ed. Sir Percy Sykes (London, 1927), p. 275. Cf. Wulff, *The Traditional Crafts of Persia*, pp. 169–71.

18. Chardin, *Travels in Persia*, p. 275.

19. Muhammad ibn 'Abdallah Ibn Battuta, *Voyages d'Ibn Batoutah*, ed. and trans. Charles Defrémery and Beniamino Sanguinetti (Paris, 1853–8), vol. I, pp. 238–9.

20. For references, see Milwright, 'Prologues and epilogues', p. 80.

21. Ibid., p. 76, fig. 2.

22. Richard Karutz, 'Von den Bazaren Turkestans', *Globus* 87.18 (11 May 1905), p. 315; Carl-Johan Charpentier, *Bazaar-e Tashqurghan: Ethnographic Studies in an Afghan Traditional Bazaar*, Studia Ethnographica Upsaliensia 36 (Uppsala, 1972), pp. 124–7. Charpentier records that there were eight *pathragar*s operating in the bazaar of Tashqurghan in 1969, but that this had reduced to five in 1972.

23. Muhammad b. Ahmad ibn Bassam, *Nihayat al-rutba fi talab al-hisba*, ed. Husam al-Din al-Samarra'i (Baghdad, 1968), pp. 158–9.

24. For examples of pistols and rifles, see Robert Elgood, *Firearms of the Islamic World in the Tareq Rajab Museum, Kuwait* (London, 1995).

25. Muhammad Sa'id al-Qasimi, Jamal al-Din al-Qasimi and Khalil al-'Azm (al-Azem), *Dictionnaire des métiers damascains*, ed. Zafer al-Qasimi, Le Monde d'Outre-Mer passé et présent, Deuxième série, Documents III (Paris and Le Haye, 1960). On the history and authorship of the text, see David Commins, *Islamic Reform: Politics and Social Change in Late Ottoman Syria* (Oxford and New York, 1990), pp. 42–6, 86.

26. *Qamus*, pp. 428–9 (Chapter 350). Another example of both making and mending an object is the comb-maker (*mashitati*). See p. 444 (Chapter 367).

27. Ibid., pp. 386–7 (Chapter 312).

28. Ibid., pp. 99–100 (Chapter 66).

29. Ibid., pp. 142–3 (Chapter 101).

30. Charles Doughty, *Travels in Arabia Deserta*, new edition in one volume (New York, 1936), p. 246.

31. On the needle makers (sing. *abbar* or *ibbir*), see *Qamus*, p. 215 (Chapter 142). The *Qamus* has no entry on the makers of glazed pottery as these artisans had ceased to operate earlier in the nineteenth century. On the decline of silk manufacturing, see: Roger Owen, *The Middle East in the World Economy, 1800–1914* (London and New York, 1981), pp. 153–88, 244–72; Donald Quataert, 'Ottoman manufacturing in the nineteenth century', in Donald Quataert (ed.), *Manufacturing in the Ottoman Empire and Turkey, 1500–1950* (Albany, NY, 1994), pp. 87–121.

32. *Qamus*, p. 330 (Chapter 252).

33. Ibid., pp. 422–3 (Chapter 342).

34. The craft evidently lasted longer in Afghanistan. The practitioners (sing. *pathragar*) would mend teapots, but also repair other items such as fishing nets. The increasing preference for metal teapots was a major factor in the decline of the craft. See Charpentier, *Bazaar-e Tashqurghan*, p. 127.

35. Vitale Cuinet, *Syrie, Liban et Palestine. Géographie administrative, statistique, descriptive et raisonnée* (Paris, 1896), pp. 67–8, 380.

36. Pierre Bazantay, *Enquête sur l'artisanat à Antioche*, Les états du Levant sous Mandat Français (Beirut, 1936), pp. 37–8.

37. Translated from Lydia Einsler, 'Das Töpferhandwerk bei den Bauernfrauen von Ramallah', *Zeitschrift des Deutschen Palästina-Vereins* 37 (1914), p. 258.

38. Johannes Kalter, Maria Zerrnickel and Margareta Pavaloi, *The Arts and Crafts of Syria: Collection Antoine Touma and Linden-Museum, Stuttgart* (London and New York, 1992), p. 105, fig. 246.

39. Sir E. A. Wallis Budge, *By Nile and Tigris: A Narrative of Journeys in Egypt and Mesopotamia on Behalf of the British Museum between the Years 1886 and 1913* (London, 1920), vol. II, pp. 72–3.

40. On the increasing use of steel nibs, see Edwin Wilbur Rice, *Orientalisms in Bible Lands: Giving Light from Customs, Habits, Manners, Imagery, Thought and Life in the East for Bible Students*, third edition (Philadelphia, 1929), pp. 230–1. The availability in Damascus of steel writing pens is also noted in the *Qamus* (p. 300 [Chapter 220]).

41. Ismaheel Akinade Jimoh, 'The art of Qur'anic penmanship and illumination among Muslim scholars in southwestern Nigeria', in Fahmida Suleman (ed.), *Word of God, Art of Man: The Qur'an and Its Creative Expressions*, The Institute of Ismaili Studies, Qur'anic Studies Series 4 (Oxford and New York, 2007), p. 178.

42. On the production of 'trench art' in Greater Syria, see Marcus Milwright and Evanthia Baboula, 'Damascene "trench art": a note on Mamluk revival metalwork in early twentieth-century Syria', *Levant* 46.3 (2014), pp. 382–98.

43. Dr Peter Northover, personal communication.

44. For example, Finbarr B. Flood, 'The medieval trophy as architectural trope: Coptic and Byzantine "altars" in Islamic contexts', *Muqarnas* 14

(1997), pp. 41–72; Marianne Barrucand, 'Remarks on the iconography of the medieval capitals of Cairo: form and emplacement', in Bernard O'Kane (ed.), *The Iconography of Islamic Art: Studies in Honour of Robert Hillenbrand* (Edinburgh, 2004), pp. 23–44 (especially pp. 24–6).

45. For example, J. Michael Rogers, 'The state and the arts in Ottoman Turkey, part 1: the stones of the Süleymaniye', *International Journal of Middle East Studies* 14.1 (1982), pp. 71–86. See also Ibn al-Dawadari's account of the moving of Pharaonic columns in the Mamluk period. Translated by Jane Jakeman and reproduced in Marcus Milwright, *Islamic Arts and Crafts: An Anthology* (Edinburgh, 2017), p. 69.

46. For evidence on wages prior to the modern period, see Eliyahu Ashtor, *Histoire des prix et des salaires dans l'Orient médiévale* (Paris, 1969).

47. Charpentier, *Bazaar-e Tashqurghan*, p. 127.

Bibliography

'Abd al-Latif al-Baghdadi, *The Eastern Key: Kitab al-Ifadah wa'l-i'tibar of 'Abd al-Latif al-Baghdadi*, ed. and trans. K. Zand, J. Videan and I. Videan (London, 1965).

Abu Jaber, N. and Z. Al Saa'd, 'Petrology of Middle Islamic pottery from Khirbat Faris, Jordan', *Levant* 32 (2000), pp. 179–88.

Allan, James, *Persian Metal Technology, 700–1300 AD* (London, 1979).

Allan, James, *Metalwork of the Islamic World: The Aron Collection* (London, 1986).

Ashtor, Eliyahu, *Histoire des prix et des salaires dans l'Orient médiévale* (Paris, 1969).

Barrucand, Marianne, 'Remarks on the iconography of the medieval capitals of Cairo: form and emplacement', in B. O'Kane (ed.), *The Iconography of Islamic Art: Studies in Honour of Robert Hillenbrand* (Edinburgh, 2004), pp. 23–44.

Bauden, Frédéric, 'The recovery of Mamluk chancery documents in an unsuspected place', in M. Winter and A. Levanoni (eds), *The Mamluks in Egyptian and Syrian Politics and Society* (Leiden and Boston, 2004), pp. 59–76.

Bazantay, Pierre, *Enquête sur l'artisanat à Antioche*, Les états du Levant sous Mandat Français (Beirut, 1936).

Bloom, Jonathan, *Paper before Print: The History and Impact of Paper in the Islamic World* (New Haven and London, 2001).

Budge, Sir E. A. Wallis, *By Nile and Tigris: A Narrative of Journeys in Egypt and Mesopotamia on Behalf of the British Museum between the Years 1886 and 1913* (London, 1920).

Chardin, Sir John, *Travels in Persia*, ed. Sir Percy Sykes (London, 1927).

Charpentier, Carl-Johan, *Bazaar-e Tashqurghan: Ethnographic Studies in an Afghan Traditional Bazaar*, Studia Ethnographica Upsaliensia 36 (Uppsala, 1972).

Commins, David, *Islamic Reform: Politics and Social Change in Late Ottoman Syria* (Oxford and New York, 1990).

Cuinet, Vitale, *Syrie, Liban et Palestine. Géographie administrative, statistique, descriptive et raisonnée* (Paris, 1896).

Doughty, Charles M., *Travels in Arabia Deserta*, new edition in one volume (New York, 1936).

Einsler, Lydia, 'Das Töpferhandwerk bei den Bauernfrauen von Ramallah', *Zeitschrift des Deutschen Palästina-Vereins* 37 (1914), pp. 249–60.

Elgood, Robert, *Firearms of the Islamic World in the Tareq Rajab Museum, Kuwait* (London, 1995).

Flood, Finbarr B., 'The medieval trophy as architectural trope: Coptic and Byzantine "altars" in Islamic contexts', *Muqarnas* 14 (1997), pp. 41–72.

Ibn Bassam, Muhammad b. Ahmad, *Nihayat al-rutba fi talab al-hisba*, ed. Husam al-Din al-Samarra'i (Baghdad, 1968).

Ibn Battuta, Muhammad ibn 'Abdallah, *Voyages d'Ibn Batoutah*, ed. and trans. Charles Defrémery and Beniamino Sanguinetti (Paris, 1853–8).

Ibn al-Ukhuwwa, *The Ma'alim al-qurba fi ahkam al-hisba of Diya' al-Din Muhammad ibn Muhammad al-Qurashi al-Shafi'i, known as Ibn al-Ukhuwwa*, ed. and trans. Reuben Levy, E. J. W. Gibb Memorial Trust (London, 1938).

Al-Jahiz, 'Abu 'Uthman Amr ibn Bahr, *Avarice and the Avaricious (Kitâb al-bukhalâ')*, trans. Jim Colville, The Kegan Paul Arabia Library 5 (London and New York, 1999).

Jimoh, Ismaheel Akinade, 'The art of Qur'anic penmanship and illumination among Muslim scholars in southwestern Nigeria', in F. Suleman (ed.), *Word of God, Art of Man: The Qur'an and Its Creative Expressions*, The Institute of Ismaili Studies, Qur'anic Studies Series 4 (Oxford and New York, 2007), pp. 175–89.

Kalter, Johannes, Maria Zerrnickel and Margareta Pavaloi, *The Arts and Crafts of Syria: Collection Antoine Touma and Linden-Museum, Stuttgart* (London and New York, 1992).

Karutz, Richard, 'Von den Bazaren Turkestans', *Globus* 87.18 (11 May 1905), pp. 312–17.

Lewis, Bernard, 'An epistle on the manual crafts', *Islamic Culture* 17 (1943), pp. 142–51.

Al-Maqrizi, Taqi al-Din, *Kitab al-mawa'iz wa'l-i'tibar bi-dhikr al-khitat wa'l-athar*, 2 vols (Bulaq, 1853–5).

Matthews, Sheila and Berta Lledó, 'Raw glass and factory waste', in George Bass, Robert H. Brill, Berta Lledó and Sheila D. Matthews (eds), *Serçe Limanı, Volume II: The Glass of an Eleventh-Century Shipwreck*, Ed Rachal Foundation Nautical Archaeology Series (College Station, TX, 2009), pp. 442–56.

Mershen, Birgit, 'Recent hand-made pottery from northern Jordan', *Berytus* 33 (1985), pp. 79–80.

Milwright, Marcus, 'Pottery in written sources of the Ayyubid–Mamluk period (c. 567–923/1171–1517)', *Bulletin of the School of Oriental and African Studies* 62.3 (1999), pp. 504–18.

Milwright, Marcus, 'Prologues and epilogues in Islamic ceramics: clays, repairs and secondary use', *Medieval Ceramics* 25 (2001), pp. 72–83.

Milwright, Marcus, *Islamic Arts and Crafts: An Anthology* (Edinburgh, 2017).

Milwright, Marcus and and Evanthia Baboula, 'Damascene "trench art": a note on Mamluk revival metalwork in early twentieth-century Syria', *Levant* 46.3 (2014), pp. 382–98.

Owen, Roger, *The Middle East in the World Economy, 1800–1914* (London and New York, 1981).

Al-Qasimi, Muhammad Sa'id, Jamal al-Din al-Qasimi and Khalil al-'Azm (al-Azem), *Dictionnaire des métiers damascains*, ed. Z. al-Qasimi, Le Monde d'Outre-Mer passé et présent, Deuxième série, Documents III (Paris and Le Haye, 1960).

Quataert, Donald, 'Ottoman manufacturing in the nineteenth century', in Donald Quataert (ed.), *Manufacturing in the Ottoman Empire and Turkey, 1500–1950* (Albany, NY, 1994), pp. 87–121.

Rice, David S., *The unique Ibn al-Bawwab Manuscript in the Chester Beatty Library* (Dublin, 1955).

Rice, Edwin Wilbur, *Orientalisms in Bible Lands: Giving Light from Customs, Habits, Manners, Imagery, Thought and Life in the East for Bible Students*, third edition (Philadelphia, 1929).

Rogers, J. Michael, 'The state and the arts in Ottoman Turkey, part 1: the stones of the Süleymaniye', *International Journal of Middle East Studies* 14.1 (1982), pp. 71–86.

Scanlon, George, 'Fustat expedition: preliminary report, 1965: Part I', *Journal of the American Research Center in Egypt* 4 (1965), pp. 7–30.

Al-Shayzari, 'Abd al-Rahman b. Nasr, *The Book of the Market Inspector: Nihayat al-rutba fi talab al-hisba* (Utmost Authority in the Pursuit of Hisba)', trans. Ronald P. Buckley, Journal of Semitic Studies Supplement 9 (Oxford and New York, 1999).

Soteriou, Alexandra, *Gift of Emperors: Hand Papermaking in India* (Middletown, NJ and Chidambaram, India, 1999).

Wulff, Hans, *The Traditional Crafts of Persia: Their Development, Technology, and Influence on Eastern and Western Civilizations* (Cambridge, MA, 1966).

CHAPTER EIGHT

A Copper-alloy Plate with Architectural Imagery in Berlin . . . and Jerusalem?

Lawrence Nees

A MAGNIFICENT COPPER-ALLOY plate in the Museum of Islamic Art in Berlin has been the object of considerable controversy and speculation since its debut in 1910 (Figure 8.1),[1] but surprisingly little about it is known with certainty. What term should we use to identify this object: plate, dish, platter, salver, charger? The answer depends upon knowing how it was used, but we do not know, indeed the issue has not hitherto been addressed. Here I cannot pretend to solve its mysteries, but perhaps some review of earlier scholarship and a few new suggestions might serve as a fitting tribute to two great scholars whose work has elucidated so many beautiful and intriguing objects.[2]

The Berlin plate is round and slightly concave, worked essentially flat, with no raised areas, but with extensive engraving of the surface on the front, concave, side. At the centre is a medallion with what appears to be a building of some sort, with a large dome, a large central portal and a row of arches across its centre (Figure 8.2). Around this medallion is another, larger, arcade, arranged radially, with the arches to the outer edge. The outer arcade comprises twenty-two arches resting on thin columns, nearly all slightly horseshoe in shape, one being slightly pointed, and all are filled with luxuriant vegetal ornament. A view of its verso (Figure 8.3) shows that the plate has no foot,[3] but is one continuous curve, and could not stand on its own. Significant signs of wear, particularly in the centre, suggest that something might have been placed there and eventually abraded the surface, but what? Huge copper-alloy plates are often set on stands for food service, which is one possibility for usage, but a purely representative function seems perfectly plausible. This is an important issue and deserves further study, but it is beyond the compass of this chapter. Photographic reproduction hides the startling scale of the Berlin plate, 645 mm in diameter. Unlike the great plates of the late antique and early medieval period, the Berlin plate

Figure 8.1 *Berlin plate, front view. Photo: The Islamic Museum, Berlin, ISL-SMB Inv.-Nr. I, 5624.*

Figure 8.2 *Berlin plate, detail of central medallion. Photo: The Islamic Museum, Berlin, ISL-SMB Inv.-Nr. I, 5624.*

Figure 8.3 *Berlin plate, back view. Photo: The Islamic Museum, Berlin, ISL-SMB Inv.-Nr. I, 5624.*

is made not of silver but of copper alloy, often described as bronze or brass in general and with regard to this object in earlier scholarship. Islamic art is famous for such copper alloy objects, but the series begins later than scholars have dated the Berlin plate. Almost the only comparable objects in copper alloy of this scale from such an early date are said to have been acquired from the Caucasus in the late nineteenth century and all are now in the Hermitage Museum.[4]

Boris Marschak proposed that all of these objects, including the Berlin plate, should be dated to the seventh–ninth centuries, and that all originated in Iran.[5] Fortunately for such an anomalous group, one of these objects was found in October 1960 during the archaeological excavation of a site in western Russia, in a Scandinavian context of roughly the tenth–eleventh century.[6] Although smaller than the Berlin plate, it still measures an impressive 500 mm, and has the same profile as the Berlin plate, a shallow continuous curve with no foot. It was severely damaged when found and included old repairs that the archaeologists dated to roughly the tenth century. Its existence relieves possible suspicion that the group as a whole might comprise modern forgeries, and since it was associated when excavated with a group of 'Abbasid coins of the eighth and ninth centuries, it also provides a *terminus ad quem* for at least this member

of the group, a dating supported on other grounds, as will be argued later. Also, its condition, damaged and roughly repaired, might be taken as suggesting that there was some utilitarian function for the object, and that it was not purely representative.

What does the Berlin plate represent, and/or mean? Where and when was it produced? These questions have been the focus of 105 years of scholarly study and debate, with widely differing answers. The object has been something of a Rorschach test, telling us a good deal about its interpreters and their points of view, as is surely true of me as well. The most recent discussion of which I am aware is in an exhibition catalogue from 2014, which used a detail of its central medallion as the frontispiece, an indication of the object's significance. In the catalogue entry Stefan Weber emphasised the many questions raised by the object, and he suggested that it might refer to Jerusalem and specifically to the Dome of the Rock.[7] Weber suggested a date in the seventh or eighth century and origin in 'Syria, Jordan or Iran'. This attribution to the early Islamic period differs from an older and frequently repeated understanding, which saw the Berlin plate as pre-Islamic and distinctly Persian, indeed Sasanian.

The debut of the Berlin plate in the scholarly world took place at the huge exhibition in 1910 in Munich of what was then called 'Muhammadan Art'.[8] It was at that time in the private collection of Fredrik R. Martin of Stockholm, who was, with Friedrich Sarre of the Berlin Kaiser-Friedrich-Museum, the organiser of the exhibition. A recent volume devoted to the centenary of that exhibition suggested something of the context in which the Berlin plate was initially presented, and received, a context focused upon design elements and 'oriental' visual and material culture, and very little upon Islam.[9] The catalogue entry written by the young Ernst Kühnel attributed the object to Persia in the sixth–seventh century, because it was said to be like Sasanian art, and interpreted the imagery in the central medallion as a garden pavilion surrounded by an arcade.

One could have taken these central designs as purely decorative, but from Kühnel's first publication they were commonly thought to represent an actual structure, and were even reconstructed graphically as such. Arthur Upham Pope followed Kühnel in interpreting the Berlin plate's central medallion as a Persian garden pavilion, and published a drawing of it.[10] Pope read the architecture as the façade of a building having three domes, a central larger one flanked by smaller versions, which rose above a zigzag crenellation and a blind arcade. The lowest story was taken to be a central entrance doorway, with vegetal patterns at the sides that could be either representations of plants in the garden or images on the walls of the structure.

The disembodied wings beneath the alleged building, deleted from Pope's drawing, are important historiographically, for they were critical to the claim that the object was Sasanian. Such wings were indeed often associated with rulers, for example on coins. They appear on

the helmets of late Sasanian kings,[11] which lends some support to dating the Berlin plate not before the end of the sixth or seventh century, as suggested by Kühnel in 1910, who took for granted that the Berlin plate has something to do with rulership.[12] However, the disembodied wings appear on many other works, some of which are not Sasanian at all, as for example in mosaics from the drum of the Dome of the Rock, dating c. 692, half a century after the conquest of Sasanian Iran by the Muslim armies, and thus consistent with Weber's suggestion that the Dome of the Rock could be the referent for the image on the Berlin plate.[13] Another example is provided by a textile in the Horyu-ji in Nara, in Japan, already in that collection in the eighth century, and most likely woven in Central Asia or China rather than in Iran.[14] Both examples are commonly taken to show that motifs we identify as Sasanian were widely distributed during the time of the Sasanian kingdom, and continued to be a 'fashion' after the Sasanian Empire was no more.[15]

Scholars engaged with Central Asian architecture have suggested that the alleged building represented on the Berlin plate might reflect a mausoleum and perhaps a Sasanian forerunner for the kind of domed mausoleum with blind arcade and central doorway famously surviving from Bukhara, and dating from the tenth century.[16] That there are formal resemblances is clear, as are the differences, which were largely ignored in the study suggesting a relationship, as is the surrounding arcade. Here, note again the assumption that what we see on the Berlin plate is the façade of a building. The mausoleum hypothesis has had no subsequent adherents, at least to my knowledge.

The long dominant interpretation of the Berlin plate understood the building allegedly represented on the Berlin plate as a Sasanian fire temple rather than a Sasanian garden pavilion, as had been first suggested. This fire-temple interpretation was advanced by Oscar Reuther in his work on Sasanian architecture for *A Survey of Persian Art*, published in 1938,[17] but he was not the originator of this idea, which stemmed from Josef Strzygowski.[18] The central cult of the Zoroastrian religion practised by the Sasanians involved the veneration of a sacred fire, but the architectural arrangement of the cult was not known, so the Berlin plate became a precious piece of evidence for its physical setting. It was known that the sacred fire was kept on an altar, and the column visible in the centre of the doorway of the Berlin plate was taken to be such an altar by Reuther. Lars-Ivar Ringbom's 1951 book devoted great attention to the Berlin plate, to which he returned repeatedly, and Ringbom extensively developed the hypothesis identifying its central element as the representation of a fire temple. The ring of arches around the circumference of the plate he took as a circular arcade, and the imagery of the central medallion he took not as the front of a building with a dome, but as the lavish interior decoration of an *iwan*.[19] One important difference

from the ideas of Strzygowski and Reuther is that Ringbom saw the Berlin plate as depicting not a generic but a specific Sasanian fire temple, the one known as Adhur Gushnap, forming an important part of the remarkable royal and religious centre of Takht-i Sulayman (now known as Šiz), in the region of north-western Iran.[20] The great *iwan* at this site was identified by Ringbom as the famous 'throne of Khosro' extensively described in medieval literature East and West,[21] and according to a famous article by Ernst Herzfeld represented on a seventh-century Sasanian silver plate.[22] Ringbom, following Strzygowski, understood the Berlin plate's imagery as showing the great *iwan* containing the royal throne, the central doorway behind the throne, leading into the fire temple behind, not being visible in the representation (Figure 8.4).

Ringbom stretched or simplified more than a little, since the lake on the site is not round, and is much too large to have been surrounded by a twenty-two columned arcade, a difficulty that he recognised, and resolved by assuming that twenty-two stands for 220. Ringbom proceeded to argue that this site was the origin of what became known in Western Europe, especially in later medieval German literature, as the Grail Temple. Ringbom was one of very few scholars to call attention to this odd number,[23] and the only one to attempt an explanation for this odd motif (twenty-two columns rather than the 'normal' twenty-four), since he found a late medieval German text that described the Grail Temple as having this number of columns.[24] Ringbom's deeply learned book is imaginative as well as scholarly, and embodied a mid-twentieth-century combination of mysticism, orientalism, romanticism and medievalism at a time of great upheaval, the Second World War.[25] Although I have not found other scholars who have endorsed its view that the Berlin plate should be linked with either Takht-i Sulayman or the Grail Temple, it has buttressed the earlier publications linking the Berlin plate with a Sasanian fire temple, which has continued to be the common interpretation.[26] Ringbom's specific claims have not stood the test of time for many reasons,[27] among them a German expedition to Takht-i Sulayman in the 1960s and early 1970s to explore and excavate the site, previously known only from rough sketches like those used by Ringbom.

The new expedition produced much more detailed plans, showing among other things that there were two separate structures with large *iwans*, one in front of a fire temple on the south side, and another separate one that served as the setting for the royal throne on the west. This German expedition made little use of the Berlin plate as evidence for the site, which did not correspond to what they found there. For example, the central *iwan* of the Adhur Gushnap complex was indeed flanked by arches, but arches borne on heavy piers on ground level, not on thin columns forming a blind arcade on a higher storey. Also problematic was the interpretation of the column in

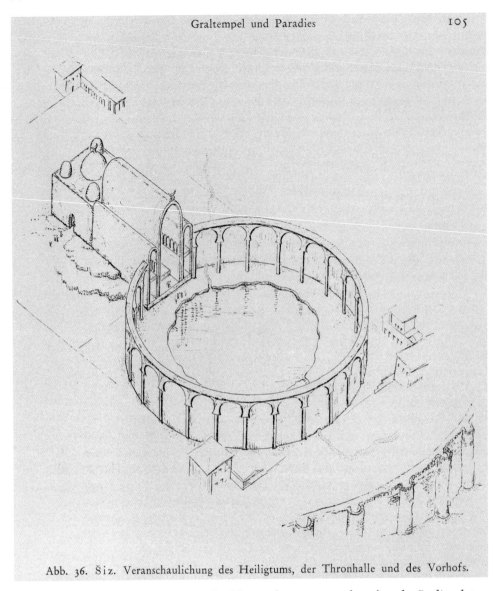

Graltempel und Paradies 105

Abb. 36. Šiz. Veranschaulichung des Heiligtums, der Thronhalle und des Vorhofs.

Figure 8.4 *Ringbom reconstruction of Takht-i Sulayman complex after the Berlin plate (after Lars-Ivar Ringbom,* Graltempel und Paradies. Beziehungen zwischen Iran und Europa im Mittelalter *(Stockholm, 1951), fig. 36).*

the central door of the structure on the Berlin plate by Strzygowski, Reuther and Ringbom as the columnar support of a fire altar. Such a columnar support was indeed found at Takht-i Sulayman, but not in the axial room, where it could have been seen through the central doorway.[28] The venerable interpretation of the Berlin plate as having to do with Sasanian fire temples has more or less collapsed in the face of newer information.[29] The fallback position that the object is

post-Sasanian in date, but nonetheless Sasanian in subject matter and meaning strikes me as a bit desperate, maintaining the conclusion when the evidence supporting it has disappeared.

As early as 1940 Jean Sauvaget asserted that there were no good Sasanian comparisons for the Berlin plate, the best available being early Islamic in date, or even not-so-early Islamic.[30] For Sauvaget, that there were some 'Sasanian motifs', such as the disembodied wings, did not mean it was a Sasanian object, since early Islamic imagery took over the motif, as seen in the Dome of the Rock mosaics. He thought that the decoration within the arcades, both horseshoe and ogival, and the vegetal decoration, was more significant for dating,[31] and described this ornament as *typiquement islamique*, the broken ogival arch being unknown in Sasanian art. He pointed out that the twenty-two arches and their ornament contain no exact repeats, and he thought that this ornament is post-arabesque and thus should be dated post-Samarra and pre-Seljuq, therefore tenth–eleventh century. Subsequently, Henri Stern compared the vegetal ornament of the Berlin plate to the mosaics in the Church of the Nativity in Bethlehem, the Dome of the Rock, and Mshatta, but although all his comparisons were to Umayyad works he derived those from Sasanian traditions.[32] Stern also cited a Syriac manuscript dated 719 for its comparable palmette ornament,[33] but did not mention the fragment of a very luxuriously decorated Greek manuscript commonly assigned to Constantinople in the seventh or eighth century with magnificent ornament of stacked palmettes, which perhaps testifies to the wide range of such ornament and the difficulty of pinning it to a single place or time.[34] More recently Claus-Peter Haase brought forward comparison with the arcades filled with vegetal motifs in the western side of the Mshatta reliefs,[35] and with one of the niches filled with a stylised tree motif from the citadel in Amman, which he dated mid-eighth century,[36] but these comparisons are not persuasive in detail. Josef Strzygowski compared the vines in the arches to the Kairouan *minbar*, which he thought originated in Baghdad, but he nonetheless believed the plate to be Sasanian, supporting this early dating through comparisons of the ornament to three objects found in Hungary, and according to him from the '*Landnahmezeit*', presumably the time of the Avars in the sixth century, although perhaps the Magyars in the tenth.[37] Better comparisons are offered by the vegetal ornament within the large arches in the mosque at Cordoba, which would put us in the tenth century, but many features of this structure recall earlier Umayyad works in Syria.[38] Nothing about the ornament seems conclusive, and certainly there is no scholarly consensus about the affiliations, much less the dating, of the ornament on the Berlin plate.

Let me return here to the issue of technique, just mentioned. The Berlin plate is usually described as cast copper-alloy with engraved decoration (Figure 8.5). No one has discussed it in more detail in

Figure 8.5 *Berlin plate, details of engraving. Photo: The Islamic Museum, Berlin ISL-SMB Inv.-Nr. I, 5624.*

terms of technique, insofar as I have been able to discover. The object is monometallic, without any inlay or gilding, and is completely flat, with no relief or repoussé work at all. 'Engraving' usually signifies carving with a tool like a burin to make a groove and remove material, making a neat smooth line. One does see such lines on the Berlin plate, as is visible in the detail illustrated here, but most of the decoration is made not with smooth lines but with repeated small triangular marks lined together. The enlarged detail shows that these triangular indentations are generally about the same size, but fall into two groups, a smaller and a larger. This appears to be punching, not engraving, repeated hammering or chasing rather than carving, with metal pushed aside rather than removed.

Such a technique is largely absent from Sasanian metalwork, most of which is in silver and makes most decoration in relief. It seems to me also foreign to the late medieval Islamic copper-alloy vessels, which are commonly inlaid with other metals. Examples of Sasanian or for that matter Mamluk punched decoration might be found, but I can cite at least two good examples of the same technique on well-known copper-alloy objects, also with decoration entirely flat. Both are probably ewers, vessels for pouring water, and both are aviform, representing a bird of prey which most have described as an eagle, a usage I would follow.

One of these is also in the Berlin collection, and in fact graced the cover of the recent exhibition that also included the Berlin plate (Figure 8.6).[39] The other example is one of the best documented early Islamic works, since it carries an inscription naming its maker as Sulayman, and giving the date of 180 AH/796–7 CE, and an indecipherable place name.[40] A related ewer in Tbilisi has an inscription stating that it was made at Basra, and Iraq is perhaps the most likely origin for this magnificent work, but localisation is even more dif-

Figure 8.6 *Berlin, eagle ewer, detail. Photo: The Islamic Museum, Berlin, ISL-SMB Inv.-Nr. I. 5623.*

ficult than dating. All three objects are worked flat, and all have the fuzzy lines punched out with repeated blows rather than carved. Such a technique is commonly used by metalworkers of many times and places, ancient and modern, and the technique alone does not prove either dating or localisation, but it is consistent with an early Islamic dating, and an origin by no means necessarily in Iran.[41]

I should mention that no metallurgical analysis of the Berlin plate has ever been undertaken,[42] a prime desideratum for future research.[43] Other clues not previously noticed also seem to indicate that the Berlin plate is post-Sasanian, and even suggest that Stefan Weber's notion of a relationship to Jerusalem might be valid and quite interesting. A perplexing later medieval Iranian plate in the Hermitage often thought to illustrate the 'Fall of Jericho', and frequently compared to the Berlin plate, also has a column in the doorway, and in that case it is clearly presented as a column holding up the lintel of the doorway and a tympanum above it, serving as a trumeau,[44] but it is not at all clear that the column on the Berlin plate is to be understood in that way. The horizontal line above it is far above the capitals of the doorway.[45] The column on the Berlin plate looks more like an iconographic than an architectural motif, indeed it reminds me a bit of the column flanked by lions above the main entrance doorway to Mycenae, commonly termed the Lion Gate, although it might be equally or more proper to term it the Column Gate, since it is a non-functional column that is the central motif, a 'bearer of meaning' to borrow the title of John Onians' important books about the history of columns.[46] The Great Church in Constantinople, Hagia Sophia, offers an intriguing comparison for a central columnar motif that is non-structural but iconographic (Figure 8.7).

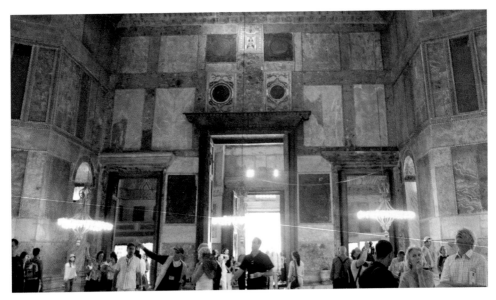

Figure 8.7 *Hagia Sophia nave looking west at central doorway.*
Photo: Robert G. Ousterhout.

In the nave looking west, towards the entrance, a rare view, since most published photos look toward the east and the apse, the sequence of domical segments rising above long rows of arches, with the door below, is very roughly comparable to what is shown on the Berlin plate, but I really have in mind a detail that is rarely noticed about Hagia Sophia. The enormous central doorway, the main imperial entrance to the church, has copper-alloy swinging doors, and is also framed in copper alloy, and upon close examination the lintel of the doorway has volutes at each end, so that the entire door is presented as a copper-alloy column.[47] In fact, the column as a metaphor of good government is an idea known from early medieval texts,[48] although not in early Islamic texts known to me. Stefan Weber's 2014 catalogue entry on the Berlin plate pointed out the occurrence of what looks like a column on a base on the earliest caliphal gold coin issued by 'Abd al-Malik around 692, contemporary with 'Abd al-Malik's building of the Dome of the Rock in Jerusalem.[49] This caliphal coinage, issued for only about two years, has often been seen as simply imitative of the Roman coins circulating in Syria and Palestine in the seventh century, and to some extent this is plausible. However, the common view that the moneyers copied the Roman reverse type of a cross on steps, simply removing the crossbar to de-Christianise it, is not very satisfactory. The cross seems not to have been altogether unacceptable to the Muslim rulers at this time, for 'Abd al-Malik's Dome of the Rock was built with several spoliated capitals on the inner arcade, the most sacred area, which had the motif of a cross in a wreath, and there is good reason to think

that the cross was removed only much later.[50] The column or pole may have its own distinct meaning. Nadia Jamil called attention to the presence in early Arabic poetry of a 'celestial *qutb*', a pole around which the heavens revolve, and found strong connection of the pole motif with the caliph as imam, religious leader of the community after the death of the Prophet, and indeed with Jerusalem as the *omphalos* even in earliest Islamic tradition.[51] Neither she nor Weber mentioned the importance of a great column in Jerusalem, which stood just inside the northern gate of the city, now known as the Damascus Gate. It is clearly visible on the famous map from the church at Madaba, showing the city as conceived in the sixth century, the main north–south axis of the Roman city marked by a great columned street, the *cardo*, ending with a triumphal victory column standing axially in front of the northern gate, the main entrance to the city.[52] Such columns featured not only in Rome and Constantinople but in other cities in the late antique Roman world. For example, the mosaic decoration of the early eighth-century church at Umm al-Rasas/Kastron Mefaa, Jordan, shows that city's triumphal column standing alone on a stepped base in a plaza before that city's main gate,[53] and the same team of workmen who laid the mosaics here probably also worked for the caliph in his villa/palace complex at Khirbat al-Mafjar a short distance away.[54]

The theme of the column as a decorative motif that likely also carried implications of rulership occurs in several grand early Qur'an manuscripts, datable according to the most recent scholarship of François Déroche to the beginning of the eighth century, and likely if not yet demonstrably produced in proximity to, if not necessarily by the command of, the Umayyad caliphs.[55] For example, a well-known grand Qur'an now in St Petersburg, MS Marcel 13, in several places used columns laid on their sides to mark the end of one sura and the beginning of another.[56] These columns and their use in a sacred context have been compared by Déroche and others to the Dome of the Rock, and were perhaps produced at the time when its builder's son, Caliph al-Walid, was constructing a magnificent new mosque building in Jerusalem between 705 and 715. Another Qur'an from the same group and time, also on a huge scale, has a long arcade along the top of one of its sura dividers.[57] Architectural decoration occurs in many other early Qur'an manuscripts, one of the most intriguing being an example of a decorative page consisting of four long arcades, all with horseshoe arches, suggesting a courtyard in a great building like a mosque.[58] However, there is little room for doubt that some kind of reference is made to architecture in a great Qur'an discovered in 1975 in the central mosque of San'a', containing two frontispiece pages with really elaborate images that seem to depict buildings (Figure 8.8).[59]

The two pages seem to depict mosques in some way, but whether it is two different mosques or a single building shown in two different

Figure 8.8 *San'a' 20–33.1 Qur'an architectural pages photograph* or *drawing (after Oleg Grabar,* The Mediation of Ornament *(Princeton, 1992), fig. 127).*

ways, and which if any specific building either or both are meant to represent (Damascus? Medina? Jerusalem?) remains an open question. One of the pages depicts three prominent doors reached by steps, one of which is central, and four superimposed arcades, culminating at the top in a protruding arch. Is this the façade of a building? Probably not, for beneath that protruding central arch at the top is a stairway at an angle, which looks remarkably like the *minbar*, which would make this an interior view. The second image from the San'a' Qur'an seems to show a mosque-like structure in plan, with a central courtyard surrounded by arcades, but the arcades are shown as if in a different view, as if seen at eye level. The Sana'a drawings singly and together show us the difficulty of 'reading' an early medieval image of a building. These images try to show characteristic features at the same time, and we simply do not know how to reconstruct the building, or buildings, that they seem to represent. This brings us back to the Berlin plate (Figures 8.1 and 8.3).

It seems to me that the San'a' Qur'an images provide the closest parallel for the represented building at the centre of the Berlin plate, combining doorways, domes, arches and plant decoration in a manner that we cannot simply read as any single 'view'. The Sana'a Qur'an is not at all an isolated phenomenon, or an exclusively Islamic one, for making an architectural representation the largest element of decoration in a manuscript occurs in a significant number of other examples from roughly this period, seventh–ninth centuries.[60] Both a remarkable Gospels in Arabic dated to the year 857 recently discovered at Mount Sinai,[61] and an Ethiopian Gospels manuscript probably from roughly the seventh century or possibly earlier,[62] include images representing complex buildings with peaked roofs, several storeys, superimposed tiers of columns and angled staircases. The Sinai Arabic Gospels is probably trying to show a single building complex in two views on the two pages, the basilica and rotunda at the Holy Sepulchre in Jerusalem, the basilica shown at the right in an exterior view, and probably the rotunda at the left with the ciborium over the venerated tomb of Christ. The reference in this and most likely in the other Christian books is probably to Jerusalem, and perhaps this is also the case in the Berlin plate, as Weber suggested. There are many representations of buildings analogous to these images in surviving Palestinian mosaics where the reference to Jerusalem and its Temple is unambiguous because of the inclusion also of Temple ritual implements.[63] How exactly we can read the represented architecture and seek to reconstruct a building is another issue, however, and I would argue that one simply cannot reconstruct a lost or unknown building on the basis of a representation.

The many cityscapes of the eighth-century mosaics at Umm al-Rasas provide a large sample of architectural vignettes analogous to the Berlin plate, and they are really a jumble.[64] They have no coherent point of view, but rather comprise assemblages of motifs, colonnades, arcades, gates, basilicas, which may or may not reflect the city 'portrayed' and necessarily identified by inscription. Without the inscription, none could be reliably linked to a particular city, not even Jerusalem. The representation of the Holy City (as it is named) bears scant resemblance to the Madaba mosaic view of the city beyond suggesting that Jerusalem had significant walls and at least one important gate. The Umm al-Rasas mosaic does not even clearly show the chief feature of the city at that time, certainly for a Christian audience in a church, namely the dome of the Holy Sepulchre. So we must interpret individual features with care, and I say this before suggesting a possible specific interpretation of one feature of the Berlin plate.

Most of the scholarship devoted to the Berlin plate has focused on the central medallion and tried to read it as a building, which is difficult to do, but little has been made of the fact that that medallion is

surrounded by an arcade of twenty-two columns, except for Ringbom's proposed connection with the Grail Temple. Nor has anyone noticed that the blind arcade across the top of the structure in the central medallion has eleven columns. These are strange numbers but do occur in built architecture of the late antique period. Old St Peter's in Rome was built in the fourth century by Emperor Constantine and/or his son Constantius with twenty-two columns on each side of the nave.[65] One could of course say that that was just the number needed to make the basilican nave the length desired, or reflected the number of column shafts readily at hand. One could also say that the fourth-century church of Santa Maria in Trastevere having eleven columns in each nave colonnade is also just a coincidence, but there are other Roman churches with the same number, as noted recently by Maria Fabricius Hansen.[66] Even were one to dismiss these strange numbers as coincidences, there is another Roman church where the odd number of columns, in this case twenty-two, is very awkward, because there are twenty-two columns arranged in a circle around the central space, so that there are also twenty-two arches, and also twenty-two windows above, in the clerestory. The building is the huge round church of Santo Stefano Rotondo, datable to the later fifth century (Figure 8.9). The problem is that one cannot construct a regular twenty-two-sided figure using ancient geometry, because it

Figure 8.9 *Rome, Santo Stefano Rotondo, interior. Photo: Lawrence Nees.*

is really just doubling an eleven-sided hendecagon, which can only be approximated, not drawn out exactly. Making an eleven-sided or twenty-two-sided figure is perverse, and very rare, as is the forty-four-sided figure underlying the placement of the columns in the outer arcade. No good parallel for this feature of the Santo Stefano plan has ever been proposed, and the issue has mostly been ignored.[67] In an early work Richard Krautheimer suggested a possible connection of the plan, although not the anomalous number of columns, with the Anastasis Rotunda in Jerusalem, but in a later work he thought Santo Stefano Rotondo so weird and unsuitable for Christian cult that he conjectured its original purpose was to serve a secular, imperial purpose.[68] The dedication to St Stephen, the protomartyr, the first Christian killed for his faith, is a hint that there may be a Jerusalem reference albeit of a different kind, for the martyrdom was generally thought to have occurred at the gate leading into Jerusalem from the east, adjacent to the Temple precinct, then still standing. Hansen has suggested that the number twenty-two might be significant in referring to the Old Testament, and recurs in other Roman buildings, noting that such patristic period writers as Augustine and Jerome seem to have used the number twenty-two as a significant symbol of the Old Testament, prompted in part by the twenty-two letters in the Hebrew alphabet,[69] but she made no suggestion that the reference is to Jerusalem, although of course the links between the Old Testament and Jerusalem are so obvious as not to need explicit recognition.[70] Certainly whoever made the Berlin plate would not have been reading Augustine or Jerome, but might well have been aware of the tradition mentioned by Origen and other early Greek writers that the number had an important reference to the Hebrew tradition and the sacredness of Jerusalem,[71] and of course any Jewish source or interlocutor could testify to the sacred significance of the number.

As noted at the outset, Stefan Weber suggested a possible reference in the Berlin plate to the Dome of the Rock, but did not mention the small structure beside it known as the Dome of the Chain. Located at the centre of the Haram al-Sharif, it has always been thought that it was perhaps even older than the Dome of the Rock, which looms over it (Figure 8.10). Recently I discussed its strange plan, with an inner arcade of six columns, and an outer arcade of eleven.[72] I will not rehearse the arguments and evidence I presented in that other study, but rather to my surprise I found a series of sources, textual and material, Christian and Jewish, that included the feature of eleven somethings that were associated very much with Jerusalem, and in some cases with this spot in Jerusalem, the ancient Temple Mount.[73] Stefan Weber's suggestion that the puzzling plate in Berlin might have something to do with Jerusalem and the Haram al-Sharif remains an hypothesis, but it is a far stronger one than the untenable Sasanian fire temple idea, and deserves further exploration.[74] There is much more to be said about elevenses, I believe.

Figure 8.10 *Jerusalem, Dome of the Chain with the Dome of the Rock behind it.*
Photo: Lawrence Nees.

Finally, art history often starts with description, and describing is very difficult. We describe with our own eyes and not with what Michael Baxandall termed a 'period eye'. We tend to read in terms of familiar tropes. Art historians see architecture readily as abstracted plans and sections and elevations above all. The scholarship on the Berlin plate has wanted to see the outer arcade as in effect a plan, and the central medallion as an elevation or section. These sorts of views were not, however, familiar in the ancient or early medieval world.[75] The mosaic map of Jerusalem and the drawing in the San'a' Qur'an share with the famous image of the Tabernacle from the great Bible known as the Codex Amiatinus produced in a monastery in northern England c. 716,[76] and for that matter with the famous Plan of St Gall from the 820s, produced in that Frankish monastery,[77] a mode of rendering architecture that seeks to convey important information by combining multiple views, elements of plan and elevation with decorative details. The problem is that we cannot confidently work out the relationships among the different representational modes in the absence of textual or other evidence. Among the many things that the Berlin plate teaches us is the virtue of humility and recognising the limits of our reconstructions of the past.

Notes

1. ISL-SMB Inv.-Nr. I, 5624. See Almut von Gladiss, *Glanz und Substanz. Metallarbeiten in der Sammlung des Museums für Islamische Kunst (8. bis 17. Jahrhundert)* (Berlin, 2012), pp. 14–16 and fig. 2, and the important catalogue entry by Gisela Helmecke in Chris Dercon, Léon Krempel and Avinoam Shalem (eds), *The Future of Tradition – the Tradition of Future: 100 Years after the Exhibition 'Masterpieces of Muhammadan Art' in Munich* (Munich, London and New York, 2010), cat. no. 1, pp. 72–4, with earlier literature.

2. For example, Sheila Blair and Jonathan Bloom (eds), *God is Beautiful and Loves Beauty: The Object in Islamic Art and Culture* (New Haven and London, 2013).

3. I am grateful to Gisela Helmecke at the Museum für Islamische Kunst for sending photographs to me when I began studying the object.

4. Boris Marschak, *Silberschätze des Orients. Metallkunst des 3.-13. Jahrhundert und ihre Kontinuität* (Leipzig, 1986), fig. 200. One of the objects also went through the F. R. Martin collection to the Islamic Museum in Berlin.

5. Marschak, *Silberschätze des Orients*, pp. 294–6.

6. Marschak, *Silberschätze des Orients*, cat. no. 7. See G. F. Korsuchina, 'Novye nachodki skadinavskich westschei blis Toropza', *Skandinavskij sbornik* 8 (1964), pp. 306–8 and pl. 4. I am grateful to David Shearer for help with this article.

7. Stefan Weber, 'Salver with architectural décor', in *Early Capitals of Islamic Culture: The Artistic Legacy of Umayyad Damascus and Abbasid Baghdad (650–950)* (Munich, 2014), pp. 30–1.

8. Friedrich Sarre and Fredrik Robert Martin (eds), *Die Ausstellung von Meisterwerken Muhammedanischer Kunst in München 1910*, 3 vols (Munich, 1912–13; repr. London, 1985), cat. no. 2988, pl. 137 for the Berlin plate. The entries on the metal objects were all written by Ernst Kühnel.

9. Avinoam Shalem and Eva-Maria Troelenberg, 'Changing views: Die Ausstellung von 1910 als ikonische Wende', Dercon, Krempel and Shalem, *Future of Tradition*, pp. 12–16.

10. Arthur Upham Pope, 'A Sasanian garden palace', *Art Bulletin* 15 (1933), p. 10.

11. For a convenient quick overview see Roman Ghirshman, *Iran. Parthes et Sassanides* (Paris, 1962), figs 304–29.

12. See Abolala Soudavar, *The Aura of Kings: Legitimacy and Divine Sanction in Iranian Kingship* (Costa Mesa, CA, 2003), whose argument is that the royal *farr*, or glory, is represented in a number of ways, among which might be numbered the disembodied wings, which appear, for example, in a stucco pearled roundel from Ctesiphon (his fig. 20) with inscription that might be read as *afzun*, from *farreh-afzun*, increased glory, which was inscribed also on the coins of Khusraw II and on a seal (his fig. 22). In Soudavar's view the motif is closely associated with the notion of victory, and may also be seen in Mithraic imagery not specifically associated with the Sasanian ruler, citing Franz Grenet, 'Mithra et les planètes dans l'Hindukush central: essai d'interprétation de la peinture de Dokhtar-i Noshirvan', in Rika Gyselen (ed.), *Au carrefour des Religions: Mélanges offerts à Philippe Gignoux, Res Orientales* 7 (1995), p. 117.

13. See Saïd Nuseibeh and Oleg Grabar, *The Dome of the Rock* (New York, 1996), pls pp. 119–33.

14. Kaneo Matsumoto, *Jōdai-Gire. 7th and 8th Century Textiles in Japan from the Shōso-in and Hōryu-ji* (Kyoto, 1984), pp. 50 and 227, cat. no. 38.

15. Vanessa Rousseau and Peter Northover, 'Style and substance: a bust of a Sasanian royal woman as a symbol of Late Antique legitimacy', *Journal of Late Antiquity* 8 (2015), pp. 3–31, on an object from the Aghayan family collection. The authors note that the appearance of this just under life-size silver bust raises doubts concerning its authenticity, but metallurgical analysis is claimed to authenticate it. The authors think it to be very late Sasanian, or part of the 'fashion' for Sasaniana in succeeding centuries.

16. Gabriele Stock, 'Die Samaniden-Mausoleum in Bukhara II', *Archäologische Mitteillungen aus Iran* 23 (Berlin, 1990), pp. 240–2; Jean Sauvaget, 'Remarques sur les monuments omeyyades, II. Argenteries "Sassanides"', *Journal Asiatique* 232 (1940/41), p. 32 noted the resemblance, and this encouraged him to suggest a date in the tenth century or later.

17. Oscar Reuther, 'Sasanian architecture: a history', in Arthur U. Pope and Phyllis Ackerman (eds), *A Survey of Persian Art from Prehistoric Times to the Present* (London, 1938, also 1967 repr.), vol. 2, pp. 510, 522 and 554–6, figs 139, 144b, 160 and 161a and b, which gives a reconstruction of the plan and elevation of the building represented on the Berlin plate.

18. Strzygowski in an unpublished lecture to the Congress on Persian Art in London, 9 January 1931, suggested that the image on the Berlin plate should be understood as a Sasanian fire temple, according to Friedrich Sarre, 'Einige Metallarbeiten parthisch-sasanidischen Stiles in der islamischen Kunstabteilung', *Berliner Museen. Amtliche Berichte aus den Preussischen Kunstsammlungen* 52 (1931), p. 98 and n. 3, figs 4 and 5, for whom the object seemed very antique and likely originated in eastern Persia or Turkestan, stemming from the Hellenistic tradition in Bactria, and dated to the fourth or fifth century. Sauvaget 'Remarques', p. 20, n. 2 also refers to Strzygowski's lecture and his fire-temple theory.

19. Lars-Ivar Ringbom, *Graltempel und Paradies. Beziehungen zwischen Iran und Europa im Mittelalter* (Stockholm, 1951), pp. 51–5 and 78–86, figs 15, 16, 18 and 23–5.

20. See Sheila Blair and Jonathan M. Bloom, *The Art and Architecture of Islam 1250–1800*, Pelican History of Art (New Haven and London, 1994), pp. 5–6 and fig. 1, on the Ilkhanid building begun by Abaqa c. 1275 and continued by Arghun, on the site known then and earlier as Šiz, and a stucco plaque with incised drawing of the dome, one of the earliest building plans in the Islamic world, studied by Jonathan M. Bloom, 'On the transmission of designs in early Islamic architecture', *Muqarnas* 10 (1993), pp. 21–8. For a lustre-painted tile probably from Takht-i Sulayman and now at the Met, see Blair and Bloom, *Art and Architecture of Islam*, fig. 2.

21. Ringbom, *Graltempel und Paradies*, pp. 78–117.

22. Ernst Herzfeld, 'Der Thron des Khosrô: quellenkritische und ikonographische Studien über Grenzgebiete der Kunstgeschichte des Morgen- und Abendlandes', *Jahrbuch der Königlichen Preuszischen Kunstsammlungen* 41 (1920), pp. 1–24 and 103–47.

23. Von Gladiss, *Glanz und Substanz*, p. 25 noted that the number was odd and could not be constructed with regular geometry but proposed no explanation.

24. Ringbom, *Graltempel und Paradies*, pp. 54–6.

25. On the Grail legend and its widespread currency in the period before Ringbom, see Reinhold Baumstark and Michael Koch (eds), *Der Gral. Artusromantik in der Kunst des 19. Jahrhunderts* (Munich, 1995), especially cat. no. 30 on the extraordinary Grail table centrepiece made in Munich in 1900, which features a building with on each side a large jewelled arch flanked by colonnades and blind arcades on the upper story.

26. For example, Kurt Erdmann, 'Bemerkungen zur Bronzeschüssel mit dem Feuerheiligtum in Berlin', *Bonner Jahrbücher des Rheinischen Landesmuseums in Bonn (im Landschaftsverband Rheinland) und des Vereins von Altertumsfreunden in Rheinland* 158 (1959), pp. 81–8, fig. 2 republished one of Ringbom's reconstructions, and linked the Berlin plate with a fire temple in his general book revised and published in 1969; see also Kurt Erdmann, *Die Kunst Irans zur Zeit der Sasaniden* (Leipzig 1943; rev. ed. Mainz, 1969), p. 111, fig. 85.

27. See Allegra Iafrate, *The Wandering Throne of Solomon: Objects and Tales of Kingship in the Medieval Mediterranean*, Mediterranean Art Histories 2 (Leiden, 2016), especially pp. 184–200 on Takht-i Sulayman and pp. 277–8 on Ringbom's notion that the ruins at Takht-i Sulayman might be somehow connected to the medieval Grail legend, mentioning in passing the 'bronze Sasanian vessel'.

28. Rudolf Naumann, *Die Ruinen von Tacht-e Suleiman und Zendan-e Suleiman und Umgebung* (Berlin, 1977), figs 29 and 30. Naumann illustrated the Berlin plate (his fig. 21) with an odd discussion (pp. 42–3) that suggests that although there is no evidence for it, an arcade surrounding the lake might have existed.

29. Barbara Kaim, 'Ancient fire temples in the light of the discovery at Mele Hairam', *Iranica Antiqua* 39 (2004), pp. 323–32 discussed the fire temple excavated at Mele Hairam in southern Turkmenistan, which does seem likely to have had a fire altar with a squat column at the centre of a square room, set in a basin filled with ash, and on axis with an *iwan*-like space, corresponding roughly with the scheme envisaged by Strzygowski, Ringbom and Erdmann for the Berlin plate. However, this site is of Parthian, not Sasanian date, and is by no means a grand royal structure with numerous columns.

30. Sauvaget, 'Remarques', p. 19 and figs 1 and 2 (drawings after Pope).

31. For drawings see Pope and Ackerman, 'A survey of Persian ornament', in *A Survey of Persian Art*, VIB, pp. 2700-27-2 and fig. 909, which shows drawings of six of the panels on the Berlin plate, in the context of 'fantastic trees' in Sasanian art.

32. Henri Stern, 'Les representations des conciles dans l'église de la Nativité à Bethléem', *Byzantion* 11 (1936), pp. 12 and 134, fig. 24 and figs 33–4. Stern noted the presence of disembodied wings on his fig. 17, which he identified as a Sasanian motif, although it was clearly contained in a monument not Sasanian.

33. London, BL Add. 14429, Stern, 'Représentations', p. 136 and fig. 36. Stern refers not to the original manuscript but to a watercolour in Wladimir Stassoff, *L'ornement slave et oriental* (St Petersburg, 1887), pl. CXXVII, figs 1–6 and text p. 57.

34. London, BL Add. 5111, for which see Michelle P. Brown (ed), *In the Beginning: Bibles before the Year 1000* (Washington, DC, 2006), cat. no. 68, pp. 304–5.

35. Claus-Peter Haase, 'Qasr al-Mshatta and the structure of late Roman and early Islamic façades', in Helen C. Evans (ed), *Age of Transition: Byzantine Culture in the Islamic World* (New York, 2015), p. 125 and fig. 14 reproduces the Berlin plate, which it terms a 'post-Sasanian bronze tray' and attributes to Iran, sixth–seventh century.

36. Haase, 'Qasr al-Mshatta', fig. 5; on this, see Alastair Northedge, *Studies on Roman and Islamic Amman: The Excavations of Mrs. C.-M. Bennett and Other Investigations, Vol. 1: History, Site and Architecture*, British Academy Monographs in Archaeology 3 (Oxford, 1992), pl. 23, A. 40.

37. Josef Strzygowski, *Altai-Iran und Völkerwanderung: ziergeschichtliche Untersuchungen über den Eintritt der Wander- und Nordvölker in die Treibhäuser geistigen Lebens, anknüpfend an einen Schatzfund in Albanien*, Arbeiten des Kunsthistorische Instituts der k. k. Universität Wien (Lehrkanzel Strzygowski) 5 (Leipzig, 1917), pp. 101–8, figs 95–8 for the Hungarian comparanda. Maurice S. Dimand, 'A review of Sasanian and Islamic metalwork in "A Survey of Persian Art"', *Ars Islamica* 8 (1941), pp. 192–214, compared the Berlin plate to Amman and Kairouan, thinking it is post-Sasanian, but then in spite of all his comparisons being from Syria or Iraq or Ifriqiya he suggested an origin of the Berlin plate in eastern Iran.

38. Mariam Rosser-Owen, *Islamic Arts from Spain* (London, 2010), fig. 1, kindly suggested by Robert Hillenbrand.

39. ISL-SMB, Inv.-Nr. I. 5623. See most recently *Early Capitals of Islamic Culture*, pp. 50–1. It was acquired by Friedrich Sarre, one of the co-organisers of the 1910 Munich exhibition with Fredrik Martin, who then owned the plate now in Berlin. Sarre published the ewer as a censer, and as late Sasanian, but for a later date in the early Islamic period, probably eighth century; see Anna Ballian in Alexandra Bonfante-Warren, Cynthia Clark, Brandie Ratcliff and Helen C. Evans (eds), *Byzantium and Islam: Age of Transition, 7th–9th century* (New York, 2012), pp. 64–6, cat. no. 38 and von Gladiss, *Glanz und Substanz*, pp. 22–3 and fig. 10.

40. Jonathan Bloom and Sheila Blair, *Islamic Arts* (London, 1997), p. 123 and fig. 67

41. The only Sasanian period copper-alloy object in the collection at the Freer, a collection that has received detailed technical study, avoids using chasing or punching, instead engraving even small details, in Paul Jett's view because the artist was aware of the brittleness of the material, an alloy high in tin and virtually without lead. See Ann C. Gunter and Paul Jett, *Ancient Iranian Metalwork in the Arthur M. Sackler Gallery and the Freer Gallery of Art* (Washington, DC, 1992), cat. no. 22, p. 146; the plate, measuring only 260 mm, in diameter is dated 'seventh century'. A copper-alloy support for a seat or throne, 'allegedly from western Iran' is generally thought to be an example of early Islamic Sasanianism, the post-Sasanian date suggested in part because of the vegetal decoration applied to the body of the beast, and although described by Prudence Harper as chased, it certainly appears to be engraved in smooth lines, rather than punched like the Berlin plate; see Prudence O. Harper, *The Royal Hunter: Art of the Sasanian Empire* (New York, 1978), cat. no. 53 and <https://www.metmuseum.org/art/collection/search/452270> (last accessed 25 September 2020).

42. I am grateful to Gisela Helmecke at the Islamic Museum in Berlin for this information.

43. Its golden hue seems to separate the Berlin plate from bowls and ewers whose very high tin content has led them to be termed 'white bronzes'. See Assadullah Souren Melikian-Chirvani, 'The white bronzes of early Islamic Iran', *Metropolitan Museum Journal* 9 (1974), pp. 123–51.

44. Marschak, *Silberschätze des Orients*, p. 322, figs 209–11. Many scholars had seen it as Sasanian, or very early Islamic, and linked the iconography with the biblical Fall of Jericho. Other than having a large central architectural motif, the comparison of the two objects is far from compelling. The Hermitage plate is silver with gilding, not copper alloy, is in fairly high relief, is full of figures, lacks anything like the arcades that dominate the Berlin plate, or their ornament. Indeed, Sauvaget suggested that the Hermitage plate should be dated to the Seljuq period, not before the eleventh century. Sauvaget thought that the key to dating the work is the architecture, which in some respects seems to him a 'réplique exacte' of the fortress-like caravanserai of Ribat-i Malik in Turkestan, constructed in 1078–9, and therefore the plate should be dated to the Seljuq period, not before the eleventh century.

45. Pope, 'Sasanian garden palace', p. 82 described the column in the central door as a column with 'wide cap [not "capital"] and wide base, so much like the columnar altar on innumerable Sasanian coins from Ardashir to Khosro that it is certain that an altar was meant'.

46. John Onians, *Bearers of Meaning: The Classical Orders in Antiquity, the Middle Ages, and the Renaissance* (Princeton, 1988).

47. Ilhan Akşit, *The History and Architecture of the Hagia Sophia* (Istanbul, 2012), p. 124 (partial view).

48. See Lawrence Nees, 'Godescalc's career and the problems of "influence"', in Alixe Bovey and John Lowden (eds), *Under the Influence: The Concept of Influence and the Study of Illuminated Manuscripts* (London and Turnhout, 2007), p. 27.

49. *Early Capitals of Islamic Culture*, pp. 30–1. On this famous coin, see Bloom and Blair, *Islamic Arts*, fig. 32 and Evans *et al.*, *Byzantium and Islam*, cat. nos 86–9.

50. Lawrence Nees, *Perspectives on Early Islamic Art in Jerusalem*, Arts and Archaeology of the Islamic World 5 (Leiden, 2016), p. 123 and figs 5.21 and 5.22, with earlier literature.

51. Nadia Jamil, 'Caliph and Qutb: poetry as a source for interpreting the transformation of the Byzantine cross on steps on Umayyad coinage', in J. Johns (ed.), *Bayt al-Maqdis: Jerusalem and Early Islam*, Oxford Studies in Islamic Art IX, Part Two (Oxford, 1999), pp. 11–57. On Jerusalem as the *omphalos* see Lawrence Nees, 'Blue behind gold: the inscription of the Dome of the Rock and its relatives', in J. Bloom and S. Blair (eds), *'And Diverse Are Their Hues': Color in Islamic Art and Culture* (New Haven and London, 2011), pp. 152–73.

52. Michele Piccirillo, *L'Arabia Cristiana. Dalla Provincia Imperiale al primo periodo Islamico* (Milan, 2002), figs pp. 168–70.

53. Michele Piccirillo, *Madaba. Le chiese e i mosaici* (Milan, 1989), p. 296 centre.

54. Piccirillo, *L'Arabia Cristiana*, p. 235.

55. St Petersburg, Marcel 13, fol. 1v; see François Déroche, *Qur'ans of the Umayyads: A First Overview*, Leiden Studies in Islam and Society (Leiden, 2014), pp. 76–94.

56. St Petersburg, Marcel 13, fol. 1v, see Déroche, *Qur'ans of the Umayyads*, fig. 25; fol. 33r, Alain George, *The Rise of Islamic Calligraphy* (London, Berkeley and Beirut, 2010), p. 148.

57. Paris BnF Arabe 324c, fol. 39r with arcade as sura divider; see George, *Rise of Islamic Calligraphy*, fig. 57.

58. George, *Rise of Islamic Calligraphy*, pp. 87–9 and fig. 58. It has been published only as a drawing and its location remains unspecified.

59. See Hans-Caspar Graf von Bothmer, 'Architekturbilder im Koran. Eine Prachthandschrift der Umayyadenzeit aus dem Yemen', *Pantheon* 45 (1987), pp. 4–20, pls I–II and figs 1, 2, 5 and 7; George, *Rise of Islamic Calligraphy*, pp. 79–86 and figs 52–5, and Déroche, *Qur'ans of the Umayyads*, pp. 111–21, both with earlier literature. For reconstruction drawings of both pages see Oleg Grabar, *The Mediation of Ornament* (Princeton, 1992), figs 127 and 128.

60. For the best synthetic study see Beatrice Leal, *Representations of Architecture in Late Antiquity* (PhD thesis, University of East Anglia, 2016).

61. Brown, *In the Beginning*, cat. no. 35, pp. 274–5, and Robert S. Nelson and Kristen M. Collins (eds), *Holy Image, Hallowed Ground: Icons from Sinai* (Los Angeles, 2006), cat. no. 32.

62. Gospels from Abba Garima III, now confusingly bound with Abba Garima II as fol. 260r; see Evans, *Byzantium and Islam*, fig. 113, and Judith McKenzie, Francis Watson, Michael Gervers, Matthew R. Crawford and Linda R. Macaulay, *The Garima Gospels: Early Illuminated Gospel Books from Ethiopia* (Oxford, 2016), pp. 121–44, fig. 169 and pl. 14; the authors here argue for a much earlier date for the manuscript.

63. Rina Talgam, *Mosaics of Faith: Floors of Pagans, Jews, Samaritans, Christians, and Muslims in the Holy Land* (Jerusalem and University Park, PA, 2014), figs 339, 358, 383,416, 418, 420.

64. Piccirillo, *L'Arabia Cristiana*, figs pp. 233, 234 and 236.

65. Dale Kinney, 'Spolia', in William Tronzo (ed.), *St. Peter's in the Vatican* (Cambridge, 2005), pp. 16–47, plan fig. 11.

66. Maria Fabricius Hansen, *The Eloquence of Appropriation: Prolegomena to an Understanding of Spolia in Early Christian Rome*, Analecta Romana Instituti Danici. Suppl. 33 (Rome, 2003), p. 205. The plan published by Richard Krautheimer, *Early Christian and Byzantine Architecture* (Baltimore, 1965), fig. 16 for the basilica at Golgotha built by Constantine has ten full columns in each nave colonnade, and a half-column engaged at each end of the series, eleven in total, although counted in a weird way. On Santa Maria in Trastevere and its spolia see the important recent article by Alison Locke Perchuk, 'Schismatic (re)visions: Sant-Elia near Nepi and Sta. Maria in Trastevere in Rome, 1120–1143', *Gesta* 55 (2016), pp. 179–212, especially 204–12 and fig. 6, which also publishes a plan of the church after Enrico Parlato and Serena Romano that has eleven columns only on the northern side.

67. For this remarkable building see Hugo Brandenburg and Jósef Pál (eds), *Santo Stefano Rotondo in Roma. Archeologia, storia dell'arte, restauro. Archäologie, Bauforschung, Geschichte. Atti del convegno internazionale Roma 10-13 ottobre 1996* (Wiesbaden, 2000), and most recently the well-illustrated guide Maria Fabricius Hansen, *The Spolia Churches of Rome: Recycling Antiquity in the Middle Ages*, trans. Barbara J. Haveland (Aarhus, 2015), pp. 206–17 and Hansen, *Eloquence of Appropriation*, pp. 71–8.

68. Richard Krautheimer, 'Santo Stefano Rotondo a Roma e la chiesa del Santo Sepolcro a Gerusalemme', *Rivista di archeologia cristiana* 12 (1935), pp. 51–102, and Richard Krautheimer, 'Santo Stefano Rotondo: conjectures', *Römisches Jahrbuch für Kunstgeschichte* 29 (1994), pp. 2–18.

69. See Ernst Robert Curtius, *Europäische Literatur und lateinisches Mittelalter* (Bern, 1948), p. 497, and Heinz Meyer and Rudolf Suntrup, *Lexikon der mittelalterlichen Zahlenbedeutungen* (Munich, 1987), cols 676–8.

70. Hansen, *Spolia Churches of Rome*, pp. 75–6 and 217, and Hansen, *Eloquence of Appropriation*, pp. 205 and 211 with references. Many thanks to the author for having brought this book to my attention.

71. For discussion of 'The sanctity of Jerusalem in Islam' see Emmanuel Sivan, *Interpretations of Islam: Past and Present* (Princeton, 1985), pp. 75–106, brought to my attention by Mehdi Mousavi.

72. Lawrence Nees, 'Muslim, Jewish and Christian traditions in the art of seventh-century Jerusalem', in Helen C. Evans (ed), *Age of Transition: Byzantine Culture in the Islamic World* (New York, 2015), pp. 94–111, and Nees, *Perspectives on Islamic Art*, pp. 72–85.

73. For the most recent discussion of the Dome of the Rock and the interrelations of Muslim, Christian and Jewish ideas about the sacrality of Jerusalem, see Vered Shalev-Hurvitz, *Holy Sites Encircled: The Early Byzantine Concentric Churches of Jerusalem* (Oxford, 2015), pp. 297–329, which also includes a (very different) presentation of special numbers related to buildings in and around the city, and elsewhere.

74. Weber, 'Salver', pp. 30–1.

75. The images discussed here, whether in metal, in manuscripts or in mosaics lack human figures, but other images from this period with figures are similarly un-reconstructible as buildings from the images. For a notable example see the story of Joseph and Potiphar's wife in the probably sixth- or seventh-century Latin manuscript known as the Ashburnham Pentateuch or *Pentateuque de Tours*, Paris, BnF n. a. lat.2334, fol. 22v; available at: <https://gallica.bnf.fr/ark:/12148/btv1b5 3019392c/f54.image.r=Pentateuque%20de%20Tours.> (last accessed 25 September 2020).

76. For the Codex Amiatinus see Celia Chazelle, 'Painting the voice of God: Wearmouth-Jarrow, Rome, and the Tabernacle miniature in the Codex Amiatinus', *Quintana* 8 (2009), pp. 13–57, with earlier literature.

77. Werner Jacobsen, *Der Klosterplan von St. Gallen und die karolingische Architektur: Entwicklung und Wandel von Form und Bedeutung im frankischen Kirchenbau zwischen 751 und 840* (Berlin, 1992).

Bibliography

Akşit, Ilhan, *The History and Architecture of the Hagia Sophia* (Istanbul, 2012).

Ballian, Anna, catalogue entry in Alexandra Bonfante-Warren, Cynthia Clark, Brandie Ratliff and Helen C. Evans (eds), *Byzantium and Islam: Age of Transition, 7th–9th century* (New York, 2012), pp. 64–6, no. 38.

Baumstark, Reinhold and Michael Koch (eds), *Der Gral. Artusromantik in der Kunst des 19. Jahrhunderts* (Munich, 1995).

Blair, Sheila S. and Jonathan M. Bloom, *The Art and Architecture of Islam 1250–1800*, Pelican History of Art (New Haven and London, 1994).

Blair, Sheila and Jonathan Bloom (eds), *God is Beautiful and Loves Beauty: The Object in Islamic Art and Culture* (New Haven and London, 2013).

Bloom, Jonathan M., 'On the transmission of designs in early Islamic architecture', *Muqarnas* 10 (1993), pp. 21–8.

Bloom, Jonathan and Sheila Blair (eds), *'And Diverse Are Their Hues': Color in Islamic Art and Culture* (New Haven and London, 2011).

Bloom, Jonathan and Sheila Blair, *Islamic Arts* (London, 1997).

Bonfante-Warren, Alexandra, Cynthia Clark, Brandie Ratliff and Helen C. Evans (eds), *Byzantium and Islam: Age of Transition, 7th–9th century* (New York, 2012).

von Bothmer, Hans-Caspar Graf, 'Architekturbilder im Koran. Eine Prachthandschrift der Umayyadenzeit aus dem Yemen', *Pantheon* 45 (1987), pp. 4–20.

Brandenburg, Hugo and Jósef Pál (eds), *Santo Stefano Rotondo in Roma. Archeologia, storia dell'arte, restauro. Archäologie, Bauforschung, Geschichte. Atti del convegno internazionale Roma 10–13 ottobre 1996* (Wiesbaden, 2000).

Brown, Michelle P. (ed.), *In the Beginning: Bibles before the Year 1000* (Washington, DC, 2006).

Chazelle, Celia, 'Painting the voice of God: Wearmouth-Jarrow, Rome, and the Tabernacle miniature in the Codex Amiatinus', *Quintana* 8 (2009), pp. 13–57.

Curtius, Ernst Robert, *Europäische Literatur und lateinisches Mittelalter* (Bern, 1948).

Dercon, Chris, Léon Krempel and Avinoam Shalem (eds), *The Future of Tradition – the Tradition of Future: 100 Years after the Exhibition 'Masterpieces of Muhammadan Art' in Munich* (Munich, London and New York, 2010).

Déroche, François, *Qur'ans of the Umayyads: A First Overview*, Leiden Studies in Islam and Society (Leiden, 2014).

Dimand, Maurice S., 'A review of Sasanian and Islamic metalwork in "A Survey of Persian Art"', *Ars Islamica* 8 (1941), pp. 192–214.

Early Capitals of Islamic Culture: The Artistic Legacy of Umayyad Damascus and Abbasid Baghdad (650–950) (Munich, 2014).

Erdmann, Kurt, 'Bemerkungen zur Bronzeschüssel mit dem Feuerheiligtum in Berlin," *Bonner Jahrbücher des Rheinischen Landesmuseums in Bonn (im Landschaftsverband Rheinland) und des Vereins von Altertumsfreunden in Rheinland* 158 (1959), pp. 81–8.

Erdmann, Kurt, *Die Kunst Irans zur Zeit der Sasaniden* (Leipzig, 1943; rev. ed. Mainz, 1969).

Evans, Helen C. (ed), *Age of Transition: Byzantine Culture in the Islamic World* (New York, 2015).

George, Alain, *The Rise of Islamic Calligraphy* (London, Berkeley and Beirut, 2010).

Ghirshman, Roman, *Iran. Parthes et Sassanides* (Paris, 1962).

von Gladiss, Almut, *Glanz und Substanz. Metallarbeiten in der Sammlung des Museums für Islamische Kunst (8. bis 17. Jahrhundert)* (Berlin, 2012).

Grabar, Oleg, *The Mediation of Ornament* (Princeton, 1992).

Grenet, Franz, 'Mithra et les planètes dans l'Hindukush central: essai

d'interprétation de la peinture de Dokhtar-i Noshirvan', in Rika Gyselen (ed.), *Au carrefour des Religions: Mélanges offerts à Philippe Gignoux* (*Res Orientales* 7) (1995), pp. 105–19.

Gunter, Ann C. and Paul Jett, *Ancient Iranian Metalwork in the Arthur M. Sackler Gallery and the Freer Gallery of Art* (Washington, DC, 1992).

Haase, Claus-Peter, 'Qasr al-Mshatta and the structure of late Roman and early Islamic Façades', in Helen C. Evans (ed), *Age of Transition: Byzantine Culture in the Islamic World* (New York, 2015), pp. 112–31.

Hansen, Maria Fabricius, *The Eloquence of Appropriation: Prolegomena to an Understanding of Spolia in Early Christian Rome*, Analecta Romana Instituti Danici. Suppl. 33 (Rome, 2003).

Hansen, Maria Fabricius, *The Spolia Churches of Rome: Recycling Antiquity in the Middle Ages*, trans. Barbara J. Haveland (Aarhus, 2015).

Harper, Prudence O., *The Royal Hunter: Art of the Sasanian Empire* (New York, 1978).

Helmecke, Gisela, catalogue entry in Chris Dercon, Léon Krempel and Avinoam Shalem (eds), *The Future of Tradition – the Tradition of Future: 100 Years after the Exhibition 'Masterpieces of Muhammadan Art' in Munich* (Munich, London and New York, 2010), no. 1, pp. 72–4.

Herzfeld, Ernst, 'Der Thron des Khosrô: quellenkritische und ikonographische Studien über Grenzgebiete der Kunstgeschichte des Morgen- und Abendlandes', *Jahrbuch der Königlichen Preuszischen Kunstsammlungen* 41 (1920), pp. 1–24.

Iafrate, Allegra, *The Wandering Throne of Solomon: Objects and Tales of Kingship in the Medieval Mediterranean*, Mediterranean Art Histories 2 (Leiden, 2016).

Jacobsen, Werner, *Der Klosterplan von St. Gallen und die karolingische Architektur: Entwicklung und Wandel von Form und Bedeutung in frankischen Kirchenbau zwischen 751 und 840* (Berlin, 1992).

Jamil, Nadia, 'Caliph and Qutb: poetry as a source for interpreting the transformation of the Byzantine cross on steps on Umayyad coinage', in J. Johns (ed.), *Bayt al-Maqdis: Jerusalem and Early Islam*, Oxford Studies in Islamic Art IX, Part Two (Oxford, 1999), pp. 11–57.

Johns, Jeremy (ed.), *Bayt al-Maqdis: Jerusalem and Early Islam*, Oxford Studies in Islamic Art IX, Part Two (Oxford, 1999).

Kaim, Barbara, 'Ancient fire temples in the light of the discovery at Mele Hairam', *Iranica Antiqua* 39 (2004), pp. 323–32.

Kinney, Dale, 'Spolia', in William Tronzo (ed.), *St. Peter's in the Vatican* (Cambridge, 2005), pp. 16–47.

Korsuchina, G. F., 'Novye nachodki skadinavskich westschei blis Toropza', *Skandinavskij sbornik* 8 (1964), pp. 306–8.

Krautheimer, Richard, 'Santo Stefano Rotondo a Roma e la chiesa del Santo Sepolcro a Gerusalemme', *Rivista di archeologia cristiana* 12 (1935), pp. 51–102.

Krautheimer, Richard, *Early Christian and Byzantine Architecture* (Baltimore, 1965).

Krautheimer, Richard, 'Santo Stefano Rotondo: conjectures', *Römisches Jahrbuch für Kunstgeschichte* 29 (1994), pp. 2–18.

Kühnel, Ernst, catalogue entry in Friedrich Sarre and Fredrik Martin (eds), *Die Ausstellung von Meisterwerken Muhammedanischer Kunst in München 1910*, 3 vols (Munich, 1912–13; repr. London, 1985), no. 2988, pl. 137.

Leal, Beatrice, *Representations of Architecture in Late Antiquity* (PhD thesis, University of East Anglia, 2016).

Marschak, Boris, *Silberschätze des Orients. Metallkunst des 3.-13. Jahrhundert und ihre Kontinuität* (Leipzig, 1986).

Matsumoto, Kaneo, *Jōdai-Gire. 7th and 8th Century Textiles in Japan from the Shōso-in and Hōryu-ji* (Kyoto, 1984).

McKenzie, Judith, Francis Watson, Michael Gervers, Matthew R. Crawford and Linda R. Macaulay, *The Garima Gospels: Early Illuminated Gospel Books from Ethiopia* (Oxford, 2016).

Melikian-Chirvani, Assadullah Souren, 'The white bronzes of early Islamic Iran', *Metropolitan Museum Journal* 9 (1974), pp. 123–51.

Meyer, Heinz and Rudolf Suntrup, *Lexikon der mittelalterlichen Zahlenbedeutungen* (Munich, 1987).

Naumann, Rudolf, *Die Ruinen von Tacht-e Suleiman und Zendan-e Suleiman und Umgebung* (Berlin, 1977).

Nees, Lawrence, 'Godescalc's career and the problems of "influence"', in Alixe Bovey and John Lowden (eds), *Under the Influence: The Concept of Influence and the Study of Illuminated Manuscripts* (London and Turnhout, 2007), pp. 21–43.

Nees, Lawrence, 'Blue behind gold: the inscription of the Dome of the Rock and its relatives', in Jonathan Bloom and Sheila Blair (eds), *'And Diverse Are Their Hues': Color in Islamic Art and Culture* (New Haven and London, 2011), pp. 152–73.

Nees, Lawrence, 'Muslim, Jewish and Christian traditions in the art of seventh-century Jerusalem', in Helen C. Evans (ed), *Age of Transition: Byzantine Culture in the Islamic World* (New York, 2015), pp. 94–111.

Nees, Lawrence, *Perspectives on Early Islamic Art in Jerusalem*, Arts and Archaeology of the Islamic World 5 (Leiden, 2016).

Nelson, Robert S. and Kristen M. Collins (eds), *Holy Image, Hallowed Ground: Icons from Sinai* (Los Angeles, 2006).

Northedge, Alastair, *Studies on Roman and Islamic Amman: The Excavations of Mrs. C.-M. Bennett and Other Investigations, Vol. 1: History, Site and Architecture*, British Academy Monographs in Archaeology 3 (Oxford, 1992).

Nuseibeh, Saïd and Oleg Grabar, *The Dome of the Rock* (New York, 1996).

Onians, John, *Bearers of Meaning: The Classical Orders in Antiquity, the Middle Ages, and the Renaissance* (Princeton, 1988).

Perchuk, Alison Locke, 'Schismatic (re)visions: Sant-Elia near Nepi and Sta. Maria in Trastevere in Rome, 1120–1143', *Gesta* 55 (2016), pp. 179–212.

Piccirillo, Michele, *Madaba. Le chiese e i mosaici* (Milan, 1989).

Piccirillo, Michele, *L'Arabia Cristiana. Dalla Provincia Imperiale al primo periodo Islamico* (Milan, 2002).

Pope, Arthur Upham, 'A Sasanian garden palace', *Art Bulletin* 15 (1933), pp. 75–85.

Pope, Arthur Upham and Phyllis Ackerman (eds), *A Survey of Persian Art from Prehistoric Times to the Present* (London, 1938; also 1967 repr.).

Reuther, Oscar, 'Sasanian architecture: a history', in A. U. Pope and P. Ackerman (eds), *A Survey of Persian Art from Prehistoric Times to the Present*, Vol. 2 (London, 1938; also 1967 repr.), pp. 493–578.

Ringbom, Lars-Ivar, *Graltempel und Paradies. Beziehungen zwischen Iran und Europa im Mittelalter* (Stockholm, 1951).

Rosser-Owen, Mariam, *Islamic Arts from Spain* (London, 2010).

Rousseau, Vanessa and Peter Northover, 'Style and substance: a bust of a Sasanian royal woman as a symbol of Late Antique legitimacy', *Journal of Late Antiquity* 8 (2015), pp. 3–31.

Sarre, Friedrich, 'Einige Metallarbeiten parthisch-sasanidischen Stiles in der islamischen Kunstabteilung', *Berliner Museen. Amtliche Berichte aus den Preussischen Kunstsammlungen* 52 (1931), pp. 95–101.

Sarre, Friedrich and Fredrik Robert Martin (eds), *Die Ausstellung von Meisterwerken Muhammedanischer Kunst in München 1910*, 3 vols (Munich, 1912–13, repr. London, 1985).

Sauvaget, Jean, 'Remarques sur les monuments omeyyades, II. Argenteries "Sassanides"', *Journal Asiatique* 232 (1940/41), pp. 19–57.

Shalem, Avinoam and Eva-Maria Troelenberg, 'Changing views: Die Ausstellung von 1910 als ikonische Wende', in Chris Dercon, Léon Krempel and Avinoam Shalem (eds), *The Future of Tradition – the Tradition of Future : 100 Years after the Exhibition 'Masterpieces of Muhammadan Art' in Munich* (Munich, London and New York, 2010), pp. 12–16.

Shalev-Hurvitz, Vered, *Holy Sites Encircled: The Early Byzantine Concentric Churches of Jerusalem* (Oxford, 2015).

Sivan, Emmanuel, *Interpretations of Islam: Past and Present* (Princeton, 1985).

Soudavar, Abolala, *The Aura of Kings: Legitimacy and Divine Sanction in Iranian Kingship* (Costa Mesa, CA, 2003).

Stassoff, Wladimir, *L'ornement slave et oriental* (St Petersburg, 1887).

Stern, Henri, 'Les representations des conciles dans l'église de la Nativité à Bethléem', *Byzantion* 11(1936), pp. 101–52.

Stock, Gabriele, 'Die Samaniden-Mausoleum in Bukhara II', *Archäologische Mitteilungen aus Iran* 23 (Berlin, 1990), pp. 231–60.

Strzygowski, Josef, *Altai-Iran und Völkerwanderung: ziergeschichtliche Untersuchungen über den Eintritt der Wander- und Nordvölker in die Treibhäuser geistigen Lebens, anknüpfend an einen Schatzfund in Albanien*, Arbeiten des Kunsthistorische Instituts der k. k. Universität Wien (Lehrkanzel Strzygowski) 5 (Leipzig, 1917).

Talgam, Rina, *Mosaics of Faith: Floors of Pagans, Jews, Samaritans, Christians, and Muslims in the Holy Land* (Jerusalem and University Park, PA, 2014).

Tronzo, William (ed), *St. Peter's in the Vatican* (Cambridge, 2005).

Weber, Stefan, 'Salver with architectural décor', in *Early Capitals of Islamic Culture: The Artistic Legacy of Umayyad Damascus and Abbasid Baghdad (650–950)* (Munich, 2014), pp. 30–1.

CHAPTER NINE

Looking Inside the Book: Doublures of the Mamluk Period

Alison Ohta

MUCH ATTENTION HAS been given to the structures of Islamic bindings and the ornament of the covers, but little has been paid to the decorative inner linings of the boards, namely the doublures, usually made of leather or silk.[1] The doublure was used in bindings in the Islamic and Eastern Christian world from the tenth century, long before it made its appearance in European bindings during the fifteenth century. Marçais and Poinssot recorded traces of pink and green silk on the inner covers of the bindings discovered in the Great Mosque of Qayrawan datable to the eleventh century,[2] and Grohmann described ornamental doublures of paper and vellum on Coptic bindings dated to the tenth and eleventh centuries.[3] In addition, two important treatises on bookbinding, one by Bakr al-Ishbili (d. 628/1231), a bookbinder at the Almohad court and the other by al-Malik al-Muzaffar Yusuf al-Ghassani (d. 694/1294), the Rasulid ruler of Yemen, specifically refer to its application in the bookbinding process.[4] This chapter examines the doublures found on Mamluk bindings (1250–1516), since these provide the earliest substantial corpus of extant material allowing for the tracing of the variety of techniques and materials that were used over a period of 250 years.

Doublures were decorated with block-pressed leather in various designs, plain and patterned silks and filigree, tooled or stamped leather. Block-pressed and tooled leather along with silk doublures are found on bindings from the beginning of the Mamluk period; however, filigree leather work on a pasteboard ground and stamped decoration only appear on doublures from the middle of the fifteenth century. These additions reflect developments in Persian binding and illumination of the late fourteenth and early fifteenth centuries which were later transferred into the Mamluk binders' repertoire.[5] These also included the introduction of lobed central medallions, quarter cloud-collar profiles for the corner pieces of the covers and the use of naturalistic floral ornament and arabesques.[6] As the orna-

ment of the doublures usually bears little or no relationship to that of the covers of the same binding, this chapter treats each doublure as an independent entity.

Block-pressed leather doublures

Block-pressed leather doublures of various patterns were widely used throughout the Islamic world in the fourteenth and fifteenth centuries (Figure 9.1).[7]

They are found on early Persian bindings, for example, the doublures of the *Manafi' al-Hayawan* copied in Maragha in 697–9/1297–1300,[8] the *ajza'* of a Qur'an produced for the Ilkhanid Sultan Uljaytu (r. 704–16/1304–16) in Baghdad between 706–8 /1306–8[9] along with those of the thirty-part Qur'an also copied for him in 713/1313 in Hamadan, which are decorated with swirling arabesques (Figure 9.2).[10] Aritan records their presence on Anatolian Seljuq bindings,[11] Jackson notes their existence on a Qaramanid Qur'an dated 714/1314[12] and thought to have been copied in Konya, and Tanındı's study of Ottoman bindings in Bursa datable to the 830–50s/1430s–1450s includes several examples.[13]

Bosch assumed that block-pressed leather doublures were only produced in Syria and Egypt.[14] However, Pinder-Wilson has shown that the technique was well developed in Khurasan by the end of the twelfth century.[15] He points out that many of the primary motifs found on silver inlaid brasses also occur on block-pressed leather. One of the stone-press moulds in the Khalili Collection bears a pattern of waqwaq scrolls which also appear on the doublures of two volumes of a Qur'an, also in the collection and datable to the period 648–751/1250–1350.[16]

Figure 9.1 *Qur'an juz', late fourteenth century, Cairo, containing a* waqf *inscription in the name of Sultan Barquq (784–801/1382–99), block-pressed doublures, 30 × 27 cm. Dar al-Kutub (DAK), Cairo, Rasid 120.*

Figure 9.2 *Qur'an, juz' 2, 713/1313, Hamadan, copied for Sultan Uljaytu (704–16/1304–16), block-pressed doublure, 56 × 41 cm. DAK Rasid 72.*

Bosch pointed to the similarity in technique between the printing of cotton and that of block-pressed leather.[17] This association was later dismissed by Raby and Tanındı in their seminal work on Turkish bindings of the fifteenth century, citing as a reason that the blocks for printing textiles were carved in relief while those for pressing the pattern into the leather were always carved in intaglio.[18] However, examination of the block-printed textiles produced in Egypt between the mid-thirteenth century and the end of the fourteenth century in the Arberry Collection, revealed two examples whose patterns can be directly compared to those found on block-pressed leather doublures of the Mamluk period, indicating that they were printed by blocks carved in relief and in intaglio.[19]

Parallels can also be drawn with stone carving for some of the patterns. For example, the doublures of a binding whose manuscript bears a dedication to the library of Sultan Qansuh al-Ghuri (r. 906–22/1501–16), has a pattern that includes heart-shaped knots which frequently occur in architectural decoration of the late Mamluk period (Figure 9.3). An almost identical design is found on the stone panels of the *minbar* in the complex of Sultan Farag ibn Barquq (r. 801–8/1399–1405) which was given as a gift by Sultan Qaitbay (r. 872–901/1468–96) in 888/1483 (Figure 9.4).

Figure 9.3 Qaṣida yaqul al-'abd, *early sixteenth century, Cairo, copied for Sultan Qansuh al-Ghuri (906–22/1501–16), block-pressed doublure, 26.5 × 17.5 cm. Topkapı Sarayi Müzesi Kütüphanesi (TSK) A.1767.*

Another example can be seen in the carving of the *wakala* (urban caravanserai, market and warehouse) of Qaitbay and on the dome of the mosque of Khayrbak (907–27/1502–21).[20] They are also used for the decoration of the walls of the *sabil-maktab* (a school for teaching children, especially orphans) of the mosque of Khayrbak, where they are outlined in black, forming cartouches running over fine arabesques, again recalling the method of decoration found in Veneto-Saracenic metalwork.[21]

This pattern was reproduced by Thompson to illustrate the revolution that occurred in carpet design with the use of complex overall repeat patterns with curvilinear forms and the relationship of such patterns with the 'arts of the book'.[22] The doublure he used relates to that of a binding whose manuscript is dated Dhu'l-Qa'da 873/June 1401, in the collection of the Victoria and Albert Museum.[23] The significant passage of time between the date of copying of the manuscript and the widespread appearance of this motif during the reign of Qaitbay deserves some explanation. Examination showed that the doublure was pasted over the turn-over of the leather cover which indicates that this must be a later repair. A similar example of this pattern has been published, dated to Muharram 593/November 1196 and attributed to Seljuq Anatolia, but again this too must be a later rebinding, an assumption supported by the decoration of the covers.[24]

Thus, these relationships between patterns for textiles, stonework and doublures suggest that designs were readily available for transfer

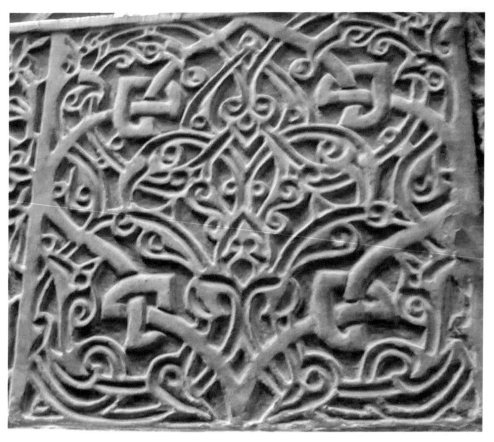

Figure 9.4 *Stone panel of minbar, late fifteenth century, Cairo, in the complex of Sultan Faraj ibn Barquq, Cairo (802–13/1399–1411) restored by Sultan Qaitbay (873–901/1468–96). Photo: Alison Ohta.*

between various media, most probably facilitated by the presence of paper pattern books.

In terms of method, the leather was probably dampened first and then the printing block was painted with a tanning stain to darken the leather. The doublures were fixed in two ways: on some the leather overlapped the gutter on the textblock occasionally with a zigzag pattern cut along the edge, while on others it was cut flush with the boards. Bosch suggested that the leather was block-pressed in sheets and then cut to size; however, close examination of several examples revealed that the leather doublures were stamped *in situ* with some made up of small pieces of leather which were glued to the boards before being stamped with a wooden block (Figure 9.5).

Many of the patterns are commonly composed of scrolling leaves, arabesques, lotuses and flowers, while others are based on trellises or geometrical interlace (Figure 9.6 and 9.7). Several examples have been found that include the name Mahmud and others have invocations

Figure 9.10 *Qur'an,* juz' *4, mid-fifteenth century, Cairo, with a* waqf *in the name of Sultan Khushqadam (865–72/1461–7), doublure, 27 × 18 cm. DAK 104.*

and 112 × 94 cm. Sadly, almost all these large volumes have been rebound and their doublures have been lost. However, a large single-volume Qur'an in the John Rylands Library (Figure 9.12)[34] retains its doublure and is datable to the second half of the fourteenth century, as the calligraphy and illumination can be compared to two other large volume Qur'ans in Cairo, namely Rasid 9 dated 770/1368 and Rasid 10 dated 778/1376.[35] The doublures of the Rylands volume are tooled with rosettes with pendants which was a common design for covers in this period while the cover is tooled with a repeat pattern of geometrical interlace based on twelve-pointed stars forming the basis of star polygons.[36]

The doublures of a loose binding of another large volume in the Dar al-Kutub in Cairo measuring 51 × 73 cm are datable to the end of the fifteenth century (Figure 9.13).[37] The doublures are stamped with large lobed profiles, filled with arabesque ornament with segmented borders made up of knotwork. The field of the central panel is covered with small tools, all gilded, creating a net-like effect. It is a good example of the

Figure 9.11 *Al-Jawhar al-naqi fi'l-radd 'ala Bayhaqi, 888/1483, doublure with all-over tooled decoration, 27.3 × 18 cm. Cairo, TSK.A.643.*

Figure 9.12 *Qur'an, mid-fourteenth century, Cairo, tooled doublure, 86 × 54 cm. John Rylands Library, Arabic manuscript no. 42.*

Figure 9.13 *Loose binding, late fifteenth century, tooled doublure, 73 × 51 cm. Cairo, DAK, no accession number.*

appropriation of ornament from the Persian binding tradition combined with decoration which is essentially Mamluk in style, with the field covered with the impressions of small tools.

By the end of the fifteenth century, large stamps were introduced which greatly facilitated the finishing process, as one large stamp replaced the need to build patterns from small tools. The doublures are often stamped with oval or circular stamps which allowed certain parts of the pattern to stand in relief. An example appears on the doublure of a binding with a manuscript dated 889/1484 copied for Sultan Qaitbay (Figure 9.14).[38] The border of the almond profile with blue and silver knotwork stands in relief.[39] The same treatment is noted on the doublure of an Islamic binding containing a Florentine manuscript of Petrarch's *Canzoniere e Trionfi* which must have been commissioned by an Italian traveller or merchant (Figure 9.15).[40] Hobson assumed that this was Ottoman, but it may be Mamluk as the cover can be closely compared to a binding which contains

Figure 9.14 Al-Durrat al-mudiyya wa'l-'arus al-mardiyya, *889/1484, pressure-moulded doublure, 32 × 21.5 cm. Cairo, TSK.A.2829.*

a manuscript copied for Sultan Qaitbay in two volumes dated 877/1473.[41] The medallion is painted in gold, silver and blue. This shows the dissemination of these techniques of ornament in both the Ottoman and Mamluk realms.

Filigree leather

The technique of filigree leather is well known and has long been used for bindings.[42] Cut filigree leather patterns on a textile background appear on Mamluk covers by the end of the fourteenth century, in spite of their susceptibility to damage.[43] However, filigree doublures on a pasteboard ground are first found on fine or 'extra' Mamluk bindings in the second half of the fifteenth century and on Ottoman bindings by the 1460s.[44] They closely follow the style and techniques used for filigree doublures on a pasteboard backing on bindings of manuscripts copied for Sultan Ahmad Jalayir, who ruled in Baghdad and Tabriz between 783/1382 and 812/1410, and from there was developed and refined in the Timurid and Turcoman court ateliers.[45]

The earliest example of filigree doublures on a pasteboard ground is found on a binding of a manuscript copied for Sultan Qaitbay in 877/1473 (Figure 9.16).[46] The doublures are decorated with a large lobed medallion with pendants of arabesque filigree work on a gold background.

Four filigree fleurs-de-lis are highlighted on a deep blue ground and the corner pieces are stamped in gold. The design can be compared to the tooled upper cover of a *Sahih* of al-Bukhari copied for Sultan Khushqadam in 867/1462 showing the availability of stencils for replicating certain designs.[47] The doublure of the flap is also in filigree with a blue cloud-collar cartouche at the centre reflecting the design of the doublure.[48]

The apogee of filigree work of Mamluk bindings is found on the doublure of a large volume Qu'ran (50.5 × 36.5 cm) produced most probably for Amir Qansuh Khamsmiyya min Tarabay who was appointed Amir Akhur Kabir (Grand Master of the Stables) in

Figure 9.15 *Petrarch,* Canzoniere e Trionfi, *1460–70, Florence, pressure-moulded doublure, 21.8 × 13.8 cm. Bodleian Library, Ms. Canon Ital.78.*

805/1481, holding this position until 901/1496 when he became commander of the army (Figure 9.17).[49] He later deposed Sultan Muhammad (r. 901–4/1496–8), the son of Qaitbay, but held power for only a few days before being killed. The doublure is remarkable for a gilded filigree cartouche dedicating the Qur'an to the Amir's library and his name and titles carry across to the back cover from the front with a small cartouche on the spine. The inscription reads: *bi rasm al-khizana al-muqarr al-ashraf al-karim al-ali'* (front doublure), *al-mawlawi al-sayyidi al-maliki al-makhdumi al-sayfi* (back doublure), *Qansuh Amir Akhur Kabir* (on the small cartouche on the spine of the flap) and *al-maliki al-ashrafi a'azza Allah ansarahu.* The lobed

Figure 9.16 Mashari' al-ashwaq ila al-'ushshaq
*of Dimyati, 877/1473, Cairo, copied for
Sultan Qaitbay, filigree doublure. TSK.A.649.*

central roundel lies on a golden pasteboard ground, with pendants outlined in blue, filled with overlapping burgundy leather filigree arabesques. The inscription in gilded filigree is on a blue background in a cartouche with smaller pendants on either side. The lobed corner pieces have filigree arabesques in red leather on a gold ground with arrangements of groups of three small punches in the pasteboard. Blue is used for the central cartouche with finials as a contrasting colour. The combination of red burgundy leather with golden yellow can be compared to the palette of the filigree binding prepared for Mehmed II dated 881/1476.[50]

By the 1490s, the innovations that had taken hold in Mamluk and Ottoman bookbinding began to appear in the Italian bookbinders' repertoire and develop into what Hobson termed the fully developed 'humanistic style'.[51] These bindings now used pasteboard for the covers, employed centre corner-piece compositions with cloud-collar and lobed profiles for decoration, and used the techniques of filigree leather and stamps for their creation. Previously, European bindings had been covered in plain leather or textiles over wooden boards with metal clasps. The covers were usually decorated with horizontal and vertical rows of repeated small tools in the blind and were not provided with doublures.[52]

The fifteenth century saw increased trade between the Levant and the Italian states of Venice, Florence, Genoa, Naples and Ancona, and by 1450 Venice had become the leading power in the eastern Mediterranean. With this development came greater opportunities for exposure to contemporary binding developments in the Mamluk realm. From the end of the fourteenth century, Venetian consuls (*baili*) were present in Alexandria, Cairo, Damascus and Beirut, and commercial treaties were agreed with the Mamluks. This period marks active interaction between Venice and the East, and the imitation and the adoption of techniques from the Islamic world by Venetian craftsmen is to be noted in the production of glassware, textiles and leather.[53] This interest extended to manuscripts, for as

Figure 9.17 *Qur'an, Cairo, late fifteenth century, copied for Qansuh Amir Akhur Kabir, filigree doublure. Museum of Turkish and Islamic Art, Istanbul (TIEM), 508.*

Figure 9.18 *Leonardo Bruni,* Commentarius rerum in Italia suo tempore, *1464–5, filigree doublure, 19.7 × 11.9 cm. Bologna, Bibl. Marciana, lat. X, 117 (=3844).*

Hobson notes, King René of Anjou (1409–80) owned Arabic and Turkish manuscripts for which he employed a translator, while the 1481 inventory of the Vatican lists twenty-two manuscripts in Arabic.[54]

The doublures of two bindings, *Commentarius rerum in Italia suo tempore* of Leonard Bruni in the Biblioteca Marciana and the *Codex Marcanova* in Modena are the earliest European bindings which incorporate filigree doublures.[55] They are attributed to Felice Feliciano (1433–79),[56] a poet and bookbinder, who copied the *Codex Marcanova* for Giovanni Marconova (1414–67), a renowned antiquarian, in Bologna to provide a record of the antiquities he had seen and the inscriptions he had copied. Both bindings have similar cloud-collar profiles with cut-away filigree work on a red, blue and green painted ground which is sprinkled with tiny resin like beads. The new Islamic styles of ornament were now used to decorate both the doublures and covers and from Italy these styles were developed, spreading through Europe to Fontainbleau and beyond, revolutionising the look of the book.[57]

The doublures of Mamluk bindings present a marvellous diversity in terms of the techniques, materials and range of decoration, providing an element of surprise and delight for the reader on lifting the cover. Block-pressed and tooled leather doublures were used to the end of the Mamluk period, showing the persistence of a tradition long after they had been abandoned by Persian and Ottoman binders. Why the use of block-pressed leather comes to an end in the Islamic world with the demise of the Mamluk sultanate in 1516 is a question that cannot be easily answered; it may be that they were just no longer fashionable. By the late fifteenth century, Mamluk binders had appropriated new styles of ornament and techniques from the Persian bookbinding tradition; however, the filigree and stamping techniques never reach the sophisticated heights of the fine bindings produced during the Timurid, Turcoman or Ottoman periods. Mamluk binders continued to retain the more traditional

approaches of using small tools to create overall patterns, as shown by the magnificent doublures of the loose binding in Cairo. Sheila Blair described the doublure as 'one of the prime decorative features of the Islamic book', and as such they deserve more attention in their own right. The examination of doublures of the Mamluk period provides a beginning for our understanding of the later textile, filigree, printed and marbled paper and lacquer doublures which were produced in the later Safavid, Ottoman and Qajar periods.[58]

Notes

1. The doublure as defined by Matt T. Roberts and Don Etherington, *Bookbinding and the Conservation of Books: A Dictionary of Descriptive Terminology*. Available at: <https://cool.culturalherit-age.org/don/dt//dt1308.html> (last accessed 28 December 2018). For structures see Karin Scheper, *The Technique of Islamic Bookbinding: Methods, Materials and Regional Varieties* (Leiden, 2015); for ornament, see Alison Ohta, *Covering the Book: Bindings of the Mamluk Period, 1250–1516* (PhD thesis, School of Oriental and African Studies, 2012), available online eprints: <soas.ac.uk/16626/1/Ohta_3496.pdf 2012> (last accessed 26 November 2019).

2. Georges Marçais and Louis Poinssot, *Objets kairouanais, IXe au XIIIe siècle, Reliures, verreries, cuivres et bronzes bijoux* (Tunis, 1948), p. 142.

3. Thomas Arnold and Arnold Grohmann, *The Islamic Book: A Contribution to Its Art and History from the VIIII–XVIII Century* (Paris, 1929), pp. 50–6.

4. Adam Gacek, 'Arabic bookmaking and terminology as portrayed by Bakr al-Ishbili in his *Kitab al-taysir fi sina'at al-taysir*', *Manuscripts of the Middle East* 5 (1990–1), pp. 106–13; al-Ishbili, *Kitab al-taysir fi sina'at al-taysir*, ed. 'Abd Allah Kanun, *Revista del instituto de Estudios Islamicos en Madrid* 7–8 (1959–60), pp. 1–42; Adam Gacek, 'Instructions on the art of bookbinding attributed to the Rasulid ruler of Yemen al-Malik al-Muzaffar', in François Déroche and Francis Richard (eds), *Scribes et Manuscrits du Moyen-Orient* (Paris, 1997), pp. 58–63.

5. Elaine Wright, *The Look of the Book: Manuscript Production in Shiraz, 1303–1452* (Seattle, 2013), pp. 258–82.

6. The term 'cloud-collar' is used to refer to bindings with a distinctive four-lobed profile; it is borrowed from a descriptive term used to describe the profiles of textile collars on Chinese robes from the Yuan period. For cloud-collar patterns, see Thomas Lentz and Glenn Lowry, *Timur and the Princely Vision: Persian Art and Culture in the Fifteenth Century* (Washington, DC, 1989), cat. no. 90, pp. 95–7, 114, 115; for cloud-collars, see Yuka Kadoi, *Islamic Chinoiserie: The Art of Mongol Iran* (Edinburgh, 2009), p. 32 and fig. 1.15.

7. François Déroche, *Islamic Codicology* (London, 2005), p. 273, however, published a block-pressed doublure of a binding with a manuscript copied in Bust, Afghanistan, dated 505/1112. It is not known if the binding is contemporary with the manuscript.

8. Pierpont Morgan Library, M.500, 35.5 x 28 cm; Richard Ettinghausen, 'On the covers of the Morgan Manafi' manuscript and other early Persian bookbindings', in Dorothy Miner (ed.), *Studies in Art and Literature for Belle da Costa Greene* (Princeton, 1954), pp. 459–73; Barbara Schmitz,

Islamic and Indian Paintings in the Pierpont Morgan Library (New York, 1996), cat. no. 1.

9. Topkapı Palace Library (TSK), EH 243, 73 × 50 cm; Zeren Tanındı, 'Topkapı Sarayı Müzesi Kütüphanesi'nde Ortaçağ İslam Ciltleri', *Topkapı Sarayi Müzesi*, Yıllık 4 (Istanbul, 1990a), p.107; David James, *Qur'ans of the Mamluks* (London, 1988), cat. no. 40 for a listing of all the known *juz'* to date.

10. Dar al-Kutub (DAK), Rasid 72; Arthur Upham Pope and Phyllis Ackerman, *Survey of Persian Art*, Vol. 3 (1955–6), pls 934–5; Ettinghausen, 'On the covers of the Morgan Manafi', pp. 461–2, fig. 346; Basil Gray, 'The monumental Qur'ans of the Ilkhanid and Mamluk ateliers of the first quarter of the fourteenth century', *Rivista degli Studi Orientali* LIX (1985), pp. 139–40; James, *Qur'ans*, pp. 111–13, cat. no. 45.

11. Ahmet Saim Arıtan, 'Anadolu Seljuklu Cild Sanati', *Türkler* 7 (2002), pp. 933–43.

12. Cailah Jackson, *Patrons and Artists at the Crossroads: The Islamic Arts of the Book in the Lands of Rum, 1270s–1370s* (PhD thesis, University of Oxford, 2017), p.138.

13. Zeren Tanındı, '15th century Ottoman manuscripts and bindings in Bursa libraries', *Islamic Art* 4 (1990), pp. 143–73.

14. Gulnar Bosch, *Islamic Bookbindings: Twelfth to Seventeenth Centuries* (PhD thesis, University of Chicago, 1952), p.169, assumed that block-pressed doublures were not found on bindings in the Eastern Islamic style.

15. Ralph Pinder-Wilson, 'Stone-pressed moulds and leather-working in Khurasan', in Francis Maddison and Emilie Savage-Smith *et al.* (eds) *Science, Tools and Magic, Part 2: Mundane Worlds* (London, 1997) pp. 338–54.

16. Khalili Collection, Qur 433 and Qur 132, 23.5 × 17 cm; David James, *The Master Scribes, Qur'ans of the 10th–14th Centuries* , Nasser D. Khalili Collection of Islamic Art, Julian Raby (ed.) (London, 1992), vol. II, cat. no. 48.

17. Bosch, *Islamic Bookbindings*, 1952, p.169.

18. Julian Raby and Zeren Tanındı, *Turkish Bookbinding in the 15th Century: The Foundation of an Ottoman Court Style* (London, 1993), pp. 9–10.

19. Ruth Barnes, *Indian Block-printed Textiles in Egypt: The Newberry Collection in the Ashmolean Museum* (Oxford, 1997), cat. nos 41–2.

20. Doris Behrens-Abouseif, *Cairo of the Mamluks* (London, 2007), pp. 312–5.

21. Alison Ohta, *Covering the Book*, figs 5.71, 5.72.

22. Jon Thompson, 'Carpets in the fifteenth century', in Daniel Shaffer and Pirjetta Mildh (eds), *Carpets and Textiles in the Iranian World 1400–1700. Proceedings of the Conference Held at the Ashmolean Museum on 30–31 August 2003* (London, 2010), pp. 30–57, fig. 3.

23. Duncan Haldane, *Islamic Bookbindings in the Victoria and Albert Museum* (London, 1983), pl. 1, p. 22.

24. Zeren Tanındı, 'Topkapı Sarayı', fig. 4, p. 120.

25. See, for example, Gulnar Bosch, John Carswell and Guy Petherbridge, *Islamic Bindings and Bookmaking* (Chicago, 1981), pl. 52.

26. TSK.A.804, 31.5 × 21.5 cm, Tanındı, 'Topkapı Sarayı', pl. 31. The colophon states it was completed in Muharram 775/July 1373 by Ibrahim Ahmed bin Sadiq al-Halabi in the *majlis* of Uljay al-Yusufi, the *atabeg*

of the army. He was married to Sultan Sha'ban's mother and after her death quarrelled with the amirs concerning the disposal of her property. He was accidentally drowned in the Nile in 775/1373, the same year as the date of completion of this manuscript. After his death, the manuscript must have been transferred to Sultan Sha'ban's library, hence the title roundel in his name on folio 2a.

27. Louise Mackie, 'Towards an understanding of Mamluk silks: national and international considerations', *Muqarnas* 2 (1984), p. 130.

28. Mackie cites the account by Abu'l-Fida of the gift of 700 silks from the Il Khan Abu Sa'id to Sultan al-Nasir Muhammad at the time of the 1323 peace treaty; see Mackie, 'Towards an understanding', p. 132.

29. Mackie, 'Towards an understanding', pl. 21 and fig. 3.

30. DAK Rasid 62, 53 × 37 cm, *juz'* of a Qur'an with *waqf* (income-generating endowment) for Uljay al-Yusufi,

31. Bosch, *Islamic Bookbindings*, pl. 52; Ohta, *Covering the Book*, figs 4.172, 4.175, 4.180–2.

32. See Michael Dols, *The Black Death in the Middle East* (Princeton, 1977); Carl Petry, *Protectors or Praetorians? The Last Mamluk Sultans and Egypt's Waning as a Great Power* (New York, 1994); Eliyahu Ashtor, *A Social and Economic History of the Near East in the Middle Ages* (Princeton 1983).

33. TSK.A.643. Exactly the same pattern is found on the fourteenth volume of a *Sahih* of al-Bukhari dated 873/1473, Süleymaniye Library, 238; Mine Esiner Özen al-, *Turk Cilt Sanatı*, Turkiye Iş Bankasi (Ankara, 1998), pl. 11.

34. John Rylands Arabic Manuscript, 42; David James, 'Recent discoveries concerning Arabic no. 42', *Bulletin of the John Rylands Library* LIX.2 (1977), pp. 1–4; Alison Ohta, 'Possibly the largest Qur'an in the world', *Riches of the Rylands*, The Special Collections of The University of Manchester Library (Manchester, 2015), pp. 94–5.

35. DAK Rasid 9, 75.5 × 56 cm, James, *Qur'ans*, cat. no. 31, pp. 209–21; DAK Rasid 10, 105 × 77 cm, James, *Qur'ans*, pp. 198–201.

36. Ohta, *Covering the Book*, see figs 4.94–6.

37. Anthony Hobson, *Humanists and Bookbinders* (Cambridge, 1989), figs 35–8.

38. TSK.A.2829, 32 × 21.5 cm; see Ohta, *Covering the Book*, fig. 4.150 for the cover and 4.195 for details of the doublure.

39. The knotwork appears to be painted with a silver-coloured compound. It shines as brightly as when it was first made so it cannot be silver as it has not tarnished. It could possibly be tin. See Benjamin Arbel, 'Venice's trade with the Mamluks', *Mamluk Studies Review* 8.2 (2004), p. 49. Tin was a common cargo on Venetian ships sailing to Egypt and Syria and was used for the tinning of copper vessels.

40. *Canzoniere e Trionfi*, Florence, c. 1460–70, Bodleian Library, Oxford, Ms. Canon. Ital. 78, 21.8 × 13.8 cm; Hobson, *Humanists*, p. 23, figs 15 and 16.

41. TSK.A.649, 36.5 × 26 cm; Ohta, *Covering the Book*, figs 4.112 and 4.190; and Hobson, *Humanists*, p. 23, fig. 15.

42. For Coptic examples, see Geoffrey Hobson, 'Some early bindings and binders' tools', *The Library* 4.19 (1939), pp. 210–11; The British Library, *The Christian Orient* (London, 1978), nos 142, 147 and 148. For filigree fragments from Turfan, see Albert von le Coq, *Die Buddhistische Späntantike in Mittelasien*, (Berlin,1923), vol. II, pp. 17, 40, pl. IVe;

Hans-Joachim Klimkeit, *Manichean Art and Architecture* (Leiden, 1982) p. 50; Zsuzsanna Gulasci, *Medieval Manichaean Book Art: A Codicological Study of Iranian and Turkic Illuminated Book Fragments from 8th–11th Century East Central Asia* (Leiden, 2005), pp. 85–8.

43. Alison Ohta, 'Filigree bindings of the Mamluk period', *Muqarnas* 21 (2004), pp. 267–8.

44. Raby and Tanındı, *Turkish Bookbinding*, see, for example, cat. nos 11 and 12.

45. Wright, *The Look of the Book*, figs 129–30 and pp. 265–82.

46. TSK.A.649, 36.5 × 26 cm; Ohta, *Covering the Book*, Figs 4.112 and 4.190.

47. TSK.A.247/2, 43.4 × 30 cm; Raby and Tanındı, *Turkish Bookbinding*, p. 12, figs 9 and 10. Ohta, *Covering the Book*, fig. 4.111.

48. Ohta, *'Covering the book'*, fig. 4.190.

49. Museum of Turkish and Islamic Art (TIEM) 508, 50 × 35 cm; Ohta, *Covering the Book*, pp. 234–6; Zeren Tanındı, 'Two bibliophile amirs: Qansuh the master of the stables and Yashbak the secretary', in Doris Behrens-Abouseif (ed.) *Arts of the Mamluks in Egypt and Syria: Evolution and Impact* (Bonn, 2012), pp. 267–9; Massumeh Farhad and Simon Rettig, *The Art of the Qur'an: Treasures from the Museum of Turkish and Islamic Arts* (Washington, 2016), cat. no. 42, pp. 262–4.

50. Doublure of Ottoman binding for Mehmed II, Keir Collection, PT1, 31 × 20 cm, dated 886/1474, illustrated in Raby and Tanındı, *Turkish Bookbinding*, p. 165.

51. Hobson, *Humanists*, pp. 33–59.

52. Hobson, *Humanists*, figs 8 and 9.

53. Anna Contadini, 'Sharing a taste? Material culture and intellectual curiosity around the Mediterranean, from the eleventh to the sixteenth century', in. Anna Contadini and Claire Norton (eds), *The Renaissance and the Ottoman World* (Farnham, 2013) pp. 23–62; Alison Ohta, 'Binding relationships: Mamluk, Ottoman and Renaissance book bindings', in Anna Contadini and Claire Norton (eds) *The Renaissance and the Ottoman World*, pp. 221–30.

54. Hobson, *Humanists*, p. 22.

55. *Codex Marcanova*, 1465, Modena Bibl. Estense, cod. L.5.15, and *Commentarius rerum in Italia suo tempore gestarum*, Venice, Biblioteca Marciana Lat. X 117 (=3844); Hobson, *Humanists*, pp. 42–3.

56. Felice Feliciano was part of the group of antiquaries that established the humanist script through the compilation of anthologies of Roman inscriptions.

57. This was facilitated by pattern books; see, for example, Francesco Pellegrino, *La Fleur de la science de pourtraicture: façon arabicaque et yitalique* (Paris, 1530) reproduced in Contadini, 'Sharing a taste?', p. 59.

58. Sheila Blair, 'Bookbinding', in Jonathan Bloom and Sheila Blair (eds), *Grove Encyclopedia of Islamic Art and Architecture* (Oxford, 2009), vol. 1, p. 296.

Bibliography

Arıtan, Ahmet Saim, 'Anadolu Seljuklu Cild Sanati', *Türkler* 7 (2002), pp. 933–43.

Arbel, Benjamin, 'Venice's trade with the Mamluks', *Mamluk Studies Review* VIII.2 (2004), pp. 37–86.

Arnold, Thomas and Arnold Grohmann, *The Islamic Book: A Contribution to its Art and History from the VIIII–XVIII Century* (Paris, 1929).

Ashtor, Eliyahu, *A Social and Economic History of the Near East in the Middle Ages* (Princeton, 1983).

Barnes, Ruth, *Indian Block-printed Textiles in Egypt, The Newberry Collection in the Ashmolean Museum* (Oxford, 1997).

Behrens-Abouseif, Doris, *Cairo of the Mamluks* (London, 2007).

Blair, Sheila, 'Bookbinding', in Jonathan Bloom and Sheila Blair (eds), *Grove Encyclopedia of Islamic Art and Architecture*, Vol. 1 (Oxford, 2009), pp. 294–9.

Bosch, Gulnar, *Islamic Bookbindings: Twelfth to Seventeenth Centuries* (PhD thesis, University of Chicago, 1952).

Bosch, Gulnar, John Carswell and Guy Petherbridge, *Islamic Bindings and Bookmaking* (Chicago,1981).

The British Library, *The Christian Orient* (London, 1978).

Contadini, Anna, 'Sharing a taste? Material culture and intellectual curiosity around the Mediterranean, from the eleventh to the sixteenth century', in Anna Contadini and Claire Norton (eds), *The Renaissance and the Ottoman World* (Farnham, 2013), pp. 22–62.

Déroche, François, *Islamic Codicology* (London, 2005).

Dols, Michael, *The Black Death in the Middle East* (Princeton, 1977).

Ettinghausen, Richard, 'On the covers of the Morgan Manafi' manuscript and other early Persian bookbindings', in Dorothy Miner (ed.), *Studies in Art and Literature for Belle da Costa Greene* (Princeton, 1954), pp. 459–73.

Farhad, Massumeh and Simon Rettig (eds), *The Art of the Qur'an: Treasures from the Museum of Turkish and Islamic Arts* (Washington, DC, 2016).

Gacek, Adam, 'Arabic bookmaking and terminology as portrayed by Bakr al-Ishbili in his *Kitab al-taysir fi sina'at al-taysir*', *Manuscripts of the Middle East* 5 (1990–1), pp. 106–13.

Gacek, Adam, 'Instructions on the art of bookbinding attributed to the Rasulid ruler of Yemen al-Malik al-Muzaffar', in François Déroche and Francis Richard (eds), *Scribes et Manuscrits du Moyen-Orient* (Paris, 1997), pp. 58–63.

Gray, Basil, 'The monumental Qur'ans of the Ilkhanid and Mamluk ateliers of the first quarter of the fourteenth century', *Rivista degli Studi Orientali* LIX (1985), pp. 135–46.

Gulasci, Zsuzsanna, *Medieval Manichaean Book Art: A Codicological Study of Iranian and Turkic Illuminated Book Fragments from 8th–11th Century East Central Asia* (Leiden, 2005).

Haldane, Duncan, *Islamic Bookbindings in the Victoria and Albert Museum* (London, 1983).

Hobson, Anthony, *Humanists and Bookbinders* (Cambridge, 1989).

Hobson, Geoffrey, 'Some early bindings and binders' tools', *The Library* 4.19 (1939), pp. 210–11.

Al-Ishbili, *Kitab al-taysir fi sina'at al-taysir*, ed. 'Abd Allah Kanun, *Revista del instituto de Estudios Islamicos en Madrid* 7–8 (1959–60), pp. 1–42.

Jackson, Cailah, *Patrons and Artists at the Crossroads: The Islamic Arts of the Book in the Lands of Rum, 1270s–1370s* (PhD thesis, University of Oxford, 2017).

James, David, 'Recent discoveries concerning Arabic no. 42' *Bulletin of the John Rylands Library* LIX.2 (1977), pp. 1–4.

James, David, *Qur'ans of the Mamluks* (London, 1988).

James, David, *The Master Scribes, Qur'ans of the 10th–14th centuries*, Nasser D. Khalili Collection of Islamic Art 2, Julian Raby (ed) (London, 1992).

Kadoi, Yuka, *Islamic Chinoiserie: The Art of Mongol Iran* (Edinburgh, 2009).

Klimkeit, Hans-Joachim, *Manichean Art and Architecture* (Leiden, 1982).

Lentz, Thomas and Glenn Lowry, *Timur and the Princely Vision: Persian Art and Culture in the Fifteenth Century* (Washington, DC, 1989).

Mackie, Louise, 'Towards an understanding of Mamluk silks: national and international considerations', *Muqarnas* 2 (1984), pp. 127–46.

Marçais, Georges and Louis Poinssot, *Objets kairouanais, IXe au XIIIe siècle, Reliures, verreries, cuivres et bronzes bijoux* (Tunis, 1948).

Ohta, Alison, 'Filigree bindings of the Mamluk period', *Muqarnas* 21 (2004), pp. 267–8.

Ohta, Alison, 'Binding relationships: Mamluk, Ottoman and Renaissance book bindings', in Anna Contadini and Claire Norton (eds), *The Renaissance and the Ottoman World* (Farnham, 2013), pp. 221–30.

Ohta, Alison, 'Possibly the largest Qur'an in the world', *Riches of the Rylands*, The Special Collections of the University of Manchester Library (Manchester, 2015), pp. 94–5.

Ohta, Alison, *Covering the Book* (PhD thesis, School of Oriental and African Studies, University of London, 2012), available online eprints: <soas.ac.uk/16626/1/Ohta_3496.pdf 2012> (last accessed 26 November 2019).

Özen, Mine Esiner, *Turk Cilt Sanatı, Turkiye İş Bankasi* (Ankara, 1998).

Petry, Carl, *Protectors or Praetorians? The Last Mamluk Sultans and Egypt's Waning as a Great Power* (New York, 1994).

Pinder-Wilson, Ralph, 'Stone-pressed moulds and leather-working in Khurasan', in Francis Maddison, Emilie Savage-Smith *et al.* (eds), *Science, Tools and Magic, Part 2: Mundane World* (London, 1997), pp. 338–54.

Pope, Arthur Upham and Phyllis Ackerman (eds), *A Survey of Persian Art*, Vol. 3 (London, 1938–39).

Raby, Julian and Zeren Tanındı, *Turkish Bookbinding in the 15th Century: The Foundation of an Ottoman Court Style* (London, 1993).

Roberts, Matt T. and Don Etherington, *Bookbinding and the Conservation of Books: A Dictionary of Descriptive Terminology*, <http://cool.conservationus.org/don/dt//dt1308.html> (last accessed 28 December 2018).

Scheper, Karin, *The Technique of Islamic Bookbinding: Methods, Materials and Regional Varieties* (Leiden, 2015).

Schmitz, Barbara, *Islamic and Indian Paintings in the Pierpont Morgan Library* (New York, 1996).

Tanındı, Zeren, 'Topkapı Sarayi Müzesi Kütüphanesi'nde Ortaçağ İslam Ciltleri', *Topkapı Sarayi Müzesi*, Yillik 4 (1990), pp. 102–49.

Tanındı, Zeren, '15th century Ottoman manuscripts and bindings in Bursa libraries', *Islamic Art* 4 (1990), pp. 143–73.

Tanındı, Zeren, 'Two bibliophile amirs: Qansuh the master of the stables and Yashbak the secretary', in Doris Behrens-Abouseif (ed.), *Arts of the Mamluks in Egypt and Syria: Evolution and Impact* (Bonn, 2012), pp. 267–83.

Thompson, Jon, 'Carpets in the fifteenth century', in Daniel Shaffer and Pirjetta Mildh (eds), *Carpets and Textiles in the Iranian World 1400–1700. Proceedings of the Conference Held at the Ashmolean Museum on 30–31 August 2003* (London, 2010), pp. 30–57.

Von le Coq, Albert, *Die Buddhistische Späntantike in Mittelasien*, Vol. II (Berlin, 1923).

Wright, Elaine, *The Look of the Book, Manuscript Production in Shiraz, 1303–1452* (Seattle, 2013).

Taj al-Din 'Alishah: The Reconstruction of his Mosque Complex at Tabriz

Bernard O'Kane

THE MOSQUE OF Taj al-Din 'Alishah at Tabriz has long been celebrated for its size and magnificence. Considering this, it is surprising how little we know about it. Its very poor state of preservation, limited to part of the *qibla ayvan* (Figure 10.1), is of little help in reconstructing its original form.[1] I have been able to find only one reference to the beginning of its construction, in Ahri's *Tarikh-i Shaykh Uvays*, where after listing the names of the enemies of Chupan who

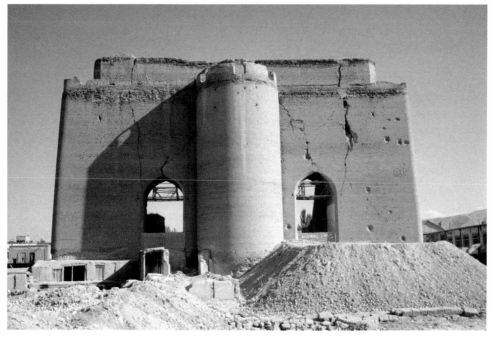

Figure 10.1 *Tabriz, complex of 'Alishah, rear of* qibla ayvan. *Photo: Bernard O'Kane, c 1974.*

were killed in 1318 (Rashid al-Din and his son), he adds: 'And Khvaja 'Alishah united in himself all power and he founded that building (*an 'imarat*) in Tabriz.'[2] This mention of a building so famous that it need not be named could only be a reference to his mosque complex. Although the end of its construction is not recorded in contemporary Persian sources, we know that it was substantially finished at the time of the Mamluk ambassador's visit in 1322 (see further below).

The only Ilkhanid account of it is in Hamd Allah's Mustawfi's *Nuzhat al-qulub*. He notes that its *qibla ayvan* was built to be bigger than the Taq-i Kisra, but that it fell from being built in too great haste. From the figures above it must have been completed in four years or less, indeed a short time considering the size of the original. He also mentions that the size of its courtyard was 200 × 250 cubits.[3]

Ibn Battuta mentions a madrasa and *khanqah* to either side of the *qibla*, together with its tile mosaic decoration and its marble courtyard which was traversed by a canal and studded with trees, vines and jasmine.[4]

The anonymous Italian merchant who visited Tabriz in the early sixteenth century also provided a succinct, if at times enigmatic description. He noted that the vault of the *qibla* (which he calls the choir) was unfinished, not realising that it had fallen down earlier. He described the portals and doors of the mosques in detail and mentioned a stream outside the main entrance. The fountain in the centre of the mosque was one hundred paces square and six feet deep with a platform containing a pedestal supported by six elaborately carved marble columns. He also mentioned the stone vaulting all around the courtyard, supported on crystal-like marble columns each five or six paces high.[5]

The sixteenth century Safavid historian Karbala'i mentions that 'Alishah was buried in the mausoleum (*maqbara*) that he had built himself behind the arch of his mosque (*dar aqab-i taq-i masjid*);[6] while the still extant remains of the *qibla* wall at this point show no signs of any building having been attached to it, it is reasonable to assume that, as with most other Ilkhanid ensembles, a mausoleum was planned from the start as part of the complex.

None of this would be sufficient to gain much of an idea of the mosque were it not that we have another source, that of the unnamed secretary (*dawadar*) who accompanied the Mamluk ambassador Aytamish al-Muhammadi on his embassy to Tabriz in 1322. His account is preserved in the Mamluk historian al-'Aini's *'Iqd al-juman* (Figure 10.9), where it was taken in turn from another Mamluk history, al-Yusufi's *Nuzhat al-nazir fi sirat al-malik al-nasir*.

The original of this text and a Russian translation were published by Tiesenhausen in the nineteenth century,[7] and these were used in the chief discussions of the mosque in scholarly literature, those of Pope[8] and Wilber.[9] However, another look at the original Arabic text[10] reveals that Tiesenhausen's published version has two lacunae,

and that the original yields more information than has been thought previously. It is also worth quoting in full as one of the most thorough accounts of a building, outside of *waqfiyyas*, ever to have been written in medieval Islamic sources.

The relevant section of the text (see the appendix for the original Arabic) reads as follows, with passages in square brackets being those omitted in Tiesenhausen's text:

He ('Alishah) founded a congregational mosque in Tabriz and built it such that no one could build one comparable. Beside it he built two baths, among the most remarkable that exist (in the world). The author of *al-Nuzha*[11] says that when the amir Aytamish al-Muhammadi travelled as ambassador to Abu Sa'id he had with him his secretary (*dawadar*), an exceedingly handsome and clever young man who wrote beautifully. When they entered Tabriz and he saw this mosque he wrote an account of it and brought it to Cairo where I copied it:

When he ('Alishah) wanted to build this mosque he assembled and brought the engineers around him and indicated that they should build it at a gate of the city known as the Kharbanda gate. He ordered that its measurements and height[12] should be like the Iwan Kisra, but ten cubits higher and ten wider than it.

He made a quadrangular pool 150 cubits wide in the middle of it (the mosque). In the middle of the pool was an octagonal dome erected on a square base, every corner of which had a statue of a lion which poured water into the basin. In the middle also are two fountains which produce a great amount of water despite its scarcity in Tabriz. In the pool are four boats. All sides of the basin are covered with marble of the type called 'Alamut'.[13] The vizier made the architect erect three cornerstones in every corner [of the basin, each measuring 23 hands.

The width of the mosque is four hundred cubits square and there is an arcade in every quarter,] and between every two arches is a monolithic octagonal column the colour of jade. Every column is some 12 cubits tall and is connected by an arch with the next; all are decorated in gold. In the mosque are two tall minarets, each 70 cubits [and each spiral.[14] Around the mosque are eighty windows of copper pieces, each seven] by five cubits.[15] In each window are 200 round panes;[16] all are inlaid and engraved with gold and silver. (In) the *qibla* in which the imam prays are a dome[17] and two pillars of Andalusian copper with glorious inlaid and engraved gold and silver.[18] There are four doors to the mosque and at each was made a bazaar and shops, and various lamps on copper chains inlaid with gold and silver were hung in each (bazaar).

The author of *al-Nuzha* said: it was related to me by Majd al-Din al-Sallami,[19] that when the vizier began the construction of this mosque in this manner I said to him: 'O Lord, this will take

immeasurable riches.' He ('Alishah) replied: 'O Majd al-Din, it is a rule of the Mongol kings that whenever they take vengeance on their vizier first there is confiscation of (his) wealth and then (his) execution, therefore in spending his wealth on holy relics his memory will rest with God, may he be praised and exalted.'

There are still several problems to be solved regarding the interpretation of some of the features mentioned in this passage, but together with the other accounts it provides the basis for a reconstruction (Figure 10.2) which differs substantially from that of Wilber (Figure 10.3).

There are three measurements given which provide the parameters for this reconstruction: that of the outer walls of the mosque, 400 cubits[20] per side, given by the *dawadar*, that of the courtyard, 200 × 250 cubits,[21] given by Hamd Allah Mustawfi, and that of the pool, 150 cubits per side according to the *dawadar*, and 100 paces according to the Italian merchant. I have assumed that the outer wall joined the *qibla ayvan* at the point c. 20 m from its rear, as a photo of Pope[22] (Figure 10.4) show that the walls south of this area were faced with brick; north of the same point they were covered with plaster, indicating an interior. The portion shown on Figure 10.4 includes an opening that was clearly filled in, but as Hamd Allah Mustawfi records that part of the vault fell during construction, it is likely that this represents a contemporary strengthening of the supporting walls of the *ayvan*. Confirmation of this is provided by the mouldings of the arch which appear on this side (Figure 10.4): its broken-headed profile and lower S-shape are closest to those of other fourteenth century monuments.[23] Why did the vault of the *ayvan* fall? The walls were even thicker than those of the Ayvan-i Kisra (10.4 m versus 7.32 m), and no special technology would have been needed for the vault. Mustawfi, writing in 1340, ascribed its downfall to haste rather than any unnatural event such as an earthquake.[24] Perhaps experimentation with transverse vaulting, combined with the unusual semi-dome which seemingly abutted it at the *qibla* end[25] was enough to render it unstable, but we do not have enough evidence to be sure.

Returning to the reconstruction (Figure 10.2), although its dimensions provide for a mosque which has a rather cramped courtyard in relation to the size of the pool, it is nevertheless closer to mainstream Seljuq and Ilkhanid plans than that of Wilber, which has a court implausibly 325 m wide, with no arcaded prayer halls surrounding it. The round figures of the sources are obviously approximations and with just a little alteration,

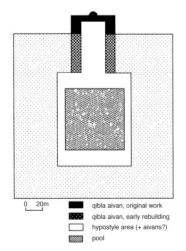

0 20m ▮ qibla aivan, original work
 ▧ qibla aivan, early rebuilding
 ▢ hypostyle area (+ aivans?)
 ▨ pool

Figure 10.2 *Tabriz, complex of 'Alishah, restoration of original plan.*
Drawing: Bernard O'Kane.

Figure 10.3 *Tabriz, complex of 'Alishah, restoration of original plan
(after D. N. Wilber,* Architecture of Islamic Iran: The Il Khanid Period
(Princeton, 1955), fig. 30).

widening the courtyard and diminishing the pool, for instance, it
is easy to imagine more plausible reconstructions. These could be
made more detailed through interpretation of the dimensions given
for the height of the columns in the hypostyle areas of the mosque
(12 cubits, five or six paces) (which would help in determining the
distance between the piers), and in the number (eighty) and dimen-
sion (7 × 5 cubits) of windows, which, as in earlier major hypostyle
mosques, may have coincided with the spaces between piers.[26]
However, I have resisted temptations to furnish any more detailed
reconstruction, not simply to give others more talented at drafting a
chance to do so, but also because of the risk of its speculations being
mistaken for certainties.[27]

My sketch plan obviously leaves many questions of detail unan-
swered. What was the elevation on either side of the *qibla ayvan*?
The plastered wall there (Figure 10.4) obviously belongs to an inner
surface, so it must have been an extremely tall abutment to the
ayvan, and not part of the hypostyle area which filled most of the
covered spaces of the mosque. Wilber reconstructed this area as part
of the *khanaqa* and madrasa that Ibn Battuta mentioned as being on

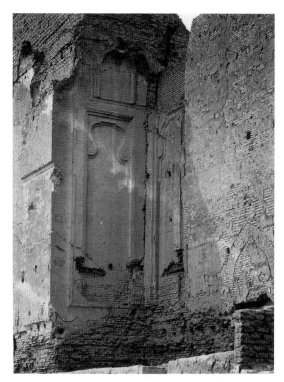

Figure 10.4 *Tabriz, complex of 'Alishah, side of* qibla ayvan.
*Photo: Arthur Upham Pope, 1930s, courtesy of the Asia Institute,
Shiraz University.*

each side of the *qibla* (Figure 10.3). However, it is more likely that
the areas immediately adjacent to the *qibla* were part of the mosque
proper. Perhaps a later parallel can be found in the plan of the Isfahan
Masjid-i Shah, where taller than usual bays abut the *qibla ayvan*,
and courtyards for two madrasas are found beyond them (Figure
10.5). These bays provided visual support for the *ayvan*, but perhaps
more importantly, they also provided structural support, buttressing
an unusually tall *ayvan*.

Were there any other *ayvan*s than that on the *qibla* side?[28] A
single-*ayvan* plan would not, of course be unprecedented, as pre-
Seljuq examples at Nayriz and at Bashan in Turkmenistan, and the
Seljuq example at Firdaus show.[29] But the most prestigious mosques
were consistently on the four-*ayvan* plan. No other *ayvan*s are men-
tioned by the commentators, but this could be because the size of
the *qibla ayvan* so overshadowed them that they were scarcely more
memorable than the arcades surrounding the courtyard.

Some decades ago fragments of columns were dug up in the court-
yard of the mosque; of those illustrated one is indeed octagonal,
as mentioned by the *dawadar*, while two others are polygonal and
carved with angular interlacing strapwork. From the reproduction

(Figure 10.6)[30] it is impossible to tell if they resemble agate as mentioned by the *dawadar*, or jasper as mentioned by the Italian merchant, although it is possible that any similarity to these stones may have been caused by paint (the *dawadar* specifically mentions gold paint).[31]

One of the most extraordinary features of the building is the large pool in the courtyard which was provided with four boats. As detailed below, 'Alishah entertained Öljeitü on a boat on the Tigris, so he was no stranger to the delights of water. It must give us pause to realise how the sacred function of the building was not deemed to be incompatible with pleasure boating, although we also know that the tradition was continued by the Safavid Shah Isma'il.[32]

No Persian source mentions Ibn Battuta's madrasa and *khanaqa*. But the argument from silence is hardly grounds for dismissing them as part of the complex: neither are the baths and bazaars mentioned by the *dawadar* found in Persian sources, but his is an impeccable authority. The complex then consisted of (at least) a mosque, a mausoleum, a surrounding bazaar, a madrasa, a *khanaqa* and two baths. This was obviously a very substantial ensemble, although in terms of the evolution of complexes the more ambitious examples of Ghazan Khan at Sham and Öljeitü at Sultaniyya obviously take precedence. In terms of complexes sponsored by viziers, however, 'Alishah's may have been built as a rejoinder to that which his rival Rashid al-Din

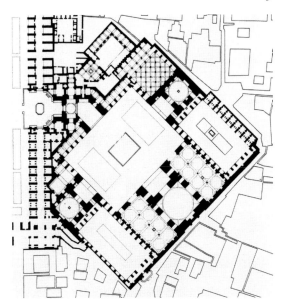

Figure 10.5 *Isfahan, Masjid-i Shah, plan (after K. Herdeg,* Formal Structure in Islamic Architecture of Iran and Turkistan *(New York, 1990), p. 15).*

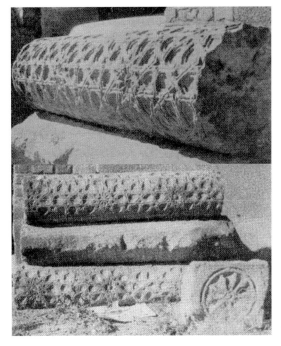

Figure 10.6 *Tabriz, complex of 'Alishah, stone columns (after A. al-'A. Karang,* Asar-i Bastani-yi Azarbaijan *(Tehran, 1351/1972), pp. 247, 249.*

had built, (consisting mainly of a *khanaqa*, a hospice, a hospital and a *rawda* or funerary garden) in a suburb to the east of Tabriz.[33]

Having got a clearer idea of the original complex, we may turn to its founder, Taj al-Din 'Alishah, to set it within the context of Ilkhanid society. Originally a jeweller and dealer in precious cloths, his increasing prominence at the court of Öljeitü attracted the jealousy of one of the main viziers, Sa'd al-Din Saviji, who consequently sent him to manage the state textile industry in Baghdad.[34] This was a tactical error, as 'Alishah proved himself an able administrator, erecting a new factory 100 × 300 *gaz* (c. 42 m × 116 m) with marble flooring (the Karkhana-yi Firdaus, Paradisial Factory) and staffing it with 4,000 workers.[35] He also continually impressed Öljeitü with gifts of jewels, a famous example being a cap ornamented with precious stones crowned by a 24-*mithqal* ruby, and by entertaining him on a splendidly decorated boat on the Euphrates.[36]

In 1310 he was made vizier,[37] together with Rashid al-Din and Sa'd al-Din. At Sultaniyya 'Alishah was credited by al-Qashani as being the designer (or overseer, *mi'mar*) of the city; he also financed the construction of a bazaar of brick and stone which was cheaper than one built of mud, mud brick, marble and plaster by his rival, Sa'd al-Din. He later built a splendid palace there.[38] Sa'd al-Din was executed in 1311 and 'Alishah's relationship with his other main rival, Rashid al-Din, soon soured. Towards the end of Öljeitü's reign matters between them were so acrimonious that the administration of the Ilkhanid Empire was divided between them.[39] On the death of Öljeitü in 1316 'Alishah accused Rashid al-Din of having poisoned the sultan, and managed to have him executed in 1318.[40] This was the moment when, having finally disposed of all his rivals he 'united all power in himself', as Ahri says,[41] and undertook his ambitious building project. He became the first Ilkhanid vizier to die a peaceful death, in the reign of Abu Sa'id in 1324.[42]

The cult of the gigantic had already been established in Ilkhanid architecture[43] when Ghazan constructed his funerary complex in the suburb of Sham near Tabriz. Öljeitü in his new capital of Sultaniyya carried on this tradition, to which his mausoleum still bears witness. While supervising the *karkhana* in Baghdad 'Alishah would have had ample opportunity to visit and wonder at the Ayvan-i Kisra which he later ordered to be surpassed. Indeed he may not have been unaware of Öljeitü's attitude to it, as reported by al-Qashani when Öljeitü visited it on Tuesday 27 Jumada II 709/14 December 1309.[44] Öljeitü went there for amusement but also to reflect on the achievement of those who had built it and to reprove himself with not achieving its equal. Al-Qashani also recounted how Hulagu had visited it and had struck his knee three times before it (a sign of despair) and then said: 'Many glances of the great and the holy have fallen on this unparalleled arch; I strike my knee on behalf of those thousand-year long glances.'[45]

As the *dawadar's* account suggested, 'Alishah did narrowly surpass the dimensions of the Ayvan-i Kisra,[46] and since it was in Ilkhanid territory, he could indeed have ordered it to be measured beforehand.

Adding to the importance of the complex of 'Alishah is the influence which it and its architect had on the development of Mamluk architecture. For Aytamish was so impressed by the minarets of the building that he brought their builder back to Egypt.[47] There the builder erected a similar minaret for Aytamish's complex of a *zawiyya* (Sufi residence) and *hawd-sabil* (water dispensary) in the town of Fishat al-Manara in the Delta. The amir Qawsun saw this, requested the builder's services from Aytamish and ordered him to erect two Tabrizi-style minarets for his mosque in Cairo.[48] The most obvious result of the Tabrizi builder's activity was a short-lived vogue for tile mosaic, seen on some dozen surviving monuments, exemplified by the minarets of al-Nasir Muhammad's mosque in the citadel, for instance.[49]

One Mamluk monument that was also supposedly erected in competition with the Ayvan-i Kisra was the complex of Sultan Hasan in Cairo (1356–61). Various Mamluk historians report that its *qibla ayvan* (Figure 10.7) was larger, and was specifically ordered by its

Figure 10.7 *Cairo, complex of Sultan Hasan,* qibla ayvan. *Photo: Bernard O'Kane.*

patron to be larger, than the Ayvan-i Kisra, even though it was in
fact smaller. As the Ayvan-i Kisra was then in Ilkhanid territory,
it is unlikely that any Mamluk engineers were able to measure it;
the mere assumption of superiority was evidently enough to satisfy
everyone.[50]

The *qibla ayvan* of Sultan Hasan's complex is disguised on the
rear (bearing the same spatial relationship to the mosque as that
of 'Alishah) by the presence of the largest mausoleum in Cairo and
one of the Islamic world's biggest dome chambers, dominating the
square in front of the Mamluk sultans' palaces in the citadel. This
massive exterior (Figure 10.8) led Sultan Selim upon seeing it in
1517 to exclaim 'this is a great castle',[51] and indeed the fabric was
regularly used in the later fourteenth and fifteenth centuries as a
base from which to launch attacks on the citadel opposite, with
the result that the staircases to the roof were knocked down in an
attempt to prevent it from being used as such.[52] Large pockmarks
caused by cannonballs are still visible in the stonework of the
façade of Sultan Hasan's complex that faces the citadel (Figure
10.8). They are paralleled by those to be seen on the exterior of
the 'Alishah mosque (Figure 10.1), for it too was converted into a
citadel, having served as an arsenal for part of the Safavid period
and for most of the nineteenth century.[53] With its 10.4 m thick
walls, it is not surprising that the cannonballs had little effect on
it. Indeed, although it has been recently transformed into Tabriz's
musalla,[54] it is still popularly known in the town as the *arg*
(fortress).

Figure 10.8 *Cairo, complex of Sultan Hasan, exterior.*
Photo: Bernard O'Kane.

[Handwritten Arabic manuscript text - 24 lines of Arabic script that are not clearly legible for accurate transcription]

Figure 10.9 *Badr al-Din Al-'Aini, 'Iqd al-juman fi ta'rikh ahl al-zaman, Istanbul, Ahmed III Ms 2912/4, f. 358.*

Both buildings also had bazaars attached to them.[55] This was sound economic practice in that their revenue would be part of the complexes' endowments. Ironically, although Taj al-Din feared execution he succumbed to a natural death and was buried in his mausoleum behind the mosque.[56] Sultan Hasan, however, never occupied the majestic mausoleum which he had built for himself; the exact circumstances of his death after his imprisonment remain unknown. Despite the five years in which Sultan Hasan's complex was being built it remained unfinished at his death,[57] a case of 'vaulting ambition which o'erleaps itself' – an even more apt epithet for the mosque of 'Alishah.

Appendix

منها و دفن في مدينته و انشاء جامعا بتبريز و بناه ببناء لا يقدر احد ان يبنى مثله و بنى بجانبه حمامين
في اقرب ما يكون و قال صاحب النزهة لما سافر الأمير ايتمش المحمدي الي ابي سعيد في الرسليه
كان معه دواداره و هو شاب حسن ذكي ذكاء مفرط و كان يكتب مليحاً و لما دخلوا تبريز وراى هذا
الجامع كتب صفته و أتى به إلى القاهره فنقلت عنه ديوانه لما أراد أن يبني هذا الجامع ركب و أخذ معه
المهندسين و أشار ببناء هذا الجامع بباب من ابواب تبريز يعرف بباب خربندا و امر ان يكون بهندسته
و علوه علي منوال ايوان كسرى و زاد فيه عنه علوى عشرة اذرع و كذلك فى سعته وعمل في وسطه
بحيره سعتها مائة و خمسون ذراعا و لها اربعة اركان و في وسطها قبه مثمنه مركبه علي مصطبه
مربعه كل ربع منها علي صوره سبع تقلب منه الماء إلي البحيره و في وسطها فرارتان يصعد منها ماء
عظيم علي قلة المياه في التبريز و في البحيره اربعه مراكب و جميع جوانب البحيره مرخم برخام يسمى
الموت و الزم الوزير المعمار أن يجعل في كل ربع فى البحيره ثلاثه احجار وعرض كل حجر مقدار
ثلاثة و عشرين شبرا و كان سعة الجامع اربعمأية زراع مثل في مثل و في كل ربع منه رواق و بين كل
رواقين عامود و ان من العمد المثمنه قطعه واحده و قواعد ها لون اليشم و طول كل عامود أثنى عشر
ذراعا و نيف و علي كل عامود طاقه معقوده و جميعها منقوشه بالذهب و فيه مأذنتان علو كل واحده
سبعون ذراعا و نيف و هي حلزون و وابر هذا الجامع شبابيك نحاس نيف عن ثمانين شباكا طول شباك سبعة
ازرع في عرض خمسه و في كل شباك مائتي اكره جميعها مطعمه بنقوش بالذهب و الفضه و القبله التي
يصلي فيها الامام قبه و قائمتان من النحاس الأندلسي مرصعه منقوشه بصنعه مفخره بالذهب و الفضه
و عمل علي كل باب من أبواب الجامع و هى اربعه ابواب سوق و دكاكين و علق فيه انواع القناديل
بسلاسل من النحاس المنقوش بالذهب و الفضه و قال صاحب النزهة و نقل لى مجد الدين السلامي ان
الوزير لما شرع في عمارة هذا الجامع علي هذا الوجه قلت له يا مولانا هذا يريد امواالا بغير حساب
فقال يا مجد الدين قاعده ملوك المغل إذا نقموا علي وزير هم ذخذ المال ثم القتل فصرف المال في ذخيره
بقى له عند الله عز و جل و ذكرا عند الناس خير .

Notes

1. In the past few years, as part of the conversion of the building and the space in front into the *musalla* of the city, part of the eastern wall of the *qibla ayvan* has been knocked down to make it symmetrical with that on the west. This chapter is based on a presentation originally given at a conference on the art of the Mongols, a subject dear to Sheila Blair's heart, at Edinburgh University in 1995.
2. Abu Bakr al-Qutbi Ahri, *Tarikh-i Shaykh Uvays*, ed. Iraj Afshar (Tehran, 1389/2010), p. 210 (printed text), f. 77a (facsimile). I am most grateful to Charles Melville for checking the reference for me.
3. Hamd Allah Mustawfi, *Nuzhat-qulub*, ed. and trans. Guy Le Strange

(London, 1918–19), text, pp. 76–7, trans. p. 80. The word used for cubit is *gaz*.

4. Ibn Battuta, *The Travels of Ibn Battuta A.D. 1325–1354*, trans. Hamilton A. R. Gibb, 3 vols (Cambridge, 1958–71), vol. 2, p. 345. As Ibn Battuta qualifies the term *qashani* by the Maghribi term *zalij*, it is clear that he meant tile mosaic. The oft quoted description by Robert Ker Porter, *Travels in Georgia, Persia, Armenia, Ancient Babylonia, etc.*, 2 vols (London, 1821), vol. 1, p. 222, of the very elaborate tilework of what he calls the mosque of 'Alishah is probably that of the Qara Quyunlu Muzaffariyya complex (the Blue mosque); he gives a separate description (loc. cit.) of the 80 feet high brick *arg* which was used as an arsenal.

5. *A Narrative of Italian Travels in Persia*, trans. and ed. Charles Grey (London, 1873), pp. 167–8.

6. Hafiz Husayn Karbala'i, *Rawdat al-jinan wa jannat al-jinan*, ed. J. Sultan Karbala'i, 2 vols (Tehran, 1349/1970), vol. 1, pp. 496–7. This is more explicit on the existence of the mausoleum than the earlier sources: Hamd Allah Mustawfi, *Zafarnama*, British Library, London, Or. 2833, f. 730a: *bi-pahlu-yi jami'*; Hafiz Abru, *Zayl-i jami' al-tavarikh-i Rashidi*, ed. Khanbaba Bayani (Tehran, 1350/1971), p. 162.

7. Vladimir Tiesenhausen, 'O Mecheti Alishakha v Tebrizi', *Zapiski Vostochnago Otdileniya Imperatorskago Russkago Arkheologicheskago Obshchestva* I (1886), pp. 115–18.

8. Arthur Upham Pope, 'Islamic architecture. H. Fourteenth century', in Arthur U. Pope and Phyllis Ackerman (eds), *A Survey of Persian Art* (London and New York, 1939), pp. 1056–61.

9. Donald N. Wilber, *The Architecture of Islamic Iran: The Il Khanid Period* (Princeton, 1955), cat. no. 51. The account of Keramatallah Afshar, 'Arg-e 'Ališah', *Encyclopaedia Iranica*, vol. 2, pp. 396–7, is closely based on this and the source in n. 6.

10. Badr al-Din al-'Aini, *'Iqd al-juman fi tarikh ahl al-zaman*, Istanbul, Ahmed III MS, f. 358a. I am most grateful to, initially, Donald Little, and more recently, Amalia Levanoni, for providing me with a copy of this, to Elizabeth Sartain and Bahia Shehab for help in reading and translating it, and to Dalia Alnashar for typing it. The background to the embassy of Aytamish is explored in Donald P. Little, 'Notes on Aitamiš, a Mongol Mamluk', in Ulrich Haarmann and Peter Bachmann (eds), *Die islamische Welt zwischen Mittelalter und Neuzeit, Festschrift für Hans Robert Roemer zum 65. Geburtstag* (Wiesbaden, 1979), pp. 387–401.

11. This, as pointed out by Little, 'Notes on Aitamiš', p. 397, is not Ibn Duqmaq's *Sahib nuzhat al-anam*, as was thought previously, but al-Yusufi's *Sahib al-nuzha*.

12. The Arabic text used by Tiesenhausen ('O Mecheti', p. 116) adds 'and width' as well.

13. The Persian Mongol historians Vassaf (n. 32) and Mustawfi (*Zafarnama*, f. 694a, describing the Shanb-i Ghazan) mention marble so frequently in their accounts of the most prestigious buildings that it may have become somewhat of a cliché; but this mention of a specific type makes it a more reliable source.

14. This is unlikely to be anything so obvious as the well-known examples of the Great and Abu Dulaf mosques at Samarra. As no other spiral minarets are known from medieval Iran, probably spiral decoration is indicated: it is found on several fourteenth-century Iranian minarets

(for example, at Ashtarjan, Du Minar Dardasht and Bagh-i Qush Khana, Isfahan; see Wilber, *Architecture*, pls 91, 158, 161).

15. The earlier sources mistakenly refer to the dimensions of the minarets as being 70 × 5 cubits, because of the omission in Tiesenhausen's text. We therefore only know that they were 70 cubits (c. 32.34 m) high. We do not know their placement: flanking the *qibla ayvan* or an entrance *ayvan*, or at the corners of the mosque are all possibilities.

16. Round windowpanes were used in Iran as early as the Sasanian period. Other examples are known from Samarra and medieval Nishapur: Jens Kröger, *Nishapur: Glass of the Early Islamic Period* (New York, 1995), pp. 184–5.

17. This must refer to the semi-dome of the *mihrab* niche. The engraving of Chardin shows the *ayvan* as having a semi-dome at the *qibla* end: Pope, 'Islamic architecture', p. 1060, fig. 381; pl. 1. Confirmation of this is also provided by al-Matraqi's illustration of Tabriz, where on the south of the city (the right of the painting) the monument is shown as a tall half-dome stuck on to the end of a lower wall with windows. No indication is given of a courtyard, and although this is not evidence that it definitely did not exist, it may already have disappeared by this stage (*Bayan-i manazil-i safar-i 'Iraqayn*, Istanbul University Library, T 5964, dated 944/1537–8, reproduced in Albert Gabriel, 'Les étapes d'une campagne dans les deux 'Irak', *Syria* (1928), pl. LXXVII).

18. Wilber plausibly interprets this as a reference to a lustre *mihrab*: *Architecture*, p. 148.

19. The merchant who was an intermediary in previous peace negotiations between 'Alishah and Karim al-Din Kabir, the Mamluk *nazir al-khass* (controller of the privy funds): Little, 'Notes', p. 396.

20. I have assumed that the common cubit (*dhar' al-'amma*) of 0.462 m was being referred to: on Mamluk metrology, see William Popper, *Systematic Notes to Ibn Taghrî Birdî's History of Egypt*, University of California Publications in Semitic Philology XVI (Berkeley, 1957), p. 33. This is perhaps more likely than the slightly larger building or work cubit of 0.5775 m (ibid., pp. 33, 35) since another passage specifically refers to the work cubit when describing a minaret: see below, n. 44.

21. Sheila Blair has shown by using the known height of the mausoleum Öljeitü at Sultaniyya that the cubit used by Hafiz Abru, based on figures taken from Hamd Allah Mustawfi (in his *Zafarnama*, f. 711a), was equivalent to 0.42 m: 'The Mongol capital of Sultaniyya, "The Imperial"', *Iran* 24 (1986), p. 143.

22. I am most grateful to Professor Sadegh Mirzaabolghasemi of Shiraz University for obtaining a copy of this from the Asia Institute Archives.

23. For example, the interior of the Bastam tomb tower: Robert Hillenbrand, 'The flanged tomb tower at Bastam', in Chahryar Adle (ed.) *Art et société dans le monde iranien* (Paris, 1982), fig. 86; for a smaller scale prototype see the lower arch of a gravestone dated 533/1139 in the Yazd Friday mosque: Iraj Afshar, *Yadgarha-yi Yazd, Vol. 2: Shahr-i Yazd* (Tehran, 1354/1976), pl. 32–15/2.

24. The table in Charles Melville, 'Historical monuments and earthquakes in Tabriz', *Iran* 19 (1981), p. 167, shows that the next earthquake after that of 704/1304 (dating from before the mosque's inception) did not occur until 746/1345.

25. See n. 16 above.

26. As, for example, in the Great Mosque of Samarra and, for the most part, in the mosque of Ibn Tulun in Cairo.

27. The dangers of this with regard to Sasanian architecture have been highlighted by Lionel Bier, 'The Sasanian palaces and their influence in early Islam', *Ars Orientalis* 23 (1993) (published 1994), pp. 57–66.

28. Pope, 'Islamic Architecture', p. 1058, asserted that the mosque had a four-*ayvan* plan, but does not provide any supporting evidence for his statement.

29. Illustrated respectively in André Godard, 'Le masdjid-é Djum'a de Niriz', *Athar-é Iran* I (1936), fig. 114; Galina A. Pugachenkova, *Puti Razvitiya Arkhitektury Iuzhnogo Turkmenistana pory Rabovladeniya i Feodalizma*, *Trudy Iuzhno-Turkmenksoi Arkheologicheskoi Kompleksnoi Ekspeditisii* (Moscow, 1958), vol. 6, p. 245; Antony Hutt and Leonard Harrow, *Iran 1* (London, 1977), pl. 78 (despite the caption, the *ayvan* illustrated is the only one of the mosque).

30. 'Abd al-'Ali Karang, *Athar-i bastani-yi Azarbayjan* (Tehran 1351/1972), vol. 1, pp. 247, 249.

31. In view of 'Alishah's background as a jeweller, Robert Hillenbrand has suggested to me that, like the twelfth-century cathedral at Cefalù in Sicily, actual semi-precious stones such as agate or jasper might have been inlaid into the polygonal fields. However, although it is difficult to be sure of the scale of the polygons from the photographs, they seem rather large to have accommodated semi-precious stones. It has been recorded that the doors and walls of 'Alishah's buildings at Sultaniyya were studded with gold, jewels and pearls, and that the pavements shone with rubies, turquoise, emeralds and other jewels, although it is difficult to view this as other than hyperbole: Abu'l-Qasim 'Abd Allah b. Muhammad al-Qashani, *Tarikh-i Uljaytu*, ed. Matin Hambly (Tehran, 1348/1969), pp. 47, 178.

32. As related by the anonymous merchant, in Grey, p. 168. Shah Tahmasp continued the practice of boating in the pool, which was then part of the royal palace, while the main *ayvan* of the mosque seems to have been converted into a store for munitions: Michele Membré, *Mission to the Lord Sophy of Persia (1539–1542)*, trans. Alexander H. Morton (London, 1993), p. 30. If this was indeed the pool of the mosque of 'Alishah it had been partially filled in, Membré describing it as a square of 38 ells (c. 43.5 m) each side. In 1673 Chardin reported that the *qibla ayvan* was used as a mosque again: *Les voyages du Chevalier Jean Chardin en Perse et autres lieux de l'Orient*, ed. Louis-MathieuLanglès (Paris, 1811), vol. 2, p. 323. By the nineteenth century it served, and was known as, the *arg* (citadel): see n. 4 above.

33. The most reliable guide to this is Sheila Blair, 'Ilkhanid architecture and society: an analysis of the endowment deed of the Rab'-i Rashidi', *Iran* 22 (1984), pp. 67–90.

34. Al-Qashani, *Tarikh*, pp. 121–2.

35. Shihab al-Din Vassaf, *Tarikh-i Vassaf* (Tabriz, 1959), p. 541.

36. Ibid., pp. 540–1; Khvandamir, *Tarikh-i habib al-siyar*, 4 vols (Tehran, 1333/1954), vol. 4, p. 193.

37. Al-Qashani, *Tarikh*, p. 109.

38. Ibid., p. 47, 122, 178; Blair, 'The Mongol capital', p. 147.

39. Al-Qashani, *Tarikh*, pp. 194–5; Ann K. S. Lambton, *Continuity and Change in Medieval Persia: Aspects of Administrative, Economic and Social History, 11th–14th Century* (Albany, 1988), pp. 56–7.

40. Mustawfi, Hamd Allah, *Tarikh-i guzida*, ed. 'Abd al-Husayn Nava'i (Tehran, 1362/1983), p. 613.

41. See n. 1 above.

42. Mustawfi, *Tarikh*, p. 616. In the two fifteenth-century histories of Yazd, Ja'far b. Muhammad b. Hasan Ja'fari, *Tarikh-i Yazd*, ed. Iraj Afshar (Tehran, 1342/1965), p. 120 and Ahmad b. Husayn b. 'Ali Katib, *Tarikh-i jadid-i Yazd*, ed. Iraj Afshar (Tehran, 1345/1966), pp. 142–3, the story is recounted that 'Abd al-Qadir, who built a madrasa in Yazd, accused 'Alishah of fiddling the state accounts in the treasury in order to get the funds to build his mosque; 'Alishah poisoned himself as a result, his accuser died at the same time and both were buried on the same day. The account is certainly false, but it is a reflection of the huge sums that must have been expended on the mosque, and the prestige which it still enjoyed in the fifteenth century.

43. For more on this subject, see Bernard O'Kane, 'Monumentality in Mamluk and Mongol art and architecture', *Art History* 19 (1996), pp. 499–522.

44. Al-Qashani, *Tarikh*, p. 87.

45. Ibid., pp. 87–8.

46. The arch at Ctesiphon is 25.63 m wide, 43.72 m deep (48.40 m including the frontal screen) and 25.62 m high: Friedrich Sarre and Ernst Herzfeld, *Archäologische Reise im Euphrat- und Tigris-Gebiet* (Berlin, 1911–20), vol. 2, p. 74. The *ayvan* of 'Alishah was 30.15 m wide and 58.7 m deep; Wilber estimated its height to the springing of the arch as 25 m.

47. As the *'Iqd al-juman* also informs us on the authority of al-Yusufi's *Sahib al-nuzha*: Little, 'Notes', pp. 397–8.

48. Ibid., p. 398, n. 69. The text of al-Yusufi mentions only that he was the builder of a mosque for 'Alishah, but it is certainly that which is the subject of this chapter. The minaret at Fishat al-Manara was singled out by al-Yusufi as being spiral on the interior (*'alazun min dakhiliha*). As all Mamluk minarets with interior staircases were already spiral, it is strange why this characteristic should be mentioned. It is extremely unlikely that anything resembling the minaret of Ibn Tulun is indicated. Al-Yusufi had already quoted the *dawadar*'s description of the minarets of 'Alishah's mosque as being spiral, which we interpreted above (n. 14) as referring to spiral decoration. Ibn Taghribirdi also described the minaret of the complex of Tashtamur (735/1334) in the northern cemetery of Cairo as spiral (Michael Meinecke, *Die mamlukische Architektur in Ägypten und Syrien (648/1250 bis 923/1517)*, Abhandlungen des Deutschen Archäologischen Instituts Kairo, Islamische Reihe, Band 5, 2 vols (Glückstadt, 1992), vol. 2, p. 167); the remains of the mausoleum of this complex display tilework, and it is likely that here too Ibn Taghribirdi was describing a minaret with spiral tile mosaic decoration.

49. The school which he founded and its surviving examples are analysed in Michael Meinecke, 'Die mamlukischen Fayencemosaikdekorationen: eine Werkstätte aus Tabriz in Kairo (1330–1350)', *Kunst des Orients* 11 (1976–7), pp. 85–144.

50. O'Kane, 'Monumentality', p. 510.

51. Quoted in Nasser Rabbat, 'The iwans of the madrasa of Sultan Hasan', *ARCE Newsletter* 143–4 (1988–9), p. 6.

52. Examples abound in Ibn Taghribirdi, *al-Nujum*. For example, in 1389 in a battle between the Mamluk amirs Yalbugha and Mintash, the latter occupied the complex of Sultan Hasan, leading to 'a constant discharge

of missiles from the Citadel upon the Mosque of Hasan and from the Mosque of Hasan upon the Citadel': trans. William Popper as *History of Egypt 1382–1469 A.D.*, University of California Publications in Semitic Philology (Berkeley, 1954), vol. 13, p. 72. Accordingly, in 1390 Sultan Barquq ordered the stairway demolished: ibid., p. 122. Although it may be doubted whether the missile throwers erected on the roof of the Sultan Hasan complex would have reached the top of the citadel, they would certainly have been within range of the stables at its foot. Since after 1377 this area became the residence of some of the most important amirs, it was obviously a strategic target: Amalia Levanoni, 'The Mamluk conception of the sultanate', *International Journal of Middle East Studies* 26 (1994), p. 384.

53. Membré, *Mission*, p. 30.
54. The place of festival prayer: see Robert Hillenbrand, 'Musalla', *Encyclopaedia of Islam*, 2nd. ed., vol. 7, pp. 658–60.
55. The existence of a *qaysariyya* (a lock-up bazaar) attached to the northern end of the complex of Sultan Hasan is noted in Michael Rogers, *The Spread of Islam* (Oxford, 1976), p. 102. It is not mentioned in the original *waqfiyya* but was added by the administrator of the endowment some time after Sultan Hasan's death: Abdallah Kahil, *The Sultan Hasan Complex in Cairo 1357–1364: A Case Study in the Formation of Mamluk Style* (Beirut, 2008), p. 39.
56. See n. 6 above. Hamd Allah Mustawfi, *Zafarnama*, f. 730a: *bi-pahlu-yi jami'*; Hafiz Abru, *Zayl-i jami'*, p. 162.
57. The decoration, particularly of the entrance portal and of the main courtyard, was considerably curtailed.

Bibliography

Afshar, Iraj, *Yadgarha-yi Yazd, Vol. 2: Shahr-i Yazd* (Tehran, 1354/1976).

Afshar, K., 'Arg-e 'Ališah', *Encyclopaedia Iranica*, Vol. 2, pp. 396–7.

Ahri, Abu Bakr al-Qutbi, *Tarikh-i Shaykh Uvays*, ed. Iraj Afshar (Tehran, 1389/2010).

Anon., *A Narrative of Italian Travels in Persia*, trans. and ed. C. Grey (London, 1873).

Al-'Aini, Badr al-Din, '*Iqd al-juman fi tarikh ahl al-zaman*, Istanbul, Ahmed III Ms 2912/4.

Bier, L., 'The Sasanian palaces and their influence in early Islam', *Ars Orientalis* 23 (1993) (published 1994), pp. 57–66.

Blair, Sheila, 'Ilkhanid architecture and society: an analysis of the endowment deed of the Rab'-i Rashidi', *Iran* 22 (1984), pp. 67–90.

Blair, Sheila, 'The Mongol capital of Sultaniyya, "The Imperial"', *Iran* 24 (1986), pp. 139–51.

Les voyages du Chavalier Jean Chardin en Perse et autres lieux de l'Orient, ed. Louis-Mathieu Langlès (Paris, 1811).

Gabriel, Albert, 'Les étapes d'une campagne dans les deux '"Irak"', *Syria* (1928), pp. 328–49.

Godard, André, 'Le masdjid-é Djum'a de Niriz', *Athar-é Iran* I (1936), pp. 163–72.

Hafiz Abru, *Zayl-i jami' al-tavarikh-i Rashidi*, ed. Khanbaba Bayani (Tehran, 1350/1971).

Hillenbrand, Robert, 'The flanged tomb tower at Bastam', in Chahryar Adle (ed.), *Art et société dans le monde iranien* (Paris, 1982), pp. 237–60.

Hillenbrand, Robert, 'Musalla', *Encyclopaedia of Islam*, 2nd ed., Vol. 7, pp. 658–60.

Hutt, Antony and Leonard Harrow, *Iran 1* (London, 1977).

Ibn Battuta, *The Travels of Ibn Battuta A.D. 1325–1354*, trans. Hamilton A. R. Gibb, 3 vols (Cambridge, 1958–71).

Ibn Taghribirdi, *al-Nujum*, trans. William Popper as *History of Egypt 1382–1469 A.D.*, University of California Publications in Semitic Philology, Vol. 13 (Berkeley, 1954).

Ja'fari, Ja'far b. Muhammad b. Hasan, *Tarikh-i Yazd*, ed. Iraj Afshar (Tehran, 1342/1965).

Kahil, Abdallah, *The Sultan Hasan Complex in Cairo 1357–1364: A Case Study in the Formation of Mamluk Style* (Beirut, 2008).

Karang, 'Abd al-'Ali, *Athar-i bastani-yi Azarbayjan*, Vol. 1 (Tehran 1351/1972).

Karbala'i, Hafiz Husayn, *Rawdat al-jinan wa jannat al-jinan*, ed. Ja'far S. Qurra'i, 2 vols (Tehran, 1349/1970).

Katib, Ahmad b. Husayn b. 'Ali, *Tarikh-i jadid-i Yazd*, ed. Iraj Afshar (Tehran, 1345/1966).

Khvandamir, *Tarikh-i habib al-siyar*, 4 vols (Tehran, 1333/1954).

Kröger, Jens, *Nishapur: Glass of the Early Islamic Period* (New York, 1995).

Lambton, Ann K. S., *Continuity and Change in Medieval Persia: Aspects of Administrative, Economic and Social History, 11th–14th Century* (Albany, 1988).

Levanoni, Amalia, 'The Mamluk conception of the Sultanate', *International Journal of Middle East Studies* 26 (1994), pp. 373–92.

Little, Donald P., 'Notes on Aitamiš, a Mongol Mamluk', in Ulrich Haarmann and Peter Bachmann (eds), *Die islamische Welt zwischen Mittelalter und Neuzeit, Festschrift für Hans Robert Roemer zum 65. Geburtstag* (Wiesbaden, 1979), pp. 387–401.

Meinecke, Michael, 'Die mamlukischen Fayencemosaikdekorationen: eine Werkstätte aus Tabriz in Kairo (1330–1350)', *Kunst des Orients* 11 (1976–7), pp. 85–144.

Meinecke, Michael, *Die mamlukische Architektur in Ägypten und Syrien (648/1250 bis 923/1517)*, Abhandlungen des Deutschen Archäologischen Instituts Kairo, Islamische Reihe, Band 5, 2 vols (Glückstadt, 1992).

Melville, Charles, 'Historical monuments and earthquakes in Tabriz', *Iran* 19 (1981), pp. 159–77.

Membré, Michele, *Mission to the Lord Sophy of Persia (1539–1542)*, trans. Alexander H. Morton (London, 1993).

Mustawfi, Hamd Allah, *Zafarnama*, British Library, London, Or. 2833.

Mustawfi, Hamd Allah, *Nuzhat al-qulub*, ed. and trans. Guy Le Strange (London, 1918–19).

Mustawfi, Hamd Allah, *Tarikh-i guzida*, ed. 'Abd al-Husayn Nava'i (Tehran, 1362/1983).

O'Kane, Bernard, 'Monumentality in Mamluk and Mongol art and architecture', *Art History* 19 (1996), pp. 499–522.

Pope, Author Upham, 'Islamic Architecture. H. Fourteenth century', in Arthur U. Pope and Phyllis Ackerman (eds), *A Survey of Persian Art* (London and New York, 1939), pp. 1056–61.

Popper, William, *Systematic Notes to Ibn Taghrî Birdî's History of Egypt*, University of California Publications in Semitic Philology, Vol. 16 (Berkeley, 1957).

Porter, Robert Ker, *Travels in Georgia, Persia, Armenia, Ancient Babylonia, etc.*, 2 vols (London, 1821).

Pugachenkova, Galina A., *Puti Razvitiya Arkhitektury Iuzhnogo Turkmenistana pory Rabovladeniya i Feodalizma, Trudy Iuzhno-Turkmenksoi Arkheologicheskoi Kompleksnoi Ekspeditisii*, Vol. 6 (Moscow, 1958).

Al-Qashani, Abu'l-Qasim 'Abd Allah b. Muhammad, *Tarikh-i Uljaytu*, ed. Matin Hambly (Tehran, 1348/1969).

Rabbat, Nasser 'The iwans of the madrasa of Sultan Hasan', *ARCE Newsletter* 143-4, (1988-9), pp. 5-8.

Rogers, Michael, *The Spread of Islam* (Oxford, 1976).

Sarre, Friedrich and Ernst Herzfeld, *Archäologische Reise im Euphrat- und Tigris-Gebiet* (Berlin, 1911-20).

Tiesenhauzen, Vladimir, 'O Mecheti Alishaha v Tebrizi', *Zapiski Vostochnago Otdileniya Imperatorskago Russkago Arkheologicheskago Obshchestva* 1 (1886), pp. 115-18.

Vassaf, Shihab al-Din, *Tarikh-i Vassaf* (Tabriz, 1959).

Wilber, Donald N., *The Architecture of Islamic Iran: The Il Khanid Period* (Princeton, 1955).

CHAPTER ELEVEN

Once More Cosmophilia: Facing the Truth, Later

Simon O'Meara

> [The minaret decorators] firmly maintained that there was no symbolic significance to the patterns they chose, but rather they were simply a part of the aesthetic heritage of their city.
>
> Trevor Marchand,
> *Minaret Building and Apprenticeship in Yemen*

WITH THIS EPIGRAPH, my allegiance to Blair and Bloom's understanding of ornament, as well as to their neologism, *cosmophilia*, is clear. Like them, I see no reason to think that ornament, when taken as the sum of its parts, is denotative.[1] I see no reason to think it is a syntagmatic symbolic system: a language. If it is a language, then it is a private language; and in that sense, as per Wittgenstein, it is not a language at all; there being no such thing as a *private* language.[2] As per Blair and Bloom, thus, ornament is meaningless. The matter is otherwise at the connotative level, however, such that the recent claim that late sixteenth-century Ottoman ornament helped define the empire's territorial borders is plausible, even though the absence of proof for this claim means that it is also conjectural.[3] A historical record confirming the interpretation is required.[4]

For Blair and Bloom, ornament serves 'to stir appreciation and pleasure in the eye of the beholder and encourage him or her to linger, think and delight'.[5] Although some scholars have imputed to Blair and Bloom a functionless, purely aesthetic view of ornament, manifestly, on the basis of these words alone, that is not their position.[6] Ornament functions to invite contemplation and delight. Might it function in other ways, too? This contribution to the Festschrift argues that, in Islamic art at least, one of these other ways is the deferral of the moment when a beholder's sight attains its object.

To make this argument requires moving from the hermeneutic grounds of Islamic art history, where the final arbiter of the

interpretative act is primarily textual (what historical records can be made to show regarding this or that artistic work), to the grounds of Islamic visual studies. Here, the final arbiter is vision and its discursive counterpart, visuality. This modern term, and the even more modern term, visual studies, merit further discussion.

Islamic visuality

The term 'visuality' is of relatively recent coinage, first found in a work by Thomas Carlyle (d. 1881).[7] It has sometimes been used by Islamic art historians, but without their giving a definition.[8] In one or two of these usages, it would seem to be a synonym of the term, visual culture, a parallel that would echo the usage of one of the foremost students and theorists of visuality, W. J. T. Mitchell.[9] This leaves us, then, with the meaning of visual culture.

As explained by Mitchell, the study of visual culture is the equivalent of 'ordinary language philosophy [in that] it looks at the strange things we do while looking, gazing, showing and showing off, such as hiding, dissembling, and refusing to look'.[10] For Mitchell, this explanation means at least two things. First, that the study of visual culture, what is often called visual studies,[11] entails, *inter alia*, 'a meditation on blindness, the invisible, the unseen, the unseeable, and the overlooked'.[12] Second, that this study cannot be limited to the 'study of images or media, but extends to everyday practices of seeing and showing, especially those that we take to be immediate or unmediated'.[13] Attempting to encapsulate this capacious field of study, Mitchell offers the chiastic aphorism that visual studies has for its remit, or object of study, *the social construction of the visual field and the visual construction of the social field*.[14] Visuality and visual culture are the two interchangeable names for this object of study; Islamic visuality and Islamic visual culture, the names for when the object pertains to Islam. Because it names this object of study, there is no plural: there are not Islamic visualities, for example, which is not to say that the visuality in question cannot comprise a number of different, historical scopic regimes. The visuality of the modern West, for example, is substantially informed by the scopic regime of what Martin Jay calls Cartesian perspectivalism, but it is not limited to it.[15] Speaking quickly, one might conjecture that two equivalent historical regimes informing Islamic visuality would involve the culturally deep-rooted concepts of modesty and the evil eye. Scopic regimes such as these act on the human organism's physiological drive to see: its scopic drive.

The benefit of pursuing Islamic visual studies in addition to Islamic art history remains to be widely accepted. The present chapter endeavours to help achieve such acceptance, and to open up ways of thinking about Islamic visuality.

Face to face

If Mitchell is a major voice in visual studies, there are others, including Nicholas Mirzoeff, editor of the *The Visual Culture Reader*. More obviously political than Mitchell, Mirzoeff nevertheless agrees with him that at the heart of visual studies lies a concern with the transverse look between seer and seen: the face-to-face encounter with the Other.[16] As Mitchell expresses this concern: 'Visual culture ... find[s] its primal scene, then, in what Emmanuel Levinas calls the face of the Other (beginning, I suppose, with the face of the Mother): the face-to-face encounter.'[17]

In the present attempt to explore the topic of Islamic visuality with regard to ornament, it is fortunate that this primal scene is well treated in the literature of Islam, being ultimately the beatific vision.

The face of God

In the Qur'an, the expression, 'seeking the face of God', is applied to those who act piously without any any thought of personal gain. It occurs eight times, and is the equivalent of an earlier, Old Testament expression.[18] In the Hadith, it occurs with even greater frequency.[19]

Although the Qur'an once states that seeing God is something the elect will experience on Judgement Day (Q. 75:22–3), nowhere does it state that seeing the face of God is a possibility for humankind, whether in the next world or, especially, this world.[20] This usage is followed in the Sunni Hadith, too;[21] but as we shall shortly see, one also finds there the vision of God's face offered as one of Paradise's greatest rewards. For the Sufis, for whom seeing God's face in this life was sometimes accepted as humanly possible,[22] from approximately the end of the tenth century even they tended to agree that, if such seeing occurred at all, it did so via the perception of the heart, not the vision of the eyes.[23]

As just noted, according to the Hadith, in Paradise the eye is unrestricted, taking in everything, including God's face.[24] A particularly developed narrative of this beatific vision is recounted in a work attributed, probably erroneously, to the Egyptian scholar, al-Suyuti (d. 1505), who attributes the traditions it comprises to the Prophet's cousin, Ibn 'Abbas (d. 667).[25] All but one of these traditions also feature in the course of two versions of a slightly differently ordered but otherwise almost identical narrative recorded in a work entitled *The Eyes' Delight*. This work is attributed, probably erroneously, to the tenth-century preacher and moralist Abu'l-Layth al-Samarqandi (d. 983?).[26] Below is an abridgement of the version attributed to al-Suyuti. Even abridged, the excerpt is still long, but as I shall be referring to it again, I need to quote it in some detail.

[First,] the reception is preceded by a procession of the Blessed, led by Adam, Muhammad and the other prophets. In the blink of an eye, the procession traverses the span of a silver palace (*qasr*) the length of 1,000 years' march, and then that of a golden palace of the same dimensions. Just as instantly, the procession next traverses the 3,000-year span of an emerald palace; the 4,000-year span of a ruby palace; the 5,000-year span of a sapphire palace; the 6,000-year span of a chrysolite palace; and lastly four more palaces of various precious stones, each up to 10,000 years long. The procession then glimpses, at a distance of 10,000 years, the lights of the divine enclave which, when reached, proves to be a green meadow 1,000 years by 1,000 years, with innumerable palaces, each with the name of one of the elect inscribed on its door. Finally, the procession reaches an even larger meadow, with two rows of trees, each tree bearing 70,000 palaces; within each palace are 70,000 couches of gold, each 300 yards long ...

[Second,] a most sumptuous banquet then proceeds ...

[Third,] the Lord says to them: My worshippers, have you any other wishes? And they say: Yes, it remains for us to see your gracious Face. The Lord then says: O Cherub, lift the greatest veil between me and my worshippers! When this is lifted [the worshippers] remain looking at the Face of Truth for three hundred years.[27]

The face of the king

In the present life, the closest one could come to seeing with one's eyes the face of the absolute Other, God, was at the royal palace: the face of the ruler. One gets a sense of the societal drive to experience this regal vision in Benjamin of Tudela's (*fl.* mid-twelfth century) account of a pre-Hajj ceremony that he witnessed in Baghdad. He relates how pilgrims would annually gather below a palace window in order to petition the caliph to show them 'the effulgence of [his] countenance' and to bestow on them his blessings. The pilgrims' petitions were rewarded with the sight and touch of the ruler's robe only: its lowered hem.[28]

The issue of the divine, semi-divine or sacrosanct nature of rulers in the Muslim world throughout history is beyond the scope of the present chapter.[29] Instead, I would like to focus on a feature shared by these rulers, namely, their otherness, even in the cases where a dynasty's ceremonial practices involved the ruler mixing closely with their subjects, as in Safavid Iran, for example, not separating and secluding themselves, as in Ottoman Turkey, for example.[30] Seeking to experience and somehow participate in this otherness, the subjects set their faces in the direction of the ruler's face, the

face being a person's essence, at least in the Qur'an and for the Arabic-speaking world.[31] In the case of the ruler's face, it was often more than that, but a source of divine effulgence (*farr*) and/or grace (*baraka*), too.[32]

This desire to witness and somehow share in these regal emanations resulted in a ceremonial theatrics of royal revelation,[33] inspired in no small part by Byzantine and, especially, Sasanian practices.[34] Sometimes the royal revelation was full, sometimes it was partial; commonly, it was mediated by windows, broadly understood (namely, framed, often decorated openings unintended for bodily traversal).[35] Once again, the Safavids are no exception to this assertion, as evidenced by the large windows of Isfahan's ceremonial palace, the 'Ali Qapu, from which the shah would appear before his people gathered below him on the city's main square.[36]

Precisely because a ruler's residence was expected to have windows from which he could reveal or half-reveal himself, the painter of a Persian miniature located in a *Shahnama* manuscript copied in Safavid Isfahan in 1628 has counterfactually added one to God's House, the Ka'ba (Figure 11.1).[37] From it, one of Iskandar's military retinue, a beardless youth, distributes largesse to the formerly oppressed descendants of Isma'il.[38]

This play between a subject's seeking the ruler's face in his residence and seeking God's face in His residence, as just illustrated by the miniature, is further highlighted by the following historical fact. The term '*qibla*' or sacred direction, which early in Islamic history came to signify the Ka'ba alone, was used as an honorific for some Muslim rulers, from the Umayyads to the Qajars.[39] Indeed, if we accept pre-Islamic poetry as authentic, a similar usage occurred before Islam, too: as an honorific for the Sasanian emperor, Khusraw I (r. 531–79), 'the *qibla* of the ambassadors'.[40] Some of these *qibla*-referenced rulers even went so far as to render the honorific architecturally apparent, situating their throne-rooms on the axis diametrically opposite to the Ka'ba.[41] As this phenomenon has been interpreted for the 'Abbasid period, facing the caliph meant facing away from the Ka'ba, presenting it one's bottom.[42]

A Byzantine progress

As noted above, unlike seeking God's face, seeking the ruler's face was in principle achievable during one's lifetime. The stage-managed progress to the curtain-closing denouement might have been a lengthy, convoluted affair, but a full view of the enthroned ruler's face was frequently possible, even for a provincial soldier.[43] After enduring delay, sight could attain its object; just as, after enduring a different delay, that of life, and then a second delay, that of the procession to the site of the beatific vision, in Paradise sight could attain it again.

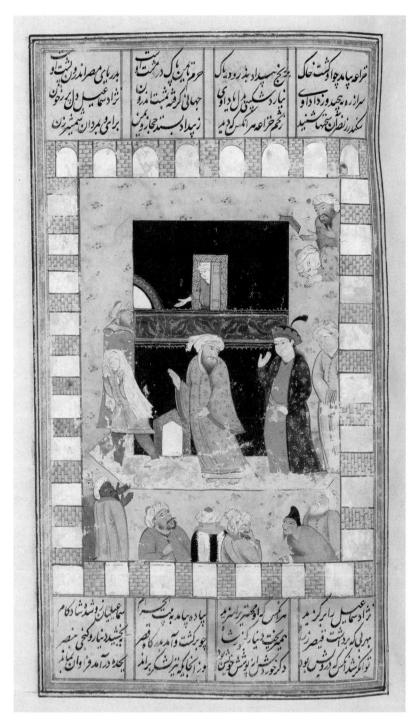

Figure 11.1 *'Iskandar at the Ka'ba', from a copy of Firdausi's* Shahnama, *produced in Isfahan in 1628, gold, gouache and ink on paper, 11.7 × 15.5 cm. Courtesy of the British Library. Add. 27258, f. 446r.*

Regarding this latter procession, it is my contention that the earlier-cited narrative recounting the paradisiacal progress is modelled on the processions of dignitaries to the audience halls of the vast, seemingly sprawling 'Abbasid palaces of Iraq. The parallels between it and, say, the celebrated account of the tenth-century Byzantine ambassadors' seemingly interminable progress through the numerous palaces comprising Baghdad's city-sized caliphal residence, the Dar al-Khilafa, for an audience with al-Muqtadir (r. 908–32) are too many for this contention to be dismissed as fanciful.[44] Short of reproducing the account in its entirety, I present an extract attentive to the spatial transitions the ambassadors experienced en route to the audience hall, but disregarding the astonishing spectacle each transition gave onto:

> [Having waited two months, the ambassadors were finally led to al-Muqtadir's residence.] They were conducted over the threshold of the great Main Gate to a palace called the Cavalry House … and then led through corridors and passageways … to a palace where there were four elephants. … They were then led to a palace containing one hundred lions. … Next, they were taken to the New Pavilion. … From here, they were conducted to the Tree Palace. … They were then led to a palace known as Paradise. … After touring twenty-three palaces, they … arrived at the presence of al-Muqtadir in the Crown [Palace]. … He was seated upon an ebony throne [on which were] the most splendid jewels, the largest of which eclipsed the daylight with its brightness.[45]

As noted by Oleg Grabar and others, across the Islamic world 'Abbasid palatial architecture became a byword for scale and much more besides, informing, for example, the description of the City of Brass in *The Thousand and One Nights*.[46] Does it tax credence to aver that this architecture, and the ceremonial staged via it, informed religious narratives, too? If not, the type of connection I suppose to subtend the material and immaterial spheres of Islam, and which is exemplified by the two foregoing procession narratives, is accounted for by scholars of material religion as follows: 'A materialized study of religion begins with the assumption that things, their use, their valuation, and their appeal are not something *added* to a religion, but rather [are] inextricable from it'.[47]

With this explanation in mind, I would further argue that the connection between the material face of the king and the immaterial face of God, which we have seen at play in this chapter, is mythically first effectuated by another material item: the veil. The imposition of this veil transforms the horizontal, earthly vector of an eye seeking the king's face to the vertical, heavenly vector of an eye seeking God's face. The veil in question belongs to Khadija, the Prophet's first wife; the moment of transformation, to a pivotal

event recorded in the Prophet's biography, the *Sira*, as identified and interpreted by the Tunisian-born psychoanalyst, Fethi Benslama. The event concerns an early moment in Muhammad's prophetic career when he was unsure if the being visiting him with words to recite was an angel or a demon. He feared demonic insanity; by discarding her veil (*khimar*), Khadija recognised the angelic truth. The visitor was Gabriel.[48]

The dynamics of sight related in the event are complex, but at their core is what Benslama provocatively notes: '[Khadija] founds the truth of the founder [of Islam]'.[49] Khadija opens the angelic heavens to Muhammad's eyes, simultaneously closing to them the abyss of demonic insanity; look heavenwards and trust, she implies. The heretofore horizontal, earthbound vector of the Prophet's sight is vertically transformed: God is welcomed in. Khadija's veil mediates this transformation. With it discarded and Khadija exposed (*tahassarat*), Gabriel, modest, disappears from the Prophet's sight, and his truth is thus revealed. No demon would have so withdrawn. However, having established the truth of the angel in this way, and thus also having founded the truth of Muhammad as God's messenger, Khadija and her veil simultaneously render the primal scene of visuality, the face-to-face encounter with the Other, an otherworldly affair. In Islam, thus, the primal scene of visuality is not just marked by Byzantine delay but, ultimately, deferral, too.[50]

Cosmophilia

All the while remembering that this chapter is written in terms of visual studies, not art history, we can now take the findings regarding the primal scene of Islamic visuality and relate them to the frequently observed phenomenon of the ubiquity of ornament in Islamic art. Oleg Grabar's observations of this phenomenon serve well. He writes:

> From ... the Dome of the Rock, all the way to Safavid mosques, the walls of Islamic monuments and the surfaces of its objects have been covered with motifs distinguishable by the fact that they so rarely reflect the physical world of men and animals. ... This tendency to overwhelm surfaces at the expense of emphasizing specific topics can properly be called ornamentation.[51]

Reflecting on this observation, Grabar immediately adds: 'Why Islamic culture developed this particular tendency is still an unresolved matter.'[52]

In the same year that Grabar published this observation and reflection, he also published additional observations and reflections on the same theme. Still tackling his conundrum as to why Islamic culture developed a tendency to overwhelm surfaces with abstract

ornament, he remarks: 'Either there was a striking cultural agree-
ment on the modalities of visual creation, or visual creation was
secondary to the realities of life, or else we are simply unable to deci-
pher the forms of the tradition.'[53] In view of the foregoing treatment
of Islamic visuality, I would argue that Grabar's first answer to his
conundrum was the correct one. I would additionally assert that this
cultural agreement was marked by delay and deferral. That is to say,
the tendency to overwhelm surfaces with non-denotational orna-
ment in Islamic art indexes this delay and deferral, and in the more
intention-minded terms of art history even serves it by suspending
the moment when sight realises its goal. The 'observer … is rarely
led from the decoration of an object to its uses', Grabar notes in the
same second article.[54] That is because, I would suggest, the eye is
held back and realisation postponed.

It would be essentialist to suppose that what defines the primal
scene of Islamic visuality is the sole explanation for the ubiquity of
ornament in Islamic art. Alfred Gell, for example, talks of decorative
patterns in general as 'sticking-points', places that are tacky to the
eye and so slow it down, even halt the eye – above all, the evil eye.[55]
This apotropaic quality of ornamentation is said to be at play in
the domestic architecture of Nishapur, for example.[56] Clearly, then,
the scopic regime referenced by the concept of the evil eye must be
considered as a second visuality-based explanation for the ubiquity
of ornament in Islamic art. And Grabar's memorable description
of the effect of this ornamentation as a 'sheath of propriety [cast]
over strife, passion and the visible world' must be considered as
a third,[57] for his description invokes the scopic regime referenced
by the concept of modesty. Even so, the argument that delay and,
ultimately, the deferral of the face-to-face encounter is an important
factor in this explanation remains. This argument can, additionally,
be tested: by finding the exception that proves the rule.

The exceptional Ka'ba

The Ka'ba's exterior is free of ornamentation, free of a 'sheath of pro-
priety'. If the tendency to overwhelm surfaces with non-denotational
ornament in Islamic art is ubiquitous, what explains the Ka'ba's
absence of the same? To answer this question, first one must dispel
the notion that the perfectly legible, thoroughly denotational *kiswa*
that robes the Ka'ba is this sheath. I have dealt with the *kiswa* at
length elsewhere, but in brief the purpose of the *kiswa* is not to cover
the Ka'ba. Although, technically speaking, the *kiswa* does indeed
cover the Ka'ba, this act of covering is similar to that of the skin that
'covers' the body. The *kiswa* traces and thus reveals the Ka'ba's form;
it does not cover it, in the sense of hide it.

What explains this exceptional absence of ornamentation on the
Ka'ba? The Qur'an explains it, when it says: 'Turn, then, thy face

54. Ibid., p. 15.
55. Alfred Gell, *Art and Agency* (Oxford, 1998), pp. 74–90.
56. Finbarr B. Flood, 'Animal, vegetal, and mineral: ambiguity and efficacy in the Nishapur wall paintings', *Representations* 133.1 (2016), pp. 33 ff.
57. Grabar, 'Art of the object', p. 16.

Bibliography

Ali, Samer, 'Praise for murder? Two odes by al-Buhturi surrounding an Abbasid patricide', in Beatrice Gruendler and Louise Marlow (eds), *Writers and Rulers: Perspectives on their Relationship from Abbasid to Safavid Times* (Wiesbaden, 2004), pp. 1–38.

Amanat, Abbas, *Pivot of the Universe: Nasir al-Din Shah Qajar and the Iranian Monarchy, 1831–1896* (London, 1997).

Asher, Catherine B., 'A ray from the sun: Mughal ideology and the visual construction of the divine', in Matthew T. Kapstein (ed.), *The Presence of Light: Divine Radiance and Religious Experience* (Chicago, 2004), pp. 161–94.

Al-Azmeh, Aziz, 'Rhetoric for the senses: a consideration of Muslim paradise narratives', *Journal of Arabic Literature* 26.3 (1995), pp. 215–31.

Al-Azmeh, Aziz, *Muslim Kingship: Power and the Sacred in Muslim, Christian and Pagan Polities* (London, 1997).

Babaie, Sussan, *Isfahan and its Palaces: Statecraft, Shiism and the Architecture of Conviviality in Early Modern Iran* (Edinburgh, 2008).

Babaie, Sussan, 'The palace', in Margaret S. Graves and Benoît Junod (eds), *Architecture in Islamic Arts: Treasures of the Aga Khan Museum* (Geneva, 2011), pp. 183–91.

Bada'uni, 'Abd al-Qadir, *Muntakhabu-t-tawarikh*, trans. George S. A. Ranking, William H. Lowe and T. Wolseley Haig, 3 vols (Calcutta, 1898–1925).

Baljon, Johannes M. S., '"To seek the face of God" in Koran and Hadith', *Acta Orientalia* 22 (1953), pp. 254–66.

Barthes, Roland, *Image Music Text*, trans. Stephen Heath (London, 1977).

Benjamin of Tudela, *The Itinerary of Benjamin of Tudela: Critical Text, Translation and Commentary*, ed. and trans. Marcus N. Adler (London, 1907).

Benslama, Fethi, 'The veil of Islam', *Journal of the Jan van Eyck Circle for Lacanian Ideology Critique* 2 (2009), pp. 14–26.

Blair, Sheila and Jonathan Bloom, 'Cosmophilia and its critics: an overview of Islamic ornament', in Lorenz Korn and Anja Heidenreich (eds), *Beiträge zur Islamischen Kunst und Archäologie* 3 (Wiesbaden, 2012), pp. 39–54.

Chelhod, Joseph, 'La face et la personne chez les Arabes', *Revue de l'histoire des religions* 151.2 (1957), pp. 231–41.

Coppens, Pieter, *Seeing God in This World and the Otherworld: Crossing Boundaries in Sufi Commentaries on the Qur'an* (PhD thesis, Utrecht University, 2015).

Elkins, James, *Visual Studies: A Skeptical Introduction* (London, 2003).

Enderlein, Volkmar and Michael Meinecke, 'Graben, Forschen, Präsentieren: Probleme der Darstellung vergangener Kulturen am Beispiel der Mschatta-Fassade', *Jahrbuch der Berliner Museen* 34 (1992), pp. 137–72.

Fierro, Maribel, 'Pompa y ceremonia en los califatos del occidente islámico (siglos VIII–XV)', *Cuadernos del CEMyR* 17 (2009), pp. 125–52.

Firdawsi, Abu'l-Qasim, *Shahnamah*, ed. Djalal Khaleghi-Motlagh and Mahmud Omidsalar, 8 vols (New York, 2005).

Firdawsi, Abu'l-Qasim, *The Shahnameh: The Persian Book of Kings*, trans. Dick Davis (London, 2007).

Flood, Finbarr B., 'Animal, vegetal, and mineral: ambiguity and efficacy in the Nishapur wall paintings', *Representations* 133:1 (2016), pp. 20–58.

García Gómez, Emilio, *Poemas árabes en los muros y fuentes de la Alhambra*, 2nd ed. (Madrid, 1996).

Gell, Alfred, *Art and Agency: An Anthropological Theory* (Oxford, 1998).

Goitein, Shlomo D., 'Beholding God on Friday', *Islamic Culture* 34.3 (1960), pp. 163–8.

Grabar, Oleg, *Ceremonial and Art at the Umayyad Court* (PhD thesis, Princeton University, 1955).

Grabar, Oleg, *The Formation of Islamic Art*, 2nd ed. (New Haven, 1987).

Grabar, Oleg, 'An art of the object', in Oleg Grabar, *Constructing the Study of Islamic Art, Volume 3: Islamic Art and Beyond* (Farnham, 2006), pp. 13–29.

Grabar, Oleg, 'What makes Islamic art Islamic?', in Oleg Grabar, *Constructing the Study of Islamic Art, Volume 3: Islamic Art and Beyond* (Farnham, 2006), pp. 247–51.

Gruber, Christiane and Sune Haugbolle (eds), *Visual Culture in the Modern Middle East: Rhetoric of the Image* (Bloomington, 2013), pp. ix–xxvii.

Ibn Hisham, *The Life of Muhammad: A Translation of Ishaq's Sirat Rasul Allah*, trans. Alfred Guillaume (London, 1955).

Ibn al-Khatib, Lisan al-Din, *Nufadat al-jirab fi 'ulalat al-ightirab: [al-juz' al-thani]*, ed. Ahmad M. al-'Abbadi (Casablanca, 1985).

Ibn Shaddad, 'Antara, *Sharh diwan 'Antara ibn Shaddad*, ed. 'Abd al-Mun'im Shalabi (Cairo, n.d.).

Jamil, Nadia, 'Caliph and Qutb: poetry as a source for interpreting the transformation of the Byzantine cross on steps on Umayyad coinage', in Jeremy Johns (ed.), *Bayt al-Maqdis: Jerusalem and Early Islam* (Oxford, 1999), pp. 11–57.

Jay, Martin, 'Scopic regimes of modernity', in Hal Foster (ed.), *Vision and Visuality: Discussions in Contemporary Culture* (Seattle, 1988), pp. 3–23.

Al-Khatib al-Baghdadi, *Ta'rikh Baghdad aw Madinat al-Salam*, 14 vols (Cairo, 1931).

Koch, Ebba, 'Diwan-i 'Amm and Chihil Sutun: the audience halls of Shah Jahan', *Muqarnas* 11 (1993), pp. 143–65.

Lange, Christian, '"On that day when faces will be white or black" (Q. 3:106): towards a semiology of the face in the Arabo-Islamic tradition', *Journal of the American Oriental Society* 127.4 (2007), pp. 429–45.

Lange, Christian, *Paradise and Hell in Islamic Traditions* (Cambridge, 2016).

Lapidus, Ira, *A History of Islamic Societies*, 2nd ed. (Cambridge, 2002).

Lassner, Jacob, *The Topography of Baghdad in the Early Middle Ages: Text and Studies* (Detroit, 1970).

Marchand, Trevor, *Minaret Building and Apprenticeship in Yemen* (Abingdon, 2001).

Marks, Laura U., 'The taming of the haptic space, from Málaga to Valencia to Florence', *Muqarnas* 32 (2015), pp. 253–78.

Mason, Herbert, *Two Statesmen of Medieval Islam: Vizir Ibn Hubayra (499–560 AH/1105–1165 AD) and Caliph an-Nasir li Din Allah (553–622 AH/1158–1225 AD)* (The Hague, 1972).

Meyer, Birgit, David Morgan, Crispin Paine and S. Brent Plate, 'The origin and mission of Material Religion', *Religion* 40.3 (2010), pp. 207–11.

Mirzoeff, Nicholas, 'On visuality', *Journal of Visual Culture* 5.1 (2006), pp. 53–79.

Mirzoeff, Nicholas, 'The subject of visual culture', in N. Mirzoeff (ed.), *The Visual Culture Reader*, 2nd ed. (London, 2002), pp. 3–23.

Mitchell, W. J. Thomas, 'Showing seeing: a critique of visual culture', *Journal of Visual Culture* 1.2 (2002), pp. 165–81.

Moin, A. Azfar, *The Millennial Sovereign: Sacred Kingship & Sainthood in Islam* (New York, 2012).

Mukhia, Harbans, *The Mughals of India* (Oxford, 2004).

Necipoğlu, Gülru, 'An outline of shifting paradigms in the palatial architecture of the pre-modern Islamic world', *Ars Orientalis* 23 (1993), pp. 3–24.

Necipoğlu, Gülru, 'Framing the gaze in Ottoman, Safavid, and Mughal palaces', *Ars Orientalis* 23 (1993), pp. 303–42.

Necipoğlu, Gülru, 'L'idée de décor dans les régimes de visualité islamiques', in Rémi Labrusse (ed.), *Purs Décors? Arts de l'Islam, regards du XIXe siècle* (Paris, 2007), pp. 10–23.

Necipoğlu, Gülru, 'The concept of Islamic art: inherited discourses and new approaches', *Journal of Art Historiography* 6 (2012), pp. 1–26.

O'Meara, Simon, 'Muslim visuality and the visibility of paradise and the world', in Sebastian Günther and Todd Lawson (eds), *Roads to Paradise: Eschatology and Concepts of the Hereafter in Islam*, 2 vols (Leiden, 2017), vol. 2, pp. 555–65.

Rippin, Andrew, '"Desiring the face of God": The Qur'anic symbolism of personal responsibility', in Issa J. Boullata (ed.), *Literary Structures of Religious Meaning in the Qur'an* (Richmond, 2000), pp. 117–24.

Ruggles, D. Fairchild, *Gardens, Landscape, and Vision in the Palaces of Islamic Spain* (University Park, 2000).

Ruggles, D. Fairchild, 'Making vision manifest: frame, screen, and view in Islamic culture', in D. Fairchild Ruggles and Dianne Harris (eds), *Sites Unseen: Landscape and Vision* (Pittsburgh, 2007), pp. 131–56.

Sanders, Paula, *Ritual, Politics, and the City in Fatimid Cairo* (Albany, 1994).

Al-Sha'rani, 'Abd al-Wahhab, *Mukhtasar Tadhkirat al-Qurtubi* (Cairo, 1939).

Soudavar, Abolala, *The Aura of Kings: Legitimacy and Divine Sanction in Iranian Kingship* (Costa Mesa, 2003).

Al-Suyuti, Jalal al-Din, *al-Janna wa'l-nar wa faqd al-awlad*, ed. M. 'Azab (Cairo, 1993).

Al-Suyuti, Jalal al-Din, *Durar al-hisan fi al-ba'th wa na'im al-jinan* (Cairo, 1870).

Al-Tabari, *The History of al-Tabari, Volume 6: Muhammad at Mecca*, trans. W. Montgomery Watt and Michael V. McDonald (Albany, 1988).

Wittgenstein, Ludwig, *Philosophical Investigations*, trans. G. Elizabeth M. Anscombe, 3rd ed. (Oxford, 1967).

Al-Ya'qubi, *Ta'rikh al-Ya'qubi*, ed. Martinus T. Houtsma, 2 vols (Leiden, 1883).

CHAPTER TWELVE

The Making, Unmaking and Making Sense of an Illustration from an Imperial Mughal *Akbarnama*

Laura E. Parodi

EXAMINATION OF A little-known Mughal painting in the collections of the Philadelphia Museum of Art (henceforth: PMA) alongside three closely related paintings may yield clues to the circumstances of their making and subsequent dispersion. The painting (Figure 12.1) was bequeathed to the Museum in 1967 by the renowned collectors Samuel S. White 3rd and his wife Vera (née McEntire), along with nearly 400 other works of art, including contemporary art pieces of world renown.[1] Only a fraction of the objects were illustrated in the catalogue of the bequest, and the Mughal painting was not among them. The short entry reads 'Mughal Miniature, first quarter 17th cent. Gouache: 13 ½ × 8 ¼', followed by the accession number, 67-30-389.[2] Comparatively marginal to the bequest, the painting has remained almost unnoticed in the Museum's collections for decades.[3] In the Museum's record, it is identifed as belonging to a partly dispersed three-volume copy of Abu'l-Fazl's *Akbarnama*, a chronicle of Emperor Akbar's reign (r. 1556–1605). The bulk of the original manuscript is divided between the British Library in London and the Chester Beatty Library in Dublin (henceforth: BL/CBL *Akbarnama*). Scholarship is largely limited to the CBL portion of the manuscript. No detailed research on the PMA painting seemingly exists to date, only cursory references and a couple of appearances at exhibitions.

In size and format, the painting is consistent with other illustrations from the BL/CBL *Akbarnama*;[4] like other dispersed illustrations from that manuscript, it was pasted onto a sheet with ornate margins extracted from an imperial Mughal dictionary, the *Lughatnama* (or *Farhang-i Jahangiri*, by the infamous dealer Georges Demotte, who then sold each page separately (Figure 12.2).[5] The BL/CBL *Akbarnama* saw the involvement of leading artists from the imperial studio, and evidence is building up in support of its attribution to the early patronage of Prince Salim (the future Emperor Jahangir, r. 1605–27).[6] The first volume, today in the BL, concerns the

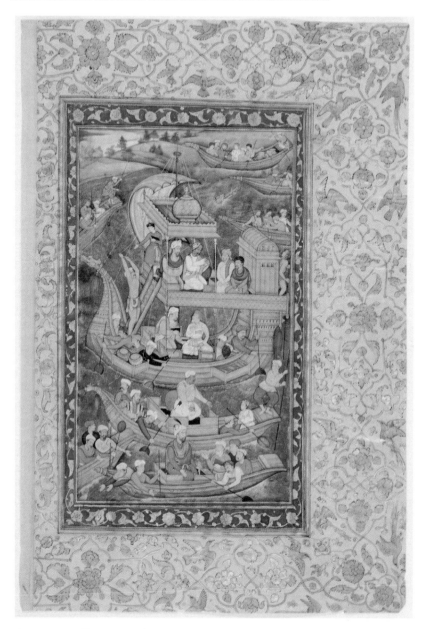

Figure 12.1 *Illustration from a c. 1596–8 copy of the* Akbarnama, *attributed here to Dharamdas, mounted on the verso of a folio from the* Lughatnama-i Jahangiri. *Philadelphia Museum of Art, 1967-38-389. Reproduced by kind permission.*

origins of Akbar's lineage, the reigns of his ancestors, and his child-hood. The second and third (unfinished) volume, today in the CBL, cover Akbar's reign up to 1579.[7] Demotte extracted illustrations from all three volumes; many remain untraced, but new scholarship

Figure 12.2 *Recto of a folio from the* Lughatnama-i Jahangiri.
Philadelphia Museum of Art, 1967-38-389. Reproduced by kind permission.

and folios occasionally turning up on the arts market continually
improve our understanding of the original iconographic programme.
The current borders of the CBL manuscript are crude and unfinished.
They were probably added in Iran,[8] where the manuscript was likely
taken after the imperial Mughal library was sacked by the Afsharid
ruler Nadir Shah (r. 1736–47) in 1739.

The catalogue of an exhibition held at the PMA in 1986 identifies the painting as the left half of a double-page composition depicting *Akbar's boat expedition to the Eastern Provinces* (an event in the twenty-fourth regnal year, 1579),[9] whose alleged right half, today in a private collection (Figure 12.3), is similarly mounted on a page from Jahangir's dictionary.[10] The figure in the second boat from foreground is mistakenly identified as Akbar, when in fact it is Man Singh Kachhwaha, the most powerful Rajput officer at Akbar's court, of whom several portraits exist.[11]

Illustrations in the BL/CBL *Akbarnama* contain inscriptions identifying the artists who designed and painted them, but Demotte's remounting resulted in the loss of this information. The PMA painting is no exception, but an attribution is still possible on stylistic grounds. It is one of four very similar pictures, including: an illustration from a copy of the *Anwar-i Suhayli* (Light of Canopus), dated 1596–7, today in the Bharat Kala Bhawan in Varanasi, inscribed to Miskin (Figure 12.4);[12] a dispersed manuscript illustration in the Freer Gallery, Washington, DC, depicting Noah's Ark, also attributed to Miskin but here reattributed to Dharamdas (Figure 12.5);[13] and the cited painting in a private collection. An attribution to Dharamdas is here also proposed for the two unattributed paintings (details below). Exernal clues point to a similar dating for at least two of the paintings. The close similarity in composition and the repetition of several figures across all four miniatures suggest Dharamdas based his three compositions on Miskin's painting, creating variations upon a single prototype. All four works are dominated by an almost identical ship surrounded by boats and/or aquatic animals. The ship, landscape (where present) and water are rendered using similar conventions.[14] One or more specimens of Miskin's signature gharial (Ganges crocodile) are seen in all but one of the paintings, and one or more Ganges river dolphins are included in all but the PMA page.[15] However, a comparison between the faces in Miskin's ascribed work and the other three paintings reveals that the latter are by a different artist, identified here as Dharamdas.

Miskin was the son of Mahesh, an artist in Akbar's studio, and was the fourth most distinguished master of his time according to Abu'l-Fazl's *A'in-i Akbari*.[16] He specialised in painting animals and natural settings but could paint accomplished portraits. Dharamdas began working in the imperial studio in the mid-1580s; his hallmarks were deep shading, vivid colours and remarkably detailed patterns. Also a capable animal painter, some of his contributions to a 1595 copy of the *Khamsa* of Nizami (British Library, Or. 12208) are true masterpieces. But he was not a distinguished portraitist, and his work in the BL/CBL *Akbarnama* is rather idiosyncratic: 'Probably because he was forced to overproduce, he reiterated the same putti-like figures and facial types.'[17] Indeed, close scrutiny of his three variations on Miskin's work reveals the use of shortcuts, including the repetition

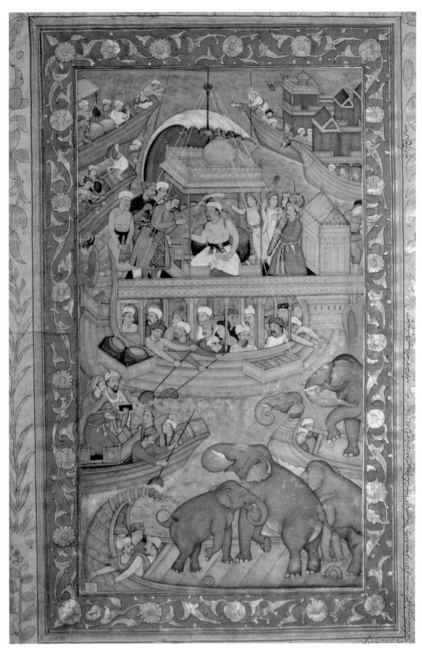

Figure 12.3 *'Akbar's Expedition to the Eastern Provinces', from a c. 1596–8 copy of the* Akbarnama, *attributed here to Dharamdas. Private collection. Reproduced by kind permission.*

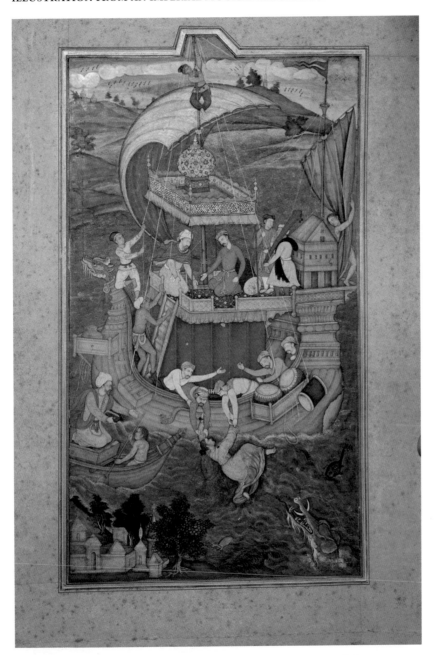

Figure 12.4 *'The Chinese Princess Thrown into the Waters of the Tigris near Baghdad', from a 1596–7 copy of the* Anwar-i Suhayli, *inscribed to* Miskin. Varanasi, Bharat Kala Bhawan, 9069/22.
Reproduced by kind permission.

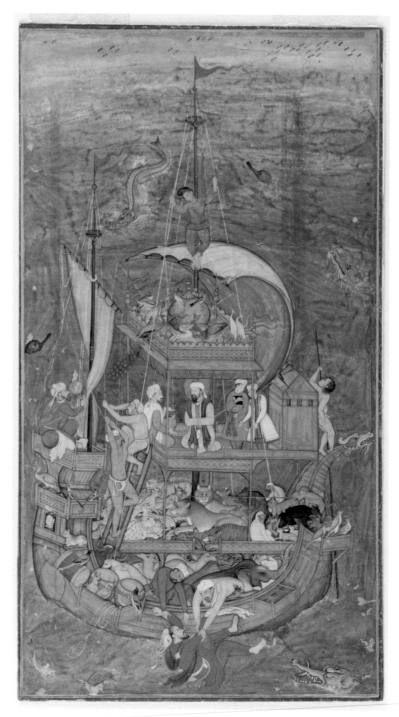

Figure 12.5 *'Noah's Ark', attributed to Miskin. Washington, DC, The Freer Gallery of Art, Smithsonian Institution, F1948.8. Reproduced by kind permission.*

of figures and structural elements with minor variations. For the sake of clarity, and in order to avoid using the word 'painting' too many times, the four works will be designated by the letters P, V, C and F respectively (for PMA, Varanasi, [Private] Collection and Freer).

P and V include landscape details – more extensive in the latter – whereas C and F show only a sheer expanse of water; but the composition is virtually identical, as are the four ships. In C and P, the ship is surrounded by smaller boats; in V and F it is virtually or literally the only subject. In P, V and C, the ship is turned to the viewer's left; in F it appears at first sight to be turned in the opposite direction, but a closer look reveals that Dharamdas repositioned only the top of the sterncastle and the figurehead, freeing a space on the left side where the figure of an astronomer was inserted – presumably relevant to the unidentified story. An additional sail, like a trysail, is seen on the sterncastle of the ships in V and F; both ships have dragon-shaped figureheads, enhanced by colour touches, which also enliven the canopy under the main sail in V. The figurehead in P is also dragon-shaped but the colour of wood, touched up in gold; in C, the figurehead is shaped like a ram's head. C is unique in its additional display of figureheads from several accompanying boats: they include an antelope, a cheetah and elephants' heads. The figurehead of Man Singh's boat in P is shaped like a cheetah's head. Both Miskin and Dharamdas are here showcasing their animal painters' skills.[18]

Two extensions like balconies protrude from the side of the ships – one empty, one containing drums; the drums are positioned to the left, except in V. An additional 'balcony' hangs out from the fore of the ship, beneath the figurehead, in three of the paintings. Inside it are one (V, C) or two jars (F), presumably containing water: in F, animals are shown drinking from a jar. V and F, which illustrate fictional works, show a fallen passenger, unlike P and C, which include additional boats, some of whose passengers are members of Akbar's court.

The ship in F has three rather than two decks; animals occupy much of the available space, including the roof of the ship, and more crocodiles and dolphins peer from the waters than in the other specimens. In V, P and F, a ladder positioned on the viewer's left leads to the upper deck; one or two scantily clad Indian oarsmen are seen climbing it.[19] One of them is repeated almost identically in P and F. Another almost nude figure, possibly adapted from a European source, is seen on the sterncastle in V, P and F. In V it is partly hidden by the trysail, and is repeated with minor variations on a smaller boat. In P and F, the figure is virtually identical; a remarkable torsion seen in P and F and the blonde hair in P further point to a European source. The corresponding figure on the sterncastle of the ship in C wears a short jacket, pantaloons and a tall hat, and also appears to be adapted from a European source.[20] An identical figure, coloured differently, is seen climbing the mast of the main sail in F and V;

in V it is even repeated a second time, with variations in scale and colouring, near the figurehead, pulling at the ship's rigging. In P, the same figure is seen steering Man Singh's boat: although the artist replaced the hat with a standard Akbari turban, he did not bother to alter the length of the jacket, which remains suspiciously European in appearance.

Figures in more prominent positions, some of which appear to be portraits of contemporary characters, are also repeated across one or more of the paintings. Note, for example, the man in a pink robe and a green scarf seated under the canopy in P. He occupies a prominent position and looks straight at the viewer, as is typical of figures adapted from European sources, frequently seen in Mughal art from the 1580s–90s. His turban and rosary suggest a Sufi. In V, a very similar figure is engaged in a lively conversation with the princely protagonist. Similarly, the youth dressed in pink seated at the fore of the ship (to the viewer's left), is framed by a window as if riding in a separate chamber in C, suggestive of special status; but in P he is probably just a space-filler.

The grey-bearded oarsman positioned near the drums in C is another figure closely inspired by European sources. His distinctive moustached face with a defiant look would suggests a specific individual; but the figure was recycled twice in P (once in the same position, and another time as the oarsman in Man Singh's boat), and at least one precedent may be identified in a much earlier boat scene, from a *Tutinama* executed in Akbar's studio c. 1560–5, which also includes a fallen passenger.[21]

A man with a book in his hand, riding the boat at lower left in two of the paintings, exemplifies repetition with variations. In V, the carefully rendered face and Central Asian, possibly Sufi, clothes again suggest the portrait of a specific individual, while in C the figure bears a strong resemblance with known portraits of Abu'l-Fazl, author of the *Akbarnama*.[22] Frustratingly, however, books are associated with various figures in all four paintings, and especially numerous in P and F. But besides the open book on a stand next to the astronomer in F, it is unclear whether there might be some connection with the narrative, or whether they are just one more conventional feature. Similarly, the man with a distinctive beard and a striped gold and black coat riding in the back of Man Singh's boat in P, is highly individualised but repeated more cursorily in C, next to the man resembling Abu'l-Fazl.

This reveals something about the way artists worked in the imperial Mughal studio. On the one hand, accurately rendered physiognomic portraits counterintuitively signal reliance on European works, while actual portraits of the artists' contemporaries are usually more stereotyped. On the other hand, visually impressive, even 'realistic' compositions are achieved by constant repetition with minimal variation.

Figure 12.6 *Detail of the painting illustrated in Figure 12.1 captured in infrared light. Photo: Laura E. Parodi.*

The virtually identical composition and the number of figures shared between P and C undermine the current opinion which sees them as two halves of a single illustration. Indeed, both include a portrait of Akbar, which is conclusive proof that they were conceived as separate illustrations. C shows Akbar receiving his foster-brother Zain Khan Koka and three other dignitaries with the paraphernalia normally reserved for a court reception.[23] Meanwhile, Akbar's portrait in P (the main figure under the canopy) has remained undetected. The face and turban show signs of damage and overpainting, but an infrared picture I took in 2012 (Figure 12.6) reveals features fully compatible with Akbar's likeness, executed in Dharamdas's distinctive manner, including a slightly protruding eye.[24] Both illustrations might well refer to the same campaign, and the gap in the CBL *Akbarnama* is wide enough to accommodate both, with illustrations 124–9 missing.[25] Although the images are quite similar, variations in colour and orientation (C reads from right to left, while most of the figures in P look to the viewer's right) effectively dissimulate their similarity.

The range of animal-shaped figureheads in C and, more markedly, in P, corresponds to the description of the 1574 expedition, where

such marvelous boats were completed according to the emperor's instructions that no amount of description could convey their splendor. Delightful chambers, pleasure-giving belvederes, and

even gardens that expert horticulturists would not have been able
to make on land were included in the ships. To the prow of each
of these aquatic edifices was affixed the shape of an animal to the
amazement of all who saw them.[26]

The identification of C as an illustration of Akbar's expedition to
the eastern provinces is secure. Zain Khan Koka, whose portrait
we identified, was among the officers who participated in the 1574
river expedition to the eastern provinces. Two of the dignitaries
shown alongside Zain Khan remain unidentified, but the third must
be Raja Birbal,[27] and the figure resembling Abu'l-Fazl could be his
brother, the Poet Laureate Faizi. Both Birbal and Faizi took part in
the campaign. The connection is further confirmed by the elephants
riding in two of the boats: according to the *Akbarnama*, 'two gigan-
tic elephants', one of which had 'a rosy face', were 'taken on board'
along with 'their female companions' on this occasion.[28]

The identification of the PMA painting is more problematic. The
visually prominent (and now securely identified) Man Singh did take
part in the same expedition; but some other figures point to a poten-
tial twist in the story. The man in a green robe respectfully seated
before Akbar bears a strong resemblance to Prince Salim, aged about
thirty; and the portly dignitary riding in a boat in the foreground
wears a black egret plume – an attribute normally associated with
royal descent.[29] The latter's face is carefully singled out, as are some
of his attributes, including the said egret plume and a dagger tucked
into his belt. Man Singh, meanwhile, holds a rosary in his right hand,
and with his left hand, gestures towards a boy riding in the same
boat, who appears to be about eight years old. The boy is identified as
a prince by his necklace – an attribute associated with the emperor's
progeny in Mughal painting – and he holds his arms to his chest, in
a gesture typical of princes in Mughal *darbar* (court) scenes.[30] The
iconography conjured up by these four figures points to a different
episode, coeval not with Akbar's expedition to the east but with the
time when the manuscript was illustrated, c. 1596–8. In his forty-
second regnal year (corresponding to 1597–8), Akbar paid his third
visit to Kashmir; Prince Salim accompanied him but committed
some unspecified offence along the way. Tension did not wane once
the party reached Kashmir:

On the 9th [30 June], some disrespect was shown by the eldest
prince during the tour of the lake. Khwaja Phul delivered an angry
message from the emperor, and the prince was much offended by
the harshness of his tone. The kind emperor softened his tone
and won the prince's heart over. Around this time an imperially
commissioned sea-worthy ship was completed to the amazement
of all. On the 20th [11 July], the emperor embarked in it and toured
the Bahat River.[31]

Remarkably, the reconciliation effected by Akbar with a rebellious-hearted Salim – who a couple of years later would style himself *padshah* and set up an independent court at Allahabad, in present-day Bihar – coincided with the building of a wondrous new ship. It is tempting to associate both occurrences with the PMA painting. Let us just assume for a moment that the illustration provided an opportunity to construct an allegory referencing a contemporary event. Salim was twenty-eight at the time when he committed the offence. Khwaja Phul is not mentioned elsewhere in the *Akbarnama*, but, as the one who interceded on behalf of the prince, he may be the figure shown at his side. Meanwhile, the portly dignitary of royal descent in the foreground could be Rustam Mirza, an exiled Safavid prince who in 1002/1593–4 pledged allegiance to Akbar: he was granted a rank (*mansab*) of commander of 5,000, and received Multan and several districts in Baluchistan as *jagir*.[32] En route to Kashmir in 1597, Rustam Mirza was dispatched to quell a rebellion in the area of Mau (today in Pakistan, close to the border with Gujarat), but by mid-June he rejoined Akbar south of Srinagar.[33] Hence, he was present at the prince's reconciliation with his father. Several portraits of Rustam Mirza exist, but only at a much older age. None is admittedly a close match for the figure in the PMA painting,[34] but the long nose and long, slender fingers are a good match, as are the elongated eyes. A comparison between Dharamdas's portrait of Man Singh and other likenesses of the Rajput general[35] reveals a similarly cursory treatment.

Man Singh did not, apparently, accompany Akbar to Kashmir in 1597, but he is mentioned a couple of times during that same regnal year, first in connection with his son's death,[36] then with a victory he gained in the east.[37] However, much more important to the picture (in every sense) may be his family connections with Prince Salim, who had married Man Singh's sister. In 1587 she had borne Khusraw, Salim's eldest son and early favourite (before the rise of Khurram, the future Emperor Shahjahan).[38] When Salim rebelled and set up court at Allahabad (1600–4), a party of courtiers turned to Khusraw as Akbar's potential successor, resisting Salim's claims. The opponents were crushed, Man Singh's sister poisoned herself and the unfortunate prince died prematurely in prison.[39] In the process, Salim even orchestrated the assassination of Abu'l-Fazl[40] – a turn of events that probably explains why the BL/CBL manuscript project was discontinued. But none of this could be foreseen in 1597: at the time and for a few years afterwards, Salim had every reason to showcase his family connections to Man Singh, then arguably Akbar's most trusted and successful officer.[41] Man Singh was Khusraw's maternal uncle, or *taghai* – in Mughal society, the most important relative after one's father,[42] and towards the end of Akbar's life, he became the prince's *ataliq* (tutor).[43] Salim also had reasons to showcase his reconciliation with his father in this particular manuscript. Hence, the artist (or,

possibly, the director of the *Akbarnama* project, who was usually in charge with decisions on what to illustrate and how)[44] could have used Akbar's 1574 expedition as a pretext to construct an allegory of the prince's reconciliation with his father that simultaneously made a statement about Salim's family connections and lineage.

The date of the episode, 1597, is intriguing, considering that the Varanasi copy of the *Anwar-i Suhayli* to which V belongs is dated 1005/1596–7, and inscriptions date the BL/CBL *Akbarnama* to 1596–8.[45] Moreover, this was the year when Akbar had a new and wondrous ship built. Could the building of the ship have triggered the creation of these four paintings? It is especially remarkable that Dharamdas chose to illustrate two historical episodes that did not take place at sea with what is clearly a 'sea-worthy' ship like the one commissioned by Akbar, rather than a large boat or a barge. That this was the iconography appropriate for a marine ship is further testi-fied by earlier, European-inspired compositions, such as the cited *Tutinama* illustration, and more specifically with the vessels in another BL/CBL *Akbarnama* folio, illustrating a 1537 battle between the Portuguese and the sultan of Gujarat.[46]

There is no question about the PMA painting's belonging to the BL/CBL *Akbarnama*. Not only is it consistent in format, but it suf-fered the same fate as other paintings excised from the manuscript by Demotte and pasted onto folios from the *Lughatnama-i Jahangiri*. However, its interpretation as merely a second illustration of Akbar's 1574 expedition to the eastern provinces appears somewhat unsatis-factory, especially in light of its close similarity to another illustra-tion of the same episode. If the proposed interpretation is accepted, its message was possibly more complex than hitherto suspected.

Mughal paintings do include anachronisms occasionally, as well as allegorical overtones.[47] In Akbar's own (c. 1590–5) copy of the *Akbarnama*, Salim's two brothers (born 1570 and 1572) become active participants in the 1573 quelling of the last rebellion led by Timurid princes,[48] and an adult Salim (similarly dressed in green) is shown riding alongside his father in the triumphal entry into Surat in 1572 – even though he would have been three at the time.[49] The latter may actually be a repurposed painting originally produced by Farrukh Beg on the occasion of Akbar's (and Salim's) visit to Kabul in 1589.[50]

Though far from satisfactory, this appears to be a reasonable compromise between the codicological evidence identifying the PMA painting as an illustration from the BL/CBL *Akbarnama* and the inclusion of figures (most notably that of Prince Khusraw) and other iconographic details which point to a much later episode. If confirmed, this more articulate interpretation of the PMA painting would further strengthen the association of the BL/CBL *Akbarnama* with the patronage of Prince Salim before his rebellion, advocated by scholars such as Milo Beach and John Seyller.

But further research is needed on the various instances in which characters not mentioned in the text, and / or anachronistically portrayed, are included in illustrations of Mughal historical manuscripts, before we can say a definitive word. It also remains to be clarified whether F, V, C and P were painted within a very short span of time, even with some overlap, as appears likely – and how common the practice might have been of creating variations on another master's composition. Much work also remains to be done on multiple versions of similar compositions, and potential cross-inspiration between artists.[51]

It is hoped this contribution will open the floor to multiple new questions concerning a manuscript increasingly connected with Prince Salim's early patronage, as well as Mughal painting more generally.

Notes

1. On the bequest, see Henry G. Gardiner, 'The Samuel S. White, 3rd, and Vera White collection', *Philadelphia Museum of Art Bulletin* 63.296/297 (1968), pp. 71–150.
2. Gardiner, 'The White collection', p. 138. Today the work is listed as 1967-38-389.
3. I am indebted to Yael Rice for first bringing this work to my attention, to Milo C. Beach for his opinions and suggestions in the initial stage of research for this chapter, and to Elaine Wright for clarifying some aspects of the CBL portion of the manuscript. Email correspondence, December 2015 – January 2016. None of them is responsible for the daring hypotheses made here.
4. Image: 8 1/2 × 5 inches (21.6 × 12.7 cm); sheet: 13 1/2 × 9 1/8 inches (34.3 × 23.2 cm), according to the PMA record (at slight variance with the measurements given in the catalogue of the bequest).
5. Sir Alfred Chester Beatty separately purchased several such remounted illustrations. Linda Y. Leach, *Mughal and Other Indian Paintings from the Chester Beatty Library* (London, 1995), vol. 1, p. 237.
6. Milo C. Beach, 'The Gulshan album and the workshops of Prince Salim', *Artibus Asiae* 73.2 (2013), pp. 445–77, especially pp. 474–5 and n. 26.
7. Leach, *Mughal Paintings*, p. 240.
8. Leach, *Mughal Paintings*, p. 232.
9. Stella Kramrisch, *Painted Delight: Indian Paintings from Philadelphia Collections* (Philadelphia, 1986), cat. no. 19. On the episode, see Wheeler Thackston (trans. and ed.), *The History of Akbar* (Cambridge, MA, 2015–), vol. 3, pp. 334–5.
10. Most recently published in Brijinder N. Goswamy and Eberhard Fischer, *Wonders of a Golden Age: Painting at the Court of the Great Mughals Indian Art of the 16th and 17th Centuries from Collections in Switzerland* (Zürich, 1987), cat. no. 36.
11. See, for example, John Seyller, 'Five folios from the Jahangir album', in Sheila Blair and Jonathan Bloom (eds), *God is Beautiful and Loves beauty: the Object in Islamic Art and Culture* (New Haven, 2013), pp. 300–39, fig. 276.

12. Previously published in Milo C. Beach, *The Imperial Image: Paintings for the Mughal Court* (Washington, DC. 1981), p. 124 and fig. 14.

13. Previously published in Beach, *Imperial Image*, cat. no. 13; Philippa Vaughan, 'Miskin', in Pratapaditya Pal (ed.), *Master Artists of the Imperial Mughal Court* (Bombay, 1991), pp. 17–30, especially p. 34.

14. Compare with the different treatment of the water in another aquatic scene, attributed to Farrukh: Beach, *Imperial Image*, cat. no. 12c.; illus. p. 108; detail p. 109.

15. Cf. Vaughan, 'Miskin', figs 11, 17.

16. On Miskin's descent and careerm see Vaughan, 'Miskin', especially n. 2.

17. Leach, *Mughal Paintings*, vol. 2, p. 1102.

18. Cf. Leach, *Mughal Paintings*, cat. no. 2.118, and Vaughan, 'Miskin'.

19. Miskin, who was of humble origins, often included this kind of character in his work: Vaughan, 'Miskin', pp. 18, 24, figs 5, 6.

20. Figures with a similar hat are seen even in the earliest known work by Miskin, an illustration from a c. 1580–5 *Darabnama*: see Vaughan, 'Miskin', fig. 1.

21. Michael Brand and Glenn D. Lowry, *Akbar's India: Art from the Mughal City of Victory* (New York, 1986), cat. no. 10.

22. Cf. Leach, *Mughal Paintings*, col. pls 33, 40.

23. Cf. his portrait in the Victoria and Albert Museum collection, IS.91-1965. Illus. in Susan Stronge *Painting for the Mughal Emperor: The Art of the Book 1560–1660* (London, 2002), pl. 68.

24. Cf. Leach, *Mughal Paintings*, cat. nos 2.123, 2.124.

25. Cf. Leach, *Mughal Paintings*, vol. 1, pp. 273–6. Illustrations in the BL/CBL *Akbarnama* are numbered: no. 123 shows Akbar's battle with Muhammad-Husain Mirza in Gujarat (Thackston, *History of Akbar*, vol. 3, pp. 45–6), and no. 130 illustrates the conquest of Hajipur (ibid., p. 78).

26. Thackson, *History of Akbar*, vol. 3, p. 68.

27. Cf. his portrait in the British Library, Add. Or. 4429. Illus. in <https://imagesonline.bl.uk/asset/1042/> (last accessed 22 September 2020).

28. Thackston, *History of Akbar*, vol. 3, p. 70.

29. On the meaning of the egret plume, see Laura E. Parodi and Bruce Wannell, 'The earliest datable Mughal painting: an allegory of the celebrations for Akbar's circumcision at the sacred spring of Khwaja Seh Yaran near Kabul (AD 1546) [*Staatsbibliothek zu Berlin - Preussischer Kulturbesitz, Libr. Pict. A117, fol. 15a*]', *Asian Art*, 18 November, 2011 (online article available at: <https://www.asianart.com/articles/parodi/index.html> (last accessed 22 September 2020), especially the paragraph titled 'The Painting'; Laura E. Parodi, 'Two pages from the late Shahjahan album', *Ars Orientalis* 40 (2011), pp. 267–94, esp. p. 270.

30. This is so far the only instance I have come across in a pre-Shahjahani painting. Cf. Laura E. Parodi and Giovanni Verri, 'Infrared reflectography of the Mughal painting *Princes of the House of Timur* (British Museum, 1913,0208,0.1)', *Journal of Islamic Manuscripts* 7 (2016), pp. 36–65.

31. Thackston, *History of Akbar*, vol. 3, p. 591.

32. Thackston, *History of Akbar*, vol. 3, pp. 535–6. For some historical background, see Barat Dahmardeh, 'The Shaybanid Uzbeks, Moghuls and Safavids in Eastern Iran', in Willem Floor and Edmund Herzig (eds), *Iran and the World in the Safavid Age*, (London, 2012) pp. 132–48, esp. p. 136.

33. Thackson, *History of Akbar*, vol. 3, pp. 588, 590.
34. The best-known is attributed to Hashim, c. 1635–40, Los Angeles County Museum of Art, from the Nasli and Alice Heeramaneck Collection, Museum Associate Purchase, M.78.9.14. See Pratapaditya Pal, *Indian Painting: A Catalogue of the Los Angeles County Museum of Art Collection (Los Angeles, 1993), Vol. 1: 1000–1700* (Los Angeles, 1993), cat. no. 76; John Seyller, 'Hashim', in P. Pal (ed.), *Master Artists of the Imperial Mughal Court* (Bombay, 1991), pp. 105–18, especially pp. 105, 116. Man Singh's likeness is also included in Shahjahani *darbars*: see Milo Cleveland Beach and Ebba Koch, *King of the world: the Padshahnama, an Imperial Mughal Manuscript from the Royal Library, Windsor Castle* (London, 1997), cat. nos 5, 9, 14, 38. The latter instance appears cursory and possibly second-hand; interestingly, it is also the most similar to the one in the PMA painting.
35. Cf. Seyller, 'Five folios', fig. 276.
36. Thackston, *History of Akbar*, vol. 3, p. 585.
37. Ibid., p. 589.
38. Ibid., p. 427–8. I previously suggested that Salim had Khusraw pictured alongside himself in a painting of dynastic significance: Parodi and Verri, 'Reflectography'.
39. See Wheeler Thackston (trans. and ed.), *The Jahangirnama: Memoirs of Jahangir, Emperor of India* (Washington, DC, and New York, 1999), p. 51. Khusraw's sister commissioned a tomb complex near Allahabad, today known as Khusraw Bagh; it contains her own tomb and separate tombs for her mother and brother: see Catherine B. Asher, *Architecture of Mughal India: The New Cambridge History of India I:4* (Cambridge, 1992), pp. 104–5.
40. On which see Ahmad Amir, 'Murder of Abul Fazl: a re-appraisal', *Proceedings of the Indian History Congress* 62 (2001), pp. 207–12.
41. Man Singh was the highest-ranking Hindu officer in Mughal history, attaining a *mansab* (rank) of 7,000 and special privileges, including permission to build large temples. See Catherine B. Asher, 'The architecture of Raja Man Singh: a study of sub-imperial patronage', in Barbara S. Miller (ed.), *The Powers of Art: Patronage in Indian Culture* (Delhi, 1992), pp. 183–201, and Laura E. Parodi, 'Mughal religious architecture', in Kathryn Moore and Hasan-Uddin Khan (eds), *Cambridge World History of Religious Architecture*, vol. 1 (in preparation).
42. *Taghai*s commanded respect and often played prominent diplomatic roles. See Maria Eva Subtelny, 'Babur's rival relations: a study of kinship and conflict in 15th–18th century Central Asia', *Der Islam* 66 (1997), pp. 102–18, and Laura E. Parodi, 'Of shaykhs, bibis and begims: sources on early Mughal marriage connections and the patronage of Babur's tomb', in Maria Szuppe, Anna Krasnowolska and Claus Pedersen (eds), *Mediaeval and Modern Iranian Studies: Proceedings of the 6th European Conference of Iranian Studies (Vienna, 2007). Cahiers de Studia Iranica* 45 (2011), pp. 121–38.
43. Thackston, *History of Akbar*, vol. 3, p. 694. On the role of *ataliq*s as guardians, tutors and surrogate fathers, see Munis D. Faruqui, *The Princes of the Mughal Empire 1504–1719* (Cambridge and New York, 2012), pp. 75–7.
44. See John Seyller, 'Scribal notes on Mughal manuscript illustrations', *Artibus Asiae* 48.3–4 (1987), pp. 247–77.
45. Seyller, 'Scribal notes', pp. 262, 269.

46. British Library, Or. 12988, fol. 66r. Illus. in <http://www.bl.uk/manu-scripts/Viewer.aspx?ref=or_12988_fs001r> (last accessed 22 September 2020). Thackston, *History of Akbar*, vol. 1, p. 130.
47. See Parodi and Wannell, 'The earliest datable Mughal painting'.
48. See Laura E. Parodi, 'From *Tooy* to *Darbar*: materials for a history of Mughal audiences and their depictions', in Joachim Bautze and Rosa M. Cimino (eds), *Ratnamala: Garland of Gems* (Ravenna, 2010), pp. 51–76, esp. pp. 65–6.
49. London, Victoria and Albert Museum, IS.2:117-1896. Illus. in Stronge, *Painting for the Mughal Emperor*, pl. 18. The identification of Prince Salim, making this a repurposed illustration, was first proposed by John Seyller, 'Farrukh Beg', in Milo C. Beach, Eberhard Fischer and Brijinder N. Goswami, *Masters of Indian Painting, Vol. 1: 1100–1650* (Artibus Asiae Supplementum 48 I/II, 2011), pp. 187–210, esp. p. 200.
50. Thackston, *History of Akbar*, vol. 3, p. 461.
51. Not all Mughal artists have left behind multiple versions of a single composition, but for Miskin it was common practice: most famous is his series on the animal kingdom (illus. in Vaughan, 'Miskin', figs 11, 17). No comparable information is available for Dharmdas.

Bibliography

Amir, Ahmad, 'Murder of Abul Fazl: a re-appraisal', *Proceedings of the Indian History Congress* 62 (2001), pp. 207–12.

Asher, Catherine B., 'The architecture of Raja Man Singh: a study of sub-imperial patronage', in B. S. Miller (ed.), *The Powers of Art: Patronage in Indian Culture* (Delhi, 1992), pp. 183–201.

Asher, Catherine B., *Architecture of Mughal India: The New Cambridge History of India, I:4* (Cambridge, 1992).

Beach, Milo C., *The Imperial Image: Paintings for the Mughal Court* (Washington, DC, 1981).

Beach, Milo C., 'The Gulshan album and the workshops of Prince Salim', *Artibus Asiae* 73.2 (2013), pp. 445–77.

Beach, Milo C. and Ebba Koch, *King of the World: the Padshahnama, an Imperial Mughal Manuscript from the Royal Library, Windsor Castle* (London, 1997).

Brand, Michael and Glenn D. Lowry, *Akbar's India: Art from the Mughal City of Victory* (New York, 1986).

Dahmardeh, Barat, 'The Shaybanid Uzbeks, Moghuls and Safavids in Eastern Iran', in Willem Floor and Edmund Herzig (eds), *Iran and the World in the Safavid Age* (London, 2012), pp. 132–48.

Faruqui, Munis D., *The Princes of the Mughal Empire 1504–1719* (Cambridge and New York, 2012), pp. 75–7.

Gardiner, Henry G., 'The Samuel S. White, 3rd, and Vera White collection', *Philadelphia Museum of Art Bulletin* 63.296/297 (1968).

Goswamy, Brijinder N. and Eberhard Fischer, *Wonders of a Golden Age: Painting at the Court of the Great Mughals Indian Art of the 16th and 17th Centuries from Collections in Switzerland* (Zurich, 1987).

Kramrisch, Stella, *Painted Delight: Indian Paintings from Philadelphia Collections* (Philadelphia, 1986).

Leach, Linda Y., *Mughal and Other Indian Paintings from the Chester Beatty Library*, 2 vols (London, 1995).

Pal, Pratapaditya, *Indian Painting: A Catalogue of the Los Angeles County Museum of Art Collection (Los Angeles, 1993), Vol. 1: 1000–1700* (Los Angeles, 1993).

Parodi, Laura E., 'From *Tooy* to *Darbar*: materials for a history of Mughal audiences and their depictions', in Joachim Bautze and Rosa M. Cimino (eds), *Ratnamala: Garland of Gems* (Ravenna, 2010), pp. 51–76.

Parodi, Laura E. 'Two pages from the late Shahjahan album', *Ars Orientalis* 40 (2011), pp. 267–94.

Parodi, Laura E., 'Of shaykhs, bibis and begims: sources on early Mughal marriage connections and the patronage of Babur's tomb', in Maria Szuppe, Anna Krasnowolska, and Claus Pedersen (eds), *Mediaeval and Modern Iranian Studies: Proceedings of the 6th European Conference of Iranian Studies (Vienna, 2007). Cahiers de Studia Iranica* 45 (2011), pp. 121–38.

Parodi, Laura E., 'Mughal religious architecture', in Kathryn Moore and Hasan-Uddin Khan (eds), *Cambridge World History of Religious Architecture*, vol. 1 (in preparation).

Parodi, Laura E., and Bruce Wannell, 'The earliest datable Mughal painting: an allegory of the celebrations for Akbar's circumcision at the sacred spring of Khwaja Seh Yaran near Kabul (1546 AD) [*Staatsbibliothek zu Berlin - Preussischer Kulturbesitz, Libr. Pict. A117, fol. 15a*]', *Asian Art*, 18 November 2011, <https://www.asianart.com/articles/parodi/index.html> (last accessed 22 September 2020).

Parodi, Laura E. and Giovanni Verri, 'Infrared reflectography of the Mughal painting *Princes of the House of Timur* (British Museum, 1913,0208,0.1)', *Journal of Islamic Manuscripts* 7 (2016), pp. 36–65.

Seyller, John, 'Scribal notes on Mughal manuscript illustrations', *Artibus Asiae* 48.3–4 (1987), pp. 247–77.

Seyller, John, 'Hashim', in Pratapaditya Pal (ed.), *Master Artists of the Imperial Mughal Court* (Bombay, 1991), pp. 105–18.

Seyller, John, 'Farrukh Beg', in Milo C. Beach, Eberhard Fischer and Brijinder N. Goswami, *Masters of Indian Painting, Vol. 1: 1100–1650* (Artibus Asiae Supplementnum 48 I/II, 2011), pp. 187–210.

Seyller, John, 'Five folios from the Jahangir album', in Sheila Blair and Jonathan Bloom (eds), *God is Beautiful and Loves Beauty: The Object in Islamic Art and Culture* (New Haven, 2013), pp. 300–39.

Stronge, Susan, *Painting for the Mughal Emperor: The Art of the Book 1560–1660* (London, 2002).

Subtelny, Maria Eva, 'Babur's rival relations: a study of kinship and conflict in 15th–18th century Central Asia', *Der Islam* 66 (1997), pp. 102–18.

Thackston, Wheeler (trans. and ed.), *The Jahangirnama: Memoirs of Jahangir, Emperor of India* (Washington, DC, and New York, 1999).

Thackston, Wheeler (trans. and ed.), *The History of Akbar*, 3 vols (Cambridge, MA, 2015–).

Vaughan, Philippa, 'Miskin', in Pratapaditya Pal (ed.), *Master Artists of the Imperial Mughal Court* (Bombay, 1991), pp. 17–30.

CHAPTER THIRTEEN

The Use of Metals in Islamic Manuscripts

Cheryl Porter

GOLD AND SILVER were used in manuscripts to add material and symbolic value to the work, as they reflected the light, literally 'illuminating' the book. Occasionally other metals, such as bronze, copper and tin, were used, although in the main, it was mostly gold and silver, in spite of the latter's inevitable blackening. Gold was used to write and to decorate even the earliest Qur'an manuscripts, but it was not commonly used to decorate other types of manuscripts until the twelfth century. Although these metals could be prepared and applied to the page in a number of ways, the gold used to write and decorate early Islamic manuscripts was largely in 'leaf' form.

'Leaf' recipes and their origins

The processing of gold and silver ores to obtain thin leaves was known from ancient times. Thin strips of metal ore were beaten to form a foil, about the same thickness as paper. The foil was then beaten out between goldbeaters' skin, until it was in its thinnest form – 'leaf' metal.[1] Few metals can be beaten out in this way without crumbling and becoming brittle, and since gold is both plastic and elastic, it is unique in that it can be beaten out into sheets so thin as to be almost without weight.[2] A number of texts record the techniques of preparing metals – gold and silver, as well as tin, copper and lead – and there are detailed instructions for applying beaten gold leaf to artwork and jewellery. Pliny and Vitruvius (first century AD) wrote of the preparation of gold and silver metals. The first known reference to the manufacturing of metal sheets and their application to different surfaces is the eighth century *Codex Lucensis*; the *Mappae Clavicula*, from the ninth century, has several hundred recipes, many of them for metals.[3] Avicenna (Ibn Sina, Iran, 980–1037) had a detailed practical knowledge of gilding techniques,[4] and al-Hamdani (c. 843–945) wrote of medieval Islamic gilding tech-

nologies, giving a detailed description of gilding methods, especially for copper and silver. He also discussed the use of leaf and foil gold to gild non-metallic objects such as wooden boxes and the outer pages of books.[5]

The earliest known visual reference to the practice of hammering gold to obtain leaves is on a wall painting in an Egyptian tomb datable c. 2300 BC There is also an early example of the use of gold leaf in an Egyptian papyrus Book of the Dead dated c. 300 BC.[6] The Egyptians frequently used gold leaf on wooden funeral sarcophagi.

Writing in leaf form

At first thought, the idea of 'writing' in leaf form seems strange. In fact, the technique of applying the leaf is exactly the same as the technique for applying leaf to illumination. The area to be gilded was first marked out with a pen, reed or brush charged with an adhesive – usually egg white or gum, although animal protein adhesives were also used. The leaf was then carefully laid onto the area covered with adhesive and a soft cloth was used to damp it into position. When the adhesive dried, the excess gold was gently brushed away, so that only that which had adhered to the marked area was left behind. Any leaf applied to a manuscript had to be applied before all the other colours, since the brushing away of the excess gold would disturb the other colours, if they had already been put down. Moreover, in the process of brushing away the excess gold, tiny pieces of leaf could embed themselves in the surrounding pigments and prove extremely difficult to remove without damaging or disrupting the artwork. Recipe books are very clear about this, and examples of the order to be followed in laying metals and then pigments can often be seen on unfinished paintings in manuscripts, where the drawing or 'inking' is in place and the leaf is down, but other colours were never applied (Figure 13.1).

Perhaps the best known of all Islamic manuscripts written in gold leaf is the Blue Qur'an, whose provenance and dating are disputed. Bloom dates it to the tenth century AD.[7] The manuscript is written on parchment, though there are many (later) examples where gold leaf was used for writing on paper (Figures 13.2 and 13.3).

Letter outlines in black

Some time after the gold (or silver) letters had been laid down and (from time to time) lightly burnished, the letter was outlined in black ink. The outlining ink may have been either metal tannate (*hibr*) or carbon black (*midad*), and possibly a mixture of both.[8] Sometimes the black line can be observed moving up and over the leaf. This technique can be clearly seen in the Blue Qur'an, where the black line forms part of the letter, with a long line over the gold. It would

Figure 13.1 *An unfinished illustration where the gold is applied before all colours. Chester Beatty Library, Per 221, f. 19b.*

otherwise be too difficult and too time-consuming to form the letter by cutting through the gold leaf.

Advantages of working in the leaf form

There are a number of advantages to working in the leaf form. It gives a realistic depiction of the properties of the metal and, as such, works well when used to depict buckles, metal ornaments and objects, as well as for armour – even when it was highly unlikely that the armour was actually made from gold or silver. There is a certain way that leaf reflects light, and as the page is turned, or the viewer moves, the light is captured and reflected in different ways.[9]

There is, too, the idea that leaf has a certain 'formality' and cultural weight, and feels appropriate for the heavier, robust, monumental

Figure 13.2 *Writing in gold leaf, folio from the Blue Qur'an. New York Metropolitan Museum, 2004.88.*

Figure 13.3 *Detail (taken through a microscope) of the black outline moving up and over gold letters of line 8 of the Blue Qur'an folio. New York Metropolitan Museum, 2004.88.*

Figure 13.4 *Long-necked ewer in gold leaf, gold paint decorating the blue outer garment. John Rylands Library, University of Manchester, Persian MS 6, f. 10b.*

letter forms that were used, for example, throughout the great Mamluk Qur'ans. Other than aesthetic issues, the availability and cost of the metals must also have had considerable bearing on the choice of leaf over paint; this issue will be dealt with in more detail below.

The assertion that Persian manuscript painters used only powdered gold and silver is simply not true. Perhaps the fact that most of our Persian material is post-fourteenth century, coinciding with

the much-increased use of powdered metals (see below), gave rise to this notion. However, both gold and silver in the leaf form continued to be much used in Persian (and other Islamic) manuscript painting, often together with the powdered form.

Although artists knew how to prepare both forms of metal (leaf and powder) from very early on, it is generally true that the leaf form was by far the preferred choice for use in the earlier manuscripts. Much of the early metal writing (chrysography) in Islamic manuscripts was also executed in leaf and it is significant that the earliest dated Islamic binding that has been published – from Marrakesh, dated 1256 – was done using gold leaf.[10]

Writing in gold and silver ink

It is likely that powdered gold was first used in manuscripts as ink, rather than as paint. Writing in gold was known as early as the third century BC.[11] Pre-Islamic recipes refer to writing letters in liquid gold and silver. The Leyden Papyrus X (third century AD) gives fifteen recipes for writing in letters of gold and silver ink, using actual metals or possible substitutes. Recipe numbers 53 and 78 are simply ground-up gold leaf added to gum, then used 'like black ink'. Others have more complicated formulae, adding red lead, sand, natron, vinegar and alum filings.[12] The *Mappae Clavicula* has recipes for preparing inks with gold, incorporating other metals such as copper, lead and tin, as well as various plant juices, brass powder, ferric sulphate, arsenic sulphide resins, and others. Saffron, arsenic (orpiment) and tortoise bile are also mentioned as additives.

The most common method for making gold powder throughout the middle ages was to make an amalgam paste of mercury and gold leaf. Recipes 54 and 71 from the Leyden Papyrus describe the use of mercury in the preparation of the gold paint: 'pulverise with mercury in a mortar; and employ them in writing, after the manner of black ink'.[13] Thompson describes a method where the paste was then put into a cloth or wash-leather, and the excess mercury was squeezed out by pressure, so that the amalgam became hard and brittle enough to grind to powder.[14] A reference describing the use of mercury for refining gold is contained in al-Hamdani's treatise, written in Yemen in the tenth century.[15] Analysis shows that Islamic medieval gilding techniques developed in antiquity. These techniques spread to al-Andalus during the tenth to twelfth centuries, primarily because mercury was available locally.[16]

Recipes number 34 and 54 of the Leyden Papyrus describe the mercury–gold amalgam mass, but do not describe the critical proportion of gold to mercury. Any mercury not evaporated off will result in a dull brownish-looking gold, which will seem to be crumbly, rather than a fine powder. Some words used by scholars to describe powdered gold in early Kufic and Andalusi manuscripts are 'thick',

Figure 13.5 *Gold ink used for writing. Chester Beatty Library, Per 108, f. 42b.*

'grainy' and 'rather crystallised gold'.[17] Gold in early manuscripts, and especially those from al-Andalus, often appears brown and 'grainy'. The fact that the great mercury mines are in this region would suggest that the powdered gold processed here was made with mercury. Déroche records that analysis shows that the 'rather grainy-looking gilt paint' on a manuscript binding from the Islamic West (BNF arabe 5844) is a mixture of gold with mercury and copper.[18] Later, this mercury amalgam method was replaced by grinding the leaf with honey, gum or salt, and then washing the honey, gum or salt away with water. This technique is still used in Turkey and the Indian subcontinent today.[19]

Silver Ink

Ibn Badis (d. 1061) provides a number of recipes for making silver ink. The various processes describe working from the leaf form and applying heat, before adding a variety of substances such as vinegar and mercury, then washing and grinding and finally, adding gum.[20] He also gives a recipe for making ink from 'white Indian tin'. There are many recipes for gold substitutes such as mosaic gold, although this has not yet been identified in any Islamic manuscript.[21]

Advantages of working in paint form

Because the main preparation of the gold (or silver) ink/paint has already been done by the time the artist (or calligrapher) has charged the pen or brush, the writing/painting flows freely from the pen/brush, without the two-step interrupted process of working with leaf. The readily flowing mixture allows for artistically fluid forms and as

Figure 13.6 *Smudged silver ink. Chester Beatty Library, Is 1449, f. 3b.*

such, it works particularly well for arabesques and small details. It is faster to write and easier to capture informal, looser letter forms, though it is equally well suited for Qur'anic and other more formal scripts. Paint is the only form of metal which it is possible to use for highlighting, since it is applied after other pigments are in place. The disadvantage is that one needs much more of it (see below).

Is it paint or leaf? How to tell the difference

There are some cases where it is perfectly obvious that the gold or silver has been applied with a brush. Very fine decoration can only have been done with metal in the paint form. Sometimes brush strokes can be seen. At other times, however, even with good magnification, it can be extremely difficult or even impossible to identify the method of the metal preparation – in other words, to know if one is looking at paint or leaf metal. Borders were executed in both paint and leaf. Script, skies, armour, clothing and implements were done in gold or silver, leaf or paint. If the gold has been burnished – and both leaf and paint very often were – then it is even more difficult to make the distinction. There are, however, some circumstances where one can make a distinction between the two forms.

Identifying paint/ink

If a pen or reed has been used to write letters in ink, there is sometimes evidence of 'welling' at the sides of the letters, where the pen has moved like a boat through the waves, depositing more paint on the letter edges. This is often accompanied by pronounced evidence of adhesive, often yellow-brown in colour, which can be seen where the paint is thinner.[22] Sometimes there is damage, such as powdering and smudging, or signs that the paint has been wiped over the support surface; this is good evidence of paint.

Identifying gold leaf

One of the easiest methods of identifying leaf is by observing the edge of the metal. Where the leaf edge has been cut or brushed, or torn away, one can often observe an identifiable knife-straight line. Another clue is where there is damage to the gold (or silver). Again, the damaged edges tend to be clean and straight, and not at all 'crumbly' or 'powdery'. There is also a way that leaf deforms as it moves across or away from the substrate. Whereas powder will usually crumble, leaf tends to crease and deform in planes.

Mix and match: 'coloured' gold

Though many Islamic manuscripts juxtapose gold of different hues, as well as counter-play the use of leaf and paint, the shift towards the use of two (and more) contrasting hues of gold became prominent in fifteenth-century Turcoman manuscript painting. The technique is especially prevalent from around the 1460s in manuscripts produced during the rule of Pir Budaq in Shiraz.[23] The various shades of the gold – green, red and yellow – are the result of additional elements of copper and silver. Native gold almost always contains silver in amounts varying between 5 and 50 per cent: the higher the silver content, the greener the hue. When gold is red or rose-coloured (for example CBL Ms. 1547), one can be sure that copper has been added, since it is rare for natural copper content to exceed 1 per cent.[24] The technology for purifying gold by removing silver and other impurities was recorded in the twelfth century, and was known from at least Roman times.[25]

Figure 13.7 *Added copper gives a red-gold tone. Chester Beatty Library, 1547, f. 2a.*

Figure 13.8 *More silver gives a green-gold tone, green-gold writing on yellow gold. Chester Beatty Library, Ar 4199, f. 9a.*

Uses of silver in manuscripts

Since silver is so often oxidised to form a dark grey, or even a black layer, it is often impossible to tell if the silver was applied in the leaf or paint form, or even, painted in black. In Islamic manuscripts silver was frequently employed to depict armour and metal implements, and very often it was used to depict water. It seems strange that artists would choose to use a metal that they knew would almost certainly turn black in time. There is no way of knowing how long this process would take, since it would depend on the metal's reaction to other pigments and dyes around it, how often the book was opened, and how polluted the atmosphere was, as well as on the purity of the metal itself. Most likely, the use of the precious metal to depict specific objects and water was simply accepted as a convention, and the inevitable blackening was accepted as a part of that, and anyway, it would most likely hold its colour for the presentation of the manuscript at least, and perhaps for many years after that.

Figure 13.9 *Ducks swim in silver (now blackened) water.*
Royal Asiatic Society, Cambridge University Library, MS 239, f. 7.

Figure 13.10 *Ducks swim in silvery-black water at Kew Gardens, London.*
Photo: Cheryl A. Porter

Uses of tin in manuscripts

Occasionally one sees particularly bright and un-blackened 'silver' used in manuscript painting. In such cases, wherever it has been analysed, the metal has been found to be tin. Tin was produced in Spain and exported to the Islamic East, although even in the tenth century it was said to be in short supply.[26] Ibn Badis wrote that in manuscript painting, safflower red could be applied to leaves of gold, silver and tin.[27] (He also recorded the use of 'white Indian tin' for making ink, as noted above.) Analysis of 'false gold' on an altar frontal from Spain, dated 1250, revealed that it was a yellow glaze applied over tin.[28] Tin was identified in a Persian manuscript from the Fitzwilliam Museum, Cambridge, made in Kashmir in 1505. With this date and in this location, it is likely that the tin came from India.[29] What is most peculiar is that the tin (which is used to depict water) in this manuscript has blackened. Analysis shows, however, that the only metal used here is tin, and it can only be supposed that some undetected organic element has been added and that it subsequently blackened. Tin foils seem to have been used more frequently for (later) Indian miniatures.[30]

Brass was identified (using XRF to identify the presence of copper and zinc) as paint for the border of manuscript 261-1949, now at

the Fitzwilliam Museum in Cambridge, made in Kashmire in 1505. The brass border painting is a later, probably seventeenth-century addition[31] and whilst the use of brass in manuscripts is known in European manuscripts, this is its first identification in an Islamic manuscript. In the absence of further chemical identification, it is not known how common its use was.

The availability of precious metals and the consequences for the uses of gold and silver in manuscripts

Except for relatively few books produced for the luxury market, it is rare to find gold or silver used in manuscripts at all until the thirteenth century – this also applies to European manuscripts. One of the reasons must be that between the fourth and the thirteenth centuries, silver and especially gold were in scarce supply; the exception is Byzantine manuscripts produced in the fourth to sixth centuries. Only in Byzantine-controlled areas were gold coins still used for trade.[32]

It might be supposed that the availability of silver and gold would influence the amount of their use in artistic works at any given time. However, we have little information on the history of gold and silver mining and processing before the thirteenth century, and not much information on trade or quantities of these commodities in those lands producing Islamic manuscripts. The greater part of our information about the availability of these metals derives from the study of coins.[33]

There have been a number of statements concerning the availability of precious metals at various times. For example:

Availability of gold:
- Gold coins were used for trade in Byzantine-controlled Sicily. The expanding Islamic world brought gold coins minted in Damascus, Baghdad and Tripoli, but these were never produced in abundance.
- In the thirteenth century, gold was controlled and supplied by Arab powers in the Mediterranean.
- Two centuries earlier, there was an influx of great quantities of gold to Afghanistan and Iran as a result of gold from the Indian subcontinent, following the campaigns of Mahmud of Ghazna.
- Still earlier, during the 'Abbasid caliphate, the output of gold in the Islamic world was insufficient for the regular coinage, especially after Spain had become detached from the 'Abbasid Empire.

Availability of silver:
- The silver mines worked during the tenth and eleventh centuries in Afghanistan had apparently ceased to operate by the twelfth century.

- Archaeological finds prove that there were vast amounts of silver that were moved from Central Asia to Scandinavia in the tenth and eleventh centuries.
- Silver was mined in the Hindu Kush as well as in Spain, Sicily, North Africa, Egypt, Iran, Upper Mesopotamia and Asia Minor. In Spain, mining flourished again under the Umayyads. But in the eleventh and twelfth centuries, there was a widespread silver famine, so the striking of silver dirhams had to be discontinued, and coins with a very low silver content, the so-called 'black dirhams', circulated widely until the thirteenth century.
- There was a revival of silver coinage in Iraq, Syria and Egypt by the beginning of the thirteenth century. In the fourteenth century, silver came from Europe and gold from Africa. Yet Pegolotti notes that Ilkhanid coins were 97 per cent pure silver.[34]

Whether any of this information can be meaningful in terms of assessing the materials available for manuscript production at any given time and in any given location is doubtful, and until dates and locations can be connected to the use of these metals in manuscripts, one should be careful in attributing absences or abundant usage to these factors.

Increase in the use of gold powder from the fourteenth century

From the fourteenth century onwards, there was an enormous increase in the use of gold powder for painting in manuscripts, and this is true for painting in European as well as in Islamic manuscripts. Gold powder was used in abundance for writing and painting, and for highlighting – almost completely replacing lead white and other colours that had traditionally been used for this purpose.

The reason may be related to what Elaine Wright notes as 'a new aesthetic – also in manuscript painting',[35] as new motifs, new techniques and even a different palette can be observed.[36] Another reason was surely that gold metal was now much more available. New mining techniques were developed in the thirteenth century and a number of new mines were opened. There was also an increase in trade, population and money supply.[37]

When looking at the use of leaf or ink/paint in a manuscript, it should be understood that the powdered form (of gold or silver) requires more of the metal to cover the same area. Thompson writes: 'a whole word could be written and gilded with leaf with the amount of metal needed for the dot on an "i" if it were done with powdered gold'.[38] In the light of this technical knowledge, added to the face that gold and silver were often unattainable, one can understand some of the reasons that would have influenced if, and how much the metals were used, as well as the technical decisions about how they were used.

A second consideration is that perhaps from this time, the new methods of making gold (and silver) powder using 'diluting' techniques – such as those referred to in sixteenth-century Persian recipes – came to be used in the Islamic East.[39] With the new way of powdering leaf metal using honey, gum and other additives, the metal was able to cover larger expanses of the surfaces.

Seemingly at odds with this finding is the fact that almost all of the gold used for the great thirteenth-, fourteenth- and fifteenth-century Mamluk Qur'ans is in leaf form – whether for the splendid illuminations, the borders, or for the roughly gilded florettes used throughout the manuscript (where the cut, straight edges of leaf can clearly be seen). At this time, thanks to the opening of new mines and with technological advances, gold was in abundant supply and other manuscripts produced at this time seem to have a preference for gold in the powder form. Yet this is not true in Egypt. It can be supposed that the choice of form was influenced by aesthetic considerations and perhaps also by traditional preferences.[40] These monumental manuscripts are well suited to the solid and angular, straight-lined gold leaf form, rather than the twinkling, light and ethereal look of powdered gold.

Gold leaf over gesso/ground

From the late twelfth century, the most prestigious and costly manuscripts made in the Christian West (not only European, but also Byzantine and Armenian) almost always used the technique of applying a thin layer of gold leaf over a white or coloured ground made of gesso (Armenian) bole, or earth clay. This gave the appearance of extreme luxury, in that the gold appeared as solid sheets of the precious metal, though only the thinnest of foils had in fact been applied. It is interesting to note that this technique of laying gold leaf over a raised ground seems not to have been practised in Islamic manuscript painting.[41] There are two reasons for this, and they both relate to the fact that Islamic manuscripts of this period – even the most costly and prestigious and those made for the most noble of patrons – use paper as the support, and not parchment (animal skin), as was so frequently the practice in the West.

Paper came early to the Islamic lands[42] and was highly regarded. In contrast, the most prestigious and expensive European manuscripts were almost always painted on parchment, which was considered superior to paper as a support, a position it held until after the advent of printing.

Gold can be lightly burnished on paper, and this was very often done – where the leaf or the powder was gently worked with a stone or tooth, or another smooth-surfaced tool – to flatten and smooth the surface. However, it cannot be worked 'hard'. To understand the sort of strain that leaf-over-ground technique puts onto the support, one

must understand the technique of its application. Once the ground[43] is laid onto the parchment, a number of procedures have to be followed in order to assist adhesion of the gold leaf to the surface of the ground. The final part of the process is the burnishing of the gold, and, crucially, the ground below, which must be glass-smooth in order to achieve the lustre and to bounce light evenly from the surface. Using a smooth stone or an animal tooth, the burnishing begins – at first gently, and then with increasing pressure and vigour 'until your forehead drips with sweat'.[44]

The enormous pressure from the burnishing stretches even the strongest and thickest parchment. Clearly, this is not at all suited to a paper substrate – even one made double thickness, sized and burnished. The fibres could not withstand the pressure and would at least distort, and probably break.

Apart from the impossibility of applying the technique to a paper substrate, there is also the fact that every time the paper page is flexed or turned in the reading of the manuscript, the sheer weight of the ground (plus leaf), and its inflexible nature, would ensure that structural damage would occur, crumbling and breakdown of the adhesion of the gesso, and subsequent flaking and peeling of the leaf. In this way, the nature of the support itself determines which techniques and materials can be used for illuminating the work.

Punching, pricking, tooling and texturing

The technique of pricking and punching into gold enabled the flat metal surface to catch and reflect light at different angles, giving depth, definition and complexity to the surface of the painting. The earliest use of the technique on gold in Islamic manuscripts dates from the 1360s.[45] This same technique was used in European manuscripts much earlier – certainly in the 1230s, though the technique was not commonly used until the early 1400s.

A particularly interesting use of the punching technique can be seen in a late sixteenth-century Persian Qur'an (CBL Ms. 1547). Here, the black letters are outlined in gold ink and tiny punch marks have been evenly placed into the gold, to reflect the light in a subtle but effective way. In fact, it is not until the un-punched letters are studied and compared that the real beauty of the punched letters can be appreciated – the un-punched letters seem quite ordinary in comparison.

Conclusions

To know the history and availability of metals, their mining and trade, the technical advances and aesthetic preferences of the age, enhances the great and very real pleasure for the viewer of these exquisite masterpieces. By understanding the environment that

Figure 13.11 *Black letters outlined in punched gold, to reflect and deflect light. Chester Beatty Library, Is 1547, f. 1b.*

the artist worked in, the reader can appreciate on another level the materials used and the technical expertise needed to create these beautiful objects. What Blair and Bloom call 'things and thinginess' is a way of contextualising all aspects of their physical production. In this way, a deeper appreciation grows for the superlative craftsmanship as well as the 'play': the juxtaposing of red, green and yellow gold, and all the hues of these; the painting and writing in pigment over gold; the use of organic glazes over leaf and powdered gold;[46] the Mamluk contrast between burnishing and not burnishing; and the scratching and the punching. Moreover, a technical and aesthetic understanding of the ways to use the sombre and formal leaf forms and the fine and sparkling powdered forms of gold and silver yields further understanding of the artists' skills. Tin and brass, used as substitutes for the noble metals, bring yet another dimension to the many ways artists used metals in Islamic manuscripts to enhance beauty and reflect light and, perhaps, simply to demonstrate bravura technical expertise, have fun and create beauty.

Notes

1. Goldbeaters' skin was made from the very thin skin from the blind gut of cattle, or other animal.
2. There is good evidence that much of this leaf was made from current coinage, as it was convenient and available – though such practices were sometimes forbidden by law.
3. Adriano Caffaro, *Scrivere in oro: ricettari medievali e artigianato (secoli IX–XI): Codici di Lucca e Ivrea* (Naples, 2003), a transcription and Italian translation of the Lucca ms., Ms. 490 in de Biblioteca Caitolare di Lucca, written between 796 and 816. For the anonymous *Mappae clavicula* (core recipes dating to the seventh to eighth centuries AD), see Cyril S. Smith and John G. Hawthorn, 'Mappae Clavicula: a little key to the world of medieval technique', *Transactions of the American Philosophical Society* 64.4 (1974), p. 56.

4. See the second section of his book on minerals, *Kitab al-ma'adin wa'l-athar*.

5. Al-Hamdani al-Hasan ibn Ahmad (942), *Kitab al-jawharatain al-'atiqatain*, trans. Joaquin Barrio Martin, 'Islamic gilding technology: written sources and scientific analysis', in Stephanos Kroustallis (ed.), *Art Technology, Sources and Methods: Proceedings of the Second Symposium of the Art Technological Source Research Working Group* (London, 2008), pp. 121, 125.

6. In the wall painting of Re'hem's Egyptian tombs (tomb number 72) dated 2300 BC, in Deir al-Gebrawi. This can be seen in the opening vignette in the *Book of the Dead* of Anhay, British Museum, London (BM accession number EA9949).

7. For the latest discussion, carried out in the context of the work of Bloom, George and Stanley, see Marcus Fraser, 'The origins and modifications of the Blue Qur'an', in Stella Panayotova and Paola Ricciardi (eds), *Manuscripts in the Making: Art and Science Volume One* (London and Turnhout, 2017), pp. 198–213.

8. Sheila S. Blair, *Islamic Calligraphy* (Edinburgh, 2006), pp. 61–2.

9. Barbara Brend, 'The management of light in Persian painting', in Jonathan Bloom and Sheila Blair (eds), *God is the Light of the Heaven and the Earth: Light in Islamic Art and Culture* (New Haven and London, 2015), p. 200.

10. British Library Ms. Or. 13126.

11. Titus Flavius Josephus, *Jewish Antiquities*, trans. Ralph Marcus (Cambridge, MA, 1957), XII. II.

12. Natron is a naturally occurring mixture of sodium carbonate decahydrate ($Na_2CO_3 \cdot 10H_2O$, a kind of soda ash) and about 17 per cent sodium bicarbonate (also called baking soda, $NaHCO_3$) along with small quantities of sodicum chloride and sodium sulfate.

13. Earle Radcliffe Caley, 'The Leyden Papyrus X, an English translation with brief notes', *Journal of Chemical Education* 3.10 (1926), p. 1149.

14. Daniel V. Thompson, *The Materials and Techniques of Medieval Painting* (New York, 1956), p. 194.

15. James W. Allan, *Persian Metal Technology, 700–1300* (London, 1979), p. 7.

16. Martin, 'Islamic gilding technology'.

17. François Déroche, *Islamic Codicology: An introduction to the Study of Manuscripts in Arabic Script* (London, 2005), p. 147.

18. Ibid., p.150.

19. This technique is still used in Turkey – with gum, and in India – with honey. For a useful explanation of this technique, see Anita Chowdry, 'Preparing shell gold', available at <https://anitachowdry.wordpress.com/> (last accessed 30 September 2020).

20. Martin Levey, 'Mediaeval Arabic bookmaking and its relation to early chemistry and pharmacology', *Transactions of the American Philosophical Society* 52.4 (September 1962), p. 33.

21. The earliest surviving recipe for mosaic gold is from a late thirteenth-century Portuguese manuscript; see David S. Blondheim, 'An old Portuguese work on manuscript illumination', *Jewish Quarterly Review* 19 (1968), pp. 97–135.

22. Déroche, *Islamic Codicology*, p. 148.

23. Elaine Wright, personal communication, November 2016.

24. Theophilus, the twelfth-century monk, described gold from the north

of the Niger and Senegal rivers in the Western Sahara as 'Arabian gold of exceptional red colour' (Theophilus, 'Schedula diversarium artium', in John G. Hawthorne and Cyril S. Smith (eds), *Theophilus: On Divers Arts: The Foremost Medieval Treatise on Painting, Glassmaking and Metalwork* (2nd ed., New York, 1979), p. 118).

25. Smith and Hawthorne, 'Mappae Clavicula', p. 56.
26. Donald R. Hill, *Islamic Science and Engineering* (Edinburgh, 1993), p. 209.
27. Levey, 'Mediaeval Arabic bookmaking', p. 31.
28. Jilleen Nadolny (ed.) *Medieval Painting in Northern Europe: Techniques, Analysis, Art History: Studies in Commemoration of the 70th Birthday of Unn Plahter* (London, 2006), p. 151.
29. Kristine Rose and Paola Ricciardi, 'Fusing findings: a cross-disciplinary approach to material analysis of manuscripts at the Fitzwilliam Museum, Cambridge', *Uluslararasi cilt sanati buluşmasi sempozyumu, tebliğler*, MS 216-1949, f.67b (Istanbul, 2014), pp. 92–7.
30. Rachael Smith, with contributions by Jessica Baldwin, 'The use of gold in Mughal painting' in Elaine Wright (ed.), *Muraqqa' Imperial Mughal Albums from the Chester Beatty Library, Dublin* (Alexandria, VA, 2008), pp. 199–205. The album was produced in the imperial Mughal atelier for Jahangir and, after him, Shah Jahan.
31. Elaine Wright dated the painting, and brass was identified by Paola Ricciardi. See Stella Panayotova (ed. with the assistance of Deirdre Jackson and Paula Riccardi), *Colour – The Art and Science of Illuminated Manuscripts* (Brepols, London and Turnhout, 2016), pp. 188–9. This publication was the catalogue accompanying the 2016 exhibition 'Colour at the Fitzwilliam Museum'. The exact folio referred to in the manuscript is fol. 53r.
32. For more information of the shortages of gold and silver at this time, see Peter Spufford, *Money and Its Use in Medieval Europe* (Cambridge, 1988).
33. John M. Smith, 'The silver currency of Mongol Iran', *Journal of the Economic and Social History of the Orient* 12.1 (1969), pp. 16–41.
34. For Pegolotti's travels in Mongol territory, see Henry Yule (trans. and ed.), *Cathay and the Way Thither* (London, 1916), vol. III, pp. 137–73.
35. Elaine Wright, *The Look of the Book: Manuscript Production in Shiraz, 1303–1452* (Washington, DC and Seattle, 2012), p. 48.
36. Sheila S. Blair, 'Colour and gold: the decorated papers used in manuscripts in later Islamic times', *Muqarnas* 17 (2000), pp. 24–36.
37. Spufford, *Money and Its Use*.
38. Thompson, *Materials and Techniques*.
39. Minorsky, Vladimir, *Calligraphers and Painters: A Treatise by Qadi Ahmad* (Washington, DC, 1959) p. 197; Martin B. Dickson and S. Cary Welch, 'Appendix 1: the canons of painting by Sadiki Bek', in *The Houghton Shahnama* (Cambridge, MA, 1981), vol. I, p. 264; Wheeler Thackston, 'Treatise on calligraphic arts: a disquisition on paper, colors, inks, and pens by Simi of Nishapur', in Michael M. Mazzaoui and Vera B. Moreen (eds), *Intellectual studies on Islam: Essays Written in Honor of Martin B. Dickson* (Salt Lake City, 1990), p. 222.
40. Cheryl A. Porter, 'The science of colour: color analysis and the roles of economics, geography, and tradition in the artist's choice of colors for manuscript painting, in Jonathan Bloom and Sheila Blair (eds), *And Diverse Are Their Hues: Colour in Islamic Art and Culture* (New Haven and London, 2011), pp. 203–21.

41. Déroche, *Islamic Codicology*, p. 148, 'unlike much Latin manuscript gilding gold in (Islamic) manuscripts has no discernible effect of relief'.
42. Jonathan M. Bloom, 'Paper in the Islamic lands', *Hand Papermaking* 27.2 (2012), pp. 3–11.
43. 'Ground' is defined as the film or stratum, which lies between the support and the paint layer.
44. Thompson, *Materials and Techniques*, p. 202.
45. Wright, *Look of the Book*, p. 58.
46. For the identification of lac and safflower glazes over gold, see Porter, 'Color analysis'.

Bibliography

Allan, James W., *Persian Metal Technology, 700–1300* (London, 1979).

Blair, Sheila S., 'The coins of the later Ilkhanids: mint organization, regionalization, and urbanism', *American Numismatic Society Museum Notes* 27 (1982), pp. 211–30.

Blair, Sheila S., 'Color and gold: the decorated papers used in manuscripts in later Islamic times', *Muqarnas* 17 (2000), pp. 24–36.

Blair, Sheila S., *Islamic Calligraphy* (Edinburgh, 2006).

Blondheim, David S., 'An old Portuguese work on manuscript illumination', *Jewish Quarterly Review* 19 (1928), pp. 97–135.

Bloom, Jonathan M., *Paper Before Print: The History and Impact of Paper in the Islamic World* (New Haven, 2001).

Bloom, Jonathan M., 'Paper in the Islamic lands', *Hand Papermaking* 27.2 (2012), pp. 3–11.

Bloom, Jonathan M., 'The Blue Koran revisited', *Journal of Islamic Manuscripts* 6 (2015), pp. 196–218.

Brend, Barbara, 'The management of light in Persian painting', in Jonathan Bloom and Sheila Blair (eds), *God is the Light of the Heaven and the Earth: Light in Islamic Art and Culture* (New Haven and London, 2015), pp. 196–229.

Caffaro, Adriano, *Scrivere in oro: ricettari medievali e artigianato (secoli IX–XI): Codici di Lucca e Ivrea* (Naples, 2003).

Caley, Earle Radcliffe, 'The Leyden Papyrus X: an English translation with brief notes', *Journal of Chemical Education* 3.10 (1926), pp. 1149–66.

Chowdry, Anita, 'Preparing shell gold', <https://anitachowdry.wordpress.com> (last accessed 30 September 2020).

Déroche, François, *Islamic Codicology: An Introduction to the Study of Manuscripts in Arabic Script* (London, 2005).

Dickson, Martin B. and S. Cary Welch, *The Houghton Shahnama* (Cambridge, MA, 1981).

Fraser, Marcus, 'The origins and modifications of the Blue Qur'an', in Stella Panayotova and Paola Ricciardi (eds), *Manuscripts in the Making: Art and Science, Volume One* (London and Turnhout, 2017), pp. 198–213.

Hill, Donald R., *Islamic Science and Engineering* (Edinburgh, 1993).

Josephus, Titus Flavius, *Jewish Antiquities*, Vol. 11, trans. R. Marcus (Cambridge, MA, 1957).

Levey, Martin, 'Mediaeval Arabic bookmaking and its relation to early chemistry and pharmacology', *Transactions of the American Philosophical Society* 52.4 (September 1962), pp. 5–79.

Martin, Joaquin Barrio, 'Islamic gilding technology: written sources

and scientific analysis', in Stefanos Kroustallis (ed.), *Art Technology: Sources and Methods: Proceedings of the Second Symposium of the Art Technological Source Research Working Group* (London, 2008), pp. 119–26.

Minorsky, Vladimir, *Calligraphers and Painters: A Treatise by Qadi Ahmad* (Washington, DC, 1959).

Nadolny, Jilleen (ed.), *Medieval Painting in Northern Europe: Techniques, Analysis, Art History: Studies in Commemoration of the 70th Birthday of Unn Plahter* (London, 2006).

Panayotova, Stella (ed. with the assistance of Deirdre Jackson and Paula Riccardi), *Colour – The Art and Science of Illuminated Manuscripts* (London and Turnhout, 2016).

Porter, Cheryl A., 'The science of color: color analysis and the roles of economics, geography, and tradition in the artists' choice of colors for manuscript painting', in Jonathan Bloom and Sheila Blair (eds), *And Diverse Are Their Hues: Color in Islamic Art and Culture* (New Haven and London, 2011), pp. 203–21.

Rose, Kristine and Paola Ricciardi, 'Fusing findings: a cross-disciplinary approach to material analysis of manuscripts at the Fitzwilliam Museum, Cambridge', in *Uluslararasi cilt sanati buluşmasi sempozyumu, tebliğler* (Istanbul, 2014), pp. 92–7.

Smith, Cyril S., and John G. Hawthorne, 'Mappae clavicula: a little key to the world of medieval techniques: an annotated translation based on a collation of the Sélestat and Phillips-Corning manuscripts, with reproductions of the two manuscripts', *Transactions of the American Philosophical Society* 64.4 (1974), pp. 1–128.

Smith, John M., 'The silver currency of Mongol Iran', *Journal of the Economic and Social History of the Orient* 12.1 (1969), pp. 16–41.

Smith, Rachael, with contributions by Jessica Baldwin, 'The use of gold in Mughal painting', in Elaine Wright (ed.), *Muraqqa': Imperial Mughal Albums* (Alexandria, VA, 2008), pp. 199–205.

Spufford, Peter, *Money and its Use in Medieval Europe* (Cambridge, 1988).

Thackston, Wheeler, 'Treatise on calligraphic arts: a disquisition on paper, colors, inks, and pens by Simi of Nishapur', in Michael Mazzaoui and Vera Moreen (eds), *Intellectual Studies on Islam: Essays Written in Honor of Martin B. Dickson* (Salt Lake City, 1990), pp. 219–28.

Theophilus, 'Schedula diversarium artium', trans. John G. Hawthorne and Cyril S. Smith, as *On Divers Arts: The Foremost Medieval Treatise on Painting, Glassmaking and Metalwork* (2nd ed., New York, 1979).

Thompson, Daniel V., *The Materials and Techniques of Medieval Painting* (New York, 1956).

Wright, Elaine, *The Look of the Book: Manuscript Production in Shiraz, 1303–1452* (Washington, DC and Seattle, 2012).

Yule, Henry (trans. and ed.), *Cathay and the Way Thither*, Vol. III (London, 1916).

CHAPTER FOURTEEN

Telling Stories: Artists' Books in the Collection of the British Museum

Venetia Porter

THIS CHAPTER TAKES as its principal point of inspiration two major interests in the work of Sheila Blair and Jonathan Bloom, writing and paper, focusing on a major art form within Middle Eastern contemporary art: artists' books. Artists' books are defined as 'books made or conceived by artists'.[1] They tend to be either unique works or produced in limited editions. The term is used to describe the contemporary manifestation of the *livre d'artiste*, or *livre de peintre*, which originated in Paris at the beginning of the twentieth century. The key exponent of the genre was the art dealer Ambroise Vollard, who commissioned lithographs from Pierre Bonnard to illustrate a collection of poems by Paul Verlaine, published in 1900, and this set a trend.[2] As described by Camille Mathieu:

> The artist's book is a rather hybrid form. It turns a story or a poem into an object; it lends the weight of materiality to the metaphorical weight of narrative ... It can be presented materially – as a bound book where only one page can be opened at a time – or immaterially, as a series of leaves and pages that feed into one another.[3]

As I hope to show in this chapter, Mathieu's description is just as applicable to books by artists of the Middle East which have remained largely unconsidered within the strongly Western- focused study of this genre.

As with many of their Western contemporaries, from Giacometti to Anselm Kiefer, Middle Eastern artists often make books as only one element of their practice. One of the first to draw attention to this genre was Marie-Geneviève Guesdon, who included a number of striking examples in the exhibition *L'art du livre arabe* at the Bibliothèque nationale in 2001.[4] Five years later, in *Islamic Calligraphy* (2006), Sheila Blair discussed artists' books in the context of later developments of calligraphy, but there have been few studies dedicated to the subject so far.[5]

The British Museum has in its collection over thirty artists' books, some of which were displayed in *Word into Art: Artists of the Modern Middle East*.[6] Varying in form and style, these books are wide-ranging in their subject matter, from poetry and folktales to those with a strong political contemporary narrative. The majority in the collection are by Arab artists, with a small number made by Iranians. This chapter will consider a number of books from across the collection, looking at how they are made, how text and image interact, and the context of their production.

Shafic Abboud and the first artists' books

The first Middle Eastern artist to create artists' books is undoubtedly the Lebanese Modernist Shafic Abboud (1926–2004), who lived between Paris and Beirut, and is associated with the group known as L'école de Paris.[7] There are three of his books in the British Museum including two of his earliest, *Le bouna* made in 1953–4 and *La souris* made in 1954 (Figure 14.1), both of which show a clear affiliation to the French *livre d'artiste*. Abboud would have been familiar with the books produced by Braque, Matissse and others. He made *Le bouna* in the traditional technique of black and white etching in the studio of the French printmaker and lithographer Edouard Goerg (1893–1969), while for *La souris* he used the new technique of silkscreen colour

Figure 14.1 *Shafic Abboud,* La souris *(1954), silkscreen on paper, 41 × 32.5 cm (closed), edition 8/20, British Museum 2007,6012.1, Brooke Sewell Permanent Fund. Courtesy of Trustees of the British Museum, © Estate of the artist.*

printing. Highlighting the duality of Abboud's French and Lebanese identities, while *La souris* is based on a French folktale and tells the story of a woman who gives birth to mice with delightful ensuing adventures, *Le bouna* is a story recounted to Abboud by his grand-mother in the village of Mhaidse, north-east of Beirut, where he spent much of his childhood. In both these books the texts accompanying the illustrations are written in Abboud's own hand in French.[8]

Abboud's third book in the British Museum collection, *Maraya li-zaman al-inhiyar* (Mirrors for a Time of Decline, hereafter *Maraya*)) was produced over twenty years later, in 1978 (Figure 14.2). While Abboud's early works are figurative, by the 1970s he was turning increasingly towards abstraction in both his works on paper and his large oil-painted canvases. Always keen on poetry, he was now working closely with poets, including the Syrian-Lebanese poet Ali Ahmad Said Esber (b. 1930), known as Adonis. *Maraya* consists of a series of pull-out pages and, on a subtle abstract background in shades of grey, white and black, float the words of Adonis' poem in Abboud's own delicate hand in Arabic:

> The Beginning of the Poem
> … It is the nakedness that uncovers the corpses of words
> It is existence that disappears

Figure 14.2 *Shafic Abboud,* Maraya li-zaman al-inhiyar *(Mirrors for a Time of Decline, 1978), etching on paper, 29.5 cm × 24.0 cm (closed), edition 10/15, British Museum 2007,6012.2, Brooke Sewell Permanent Fund. Courtesy of Trustees of the British Museum, © Estate of the artist.*

I lost my fire
My language is another one
My footsteps
are no longer my footsteps.[9]

Of the poets who have proved most inspirational to Middle Eastern artists it is Adonis and the late Palestinian poet Mahmoud Darwish (1941–2008) who stand out. Often political in nature, their poems have particular resonance for people of the Arab world by speaking of the human condition or the condition of exile. In many cases, a close bond developed between artist and poet and the resulting work is often a real collaboration, not merely illustration. An exhibition at the Institut du monde arabe, Paris, in 2000, *Adonis un poète dans le monde d'aujourd'hui*, demonstrated Adonis' strong connection with artists from as early as 1950, when he took up his studies at the University of Damascus and mixed with avant-garde artists and poets – an engagement that continued in Lebanon, where he moved to in 1957. In later years, during the 1990s, he also began to create his own artworks, abstract compositions based on text.[10] In the British Museum alone, there are six artists' books inspired by Adonis' poetry: the afore-mentioned *Maraya* by Shafic Abboud; two by Dia al-Azzawi (one of which is described below); one by Sudanese artist Mohammed Omar Khalil (1999), in which the printed text of 'Harlem' from *Grave for New York* is separate from the paintings; *Beginnings* (1993), printed poems in Arabic and English accompanied by geometric designs by Kamal Boullata (1942–2019), the first artist's book he made; and *The Book of Cities*, with etchings by Syrian artist Ziad Dalloul.[11] Arguably also a 'book' in its widest sense is the print series *The Petra Tablets*, made by the Jordanian artist Mona Saudi in which her modernist sculptural forms are surrounded by the verses of Adonis written in her own hand.[12]

Azzawi's *Adonis LX* is a limited-edition book made in 1990 on the occasion of the poet's sixtieth birthday. The texts of the five lithographs, as with Abboud's *Maraya*, fold out and consist of excerpts of poems written in the artist's own hand: (I) 'The Days of the Falcon'; (II) 'This is my Name'; (III) 'A Tomb for New York'; (IV) 'Isma'il'; and (V) 'I Dream and Obey the Sun's Verse'. Each composition is abstract, using a different, bold colour palette, and each contains a haunting face, sculptural in form. In 'This is my Name' (Figure 14.3), a poem written in 1968, Azzawi employs a palette that is predominantly blue, a haunting face staring out of the page on the right, with a block of text, written in different directions, in the centre. He starts the text about a third of the way through the poem:

> The meek of the earth approached, they immersed this age in
> ragged dreg-drops and tears, they immersed the searching
> body, away from its warmth

Figure 14.3 *'This Is My Name', from Dia al-Azzawi,* Adonis LX *(1990), hand-coloured lithograph on paper, 39 × 28 cm (closed), edition 1/6, British Museum 1990,1123,0.1. Courtesy of Trustees of the British Museum, © the artist.*

> The city is arcs of madness
> I saw that the revolution bore its children, I buried millions of
> songs and I came (are you in my grave)? Come that I may
> touch your hands. Follow me my time has not come though
> the graveyard of the world has
> I have ashes for all the Sultans
> Give me your hands, follow me ...[13]

The books that Azzawi makes (he has now produced close to 100) are an essential and intrinsic part of his overall practice. Like his paintings and sculptures, they are abstract and use pure and vibrant colour. Every aspect is the focus of production, from the cover of the book to its interior contents.[14] Very often there are hints of something ancient connected to the deep past of Iraq – Sumerian or Babylonian – in the sculptural figural forms. Azzawi (b. 1939) began his studies as an archaeologist before turning to art, and much of his youth was spent in the Iraq Museum in Baghdad.[15] Like many of his Iraqi contemporaries, he sees his work as part of a continuum which links the artistic production of Iraq from ancient times to the present; we shall return to this point later. His interests, however, also encompass a deep love for wider Arab culture.[16] In *Adonis LX*, each box of prints includes a unique drawing: in the British Museum example (Figure 14.4), the image is an abstracted female figure, entitled *Suq al-harir* (The Silk Market). The text, in red and black ink, one line scrubbed out, reads: 'A woman of the *jinn* of Saba her dress punctured with wantonness and perforated with secret lusts, and her sleeves wings of board ... only permitted to whinny and fight.'[17] The allusions are to ancient Yemen, to the Queen of Sheba and her relationship with Solomon which is told in the Qur'an (Q. 34:12).

Mahmoud Darwish was a poet not only of international repute, but one who continues to be regarded as the voice of the Palestinian people. Four books in the British Museum collection feature his

Figure 14.4 *'The Silk Market', from Dia al-Azzawi,* Adonis LX *(1990), gouache and ink on paper, 39 × 30 cm, British Museum 1990,1123,0.1. Courtesy of Trustees of the British Museum, © the artist.*

poetry, including those by the French-Algerian artist Abdallah Benanteur, the Algerian artist Rachid Koraïchi and the Iraqi artist Rafa al-Nasiri, as well as a set of prints by Mona Saudi, made in 1979. In her *Homage to Mahmoud Darwish*, as with *The Petra Tablets* (mentioned above), Saudi writes the poems in her own distinctive hand around the sculptural form of the image:

I am the land and the land is you
This is my song
And this is the emergence of Jesus from the wound
And the wind is green like grass covering the nails and my chains
And this is the ascendance of the Arab boy to the dream and
 Jerusalem ...[18]

The French-Algerian artist Abdallah Benanteur (1931–2017), enthral-
led by books and literature from childhood, produced artists' books
for decades. He made them entirely himself, from the paper to the
typography, and printed them on a hand press.[19] His subject is world
literature, from Dylan Thomas to Marguerite Yourcenar and, amongst
them, the poetry of Mahmoud Darwish. In *Birds Die in Galilee*, an
extraordinarily moving poem written in 1969, each of the thirty pages
of the book consists of three sections: two outer leaves, one of which
has the verse of poetry and the other is printed with birds; and an inner
page with a separate abstract monoprint. This is the last verse:

Flocks of birds fell like paper
into the wells
And when I lifted the blue wings
I saw a growing grave.
I am the man on whose skin
Chains have carved a country ...[20]

Algerian artist Rachid Koraïchi (b. 1947), who also loves the form of
the artist's book, knew Darwish personally – they were close friends,
particularly during the years that Darwish spent in Tunis from 1981
onwards. Two extraordinary books resulted from their friendship: *Une
nation en exil* and *La qasida de Beyrouth*. In both books, Koraïchi's
prints are accompanied by the full texts of the poems, written by cal-
ligraphers Hassan Massoudy and Kamel Ibrahim. Interviewed about
his collaboration with Darwish, Koraïchi asserted:

In this project, it was not a question for me of illustrating his
poems. I loved his texts and he appreciated my work. I wanted to
seize aesthetically the emotion that was the essence of the poem
... and thus I followed the movement of these texts in an exhila-
rating pictorial adventure which lasted three years ...[21]

Koraïchi's compositions are in his hallmark style that appears on all
the work he makes which includes ceramics and textiles. Arabic text
is written in all directions, and there are symbols derived both from
the tattoos and designs on pottery and rugs of the Qabyle in Algeria,
to amulets and signs from the Islamic magical tradition. In *Bitaqat
hawiya* (Identity Card), written in 1964 (Figure 14.5), the first line of
the poem is found three-quarters the way down the page:

Figure 14.5 *'Identity Card', from Rachid Koraichi,* Une nation en exil *(1981), etching on paper, dimensions 76 × 56 cm, British Museum 2016,6059.11.a, gift of the artist. Courtesy of October Gallery, © the artist.*

Write down:
I am an Arab
My ID card number is 50,000
My children: eight
And the ninth is coming after the summer
Are you angry?[22]

Rafa al-Nasiri and *dafatir*

Rafa al-Nasiri (1940–2013), one of the leading printmakers of the Arab world and of the same generation as Azzawi, also worked a great deal with the book, the creation of which is very much linked to his great love of poetry.[23] Thanks to a gift to the British Museum from Nasiri's widow, the poet May Muzaffar, the museum has recently acquired three works: *From that Distant Land* (2007) with the poetry of May Muzaffar, *A Library Set on Fire* with the words of Etel Adnan (2008) – both portfolio editions – and *To Describe an Almond Blossom* (Figure 14.6), a bound book of silkscreen prints made in 2009, inspired by the poem of that name by Mahmoud Darwish, published in 2005.[24]

Although the actual difference between *To Describe an Almond Blossom* and the portfolio editions is that the first is bound and acts like a book, while the others are prints that can be studied and displayed in different ways – as prints on a wall rather than the more intimate experience of turning the pages – they can also be considered 'books' (as we have seen with the works of Mona Saudi mentioned above). Nasiri's style is abstract, often including the Arabic letter, a style known as *hurufiyya*.[25] In some of his books, he commissioned Syrian calligrapher Salih Nasab to write texts combining the calligraphic hand with typewritten Arabic text.[26] About the juxtaposition between these different forms, Nasiri wrote:

> I made use of the graphic element of the Arabic script in these texts and employed it to enhance the painting. This has tempted me into another experiment and that is using parts of texts written in *thuluth* by contemporary calligraphers. I make use of the words of these texts, or parts of a word, as graphic elements within a composition, and also as a symbolic representation regardless of its linguistic meaning.[27]

If we consider the opening page of *To Describe an Almond Blossom*, where the poem starts, the Arabic text, placed within bands of colour is written in different ways. On the left in *thuluth* script are the words *zahr al-lawz* (almond blossom) in white at the top with *al-lawz* repeated on its own below. On the right the longer extract of text is in *naskh*. It is preceded by the first two lines repeated in yellow, the stripes of colour were torn, collaged paper in the original. Nasiri's

Figure 14.6 *Rafa al-Nasiri,* To Describe an Almond Blossom *(2009), silkscreen on paper, 38.5 × 29 cm (closed), edition 9/10, British Museum 2015,6019.1, gift of May Muzaffar. Courtesy of Trustees of the British Museum, © Estate of the artist.*

intention was that, as well as creating a beautiful composition, the words of the poem could be read:

> To describe an almond blossom no encyclopaedia of flowers
> is any help to me, no dictionary.
> Words carry me off to snares of rhetoric
> that wound the sense, and praise the wound they've made.
> Like a man telling a woman her own feeling.
> How can the almond blossom shine in my own language,
> when I am but an echo?[28]

The second of Nasiri's books in the British Museum, *A Library Set on Fire*, takes us into the realm of another category of artists' books: those with a strongly political narrative. For this book is one of a number of works by Iraqi artists that highlight the destruction of libraries and cultural heritage more widely in Iraq following the US-led invasion of Iraq in 2003. Artist and poet Etel Adnan, herself a creator of artists' books,[29] wrote the frontispiece text for this work:

> Lines running in all directions, silence, displacements, verticals turning, rotating, manuscripts burning, each flame annihilating a word, then a sentence, unread and unpublished secrets … the deconstructing of a civilisation, Al Hallaj running wild through

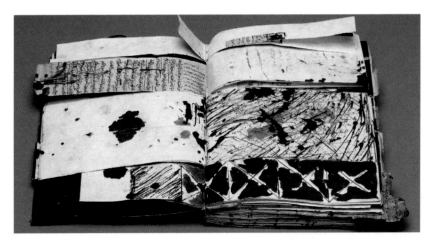

Figure 14.7 *Hanaa Malallah,* Conference of the Birds *(2007), ink and burning on paper, 40 × 20 cm (closed), British Museum 2007,6020.1, Brooke Sewell Permanent Fund. Courtesy of Trustees of the British Museum, © the artist.*

the fire proclaiming 'I am God' over any standing loudspeaker, with his toes, his nails, and his hair catching fire, all this made for ever unknown by the rape of Baghdad an April day when the Tigris was pregnant with apprehension and dreading its merger with the betraying waters of the Gulf.[30]

Accompanying this text, each silkscreen includes a torn, printed extract of verses from the *diwan* of al-Mutanabbi (d. 965), a poet Nasiri was inordinately fond of,[31] placed within a dark abstract composition, the colours powerfully evoke the orange and red flames of a fire. On one of the pages, these words, as translated by A. J. Arberry, emerge: 'With what shall I console myself being without people and home, having neither boon-fellow nor cup, nor any to comfort me.'[32] Nasiri himself left Iraq in 1991, and so these verses clearly held a particular poignancy.

Another artist's book in the British Museum, *Conference of the Birds* by Hanaa Malallah (b. 1958) (Figure 14.7), also highlights those terrible moments of destruction when many Iraqis felt as though their entire heritage was literally being burnt before their eyes. Malallah's book is made up of torn and burnt pages, on which fragments of the text of Farid al-Din 'Attar (c. 1145–1221) are pasted.[33] This work epitomises her practice over almost two decades which she describes as 'Ruins Technique' in which she deliberately distresses her material, and, as Mejcher-Atassi has observed: 'The result is a beautiful but highly fragile book that gives its reader/spectator an idea about the preciousness of manuscripts as well as about the destruction of Iraq's cultural heritage.'[34]

Books such as those described above by Nasiri and Malallah are

considered part of a particular phenomenon – the production of artists' books by Iraqi artists born out of the context of the first Gulf War (1991), the subsequent imposition of sanctions and the context of the US-led allied invasion of Iraq in 2003. These are the decades framed by the rule of Saddam Hussein (r. 1979–2003), and it was Dia al-Azzawi who was instrumental in encouraging Iraqi artists to work with the form of the book, in part for practical reasons as it was hard to obtain art materials in Iraq at this time. Attention was first drawn to this category of artistic production by Nada Shabout in 2007, in an important exhibition she curated at the University of North Texas Art Gallery.[35] The exhibition was entitled *Dafatir*, which is the plural form of the Arabic word *daftar*, whose meanings range from exercise book to notebook, journal, or ledger – a tool of bureaucracy in which all matters of running the state were recorded across the Middle East in the pre-computer age. Shabout chose to give these books their own name, in order to highlight both their distinctive nature, as well as the circumstances of their production and the themes expressed within them. Many of the artists in this exhibition make specific allusions to Iraq's past cultural heritage, while at the same time speaking of the devastating consequences of the Iraq war. As Malallah has described, one of the features that defines them (the *dafatir*) is an obvious use of 'Iraqi' themes as 'a conscious return to the roots made more palpable existentially and creatively by the precarious realities that have continued to bear on every aspect of their lives'.[36]

These allusions to the past artistic traditions of Iraq evident in these books build on an element that is frequently present in the wider work of Iraqi artists, mentioned above in the context of Dia al-Azzawi. This is encapsulated in the use of the term *istilham al-turath* (seeking inspiration through tradition), a view articulated by Jewad Selim (1919–61), Shakir Hassan Al Said (1925–2004) and others in the early 1950s as part of their philosophy of how to shape Iraqi art in the modern era.[37] Within this was the conscious link to the medieval art of the book, as exemplified by the manuscript of *Maqamat al-Hariri*, illustrated by Yahya al-Wasiti in 1237. For Iraqis, this masterpiece of Arab painting is particularly meaningful and a source of immense pride. For Shabout, the *dafatir*, are therefore: 'contemporary Iraqi art productions that synthesize various historical threads from Iraq's past. In fact,' she writes, 'they offer a postmodern articulation of various elements and contemplate the notion of globalization as it is understood by Arab artists'.[38]

Whether the term *dafatir* can be used in a generic way for all artists' books made by Iraqi artists, or whether the term simply applies to those works made in response to the conflict in Iraq is debatable. In 2015, the British Museum acquired *Ali's Boat Diary 1* by Sadik Kwaish Alfraji (Figure 14.8), whose work includes books and video art, and he is clear that *Ali's Boat* is not a *daftar* but a diary.[39] Alfraji, who now lives in the Netherlands, left Iraq in 1991,

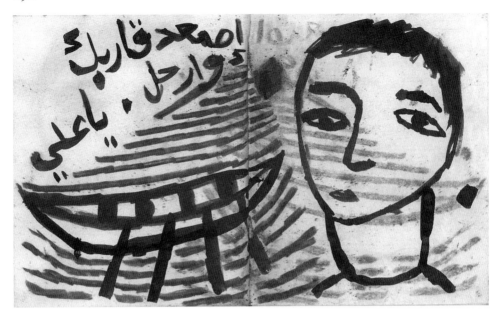

Figure 14.8 *Sadik Kwaish Alfraji*, Ali's Boat Diary *1 (2014), ink and charcoal on paper, 19 × 16 cm (closed), British Museum 2015,6022.1, funded by CaMMEA (Contemporary and Modern Middle East Art Acquisition Group). Courtesy of Trustees of the British Museum, © the artist.*

and did not see Baghdad again until he returned in 2008, following the death of his father. During this visit, he met his nephew Ali for the first time, who gave him a letter in which he had drawn a picture of a boat, with the accompanying words: 'this boat will bring me to you'. Out of this, Alfraji created the book that is in the British Museum, a poignant meditation on the theme of exile, written in the form of a reply to Ali, articulating the pain he felt by having to leave the country of his birth. The text is accompanied by illustrations in child-like style and the first few pages have the following words:

> Get on your boat and leave, Ali/ Take the water spring, my Ali/ My dear Ali, you have made a boat to carry you to me ... I have stolen it to carry me to where you are./ I was like you, Ali ... I had a boat ... It was the colour of gold in dreams and it was studded with lapis lazuli, with lapis lazuli Ali./ Don't put all your dreams in one boat, Ali./ Beware of snakes, Ali./ Stay as far away from your boat as you can, Ali ... This boat will lead to delusion after delusion after darkness. No it does not give you the redemption that you seek./ Ride the cloud. Do not be afraid, Ali.[40]

Before closing this brief discussion of some of the artists' books in the British Museum, two further works need to be mentioned: *The Wedge* by Saudi artist Muhannad Shono (Figure 14.9), and *The Grand*

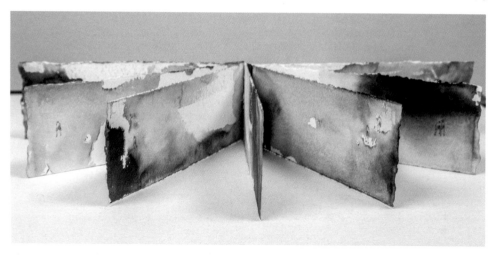

Figure 14.9 *Muhannad Shono*, The Wedge, *2016 Ink on paper; polymer clay, H: 10 cm W: 29 cm (closed), British Museum 2017,6024.1, funded by CaMMEA. Courtesy of Trustees of the British Museum, © the artist.*

Book of Heech by Parviz Tanavoli. Shono (b. 1977) has been exploring ideas around displacement and migration with abstract works that are made up of sheets of handmade paper and ink, which become the basis of video art pieces, like Alfraji's works. Shono has also been making books, and *The Wedge* is a story that can be 'read' in two directions: opened left to right, a single figure in a desolate landscape meets his mate and they continue their journey together; alternatively, opened right to left, the two figures start together but lose one another halfway. There is no need for words – the human story is clear.[41]

The unfolding of a story from two opposing directions is also the theme of the final book discussed here: *The Grand Book of Heech* by artist and sculptor Parviz Tanavoli (b. 1937).[42] Among his most iconic works are sculptures made up of the word *Heech* (meaning 'nothing'). Since 1964, he has created hundreds of different examples of this, from monumental sculptures in bronze and fibreglass to tiny brooches.[43] For Tanavoli, the word has many meanings, at the heart of which are the Sufi ideals expressed by Rumi (1207–73):

> God created everything from nothingness, and in order to reach the highest level of spiritual connection, we, in turn, must strive for the purest form of nothingness … Mine was the nothingness of hope and friendship, a nothingness that did not seek to negate. In my mind, it was not life that amounted to nothing, but rather nothing which brimmed with life itself.[44]

In 2014, the *Heech* appeared in an entirely new form: a fifteen-page book, made from recycled paper, in which the *Heech* in high relief gets gradually smaller, disappearing to literally nothing. Or vice

Figures 14.10a, b and c *Parviz Tanavoli,* The Grand Book of Heech, *or* Nothing from Nothing, *2014, handmade from hemp, British Museum 2016,6054.1, gift of Vali Mahlouji. Photo: Nazanin Peikar Ara.*

versa, if viewed from right to left, a tiny dot expands into the full form of the word (Figures 10a–c).[45]

As I hope to have shown with these few examples, there is richness and depth and subtlety of execution in these artists' books. Engaging in subjects from conflict and destruction to poetry and story telling, whole worlds are evoked in these remarkable creations.[46]

Notes

1. I am extremely grateful to Robert Hillenbrand for inviting me to contribute to this volume and to Louisa Macmillan for her comments and advice in the preparation of this chapter.
2. The Victoria and Albert Museum holds one of the largest collections of artists' books, available at <http://www.vam.ac.uk/content/articles/a/books-artists/> (last accessed 6 April 2020). In 2008, Rowan Watson curated the important exhibition *Blood on Paper: The Art of the Book*, see <https://www.vam.ac.uk/__data/assets/pdf_file/0010/179317/45746_file.pdf> (last accessed 6 April 2020).
3. Lecture given by Mathieu about the collection of artists' books at the Taylorian Library in Oxford on 1 March 2016, available at <http://blogs.bodleian.ox.ac.uk/taylorian/2016/04/04/livres-dartistes-french-artists-books-the-avant-garde/> (last accessed 6 April 2020).

4. Marie-Geneviève Guesdon and Annie Vernay-Nouri, *L'art du livre arabe: du manuscript au livre d'artiste* (Paris, 2001), pp. 176–99.

5. Sheila S. Blair, *Islamic Calligraphy* (Edinburgh, 2006), ch. 13, pp. 589–627. These include Nada Shabout, *Dafatir: Contemporary Iraqi Book Art* (Denton, 2007), discussed below, and Sonja Mejcher-Atassi, 'Contemporary book art in the Middle East: the book as document in Iraq', *Art History* 35.4 (2012), pp. 816–39.

6. Venetia Porter, *Word into Art*: *Artists of the Modern Middle East* (London, 2006), pp. 36–67; (Dubai, 2008), pp. 44–73.

7. Pascale Le Thorel, *Shafic Abboud* (Milan, 2015).

8. Claude Lemand, 'An account of the first Arab artist to initiate the Arab revival of artists' books', *Art Bahrain* 7 (2016), pp. 2–5. I am grateful to my colleague Zeina Klink-Hoppe for giving me the context of the story and the name of the village. See also Venetia Porter with Natasha Morris and Charles Tripp, *Reflections: Contemporary Art of the Middle East and North Africa* (London, 2020), pp. 34–5, and see British Museum Collection online under registration number 2016, 6060.1.

9. Porter, *Word into Art* (2008), p. 55. Translated by Fergus Reoch, full text on the British Museum Collection online, under registration number 2007,6012.2.

10. Alain Jouffroy (ed.), *Adonis: un poète dans le monde d'aujourd'hui 1950–2000* (Paris, 2000), especially the biographical timeline by Anne Wade Minkowsky, pp. 201–86. For Adonis's compositions, see British Museum Collection online, 2007,6012.3.a-c.

11. Porter, *Word into Art* (2006), pp. 48; 54–5. For *The Book of Cities* by Dalloul, see Guesdon and Vernay-Nouri, *L'art du livre arabe*, p. 188; see also Porter, *Reflections* (London, 2020), p. 111. Kamal Boullata discussed his book, *Beginnings*, in 'A Book of Mirrors' reprinted in Finbar Barry Flood (ed.), *There Where You Are Not: Kamal Boullata Selected Writings* (Berlin 2019), pp. 384–7. For illustrations of these, see British Museum Collection online under these registration numbers: Mohammed Omar Khalil: 2007,6012.4, Boullata: 1997,0716,0.1 and Dalloul: 2017,6008.7.

12. *Petra Tablets: The Hand of Stone Draws the Place*, drawings by Mona Saudi, poem by Adonis (Beirut 2011). British Museum Collection online, registration number: 2015,6031.1; see also Porter, *Reflections* (London, 2020), p. 110.

13. Translation by Shawkat M. Toorawa in '"This is my name," by Adonis', *Journal of Arabic Literature* 24.1 (March 1993), pp. 28–38. Available at <https://www.jstor.org/stable/4183288?_=1459014630278> (last accessed 6 April 2020).

14. Dia al-Azzawi, Saleem al-Bahloly, Zainab Bahrani, May Muzaffar and Nada Shabout, *Dia al-Azzawi: A Retrospective (from 1963 until Tomorrow)* (Doha and Milan, 2017), especially pp. 320–89.

15. Ibid., pp. 32–3.

16. Nada Shabout, *Modern Arab Art: Formation of Arab Aesthetics* (Gainesville, 2007), pp. 121 f. For other works connected to poetry by Dia al-Azzawi in the British Museum see *Mutanabbi: Nusus Shi'riya Mukhtara* in Porter, *Word into Art* (2008), p. 47; and, with Shafic Abboud and Mohammed Omar Khalil, *Homage to Tawfiq Sayegh, Khalil Hawi and Salah Abd al-Sabbour* in Porter, *Word into Art* (2006), pp. 56–7.

17. Translated by Fergus Reoch. Extract from *al-Mahd* ('The Cradle', 1983) by Adonis, published in *Kalamat* 4 (October 1984), verse 4, p. 17. See

also <https://www.adab.com/modules.php?name=Sh3er&doWhat=shq as&qid=6168> (last accessed 6 April 2020).

18. This work, alongside Benanteur's *Birds Die in Galilee* was displayed in a small exhibition called *Poetry and Exile* (British Museum, 1 October 2014 – 1 March 2015), available at <https://artsandculture.google.com/exhibit/poetry-and-exile/3AJCclZDRvt-Kg> (last accessed 6 April 2020). The extract from 'The Poem of the Land' was translated by Atef Alshaer.

19. Claude Lemand (ed.), *Benanteur: Graphic Works* (Paris, 2005).

20. Translated by Rana Kabbani. See Porter, *Word into Art* (2006), pp. 58–9, and see British Museum Collection online under registration number 2006,0203,0.1.

21. These works were published in Mahmoud Darwich and Rachid Koraïchi, *Une nation en exil: hymnes gravés suivi de la qasida de Beyrouth* (Paris, 2010). The quotation is my own translation from the interview available at <https://lelitterairecom.wordpress.com/2012/09/17/entretien-avec-rachid-koraichimahmoud-darwich-une-nation-en-exil/> (last accessed 6 April 2020). See also Porter, *Reflections* (London, 2020), pp. 224–5; for other works by this artist in the British Museum see Collections on line under Koraichi.

22. Translated by Salman Hilmy, '"ID Card" by Mahmoud Darwish – A translation and commentary' in *Washington Report on Middle East Affairs* (November/December 2017), pp. 65–6. Available at <https://www.wrmea.org/017-november-december/id-card-by-mahmoud-darwish-a-translation-and-commentary.html> (last accessed 6 April 2020).

23. May Muzaffar and Sonja Mejcher-Atassi, *Rafa Nasiri: Artist Books* (Milan, 2016). I am extremely grateful to May Muzaffar for showing me the text of the book before publication, for her gift of the artists' books to the British Museum and for her very helpful comments on this chapter.

24. Sabah Al Nasiri and May Muzaffar (eds), *Rafa Nasiri: His Life & Art* (Amman, 2010), pp. 184–95.

25. One of the earliest proponents of this style was the Iraqi artist Madiha Omar, who, on seeing Nabia Abbot's *The Rise of the North Arabic Script and its Kur'anic Development* (Chicago, 1939), was encouraged to incorporate Arabic letter forms into her abstract art in the 1940s by Richard Ettinghausen, whom she met in New York: see Wijdan Ali, *Modern Islamic Art: Development and Continuity* (Gainesville, 1997). For Nasiri's abstract compositions during the 1960s, see Al Nassiri *et al.*, *His Life & Art*, pp. 62–3; for a work in the British Museum in this style, see Porter, *Word into Art* (2006), p. 74. Shabout, *Modern Arab Art*, pp. 59 ff.

26. I am grateful for this information to Siba Aldabbagh, who studied Nasiri's work as part of her PhD thesis *Poetics of Resistance: Objects, Word and Image in Literatures and Visual Arts of Iraq and Palestine* (SOAS, University of London, 2017). I grateful to her for allowing me to use this information. Available at <https://eprints.soas.ac.uk/24905/1/Aldabbagh_4417.pdf> (last accessed 6 April 2020).

27. Muzaffar and Mejcher-Atassi, *Artist Books*, p. 58.

28. Al Nasiri and Muzaffar, *His Life & Art* p. 195; Muzaffar and Mejcher-Atassi, *Artist Books*, pp. 72–3.

29. For *Nahar Mubarak* ('Blessed Day', 1990), see Porter, *Word into Art* (2006), p. 22; and other works by Etel Adnan, see Sonja Mejcher-Atassi,

'The forbidden paradise: how Etel Adnan learnt to paint in Arabic' in Angelika Neuwirth, Andreas Pflitsch and Barbara Winckler (eds), *Arabic Literature: Postmodern Perspectives* (London, 2010), pp. 311–20.

30. Muzaffar and Mejcher-Atassi, *Artist Books*, p. 64.
31. Ibid., p. 22.
32. Translation by Arthur J. Arberry, quoted in Muzaffar and Mejcher-Atassi, *Artist Books*, p. 59. See also Porter, *Reflections* (London, 2020), p. 182.
33. Porter, *Word into Art* (2008), pp. 132–3.
34. Mejcher-Atassi, 'Contemporary Book Art in the Middle East', p. 830. Malallah, Hanaa, 5.50.1.1.40.1.30.1.30.30.5 (London, 2018), pp. 14 ff. and 199. Another moment of destruction is evoked in Karim Risan's book *Every Day* (2005), which is broken and painted bright red with tyre marks, as though the aftermath of another car bomb in the streets of Baghdad. See Porter, *Word into Art* (2008), p. 122. See British Museum Collection online: 2007,6005.1. For other books by Risan, see Nada Shabout, 'Dafatir: testimonies of forgotten times', in Peter Eleey, Ruba Katrib and Jocelyn Miller (eds), *Theater of Operations: The Gulf Wars 1991–2011* (New York, 2019), pp. 181 ff.
35. Shabout, *Dafatir*. A number of these books were displayed in *Theater of Operations*, MoMA 2019; see Shabout, 'Dafatir: Testimonies of Forgotten Times', pp. 181–203.
36. Malallah in Shabout, *Dafatir*, p. 18.
37. Maysaloun Faraj (ed.), *Strokes of Genius: Contemporary Iraqi Art* (London, 2011), pp. 44–5; Shabout, *Modern Arab Art*, pp. 28; 98, 114–15. Anneka Lenssen, Sarah A. Rogers, and Nada Shabout (eds) *Modern Art in the Arab World: Primary Documents* (Durham, NC, 2018) p. 150 ff.
38. Shabout, *Dafatir*, p. 18.
39. Personal communication with the artist.
40. Translated by Fergus Reoch and Sadik Alfraji. The poems are transcribed on the British Museum Collection online, available at <https://research.britishmuseum.org/research/collection_online/collection_object_details.aspx?assetId=1613036321&objectId=3664709&partId=1> (last accessed 6 April 2020); see also Nat Muller (ed.) *Sadik Kwaish Alfraji* (Amsterdam, 2015), p. 154 f.; and Venetia Porter, 'I am the hunter … I am the prey', in *Archaic. The Pavilion of Iraq. 57th International Art Exhibition La Biennale di Venezia* (Naples, 2017), pp. 44–7.
41. Porter, *Reflections*, p. 221
42. Edition of thirty produced by AB Bookness (2014). Available at <http://abbookness.com/issue1/> (last accessed 6 April 2020); <https://m.youtube.com/watch?v=uCI3OsRQDNQ> (last accessed 6 April 2020).
43. Lisa Fischman *et al.* (eds), *Parviz Tanavoli* (Wellesley, 2015).
44. Amin Saeidian, 'Heech a nothing that is, sculpted in poem by Parviz Tanavoli', *Elixir Sustainable Architecture* 56A (2013), p. 13578; revised in vol. 93 (2016), p. 39678. Available at <https://www.elixirpublishers.com/articles/1461138280_93%20(2016)%2039676-39684.pdf> (last accessed 6 April 2020).
45. Available at <https://vimeo.com/93362509> (last accessed 6 April 2020).
46. Further examples from the British Museum's collection of artists' books are included in Porter, *Reflections*.

Bibliography

Adonis and Shawkat M. Toorawa in '"This is my name," by Adonis', *Journal of Arabic Literature* 24.1 (March 1993), pp. 28–38.

Adonis, 'Al-Mahd' ('The Cradle', 1983), *Kalamat* 4 (October 1984), pp. 11–25.

Aldabbagh, Siba, *Poetics of Resistance: Objects, Word and Image in Literatures and Visual Arts of Iraq and Palestine* (PhD thesis, SOAS, University of London, 2017).

Ali, Wijdan, *Modern Islamic Art: Development and Continuity* (Gainesville, 1997).

Al-Azzawi, Dia, Saleem al-Bahloly, Zainab Bahrani, May Muzaffar and Nada Shabout, *Dia al-Azzawi: A Retrospective from 1963 until Tomorrow* (Doha and Milan, 2017).

Blair, Sheila S., *Islamic Calligraphy* (Edinburgh, 2006).

Darwich, Mahmoud and Rachid Koraïchi, *Une nation en exil : hymnes gravés suivi de la qasida de Beyrouth* (Paris, 2010).

Eleey, Peter, Ruba Katrib and Jocelyn Miller (eds), *Theater of Operations: The Gulf Wars 1991–2011* (New York, 2019).

Faraj, Maysaloun (ed.), *Strokes of Genius: Contemporary Iraqi Art* (London, 2001).

Fischman, Lisa, Maryam Homayoun Eisler, Shiva Balaghi and Hossein Amirsadeghi, *Parviz Tanavoli* (Wellesley, 2015).

Flood, Finbarr Barry, (ed.), *There Where You Are Not: Kamal Boullata Selected Writings* (Berlin, 2019).

Guesdon, Marie-Geneviève and Annie Vernay-Nouri, *L'art du livre arabe. Du manuscript au livre d'artiste* (Paris, 2001).

Hilmy, Salman, '"ID Card" by Mahmoud Darwish: a translation and commentary', *Washington Report on Middle East Affairs* (November/December 2017), pp. 65–6.

Jouffroy, Alain (ed.), *Adonis: un poète dans le monde d'aujourd'hui 1950–2000* (Paris, 2000).

Le Thorel, Pascale, *Shafic Abboud* (Milan, 2015).

Lemand, Claude, 'An account of the first Arab artist to initiate the Arab revival of artists' books', *Art Bahrain* 7 (2016), pp. 2–5.

Lemand, Claude (ed.), *Benanteur: Graphic Works* (Paris, 2005) [artist's monograph, Vol. 2].

Lenssen, Anneka, Sarah A. Rogers, and Nada Shabout (eds), *Modern Art in the Arab World: Primary Documents* (Durham, NC, 2018).

Mejcher-Atassi, Sonja, 'Contemporary book art in the Middle East: the book as document in Iraq', *Art History* 35.4 (2012), pp. 816–39.

Mejcher-Atassi, Sonja, 'The forbidden paradise: how Etel Adnan learnt to paint in Arabic', in Angelika Neuwirth, Andreas Pflitsch and Barbara Winckler (eds), *Arabic Literature: Postmodern Perspectives* (London, 2010), pp. 311–20.

Muller, Nat (ed.) *Sadik Kwaish Alfraji* (Amsterdam, 2015).

Muzaffar, May and Sonja Mejcher-Atassi, *Rafa Nasiri: Artist Books* (Milan, 2016).

Al Nasiri, Sabah and May Muzaffar (eds), *Rafa al-Nasiri: His Life & Art* (Amman, 2010).

Neuwirth, Angelika, Andreas Pflitsch and Barbara Winckler (eds) *Arabic Literature Postmodern Perspectives* (London, 2010).

Petra Tablets: The Hand of Stone Draws the Place. Drawings Mona Saudi – Poem by Adonis (Published by Mona Saudi, printed by Samo Press 2011).

Porter, Venetia, *Word into Art: Artists of the Modern Middle East* (London, 2006 and Dubai, 2008).

Porter, Venetia, 'Sadik Kwaish Alfraji: I am the hunter. I am the prey', *Archaic: The Pavilion of Iraq. 57th International Art Exhibition La Biennale di Venezia* (Naples, 2017) pp. 44–7.

Porter, Venetia with Natasha Morris and Charles Tripp, *Reflections: Contemporary Art of the Middle East and North Africa* (London 2020).

Saeidian, Amin, 'Heech a nothing that is, sculpted in poem by Parviz Tanavoli', *Elixir Sustainable Architecture* 56A (2013), pp. 13575–83; revised in Vol. 93 (2016), pp. 39676–84.

Shabout, Nada *Dafatir: Contemporary Iraqi Book Art* (Denton, 2007).

Shabout, Nada, *Modern Arab Art: Formation of Arab Aesthetics* (Gainesville, 2007).

Shabout, Nada, 'Dafatir: testimonies of forgotten times', in Peter Eleey, Ruba Katrib and Jocelyn Miller (eds), *Theater of Operations: The Gulf Wars 1991–2011* (New York, 2019), pp. 181–203.

CHAPTER FIFTEEN

The Freer Beaker in Text and Image

Marianna Shreve Simpson

Introduction

THE HISTORY OF medieval Persian ceramics includes numerous examples decorated with images recognisable from illustrations in later *Shahnama* manuscripts.[1] The most iconic such object, renowned for its series of figural scenes arranged in three superimposed registers, is the small, meticulously painted *mina'i* beaker dating from the twelfth or early thirteenth century and belonging today to the Smithsonian Institution's Freer Gallery of Art in Washington, DC (F1928.2).[2] From the beaker's earliest appearance in the scholarly literature, it has been generally assumed that the vessel's iconography was directly related to, and so derived from, the *Shahnama* story of Bizhan and Manizha. In an important note accompanying this chapter, the late 'Abdullah Ghouchani provides concrete evidence for that long-held thesis by matching the *mina'i* scenes with specific verses in Firdausi's great Persian epic. This confirmation of the poetic basis for the vivid Bizhan and Manizha imagery prompts a review, building on previous studies, of the beaker's visualisation and treatment of the *Shahnama* narrative. The chapter then takes up the resemblance, noted in more recent scholarship, between the beaker's pictorial format and that of modern-day comic books, a medium understood here as a popular form of graphic narrative. It also gives the beaker a quick 'narrative turn' as a work of art in three dimensions. By way of conclusion, the chapter argues that the Freer Beaker, while still worthy of its long-established status in Islamic art history, cannot be considered unique in terms of its serial depiction of scenes from Firdausi's Bizhan and Manizha tale.

Figure 15.1 *Freer Beaker, overview 1. Courtesy of Freer Gallery of Art, Smithsonian Institution.*

The story of Bizhan and Manizha

This tale, at once romantic and dramatic, is best known today through the account narrated by Firdausi and may have been the first story that the poet composed for his *Shahnama*.[3] That he based the poem on a pre-existing, possibly oral, rendition is clear from the prelude, in which a companion comforts him during a dark and sleepless night.[4] It may also be assumed that variants of the popular tale of Bizhan and Manizha were recounted after Firdausi's time, parallel with readings or recitations of the *Shahnama* poem itself.[5] The précis here follows the *Shahnama* narrative as the oldest and most complete compilation of the story.[6]

After the explanatory prologue, the episode begins with Kai Khusrau, third ruler of Iran's legendary Kayanid dynasty, feasting at court. A delegation of Armanis appears with a plea for assistance in ridding their lands of an onslaught of wild boars. Kai Khusrau offers

rich rewards to his chieftains to clear the ravaged Armani countryside
on the border between Iran and the enemy neighbour, Turan. Bizhan,
the young son of Giv, volunteers and immediately sets out for this
mission accompanied by Gurgin, an older, and soon-to-be resent-
ful, warrior. After successfully exterminating the marauding boars,
Bizhan is lured across the border by Gurgin's fulsome description of
Manizha, the beautiful daughter of the Turanian ruler Afrasiyab, and
of a yearly festival on the Turanian plain. From her tent, the princess
sees Bizhan stretched out under a tree, becomes enamoured with
the youth, and sends her nurse to ascertain his identity. Bizhan and
the nurse converse. Manizha entertains Bizhan in her meadowlands
pavilion and then drugs his drink and conveys him in secret to her
apartments. Bizhan wakes up and realises that Gurgin has led him
astray, but Manizha persuades him to stay and continue their tryst.

After a few days Afrasiyab learns in outrage of this surreptitious
affair and has Garsivaz and armed men surround Manizha's palace
and seize the Iranian interloper. Garsivaz cajoles Bizhan into sur-
rendering his dagger and brings him pinioned before Afrasiyab.
The Iranian youth tells a fanciful story about meeting Manizha
and swears their innocence, to no avail. Afrasiyab initially sends
Bizhan to the gallows, but commutes this death sentence following
Piran's sage counsel about possible military repercussions from Iran.
Instead, the Turanian king orders Bizhan to be bound in heavy chains
and lowered into a deep pit, sealed by an enormous boulder brought
by elephants. He also banishes his daughter from the royal house-
hold. Notwithstanding her destitution, Manizha remains devoted to
Bizhan and pushes food scraps through a crack in the stone dungeon
to sustain him.

Meanwhile, Gurgin flees back to Iran and tells Bizhan's distraught
father Giv that the youth was killed by a massive boar. This fantastic
account convinces no one at the Iranian court, and Kai Khusrau
has Gurgin shackled and sends out scouting parties to find Bizhan,
without success. At the start of the new year, the shah gazes into his
'world-seeing' cup and discovers Bizhan imprisoned in Turan. Kai
Khusrau then sends Giv with a letter to Rustam, at his homeland
in Zabulistan [Sistan]; once the great hero arrives at court, the king
persuades him to mount a rescue operation. Rustam in his turn
convinces Kai Khusrau to pardon Gurgin. Disguised as a merchant,
Rustam travels in a richly laden caravan (in actuality an army that
included Gurgin) to Turan. There he is welcomed by Piran as a trader
from Iran selling jewels and other fine goods. Hearing about the
Iranian visitors, Manizha comes to Rustam and tearfully pleads with
him for help in freeing her captive lover. Initially Rustam rebuffs the
princess's appeals. After realising her anguish, however, he slips her
a token, wrapped in food, to take to Bizhan. The imprisoned youth
immediately recognises the Iranian hero's signet ring. That night
Manizha lights a bonfire to guide Rustam and his men to Bizhan's

pit. Rustam heaves the great boulder from the rim of the pit and has a long conversation with Bizhan, before hoisting him up with a rope and breaking his chains.

Rustam, Bizhan and the other Iranian warriors then launch a successful night-time raid on Afrasiyab's palace before taking off for the border. Afrasiyab seeks revenge for this humiliation and sends his army into battle against the Iranians. Under Rustam's command, the Iranian forces prevail. The victors then return in triumph to Iran, and Bizhan is reunited with his grateful father. Kai Khusrau rewards Rustam and the other champions with a feast, jewels and other gifts, whereupon the great hero departs for Sistan. Finally, Kai Khusrau meets with Bizhan, asks about the travails that both the former prisoner and his beloved had endured, and provides clothing, coins and other fine goods for the pair. The king concludes this conversation – and so the story of Bizhan and Manizha – with thoughts about the workings of fate and with warm wishes for a 'heart free from all sorrows'.

Bizhan and Manizha on the Freer Beaker

While early publications of the beaker reproduce it in several different views, they say little about the subject of its polychrome imagery.[7] It was only in 1939 that the Hermitage Museum scholar M. M. Diakonov, working from published reproductions, recognised two panels as clues to the beaker's decoration – on the top register, Bizhan and Gurgin hunting boar, and on the bottom, Rustam saving Bizhan from the pit – and deduced that it represented the story of Bizhan and Manizha as recounted by Firdausi. Diakonov accompanied his identification of the individual scenes with *Shahnama* verses in Russian translation.[8] This pioneering study led the Freer curator Grace Guest to further consider, with the advantage of first-hand examination, the beginning, sequence and flow of the *mina'i* decoration and the particularities of its individual panels. Her 1943 article also included *Shahnama* text in English translation.[9] Studies published independently in the early 1980s by S. M. Shukarov and M. S. Simpson offered still further discussions of the beaker's iconography and narrative progression, without, however, linking specific scenes with specific *Shahnama* verses.[10] The contribution here by 'Abdullah Ghouchani constitutes the first, systematic effort to correlate the beaker's pictorial programme with the *Shahnama* text in Persian (as opposed to either Russian or English) and, in the process, to propose new identifications for entire panels and for certain scenes within the same panel.[11]

Figure 15.2 *Freer Beaker, overview 2. Courtesy of Freer Gallery of Art, Smithsonian Institution.*

The Freer Beaker as *Shahnama* narrative

In his seminal article Diakonov aptly described the Freer Beaker as a 'story in pictures' and identified the source of the imagery as Firdausi's *Shahnama*, a conclusion with which subsequent scholars generally have concurred and which can be affirmed once again, thanks to 'Abdullah Ghouchani.[12] Recognising the beaker's literary inspiration does not automatically carry over, however, to defining or pinpointing its visual origins. Nor does the iconographic connection to Firdausi's poem necessarily prove, as also has been averred, that this pictorial cycle in *mina'i* must have been based on pre-existing pictures, and more particularly on manuscript illustrations.[13] Although the beaker's formal, and especially figural, style does resemble certain early Islamic manuscripts, notably the *Warqa and Gulshah* attributed to Anatolia, c. 1200–50,[14] there are,

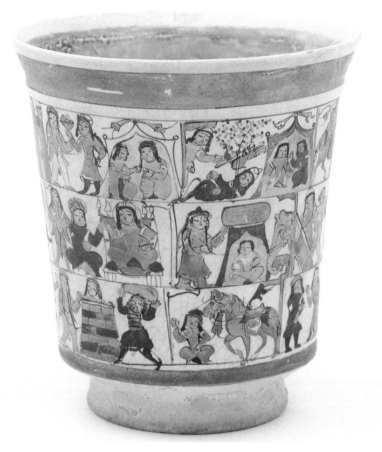

Figure 15.3 *Freer Beaker, overview 3. Courtesy of Freer Gallery of Art, Smithsonian Institution.*

of course, no known illustrated volumes of the *Shahnama* from pre-Mongol times. Indeed, the twin assumption that the beaker scenes derived from manuscript illustrations and, that, in turn, these scenes prove the existence of illustrated copies of the *Shahnama* during the twelfth to thirteenth centuries, becomes (all punning aside!) a circular argument. Furthermore, while the beaker's overall shape and size has parallels within the recorded corpus of medieval Islamo-Persian ceramics, the distinctive tripartite arrangement of its décor does not.[15]

In the absence of any extant evidence for visual models or proto-types for either the beaker's iconography or the beaker's decoration, it seems more productive, admittedly still speculative, to consider instead how the *Shahnama* story was pictured on this particular object. To do so, we may imagine ourselves in the position of a medieval ceramic artist, or more likely a ceramic collaborative (that is,

workshop), faced with the task of decorating a small cylindrical vessel with scenes from the story of Bizhan and Manizha. To begin with, we can assume that the beaker's designer/s already was/were familiar with the *Shahnama* tale, either through reading or recitation, and/or that he/they had received detailed instructions about the story's narrative progression. But what was the process through which he/they conceived and constructed a pictorial programme in the round when a narrative existed but images did not? The first step would have been to plot out the story on the available space – consisting of a curved surface slightly less than 8 cm in height and with a slightly tapering circumference (that is, the beaker's walls are not straight).[16] It was doubtless the beaker's materiality, coupled with the aim of depicting multiple episodes in the *Shahnama* story, that resulted in the decision to divide the ceramic surface – essentially the picture plane – into three, basically co-equal tiers or registers. Whatever the balance of factors (physical form, on the one hand, and narrative content, on the other), it is likely that the conceptualisation of the overall design was done in advance and with the aid of basic measurements and two-dimensional drawings on a clay tablet or paper, comparable, albeit in more rudimentary form, to the rolls or scrolls known to have been used for the design of architectural elements, such as dome chambers and *muqarnas* vaults, in late medieval and early modern Iran.[17]

If the initial step in the plotting out of the beaker's decorative scheme was basically practical and objective, the next was seemingly far more subjective since it involved the selection of specific scenes for representation from the multiple moments that make up the Bizhan and Manizha story.[18] Of course, we can never know the artistic rationale behind the choice of individual scenes. It is clear, however, and notwithstanding another wide-spread assertion that the beaker's decoration depicts the complete *Shahnama* tale of Bizhan and Manizha,[19] that the decoration depicts only what amounts to the story's first half, from the start of Bizhan's mission to his rescue by Rustam. Furthermore, there are noticeable gaps in the narrative's visualisation, such as the sequence of events following Gurgin's return to Iran, Giv's grief for his missing son, and Kai Khusrau's use of his 'world-revealing' cup to find Bizhan imprisoned in the pit. (Another way to characterise this visual pacing is that there are long 'pauses' between certain critical developments in the first half of the story.) On the other hand, some moments that occur in rapid, textual succession here receive concentrated pictorial attention; for instance, the interchange between Bizhan and Manizha that occupies three scenes in panels 10 and 11.

Pairing the scenes with actual Persian verses, as Ghouchani has done here, also reveals that the progression of the visual narrative does not always follow the textual order found in critical editions of the *Shahnama*.[20] For instance, in Firdausi's text Afrasiyab commands

elephants to raise the huge rock to block the pit *before* Bizhan is dragged from the gallows to the pit. On the beaker, the two moments are reversed, suggesting either that the beaker's representation was based on another version or recension of the story or that, in the interest of compositional 'flow', it made more sense to combine cause (the elephant bringing the rock) and effect (Bizhan inside the pit sealed with the rock) in the same panel (7a and 7b). This possible pictorial adjustment of the *Shahnama* narrative also allows the previous panel to begin with Bizhan entering on the right (6a) and exiting on the left (6b) – again, a satisfactory arrangement from a design point of view.

Ghouchani's text–image correlation likewise confirms what has been observed in previous studies, namely that the first and last panel of each tier or register are aligned vertically (for example, panel 1 in the top register aligns with panel 5 in the middle register and in turn with panel 9 in the bottom register). In addition, it draws renewed attention to the size and contents of the individual panels, and to what might seem like artistic irregularities or inconsistencies. Whereas the three stacked tiers are fundamentally uniform in height (2.5–2.7 cm) and separated from one another by thin black or brownish black lines that do double duty as the base line for the figures, there is considerable variation in panel division and width. This variation is partly to do with the beaker's spreading cylindrical profile, but more significantly with the number of scenes in each panel, which again goes back to the now more elusive phase of the beaker's artistic production. While panels 1 and 9 are monoscenic, containing one narrative moment depicted as a single scene, the ten other panels contain two and sometimes three narrative moments and scenes, including at least one case where two moments appear out of textual sequence (6b and 7a), as previously noted. Equally noteworthy is the variability in the demarcation of adjacent panels. Most are separated by pairs of somewhat unsteady lines, usually (but not always) filled in with colour and topped with a curved projection. The overall effect resembles columns supporting brackets or half arches. The placement and direction of these framing devices is, however, markedly inconsistent. Sometimes they are paired (although not necessarily similarly coloured) and face towards each other on either side of a panel, as in panels 2, 5 (although here the right-hand column is incorporated into the doorframe) and 11. In other instances, the device either stands alone (that is, it has no mate), or bisects what seems to be a continuous narrative moment, as when Rustam heads with his caravan towards Turan (panel 9). By contrast, there are no frames in panels with successive narrative moments where one might expect them: for instance, where first Bizhan is brought before Afrasiyab, and then led away (6a and 6b). Instead the orientation of the figures serves to indicate the succession of narrative moments. Interestingly too, the devices never appear as back-to-back pairs,

which is perhaps why certain panels have no frames whatsoever (1, 6 and 12). This diversity suggests a lack of artistic experience with the function and application of framing devices. At the same time, the division of the decoration into three coeval and superimposed registers and the vertical alignment of the initial and final panels in each register reflects the need for an overall visual structure for this pictorial programme, just as the variable panel width indicates flexibility in the representation of individual scenes.

Correlating the panels with verses highlights still further points. Whereas any précis of the Bizhan and Manizha story, including the one presented here, emphasises action (Bizhan and Gurgin hunting, Bizhan being taken captive, Rustam heaving the stone off Bizhan's pit), in fact the *Shahnama* poem itself progresses largely through dialogue, beginning with the Armanis pleading for assistance and ending with Kai Khusrau bestowing his blessing on Bizhan and Manizha.[21] It is not surprising, therefore, that most of the panels on the beaker feature speech acts, in the form either of pronouncements or verbal outbursts, such as Afrasiyab condemning Bizhan (6a) or, more frequently, exchanges between characters: Kai Khusrau and Bizhan (1), Manizha and her nurse (3a and 4a), the nurse and Bizhan (3b, 4b and 4c), Rustam and Kai Khusrau (8a and 8b) and Rustam and Manizha (10a, 10b and 11). The beaker's depiction of speech is cued, as within medieval representational imagery as a whole, by the relative placement of figures in conversation, usually next to and facing one another, and by particular gestures, such as raised or outstretched hands.[22]

Perhaps because Firdausi primarily relies on dialogue to advance his narrative, he often makes only passing reference to the surroundings where events and interactions occur.[23] The beaker's artist/designer has dealt with this paucity of poetic directives in various ways, sometimes by drawing on what could be considered common, real-life perceptions. Exterior settings seem to have been the easiest to convey and appear the most recognisable today: a horse usually gallops and a tree typically grows out-of-doors (panels 2, 3b and 9); likewise, a façade by definition signifies the exterior of a building (panel 4c). Tents and pavilions, on the other hand, represent what amounts to dual spatiality since they are erected outside and enclose figures inside (panels 3a, 4a and 10a). The designer/artist also varied the visualisation of the same locale in the interest of narrative clarity. Thus, Bizhan's pit is first depicted as a tent, comparable to a cross-section view, presumably to show the captive youth within, while in the final panel the pit is shown as a brick or stone structure, to better reveal the prisoner emerging from the top (7b and 12a). Other spaces are less clearly defined, and sometimes not at all. Is the doorway to the right in the scene of Bizhan's capture (panel 5a) one that Bizhan and his captors have passed through while leaving Manizha's abode (that is, so they are now standing outdoors) or while

entering Afrasiyab's palace (vice versa)? The venues for the beaker's enthronement scenes are equally enigmatic (panels 1, 6a and 5a); they not only lack any architectural or spatial markers, but two of these scenes include horses, which presumably would place them out-of-doors. It may be that what now seems like ambivalence was the result of artistic uncertainty regarding the proper setting for such a scene or, on the contrary, deliberate omission of details for the sake of compositional concision.

Although Firdausi provides relatively few details about the places or spaces where events and conversations occur in his Bizhan and Manizha story, he is often very explicit about the time frame within which the narrative unfolds. Thus, for instance, he gives the number of days that Bizhan and Gurgin spent at the hunt and that Manizha and Bizhan spent enjoying one another's company. Temporal prompts of the poetic kind do not easily translate into visual representation, however. The beaker's designer dealt with this challenge by indicating the passage of protracted time through changes in the characters' attire, hairstyle, and other pertinent accouterment, and temporal stasis through corporeal and sartorial uniformity. So Bizhan wears a green robe and short hair when first meeting with Kai Khusrau (panel 1), a blue robe and long locks while riding to the hunt (panel 2, right), and returns to a green robe and a page-boy hairdo when wielding his sword (panel 2, left). Similarly, he switches mounts in the hunting scene, initially riding a red horse, caparisoned with a white saddle blanket and green saddle (panel 2, right), and then a blue horse with a red saddle blanket and pink saddle (panel 2, left). But when he is captured and brought before Afrasiyab and then imprisoned – events that transpire in rapid succession – Bizhan appears repeatedly short-haired, bare-chested and barefoot, wearing only white trousers and with his elbows at angles to show that his hands are tied behind his back. Rustam is also variously depicted: when conversing with Kai Khusrau he is beardless and dressed in a red robe, green pants and a green turban (panel 8a); when meeting with Manizha after his arrival in Turan, he remains beardless, but wears a blue robe (with white tiraz bands), red boots and a white cap (panel 10b). When finally rescuing Bizhan, he sports a black moustache and goatee and wears a short red robe with an orange and black-striped bodice and black boots – evoking the customary tiger-skin cuirass (*babr-i bayan*) that Rustam is described as wearing in the *Shahnama*.[24]

Tracking the progression of space and time on the beaker in concert with the *Shahnama* text also underscores another point about the *mina'i* narrative; namely that it relies on the repetition of generic images familiar from many other, contemporary Persian objects. For instance, the three enthronement scenes all depict the throne and the monarch in standard fashion (panels 1, 6a and 8a). The thrones are supported on four short legs, have flat, wide seats covered with a cushion and straight, high backs topped with finials. Kai Khusrau

(panels 1 and 8a) and Afrasiyab (panel 6a) sit cross-legged; the Iranian king raises his hand in speech and the Turanian inclines his head. The three tents likewise repeat each other (panels 3a, 4a and 10a), although only the first two, representing Manizha's pavilion, are adorned with a pair of streamers flying from the central peak. As already noted, Bizhan's pit also takes the form of a tent, albeit its top flattened and sealed by the huge rock (panel 6b). Another duplicated image is the waiting horse, seen twice in full view and mirror reversed (panels 1 and 11) and another time with only its forequarters visible (panel 8b).

While set images and familiar typologies predominate, others seem to have been expressly designed for particular narrative purposes. In the upper register, for instance, Bizhan is stretched out beneath a tree, with his bow and quiver hanging from the lowest branches (panel 3b). The middle register stresses the young Iranian's subsequent capture and captivity, and includes two novel details: first, an elephant with its trunk grasping the boulder that Afrasiyab has ordered to be brought up from the ocean depths, and then the boulder sealing the pit in which Bizhan has been imprisoned (panel 7a and 7b). Of course, by far the beaker's most distinctive scene, and one of the visual clues initially recognised by Diakonov in his identification of the Bizhan and Manizha narrative, comes in the bottom register and final panel where Rustam lifts the rock and frees Bizhan from captivity. As will be discussed later, however, this scene may not have been especially novel in medieval times, raising the question of the extent of the Freer Beaker's uniqueness.

The Freer Beaker as graphic narrative

Among the comments made about the Freer Beaker from the mid-1980s onwards, including by Sheila Blair and Jonathan Bloom, is that the vessel's decoration resembles strip-cartoon format or comic-book style.[25] The relevance of this observation is immediately apparent when the beaker is reproduced in a panorama or rollout view and compared with any number of comics and cartoons dating from the nineteenth century through the present day.[26] The burgeoning scholarship on this material suggests an equally apt comparison with graphic novels,[27] given that the beaker's imagery can be directly related to a known work of literature, that is, Firdausi's *Shahnama*. More apropos still, since the beaker contains no actual written text, is the relatively recent scholarly view that comic book and graphic novel narratives do not need literary dialogue or even any dialogue at all. In other words, they can be wordless.[28] What is fundamental in such production is its visual narration or the capacity for storytelling – 'the images themselves perform the telling of the story'.[29] This is, of course, the *raison d'être* for the beaker's pictorial programme. It is also what defines the beaker as a graphic narrative, an

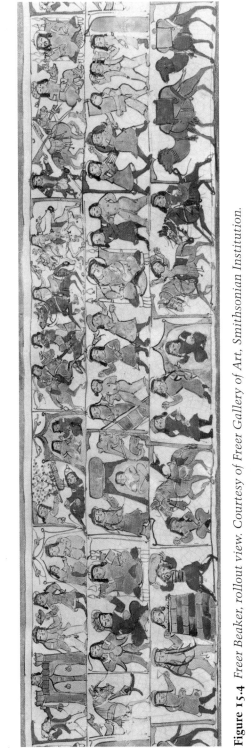

Figure 15.4 *Freer Beaker, rollout view. Courtesy of Freer Gallery of Art, Smithsonian Institution.*

inclusive category employed nowadays in the study of both comic books as medium and graphic novels (voiceless and otherwise) as literary genre.[30]

On the structural level, the Freer Beaker constitutes a graphic narrative through its layout, that is, the arrangement of its three superimposed registers and series of panels. Interestingly, the picture planes in many modern-day comics and graphic novels are also divided into three vertical zones.[31] It is more than this ubiquitous, grid-like format, however, that connects the medieval beaker with modern production, as becomes evident when the scenario proposed above for the beaker's decoration as a *Shahnama* narrative is recast in terms used to analyse the creative process and techniques of contemporary graphic narratives.[32]

After – or perhaps simultaneously with – devising the beaker's tripartite structure, the designer/s developed a script, comprised of moments chosen from the multiple possibilities that make up the Bizhan and Manizha tale, appropriate for translation into visual form. The next step would have been to divide that script into intelligible units or instalments, which in turn determined the width of the individual panels and the number of narrative moments each panel was to contain, as well as their placement and alignment relative to one another. Finally, the artist/s determined the graphic elements that would form each panel's specific composition.

In classic comic studies, the script is known as narrative breakdown and is regarded as what first and foremost advances a story and builds suspense. On the beaker, the tripartite registration is what structures the narrative's beginning, development and resolution. The succession of panels – or sequential art, regarded as the quintessential comic mode – in turn constitutes the mechanism that controls narrative progression, by indicating time and space. This control is partly a function of the panels' varied sizes and contents. For instance, extra-wide or stretched-out panels can both conflate and extend narrative pace and place, as in the panel where Bizhan and Gurgin set off to the hunt (panel 2), or when Rustam and his party are en route to rescue Bizhan (panel 9) – obviously first the hunters and later the rescuers spent some time on the road. By contrast, small, square panels (for example, panels 7a, 7b and 11) indicate the suspension of time and motion, that is, moments of narrative stasis.[33] Panels that represent moments narrated by Firdausi in the same verse or in two successive verses, such as Bizhan talking with Manizha's nurse (panels 4b and 4c) or Afrasiyab confronting Bizhan and then sending him away (panels 6a and 6b), are also examples of the comic-book definition of sequential art.[34]

In comic books and graphic novels, as on the Freer Beaker, panels may be serial, but they rarely form a complete spatial or temporal scheme. Rather they delineate parts of a story, and there is a great deal of narrative action that is not represented and that takes

place, as it were, between panels. As previously discussed, there are a number of events in the beaker's representation of the Bizhan and Manizha story that occur between the time when Bizhan is captured and imprisoned and when Kai Khusrau and Rustam discuss a plan to free him. The designer has left it to the viewer to fill the narrative gaps or, to put it another way, to make the narrative leaps between the panels and thus to mentally merge narrative time and space. This deliberate narrative strategy – known variously as ellipsis, elliptical cuts and closure in comic book studies – provides continuity between the beaker's temporal intervals and spatial dislocations.

As for individual panel composition, the key requirement for graphic narratives is that their features must be clearly understandable in terms of content and purposeful in terms of function, that is, in telling the story. To achieve this aim, each panel should contain only those components necessary for maximum story-telling effectiveness and for audience recognition – what comic scholars call the graphic centre of narrative focus. With a few exceptions, most of the panels on the Freer Beaker meet this criterion by presenting their essential elements with visual clarity and economy.[35] The vessel's décor achieves narrative focus through interactions among characters and their codified gestures, themselves forming a grammar of expression, and by typological or generic groupings, as well as by iconographically specific, even unique, attributes or actions (panels 7a, 7b and 12a).

Another device regularly used to further sequential art is the appearance of the same figure in adjacent panels. This technique pervades the Freer Beaker and is most visually explicit and evident on the second register in the scenes depicting Bizhan's captivity and imprisonment (panels 5–7). Throughout this series the Iranian youth wears standard captive attire: white trousers, bare chest and bare feet, as previously mentioned. Besides reinforcing sequentiality, Bizhan's recurrence doubles the number of moments that are represented in the same panel, thus making them polyscenic.[36] More importantly, perhaps, it emphasises cause and effect relations among successive events, yet another *sine qua non* for the development of sequential art and graphic narrative.

And now regarding the notion of 'wordless' graphic novel: while the Freer Beaker lacks visible text, it definitely is not mute. Its text is embedded both in its artistic conception and realisation and in its subsequent reception and use. As previously observed, clearly the person or persons who designed and executed the beaker and the person or persons who used it were cognisant of the Bizhan and Manizha tale as recounted by Firdausi and perhaps other medieval authors. Notwithstanding the seeming ambiguity of certain graphic elements and even certain scenes, in its own day the beaker surely generated and communicated an understandable 'visual text'. The pictorial and the verbal thus coexisted as parallel narrative discourses,

the one clearly represented and thus permanently inscribed, and the other recited, read or at least remembered from the *Shahnama* account and so more variable, and both essential actors, agents or enunciators in a complementary performance of word and picture, text and image.

A final point: it has long been understood that narratives in the form of comic books and graphic novels tell a moral story and conclude with resolutions in favour of truth and justice. The decoration of the Freer expresses an equivalent theme, beginning with Bizhan volunteering to free the Armani territory of its scourge of wild boars, and ending with Rustam liberating Bizhan from imprisonment. So, from start to finish the beaker conveys a powerful message of good triumphing over adversity.

The Freer Beaker in three dimensions

One of the accepted definitions of graphic narratives writ large is that such works take the material form of books and exist on a two-dimensional surface, namely, the flat, printed page.[37] In this respect, of course, the beaker manifestly differs. Yet it is the beaker's very three-dimensionality and rounded surface that allows for the production of narrative progression since the vessel must be rotated counterclockwise for the painted story of Bizhan and Manizha to unfold, first horizontally across the top zone, and then spiralling downwards and again horizontally through the other two registers. And because only about a third of the painted decoration is visible at a stretch, the vessel needs to be turned repeatedly for the full sequential art to be read. This necessary tactile or hands-on experience – what in modern parlance might be called 'interactive engagement' or 'audience interaction' – activates the movement of the Bizhan and Manizha tale through time and place and allows the beaker to fulfil its performative function. At the same time, and as we already have seen, the beaker's pictorial narration, while sequential, is not a smooth or continuous, much less a complete representation of the *Shahnama* story on which it is based. Thus, anyone holding and turning the vessel must simultaneously 'work' to construct the *Shahnama* story and to connect the decoration's various temporal and spatial gaps. So 'interactive engagement' with the beaker becomes at once a physical, visual and cognitive experience. More than being just a striking work of art in the round, therefore, the beaker requires animation and acquires value through audience participation or interaction – adding another dimension to the object's identity as both a *Shahnama* narrative and a graphic narrative.

The Freer Beaker as unicum

The long-standing reputation of the Freer Beaker has rested largely on its serial rendition of a popular *Shahnama* story and on its presumed singularity as a codex in ceramic, *avant la lettre*.[38] The painted decoration's most distinctive and recognisable scene remains today the final panel in the bottom register where Rustam lifts up the rock sealing Bizhan's pit. But this particular image may not have been such a novelty at the time the beaker originated since it appears on at least two rectangular lustre-painted tiles, datable to late twelfth to early thirteenth-century Iran.[39] Both feature, on one side of the composition, Bizhan kneeling or crouching inside an enclosure with sloping stone or brick walls, and on the other, Rustam looming large and lifting the dungeon's capstone over his head. In addition to the figures, each tile includes an inscription, comparable to a caption, that identifies the scene.[40] While the inscriptions differ somewhat in their wording, none is actually a verse or line from the *Shahnama* or other literary source.[41] Rather they resemble the rubrics or headings that punctuate the text in copies of the *Shahnama*, both in manuscript and printed volumes.[42] Presumably these lustre tiles once formed part of wall revetments; conceivably such architectural ensembles could have featured a series of images from the Bizhan and Manizha story. It is equally possible, however, that the tiles were not part of such a coherent, sequential arrangement and that the need for written captions was precisely because their images were extracted from narrative context and so their singular iconography required explanation.[43] In short, while the concluding scene on the Freer Beaker might have been common currency, as it were, at the time of the vessel's production, its use as the finale for an extended, albeit selective, narrative sequence seems to have been unusual.

Unusual, of course, does not necessarily mean unique. A *mina'i* bowl, now in the Museum of Islamic Art, Doha and the subject of recent scientific and art historical investigation, features rows of decoration across its interior surface. These include a large central band with two figure groupings that resemble the Freer Beaker scenes of Bizhan before Kai Khusrau (panel 1) and Bizhan at the hunt (panel 2).[44] Perhaps, like the images of Rustam freeing Bizhan on the lustre-painted tiles, these two scenes from early on in the Bizhan and Manizha narrative were meant to exemplify or conjure up the whole story. In any case, they reinforce the sense that the Bizhan and Manizha tale was a ready source of decorative inspiration for ceramic painters during the late twelfth and early thirteenth centuries.

Even more convincing in this regard is the fragment of a shallow *mina'i* bowl belonging to the Khalili Collection, with figural scenes arranged in two concentric rows around its inner walls. Previous

scholarship has identified the décor as depicting scenes from the *Shahnama* story of the mythical King Faridun and his three sons, with the qualifier that the narrative sequence appears out of order.[45] In point of fact, the scenes seem to correspond closely to several on the Freer Beaker. The top register represents an enthroned figure who inclines his head towards three figures seated on the other side of what looks like a cabinet and with a horse, crouching groom and a bowing man, possibly a warrior, to the left. This seems to be an elongated or elaborated version of the beaker's first panel, expanded to include Iranian warriors beside Bizhan and the dias on which, following the *Shahnama* account, the court treasurer set a salver with gems meant to entice Kai Khusrau's courtiers to volunteer for the Armani mission.[46] Instead of gems, however, a sword rests on top of the dias, perhaps in anticipation (or recognition) of Bizhan's later hunting feat. At the fragment's left edge, a rider leans forward towards what now reads like a tapering swath of reddish-brown colour, perhaps part of an animal's body and thus related to the beaker's depiction of Bizhan and Gurgin hunting in the second panel. Assuming that the narrative on the Khalili bowl originally moved from right to left (that is, counterclockwise), the last scene on the top row would have been to the right of the opening enthronement, that is, at the fragment's right edge. What is visible today consists of two ribbons or streamers, possibly flying from the back of someone's head; a figure standing underneath, or perhaps walking, through an arched opening; and another figure standing behind. This grouping seems related to the fourth panel on the Freer Beaker, and to the architectural setting where Bizhan converses with Manizha's nurse.

It is on the lower row of the *mina'i* fragment that the affinity with the Freer Beaker becomes most evident. There at the right we can just make out part of a figure with long hair and in a patterned robe, plus a figure attired as a prisoner and with his hand secured to a wooden board like a stock, and finally a guard armed with a shield (or possibly a bow) and short sword or dagger, and with what looks like a quiver near his knees. These elements – and especially the prisoner in stocks – immediately recall the fifth panel on the Freer Beaker where Bizhan gives up his dagger and is taken prisoner.[47] The fragmentary bowl's final unit features another enthronement, with the figure on the throne conversing with a standing figure carrying a large shield. Following along with the Bizhan and Manizha narrative, this scene could be the moment when Afrasiyab pronounces Bizhan's sentence, or alternatively, when Piran counsels the Turnian king to imprison the Iranian rather than executing him. In either case, the imagery equates to the beaker's sixth panel.

Another point of compositional comparison between the Freer Beaker and the fragmentary Khalili bowl are the column and bracket

devices that divide the scenes. Because of the bowl's incomplete and fractured state, there is no way to evaluate if these devices were originally paired to create symmetrical frames, as, for instance, on the beaker's second and eleventh panel. It is perhaps telling, however, in terms of the *mina'i* design and painting practice, that the bowl's opening scene, depicting Kai Khusrau's court, is bisected with a frame so that the horse, groom and bowing figure seem to exist in exterior space, similar to the treatment of Kai Khusrau's enthronement and audience with Rustam on the beaker's eighth panel.

Given that less than a quarter of the original Khalili bowl survives today,[48] we will never know if it once represented the same or similar scenes of the Bizhan and Manizha story as the Freer Beaker or the extent to which its sequential art followed Firdausi's *Shahnama* narrative. What the fragment can confirm, however, is that the Freer Beaker was not a one-off effort in its own time. While the beaker remains today the only all-but-intact example of sequential art in three dimensions, it must share its status as a *Shahnama* narrative and as a graphic narrative with at least one other polychrome piece of medieval Persian ceramic art.

A Note: Bizhan and Manizha on the Freer Beaker
'Abdullah Ghouchani (†)

Top Register:

Panel 1 Bizhan, before Kai Khusrau, volunteers for the mission
K-M 3: 309, verse 74

ز بهر تو دارم تن و جان خویش می آیم به فرمان بدین کار پیش

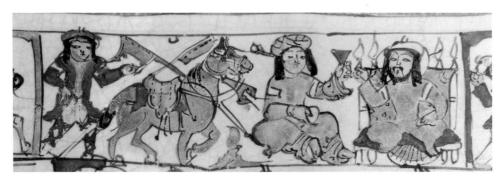

Figure 15.5 *Freer Beaker, Panel 1. Courtesy of Freer Gallery of Art, Smithsonian Institution.*

Panel 2a Bizhan and Gurgin ride off to the hunt[49]
K-M 3: 310, verse 92

به نخجیر کردن به راه دراز برفت از درِ شاه با یوز و باز

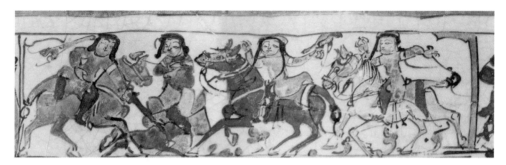

Figure 15.6 *Freer Beaker, Panels 2a and 2b. Courtesy of Freer Gallery of Art, Smithsonian Institution.*

Panel 2b Bizhan kills a boar with his sword

K-M 3: 312, verse 114

بزد خنجری بر میان بیژنش به دو نیم شد بیل بیکر تنش

Panel 3a Manizha sends her nurse to identify the young man resting under a tree[50]

K-M 3: 317, verse 171

فرستاد مر دایه را چون نوند که رو زیر آن شاخ بلند

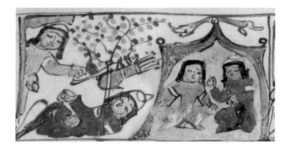

Figure 15.7 *Freer Beaker, Panels 3a and 3b. Courtesy of Freer Gallery of Art, Smithsonian Institution.*

Panel 3b Manizha's nurse bows to Bizhan

K-M 3: 318, verse 178

چو دایه بر بیژن آمد فراز برو آفرین کرد و بردش نماز

Panel 4a The nurse reports back to Manizha[51]

K-M 3: 318, verse 189

چو بیژن چنین گفت شد دایه باز به گوش منیژه سرایید راز

Panel 4b Bizhan offers Manizha's nurse jewelry in return for kind treatment[52]

K-M 3: 31, verse 187, 1st hemistich

اگر نیك رایی كنی تاج زر

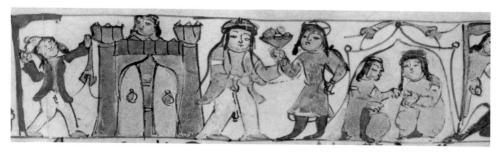

Figure 15.8 *Freer Beaker, Panels 4a, 4b and 4c. Courtesy of Freer Gallery of Art, Smithsonian Institution.*

Panel 4c Bizhan offers the nurse a belt and earrings[53]

K-M 3: 318, verse 187, 2nd hemistich

ترا بخشم و گوشوار و کمر

Middle Register:

Panel 5a Bizhan is taken prisoner and agrees to give up his dagger[54]

K-M 3: 325, verse 272, 1st hemistich

بپیمان جدا کرد زو خنجرا

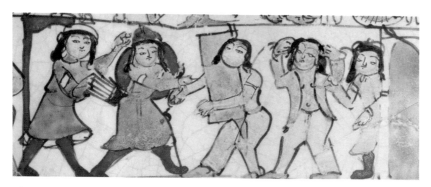

Figure 15.9 *Freer Beaker, Panels 5a and 5b. Courtesy of Freer Gallery of Art, Smithsonian Institution.*

Panel 5b Bizhan is bound

K-M 3: 325, verse 272, 2nd hemistich

بخوبی کشیدش ببند اندرا

Panel 6a Bizhan brought before Afrasiyab

K-M 3: 325, verse 275

چن آمد بنزدیک شاه اندرا گو دست بسته برهنه سرا

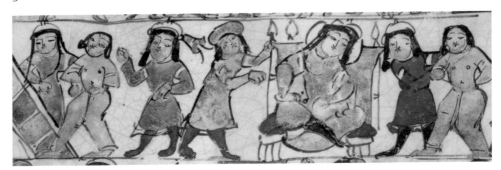

Figure 15.10 *Freer Beaker, Panels 6a and 6b. Courtesy of Freer Gallery of Art, Smithsonian Institution.*

Panel 6b Bizhan is taken from the gallows to a deep pit[55]

K-M 3: 333, verse 381

یکی بند رومی بکردار پل دو دستش به زنجیر برکش به غل

Panel 7a The elephant carries a huge rock, as per Afrasiyab's order[56]

K-M 3: 333, verse 384

که از ژرف دریای گیهان خدیو ببر پیل و آن سنگ اکوان دیو

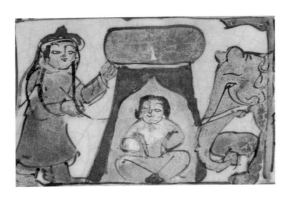

Figure 15.11 *Freer Beaker, Panels 7a and 7b. Courtesy of Freer Gallery of Art, Smithsonian Institution.*

Panel 7b Manizha pushes scraps of food through the cracks in Bizhan's pit

K-M 3: 335, verse 405

یکی دست را اندرو کرد راه بیامد خروشان بنزدیک چاه

Panel 8a Rustam sits with Kai Khusrau[57]

K-M 3: 365, verses 820

به خواهش بر شاه خورشید فر بیامد تهمتن بگسترد پر

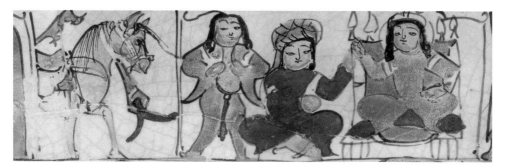

Figure 15.12 *Freer Beaker, Panels 8a and 8b. Courtesy of Freer Gallery of Art, Smithsonian Institution.*

Panel 8b Kai Khusrau forgives Gurgin for his treachery and releases him to Rustam

K-M 3: 366, verse 833

به رستمش بخشید پیروزشاه رهانیدش از بند و تاریک چاه

Bottom Register:

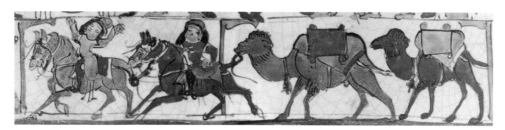

Figure 15.13 *Freer Beaker, Panel 9. Courtesy of Freer Gallery of Art, Smithsonian Institution.*

Panel 9 Rustam goes to Turan disguised as a merchant

K-M: 3: 368-69, verses 871–3

یکی کاروانی پر از رنگ و بوی سوی شهر توران نهادند روی
یکی رخش و دیگر نشست گوان گرانمایه هفت اسب با کاروان
صد آستر همه جامه لشکرا صد اشتر همه بار بد گوهرا

Panel 10a Manizha explains her situation to Rustam[58]

K-M 3: 373, verse 937

منیژه بدو گفت کز کار من چه جویی ز بد بخت و تیمار من

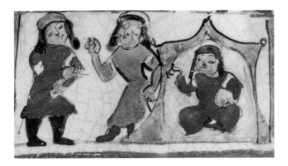

Figure 15.14 *Freer Beaker,*
Panels 10a and 10b.
Courtesy of Freer Gallery of Art,
Smithsonian Institution.

Panel 10b Rustam respectfully gives Manizha his signet ring

K-M 3: 375, verse 957

سبک دست رستم بسان پری بدو در نهان کرد انگشتری

Figure 15.15 *Freer Beaker, Panel 11.*
Courtesy of Freer Gallery of Art,
Smithsonian Institution.

Panel 11 Rustam instructs Manizha to take his ring to Bizhan in
the pit[59]

K-M 3: 375, verse 958

بدو داد وگفتش: بدان چاه سر که بیچارگان را توی راهبر

Panel 12a Rustam lifts the stone from the pit[60]

K-M 3: 381, verse 1050

ز یزدان زور آفرین زور خواست بزد دست و آن سنگ برداشت راست

Panel 12b Bizhan emerges from the pit

K-M 3: 382, verse 1070–1

فرو هشت رستم به زندان کمند برآوردش از چاه با پای وند
برهنه سر و موی و ناخن دراز گذازنده از درد و رنج و نیاز

Panel 12c Bizhan and Manizha make their way home[61]

K-M 3: 382, verse 1075

سوی خانه رفتند از آن چاهسار به یک دست بیژن، به دیگر زوار

Figure 15.16 *Freer Beaker, Panels 12a, 12b and 12c. Courtesy of Freer Gallery of Art, Smithsonian Institution.*

Notes

1. For recent discussions, see: Barbara Brend and Charles Melville, *Epic of the Persian Kings: The Art of Ferdowsi's Shahnameh* (Cambridge, 2010), cat. nos 12, 15–16; Julia Gonnella and Christoph Rauch (eds), *Heroic Times: A Thousand Years of the Persian Book of Kings* (Berlin, 2012), pp. 160–1, 172 and cat. nos 81–2 and 94; Marianna Shreve Simpson, '*Shahnama* images and *Shahnama* settings in medieval Iran', in Olga M. Davidson and Marianna Shreve Simpson (eds) *Ferdowsi's Shahnama*: *Millennial Perspectives* (Boston, Washington, DC and Mumbai, 2013), pp. 72–85; Sheila Canby, Deniz Beyazit, Martina Rugiadi and Andrew C. S. Peacock, *Court and Cosmos: The Great Age of the Seljuqs* (New York, 2016), cat.no. 83 (and especially n. 2).

2. My fascination with the Freer Beaker has been decades long, starting as a Smithsonian Fellow (1977–8), with the encouragement of Esin Atıl, Curator of Islamic Art, and continuing during my own curatorial tenure at the Freer and Sackler Galleries (1992–5). On 28 August 2018 I once again was privileged to study the Freer Beaker *in situ*, together with Massumeh Farhad (Chief Curator and The Ebrahimi Family Curator of Persian, Arab, and Turkish Art), Simon Rettig (Assistant Curator of Islamic Art) and Blythe McCarthy (Andrew W. Mellon Senior Scientist), all of whom I thank for such a rewarding opportunity. Our goal on this occasion was to verify the object's materiality and condition through both first-hand examination and a review of the museum's conservation records. What follows here is an art historical (as opposed to technical) summary of the session's findings, with reference to the panel numbers given in the Note to this chapter.

 The Freer Gallery purchased the beaker as an intact object from Parish-Watson Co., New York, in 1928; <https://asia.si.edu/object/F1928.2> (29 November 2018). See also n. 7 here for earlier provenance, publications and reproductions. Scientific testing and conservation analysis have since revealed that the object's 'slightly spreading cylindrical form on a low foot ring' (as it is described on the Freer/Sackler website) previously had been broken and assembled, but not refired. Furthermore, and with one exception, the pieces are of uniform

thickness and originally belonged together. The sole exception is a triangular sherd insert, which is clearly visible on the beaker's interior and only partly visible on the right side of panel 5a. Also visible on both interior and exterior (under magnification) are two vertical breaks (which might have occurred during firing) stretching from the beaker's rim to the lower blue band above its foot rim and a series of horizontal and diagonal breaks cutting across the surface. These break lines are all well-matched, as is the surface cracklure, again confirming the beaker's material uniformity. In addition to the sherd insert, there is an area of fill on the rim above panel 4c and some minor losses along the interior crack lines.

Conservation work on the beaker's decoration in 1998 involved the removal of considerable over-painting. The beaker's original enamel palette consists of four colours commonly found on *mina'i* ware – cobalt blue, turquoise, red and black – plus other, more unusual ones: green, magenta, lighter cobalt blue, brown, flesh colour or pink, and white. Originally these colours would have been shiny as opposed to their somewhat abraded appearance today. The beaker's opacified glaze is the same white tin oxide found on many deluxe *mina'i* vessels. Traces of under-drawing are visible, for instance, around the horse's ear in panel 8b.

In short, the beaker's material and surface condition is very good, and there is no question about the integrity of its ceramic body or the originality of its enamel-painted imagery.

3. For a detailed study and interpretation, see Charles Melville with contributions by Firuza Abdullaeva, 'Text and image in the story of Bizhan and Manizha: I', in Charles Melville (ed.), *Shahnama Studies I* (Cambridge, 2006), pp. 71–96; Charles Melville, 'Text and image in the story of Bizhan and Manizha: II' (forthcoming). For additional discussion, focused on the Freer Beaker, see Eleanor Sims, *Peerless Images: Persian Painting and Its Sources* (New Haven and London, 2002), pp. 135–6.

4. Kumiko Yamamoto, *The Oral Background of Persian Epics: Storytelling and Poetry* (Leiden and Boston, 2003), pp. 29 n. 50, 72, 171, 173.

5. The tale's continued transmission in popular culture is discussed by Mohammad Mokri, *La Légende de Bižan-u Manija* (Paris, 1966).

6. The summary provides only the story's main developments. For the full *Shahnama* text, see Djalal Khaleghi-Motlagh (ed.), *Abu'l-Qasim Firdausi Shahnama* (New York, 1993), vol. 3: 303–97; Dick Davis (trans.), *Shahnameh: The Persian Book of Kings* (New York, 2007), pp. 306–45.

7. The beaker's historiography is a fascinating subject in its own right and merits further discussion. The earliest publications (in chronological order) are: Horace Townsend, *Illustrated Catalogue of the Rate and Beautiful Ancient Faiences, Glass and Other Objects Belonging to Messieurs Tabbagh Frères of Paris and New York* (New York, 1911), cat. no. 327 and reproductions; Henri Rivière, *La ceramique dans l'art musulman* (Paris, 1913), vol. 1, pl. 45; Arthur Sambon, *Catalogue des objets d'art et de haute curiosité de l'antiquité* (Paris, 1914), cat. no. 152; F. R. Martin, *The Miniature Painting and Painters of Persia, India and Turkey* (London, 1918), vol. 1, fig. 3; Ernst Kühnel, *Islamische Kleinkunst* (Berlin, 1925), Abb. 54; Arthur U. Pope, *A Survey of Persian Art* (London and New York, 1939), vol. 2, pp. 1561 and 1563; vol. 5, pl. 660b.

8. Mikhail M. Diakonov, 'Faiansovyi sosud s illustratsiiami k Shakh-name' [Une vase en faience avec les illustrations de Shah-name], *Trudy otdela vostoka* I (1939), pp. 317–25. The Russian translations follow the edition of the *Shahnama* by Johann August Vullers.

9. Grace Dunham Guest, 'Notes on the miniatures on a thirteenth-century beaker', *Ars Islamica* 10 (1943), pp. 148–52. The *Shahnama* verses given here come from the English translation in Arthur G. Warner and Edmond Warner (trans.), *The Shahnama of Firdausi* (London, 1906–8), vols 2–3.

10. Sharif Mukhammadovich Shukurov, '*Shakh-name*' Firdousi i ranni-aia illustrativnaiai traditsiya: tekst i illustratitsiia v sistema iranskoi kul'tury XI–XIV vekov (Moscow, 1983), pp. 12–37. Marianna Shreve Simpson, 'The narrative structure of a medieval Iranian beaker', *Ars Orientalis* 12 (1981), pp. 15–24. Both articles reference the Bertels edition of the *Shahnama*.

11. Unless otherwise stated, the Persian text comes from volume three of Firdausi's *Shahnama* edited by Djalal Khaleghi-Motlagh (cited as K-M). Note is also taken of scenes that have been given substantially different identifications in previous studies.

12. Simpson, 'Narrative structure', p. 15, however, differs on this point.

13. This point is argued forcibly by Shukurov, '*Shakh-name*', pp. 34–5, who posits further that the beaker's design followed the chapter headings to the Bizhan and Manizha story found in various *Shahnama* manuscripts of the thirteenth–fifteenth centuries. Simpson, 'Narrative Structure', p. 22 finds monumental wall paintings a more convincing prototype for the beaker's decoration. Sims, *Peerless Images*, p. 225 also raises pertinent questions about the beaker's pictorial sources. See also below, n. 14.

14. For instance the depiction of prisoners with naked torsos and white trousers, similar to Bizhan in Freer Beaker panels 5, 6 and 7, and of horses with raised forelegs in panels 1 and 11. See Assadullah Souren Melikian-Chirvani, 'Le roman de Varque et Golšah: Essai sur les rapports de l'esthéthique littéraire et de l'esthéthique plastique dane l'Iran pré-mongol', *Arts Asiatiques* 22 (1970), figs 21, 22 and 38.

15. Oliver Watson, *Ceramics from Islamic Lands* (London, 2004), cat. no. N.4, and with reference to other published examples. A *mina'i* beaker in the Hermitage does have three rows of seated figures in pairs, but the rows are not delineated and the figures are repeated. Vladimir Loukonine and Anatoli Ivanov, *Lost Treasures of Persia* (Washington, DC, 1996), cat. no. 135.

16. The precise measurements are 7.7 cm from the blue band above the foot to the set of blue and white bands beneath the rim.

17. Necipoğlu, Gülru, *The Topkapi Scroll: Geometry and Ornament in Islamic Architecture* (Santa Monica, CA, 1995).

18. Melville, 'Text and image', pp. 90–3 outlines the story in five phases comprising altogether some seventy-five individual moments or units and cites Amin Mahdavi's more detailed break-down of nearly 350 'verbal units'.

19. Oliver Watson, *Persian Lustre Ware* (London and Boston, 1985), p. 124, n. 3; *Ideals of Beauty: Asian and American Art in the Freer and Sackler Galleries* (New York, 2010), p. 133. The beaker is also described as a complete narrative cycle from the *Shahnama* on the Freer/Sackler website (URL given here in n. 2).

20. The vagaries in narrative order on the beaker offer a useful reminder that the *Shahnama* text was organic, rather than fixed, and lent itself to change and revision over the centuries following Firdausi's original compilation. Thus, the verse order in manuscript copies of the *Shahnama*, even those transcribed at the same time and in the same place, can differ significantly.

21. This point is confirmed by the scene identifications in Melville, 'Text and image', pp. 91–3, the majority of which feature 'talking' or 'listening' verbs, that is, 'tells', 'orders', 'agrees', 'asks', and so on.

22. For a very pertinent discussion of this same point, see David J. Roxburgh, 'In pursuit of shadows: al-Hariri's *Maqamat*', *Muqarnas* 30 (2013), pp. 189–90.

23. Shukurov, '*Shakh-name*', pp. 16–18. For a general discussion of this point see Jerome W. Clinton, 'Ferdowsi and the illustration of the *Shahnameh*', in Oleg Grabar and Cynthia Robinson (eds), *Islamic Arts and Literature* (Princeton, 2001), pp. 57–74.

24. For example, Khaleghi-Motlagh, 2:32, verse 425; Warner and Warner, 2:52.

25. Watson, *Persian Lustre Ware*, p. 124, n. 3; Sheila S. Blair and Jonathan Bloom, *Islamic Arts* (1997), pp. 269; Robert Hillenbrand, *Islamic Art and Architecture* (London, 1999), p. 98; Oleg Grabar, *Mostly Miniatures: An Introduction to Persian Painting* (Princeton and Oxford, 2000), caption for fig. 10; Matthias Ostermann, *The Ceramic Narrative* (London and Philadelphia, 2006), p. 49.

26. Sambon, *Catalogue des objets d'art*, cat. no. 152 published the first such panorama, resembling a fan, without however, relating the vessel either to the *Shahnama* or to cartoons.

27. Jan Baetens, 'Graphic novels', in Leonardo Cassuto, Claire V. Eby and Benjamin Reiss (eds), *The Cambridge History of the American Novel* (2011), pp. 1137–53. The beaker was already characterised as a graphic novel in *Ideals of Beauty*, p. 133; Simpson, '*Shahnama* images and *Shahnama* settings', p. 79.

28. David A. Beronä, *Wordless Books: The Original Graphic Novel* (New York, 2008); David A. Beronä, 'Wordless comics: the imaginative appeal of Peter Kuper's *The System*', in Matthew J. Smith and Randy Duncan (eds), *Critical Approaches to Comics: Theories and Methods* (New York and London, 2012), pp. 17–26; Maahen Ahmed, *Openness of Comics: Creating Meaning within Flexible Structures* (Jackson, MS, 2016), pp. 139–42.

29. Baetens, 'Graphic novels', p. 1145.

30. Hillary Chute, 'Graphic narrative', in Joe Bray, Alison Gibbons and Brian McHale (eds), *The Routledge Companion to Experimental Literature* (Abingdon-on-Thames, 2012); pp. 407–19; Hillary Chute, *Why Comics: From Underground to Everywhere* (New York, 2017), pp. 1–32.

31. For pertinent examples, see 'New York Stories', in *The New York Times Magazine* (4 June 2017).

32. The analytic and scholarly literature on comic books and graphic novels is now vast. What follows here was aided in particular by: Lawrence L. Abbott, 'Comic art: characteristics and potentialities of a narrative medium', *Journal of Popular Culture* 19 (1986); pp. 155–76; David Carrier, *The Aesthetics of Comics* (University Park, PA, 2000); Will Eisner, *Comics and Sequential Art* (Tamarac, FL, 1985); Will Eisner, *Graphic Storytelling & Visual Narrative* (Tamarac, FL, 2001); Jeanne

Grabar, Oleg, *The Illustrations of the Maqamat* (Chicago and London, 1984).

Grabar, Oleg, *Mostly Miniatures: An Introduction to Persian Painting* (Princeton and Oxford, 2000).

Groensteen, Thierry, *The System of Comics* (Jackson, MS, 2007).

Grube, Ernst J., *Cobalt and Lustre: The First Centuries of Islamic Pottery* (London and Oxford, 1994).

Guest, Grace Dunham, 'Notes on the miniatures on a thirteenth-century beaker', *Ars Islamica* 10 (1943), pp. 148–52.

Harvey, Robert C., 'The aesthetic of the comic strip', *Journal of Popular Culture* 12 (1979), pp. 640–52.

Harvey, Robert C., *The Art of the Comic Book: An Aesthetic History* (Jackson, MS, 1996).

Hillenbrand, Robert, *Islamic Art and Architecture* (London, 1999).

Ideals of Beauty: Asian and American Art in the Freer and Sackler Galleries (New York, 2010).

Khaleghi-Motlagh, Djalal (ed.), *Abu'l-Qasim Firdausi Shahnama*, Vol. 3 (New York, 1993).

Kuhnel, Ernst, *Islamische kleinkunst* (Berlin, 1925).

Lefèvre, Pascal, 'Narration in comics', *Image [&] Narrative: Online Magazine of the Visual Narrative* 1.1 (2000), <imageandnarrative.be/inarchive/narratology/pascallefevre.htm> (7 September 2008).

Lefèvre, Pascal 'The construction of space in comics', *Image [&] Narrative: Online Magazine of the Visual Narrative* 7/3.16 (2006), <imageand narrative.be/inarchive/house_text_museum/lefevre.htm> (7 September 2008).

Loukonine, Vladimir and Anatoli Ivanov, *Lost Treasures of Persia* (Washington, DC, 1996).

Martin, F. R., *The Miniature Painting and Painters of Persia, India and Turkey*, Vol. 1 (London, 1918).

McCloud, Scott *Understanding Comics: The Invisible Art* (Northampton, MA, 1993).

Mehrabadi, Mitra, *Shahnama Kimal-i Firdausi bi Nathr* (Tehran, 2000).

Melikian-Chirvani, Assadullah Souren, 'Le roman de Varque et Golšāh: Essai sur les rapports de l'esthéthique littéraire et de l'esthéthique plastique dane l'Iran pré-mongol', *Arts Asiatiques* 22 (1970), pp. 1–262.

Melikian-Chirvani, Assadullah Souren, 'Le Livre des Rois, miroir du destin', *Studia Iranica* 17 (1988), pp. 7–46.

Melikian-Chirvani, Assadullah Souren, 'Le Livre des Rois, miroir du destin: II, Takht-i Soleyman et la symbolique du *Shah-name*', *Studia Iranica* 20 (1991), pp. 33–148.

Melikian-Chirvani, Assadullah Souren, *Les frises du Shah Name dans l'architecture sous les IlKhāns* (Paris, 1996).

Melville, Charles, with contributions by Firuza Abdullaeva, 'Text and image in the story of Bizhan and Manizha: I', in Charles Melville (ed.), *Shahnama Studies I* (Cambridge, 2006), pp. 71–96.

Melville, Charles, 'Text and image in the story of Bizhan and Manizha: II' (forthcoming).

Melville, Charles, 'Rubrics and chapter headings in texts of the *Shahnameh*', *Namah-i Baharistan* 19 (2016), pp. 236–47.

Michelsen, Leslee Katrina and Johanna Olafsdotter, 'Telling tales: investigating a *mina'i* bowl', in David J. Roxburgh (ed.), *Envisioning Islamic Art and Architecture: Studies in Honor of Renata Holod* (Leiden and Boston, 2014), pp. 66–87.

Mokri, Mohammad, *La Légende de Bižan-u Manija* (Paris, 1966).

Necipoğlu, Gülru, *The Topkapi Scroll: Geometry and Ornament in Islamic Architecture* (Santa Monica, CA, 1995).

Ostermann, Matthias, *The Ceramic Narrative* (London and Philadelphia, 2006).

Pancaroğlu, Oya, *Perpetual Glory: Medieval Islamic Ceramics from the Harvey B. Plotnick Collection* (New Haven and London, 2007).

Pope, Arthur U. and Phyllis Ackerman (eds), *A Survey of Persian Art*, Vols 2 and 5 (London and New York, 1939).

Rivière, Henri, *La ceramique dans l'art musulman*, Vol. 1 (Paris, 1913).

Roxburgh, David J., 'Micrographia: toward a visual logic of Persianate painting', *RES* 43 (2003), pp. 12–30.

Roxburgh, David J., 'In pursuit of shadows: al-Hariri's *Maqamat*', *Muqarnas* 30 (2013), pp. 171–212.

Sambon, Arthur *Catalogue des objets d'art et de haute curiosité de l'antiquité* (Paris, 1914).

Schmitz, Barbara, 'A fragmentary *mina'i* bowl with scenes from the *Shahnama*', in Robert Hillenbrand (ed.), *The Art of the Saljuqs in Iran and Anatolia* (Costa Mesa, 1994), pp. 156–65.

Shukurov, Sharif Mukhammadovich, *'Shakh-name' Firdousi i ranniaia illustrativnaiai traditsiya: tekst i illustratitsiia v sistema iranskoi kul'tury XI–XIV vekov* (Moscow, 1983).

Simpson, Marianna Shreve, 'The narrative structure of a medieval Iranian beaker', *Ars Orientalis* 12 (1981), pp. 15–24.

Simpson, Marianna Shreve, 'Narrative allusion and metaphor in the decoration of medieval Islamic objects', in Herbert Kessler and Marianna Shreve Simpson (eds), *Pictorial Narrative in Antiquity and the Middle Ages* (Washington, DC, 1985), pp. 131–49.

Simpson, Marianna Shreve, '*Shahnama* images and *Shahnama* settings in medieval Iran', in Olga M. Davidson and Marianna Shreve Simpson (eds), *Ferdowsi's Shahnama: Millennial Perspectives* (Boston, Washington, DC and Mumbai, 2013), pp. 72–85.

Simpson, Marianna Shreve, 'A medieval representation of Kay Khusraw's *jam-i giti namay*', in Robert Hillenbrand, Andrew C. S. Peacock and Firuza Abdullaeva (eds), *Ferdowsi, the Mongols and the History of Iran: Art, Architecture and Culture from Early Islam to Qajar Persia* (London and New York, 2013), pp. 351–8.

Sims, Eleanor, *Peerless Images: Persian Painting and Its Sources* (New Haven and London, 2002).

Townsend, Horace, *Illustrated Catalogue of the Rare and Beautiful Ancient Faiences, Glass and Other Objects belonging to Messieurs Tabbagh Frères of Paris and New York* (New York, 1911).

Warner, Arthur G. and Edmond Warner (trans.), *The Shahnama of Firdausi*, Vols 2–3 (London, 1906–8).

Watson, Oliver, *Persian Lustre Ware* (London and Boston, 1985).

Watson, Oliver, *Ceramics from Islamic Lands* (London, 2004).

Wichmann, Søren and Jesper Nielsen, 'Sequential text-image pairing among the Classic Maya', in Neil Cohn (ed.), *The Visual Narrative Reader* (London and Oxford, 2016), pp. 283–313.

Yamamoto, Kumiko, *The Oral Background of Persian Epics: Storytelling and Poetry* (Leiden and Boston, 2003).

When Muslims Died in China

Nancy Steinhardt

As recently as January of 2015, King Abdullah of Saudi Arabia was buried beneath a three-tier uninscribed rectangular prism in a Muslim cemetery in which his grave was undistinguished from the myriad in that complex or countless others like it. The interment was in accordance with Muslim orthodoxy that since the time of Muhammad had followed hadiths favouring burial just below ground level without elaboration in unmarked graves. Yet by *c.*700, Muhammad's own grave had been moved from below his residence, first to a place separate from his house with a shrine above it and then to mosque.[1] The varying views of marking death, from anonymity in a cemetery to an elaborate shrine or mausoleum, travelled with both Sunni and Shi'a Muslims across the Asian continent, reaching China in the Tang dynasty (618–907) by land along the Silk Routes and around southern India by the Silk Road of the Sea.[2] The earliest physical evidence of Muslim burial in China is from the twelfth century.

By that time, every province of China had a history of 4,000 years, at least, of tomb construction. In literature, burial practices were detailed in the first millennium BC.[3] It was assumed during that time that little expense would be spared on death: preparation began years in advance, in the case of rulers sometimes before ascending the throne; graves were marked above ground by mounds, and for elite members of society and royalty, by statuary that defined a long approach to the tumulus. In contrast to the ubiquitous timber-frame tradition that was adaptable to palatial, ceremonial, residential, Buddhist, Daoist, Confucian and other religious architecture including mosques, the subterranean tomb was made of permanent materials, either brick or stone.[4] Occasionally *houzang*, or lavish burial, was challenged at the Chinese court, but stipulations against it always faded away quickly.[5] During whichever century between the seventh and twelfth the first Muslims were buried in China, they

and those who made decisions about their burials had seen Chinese tombs.

One explanation for the lack of evidence of Muslim burial in China before the twelfth century may be that whenever possible, those who practised Islam in China returned home rather than die in a foreign land, for a Muslim is supposed to be buried as soon as possible after death, wherever it occurs. Muslims who came to China by land had long journeys through many terrains: there is no evidence that they timed departures to coincide with optimal weather or that they stayed in China longer than trade required. The trade winds on the sea route, however, necessitated that someone who docked in one of China's south-eastern coastal ports would stay at least fifteen months, and if he stayed a sixteenth month, he would be in China for another year before he could set sail. Muslim communities with mosques and schools rose in China's most active ports: Quanzhou, Guangzhou, Hangzhou and Yangzhou. China's oldest mosques and Muslim cemeteries are in these cities, where the interred either had settled or died unexpectedly during these stays.[6]

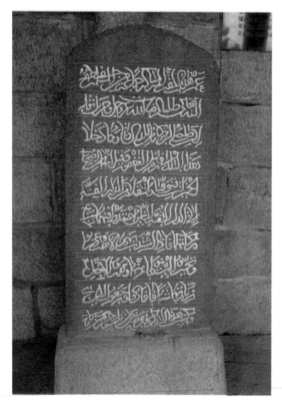

Figure 16.1 *Tombstone, site of Song-period Muslim cemetery, Quanzhou.*
Photo: Nancy Steinhardt.

Song

Zhao Rugua (1170–1231) writes in *Zhufanshi* (Record of Foreigners) of a cemetery for foreigners, not specifically Muslims, on a hill on the eastern side of Quanzhou. A Muslim named Pu Xiaxin was in charge of the cemetery and a wealthy merchant named Shi Nawei from Srivijaya gave funds to build it. It was enclosed by a wall and covered with a roof, suggesting it was small, and kept locked.[7] Nothing survives today. However, nearly 200 twelfth–fourteenth-century tombstones and funerary steles of non-Chinese do survive in Quanzhou. Cenotaphs and steles record Muslims' birthplaces, the dates in Chinese as well as the year after the *hijra*, and usually include the verse: 'Whoso hath died a stranger hath died a martyr' (Figure 16.1).[8] The oldest Muslim tomb in Hangzhou dates to the Southern Song dynasty (1127–1279). It belongs to Buhatiya'er

(Persian: Bakhtiyar?),[9] a doctor who came from Mecca to teach and practise medicine. He was buried beneath a three-tier cenotaph, the top tier trapezoidal in section, that today has been moved alongside those of two of his followers. In Yangzhou, the oldest Muslim tomb belongs to Buhading, who fell ill on a journey in 1275 and returned to Yangzhou to die. He, too, has a five-layer cenotaph, today covered in a simple building among other buildings in a garden-like setting. We thus confirm that a Chinese who lived in Song China (Yangzhou did not fall to the Muslims until 1279) returned home to die.

We further confirm that in the Song dynasty there is no evidence of Muslim burial other than underground, marked by a standardised cenotaph and sometimes with an accompanying stele. The situation changed dramatically during the Yuan dynasty (1267–1368), the period of Mongolian rule. One reason is that whereas Muslims had come to China primarily as merchants in the Tang and Song dynasties, in Yuan China, Muslims were employed by the government, some rising to high positions. Ahmad Fanakati (d. 1282), for example, Khubilai's (1215–94) finance minister, was 'buried in a tomb', but nothing about it is known since soon afterwards his body was exhumed and eaten by dogs.[10]

Yuan

Al-Sayyid al-Ajall Shams al-Din 'Umar al-Bukhari (1211–79), known in Chinese as Saidianchi Shansiding, was among the Muslims who came to China in the service of the Mongols. As his name indicates, he was born in Bukhara. Al-Bukhari's father entered Genghis' elite bodyguard as a hostage; al-Bukhari trained for membership in this group at a young age. He began his rise through officialdom in 1229 under Ögedei (1186–1241), becoming *yarghachi* (judge arbitrator) of the city that in the 1260s would become Khubilai's capital, Dadu (today Beijing). In 1253, he served Möngke (1209–59) in wars in Sichuan. About the same time, he was in charge of food and supplies for Khubilai's troops in Dali, Yunnan province. In the 1260s, al-Bukhari served Khubilai, first in the Dadu circuit and then in Sichuan. With Sichuan securely in Mongol hands, he moved into Yunnan, rising to head of the Regional Secretarial Council in western China. In 1273, al-Bukhari returned to Dali as provincial governor where he supported Confucian institutions and encouraged construction of Buddhist worship spaces even as he built two mosques. He spent the last five years of his life working to improve life in Yunnan. When he died in 1279, the entire city of Kunming, in Yunnan, mourned. His sons continued his work. Tombstones in Hangzhou and Quanzhou record the presence of his descendants. The seafarer Zheng He was his descendant (1371–1433).

Three locations have been proposed for al-Bukhari's remains. One in Kunming has been a Muslim pilgrimage site since his death, and

was repaired in 1692 and 1736. Henri d'Ollone sketched it between 1906 and 1909. From the sketches and pictures taken after later repairs, it is very likely that the cenotaph one sees today is or is a replica of the one made in 1279. Measuring 4 × 2.5 m at the base, the stone layers above it were successively smaller, all of them capped by a semicircular prism. Originally the monument was enclosed by a pillar-supported wall or structure of 8 × 6.5 m. The tomb of the esteemed governor, in other words, was marked with no more glory than any Muslim who could afford a stone marker.

Tughluq Temür (1329/30–63) is another esteemed Muslim buried in Yuan China. His is the only brick mausoleum of its kind in China built for a confirmed Muslim (Figure 16.2). As the last monument of the Chaghatai Khans, it also is one of the westernmost pre-fifteenth-century Islamic structures in China, situated in territory that would become part of the Timurid Empire. A seventh-generation descendant of Genghis, Tughluq Temür came to power in 1346 and converted to Islam the next year. His khanate, some 160,000, converted in 1352.[11]

Tughluq Temür's dome-on-square tomb, in his case with an extension at the back, calls to mind the mausoleum of Buyan Quli Khan (d. 1356), also a Chaghatai, in Fathabad (Bukhara). The twenty-six different sizes of glazed and carved tiles on Tughluq Temür's tomb are of the same technique as those on the Buyan Quli Khan mausoleum, and the same colours of white, turquoise and manganese are used with the only apparent distinction being that in Bukhara the turquoise sometimes runs into white areas, and only the front of Tughluq Temür's tomb is tiled.[12] No record or on-site investigation indicates whether the original intention was to tile all four sides.

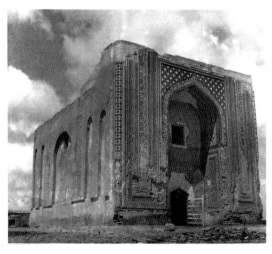

Figure 16.2 *Tomb of Tughluq Temür, Huocheng, Inner Mongolian Autonomous Region. Public domain.*

Similar mausoleums for two Chaghatai khans who died within seven years of each other indicates both that the practice of a shrine-mausoleum was implemented in today's Xinjiang in the mid-fourteenth century and that Muslims this far north and west of China's south-eastern port cities engaged in such construction. It further emphasises that al-Bukhari and his descendants chose much simpler burial.

At the tombs of Tughluq Temür, Buyan Quli, the Tomb of the Samanid in Bukhara, dated to 943 to which dome-on-square tomb construction is often traced, and the Arab-Ata mausoleum in

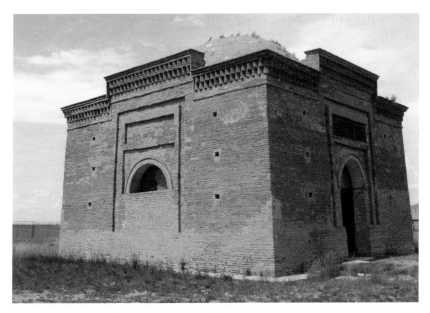

Figure 16.3 *Mausoleum, Guyuan, Hebei province.*
Photo: Nancy Steinhardt.

Tim, dated 977–8, columns are placed at the four corners of the building. They are not present in a tomb in Guyuan, Hebei province (Figure 16.3). Although the occupant and date of this structure are unknown, Chinese documentation exists. The monument is referred to in the geographic study of a part of Inner Mongolia and contiguous regions undertaken at the Qianlong (1711–99) court by the official Jin Zhizhang sometime between 1732 and 1741, and published with additions by Huang Kerun in 1758 under the title *Koubei santing-zhi* (Record of the three areas of Koubei). Jin and Huang mention a structure named Shuzhuanglou (Comb and Make-up Tower). They tell us that the territory in question was part of the appanage of Empress Dowager Chengtian (932–1009) of the Liao dynasty, who was regent for her son Shengzong (972–1031) after her husband Jingzong died in 982. She was awarded the lands in 986 when the son ascended the throne. Until her death, Chengtian spent summers here. Shuzhuanglou probably refers to the fact that the lands were controlled by a woman. In the text, the building also goes by the name Xiliangge (West Cool Pavilion), *ge* (pavilion) perhaps chosen as the building type because although domes were constructed in underground tombs and built into ceilings in China since the last centuries BC, a dome from the outside even in the eighteenth century would have been striking.

Jin and Huang tell us that Shuzhuanglou was squarish, brick-faced, more than two *zhang* (nearly 13 m) high and had a semicircular dome rising from the centre of a flat roof. The text says, further, that the

front entry was in the south-east with a window there and at the back.[13] The twentieth-century local record *Guyuanxian zhi* (Record of Guyuan County) states that the building stood 7.5 km south-east of the centre of Guyuan, facing south-east, that it was 10 m sq. and 13 m high, and cubic in appearance, and that an arched window was on either side of the arched front entry. This is what one sees today.[14]

Inside, the walls and ceiling are whitewashed. The interior vaulted ceiling is made of bricks that are 35 × 5 × 1.75 cm. It joins an eight-sided upper wall that interfaces the four main walls. At the eight corners are imitation pillars of the kind that for centuries have been moulded into the walls of Chinese tombs to replicate wooden architecture; above the pillars, cantilevered components interface the corners and upper walls. This feature may represent bracket sets, as one would see in a Chinese building, but the intent may also be to imitate *muqarnas*.[15]

The description in *Guyuanxian zhi* was confirmed by the Chinese scholar Wang Beichen (1921–96), who saw the building in 1993 and 1995. At the time of his death, Wang was working on a paper that was completed and published posthumously by his colleague Lin Meicun, an eminent scholar of Yuan history and archaeology, based on conversations during Wang's final illness. To have spent his last hours working on this paper can only mean that Wang anticipated controversy, and he wanted to be associated with an idea that he knew was likely to find resistance.

Wang wrote that an earthen mound and traces of architecture, including glazed ceramic tiles of gold, blue and white remained about 50 m to the north of this building. Wall remains also were found in the vicinity. Wang was convinced that in spite of associations with the Liao empress, the structure had to date from the Yuan period.

Excavation began in 2000. Three side-by-side burials, each in a wooden coffin, a male flanked by females, were found. Pieces of brocade clothing with gold decoration and parts of other garments were among the grave goods. The finds are significant: Chinese royalty are always buried with extra clothing and objects around them for use in an anticipated afterlife. Grave goods should not be found in a Muslim tomb. Even a simple wooden coffin challenges orthodox Muslim practice that prescribes burial in white cloth directly into the earth. However, the interior walls of the mausoleum bore no traces of human or animal imagery, and heads pointed north-west, as is also customary in Muslim burial.

Today's Guyuan was part of the appanage of Ananda, Prince of Anxi, son of Khubilai's son Mangqala (d. 1278) and thus Khubilai's grandson.[16] Ananda inherited some of his father's lands, although the precise boundaries of this territory remain uncertain.[17] Ananda's conversion to Islam is especially interesting because Mangqala was a devout Buddhist and had given his son the name of a disciple of the Buddha Shakyamuni.[18] Ananda also was a cousin of Khubilai's suc-

cessor, the sixth Mongol ruler, Temür Öljeytü (r. 1294–1307). Upon Temür Öljeytü's death in 1307, Ananda was a contender for the throne. Ananda was a successful general, and Temür's widow supported him. His opponents were two brothers, Qaishan (1281–1311) and Ayurbarwada (1285–1320), great-grandsons of Khubilai, but direct descendants of Temür. Ananda lacked support in Dadu and he had converted to Islam. He was executed in 1307, and Qaishan succeeded Temür Öljeytü. Ayurbarwada would succeed him.[19] Wang Beichen proposed that the Guyuan monument was Ananda's tomb.

Qaishan, the seventh Khaghan of China whose way to the throne was opened by Ananda's execution, built a pleasure retreat that became the Yuan central capital immediately upon accession. The central capital is in Zhangbei, the county of which Guyuan is also a part. If Ananda was buried in Guyuan in 1307, a decision of Qaishan (r. 1307–11) to begin construction of a new capital adjacent to Guyuan becomes clear. His new capital, on the route between Dadu and the summer capital Shangdu (Xanadu), put his workers and then officials in territory that had once belonged to Ananda. Upon Qaishan's death, construction of the central capital almost came to a halt; it was never again used to the extent of Dadu or Shangdu.

Some have been resistant to seeing this as a Muslim tomb. They argue that like Genghis, all his blood descendants were buried in unmarked graves, never to be discovered. Ananda, of course, was a Muslim. When asked about Ananda's conversion, Persian historian Rashid al-Din (1247–1318) said Ananda had been guided by Ghazan (1271–1304), his cousin who rose to be Khan of the Ilkhanate (Mongol rulers of Iran), and converted to Islam in 1295. Others turn to stones inscribed in Chinese that surfaced in the twenty-first century with the name Kuolijisi that has been transcribed from the Syriac as Giwargis, the son-in-law of Temür Öljeytü who was a descendant of the Onguts, among whom were many converts to the Church of the East (Nestorianism). By their reckoning, this is a Christian tomb.[20]

When I saw the building in June 2013, it was as Wang had described it. Pieces of tile mentioned in his report had been moved into a museum inside the mausoleum, and there were building foundations a short distance behind it. About three weeks later, bloggers proposed that this was Mongol tomb, but not of a Mongol who was a Muslim. Wanting to see it as one of a group, replicas had been erected on the mounds behind it by mid-July of the same year (Figure 16.4).

Figure 16.4 *Site of Mausoleum in Guyuan, 14 July 2013. Courtesy of Haiwei Liu.*

Returning in June 2015 with Sheila Blair and Jonathan Bloom, the additional mausoleums had been torn down. A local told me that they had been erected for a festival. I found only one mention of Kuolijisi. The site had been developed for tourism, with a car park and admission fee, waterpark, resort, new hotels and lantern-lined approach from the town of Guyuan. Signage highlighted the importance of astronomy for the Mongols, and that this site had been laid out according to the cosmos. It was emphasised that new development was intended as a model greenspace.

To me, the dome-on-square structure of eastern Iranian/Inner Asian origin is as hard to ignore as the fact that, to date, no grave of a Yuan Khaghan or khan has been found, except for the khan Tughluq Temür, who was a Muslim.[21] It is also a fact that except for this structure, beneath which the interred are buried with a nod towards China as represented with grave goods, verifiable Muslims in China until Tughluq Temür's burial in 1363 in Almaliq were laid to rest with nothing but cenotaphs to mark their lives.[22] From Ming onwards, one can document that burial of Muslim princes not only included monumental architecture, but had turned exclusively to the Chinese system.

Ming

Although some say he died at sea, the famous Muslim seafarer Zheng He (1371–1433) has a tomb in Nanjing. This man, who held a high official title in the Chinese government, was a strong sponsor of mosques in Nanjing and Xi'an. He was memorialised in the same way as countless Muslims who had little impact on world history. The seafarer's grave is marked by a stone cenotaph of five cylindri-cal lobes above the base. Repaired in 1959, in the 1980s and more recently, it is a tourist site in an isolated setting where the Nanjing city government has added a shrine, stele and statue.

In 2010 the location was challenged. While digging near Zutang Mountain of Nanjing, workers came across an empty tomb in a cemetery of powerful eunuchs; like many Ming officials of his day, Zheng He was a eunuch. The 8.5 × 4 m, brick, subterranean tomb in Chinese style was identified as his.[23] One does not want to read too deeply into the identification. Yet considered alongside Chinese assessments that the mausoleum in Guyuan belongs either to a Mongol who was not Muslim or to Giwargis, one should query if resistance to documentation of the presence of Muslims who were powerful in the Chinese government guides twenty-first-century assessments of the fourteenth- and fifteenth-century monuments.

Zheng He had served the first emperor of the Ming dynasty, Hongwu (1328–98) and the third emperor, Yongle (1360–1424). It has been proposed that Hongwu was a Muslim.[24] Under Yongle's reign, Islam flourished along the Grand Canal, rebuilt by the emperor to

enhance transport between the capital Beijing and south-eastern coastal cities. Muslims were active in the trade, evidenced by the number of mosques built in cities along the canal in the Ming dynasty.[25]

Muslim royalty visited the Yongle court by way of the canal. The King of Boni (Brunei) came to China with around 150 relatives and officials in 1408, three years after sending a tribute mission to Beijing. The emperor held a banquet for him and then met him in Fengtian Hall (today Huangji Hall), one of the two main structures of the Back Halls along the main axis of the Forbidden City.[26] The trip was predicated by the good relations between Boni and China that had begun early in the Hongwu reign. When the king became ill in China, Yongle sent the imperial physician to him, but the king died. Between 1412 and 1425, a king or his emissaries made five more trips to China.

Yongle awarded the King of Boni a tomb in Nanjing. It was discovered in 1958 and thereafter restored. Although the tomb is known as Ma Huihui fen, or Mound of the Muslim Ma, the architecture above ground is indistinguishable from the tomb of a Ming prince. A pair of steles followed by pairs of horses, Confucian officials, sheep, tigers, military officials and a stele pavilion leads to the tumulus located just outside Ande Gate of the Ming city wall. This approach, defined by pairs of monumental sculptures known as a spirit path, bends sharply from the stele pavilion to the funerary mound, a feature of the approach to the Yongle emperor's own tomb intended to steer evil spirits off course, for according to tradition, they travel in straight lines (Figure 16.5).

A similar Muslim tomb is in Dezhou, a town on the Grand Canal near Shandong's border with Hebei. In 1417, during the land journey from Beijing to the ship that would carry him home, the King of Sulu, believed to be an island between Kalimantan and the Philippines, died in Dezhou. The Muslim ruler had come earlier that year with an entourage of around 350 to pay tribute and personally establish friendly relations with Yongle. The emperor awarded him burial with the accoutrements of Chinese royalty (Figure 16.6).

The tomb approach begins with a *pailou* (ceremonial archway) followed by a stele pavilion, then a second *pailou* and another pavilion that contains a stele with an epitaph written by the emperor. Four pairs of animals, a pair of ceremonial columns and then the standard pairs of civil and military officials (one of each pair is now missing) of a spirit path follow. Beyond the spirit path is a funerary temple with the king's tumulus behind it. The pair of columns and positions of officials and horses differ from the arrangement of statues at the approach to the King of Boni's tomb. East of the spirit path are tombs of three of the king's relatives who stayed in Dezhou and established a Muslim community there. They, too, are buried beneath Chinese-style funerary mounds.

Figure 16.5 *Spirit path approach to tomb of King of Boni showing bend to avoid evil spirits, Nanjing, 1408. Photo: Nancy Steinhardt.*

Figure 16.6 *Approach to tomb of King of Sulu, showing stele pavilion in distance, pailou and spirit path; funerary mound outside photograph. Photo: Nancy Steinhardt.*

No record informs us if the families of the Muslim rulers had any say in the design of either prince's tomb. Nor do we know the conditions in which the corpses were placed underground. The statues of the spirit path alone, however, would have been anathema to a Muslim. Although of unquestionably Chinese fashion, the above-ground architecture of both princely tombs is as Chinese as the mausoleum in Guyuan is Muslim.

In Ming China, a spirit path was a privilege that only the Chinese emperor could confer. The privilege was widespread and expensive. Emperor Hongwu had a primary wife and twenty-four concubines who produced twenty-six sons, one of whom was Yongle. Because of concerns about succession (Yongle, in fact, usurped the throne from his nephew), Hongwu awarded expansive fiefdoms to all his living sons. The tombs, collections and possessions of four descendants are especially well documented.[27]

Only excavation can confirm if any accommodation to Muslim law was made to the kings of Boni and Sulu. Just as the disparity between the simple wooden coffins and a few burial garments and objects beneath the Guyuan mausoleum and a royal Chinese burial may have been an accommodation to Islam, it is possible that the underground ambiance of the Muslim kings would be shockingly meagre by comparison with a Ming prince. Yet the status of *wang*, translated as prince or king according to context, meant that above ground the tombs of a son of Hongwu or of one of his successors and those of the two Muslim kings were indistinguishable. King Sejong (1397–1450), fourth ruler of the Joseon dynasty of Korea, also entitled *wang* by the Ming court, is buried similarly. Statues of men and beasts line the spirit path to his tumulus. For him, the status was so significant that the tomb style was implemented in his native land. Sejong is buried in Gyeonggi among other Korean royalty, as are Hongwu and Yongle and their relatives in Nanjing and Beijing, respectively. As was the case for mosques constructed in China from the Song dynasty onwards that resulted in prayer halls in the architectural setting of Chinese Buddhist and Daoist temples,[28] in the Ming dynasty, above ground the Chinese system of royal burial was easily recognisable, and those below it could not be distinguished by the nationality or faith of a prince or princess.

Qing

The Qing dynasty (1644–1911) was founded by Manchus and included all of Ming China as well as today's autonomous regions (including Xinjiang, Tibet and Inner Mongolia) and the part of Mongolia known as Outer Mongolia. It is the period during which the mosques of Kashgar and the lamaseries of Inner Mongolia were built, a time when architecture could represent the ethnicity of its builders first and China second, if at all. The Chinese structure known as *gongbei*,

a transliteration of *qubba*, the Arabic for dome and for the structural type that can be called a shrine-mausoleum, is associated almost exclusively with the Qing period. In China as in the Muslim world, it is a memorial to a holy man, and in China, *gongbei* are almost always domed. The majority of *gongbei* cluster in an area known as Gan-Ning-Qing, short for Gansu, Ningxia and Qinghai, a region to which highly influential leaders of four Sufi orders, *menhuan* in Chinese, became active transmitters of their doctrines in the late Ming period.

The convergence into a Sino-Islamic architecture and decoration, perhaps even iconography, is apparent in *gongbei* to an extent not observed in pre-Ming Muslim tombs or mosques in China. Yihachi Gongbei in Dongxiang, a Muslim autonomous region in Gansu province, is exemplary. Details about it are scant; the *gongbei* memorialises Ma Enyun (1767–1845) of the Qadariyya order, but the imagery is as new as the turn of the twenty-first century. A *pailou* with an incense burner in front of it announces the shrine (Figure 16.7). Lining the courtyard behind are relief panels set into individual frames. One shows a Qur'an and Buddhist sutra alongside a Chinese cup and vase containing Chinese writing brushes, a quill and a fan. Another takes incense sticks, labelled 'Qur'an incense' as its subject. Yet other panels depict *pailou*, minarets and shrines similar to Yihachi Gongbei itself. A relief panel at the base of an incense burner

Figure 16.7 *Entrance to Yihachi Gongbei, Dongxiang Autonomous County, Gansu province, eighteenth century with recent restoration. Photo: Nancy Steinhardt.*

Figure 16.8 *Relief sculpture on panel of decorative wall showing 'Qur'an Sutra', Chinese scrolls, calligraphy brush, swastika symbolising the Buddha, auspicious bat, Chinese vase, teapot, cylindrical jar, and strawberries(?), Yihachi Gongbei, Dongxiang Autonomous County, Gansu province, eighteenth century with recent restoration. Photo: Nancy Steinhardt.*

in this courtyard illustrates an incense burner alongside an open jar containing Buddhist prayer beads and a Chinese decorative box (Figure 16.8). The gateways, screen wall, courtyards, bracket sets, and sloping, ceramic tile roof eaves, all in brick, follow the forms of Chinese architecture. Prayer halls, local dress and posted schedules for prayer confirm that this is a fully functioning Muslim shrine. Isolated and difficult to access because of the mountainous location and dirt roads, patrons in this local community could have designed and built at will. They made the conscious decision to construct and decorate with Chinese elements as recently as this century.

Gongbei are a unique building type, different not only from the memorial shrines of Sufi spiritual leaders in Iran or Central Asia, but also different from famous shrine-mausoleums in Kashgar, such as the one built to Aba Khoja in the late seventeenth century. An important distinction between the architecture of Kashgar and more generally Xinjiang autonomous region is that this westernmost part of China has been more or less part of China depending on the historical period, but its Muslim population, known as Uyghur, has always had its strongest ethnic and ritual ties as far west as Iran. Yihachi Gongbei, by contrast, is a Hui, or Sinophone Muslim, monument. These distinctions become highly significant beginning in the Qing dynasty, when the Sufi orders made their way into the Gan-Ning-Qing region.

Of all tombs discussed here, only the one in Guyuan has been excavated. Without information about interment, one can only

speculate about the religious practices of Muslim merchants or Muslim kings who planned for death or who died unexpectedly in China. On the surface, the architecture of Song and Yuan period Muslims, merchants, al-Bukhari and, it is believed here, the interred in Guyuan, Hebei, make the definitive declarations of Islam in permanent materials. By contrast, for as long as they stand, spirit paths leading to tumuli indicate the death of a Chinese royal subject.

Notes

1. On Muslim burial practice and the hadiths that guide it, see Leor Halevi, *Muhammad's Grave: Death Rites and the Making of Islamic Society* (New York and Chichester, 2011), pp. 1–113 and 165–96.
2. Scholars disagree about the date of arrival of Muslims in China. Surely Muslims were in the Tang capital Chang'an, but neither prayer spaces nor burials can be documented; perhaps Muslims followed the practice of early Islam by praying in residences. Muslims in Chang'an in the Tang dynasty in all likelihood came across Central Asia by land. Ibn Khurdadhbih's *Kitab al-Masalik wa'l-Mamalik* of 885, Abu Zayd al-Hasan ibn al-Yazid's commentary on *'Akhbar al-Sin wa'l-Hind* of 916, and Liu Xu (887–946), chief editor, *Jiu Tangshu* (History of the earlier Tang dynasty) of 940–5 all offer stronger evidence of a Muslim presence in the southern port cities of Guangzhou and Quanzhou. Muslims in the port cities most often came by sea along the route nicknamed Silk Road of the Sea rather than across land in the north and then southwards along the Grand Canal.
3. On burial practices of the Han period and before, see Michael Loewe, *Chinese Ideas of Life and Death: Faith, Myth and Reason in the Han Period (202 BC – AD 220)* (Taipei, 1994) and Mu-chou Poo, *In Search of Personal Welfare: a View of Ancient Chinese Religion* (Albany, 1998), pp. 165–77.
4. For heavily illustrated surveys of Chinese tomb architecture through four millennia, see Yang Kuan, *Zhongguo gudai lingqin zhidu shi yanjiu* [Research on the history of the Chinese imperial tomb system] (Shanghai, 1985); Yang Daoming, *Zhongguo meishu quanji: jianzhu yishu bian* [Comprehensive arts of China: Architectural art series], Vol. 2: *Lingmu jianzhu* [Tomb architecture] (Beijing, 1991).
5. For examples of requests for 'meagre' burial rather than 'lavish burial', followed by returns to huge expenditures on tomb construction, see Mu-chou Poo, 'Ideas concerning death and burial in pre-Han and Han China', *Asia Major* 3rd series, 3.2 (1990), pp. 25–62, and his *In Search of Personal Welfare*, p. 196. On the ideology of Han funerals, see Loewe, *Chinese Ideas of Life and Death*, pp. 114–26.
6. Nancy Steinhardt, *China's Early Mosques* (Edinburgh, 2015), pp. 34–91.
7. Billy Kee-long So, *Prosperity, Region, and Institutions in Maritime China: The South Fukien Pattern, 946–1368* (Cambridge, MA, 2000), and Friedrich Hirth and William W. Rockhill, *Chao Ju-kua: His Work on the Chinese and Arab Trade in the Twelfth and Thirteenth Centuries, entitled Chu-fan-chi* (St Petersburg, 1911), pp. 119, 124.
8. Many of the steles are published in Wu Wenliang and Wu Youxiang, *Quanzhou zongjiao shike* [Religious stone carving in Quanzhou]

(Beijing, 2005); many are translated into French in Chen Dasheng and Ludvik Kalus, *Corpus d'Inscriptions Arabes et Persanes en Chine, tome 1: Province de Fujian (Quan-zhou, Fu-zhou, Xia-men)* (Paris, 1991); many are translated into English and French in Kalus, *Quanzhou Yiselanjiao shike* [Stone-carved Islamic inscriptions in Quanzhou] (Yinchuan and Fuzhou, 1984).

9. In Chinese, Persian names are rendered in single-syllable Chinese characters. Unless one can match a name in a Persian source with one in a Chinese source, one cannot be certain about the Persian name.

10. On Ahmad, see Christopher Atwood, *Encyclopedia of Mongolia and the Mongol Empire* (New York, 2004), pp. 15–16.

11. Svat Soucek, *A History of Inner Asia* (Cambridge, 2000), p. 21.

12. Bernard O'Kane, 'Chaghatai architecture and the tomb of Tughluq Temur at Almaliq', *Muqarnas* 21 (2007), pp. 278–9.

13. Jin Zhizhang, with additions by Huang Kerun, *Koubei santingzhi* [Record of the three areas of Koubei] (Taipei, 1758), p. 53.

14. Wang Beichen, *Wang Beichen xibei lishi dili lunwen ji* [Collected essays on historical geography of north-western China by Wang Beichen] (Beijing, 2000), pp. 421–36.

15. The formation is smaller but similar to cornice decoration in Hangzhou's Fenghuang (Phoenix) Mosque, dated 1314–20. One also finds this feature in the shrine of Sayf al-Din Bakharzi.

16. On Anxi, today part of greater Xi'an in Shaanxi province, Mangqala and Ananda, see Ruth W. Dunnell, 'The Anxi principality: [un]making a Muslim Mongol prince in northwest China during the Yuan dynasty', *Central Asiatic Journal* 57 (2014): pp. 185–200.

17. The territory included much of the Tang(q)ut Empire that had fallen to the Mongols in 1227 and thus was also part of the Chaghatai khanate; Dunnell, 'The Anxi principality', pp. 188–9.

18. The conversion is also mentioned in Persian sources. See Rashiduddin Fazlullah, *Jami'u't-Tawarikh: Compendium of Chronicles: A History of the Mongols*, trans. and annotated by Wheeler M. Thackston, 3 parts (Cambridge, MA, 1999), pt 2, p. 422.

19. For this history, see Herbert Franke and Denis Twitchett (eds) *The Cambridge History of China, Vol. 6: Alien Regimes and Border States, 907–1368* (Cambridge, 1994), pp. 505–6.

20. Li Tang, 'Rediscovering the Ongut King George: remarks on a newly excavated archaeological site', in Li Tang and Dietmar W. Winkler (eds), *From the Oxus River to the Chinese Shores: Studies on East Syriac Christianity in China and Central Asia* (Zurich, 2013), pp. 255–66.

21. Sheila Blair is more open to the Christian associations; see her article 'Muslim-style mausolea across Mongol Eurasia: religious syncretism, architectural mobility and cultural transformation', *Journal of the Economic and Social History of the Orient* 62, special issue: *Mobility and Transformations in Mongol Eurasia: Economic and Cultural Exchanges*, Michal Biran (ed.) (2019), pp. 318–55.

22. A dome-on-square structure with four corner pillars also stands among the ruins of Khara-Khoto in Inner Mongolia. Some believe it is Tangut, dating before 1227 when the Mongols destroyed Khara-Khoto. I believe that it, too, was built during the Yuan period.

23. See 'Admiral Zheng He's tomb is empty', available at: <http://mongolsc hinaandthesilkroad.blogspot.com/2010/07/admiral-zheng-hes-tomb-is-empty.html> (both last accessed 23 September 2020).

24. Zvi ben Dor Benite, 'The Marrano Emperor: the mysterious bond between Zhu Yuanzhang and the Chinese Muslims', in Sarah Schneewind (ed), *Long Live the Emperor!: Uses of the Ming Founder Across Six Centuries of East Asian History*, Ming Studies Research Series 4 (Minneapolis, 2008), pp. 275–308.

25. Ming mosques that survive rose in Jining, Jinan, Linqing, Dezhou, Qingzhou, Botou, Cangzhou, Mengcun and Tianjin, along with many that are no longer extant.

26. The visit and gift list are recorded in the official histories of the Ming dynasty. For a summary, along with a study of the tomb, see Yang Xinhua and Yang Jianhua (eds), *Boniguo wangmu tanyuan* [Discussion of the sources of the tomb of the king of Boni] (Nanjing, (1958)).;

27. This is the subject of Craig Clunas, *Screen of Kings: Royal Art and Power in Ming China* (Honolulu 2013). See also David Robinson (ed.), *Culture, Courtiers, and Competition: The Ming Court (1368–1644)* (Cambridge, MA, 2008), pp. 1–60.

28. This is a thesis of Steinhardt, *China's Early Mosques*.

Bibliography

Atwood, Christopher, *Encyclopedia of Mongolia and the Mongol Empire* (New York, 2004).

Benite, Zvi ben Dor, 'The Marrano Emperor: the mysterious bond between Zhu Yuanzhang and the Chinese Muslims', in Sarah Schneewind (ed), *Long Live the Emperor!: Uses of the Ming Founder Across Six Centuries of East Asian History*, Ming Studies Research Series (Minneapolis, 2008), pp. 275–308.

Blair, Sheila, 'Muslim-style mausolea across Mongol Eurasia: religious syncretism, architectural mobility and cultural transformation', *Journal of the Economic and Social History of the Orient 62, special issue: Mobility and Transformations in Mongol Eurasia: Economic and Cultural Exchanges*, Michal Biran (ed.) (2019), pp. 318–55.

Chen Dasheng and Ludvik Kalus, *Corpus d'Inscriptions Arabes et Persanes en Chine, tome 1: Province de Fujian (Quan-zhou, Fu-zhou, Xia-men)* (Paris, 1991).

Clunas, Craig, *Screen of Kings: Royal Art and Power in Ming China* (Honolulu, 2013).

Dunnell, Ruth W., 'The Anxi principality: [un]making a Muslim Mongol prince in northwest China during the Yuan Dynasty', *Central Asiatic Journal* 57 (2014), pp. 185–200.

Franke, Herbert and Denis Twitchett (eds), *The Cambridge History of China, Vol. 6: Alien Regimes and Border States, 907–1368* (Cambridge, 1994).

Halevi, Leor, *Muhammed's Grave: Death Rites and the Making of Islamic Society* (New York and Chichester, 2011).

Hirth, Friedrich and William W. Rockhill, *Chao Ju-kua: His Work on the Chinese and Arab Trade in the Twelfth and Thirteenth Centuries, entitled Chu-fan-chi* (St Petersburg, 1911).

Jin Zhizhang, with additions by Huang Kerun, *Koubei santingzhi* [Record of the three areas of Koubei] (Taibei repr., 1758).

Kalus, Ludvik, *Quanzhou Yiselanjiao shike* [Stone-carved Islamic inscriptions in Quanzhou] (Yinchuan and Fuzhou, 1984).

Li Tang, 'Rediscovering the Ongut King George: remarks on a newly excavated archaeological site', in Li Tang and Dietmar W. Winkler (eds), *From*

the Oxus River to the Chinese Shores: Studies on East Syriac Christianity in China and Central Asia (Zurich, 2013), pp. 255–66.

Loewe, Michael, Chinese Ideas of Life and Death: Faith, Myth and Reason in the Han Period (202 BC – AD 220) (Taipei, 1994).

Mu-chou Poo, 'Ideas concerning death and burial in pre-Han and Han China', Asia Major, 3rd series, 3.2 (1990), pp. 25–62.

Mu-chou Poo, In Search of Personal Welfare: A View of Ancient Chinese Religion (Albany, 1998).

O'Kane, Bernard, 'Chaghatai architecture and the tomb of Tughluq Temur at Almaliq', Muqarnas 21 (2007), pp. 278–9.

Rashiduddin Fazlullah, Jami'u't-Tawarikh: Compendium of Chronicles: A History of the Mongols, trans. and annotated by Wheeler M. Thackston, 3 parts (Cambridge, MA, 1999).

Robinson, David (ed.), Culture, Courtiers, and Competition: The Ming Court (1368–1644) (Cambridge, MA, 2008).

van Roon, Hans, 'Admiral Zheng He's tomb is empty', 4 July 2010, <http://mongolschinaandthesilkroad.blogspot.com/2010/07/admiral-zheng-hes-tomb-is-empty.html> (last accessed 6 November 2017).

So, Billy Kee-long, Prosperity, Region, and Institutions in Maritime China: The South Fukien Pattern, 946–1368 (Cambridge, MA, 2000).

Soucek, Svat, A History of Inner Asia (Cambridge, 2000).

Steinhardt, Nancy S., China's Early Mosques (Edinburgh, 2015).

Wang Beichen, Wang Beichen xibei lishi dili lunwen ji [Collected essays on historical geography of northwestern China by Wang Beichen] (Beijing, 2000).

Wu Wenliang and Youxiang Wu Youxiang, Quanzhou zongjiao shike [Religious stone carving in Quanzhou] (Beijing, 2005).

Yang Daoming, Zhongguo meishu quanji: jianzhu yishu bian [Comprehensive arts of China: Architectural art series], Vol. 2: Lingmu jianzhu [Tomb architecture] (Beijing, 1991).

Yang Kuan, Zhongguo gudai lingqin zhidu shi yanjiu [Research on the history of the Chinese imperial tomb system] (Shanghai, 1985).

Yang Xinhua and Yang Jianhua (eds), Boniguo wangmu tanyuan [Discussion of the sources of the tomb of the king of Boni] (Nanjing, 1958).

CHAPTER SEVENTEEN

Abū'l-Fażl's Description of Akbar's 'House of Depiction'

Wheeler M. Thackston

WHEN ABŪ'L-FAŻL BEGAN work in 1588 on the *Akbarnāma*, the history of the Timurid rulers of India and primarily of Akbar's reign, the *Ā'īn-i Akbarī* (Akbar's Institutions) was planned to be Tome Three, but in modern times it has been detached from the *Akbarnāma* and is considered a separate work. In several places in the *Ā'īn* in which he refers to 'this year', it is the fortieth year of Akbar's reign, 1595–6,[1] and Abū'l-Fażl must have been still working on it when he was murdered in 1602, as much of the *Ā'īn* appears to be in draft form that never received the final polish of the author's idiosyncratically ornate prose.

Every conceivable institution, department and administrative unit of the empire is treated in varying detail. One of the most interesting is the account of what Abū'l-Fażl calls the *taṣwīrkhāna*, the 'house of depiction', which includes both the scriptorium where books were copied and the artists' studio where they were illustrated. In typical fashion he begins with a philosophical statement, here a statement of aesthetics with extended metaphors, and then goes on to give details. As might be expected, calligraphy and calligraphers are given pride of place, and artists are given short shrift at the end. The section is on pp. 111–18 of volume one in the 1872 edition of the Persian text in the Bibliotheca Indica series of the Asiatic Society of Bengal.

Apropos of Sheila Blair's work on calligraphy and Jonathan Bloom's abiding passion for paper, the following translation of and commentary on the section on the imperial 'house of depiction' is offered in tribute.

The institution of the house of depiction

A picture (*ṣūrat*) is a guide to the subject and the underlying reality, just as a graphic form leads one to sounds and words and brings one to the designatum. Although in traditional depiction existential

phantoms are drawn, European practitioners produce many crea-
tional meanings in marvellous pictures and lead external viewers
to the realm of reality.[2] However, it is through writing that the
experiences of the ancients are acquired, and it forms the basis of the
growth of wisdom.

Therefore, we will report first on the library, which is the choicest
part of the gallery. His Majesty has devoted much attention to it and
looks deeply at form and content. Truly in the view of lovers of beauty
it is a stage for captured light, and in the opinion of the foresighted
it is an absolute world-revealing goblet.[3] The talisman of calligraphy
is a spiritual geometry from the pen of creativity and a heavenly
inscription from the hand of destiny, a repository of the secrets of
speech, the tongue of the hand. Speech empowers the minds of those
who are present; [112] writing informs far and near alike. If there
were no writing, speech would have no life, and the mind would
receive no gift from those who have passed away. Those who see
only the external form may think it a sooty design, but those who
go for inner meaning know that it is a lamp of cognition. It is a dark-
ness with thousands of lights. No, no, it is a light with a mole no
eye has seen, a designer of awareness, the realm of the city of inner
meaning, a dark night that gives birth to the sun, a black cloud that
rains knowledge. It is an amazing talisman over the treasure-trove
of insight, silent but eloquent. Despite its immobility it moves, and
despite its fallen state it flies high.

From a field of divine knowledge a ray falls on the rational soul.
The mind sends it to the realm of mental images (khayāl), which is
an isthmus between the abstract and the material, so that an abstrac-
tion and an absoluteness with worldly connections and bonds come
to be. From there it steps onto the roof of the tongue and, with the
assistance of the air, enters the orifice of the ear. Then, by degrees,
it removes the load of worldly connection from its back and hastens
to its proper place. Sometimes that heavenly traveller is aided by the
fingers, and, having traversed the land and sea of pen and ink, puts
down its baggage in the pleasure park of pages and moves through
the highway of the eye.

Since writing conveys sound it is necessary for me to say something
about it to light the lamp of awareness. A sound (harf)[4] is a special
quality dependent upon the quality of the air. When two hard things
collide violently it is called a crash (qar'); if they are separated by
force it is called a rip (qal'). Necessarily the ambient air rushes in like
a wave in the sea, and from that there comes about a quality called
sound (āwāz). Some speak of the ultimate cause and say that sound
is a churning of the air in waves. Others look to the proximate cause
and say that sound is a violent crash or rip. Sound (ṣawt)[5] has other
qualities too, like treble, bass, nasal or guttural, which is produced in
the depth of the throat. From [different] points of articulation and the
segmentation of parts of air sound acquires other qualities as when

two treble sounds, two bass sounds, two nasal sounds or two guttural sounds come apart. This is called a phonological unit (*harf*), and this is the view of Avicenna.[6] Some investigators reckon a phonological unit to be what is affected by accidental qualities. One group of farsighted scientists call a phonological unit the amalgamation of the accidental qualities with that which is affected by them, and this view is the nearest to the truth.

In Hindi there are fifty-two letters, in Greek there are ___, and in Persian there are eighteen.[7] In Arabic there are twenty-eight letters with eighteen different forms; in the combinational forms there are only fifteen if the *hamza* is not considered separately from the *alif*.[8] The reason the *lām-alif* is listed separately at the end of the alphabet is that a letter without a vowel must necessarily be joined to another letter. The *lām* was singled out because it is the middle letter of the word *alif* and the *alif* is the middle letter of the word *lām*.[9]

In olden times the vowel points did not exist, but sometimes they were indicated by dots [113] in a colour other than that of the text: the *zabar* vowel (*a*) was indicated by a red dot above the letter, for the *pēsh* (*u*) the dot was placed in front, and the *zēr* (*i*) was put underneath.[10] Khalīl b. Aḥmad the prosodist gave each vowel a distinct form as is in use today.[11] Everyone knows that beauty is in the eye of the beholder, and every group has chosen a different way to write, like Hindi, Syriac, Greek, Hebrew, Coptic, Ma'qilī, Kufic, Kashmiri, Abyssinian, Raiḥānī, Arabic, Persian, Anatolian, Himyaritic, Berber, Andalusian and Rūḥānī[12] – aside from all the ancient ones mentioned in books. In some old tomes the Hebrew alphabet is attributed to Adam 7,000 years ago, but others attribute it to Enoch, who, some say, invented the Ma'qilī script, while others report that the Commander of the Faithful 'Alī derived Kufic from Ma'qilī. Differences in script have to do with roundness and linearity.[13] The Kufic script is one sixth round and the rest is linear. The Ma'qilī is totally linear, and inscriptions on ancient buildings are in this script.[14] It is best for black and white to be well separated so that no mistake occur in reading.

Today in Iran, Turan, Anatolia and India there are eight forms of writing current. Every group prefers one or another of them. Six of them were derived by Ibn Muqla in the lunar year 310 [AD 922] from the Ma'qilī and Kufic scripts.[15] They are *thuluth*, *tauqī'*, *muhaqqaq*, *naskh*, *raiḥān* and *riqā'*.[16] Some add *ghubār* and reckon seven forms by him.[17] Some attribute *naskh* to Yāqūt Musta'simī.[18] *Thuluth* and *naskh* are one-third round and two-thirds linear.[19] The former (*thuluth*) is also called majuscule, and the latter is also called minuscule. *Tauqī'* and *riqā'* are two-thirds round, and the rest is linear. Those two are also a majuscule–minuscule pair. *Muhaqqaq* and *raiḥān* are three-quarters linear, and they too are a majuscule–minuscule pair. 'Alī b. Hilāl, who is also known as Ibn Bawwāb,[20] wrote all six well, and Yāqūt brought them to perfection. His six

pupils acquired great fame: Shaikh Aḥmad, known universally as Shaikhzāda Suhrawardī,[21] Arghūn Kāmilī,[22] Maulānā Yūsufshāh Mashhadī,[23] Maulānā Mubārakshāh Zarrīn-Qalam,[24] Ḥaidar Gundanawīs[25] and Pīr Yaḥyā Ṣūfī.[26] The following also wrote the Six Scripts marvellously well: Naṣrullāh, who is also called Ṣadr 'Irāqī,[27] Arqūn 'Abdullāh,[28] Khwāja 'Abdullāh Ṣairafī,[29] Ḥājjī Muḥammad, Maulānā 'Abdullāh Āshpaz,[30] Maulānā Muḥyī Shīrāzī,[31] Mu'īnuddīn Tannūrī (?),[32] Shamsuddīn Qaṭṭābī,[33] 'Abdul-Raḥīm Khalwatī,[34] 'Abdul-Ḥayy,[35] Maulānā Ja'far Tabrīzī,[36] Maulānā Shāh Mashhadī,[37] Maulānā Ma'rūf Baghdādī,[38] Maulānā Shamsuddīn Bāysunghurī,[39] Mu'īnuddīn Farāhī, 'Abdul-Ḥaqq Sabzawārī,[40] Maulānā Ni'matullāh Bawwāb,[41] Khwājagī Mu'min [b.] Murwārīd,[42] who invented gold-flecking and colouring in paper, [**114**] Sulṭān Ibrāhīm son of Mīrzā Shāhrukh,[43] Maulānā Muḥammad Ḥakīm Ḥāfiẓ,[44] Maulānā Maḥmūd Siyāvush,[45] Maulānā Jamāluddīn Ḥusain, Maulānā Pīr-Muḥammad[46] and Mīr Faẓlul-Ḥaqq Qazwīnī.

The seventh style is *ta'līq*.[47] It was derived from *riqā'* and *tauqī'*. It has little linearity. Khwāja Tāj Salmānī, who was quite strong in the Six Scripts, made it acceptable. Some believe he invented it. A latter-day practitioner, Maulānā 'Abdul-Ḥayy, Sultan Abu-Sa'id Mīrzā's secretary, wrote it very well.[48] Maulānā Darwēsh,[49] Amīr Manṣūr,[50] Maulānā Ibrāhīm Astarābādī,[51] Khwāja Ikhtiyār Munshī,[52] Jamāluddīn Muḥammad Qazwīnī, Maulānā Idrīs,[53] and Khwāja Muḥammad Ḥusain Munshī[54] were also renowned. His Majesty's secretary, Ashraf Khān, has brought it to perfection.[55]

The eighth script is *nasta'līq*, which is totally round. It [is said to have been] developed in the time of Tamerlane by Khwāja Mīr 'Alī of Tabriz from *naskh* and *ta'līq*, but this is not believable since books written in *nasta'līq* have been seen from before Tamerlane's time.[56] Two of his pupils, Maulānā Ja'far Tabrīzī and Maulānā Aẓhar,[57] improved it. Among the calligraphers of this script are Maulānā Muḥammad Āwbihī,[58] who was without equal in the secretarial art, and Maulānā Yārī Harawī.[59] The most famous of all is Maulānā Sulṭān-'Alī Mashhadī.[60] Although he did not learn [directly] from Maulānā Aẓhar, he benefitted greatly from specimens of his writing. Six of his students gained renown: Sulṭān-Muḥammad Khandān,[61] Sulṭān-Muḥammad Nūr,[62] Maulānā 'Ala'uddīn Harawī,[63] Maulānā Zainuddīn,[64] Maulānā 'Abdi Nīshāpūrī[65] and Muḥammad Qāsim Shādīshāh.[66] Each of them wrote in a different style that is pre-ferred by some. Maulānā Sulṭān-'Alī Qāyinī,[67] Maulānā Sulṭān-'Alī Mashhadī, and Maulānā Hijrānī were also competent in this style. Then comes the foremost of all calligraphers, Maulānā Mīr 'Alī Harawī.[68] Although he took lessons with Maulānā Zainuddīn, he became a master through the specimens of Sulṭān-'Alī. With his brilliant understanding he introduced alterations in the style and left behind stunning changes. Someone once asked him what the difference was between him and Maulānā Sulṭān-'Alī. He replied,

'I too have brought it to perfection, but his calligraphy has more charm.' The following spent their lives practising this art: Shāh-Maḥmūd Nīshāpūrī,[69] Maḥmūd Isḥāq,[70] Shamsuddīn Kirmānī,[71] Maulānā Jamshēd Muʻammāʼī,[72] Sulṭān-Ḥusain Khujand, Maulānā ʻAishī,[73] Ghiyāsuddīn Muzahhib,[74] Maulānā ʻAbdul-Ṣamad,[75] Maulānā Mālik,[76] Maulānā ʻAbdul-Karīm,[77] Maulānā ʻAbdul-Raḥīm Khwārazmī,[78] Maulānā Shaikh-Muḥammad,[79] Maulānā Shāh-Maḥmūd Zarrīn-Qalam,[80] Maulānā Muḥammad Ḥusain Tabrīzī,[81] Maulānā Ḥasan ʻAlī Mashhadī,[82] Mīr Muʻizz Kāshī,[83] Mīrzā Ibrāhīm Iṣfahānī,[84] and others.

Through His Majesty's connoisseurship and appreciation many calligraphic styles have attained a high rank, and rare practitioners flourish. [115] In particular, nastaʻlīq enjoys great favour. One person with a magical pen who has become a master of this beautiful script in the shadow of the throne of the caliphate can be mentioned, and he is Muḥammad Ḥusain Kashmīrī, who has received the title of Zarrīn-Qalam.[85] He was a pupil of Maulānā ʻAbdul-ʻAzīz, but he has surpassed his master. His extensions and rounds are in proportion to each other. Cognoscenti put him on a level with Mulla Mīr ʻAlī.

The Emperor, in his enlightened awareness, has divided the library into several sections. Some books are inside the imperial harem, and some are outside. Each division has several departments. Every branch of learning and book has constantly been elevated according to its value. Books are arranged by prose and poetry and by language, Hindi, Persian, Greek, Kashmiri, or Arabic, and in that order they are brought before the imperial gaze. Day by day competent experts bring them to the Emperor's attention, and every book is heard from beginning to end. At whatever point is reached every day a mark is made by the Emperor's pearl-scattering pen, and the reader is paid in cash according to the number of folios read. Few are the famous books that are not mentioned in imperial gatherings. What ancient tales, rarities of learning, or uncommon anecdotes are not in the memory of that leader of the learned? He never tires of repetition and begs to hear more. The books that are constantly read aloud in the Emperor's presence are The Nasirian Ethics, The Alchemy of Happiness, Qābūsnāma, The Letters of Sharaf Manerī, The Rosegarden, The Garden, The Spiritual Mathnavi, Jam's Goblet, The Orchard, The Book of Kings, Shaikh Niẓāmī's Quintet, the collected works of Khusrau and Maulānā Jāmī, the dīvān of Khāqānī and Anvarī, and histories.[86] Indian, Greek, Arabic, and Persian books are always being translated into other languages by linguists. For instance, the Mīrzā's new Zīj was translated from Persian into Hindi under the supervision of Amīr Fatḥullāh Shīrāzī by the writer of [this] felicitous book, Kishan Joshī, Gangādhar, and Mohēs Mahānand.[87] The Mahābhārata, one of the ancient books of India, was translated from Indian into Persian by Naqīb Khān, Maulānā ʻAbdul-Qādir Badaʼunī and Shaikh Sulṭān Thanēsarī. It consists of nearly a lac of

verses. His Majesty named that ancient tale the *Razmnāma*.[88] That same group of people translated into Persian the *Rāmāyana*, which is one of the ancient compositions of India and tells the history of Rām Chandra in detail along with rare pieces of wisdom. The book *Atharban*,[89] which is, according to that group [Hindus], one of the four divine books, was translated into Persian by Ḥājjī Ibrāhīm Sirhindī. [116] *Līlāvatī*, a choice work on mathematics by one of the wise men of India, was deprived of its Indian veil and had a Persian robe thrown over its shoulders by my elder brother, Abū'l-Faiż Faiżī.[90] The book *Tājik*,[91] a standard work on astrology, was turned into Persian by imperial command by Mukammal Khān Gujarātī. The record of events of His Majesty Gītī-Sitānī [Babur], which is a manual for awareness, was translated from Turkish into Persian by Mīrzā Khān Khānkhānān.[92] *The History of Kashmir*, an account of four thousand years of that country, was translated into Persian from the language of Kashmir by Maulānā Shāh-Muḥammad Shāhābādī.[93] *Muʿjam al-buldān*, an amazing book on countries and cities, was translated from Arabic into Persian by a group of linguists like Mulla Ahmad of Tatta, Qāsim Beg, Shaikh Munawwar, and others.[94] *Haribans*, which contains the biography of Krishna, was turned into Persian by Maulānā Shērī.[95] The book *Kalīla and Dimna*, which is a rare masterpiece of practical wisdom, although it had already been translated into Persian by Naṣrullāh Mustaufī and Maulānā Ḥusain Wāʿiz, since it contained strange metaphors and difficult words, was given a fresh Persian garb by the present writer and became known as *The Touchstone of Wisdom*.[96] The story of Nal and Daman's love, which was a tale in Hindi that melted the hearts of those suffering yearning, was versified in the metre of *Lailī and Majnūn* by Shaikh Faiżī Fayyāżī and became known throughout the world as *Nal-Daman*.[97] When the imperial mind gained awareness of the treasure-trove of history, he ordered accounts of the last thousand years in the seven climes of the world to be assembled in one place by experts in history. First Naqīb Khān and some others began the project. Maulānā Aḥmad Tattavi wrote much, Jaʿfar Beg Āṣaf Khān brought it to completion, and the writer of this work wrote a preface for it. It was entitled the *Millenial History*.[98]

The drawing of likenesses is commonly called depiction. Inasmuch as seriousness and lightheartedness are both excellent bases, the Emperor of the world has, from the very beginning of his enlightenment, fostered this art and encouraged it to flourish and spread. Therefore, this amazing magical art has prospered, and many have gained renown. Every week the overseers and secretaries bring works by all sorts of people to the Emperor's attention, and they are rewarded according to their excellence and monthly stipends are increased. A profound investigation was made into materials, and values were established based on availability. Colours acquired a new beauty, and the pleasure given by pictures was given a

new lease on life. Artists used their charming brushes to produce
likenesses in such a manner that the unequalled productions of a
Bihzād and the magical works by artists of Europe, which are known
throughout the world, were collected into a beautiful gallery, where
subtlety of execution, charm of design, mastery of touch, and other
qualities are combined [117] and inanimate phantoms acquire a
veneer of animation. More than a hundred persons have attained
the rank of master and acquired renown, and many are those who
have approached that station and who are halfway there. What can
I say of Indians? Few, if any, in all the climes of the world can be
shown to have depicted inner meaning on the pages of imagination
like them.

Among the leaders on this highway of enlightenment is Mīr Sayyid
'Alī of Tabriz.[99] He learned a bit from his own father, and when he
attained the felicity of kissing the imperial threshold he basked in
rays of favour and became renowned in his craft and attained success.

Khwāja 'Abdul-Ṣamad Shīrīn-Qalam is from Shiraz.[100] Although
he knew his craft before he joined the imperial retinue, by virtue
of the alchemy of imperial favour he attained high rank, and the
external form of his painting shows inner meaning. Masters became
pupils to learn from him.

Daswanth, a child of the Kahār caste, grew up in this workshop,
eagerly drawing pictures on the walls and making designs. One day
the far-sighted imperial gaze fell upon these, and in his perception
he comprehended the promise of a master and entrusted him to
Khwāja ['Abdul-Ṣamad]. In a short time he became the unique one
of the age, but dark melancholy clouded the brilliance of his mind
and he ended his life by his own hand. Many amazing works were
left by him.[101]

In design, portraiture, mixing colours, painting likenesses and
other branches of this art, Basāwan became the foremost exponent
of his time, and many knowledgeable connoisseurs prefer his works
to Daswanth's.[102] Kesav, La'l, Mukund, Miskīn, Farrukh Qalmaq,
Madhū, Jagan, Mahēs, Khēmkaran, Tārā, Sānwala, Harbans and Rām
are at the top of the list of those of name.[103] If we were to deal with
the works of each of them, it would take too long. I will select a
flower from every meadow, a sheaf from every haystack.

Amazingly, from the fullness of thought, seeing pictures and
making likenesses, which are the foundations of the happy dream of
negligence, became panaceas of enlightenment and a cure-all for the
remediless pain of ignorance. The eyes of unthinking conservatives
who hate depiction have been opened to see reality. One day in a
private assembly attended by the lucky few the following words
chanced to cross the Emperor's tongue:

Some decry this craft, but their hearts are unenlightened. It occurs
to [our] mind that a painter has more than a little awareness of

the divine because, when he depicts an animal, drawing it limb by limb, and cannot give it a spiritual connection, he draws closer to an awareness of the magic of the soul-creator.

Truly, the higher this craft rose in rank, the more amazing were its productions. Persian books in prose and poetry were produced, and captivating illustrations were painted. The tale of Ḥamza was produced in twelve volumes and illustrated by master painters with 1,400 scenes that astonished [118] all who saw them.[104] The *Chingīznāma*,[105] the *Ẓafarnāma*,[106] this felicitous work,[107] the *Razmnāma*,[108] the *Rāmāyana*,[109] *Nal-Daman*,[110] *Kalīla-Dimna*,[111] *'Iyār-i dānish*,[112] and other works were illustrated, and the places for illustration were indicated by the Emperor himself.

By imperial command portraits of all the officers of state were made, and a huge volume was produced. It gave new life to those who had passed away and eternal life to the living. Just as portraitists (*muṣawwirān*) received high rank, painters (*naqqāshān*), gilders (*muzahhibān*), margin illustrators (*jadwal-ārāyān*) and binders (*ṣaḥḥāfān*) also flourished.

Through service to this department many office-holders, *aḥadīs*, and other mounted personnel have received distinction, and the monthly stipend of an unmounted member is no more than 1,200 *dām*s and no less than 600 *dām*s.[113]

Notes

1. Abū'l-Fażl, *Ā'īn-i Akbarī*, vol. 2, p. 111.
2. A typical Abū'l-Fażlian statement in which much has been packed into a few words, not a few of his own coining. He seems to be saying that European painters load (*barguzārand*) their fabulous productions with so many physical verisimilitudes (*ma'ānī-i khalqī*) that viewers are led to the inner truth in the same way that the graphic form of a word leads a reader to what the word stands for.
3. The 'world-revealing goblet' (*jām-i gītī-numāy*) is Jamshed's goblet, which had the magical ability to reveal everything in the world.
4. In addition to the common meaning of 'letter', *ḥarf* has the technical meaning of a phonological unit, that is, any meaningful utterance as opposed to a random sound.
5. *Ṣawt* is the most general word for 'sound' of any sort.
6. See Avicenna's *Makhārij al-ḥurūf, yā asbāb ḥudūth al-ḥurūf*, ed. Parvīz N. Khānlarī (Tehran, 1391).
7. Hindi has thirty-three consonantal phonemes with a Devanagari letter to represent each of them: p, ph, b, bh, t, th, d, dh, ṭ, ṭh, ḍ, ḍh, k, kh, g, gh, ch, chh, j, jh, s, ś, ṣ, r, –ṛ, –ṛh, l, m, n, ṇ, w/v, y, ', and ten vowels: a, ā, i, ī, e, o, u, ū, ai, au, but since an initial a is written with the akāra, which has already been counted as the glottal stop, and non-initial a is not written, this gives a total of forty-two phonemes/sounds/letters. Since all the vowels also occur as nasalized, if we count the ten vowels again as nasals, we would arrive at Abu'l-Fazl's fifty-two, but there is no assurance that this is what he meant since he has omitted a

number of letters and signs and has not counted any of the numerous combinational forms. The number of letters in the Greek alphabet (twenty-five) has been omitted in the text. Since the Persian Abu'l-Fazl spoke and wrote used the Arabic alphabet, which is treated next, here he must mean the Pahlavi alphabet of Middle Persian, one version of which, Psalter Pahlavi, does have eighteen letters: ', b, g, d, h, w/'/r, z, ḥ, y, k, l, m/q, n, s, p, ṣ, ś/š, t. Normal Book Pahlavi has only fourteen distinct letter forms: '/ḥ, b, g/d, h, w/n/'/r, z, k, l, m/q, s, p, ṣ, ś/š, t. It is unlikely in the extreme that Abu'l-Fazl had any familiarity with Middle Persian, information about which he would have gotten from Zoroastrians at court.

8. This is correct. There are twenty-eight letters in the Arabic alphabet (ا ب ت ث ج ح خ د ذ ر ز س ش ص ض ط ظ ع غ ف ق ك ل م ن ه و ی) but only eighteen distinct shapes (discounting the distinguishing dots): ا ب ح د ر س ص ط ع ف ق ك ل م ن ه و ی. Of 'combinational,' that is, either initial or medial, forms there are only fifteen distinct shapes ا ـبـ ـحـ د ر ـسـ ـصـ ـطـ ـعـ ف ـكـ ل ـمـ ـهـ و since ن and ی have the same tooth as the ب, and ف and ق share the same initial/medial shape.

9. *Alif* is the only letter that has no function other than to lengthen the vowel *a* (discounting أ *alif-hamza* and آ *alif-madda*, which are not under consideration here), and therefore, Abū'l-Faẓl reasons, the lengthening *alif* has to be joined to another letter. Traditionally *lām-alif* (لا), the only two-letter combination to have a form considered a separate grapheme, is added at the end of the alphabet. Abū'l-Faẓl's reasoning for why the *lām* was chosen is fanciful.

10. This explains the old designations of the vowel points: *zabar* ('over') is the *a* vowel; *pēsh* ('in front') is the *u* vowel; and *zēr* ('under') is the *i* vowel. An example of such dots can be seen in Sheila Blair, *Islamic Calligraphy* (Edinburgh, 2006), p. 112, fig. 44.4. In the second line the red dot for *a* can be seen over the *n* of *inna* and the *h* of *allāha*; the *u* dot can be seen after (which apparently is what is meant by 'in front of') the final *t* of *tamūtu* at the end of the first line and doubled for *un* after the *m* of *'alīmun* and the *r* of *khabīrun* in the second line; and the red dot for *i* can be seen in the third line under the *m* of *bismi*, the *h* of *allāhi*, and the *n* of *al-raḥmāni*.

11. Al-Khalīl b. Aḥmad of Basra (718–86 or 791), renowned for his systematisation of Arabic prosody and his work in lexicography, is credited with the invention of the vowel marks for Arabic that are used now.

12. This is a curious list. Although most are actual languages and writing systems or alphabets, some (Ma'qilī, Kufic, Raihānī) are forms of the Arabic script. There is no telling what he means by 'Anatolian' (*Rūmī*) since he has already mentioned Greek. Himyaritic refers to Old South Arabian lapidary script, which was written in a syllabary that is the immediate ancestor of Ethiopic (Abyssinian) letters (አ *'a*, በ *ba*, ገ *ga*, ደ *da*, and so on). By 'Andalusian' he must mean some variant of North African *maghribī* script (Blair, *Islamic Calligraphy*, p. 221). *Rūḥānī* means 'spiritual', and no known writing system has this name.

13. The terms used by Abū'l-Faẓl are *daur* (roundness, that is, curvilinear) and *saṭh* (linearity, that is, having straight lines).

14. The highly geometric Ma'qilī script, which has no curves at all, was often executed in brickwork.

15. Ibn Muqla (886–940) is universally credited with the proportional

system of Arabic calligraphy. There are no authentic examples of his work extant.

16. These are the classic 'Six Pens' (al-aqlām al-sitta) of Arabic-script calligraphy. They form majuscule-minuscule pairs, thuluth–naskh, tauqī'–raihān and muhaqqaq–riqā'. See Blair, Islamic Calligraphy, pp. 241–70.

17. Ghubār ('dust') script is a very small variant of riqā' that was used for messages carried by pigeons. See Blair, Islamic Calligraphy, p. 259 f.

18. Yāqūt (d. 1298), famed calligrapher of al-Musta'sim, the last 'Abbasid caliph in Baghdad. There are specimens purporting to be by him in Istanbul albums with dates ranging from 681/1282 (TSM, B.411, fol. 64b) to 695/1295 (TSM, H.2160, fol. 82a).

19. This reflects an old hypothesis for the derivation of the word thuluth ('third'). See Blair, Islamic Calligraphy, p. 167.

20. For a Qur'an written by 'Alī b. Hilāl in 391/1000, see David S. Rice, The Unique Ibn al-Bawwab Manuscript in the Chester Beatty Library (Dublin, 1955).

21. The earliest surviving specimen of the work of Ahmad b. al-Suhrawardī of Baghdad, known as Shaikhzāda, dated 702/1303, is in Istanbul (Topkapı Sarayı Müzesi, hereafter abbreviated as TSM, H.2310, fol. 55b), and the latest, dated 782/1327, is a page from a Nahj al-balāgha in the Taqvā Collection in Tehran (Bayānī, AAK, 1025).

22. Arghūn Kāmilī's surviving specimens range from an album page dated 700/1300 in Istanbul (TSM, H.2156, fol. 92a) to one dated 753/1352 (TSM, H.2310, fol. 33b).

23. No examples of Mawlānā Yūsuf (or Yūsufshāh) Mashhadī's work has been found despite the fame he had as a student of Yāqūt. He is mentioned by Mustafā 'Ālī (Manāqib-i hunarvarān (Istanbul, 1926), p. 23) and by Qāżī Ahmad (Gulistān-i hunar: Tazkira-i khwashnivīsān u naqqāshān (Tehran, 1352), p. 22), and he is listed as one of the 'Seven Masters' in the album made for Baysunghur Mirza now in Istanbul (TSM, H.2310).

24. Mubārakshāh b. Qutb 'Zarrīn-Qalam' is said to have executed the epigraphic calligraphy in the shrine of 'Alī ibn Abī-Tālib in Najaf commissioned by Sultān-Uwais Jalāyir (r. 1356–74). A single undated specimen by him has been found in Istanbul (TSM, H.2310, fol. 25b); another by Mubārakshāh b. 'Abdullāh, who may or may not be the same person, on fol. 61a of the same album is dated 732/1331–2. See Mahdī Bayānī, Ahvāl u āsār-i khwashnivīsān (Tehran, 1363), p. 1134.

25. Sayyid Haidar, known as Gundanivīs ('majuscule writer'), was the teacher of Khwāja 'Abdullāh Sairafī, who is named below. No works attributable to him have been located.

26. The extant works of Yahyā b. Jamāl al-Sūfī, a pupil of Mubārakhshāh Zarrīn-Qalam, range from 731/1330-1 (Bayānī, AAK, p. 1233) to 746 (İstanbul Üniversitesi Kütüphanesi, F.1422, fol. 531). Yāqūt's six pupils are normally given as (1) Shaikhzāda Suhrawardī, (2) Arghūn Kāmilī, (3) Yūsuf Mashhadī, (4) Mubārakshāh Zarrīn-Qalam, (5) Sayyid Haidar Gundanawīs and (6) Nasrullāh Tabīb (instead of Pīr Yahyā). See Wheeler Thackston, Album Prefaces and Other Documents on the History of Calligraphers and Painters (Leiden, 2001), pp. 8, 24.

27. Sadr 'Irāqī, Nasrullāh Tabīb, is normally given as the sixth student of Yāqūt. His and Pīr Yahyā Sūfī's names may have been switched in

the text. There are specimens by Naṣrullāh al-Ṭabīb in Istanbul (TSM, H.2161, fol. 24a, dated 729/1328 and B.411, fol. 106b, dated 735/1334).

28. There is a single example of the calligraphy of Arghūn b. 'Abdullāh in an album in Istanbul (TSM, H.2156, fol. 92a) dated 700/1300.

29. 'Abdullāh b. Maḥmūd al-Ṣairafī was an active epigraphic and architectural calligrapher during the reign of Öljeitü (1304–17), and many buildings in and around Tabriz bear his signature. Extant examples of his work range from an album page dated 710/1310 in Istanbul (TSM, B.411, fol. 70b) to a Qur'an dated 744/1343 in Istanbul, Türk ve İslam Eserleri Müzesi.

30. Extant examples of the calligraphy of Shihābuddīn 'Abdullāh Harawī, known as both Āshpaz and Ṭabbākh ('cook'), range from 833/1429 (Tehran, Sulṭān al-Qurrā'ī Collection, album page) to 867/1462 (Istanbul, TSM, H.2161, fol. 27b). He also produced the inscriptions at Gāzargāh in Herat and in the Āghācha Mosque in Mashhad.

31. There are specimens by a Muḥyī dated 856/1452 (Istanbul, TSM, H.2153, fol. 107b) and 890/1485 (Istanbul, TSM, H.2139, fol. 50b) that may be by him. Otherwise this Muḥyī Shīrāzī is unknown.

32. There is a Mu'īnuddīn mentioned by Qāżī Aḥmad (Gulistān-i hunar, p. 25) who executed the inscriptions on the four minarets in Tabriz. Nothing more is known of him.

33. Shamsuddīn Khaṭā'ī in the text, a mistake for Shamsuddīn Qaṭṭābī, also known as Shams Ṣūfī, was the teacher of Ja'far Bāysunghurī. He is mentioned in the prefaces to the Bahrām Mīrzā Album and the Amīr Ghaib Beg Album (Thackston, Album Prefaces, pp. 8, 24). Qāżī Aḥmad calls him Maulānā Shamsuddīn Mashriqī Qaṭṭābī and says he was a student of Mu'īnuddīn (Gulistān-i hunar, p. 25).

34. 'Abdul-Raḥīm Khalwatī, the teacher of Ni'matullāh Bawwāb, is mentioned in the Amīr Ghayb Beg Album (Thackston, Album Prefaces, p. 25). There are two specimens in the album by 'Abdul-Raḥīm, both undated. The first is by 'Abdul-Raḥīm al-Ya'qūbī (Istanbul, TSM, H.2161, fol. 161a), and the other is signed simply 'Abdul-Raḥīm (fol. 166a).

35. 'Abdul-Ḥayy Sabzawārī, a student of 'Abdullāh Ṭabbākh who executed the inscription on the dome of the Imam Riza shrine in Mashhad (Qāżī Aḥmad, Gulistān-i hunar, p. 32).

36. Farīduddīn Ja'far b. 'Alī Tabrīzī is known as Ja'far Bāysunghurī, the 'Second Master of Nasta'līq'. He worked at the court of Shāhrukh and was the supervisor of Prince Bāysunghur Mīrzā's library. His dated works range from a Kulliyyāt of Humāmuddīn Tabrīzī dated 816/1413 (Paris, Bibliothèque Nationale, Blochet 1508) to a Kalīla wa-Dimna (Istanbul, TSM, H.372) dated 835/1431.

37. Shāh-Muḥammad Mashhadī (fl. 1528–68), a student of Mālik Dailamī, left works ranging in date from 935/1528 (Ardabil, Shaikh Ṣafīuddīn Shrine, 4331, Shāhnāma of Firdausī) to 976/1568 (Tehran, Golestan Palace Library, 573/11083, Ṣad kalima of 'Alī ibn Abī-Ṭālib). There is also a calligraphic specimen by him dated 968/1560 in Istanbul (TSM, R.2056, fol. 4b).

38. Ma'rūf Baghdādī worked for Iskandar Sultan in Shiraz and was then taken to Herat by Shāhrukh (Khwāndamīr, Ḥabību'l-siyar fī akhbār-i afrād-i bashar (Tehran, 1333), vol. 3, p. 616). There is a rare, undated specimen of his calligraphy in Tehran (Badrī Ātābāy, Fihrist-i dīvānhā-yi khaṭṭī-i kitābkhāna-i salṭanatī (Tehran, 2435), p. 440).

39. Shamsuddīn Muḥammad b. Ḥusām, known as Shams Bāysunghurī (*fl.* 1418–30), a student of the aforementioned Maʿrūf Baghdādī, is known from the Bahrām Mīrzā Album (Thackston, *Album Prefaces*, p. 9). He calligraphed a copy of *Humāy u Humāyūn* in Vienna (Nationalbibliothek, cod. NF 382), dated 831/1427 and a *Kalīla wa-Dimna* in Istanbul (TSM, R.1022) dated 833/1429. He also produced inscriptions in the Gauharshād Mosque in Mashhad dated 821/1418.

40. ʿAbdul-Ḥaqq b. Muḥammad Sabzawārī's name is known only from a mention in Waṣfī's preface to the Shāh Ismāʿīl II Album (Thackston, *Album Prefaces*, p. 33) and from an *Arbaʿīn ḥadīth* in Paris (Bibliothèque Nationale, Blochet 1741) dated 905/1499 at Herat.

41. Niʿmatullāh b. Muḥammad al-Bawwāb is known only as the pupil of ʿAbdul-Raḥīm Khalwatī from Mīr Sayyid Aḥmad Mashhadī's preface to the Amīr Ghaib Beg Album (Thackston, *Album Prefaces*, p. 25). According to Bayānī (*AAK*, p. 1223) he produced an inscription in the Blue Mosque in Tabriz dated 4 Rabiʿ I 870 (25 October 1465). See also Qāżī Aḥmad, *Gulistān-i hunar*, p. 28.

42. This 'Khwājagī Muʾmin [b.] Murwārīd' is Khwāja Nūruddīn Muḥammad Muʾmin, the son of Khwāja Shihābuddīn ʿAbdullāh Bayānī Murwārīd. He was supervisor and director of the Safavid royal library according to Dōst-Muḥammad's preface to the Bahrām Mīrzā Album (Thackston, *Album Prefaces*, p. 9). Extant examples of his calligraphy range in date from 924/1518 (İstanbul Üniversitesi Kütüphanesi, F.1422, fol. 56a) to 947/1540–41 (Istanbul, TSM, H.2151, fol. 8a).

43. Shāhrukh's son Sultān Ibrāhīm Mīrzā, who was governor of Fars 1415–35, was trained in calligraphy by Pīr-Muḥammad Shīrāzī. The Āstān-i Quds-i Riżavī in Mashhad has a section of the Qurʾan written by him and dated 827/1424 (no. 414), and there is a page of calligraphy by him dated 822/1419 in Istanbul (İstanbul Üniversitesi Kütüphanesi, F.1423, fol. 12b) and another dated 823/1420 (TSM, H.2152, fol. 6a). There is also a Qurʾan fragment dated 830/1427 in the Metropolitan Museum (13.228.2).

44. There are two examples of the work of Muḥammad Ḥakīm al-Ḥāfiẓ in Istanbul, one dated 857/1453 (TSM, H.2160, fol. 24a) and another dated 860/1455 (İstanbul Üniversitesi Kütüphanesi, F.1422, fol. 60a).

45. Maḥmūd Siyāwush is mentioned briefly by Qāżī Aḥmad (*Gulistān-i hunar*, p. 28) as having executed inscriptions for the mosques and madrasas of Shiraz and was alive in 920/1514.

46. There are several Pīr-Muḥammads, including one who was Sultān-Ibrāhīm's teacher and another who was a student of Mīr ʿAlī, but none has been satisfactorily identified. See Bayānī, *AAK*, p. 107 f.

47. The *taʿlīq* script is the first of two 'hanging' (that is, written on a bias against the horizontal line) scripts. It was developed as a vehicle for chancery documents and was rarely used for any other purpose. Writers of album prefaces consider Khwāja Tājuddīn Salmānī the 'founder' and codifier of *taʿlīq* (Thackston, *Album Prefaces*, p. 9 and Qāżī Aḥmad, *Gulistān-i hunar*, p. 42).

48. ʿAbdul-Ḥayy Astarābādī Munshī is known as the 'perfecter' of *taʿlīq* primarily from Dōst-Muḥammad's preface to the Bahrām Mīrzā Album. He is also mentioned in the Amīr Ghaib Beg Album and the Shāh Ismāʿīl II Album (Thackston, *Album Prefaces*, pp. 9, 25, 33). There is a specimen in the Amīr Ghaib Bēg Album by an ʿAbdul-Ḥayy dated 870/1465 that may be by him (Istanbul, TSM, H.2161, fol. 183b).

49. Darwēsh 'Abdullāh Balkhī Munshī is mentioned in the preface to the Bahrām Mīrzā Album (Thackston, *Album Prefaces*, p. 9). There is a specimen of his work in Istanbul (TSM, H.2161, fol. 182) dated 917/1511. See also Qāżī Aḥmad, *Gulistān-i hunar*, p. 44.

50. Manṣūr Astarābādī (d. 1529) is mentioned by Qāżī Aḥmad, *Gulistān-i hunar*, p. 48 as a writer of *shikasta ta'līq*. See also Bayānī, *AAK*, p. 1280.

51. Ibrāhīm Astarābādī is mentioned as a writer of *ta'līq* by Qāżī Aḥmad, *Gulistān-i hunar*, p. 47.

52. There are specimens by Khwāja Ikhtiyār Munshī in Istanbul (TSM, H.2157, fol. 61b dated 951/1544; H.2138, fol. 53a dated 954/1547 at Herat; H.2157, fol. 62a dated 964/1556; and H.2161, fol. 185b dated 966/1558). He is mentioned in the preface to the Shah Isma'il II Album (Thackston, *Album Prefaces*, p. 34).

53. Mullā Idrīs is mentioned briefly by Muṣṭafā 'Ālī, *Manāqib-i hunar-varān*, p. 61. No examples of his work have been found.

54. This is likely Mīrzā Muḥammad Ḥusain, son of Shah Tahmasp's grand vizier Mīrzā Shukrullāh Iṣfahānī, who left Iran for India, where he worked as a *munshī* (Qāżī Aḥmad, *Gulistān-i hunar*, p. 54).

55. For Ashraf Khān, Muḥammad Aṣghar Mashhadī, known as Mīr Munshī (d. 1575), see Shāhnawāz Khān Aurangābādī and 'Abdul-Ḥayy, *Ma'āthiru'l-umarā*, ed. Maulavī 'Abdul-Raḥīm, 3 vols (Calcutta, 1888–92), vol. I, pp. 73–5.

56. The elegantly curvilinear *nasta'līq* script, the second of the 'hanging' scripts, rapidly became the script *par excellence* for Persian around 1400. As its name implies *(naskh-ta'līq > nasta'līq)*, it was created by combining features of *naskh* and *ta'līq*. Mīr 'Alī of Tabriz is usually credited with its invention, but, as Abū'l-Fażl notes, there are examples of proto-*nasta'līq* from well before his time. A manuscript of three *masnavī*s by Khwājū Kirmānī in the British Library (Add. 18,113, Charles Rieu *Catalogue of the Persian Manuscripts in the British Museum*, 3 vols (London, 1879–83), vol. 2, pp. 620–2), copied by Mīr 'Alī b. Ilyās al-Tabrīzī al-Bāwurchī in 798/1396, may be by this Mīr 'Alī. See Thackston, *Album Prefaces*, p. 9, n. 26 and Bayānī, *AAK*, pp. 441–6.

57. Ẓahīruddīn Aẕhar Tabrīzī (d. c. 1475), a student of Ja'far Tabrīzī who worked for Bāysunghur Mīrzā, Sulṭān-Ibrāhīm, and Pīr-Būdāq Qaraqoyunlu, was taken to Samarqand by Ulughbeg. His dated works range from 824/1421 (Manchester, Rylands Library, Pers. 6, *Khusrau u Shīrīn* of Niẕāmī) to 877/1472 (Lahore, Punjab University Library, Shīrānī Collection 4588/1538, *Khamsa* of Niẕāmī).

58. Muḥammad Āwbihī is known primarily for being the teacher of Yārī Harawī. There is one known undated specimen of his calligraphy in the Amīr Ghaib Bēg Album (Istanbul, TSM, H.2161, fol. 149b). See Bayānī, *AAK*, p. 652.

59. Yārī al-Kātib Harawī has extant works ranging in date from 954/1547 (Istanbul, Türk ve İslām Eserleri Müzesi, 1915, *Bōstān* of Sa'dī) to 962/1554 (Istanbul, TSM, R.1012, *Dīvān* of Hilālī).

60. One of the most celebrated calligraphers of *nasta'līq*, Sulṭān-'Alī Mashhadī left numerous works. Examples bearing his name range in date from 857/1453 (London, British Library Add. 7768, *Kulliyyāt* of Kātibī) to 930/1523 (Istanbul, TSM, H.2157, fol. 38b, calligraphic specimen), and while it is possible for a calligrapher to have worked for

seventy years, it is unlikely. Many of the later works bearing his name are probably 'licensed signatures' by his pupils.

61. Sultān-Muhammad Khandān (fl. 1504–28) left works ranging in date from 910/1504 (St Petersburg, National Library of Russia, Dorn 418, ghazaliyyāt of Shāhī) to 935/1528 (St Petersburg, Dīvān of 'Alī-Shēr Navā'ī).

62. Sultān-Muhammad Nūr (fl. 1501–50) was known especially for his khafī (minuscule) writing. He left works ranging in date from 912/1506 (Vienna, Nationalbibliothek, Mxt., Sultān-Murād Album) to 957/1550 (London, British Library, Or.4124, Sifātu'l-'āshiqīn by Hilālī).

63. Among 'Alā'uddīn Muhammad Harawī's works are a Dīvān of Kātibī dated 888/1483 (Berlin, Staatsbibliothek, Pertsch 864) and a copy of the dīwān of Husainī dated 919/1513 (Istanbul, Süleymaniye, Nuru Osmaniye 2633).

64. Zainuddīn Mahmūd al-Kātib (d. c. 1519) was the student and son-in-law of Sultān-'Alī Mashhadī and the teacher of Mīr 'Alī. His dated works range from 901/1495 (St Petersburg, National Library of Russia, Dorn 440, Gūy u chaugān of 'Ārifī) to 924/1518 (Dorn 386, Kulliyyāt of Amīr Khusrau).

65. Dated works by 'Abdī Nīshāpūrī, the teacher of Shāh-Mahmūd Nīshāpūrī, include a calligraphic specimen dated 928/1521 (Istanbul, TSM, H.2154, fol. 86b) and another in the same album dated 940/1533 (fol. 92a).

66. Muhammad Qāsim b. Shādīshāh (d. after 1552) was a student of Sultān-Muhammad Nūr and Sultān-Muhammad Khandān. His dated works range from 929/1522 (Istanbul, TSM, H.2159, fol. 19a) to 955/1548 (Tehran, Golestan Palace Library, 510, #380, Dīvān of Amīr Shāhī), and undated works abound. Sultān-'Alī Mashhadī's six students are mentioned by almost all writers on calligraphers. See Mālik Dailamī's preface to the Amīr Husain Beg Album (Thackston, Album Prefaces, p. 21).

67. Darwēsh Sultān-'Alī Qāyinī, a student of Azhar Tabrīzī, began his career as a scribe for Sultan Ya'qūb Aqqoyunlu (r. 1478–90) and was later employed in Herat at the court of Sultān-Husain Mīrzā (r. 1470–1506). His works range in date from 882/1477 (Istanbul, TSM, H.2153, fol. 51b) to 900/1494 (Istanbul, TSM, H.2160, fol. 40a). There is also an undated section of a Qur'an in Washington, DC (Arthur M. Sackler Gallery, S1986.27).

68. By far the most famous and most avidly collected of all nasta'līq calligraphers, Mīr 'Alī al-Husainī al-Harawī died in 1544. He worked in Herat and occasionally in Mashhad until the Uzbek invasion of 1529, when he was taken to Bukhara. His extant works range in date from 919/1513 (İstanbul Üniversitesi Kütüphanesi, Farsi 477, Bōstān of Sa'dī) to 950/1543 (Paris, Bibliothèque Nationale, Suppl. Pers. 1958, Gulistān of Sa'dī). Specimens of his calligraphy are exceptionally well represented in albums. The section of the Gulshan Album preserved in the Golestan Palace Library in Tehran (no. 1663) contains no fewer than seventy-three specimens of his work.

69. Shāh-Mahmūd Nīshāpūrī 'Zarrīn-Qalam' was called the foremost of Shah Tahmasp's artists (Dōst-Muhammad, preface to the Bahrām Mīrzā Album). His dated works range from 922/1516 (Istanbul, TSM, H.2156, fol. 63b) to 979/1571 (Istanbul, Türk ve İslam Eserleri Müzesi, H.750, Khamsa of Nizāmī). See Bayānī, AAK, pp. 295–307. He also

produced the *Subhat al-abrār* section of Jāmī's *Haft aurang* commis-
sioned by Sultān Ibrāhīm Mīrzā dated 963/1556 (Washington, Freer
Gallery, F1946.12).

70. Khwāja Maḥmūd b. Isḥāq al-Shihābī Siyāwushānī flourished from
1520 to 1565. Examples of his calligraphy include a specimen dated
944/1537 (Istanbul, TSM, H.2138, fol. 36a) and a copy of 'Ārifī's *Gūy
u chaugān* dated 946/1539 (St Petersburg, National Library of Russia,
Dorn 442).

71. Shamsuddīn Muḥammad Kirmānī is mentioned in Mālik Dailamī's
preface to the Amīr Ḥusain Beg Album (Thackston, *Album Prefaces*,
p. 21). He may be the Shaikh Shamsuddīn Muḥammad al-Sharīf
al-Kirmānī who copied a *Ḥadīqatu'l-ḥaqīqat* of Sanā'ī in 916/1510
(Istanbul, TSM, R.1040) and a *Farhangnāma* dated 921/1515 (Berlin,
Staatsbibliothek, Ms. orient. fol. 114, Pertsch no. 74).

72. Jamshēd Mu'ammā'ī was known in Herat as a composer of enigmas
but not as a calligrapher. See Bayānī, *AAK*, p. 128.

73. 'Aishī Harawī, a poet and calligrapher, was a student of Sultān-
Muḥammad Khandān according to Mālik Dailamī in the preface to the
Amīr Ḥusain Beg Album (Thackston, *Album Prefaces*, pp. 21, 34 and
Bayānī, *AAK*, p. 546). His works range from 956/1549 (Istanbul, TSM,
H.2161, fol. 115b) to 984/1576 at Qazwin (TSM, H.2156, fol. 52b).

74. Ghiyāṣuddīn Muḥammad Mashhadī Muẕahhib (d. 1535) has three
specimens of calligraphy in the Bahrām Mīrzā Album (Istanbul,
TSM, H.2154) and a copy of Sa'dī's *Gulistān* dated 939/1532 (Vienna,
Nationalbibliothek, AF317). He is also mentioned in Mālik Dailamī's
preface to the Amīr Ḥusain Beg Album (Thackston, *Album Prefaces*,
p. 21).

75. 'Abdul-Ṣamad is known only from an anecdote. Mīr 'Alī-Shēr Nawā'ī
gave him Jāmī's divan to copy, and when it was given to Jāmī to proof-
read, he said, 'The scribe has written it in such a way that it seems he
was determined not to write a hemistich without a mistake.' Bayānī,
AAK, p. 402.

76. Mālik Dailamī (1518–61) executed many inscriptions for Shah Tahmasp
in Qazwin and also wrote the preface to the Amīr Ḥusain Beg Album
(TSM, H.2151). His dated works range from 951/1544 (Istanbul, TSM,
H.2161, fol. 176a) to 969/1561 (a *ghazal* of Ḥāfiẓ in the Chihil Sutūn
ayvān in Qazwin). There is also a copy of the *Dīvān* of Amīr Khusrau
dated 967/1559 in Paris (Bibliothèque Nationale, Ancien Fonds 245)
and parts of a *Haft aurang* by Jāmī at the Freer Gallery (F1946.12) dated
963–4/1556–7.

77. 'Abdul-Karīm Khwārazmī worked at the Aqqoyunlu court. His works
include a *Hālnāma* by 'Ārifī dated 883/1478 (Tehran, Majlis), a copy
of Jāmī's *Dīvān* (New York, Metropolitan Museum, 13.228.4) and a
copy of 'Aṭṭār's *Wuṣlatnāma* dated 890/1484 (Istanbul, Süleymaniye,
O.1659).

78. 'Abdul-Raḥīm Khwārazmī 'Anīsī, the brother of 'Abdul-Karīm (above),
also worked at the Aqqoyunlu court. His dated works range from
864/1459 (Tehran, Bayānī Collection, *Dīvān* of Ḥāfiẓ) to 899/1493
(Tehran, Bayānī Collection, *Dīvān* of Anīsī).

79. There are several well-known Shaikh-Muḥammads, but given where
he comes in the list, this one should be Maulānā Niẓāmuddīn Shaikh-
Muḥammad Muṣawwir Sabzawārī, a calligrapher and painter at Shah
Tahmasp's court. Calligraphic works by him include a specimen dated

970/1562 at Mashhad (Istanbul, TSM, H.2137, fol. 18b) and another dated 976/1568 (Istanbul, TSM, H.2151, fol. 39a).

80. Shāh-Maḥmūd 'Zarrīn-Qalam' is the Shāh-Maḥmūd Nīshāpūrī who has already been mentioned (see n. 69 above).

81. Muḥammad Ḥusain Tabrīzī (d. 1577) was a Shah Tahmasp-period calligrapher (Bayānī, *AAK*, pp. 680–3). Iskandar Bēg says that if he had not died young he would have surpassed the great calligraphers of the day (Iskandar Bēg, *Tārīkh-i 'ālam-ārā-yi 'Abbāsī*, 2 vols (Tehran, 1350), vol. 1, p. 170 f.). Works by him include an undated copy of Khwāja 'Abdullāh Anṣārī's *Munājāt* in St Petersburg (National Library of Russia) and a copy of *Ḥadīqatu'l-ḥaqīqat* by Sanā'ī in Istanbul, İstanbul Üniversitesi Kütüphanesi.

82. Specimens of Ḥasan 'Alī Mashhadī's calligraphy include pages from Khwāja 'Abdullāh Anṣārī's *Munājāt* (Istanbul, TSM, R.1046, 19b–26a) and an undated *risāla* of Khwāja 'Abdullāh Anṣārī written at Karbala (Istanbul, TSM, H.281).

83. Mīr Mu'izzuddīn Muḥammad Kāshānī, known as Mīr Mu'izz Kāshī, was a Shah Tahmasp-period calligrapher who wrote only *qiṭ'as* and did not work as a scribe. He is mentioned by Iskandar Bēg, who says his work was not up to the standards of Khurasani calligraphers *(Tārīkh-i 'ālam-ārā-yi 'Abbāsī*, vol. 1, p. 171). See Bayānī, *AAK*, p. 822.

84. Mīrzā Ibrāhīm Iṣfahānī was the son of Shah Isma'il I's majordomo, Mīrzā Shāh-Ḥusain (Iskandar Bēg, *Tārīkh-i 'ālam-ārā-yi 'Abbāsī*, vol. 1, p. 172). No works by him have been located. See Bayānī, *AAK*, p. 15 f.

85. Muḥammad Ḥusain Kashmīrī, awarded the title of 'Zarrīn-Qalam' (He of the Golden Pen) by Akbar, lived well into Jahangir's reign (see *Jahāngīrnāma*, fol. 36b) and is thought to have died around 1610. The Gulshan Album (Tehran, Golestan Palace Library, no. 1663) contains six calligraphic specimens by him: p. 12 (dated 1017/1608), p. 13 (dated 1017/1608), p. 56 (dated 1018/1609), p. 97 (undated), p. 104 (undated) and p. 132 (dated 1017/1608). See Bayānī, *AAK*, p. 702–4.

86. The books mentioned, all well-known Persian classics, are respectively *The Nasirian Ethics (Akhlāq-i Nāṣirī)* by Naṣīruddīn Ṭūsī (1201–74), *The Alchemy of Happiness (Kīmiyā-yi sa'ādat)* by Abū-Ḥāmid al-Ghazālī (1058–1111), *The Letters of Sharaf Manērī*, a collection of letters by the mystic Sharafuddīn Manērī (fl. 1346), *The Rosegarden (Gulistān)* by Sa'dī (c. 1210–c. 1290), *The Garden [of Truth] (Ḥadīqatu'l-ḥaqīqat)* by Abū'l-Majd Majdūd Sanā'ī (1080–1131), *The Spiritual Mathnavi (Mathnavī-i ma'navī)* by Jalāluddīn Rūmī (1207–73), *Jam's Goblet (Jām-i Jam)* by Auḥadī of Maragha (1271–1338), *The Orchard (Bōstān)* by Sa'dī (completed 1257), *The Book of Kings (Shāhnāma)* by Firdausī (completed 1010), the *Quintet (Khamsa)* by Niẓāmī Ganjavī (1141–1209), and the collected works of the poets Amīr Khusrau (1253–1325), Jāmī (1414–92), Khāqānī (1120–90), and Anvarī (1126–89).

87. The 'Mīrzā's new *Zīj*', known variously as *Zīj-i jadīd-i sulṭānī* and *Zīj-i jadīd-i Gūrkānī*, is a compilation of astronomical tables assembled by Mīrzā Ulughbeg and his collaborators c. 1437. It is called 'new' because it replaced the older *Zīj-i Īlkhānī* by Naṣīruddīn Ṭūsī of c. 1270. Amīr Fatḥullāh Shīrāzī 'Aẓududdaula Amīnulmulk (d. 1589) came to Akbar's court from the Deccan in 1583 (Abū'l-Faẓl, *Akbarnāma*, 3 vols (Calcutta, 1873–87), vol. 3, p. 401). The revision of the calendar was largely his doing, and in collaboration with Raja

Todar Mal he reorganised the fiscal administration. See Shāhnawāz Khān, *Ma'āthiru'l-umarā*, vol. 1, pp. 100–5. The statement that the *Zīj* was translated into Hindi appeared so strange that the editors of the text of the *Ā'īn* suggested that perhaps it should be 'from Hindi to Persian', but since the *Zīj* was written in Persian that cannot be correct. It is not the only instance of tables being translated into Hindi. In the *Pādshāhnāma* by 'Abdul-Ḥamīd Lāhaurī (Calcutta, 1867–8, vol. 1/1, p. 287) it is stated that the *Zīj-i Shāhjahānī*, an updating and emendation of previous astronomical tables, was completed in the second year of Shahjahan's reign (1629–30), and 'in order that the benefits of the book be general and extend to all, by imperial command the astronomers of Hindustan, with the concurrence of practitioners of Greek astronomy, should translate it into the Hindustani language. Prior to this the right ascensions of the planets had been extracted from Ulughbeg's tables and inserted in the ephemerides. Now, with these new and improved tables, which are devoid of errors, one may easily draw inferences.'

88. For the *Razmnāma Mahābhārata*, see n. 108 below.

89. *Atharban* is for the Sanskrit *Atharvaveda*, one of the four Vedas. Of the translation 'Abdul-Qādir Badā'unī writes: 'In this year [983/1575] Shaikh Bhāwan, a learned Brahman from the Deccan, joined the retinue, willingly adopting Islam, and was enrolled among the elite. [The emperor] ordered him to interpret the Atharvaeda, the fourth of the four books well known to the people of India that contains some precepts similar to those of the Islamic nation, and I was to translate it from the Indian language into Persian. Since some of its expressions were quite inscrutable and the interpreter was unable to explain them, I told the emperor that the meaning could not be understood. First he ordered Shaikh Faizi to translate it, and then he ordered Ḥājjī Ibrāhīm Sirhindī to do it. He did not produce what the emperor wanted, and therefore it was left in abeyance' (*Muntakhabu'l-tawārīkh*, ed. W. Nassau Lees and Aḥmad 'Ali, 2 vols (Calcutta, 1865–8), vol. 1, p. 212 f.).

90. *Līlāvatī* is a mathematical treatise by Bhāskara II written in 1150. A Persian translation was made by Abū'l-Faẓl's brother Abū'l-Faiż Faiżī (d. 1595) in 995/1587. The earliest-known copy, dated 8 Muḥarram 1015 (16 May 1606), is in the India Office Library (no. 1411, Ethé 1998). Henry Thomas Colebrooke's 1817 English translation was published with notes by Haran Chandra Banerji (Calcutta, 1927).

91. *Tājik* is the astrological work *Tājikanīlakaṇṭhī* by the court astrologer Nīlakaṇṭha. No copies of the Persian translation have been located. The Sanskrit text with English translation by Dayal Prasad Saxena is available (New Delhi, 2001).

92. 'Mīrzā Khān' is Mīrzā 'Abdul-Raḥīm Khānkhānān, who translated Babur's memoirs from Turkish into Persian and presented them to Akbar in 1589 (Abū'l-Faẓl, *Akbarnāma*, vol. 3, p. 570). While nothing has been located that purports to be the original Persian translation, there are several lavishly illustrated copies dating from Akbar's reign, including a c. 1589 copy in the Victoria and Albert Museum (1992.77–8), a c. 1591 copy in the British Library (Or.3714), a c. 1593 copy in Moscow, State Museum of Eastern Cultures (W.596), a 1597–8 copy in New Delhi, National Museum of India (50.326). For some of the many dispersed folios of the *Bāburnāma*, see Ellen Smart, 'Four illustrated Mughal *Baburnama* manuscripts', *Art and Archaeology*

Research Papers 3 (1973), pp. 54–8, and Susan Stronge, *Painting for the Mughal Emperor: The Art of the Book 1560–1660* (London, 2002).

93. The *Rājataraṅgiṇī* is a twelfth-century history of Kashmir written in Sanskrit verse by Kalhaṇa. Shāh-Muḥammad Shāhābādī's Persian translation was edited by 'Abdul-Qādir Badā'unī (Badā'unī, *Muntakhabu'l-tawārīkh*, vol. 1, p. 374). Incomplete copies of the Persian translation are in the India Office (no. 2442, Ethé 508) and the British Library (Add. 24,032, Rieu i 296a). An eighteenth-century copy is held by the Asiatic Society of Bengal (Ivanow 1698). An English translation of the original was made by Sir Aurel Stein, *Kalhana's Râjataranginî, or Chronicle of the Kings of Kashmir* (Bombay, 1892). Abū'l-Faẓl's list of the rulers of Kashmir in the geographical section of the *Ā'īn-i Akbarī* is clearly taken from this work.

94. *Mu'jam al-buldān*, an encyclopedic work on geography, was written by Yāqūt al-Ḥamawī (1179–1229). No trace of the Persian translation, the existence of which is attested here and by 'Abdul-Qādir Badā'unī (*Muntakhabu'l-tawārīkh*, vol. 1, p. 375), has been found.

95. Abū'l-Faẓl's *Haribans* is the Sanskrit *Harivaṃśa*, an appendix to the *Bhagavad Gīta*. One leaf of a dispersed manuscript with an illustration of the bears' palace (c. 1586) is in the Chester Beatty Library (32.2.12). An illustration of *Krishna and the Golden City of Dwarka* by Miskīn (c. 1585) is in the Freer Gallery of Art (F1954.6).

96. The Bidpai fables of the jackal viziers Kalīla and Dimna, who began life in Sanskrit as Karataka and Damanaka, became popular in the Islamic world when Ibn al-Muqaffa' (d. 759) wrote them in Arabic, supposedly adapted from a Middle Persian translation of the Sanskrit. They were first put into Persian by Abū'l-Ma'ālī Naṣrullāh of Shiraz c. 1145 (*Kalīla u Dimna-i Bahrāmshāhī*). Later Kamāluddīn Ḥusain Wā'iz Kāshifī (d. 1505) rewrote the tales in the approved style of Timurid times and entitled them *Anwār-i Suhailī*, and lastly Abū'l-Faẓl recast them under the title *'Iyār-i dānish (The Touchstone of Wisdom)*. The School of Oriental and African Studies, London, has an *Anwār-i Suhailī* dated 1570 (Ms. 10102) with twenty-seven miniatures. Two miniatures mounted together from an *Anwār-i Suhailī* c. 1580–5 are in the Chester Beatty Library (11A.32). Other leaves from the same work are in the Philadelphia Museum of Art on long-term loan from the City of Philadelphia (17-1964-20 and 17-1964-21), and the British Museum (1920,0917,0.5). What is described as a lavish *Anwār-i Suhailī* dated 1596–7 is in the Bharat Kala Bhavan in Benares (no. 9069). The Chester Beatty Library has a copy of *'Iyār-i dānish* made c. 1595 (Ms. 4) with ninety-six miniatures, and the Chhatrapati Shivaji Maharaj Vastu Sangrahalaya (formerly Prince of Wales Museum) in Bombay has a copy from 1580–1600. See Linda Leach, *Mughal and other Indian Paintings*, 2 vols (London, 1995), vol. 1, pp. 74–9.

97. The tale of the loving couple Nal (Nala) and Daman (Damayanti) from the *Mahābhārata* was adapted and rendered into Persian verse by Abū'l-Faẓl's brother Abū'l-Faiż Faiẓī Fayyāẓī in 1594–5. The British Library has several copies (Add. 23,981 and Add. 6625), and the India Office Library (1468–78) and the Bodleian (1057, 1060–2) have multiple copies, all later than Akbar's reign. The first line of *Nal-Daman* is: عنقای نظر بلندپرواز * ای در تک و پوی تو ز آغاز, the metre of which is *hazaj akhrab maqbūḍ maḥdhūf*, the metre of Niẓāmī's *Lailī u Majnūn*, considered appropriate for a romantic tale.

98. The *Millennial History* (*Tārīkh-i alfī*) was commissioned by Akbar in
1585. It was to be a history of Islam down to the year 1000 (1591–2).
The compilers were Mīr Ghiyāsuddīn Qazwīnī Naqīb Khān, Mīr
Fatḥullāh Shīrāzī, Ḥakīm Humām, Ḥakīm 'Alī, Ḥājjī Ibrāhīm Sirhindī,
Mīrzā Niẓāmuddīn Aḥmad, 'Abdul-Qādir Badā'unī, Mullā Aḥmad
Tattawī and Ja'far Bēg Āṣaf Khān. Illustrations from a dispersed copy
of the *Tārīkh-i alfī* made for Akbar c. 1592–4 are in the Art Institute of
Chicago (*al-Mu'tazz*, 1934.491), the British Museum (*al-Mutawakkil
Destroys the Tomb of Husain*, 1934,0113,0.1), the Cleveland Museum
of Art (*Page of Disasters*, 1932.36), the Freer Gallery of Art (*The Siege
of Baghdad* by Ṭāhir, F1931.25, *The Imam of Baghdad Brought Before
the Caliph on a Charge of Heresy* by Basawan, F1931.26, *A Banquet
Scene* by Tarya, F1931.27, and *Mu'ayyad Put to Death in the Ice*,
F1931.28), the Los Angeles County Museum of Art (*Deaths of al-
Wathiq and Muhammad ibn Bu'ayth ibn Jalis*, M.78.9.4, and *Attack
of the People of Homs*, M.83.105.3), the Museum of Fine Arts, Boston
(*Audience Scene*, 62.284), the National Museum of India, New Delhi
(*Amin Proclaims His Son's Name in the Public Prayers*, 50.356), the
Raza Library, Rampur (*The Caliph Ma'mun Talking with Ali ibn Musa
Rida*, D.B.9247), the San Diego Museum of Art (*The Populace Pays
Allegiance to the New Abbasid Caliph, al-Ma'mun*, 1990.291), the
Seattle Art Museum (*Battle Scene*, 62.111), the Virginia Museum of
Fine Arts (events in the reign of the Caliph al-Mu'taṣim, 68.8.48) and
the Worcester Art Museum (*A Ruler on Horseback Leading an Army
across a Battlefield*, 1985.315). There are in addition several folios in
private collections or the location of which is presently unknown.
See Milo C. Beach, *The Imperial Image* (Washington, DC, 2012), pp.
78–80. For a highly biased and personal account of the composition
of the *Millennial History*, see 'Abdul-Qādir Badā'unī, *Muntakhabu'l-
tawārīkh*, vol. 1, p. 318 f, and vol.1, 392 f.

99. Mīr Sayyid 'Alī Tabrīzī, son of the artist Mīr Muṣawwir, met
Humayun in Tabriz and joined his retinue in Kabul in 1549 (Abū'l-
Fażl, *Akbarnāma*, vol. 1, p. 292; Shāhnawāz Khān, *Ma'āthiru'l-umarā*,
vol. 2, p. 626).

100. Khwāja 'Abdul-Ṣamad, 'Shīrīn-Qalam' ('He of the Sweet Pen',
d. between 1600 and 1605), joined Humayun's retinue in Kabul with
Mīr Sayyid 'Alī, and during Akbar's reign he held several official
posts such as superintendent of the mint at Fatehpur and chief of the
Multan *dīvān* (Abū'l-Fażl, *Akbarnāma*, vol. 3, pp. 227, 511). 'During
Arsh-Ashyani [Akbar]'s reign, even though he held only the rank of
400, he ranked much higher as a companion and intimate and was
important and influential. [He] is said to have written the Ikhlāṣ
chapter of the Koran on a poppy seed' (Shāhnawāz Khān, *Ma'āthiru'l-
umarā*, vol. 2, p. 626). There are calligraphic specimens by him in the
Gulshan Album (Tehran, Golestan Palace Library, no. 1663, pp. 63, 70,
151, 158, 159, 206, 233). For 'Abdul-Ṣamad's pictorial works see Sheila
Canby, 'Abd al-Samad', in Milo C. Beach, Brijinder N. Goswamy and
Eberhard Fischer (eds), *Masters of Indian Painting 1100–1650* (Zurich,
2011), pp. 97–110.

101. In a notice in the *Akbarnāma* for the year 1584 Abū'l-Fażl writes:
'Daswanth the painter passes away: he was the son of a *kahār* [palan-
quin bearer], and through the farsightedness and appreciation of the
imperial patron of the arts, he attained such a high rank in painting that

his works could not be distinguished from those of Bihzad or the paint-
ers of Cathay. Without warning melancholia went to his brain and he
stabbed himself with a dagger. He died two days later, sorely afflicting
the hearts of the cognoscenti with grief' (Abū'l-Fażl, *Akbarnāma*, vol.
3, p. 434). For Daswanth and his works see Milo C. Beach, 'The Mughal
painter Daswanth', *Ars Orientalis* 13 (1982), pp. 121–33 and the index
to Milo C. Beach *et al.*, *Masters of Indian Painting*.

102. For Basāwan (active c. 1565–98) and his works see John Seyller,
'Basawan', in Milo C. Beach, Brijinder N. Goswamy and Eberhard
Fischer (eds), *Masters of Indian Painting 1100–1650* (Zurich, 2011),
pp. 119–34.

103. For the artists named in this section and their works, see Milo
C. Beach *et al.*, *Masters of Indian Painting*: Kesav (= Kēshav Dās,
active 1570–99), pp. 153–66; Miskīn (active late 1570s–c. 1604), pp.
167–86. For La'l, Mukund, Farrukh Qalmaq, Madhū, Jagan, Mahēs
(Mahēsh), Khēmkaran, Tārā, Sānwala and Harbans, see the index to
Masters of Indian Painting.

104. For the production of the *Ḥamzanāma* and surviving illustrations,
see John Seyller, *The Adventures of Hamza* (Washington, DC, 2002),
pp. 37–51.

105. Most of a manuscript of the *Chingīznāma*, the section on the history
of Genghis Khan from Rashīduddīn Fażlullāh's *Jāmiʿuʾt-tawārīkh*,
dated 1004/1596 – undoubtedly the one referred to by Abū'l-Fażl –
is in the Golestan Palace Library in Tehran (304 folios with ninety-
eight illustrations). The Chester Beatty Library in Dublin has three
leaves (*Mosul Besieged by Hulagu Khan*, 60.1; *Mounted Mongol
Troops*, 60.2; and *Battle of Toqta and Nogai*, 60.3), and others are in
the Aga Khan Museum of Art (*Mourning of Abaqa Khan's Death*),
the St Louis Art Museum (*Siege of Khazar*, 388:1952), the Cleveland
Museum of Art (*Hulagu Khan Holds a Feast* by Lal, Dharm Das, and
Padarath, 2013.304 and *The Siege of Arbela* by Basawan and Sur Das,
1947.502), the Cincinnati Art Museum (*The Capture of Baghdad by
Hulagu Khan*, 1947.582), Freer Gallery of Art (*Kublai Khan and His
Empress Enthroned* by Keshav Kalān and Kamali Chela, F1954.31),
the Metropolitan Museum of Art (*Tumanba [Tumina] Khan, His Wife,
and His Nine Sons* by Basawan, 48.144), Los Angeles County Museum
(*Toda Mongke and His Mongol Horde* by Tulsi and Madhu, M.78.9.8;
Alanquva and Her Three Sons, M.78.9.9), the San Diego Museum of
Art (*Mangu Khan Judges the Rebels*, 1990.305), the Virginia Museum
of Fine Art (*Hulagu Khan Destroys the Fort at Alamut* by Basawan,
68.8.53), and the Worcester Art Museum (*Birth of Ghazan Khan* by
Basawan, 1935.12). There are other illustrations either in private col-
lections or the location of which is unknown. See Leach, *Mughal
Paintings*, vol. 1, p. 133 and Beach, *Imperial Image* (2012), p. 82.

106. The *Zafarnāma* by Sharafuddīn ʿAlī Yazdī (c. 1425), commissioned
by Tamerlane's grandson Sulṭān-Ibrāhīm, chronicles Tamerlane's
conquests. Despite the importance this book held for Tamerlane's
descendants and the large number of illustrated copies produced, there
do not seem to be any known from Akbar's reign.

107. By 'this felicitous work' Abū'l-Fażl means the *Akbarnāma*. The
earliest known illustrated copy of c. 1585–90 is in the Victoria and
Albert Museum (IS.2–1896) with 273 folios of text and 116 illustra-
tions. Volume one of the second major *Akbarnāma*, with thirty-nine

of the original fifty paintings, is in the British Library (Or.12988), and volume two and part of volume three, 268 folios with sixty-one paintings, are in the Chester Beatty Library (Ms. 3). For a list of dispersed folios see Beach, *Imperial Image* (1981), pp. 117–23. Manuscripts of the *Akbarnāma* abound (see Charles A. Storey, *Persian Literature: A Bio-Bibliographical Survey* (London, 1970–2), vol. 1, pp. 543–6).

108. The first great copy of the *Razmnāma*, the Persian translation of the *Mahābhārata*, was completed in 1586 and is now in the Maharaja Sawai Man Singh II Museum in Jaipur. The British Library has a two-volume copy without illustrations dated 1007/1599, Add. 5641 and 5642 (Rieu, *Catalogue of Persian Manuscripts*, vol. 1, p. 58). The Indian Office Library has numerous copies of this work (Ethé 1928–48), but none is early.

109. The Persian translation of the *Rāmāyana*, begun in 1584, was completed by 'Abdul-Qādir Badā'unī in 1589: 'In the month of Jumada I 997 [March 1589], I presented the translation of the *Rāmāyan*, which had taken me four years and had been completely recopied. … It was highly applauded' (Badā'unī, *Muntakhabu'l-tawārīkh*, vol. 1, p. 366). The most complete copy of the Persian *Rāmāyana* is in Jaipur, but it has long been inaccessible. The Freer Gallery of Art in Washington, DC has two volumes produced between 1597 and 1605 under the patronage of 'Abdul-Raḥīm Khānkhānān (F1907.271.1–346). See John Seyller, 'A sub-imperial Mughal manuscript: the *Ramayana* of 'Abd al-Rahim Khankhanan', in Vidya Dehejia (ed.), *The Legend of Rama: Artistic Visions* (Bombay, 1994), pp. 85–100, and John Seyller, *Workshop and Patron in Mughal India: The Freer Ramayana and Other Illustrated Manuscripts of 'Abd al-Rahim* (Zurich, 1999).

110. For *Nal-Daman*, see n. 97 above.

111. For *Kalīla-Dimna*, see n. 96 above.

112. For copies of *Iyār-i dānish* produced during Akbar's time, see n. 96 above.

113. At forty *dām*s to the rupee, the salary range is Rs. 15 to Rs. 30 a month. This is far less than the salary of a mounted officer of the lowest rank, that of 10, which ranged from Rs. 75 to Rs. 100.

Bibliography

'Abdul-Ḥamīd Lāhaurī, *Pādshāhnāma*, eds Maulvī Kabiruddīn Aḥmad and Maulvī 'Abdul-Raḥīm, 2 vols (Calcutta, 1867–8).

Abū'l-Fażl, *Ā'īn-i Akbarī*, Persian text ed. Henry Blochmann, 2 vols (Calcutta, 1869–72).

Abū'l-Fażl, *Akbarnāma*, Persian text ed. Āghā Aḥmad 'Alī, 3 vols (Calcutta, 1873–87).

Aḥmad Ibrāhīmī Ḥusainī Qummī, Qāżī Mīr, *Gulistān-i hunar: Tazkira-i khwashnivīsān u naqqāshān*, ed. Aḥmad Suhailī-Khwānsārī (Tehran, 1352).

Ātābāy, Badrī, *Fihrist-i dīvānhā-yi khaṭṭī-i kitābkhāna-i salṭanatī* (Tehran, 2535).

Avicenna (Ibn Sīnā), *Makhārij al-ḥurūf, yā asbāb ḥudūth al-ḥurūf*, ed. P. N. Khānlarī (Tehran, 1349).

Badā'unī, 'Abdul-Qādir b. Mulūkshāh, *Muntakhabu'l-tawārīkh*, ed. W. Nassau Lees and Aḥmad 'Ali, 2 vols (Calcutta, 1865–8).

Bayānī, Mahdī, *Aḥvāl u āsār-i khwashnivīsān* (Tehran, 1363).

Beach, Milo C., *The Imperial Image: Paintings from the Mughal Court* (Washington, DC, 1981; revised and expanded edition, 2012).

Beach, Milo C., Brijinder N. Goswamy and Eberhard Fisher (eds), *Masters of Indian Painting 1100–1650* (Zurich, 2011).

Beach, Milo C., 'The Mughal painter Daswanth', *Ars Orientalis* 13 (1982), pp. 121–33.

Blair, Sheila, *Islamic Calligraphy* (Edinburgh, 2006).

Blochet, Edgard, *Catalogue des manuscrits persans de la Bibliothèque nationale*, 4 vols (Paris, 1905–34).

Canby, Sheila, 'Abd al-Samad', in Milo C. Beach, Brijinder N. Goswamy and Eberhard Fischer (eds), *Masters of Indian Painting 1100–1650* (Zurich, 2011), pp. 97–110.

Dorn, Boris Andreevich, *Catalogue des manuscrits et xylographes orientaux de la Bibliothèque impériale publique de St Pétersbourg* (St Petersburg, 1852).

Ethé, Hermann, *Catalogue of Persian Manuscripts in the Library of the India Office* (Oxford, 1903).

Iskandar Bēg Turkmān, *Tārīkh-i 'ālam-ārā-yi 'Abbāsī*, 2 vols (Tehran, 1350).

Ivanow, Wladimir, *Concise Descriptive Catalogue of the Persian Manuscripts in the Collection of the Asiatic Society of Bengal* (Calcutta, 1924).

Jahāngīr Pādishāh, *The Jahāngīrnāma: Memoirs of Jahangir, Emperor of India*, trans. Wheeler M. Thackston (New York, 1999).

Khwāndamīr, Ghiyāthuddīn b. Humāmuddīn al-Husainī, *Habību'l-siyar fī akhbār-i afrād-i bashar*, 4 vols (Tehran, 1333).

Leach, Linda York, *Mughal and Other Indian Paintings from the Chester Beatty Library*, 2 vols (London, 1995).

Muṣṭafā 'Ālī, *Manāqib-i hunarvarān*, ed. Ibnülemin M. Kemāl, Türk Tarih Encümeni Küllīyātı 9 (Istanbul, 1926).

Pertsch, Wilhelm, *Verzeichniß der persischen Handschriften der Königlichen Bibliothek zu Berlin* (Berlin, 1888).

Rice, David S., *The Unique Ibn al-Bawwab Manuscript in the Chester Beatty Library* (Dublin, 1955).

Rieu, Charles, *Catalogue of the Persian Manuscripts in the British Museum*, 3 vols (London, 1879–83).

Seyller, John, 'A sub-imperial Mughal manuscript: the *Ramayana* of 'Abd al-Rahim Khankhanan', in Vidya Dehejia (ed.), *The Legend of Rama: Artistic Visions* (Bombay, 1994), pp. 85–100.

Seyller, John, *Workshop and Patron in Mughal India: The Freer Ramayana and Other Illustrated Manuscripts of 'Abd al-Rahim* (Zurich, 1999).

Seyller, John, *The Adventures of Hamza* (Washington, DC, 2002).

Seyller, John, 'Basawan', in Milo C. Beach, Brijinder N. Goswamy and Eberhard Fischer (eds), *Masters of Indian Painting 1100–1650* (Zurich, 2011), pp. 119–34.

Shahnawāz Khān Aurangābādī and 'Abdul-Hayy, *Ma'āthiru'l-umarā*, ed. Maulavī 'Abdul-Raḥīm, 3 vols (Calcutta, 1888–92).

Smart, Ellen, 'Four illustrated Mughal *Baburnama* manuscripts', *Art and Archaeology Research Papers* 3 (1973), pp. 54–8.

Storey, Charles A., *Persian Literature: A Bio-Bibliographical Survey*, Vol. 1, 2 parts (London, 1970–2).

Stronge, Susan, *Painting for the Mughal Emperor: The Art of the Book 1560–1660* (London, 2002).

Thackston, Wheeler, *Album Prefaces and Other Documents on the History of Calligraphers and Painters* (Leiden, 2001).

CHAPTER EIGHTEEN

'Migration Theory' in Islamic Pottery

Oliver Watson

IT IS IN the history of lustre decoration on pottery in the Islamic world that migration theory was first proposed and has long been generally accepted. The manufacture of lustreware moves around the Islamic world to different locations at different times and the migration of potters is given as explanation.[1] Lustre has received particular attention from collectors and writers ever since the nineteenth century,[2] but there are other wares whose migrations are visible in the ceramic record – migrations which likewise deserve notice and which may have more important and further-reaching implications.

'Migration' posits the physical movement of potters to establish workshops and produce wares in a new part of the world where such wares were not made before. It implies that the potters moved permanently, taking with them their usual habits of making. It explains, for example, the establishment of tin-glazed pottery workshops throughout Europe from the sixteenth century onwards – migrations for which archival as well as archaeological evidence is plentiful.[3] The evidence for potters' migrations in the Islamic world is found mainly in the surviving pots, although in one important case in the use of particular kiln furniture, and to a less certain extent, in potters' signatures. We cannot know exactly how potters moved, or how much they took with them in the way of family members or tools of their trade. However, the evidence that they did move and settle elsewhere is incontrovertible.

Migration stands in contrast to other explanations: that local potters simply copied new wares brought to their attention ('imitation'), that ideas passed gradually from workshop to workshop ('diffusion') or that itinerant workshops set up temporary residence ('mobile workshops'). These mechanisms surely were at work as well and may for some cases offer the simplest and therefore the more compelling argument; migration needs to be justified as an explanation which best fits the evidence in any particular case.

Offered here are a number of case studies, in which migration appears to be the best and most plausible explanation:

1. glazing on pottery
2. yellow glaze family
3. opaque white glaze
4. lustre
5. the frit body
6. underglaze painting
7. 'Sultanabad' decoration
8. Chinese blue-and-white styles

1. Glazing on pottery

Immediately before the arrival of Islam, glazed pottery was being made in only one part of the lands that were to become the Islamic world. In lower Iraq, rough earthenwares were covered with alkaline-fluxed glazes, mostly coloured turquoise with copper. This production continued into the Islamic period when the best known and most striking examples are large jars used for transport and storage.[4]

Elsewhere, however, pottery, whether functional or fine table-ware, was unglazed. But by the second half of the eighth century glazed finewares were being made in large quantities in Egypt and across Syria, and by the tenth century highly decorative glazed table-wares were being made and used throughout the Islamic world, from Cordoba in Spain to Samarqand in Central Asia – a transformation of the ceramic landscape rightly called a 'revolution'.[5] Glazing adds technical complexity and extra expense to the ceramic enterprise: knowledge of glass making and colouring, different and less efficient kilns, higher wastage rates. The change is not just technical but indicates an equally large change in social habits: where in earlier times metal (especially silver) and glass graced the tables of the moneyed classes, now glazed and decorated pottery competed for attention and sale to a large swathe of society. The reasons for this transformation are not yet clear, but it took place at the same time as the accelerating growth of urban populations in cities and towns, the boom in manufacturing and trade, and hence the wealth of the commercial classes and the 'monetising' of the economy as larger numbers of professionals and artisans began to be paid cash wages. All these factors no doubt contributed to new waves of material consumption by new social classes in which glazed pottery made a substantial contribution.

That the spread of glazed pottery was carried out by migrating potters is shown by the accompanying spread of a most particular, indeed peculiar, technique of stacking the kiln: the use of kiln rods or bars.[6] These are lengths of clay, usually some 50 cm or more long

and 5 cm in diameter, which are set in rows of holes on the inside wall of the kiln, like spokes in a wheel, to provide a set of radial shelves on which the pots were stacked for firing.[7] This unique (not to say bizarre) method, not found anywhere else in the world before or since, is found in the early and medieval period everywhere that glazed pottery was made, from one end of the Islamic world to the other.[8] And it is best explained by the migration of potters who had initially developed this idiosyncratic but effective method and who took it with them as they or their descendants and fellow artisans moved to practise the craft in new and ever more distant parts of the world.

Evidence for the migration of potters to explain the spread of glazing is furthermore supported by the spread of particular techniques of making and styles of decoration – outlined below, especially in the sections on the yellow glaze and opaque white glaze families.

2. Yellow glaze family

The Syrian yellow glaze family (YGF), and its Egyptian precursor, Coptic glazed ware (CGW), represent the first well-established glazed wares to appear after the Islamic conquests. Coptic glazed ware was first reported from Alexandria in the layers immediately succeeding those of the Late Antique period and copying in many of its shapes the earlier unglazed African red slipware, a development of Roman *terra sigillata*. The Islamic invasions of North Africa had destroyed the kilns near Carthage that had been for centuries the main supplier of this fine tableware in enormous quantities for the eastern Mediterranean markets. CGW appears to be a local replacement, but now with coloured glaze decoration, not just the plain gloss surface of its ancestor. This is a dramatic visual transformation – bright coloured glazes are painted across the dish, not necessarily covering the entire surface. The know-how to make such glazes was readily available from glassworkers whose highly developed industry continued in Egypt and the Levant uninterrupted from Roman times until the late medieval period. The application of glass as a glaze to the the surface of the ceramic required ingenuity, particularly in the development of kiln furniture. Unlike unglazed pottery, glazed wares must not be in contact with each other during the firing, and kiln-rod supports, described above, were apparently part of the newly invented solution alongside more conventional devices such as tripods.

Coptic glazed ware found favour: it was evidently made in large quantities in Fustat[9] and was also exported to the Levant.[10] By the second half of the eighth century potters had carried the same techniques and styles of decoration into Syria where at least three separate centres (Antioch, Tarsus and Raqqa) have been identified as major manufacturers.[11] Differences in fabric, details of making,

such as the cutting of the footring, and the range of decorative styles distinguish the different centres, but the common ancestry of all three is shown in the basic technology (including kiln rods and glaze-painted decoration), in the vessel shapes, and in the predominant use of a sharp opaque-yellow glaze made by inclusion of lead-stannate (lead-tin yellow).

Further movement eastwards of yellow-glaze potters into Iraq in the 'Abbasid period is evidenced by finds at Susa, where a series of apparently locally made wares follow the Syrian YGF closely in vessel shape, styles of decoration and the continuing use of opaque yellow as the chief background glaze.[12] We can plausibly account for the spread of this ware to Iraq by the movement of populace from Syria to Iraq which became the homeland of the 'Abbasid regime. Both potters and their customers moved, taking with them their established habits of making and using such pottery.

We might even see a more distant migration of the yellow glaze potters, both eastwards and westwards, reflected in distinct but confusingly similar wares made in the ninth and tenth centuries in North Africa (for example, wares from Raqqada and elsewhere in Tunisia)[13] and eastern Iran ('buff ware').[14] Similarity in plain bowl shapes, use of underglaze lead-stannate yellow and in decorative motifs (for example, half-moon borders and chequerboard hatching) might readily be explained by the further migration of YGF potters from Syria seeking markets even further afield. It removes the necessity of calling for an implausible direct contact between these far-flung places.[15]

3. Opaque white glaze

The fashion for opaque white glazes in ninth-century Iraq is ascribed to the arrival in quantity of Chinese porcelains. Indeed, this exotic import is credited with inspiring the whole development of glazed pottery in the Islamic world generally[16] – a view seriously challenged by the discovery of the earlier Egyptian Coptic glazed wares and the Syrian yellow glaze family described above.[17] However, the appearance of the Chinese imports and the superior quality of the white porcelain material inspired a major change in ceramic production – most importantly that opaque-white replaced opaque-yellow as the favoured background colour. However, many other elements of the YGF wares continued: the vessel shapes, though some with distinct Chinese details, follow the basic form and size of the earlier Islamic bowls, and the commonly found painting or splashing in green is not Chinese-derived as usually suggested in earlier literature but is the continuation of a standard YGF type of decoration but now painted into the more-favoured white glaze.[18] Colours other than green, such as manganese purple and more rarely a yellow, were colours already used by YGF potters, and are found again with white glazes.

The fashion for opaque-white glazed wares (OWG) spread rapidly. There were clearly many centres making the ware in Iraq and Syria, and some were most likely to be workshops which had been producing YGF wares and OWG wares, and which either replaced them or made them alongside.[19] Recent research by Moujan Matin at Oxford has revealed that opaque yellow and opaque white glazes are very closely related: both use tin compounds (lead-stannate for yellow, tin-oxide for white), and variations in the method of preparation and firing account for the dramatic difference in colour. The change from one to another by the same potters is technically simple.[20]

By the tenth century, opaque-white glazed wares were being made widely across the Islamic world: large-scale production can be identified in Fustat and Nishapur, and wares made in Spain (Cordoba) and Central Asia (Samarqand) have different styles of painting while sharing a common technical ancestry.[21] The use of kiln rods in all these centres indicates again that migration was responsible for this astonishing technological movement.

4. Lustre

Lustre is a technique that was applied to opaque-white glazed ware in ninth-century Iraq.[22] Lustre decoration, however, had an earlier history on glass in eighth-century Syria, and was used possibly also on glass in early Islamic Egypt. It appears to have arrived in Iraq in the ninth century, where it was again used on glass. But its most prolific and best-known use was on white-glazed pottery of a kind found particularly at Samarra – hence its earlier name 'Samarra ware'. It is noteworthy that all lustre decoration (and indeed, decoration with cobalt blue) is found solely on one distinctive type among the several identifiable groups of Iraqi white wares. The wares decorated in lustre are distinguished by the fine clay fabric, the generally high quality of the shaping and finishing, and with distinct characteristics, such as the foot completely covered in glaze.[23]

Several styles of decoration are observable in Iraq lustrewares: from polychrome decoration (usually deemed to be the earliest); bi-chrome decoration (which may be a separate workshop); and monochrome painting (dated to the tenth century) with its distinctive stylised animals and people. This last group appears to mark the end of lustre painting in Iraq, for no wares later than the tenth century can be identified. However, just at this date lustreware appears in Fatimid Egypt. While OWG wares have been made in Egypt probably from the ninth century, lustre appears towards the end of the tenth, with two datable pieces from the reign of Caliph al-Hakim (r. 996–1021).[24] The Egyptian products are easily separated from imports from Iraq (also found in large quantities in Fustat) by the nature of the clay fabric which though variable is never of the fine light-coloured Iraqi type. The decoration, however, initially shows

clear affinities with Iraqi styles, to the extent that the two can be difficult to classify if the body fabric is not visible.[25]

During the eleventh and twelfth centuries, lustre painting in Egypt developed into a large industry producing a wide variety of styles, with many different potters' names recorded; glass was also decorated with lustre.[26] A newly introduced artificial body fabric – fritware (see section 5 below) – was also decorated with lustre. At some point in the twelfth century, lustre ceases to be made in Egypt, but the technique appears in Syria and in Iran, and in both cases associated with the new fritware fabric.

In Syria two types are found: the earlier (eleventh–twelfth-century) 'Tell Minis' type had long been attributed to Fatimid Egypt, which underlines the strong stylistic connection between the two.[27] The later (twelfth–thirteenth-century) 'Raqqa' ware, which developed out of the Tell Minis type, has a stronger stylistic connection to contemporary Iranian production.[28] Raqqa lustre production appears to have been brought to an end by the Mongol invasions which laid the town to waste in 1258, though some production dating into the fourteenth century is attributed to Damascus.[29]

In Iran, in the small town of Kashan, we are able to plot the history of lustre in some detail, thanks to the potters' habit of inscribing dates as well as signatures on their wares.[30] The earliest date is Shawwal 574/March 1179[31] and more than 100 dated pieces are recorded up to the mid-1220s when the Mongol incursions appear to have caused a hiatus in production for over three decades. Production, particularly of lustred tilework, was then resumed on a large scale and continued into the 1330s.[32] The lustre-tile productions of the Abu Tahir family can be tracked over at least three generations from the late twelfth to the fourteenth centuries.[33] After this, lustre appears to have had a chequered history in Iran, the technique being preserved for the small-scale manufacture of tombstones until a flourishing production of small vases and coffee wares took place in the seventeenth century. After this, sporadic production continues into the nineteenth century.[34]

At some point, probably at about the same time as it moved to Syria and Iran in the eleventh–twelfth centuries, the lustre technique moved westwards to Spain where it was established as a major industry, continuing in high production into the modern period.[35]

Two comments are relevant when considering lustre decoration: first, that its technique is impossible to guess from an examination of the finished article alone, and second, that its appearance in different parts of the Islamic world coincides with its disappearance elsewhere. Both of these phenomena are consistent with the proposal that a group of potters kept the lustre technique as something of a monopoly, holding their method secret, and taking it with them as they moved across the world. This stands in contrast, for example, to the spreading of opaque-white glazed wares in the ninth and tenth

centuries when new centres were founded in addition to the original manufacturing sites which continued to produce.

5. The frit body

As mentioned above, the frit body was developed in Fatimid Egypt, possibly already in the eleventh century.[36] Soon afterwards it appears in Syria. A ware known as 'Tell Minis' was not made at that site, but in more than one site along the Euphrates – Raqqa, Qal'at Jabar and Balis Meskene.[37] Tell Minis wares were made in a variety of styles – with transparent or opaque coloured glazes (white, blue, turquoise, purple), with or without incised and pierced decoration and, significantly, with lustre painting.[38] The connection with Egypt is underlined by the fact that for decades examples of Tell Minis ware, even when found in Syria, were assigned to Fatimid Egypt. Egypt remains the source of the frit body and of the variety of techniques with which it was decorated when emigrating potters started production in Syria.

This emigration to Syria may have predated a second wave of migration that took the frit body and its accompanying techniques to Iran. The town of Kashan in central Iran became the pre-eminent centre of fine ceramic production for more than 150 years. The potters obligingly signed and dated many of their their wares, which allows us to plot their history in a degree of detail impossible for earlier types. Dated wares start in the 1170s, build dramatically in the first two decades of the thirteenth century, fall abruptly with the incursions of the Mongols in about 1220 and only revive in quantity in the 1260s. A direct connection with Egypt is suggested by the 'monumental' style of lustre painting in Iran which is closely based on one of the predominant Egyptian Fatimid styles.[39]

It is possible that the fritware technology arrived in Iran some time before the earliest dated examples, but only few of the types carry inscriptions which would in turn encourage the potter to record a name or the date.[40]

Kashan has rightly taken centre stage as the origin of the finest, most inventive and most impressive fine ceramic wares of medieval Iran. However, simpler fritware manufacture, to judge by the great variety of styles and qualities among surviving pieces, was clearly made in a large number of centres, though clear archaeological evidence has been published only for production in Nishapur, and for Afrasiyab in Central Asia.[41]

6. Underglaze painting

Underglaze painting, in which pigments are painted onto the surface of the vessel before the glaze is applied, and the two are fired together in a single firing, combines two highly desirable features.

It enables detailed polychrome patterns to be painted in fine detail under a protective covering of glaze, and it enables the process to be accomplished in a single firing. Detailed patterns were restricted by less subtle materials or techniques (slip-painting, incising, inglaze-painting) or by the added expense of the second firing required by lustre and overglaze enamel decoration. It is understandable that this technology has been the preferred decorative technique of potters from the time of its invention into our own age.

The precise moment or place of invention is unclear. A possible development is seen in Iran where a thick black underglaze slip (in 'silhoutte ware') is gradually thinned down until a thin pure pigment alone is used, giving patterns of the utmost delicacy.[42] The earliest of these is dated to the very beginning of the thirteenth century, at which time it also then makes its full appearance in Syria in so-called 'Raqqa wares'. These also show a strong Iranian connection in features such as vessel shape and painting style, and together such features may argue for another migration of potters from Iran to Syria. However, a possibly earlier version of underglaze painting in Egypt might eventually be shown to be the ultimate origin.[43]

By the thirteenth century we find underglaze painting throughout Egypt, Syria, Iran and Central Asia, and it is possible that the migrating potters who took the frit body across these lands also took with them this closely associated technique.

These two last techniques – the frit body and underglaze painting – represent the last major technical innovations that were taken by migrating potters over large distances, and they form together the essential pottery technique for all fine pottery in the central and eastern Islamic lands from the thirteenth century onwards. Only in North Africa and Spain did the older technique of opaque-white glazed earthenwares continue into the modern period.

After these innovations, what can be observed is the movement of styles of decoration. The following two are particularly worthy of interest.

7. 'Sultanabad' decoration

In Ilkhanid Iran, probably in Kashan, new styles of ceramic painting developed, rather darker in general tone, and with images drawn from contemporary book painting. Generally known as 'Sultanabad wares', they encompass a number of different painting techniques.[44] Of particular note is the method of covering the ground with a grey-green slip before using a thick white slip for the main motifs which are then outlined and detailed in conventional black and blue underglaze painting.[45] This strangely regressive manner of painting, using a white slip in perceptible relief, is then found on a number of provincial Iranian wares which are evidently copying them.[46] More curiously, the same manner of painting with similar motifs and

vessel shapes, and clearly of local origin, is found on vessels much further afield: in the lands of the Golden Horde to the north of the Caspian Sea, in Syria and in Egypt.[47]

These late slipwares are accompanied by a move of the more conventional 'panel-style' motifs westwards from Iran, also to Golden Horde lands as well as to Syria and Egypt. It is, however, the unusual use of the grounds and raised slip motifs that indicate that this is a migration of potters taking their techniques with them, rather than just local potters copying motifs from imported wares.

8. Chinese blue-and-white styles

During the fifteenth century, the imitation of imported Chinese blue-and-white porcelain styles became the favoured product of many potteries across the central and eastern Islamic lands. Finds from Hama suggest that Chinese imitations were being made even before Timur's incursions in the early fifteenth century, but Golombek and her colleagues have plausibly argued that it was in Timurid Samarqand that the Chinese mode was fully generated and learned by craftsmen brought back to that city as indentured labour.[48] Their release from bondage in 1411 after Timur's death was the impetus that carried Chinese styles back across Iran and westwards as potters returned to their homelands. This wave can be traced by dated pieces made in centres ever more westward (Nishapur and Mashhad, Tabriz, Damascus, Cairo and the Ottoman lands). The numerous potters who ended up working in fifteenth-century Cairo show evidence of travel in their *nisba*s. The most prolific, Ghaibi, signed himself both *al-taurizi* (of Tabriz) and *al-shami* (of Syria), others signed simply *al-shami*, *al-hurmuzi* (of Hurmuz, on the Iranian side of the Gulf), *al-'ajami* (the foreigner – particularly Iranian). Perhaps this influx of 'foreign' potters led one local to sign himself forcibly *al-ustad al-misri* (the Egyptian master), though, ironically, he painted in the Iranian-derived panel style.[49]

There is documentary reference to an Ottoman artist – Naqqash 'Ali – who had been taken to Samarqand, returned to work in Konya with a group of potters who signed themselves *al-ustadan al-tabrizi* (the Tabrizi masters), and ended up as a court architect.[50] The tile-makers appear to form an itinerant workshop working elsewhere in the Ottoman lands.

Conclusions

The details of these proposed migrations are not known: we do not know how long these journeys took, whether the craftsmen went alone or with family members, whether they took their tools or just their knowledge, how they were financed, whether they travelled by invitation or 'on spec'. Such artisans are invisible in contemporary

literature. But what is clear from the material evidence is that individuals travelled significant distances – hundreds, or even thousands of miles – and set up workshops. The ones we can see flourished, but many others may have failed. And this must have happened time after time, over many centuries.

These migrations were surely not the sole prerogative of potters, and we can reasonably assume that they form part of a wider social history – of many classes and many occupations moving to new areas where a better life might be earned. The reasons for some of these movements readily suggest themselves – the transfer of the caliphal city from Damascus to Baghdad under the early 'Abbasids, which prompted a similar move of populace and of the artisans who supplied their preferred goods. The bleak economic and political times in Iraq in the tenth century or in Egypt at the end of the Fatimid dynasty coincide nicely with the move of the lustre potters into and out of Egypt. Other reasons for the moment elude us. Why move to Kashan in the mid-twelfth century, when political and economic circumstances do not look from the outside at all promising? What attracts an Iraqi potter to Cordoba or Samarqand in the ninth or tenth century? However, move they did, and successfully. And if potters moved, then surely metalworkers, jewellers, weavers and glassmakers, indeed, any of the manufacturing industries, did too.

In the consideration of pottery, we are helped in deciding provenance by the materials, especially of the clay fabrics – the differences are often marked and reliably distinguishable. The clay of lower Iraq is quite distinct from that of Egypt or the Iranian plateau. Even if the vessel shape and motifs are similar, wares can usually be clearly provenanced by a study of the clays used. But this is not the case with other materials. Determining provenance by analysis of metal, glass, textile, wood or ivory is a much more challenging task, particularly when raw materials were traded over long distances, and even more challenging, as the glass cullet from the Serçe Limani shipwreck so clearly highlights, when the raw material traded for new production is itself recycled fragments of earlier production.[51]

Migrating craftsmen take with them their techniques of making – and this fact makes a technical analysis as the sole evidence for provenance unreliable. What techniques did weavers from across the Islamic lands bring when they too migrated? Can we be sure that a 'local' technique is dominant among fine textiles, for example, rather than production in any single cosmopolitan area – Baghdad, Samarqand, Cordoba or Cairo – being composed of a mixture of techniques brought by craftsmen from very different parts of the world? Likewise, style as an indicator of provenance is similarly unreliable – craftsmen are successful because they produce in popular styles, and fashions in styles move by both diffusion and migration, and they move long distances.

There are no answers to these questions at the present moment, but they are surely to be borne in mind whenever and wherever manufactured articles and their provenance are being considered.

Notes

1. Arthur Lane, *Early Islamic Pottery, Monographs on Pottery and Porcelain* (London, 1947), pp. 16, 21, 37.
2. Oliver Watson, *Ceramics from Islamic Lands* (London, 2004), pp. 14–15.
3. Alan Caiger Smith, *Tin-Glaze Pottery in Europe and the Islamic World: The Tradition of 1000 Years in Maiolica, Faience and Delftware* (London, 1973).
4. Fragments of these containers (*dibs*, date syrup, is thought to be the main commodity) are found on archaeological sites on the sea routes down through East Africa, round South and South-Eastern Asia as far as China and Japan. Watson, *Ceramics*, sect. B, cat. no. B44; St John Simpson, 'Partho-Sasanian ceramic industries in Mesopotamia', in Ian Freestone and David Gaimster (eds), *Pottery in the Making, World Ceramic Traditions* (London, 1997), p. 79.
5. Alastair Northedge, 'Thoughts on the introduction of polychrome glazed pottery in the Middle East, in Estelle Villeneuve and Pamela M. Watson (eds), *La Céramique Byzantine et Proto-Islamique en Syrie-Jordanie (IVe–VIIIe Siècles Apr. J.-C.)* (Beirut, 2001).
6. The French term *'four à barres'* suggests that we should adopt the term bar, rather than rod.
7. Several rather unsatisfactory reconstruction drawings have been published, but for a reconstructed model see *Le Vert et le Brun: De Kairouan à Avignon, Céramiques du Xe au XVe Siècle* (Marseilles, 1995), fig. 13.
8. See in particular Jacques Thiriot, 'Bibliographie du four de potier à barres d'enfournement', *IV Congreso de Arqueología Medieval Española: socie-dades en transición: acta Alicante, 4–9 de octubre 1993* (Alicante, 1994) for the most important and detailed survey. Evidence is found, for example, in Marseilles in France, and Valencia, Cordoba and Saragossa in Spain, see *Le Vert et le Brun*. Syrian sites include Tiberias, Antioch and Raqqa, see Edna J. Stern, 'An early Islamic kiln in Tiberias', *'Atiqot* 26 (1995); Frederick O. Waage, *Antioch-on-the-Orontes, IV, Part One: Ceramics and Islamic Coins* (Princeton, 1948), fig. 92/16; and Oliver Watson, 'VIII. Report on the glazed ceramics', in Peter A. Miglus (ed.), *Raqqa I: Die Frühislamische Keramik von Tall Aswad* (Mainz, 1999), p. 84. Rods have been found in Susa and Basra in Iraq, see Robert B. Mason and Edward J. Keall, 'The 'Abbasid glazed wares of Siraf and the Basra connection: petrographic analysis', *Iran* XIX (1991), fig. 2. For Takht-i Sulayman, Kashan, Gurgan and Siraf in Iran, see Rudolf Naumann, 'Brennöfen für Glasurkeramik', *Istanbuler Mitteilungen* 21 (1971), pp. 173–90; James W. Allan, 'Abu'l-Qasim's treatise on ceramics', *Iran* XI (1973), pp. 111–20, para. 26; Mehdi Bahrami, *Gurgan Faiences* (Cairo, 1949), pl. 10; and David Whitehouse, 'Excavations at Siraf: fourth interim report', *Iran* IX (1971), p. 15, and for Samarqand, see Galina V. Shishkina and L. V. Pavchinskaja, *Terres secretes de Samarcande: Céramiques du VIIIe au XIII Siècle* (Paris, 1992). It is significant that the kilns for unglazed wares seem to follow varied designs based on local practice in pre-Islamic times.

9. Mieczysław Rodziewicz, *Alexandrie I: La Céramique romaine tardive d'Alexandrie* (Warsaw, 1976); Mieczysław Rodziewicz, 'La céramique émailée copte de Kom el Dikka', *Etudes et Traveaux* 10 (1978), pp. 337–45; Mieczysław Rodziewicz, 'Egyptian glazed pottery of the eighth to ninth centuries', *Bulletin de la société d'archéologie copte* 25 (1983), pp. 73–5; George T. Scanlon, 'Slip-painted early lead-glazed wares from Fustat: a dilemma of nomenclature, in Roland-Pierre Gayraud (ed.), *Colloque International d'Archéologie Islamique* (Cairo, 1998), pp. 21–55.

10. Donald Whitcomb, 'Coptic glazed ceramics from the excavations at Aqaba, Jordan', *Journal of the American Research Center in Egypt* 26 (1989), p. 20.

11. Watson, 'VIII. Report on the glazed ceramics', pp. 84–5.

12. Oliver Watson, 'Revisiting Samarra: the rise of Islamic glazed pottery', *Beiträge zur Islamischen Kunst und Archäologie* 4 (2014), p. 129, fig. 12.

13. For example, *Couleurs de Tunisie* (Paris, 1994), nos 58, 62–4, 73.

14. Watson, *Ceramics*, sect. H.

15. See, for example, Soundes G. Chatti, 'La céramique aghlabide de Raqqada et les productions de l'Orient islamique: parenté et filiation', in Glaire D. Anderson *et al.* (eds), *The Aghlabids & their Neighbors: Art & Material Culture in Ninth-Century North Africa* (Leiden and Boston, 2017), pp. 339–61.

16. An argument found from Lane, *Early Islamic Pottery*, and before, up to, for example, Northedge, 'Thoughts on the introduction'.

17. Watson, 'Revisiting Samarra'.

18. Splashed decoration in green is commonly found in Chinese wares both for home and export markets – but it is not the source of the Islamic practice. It is found on YGF wares before the arrival of Chinese imports. It is more likely the case that such Chinese wares were imported because they matched an already known and favoured decorative treatment in local Islamic YGF pottery.

19. OWG wares were made in Raqqa, see Watson, 'VIII. Report on the glazed ceramics', sects 1.2 and 3.3, and a distinct variety, perhaps imported from Antioch, is found amongst the sherds from al-Mina held by the Victoria and Albert Museum, see Tasha Vorderstrasse, *Al-Mina: a Port of Antioch from Late Antiquity to the end of the Ottomans* (Leiden, 2005), sect. Imitation Chinese. Northedge identifies five different fabrics among plain white wares from Samarra in addition to lustre- and blue-painted wares, see Alastair Northedge and Derek Kennet, 'The Samarra horizon', in Ernst J. Grube (ed.), *Cobalt and Lustre: The First Centuries of Islamic Pottery*, Vol. 9 (London and Oxford, 1994), pp. 21–35. OWG wares found on a kiln site at Basra are in fact distinct from the Samarra lustre- and blue-painted wares, contra Mason and Keall, 'The 'Abbasid glazed wares'. Museum collections hold a great variety of styles of white-glazed wares, though mostly without provenance.

20. Research by Moujan Matin, *Revisiting the Origins of Islamic Ceramics: A Technological Examination of 8th- to 10th-Century AD Ceramics from Islamic Lands* (DPhil thesis, University of Oxford, 2016), and Moujan Matin *et al.*, 'Rethinking early Islamic ceramics: evidence for the invention of tin-opacified glazes in Egypt and the Levant, part 1: chemical analysis' and 'Part 2: Replication and reverse engineering', *Journal of Archaeological Science* (in press). For a preliminary report, see Michael Tite *et al.*, 'Revisiting the beginnings

of tin-opacified Islamic glazes', *Journal of Archaeological Science* 57 (2015), pp. 80–91.

21. *Le Vert et le Brun, Terres secrètes de Samarcande*, nos 98–109, pls pp. 43, 51).

22. Potters making this ware also decorated their pots with in-glaze painting in blue, a colour almost never used by other OWG potters. Both lustre and blue-painting may also be accompanied by painting in green.

23. The lustre wares have been attributed to Basra, based on clay analysis in comparison with that of a series of fragments collected from that site, see Mason and Keall, 'The 'Abbasid glazed wares'. However, the comparison is flawed as the fabrics are not actually the same (the Basra fragments contain significant inclusions); the production site of the lustre ware is therefore still unknown.

24. Marilyn Jenkins, 'Muslim: an early Fatimid ceramist', *Bulletin of the Metropolitan Museum of Art* 5.25 (1968), pp. 359–69.

25. For example, Watson, *Ceramics*, cat. no. E.18.

26. Watson, *Ceramics*, sect. Ja.

27. Venetia Porter and Oliver Watson, '"Tell Minis" wares', in James W. Allan and Caroline Roberts (eds), *Syria and Iran: Three Studies in Medieval Ceramics*, Oxford Studies in Islamic Art, Vol. IV (Oxford, 1987), pp. 175–248.

28. Watson, *Ceramics*, cat. no. K3–4.

29. Ibid., cat. no. R1.

30. Oliver Watson, *Persian Lustre Ware* (London, 1985).

31. *Islamic Arts and Manuscripts*, auction catalogue, Christies (London, 11 April 2000), lot 236.

32. Watson, *Persian Lustre Ware*, cpts 8 and 10.

33. Ibid., pp. 178–9.

34. Oliver Watson, 'Persian lustre ware from the 14th to the 19th centuries', *Le Monde Iranien et l'Islam* III (1975), pp. 63–80.

35. Anthony Ray, *Spanish Pottery, 1248–1898* (London, 2000).

36. Oliver Watson, 'Pottery and light', in Jonathan Bloom and Sheila Blair (eds), *God Is the Light of the Heavens and the Earth: Light in Islamic Art and Culture* (New Haven and London, 2015), pp. 156–75.

37. Christina Tonghini, 'The fine wares of Ayyubid Syria', in Ernst J. Grube (ed.), *Cobalt and Lustre: The First Centuries of Islamic Pottery*, Vol. 9 (London and Oxford, 1994), pp. 249–57.

38. Porter and Watson, 'Tell Minis'.

39. Watson, *Persian Lustre Wares*, p. 26, figs 1–4.

40. A small monochrome fritware vase in the Khalili Collection is said to be dated 534/1139: the date is not illustrated and the style of the motifs raises questions. Sheila S. Blair, *Islamic Inscriptions* (New York, 1988, p. 155) doubts its authenticity. See Ernst Grube, *Cobalt and Lustre: The First Centuries of Islamic Pottery*, Vol. 9 (London and Oxford, 1994), no. 148.

41. Charles Wilkinson, *Nishapur: Pottery of the Early Islamic Period* (New York, 1973), cpt. 11; Shishkina and Pavchinskaja, *Terres secrètes de Samarcande*.

42. Oliver Watson, 'Persian silhouette ware and the development of underglaze painting', in Margaret Medley (ed.), *Decorative Techniques and Styles in Asian Ceramics*, PDF Colloquy 8, SOAS (London, 1979), pp. 86–103, and Watson, *Ceramics*, sect. N.

43. Watson *Ceramics*, cat. no. Jb.3.
44. Ibid., cat. no. Q5–Q14; Oliver Watson, 'Pottery under the Mongols', in Linda Komaroff (ed.), *Beyond the Legacy of Genghis Khan* (Leiden and Boston, 2006), pp. 325–45.
45. Watson, *Ceramics*, cat. no. Q11–Q14.
46. Ibid., cat. no. Q15–17.
47. Lane, *Early Islamic Pottery*, pl. 5; Watson, *Ceramics*, cat. no. R3–R4; *The Golden Horde: History and Culture*, exhibition catalogue, the Hermitage-Kazan Centre (Kazan, 2005), cat. nos 554, 577, 605, 625, 626. Rosalind Wade Haddon, *Fourteenth Century Glazed Finewares Produced in the Iranian World and Comparisons with Contemporary Ones from the Golden Horde and Mamlūk Syria/Egypt* (PhD Thesis, SOAS, University of London, 2012).
48. Lisa Golombek *et al.*, *Tamerlane's Tableware: A New Approach to the Chinoiserie Ceramics of Fifteenth- and Sixteenth-century Iran* (Costa Mesa, CA, 1996).
49. Armand Abel, *Gaibi et les grands faïenciers égyptiens d'époque mamlouke* (Cairo, 1930); Watson, *Ceramics*, sect. S.
50. Nurhan Atasoy and Julian Raby, *Iznik, The Pottery of Ottoman Turkey* (London, 1989), pp. 82ff.
51. George Bass *et al.*, *Serçe Limanı, Volume II: The Glass of an Eleventh-Century Shipwreck* (College Station, TX, 2009).

Bibliography

Abel, Armand, *Gaibi et les grands faïenciers égyptiens d'époque mamlouke* (Cairo, 1930).

Allan, James W., 'Abu'l-Qasim's treatise on ceramics', *Iran* XI (1973), pp. 111–20.

Bass, George F., Robert H. Brill, Berta Lledo and Sheila D. Matthews, *Serçe Limanı, Volume II: The Glass of an Eleventh-Century Shipwreck* (College Station, TX, 2009).

Atasoy, Nurhan and Julian Raby, *Iznik, The Pottery of Ottoman Turkey* (London, 1989).

Bahrami, Mehdi, *Gurgan Faiences* (Cairo, 1949).

Blair, Sheila S., *Islamic Inscriptions* (New York, 1998).

Caiger-Smith, Alan, *Tin-Glaze Pottery in Europe and the Islamic World: The Tradition of 1000 Years in Maiolica, Faience and Delftware* (London, 1973).

Chatti, Soundes G., 'La céramique aghlabide de Raqqada et les productions de l'Orient islamique: parenté et filiation', in Glaire D. Anderson, Corisande Fenwick and Mariam Rosser-Owen (eds), *The Aghlabids & their Neighbors: Art & Material Culture in Ninth-Century North Africa* (Leiden and Boston, 2017), pp. 339–61.

Couleurs de Tunisie, exhibition catalogue, Institut du Monde Arabe (Paris, 1994).

The Golden Horde: History and Culture, exhibition catalogue, the Hermitage-Kazan Centre (Kazan, 2005).

Golombek, Lisa, Robert B. Masson and Gauvin Bailey, *Tamerlane's Tableware: A New Approach to the Chinoiserie Ceramics of Fifteenth- and Sixteenth-century Iran* (Costa Mesa, CA, 1996).

Grube, Ernst J., *Cobalt and Lustre: The First Centuries of Islamic Pottery*, Vol. 9 (London and Oxford, 1994).

Islamic Art and Manuscripts, auction catalogue, Christies (London, 11 April 2000).

Jenkins, Marilyn, 'Muslim: an early Fatimid ceramist', *Bulletin of the Metropolitan Museum of Art* 5.26 (1968), pp. 359–69.

Kambakhsh Fard, Sayfallah, *Kavushha-yi Naishapur wa Sufalkari-yi Iran*, Intisharat Wuzarat Farhang u Hunar (in Persian with English translation) (Tehran, 1971/1349).

Lane, Arthur, *Early Islamic Pottery, Monographs on Pottery and Porcelain* (London, 1947).

Le Vert et le Brun: De Kairouan à Avignon, Céramiques du Xe au XVe Siècle, exhibition catalogue, Musées de Marseilles (Marseilles, 1995).

Mason, Robert B. and Edward J. Keall, 'The 'Abbasid glazed wares of Siraf and the Basra connection: petrographic analysis', *Iran* XIX (1991), pp. 51–66.

Matin, Moujan, *Revisiting the Origins of Islamic Ceramics: A Technological Examination of 8th- to 10th-Century AD Ceramics from Islamic Lands* (DPhil thesis, University of Oxford, 2016).

Matin, Moujan, Oliver Watson and Michael Tite, 'Rethinking early Islamic ceramics: evidence for the invention of tin-opacified glazes in Egypt and the Levant, part 1: chemical analysis' and 'Rethinking early Islamic ceramics: evidence for the invention of tin-opacified glazes in Egypt and the Levant, part 2: replication and reverse engineering', *Journal of Archaeological Science* (in press).

Naumann, Rudolf, 'Brennöfen fur Glasurkeramik', *Istanbuler Mitteilungen* 21 (1971), pp. 173–90.

Northedge, Alastair, 'Thoughts on the introduction of polychrome glazed pottery in the Middle East', in Estelle Villeneuve and Pamela M. Watson (eds), *La Céramique Byzantine et Proto-Islamique en Syrie-Jordanie (IVe–VIIIe Siecles Apr. J.-C.)* (Beyrouth, 2001), pp. 207–14.

Northedge, Alastair, and Derek Kennet, 'The Samarra horizon', in Ernst J. Grube (ed.), *Cobalt and Lustre: The First Centuries of Islamic Pottery*, Vol. 9 (London and Oxford, 1994), pp. 21–35.

Porter, Venetia and Oliver Watson, '"Tell Minis" wares', in James W. Allan and Caroline Roberts (eds), *Syria and Iran: Three Studies in Medieval Ceramics*, Oxford Studies in Islamic Art, Vol. IV (Oxford, 1987), pp. 175–248.

Ray, Anthony, *Spanish Pottery, 1248–1898* (London, 2000).

Rodziewicz, Mieczysław, *Alexandrie I: La Céramique romaine tardive d'Alexandrie* (Warsaw, 1976).

Rodziewicz, Mieczysław, 'La céramique émailée copte de Kom el Dikka', *Etudes et Traveaux* 10 (1978), pp. 337–45.

Rodziewicz, Mieczysław, 'Egyptian glazed pottery of the eighth to ninth centuries', *Bulletin de la société d'archéologie copte* 25 (1983), pp. 73–5.

Rosen-Ayalon, Myriam, *La Poterie Islamique, Mémoires de la Délégation Archéologique en Iran, Mission Susiane* (Paris, 1974).

Scanlon, G. T., 'Slip-painted early lead-glazed wares from Fustat: a dilemma of nomenclature, in R.-P. Gayraud (ed.), *Colloque International d'Archéologie Islamique* (Cairo, 1998), pp. 21–55.

Shishkina, Galina V. and L. V. Pavchinskaja, *Terres secrètes de Samarcande: Céramiques du VIIIe au XIIIe Siécle*, catalogue of an exhibition, Institut du Monde Arabe (Paris, 1992).

Simpson, St John, 'Partho-Sasanian ceramic industries in Mesopotamia', in Ian Freestone and David Gaimster (eds), *Pottery in the Making: World Ceramic Traditions* (London, 1997), pp. 74–9.

'The origin and development of square Kufic script', in *Actes du Colloque International: l'Art Iranien, Hier et Aujourd'hui*, Hossein Beikbaghban (ed.) (Tehran: Presses universitaires d'Iran, n.d.), pp. 1–5.

'On giving to shrines: "Generosity is a quality of the people of Paradise"', in *Gifts of the Sultans: The Art of Giving at the Islamic Courts*, Linda Komaroff (ed.) (New Haven: Yale University Press, 2011), pp. 51–74.

'Baghdad: calligraphy capital under the Mongols', in *Islam Medeniyetinde Bağdat (Medînetü's-Selâm) Uluslararasi Sempozyum / International Symposium on Baghdad (Madinat al-Salam) in the Islamic Civilization*, Ismail Safa Üstün (ed.) (Istanbul: Marmara Üniversitesi, İlahiyat Fakültesi, İslam Tarihi ve Sanatları Bölümū, 2011), pp. 297–316.

'Dschamschid erfindet die Handwerke', in *Heroische Zeiten: Tausend Jahre persisches Buch der Könige*, Julia Gonnella and Christoph Rauch (eds) (Berlin: Museum für islamische Kunst, Staatliche Museen zu Berlin, 2011), pp. 54–7; English translation as 'Jamshid invents the crafts', in *Heroic Times: A Thousand Years of the Persian Book of Kings*, Julia Gonnella and Christoph Rauch (eds) (Berlin: Museum für islamische Kunst, Staatliche Museen zu Berlin, 2012), pp. 54–5.

'The power of the word: Ayyubid inscriptions in Jerusalem', in *Ayyubid Jerusalem: The Holy City in Context 1187–1250*, Robert Hillenbrand and Sylvia Auld (eds) (London: Altajir Trust, 2009), pp. 118–28.

'Arabic calligraphy in West Africa', in *The Meanings of Timbuktu*, Shamil Jeppie and Souleymane Bachir Diagne (eds) (Cape Town: HSRC Press, 2008), pp. 9–75.

'Written, spoken, envisioned: the many facets of the Qur'an in art', in *Word of God, Art of Man: The Qur'an and Its Creative Expressions*, Fahmida Suleman (ed.) (London: Oxford University Press, 2007), pp. 271–84.

'Writing and illustrating history: Rashid al-Din's *Jami' al-tavarikh*', in *Theoretical Approaches to the Transmission and Edition of Oriental Manuscripts*, papers from an international conference held in Istanbul in 2001, Judith Pfeiffer and Manfred Kropp (eds), *Beiruter Texte und Studien* 111 (Beirut: Orient-Institut der Deutschen Morgenländischen Gesellschaft, 2007), pp. 57–66.

'Calligraphers, illuminators and painters in the Ilkhanid scripto-rium', in *Beyond the Legacy of Genghis Khan*, Linda Komaroff (ed.) (Leiden: E. J. Brill, 2006), pp. 167–82.

'A Mongol envoy', in *The Iconography of Islamic Art: Studies in Honour of Robert Hillenbrand*, Bernard O'Kane (ed.) (Edinburgh: Edinburgh University Press, 2005), pp. 45–60.

'Islamic art as a source for the study of women in pre-modern socie-ties', in *Beyond the Exotic: Women's Histories in Islamic Societies*, Amira Sonbol (ed.) (Syracuse: Syracuse University Press, 2005), pp. 336–47.

'Rewriting the history of the great Mongol *Shahnama*', in *Shahnama: The Visual Language of the Persian Book of Kings*, Robert Hillenbrand (ed.) (Aldershot and Burlington, VT: Ashgate and VARIE, 2004), pp. 35–50; Persian translation by Valiollah Kavusi, 'Baznivisi sarguzhasht-i shahnama-yi buzurg-i ilkhani', *Zaban-i tasviri-yi shahnama* (Tehran: Intisharat-i farhangistan-i hunar, 1387), pp. 65–92.

'The Ardabil carpets in context', in *Society and Culture in the Early Modern Middle East*, Andrew J. Newman (ed.) (Leiden: E. J. Brill, 2003), pp. 125–44.

'Religious art of the Ilkhanids', in *The Legacy of Genghis Khan: Courtly Art and Culture in Western Asia, 1256–1353*, Linda Komaroff and Stefano Carboni (eds) (New York: Metropolitan Museum of Art, 2002), pp. 104–33.

'Coins and seals', in *The Splendour of Iran*, N. Pourjavady (ed.) (London: Booth-Clibborn Editions, 2001), pp. 3:236–43.

'Decoration of city walls in the medieval Islamic world: the epi-graphic message', in *City Walls: The Urban Enceinte in Global Perspective*, James D. Tracy (ed.) (Cambridge: Cambridge University Press, 2000), pp. 488–530.

'Arabic', part 5 of chapter 13, 'Language situation and scripts', in *The Age of Achievement: A.D. 750 to the Fifteenth Century*, C. E. Bosworth and the late M. S. Asimov (eds), volume IV, part 2 of the History of Civilizations of Central Asia (Paris: UNESCO, 2000), pp. 340–50.

'Floriated Kufic and the Fatimids', in *Actes du Colloque sur l'Égypte Fatimide: Son art et son Histoire*, Marianne Barrucand (ed.) (Paris: Presses de l'Université de Paris-Sorbonne, 1999), pp. 107–16.

'Texts, inscriptions and the Ardabil carpets', in *Iran and Iranian Studies: Essays in Honor of Iraj Afshar*, Kambiz Eslami (ed.) (Princeton: Zagros Press, 1998), pp. 137–47.

'Patterns of patronage and production in Ilkhanid Iran: the case of Rashid al-Din', in *The Court of the Il-khans 1290–1340*, J. Raby and T. Fitzherbert (eds), Oxford Studies in Islamic Art 12 (Oxford: Oxford University Press, 1997), pp. 39–62; Persian translation by Valiallah Kavusi as 'Ulguha-yi hunarparvari wa afrinish-i hunari dar iran-i dawra-yi ilkhani: mawrid-i rashid al-din', *Golistan-i honar* 13 (August 2008), pp. 32–47.

'An inscription from Barujird: new data on domed pavilions in Saljuq mosques', in *The Art of the Saljuqs in Iran and Anatolia*, Robert Hillenbrand (ed.) (Malibu, CA: Undena, 1994), pp. 4–11.

'What is the date of the Dome of the Rock?', in *Bayt al-Maqdis: 'Abd al-Malik's Jerusalem*, J. Raby and J. Johns (eds), Oxford Studies in Islamic Art 9 (Oxford: Oxford University Press, 1993), pp. 59–88.

'Legibility versus decoration in Islamic epigraphy: the case of interlacing', in *World Art: Themes of Unity in Diversity*, Acts of the XXVIth International Congress of the History of Art, I. Lavin (ed.) (University Park and London: Pennsylvania State University Press, 1989), pp. 229–31.

'The post-classical period (1250–1500)', in *Islamic Art & Patronage: Treasures from Kuwait*, Esin Atil (ed.) (New York: Rizzoli, 1990), pp. 151–65.

'On the track of the 'Demotte' *Shahnama*', in *Les Manuscrits du Moyen-Orient: Essais de codicologie et de paléographie* (Institut Français d'Études Anatoliennes d'Istanbul, Varia Turcica VII), F Déroche (ed.) (Istanbul/Paris: Institut français d'études anatoliennes d'Istanbul et de la Bibliothèque nationale, 1989), pp. 125–31.

'The inscription from the tomb tower at Bastam', in *Art et Société dans le Monde Iranien*, C. Adle (ed.) (Paris: Institut Français d'Iranologie de Téhéran, 1982), pp. 263–86.

'Mawzu'-i tawavir-i Shahnama-yi buzurg-i qarn-i hashtum-i hijri', in *Shâhnâma-yi Firdawsî: Hamasa-yi Jahânî* , Muhammad Taqizada (ed.) (Tehran, 1977), pp. 85–90.

Journal articles

'Muslim-style mausolea across Mongol Eurasia: religious syncretism, architectural mobility and cultural transformation', *Journal of the Economic and Social History of the Orient* 62, special issue *Mobility and Transformations in Mongol Eurasia: Economic and Cultural Exchanges*, Michal Biran (ed.) (2019), pp. 318–55.

'Illustrating history: Rashid al-Din and his *Compendium of Chronicles*', *Iranian Studies* 50/3, Nacim Pak-Shiraz (ed.) (2017), pp. 1–24.

'Invoking the Prophet Muhammad through word, sound, and image: verbal, vocal, and visual images in the religious arts of Islam', *Religion and the Arts* 20 (2016), pp. 29–58.

'Architecture as a source for local history in the Mongol period: the example of Waramin', *Journal of the Royal Asiatic Society*, special issue *The Mongols and Post-Mongol Asia: Studies in Honour of David O. Morgan*, 3rd series, 26.1–2 (2016), pp. 215–29.

'The Ilkhanid Qur'an: an example from Maragha', *Journal of Islamic Manuscripts* 6 (2015), pp. 174–95.

'Transcribing God's word: Qur'an codices in context', *Journal of Qur'anic Studies* 9.1 (2008), pp. 71–97; reprinted in *The Qur'an: A Revised Translation: Origins: Interpretations and Analysis: Sounds, Sights, and Remedies: The Qur'an in America*, Jane McAuliffe (ed.) (New York: W. W. Norton, 2017), pp. 614–25.

'Ascending to Heaven: fourteenth-century illustrations of the Prophet's Mi'rāğ', *The Arabist: Budapest Studies in Arabic* 28–29, Proceedings of the Colloquium on Paradise and Hell in Islam, Keszthely, 7–14 July 2002, K. Dévényi and A. Fodor (eds) (2008), pp. 19–36.

'A brief biography of Abu Zayd', *Muqarnas* 25 (2008), pp. 155–76.

'The art of the word: a brief history of Islamic calligraphy', *Hadeeth ad-Dar* 24 (2007), pp. 9–13.

'Uses and functions of the Qur'anic text', *Mélanges de l'Université Saint-Joseph* 59 (2006), pp. 183–201.

'What the inscriptions tell us: text and message on the ivories from al-Andalus', in *The Ivories of Muslim Spain*, Papers from a symposium held in Copenhagen from the 18th to the 20th of November

2003, Kjeld von Folsach and Joachim Meyer (eds), *Journal of the David Collection* 2 (2005), pp. 75–100.

'East meets West under the Mongols', *The Silk Road* vol. 3.2, (2005), pp. 27–33, available on-line at <http://www.silkroadfoundation.org/toc/index.html>.

'Yaqut and his followers', *Manuscripta Orientalia* 9.3 (2003), pp. 39–47; Persian translation, 'Yaqut wa piravanish', *Ayene-ye Miras (Mirror of Heritage)* 3.2 (2005), pp. 102–28.

'Ivories and inscriptions from Islamic Spain', in *Kunst und Kunsthandwerk im frühen Islam: 2. Bamberger Symposium der Islamischen Kunst 25.–27. Juli 1996*, Barbara Finster, Christa Fragner and Herta Hafenrichter (eds), *Oriente Moderno* n.s. 23.2 (2004), pp. 375–86.

'An amulet from Afsharid Iran', *Journal of the Walters Art Gallery* 59 (2001), pp. 85–102.

'Color and gold: the decorated papers used in manuscripts in later Islamic times', *Muqarnas* 17 (2000), pp. 24–36.

'Inscriptions and texts: evidence from early Islamic Iran', *Quaderni di Studi Arabi* 16 (1998), pp. 59–68.

'An inscribed rock crystal from 10th-century Iran or Iraq', *Entlang der Seidenstraße: Frühmittelalterliche Kunst zwischen Persien und China in der Abegg-Stiftung; Riggisberger Berichte* 6 (1998), pp. 345–54.

'Timurid signs of sovereignty', *La civiltà timuride come fenomeno internazionale, Oriente Moderno* n.s. 15 (Rome: Istituto per l'Oriente C. A. Nallino, 1996), pp. 551–76.

'Inscriptions on medieval Islamic textiles', *Islamische Textilkunst des Mittelalters: Riggisberger Berichte* 5 (1997), pp. 95–104.

'A note on the prayers inscribed on several medieval silk textiles in the Abegg Foundation', *Riggisberger Berichte* 5 [Islamische Textilkunst des Mittelalters: Aktuelle Probleme] (1997), pp. 129–38.

'The Ilkhanid palace', *Ars Orientalis* 23 (1993), pp. 235–44.

'The development of the illustrated book in Iran', *Muqarnas* 10 [Essays in Honor of Oleg Grabar] (1992), pp. 266–74.

'Surveyor versus epigrapher', *Muqarnas* 8 [K. A. C. Creswell and His Legacy] (1991), pp. 66–73.

'Sufi saints and shrine architecture in the early fourteenth century', *Muqarnas* 7 (1990), pp. 35–49.

'The epigraphic program of Uljaytu's tomb at Sultaniyya: meaning in Mongol architecture', *Islamic Art* 2 (1987), pp. 43–96.

'Sunnis and Shi'ites in medieval Iran: the Masjid-i Sar-i Kûcha at Muhammadiyya', *Revue des Études Islamiques* 24 [Mélanges Dominique Sourdel] (1986), pp. 51–60.

'A medieval Persian builder', *Journal of the Society of Architectural Historians* 45.4 (December 1986), pp. 389–95.

'The Mongol capital of Sultaniyya, "the Imperial"', *Iran* 24 (1986), pp. 139–52.

'The madrasa at Zuzan: Islamic architecture in eastern Iran on the eve of the Mongol invasions', *Muqarnas* 3 (1986), pp. 75–91; Persian translation, 'Madrasa-yi zawzan: mi'mari-yi islami-yi sharq-i iran dar astana-yi hamla-yi mughul', *Athar* 29–30 (1377), pp. 66–89.

'Artists and patronage in late fourteenth century Iran in light of two catalogues of Islamic metalwork', *Bulletin of the School of Oriental and African Studies* 48.1 (1985), pp. 53–9.

'Ilkhanid architecture and society: an analysis of the endowment deed of the Rab'-i Rashidi', *Iran* 22 (1984), pp. 67–90; Persian translation by Mehrdad Qayyoomi, 'Mi'mari wa jama'a dar dawra-yi ilkhaniyan: tahlil-i waqfnama-yi rab'-i rashidi', *Golestan-i honar* 13 (August 2008), pp. 48–73.

'The octagonal pavilion at Natanz: a reconsideration of early Islamic architecture in Iran', *Muqarnas* 1 (1983), pp. 69–94.

'The coins of the later Ilkhanids: a typological analysis', *Journal of the Economic and Social History of the Orient* 26 (1983), pp. 295–317.

'The coins of the later Ilkhanids: mint organization, regionalization and urbanism', *American Numismatic Society Museum Notes* 27 (1982), pp. 211–30.

Entries in encyclopedias

'Calligraphy and epigraphy' and 'Ceramics, women's representations in', in *The Oxford Encyclopedia of Islam and Women*, Natana Delong-Bas (ed.) (Oxford: Oxford University Press, 2013).

"Arg-i 'Ali Shah', in *Encyclopaedia Islamica*, Wilferd Madelung and Farhad Daftary (eds) (Leiden: E. J. Brill, 2008–), vol. 3, pp. 610–14.

'Epigraphy (Islamic)' and 'Kufic' in *Encyclopedia of Arabic Language and Linguistics*, Kees Versteegh (ed.) (Leiden: E. J. Brill, 2006–), vol. 2, pp. 40–7 and vol. 2: pp. 597–604.

'Writing and writing materials' in *Encyclopaedia of the Qur'an*, Jane McAuliffe (ed.) (Leiden, E. J. Brill, 2003).

'Abu Tahir'; 'Cenotaph, §2. Islamic world'; 'Haydar'; 'Islamic art, §II, 5(i)(b), Architecture: Iran, c. 1050–c. 1250', 'Islamic art, II, 6(i)(a), Architecture: Iran, c. 1250–c. 1375'; 'Islamic art, II, 9(vi), Architectural decoration: Epigraphy'; 'Islamic art, II, 10(ii), Urban development: Eastern Islamic lands'; 'Islamic art, III, 4(ii)(d), 'Painted illustration: Subject matter: Historical writing'; 'Islamic art, III, 4(v)(b), 'Painted illustration: Iraq and Iran, c. 1250–c. 1350'; 'Mirza 'Ali'; 'Muzaffar 'Ali'; 'Natanz'; 'Shaykh Muhammad'; 'Shiraz, 1. History and Urban Development'; 'Stele §V. Islamic lands', 'Tabriz, §3(i) Buildings: Rab'-i Rashidi', 'Tiraz', and 'Yahya al-Sufi', in *The Dictionary of Art*, Jane Shoaf Turner (ed.) (London: Macmillan Publishers, 1996), 34 vols.

'Ilkhanidi', 'Soffitto, Islam' in *Enciclopaedia dell'Arte Medievale*.

'Amol: Islamic monuments'; 'Astarabad: Islamic monuments'; 'Babol: Islamic monuments'; 'Damgani'; 'Ebn Babawayh'; 'Ebrahim b. Esma'il'; 'Ebrahim b. Otman b. 'Ankawayh Haddad'; 'Enayatallah'; 'Epigraphy iii. Arabic inscriptions in Persia'; Gereh-sazi: 1. Woodwork'; 'Gonbad-i Qabus'; 'Ilkhanid architecture' and '*Jame' al-tawarik*. ii. Illustrations'; 'Rab'-e rašidi', in *Encyclopaedia Iranica*, Ehsan Yarshater (ed.) (London: Routledge, New York: Bibliotheca Persia, 1985–).

'Iranian and Central Asian carpets', 'Felt', 'Gardens', 'Metalware painting' and 'Weaving' in *Encyclopaedia of Asian History*.

'Radkan (tomb tower)', 'Saray (palace)', 'Sultaniyya 2. Monuments', 'Tabriz. Architecture', 'Zawiya 3. Architecture', and with Jonathan Bloom 'Yashm. 2' and 'Iran. Architecture' (for the supplement) in the *Encyclopaedia of Islam*, 2nd edition (Leiden: E. J. Brill, 1960–).

'Mosque inscriptions', in *Oxford Encyclopedia of Archeology in the Near* East Eric M. Meyers (ed.) (Oxford, 1997), vol. IV: pp. 58–60.

'Muhammad b. al-Husayn al-Damghani' in the *Macmillan Encyclopaedia of Architects*.

'Buyid art and architecture' and 'Cenotaph' in the *Encyclopaedia of Islam*, 3rd edition (Leiden: E. J. Brill, 2007–).

Popular articles

'From warriors to connoisseurs: the arts of the Mongols', *Saudi Aramco World* 54.1 (January–February 2003), pp. 24–33.

'The ivories of al-Andalus', *Saudi Aramco World* 52.5 (September–October 2001), pp. 22–31.

Book reviews

Mohamad Reza Ghiasian, 'Lives of the prophets: the illustrations to Hafiz-i Abru's "Assembly of Chronicles"', for *Iranian Studies* 52 (2019), DOI: 10.1080/00210862.2019.1692769.

Daniella Talmon-Heller and Katia Cytryn-Silverman (eds), *Material Evidence and Narrative Sources: Interdisciplinary Studies of the History of the Muslim Middle East* for *Der Islam* 94.2 (2017), pp. 609–11.

Michael Jung, *Wall Paintings of the Great Mosque of Isfahan* for *Journal of the Royal Asiatic Society* 27.1 (2017), pp. 166–7.

Jila Peacock, *Ten Poems from Hafez* for *Middle Eastern Literatures* 15.2 (2012), pp. 213–15.

Barbara Kellner-Heinkele, Joachim Gierlichs, and Brigitte Heuer (eds), *Islamic Art and Architecture in the European Periphery: Crimea, Caucasus, and the Volga-Ural Region* for *Islamic Studies* 48.4 (2009), pp. 591–3.

Ahmad Ghabin, *Hisba, Arts and Craft in Islam* for *Journal of the Royal Asiatic Society* 20.1 (2009), pp. 93–4.

Éloïse Brac de la Perrière, *L'art du livre dans l'Inde des sultanates* for *CAA Reviews Online* (March 10, 2009).

Colette Sirat, *Writing as Handwork: A History of Handwriting in Mediterranean and Western Culture* for *Bulletin of the School of Oriental and African Studies* 70.2 (June 2007), pp. 418–20.

Robert Hillenbrand (ed.), *Persian Painting from the Mongols to the Qajars: Studies in Honour of Basil W. Robinson* and Julian Raby, *Qajar Portraits* for *Iranian Studies* 36.3 (June 2003), pp. 268–72.

Ebba Koch, *Mughal Art and Imperial Ideology: Collected Essays* for *CAA Reviews Online* (September 3, 2002).

Layla S. Diba (ed.), with Maryam Ekhtiar, *Royal Persian Paintings: The Qajar Epoch 1783-1925* for *Iranian Studies* 33.1–2 (2000), pp. 228–31.

Vesta Sarkhosh Curtis, Robert Hillenbrand and J. M. Rogers (eds), *The Art and Archaeology of Ancient Persia: New Light on the Parthian and Sasanian Empires* for *MESA Bulletin* 33.1 (1999), p. 52.

Lisa Golombek, Robert B. Mason, and Gauvin A. Bailey, *Tamerlane's Tableware: A New Approach to the Chinoiserie Ceramics of Fifteenth- and Sixteenth-Century Iran* for *Iranian Studies* 32.3 (1999), pp. 438–9.

Raya Shani, *A Monumental Manifestation of the Shi'ite Faith in Late Twelfth-Century Iran: The Case of the Gunbad-i 'Alawiyan, Hamadan* for *Iranian Studies* 32.3 (1999), pp. 451–3.

Thomas T. Allsen, *Commodity and Exchange in the Mongol Empire: A Cultural History of Islamic Textiles* for *Journal of the American Oriental Society* 119.2 (1999), pp. 331–2.

William L. Hanaway and Brian Spooner, *Reading Nasta'liq: Persian and Urdu Hands from 1500 to the Present* for *Edebiyât* 9 (1998), pp. 149–51.

Patricia Berger and Terese Tse Bartholomew, *Mongolia: The Legacy of Chinggis Khan* and Martha Boyer, *Mongol Jewelry* for *Iranian Studies* 30.1–2 (1997), pp. 143–6.

Madeleine Schneider, *Mubârak al-Makkî: An Arabic Lapicide of the Third/Ninth Century* for *Journal of Semitic Studies* 42.2 (1997), pp. 431–3.

Barbara Schmitz with Latif Khayyat, Svat Soucek and Massoud Pourfarrokh, *Islamic Manuscripts in the New York Public Library* for *Ars Orientalis* 24 (1994), pp. 153–4.

Raymond Lifchez, *The Dervish Lodge: Architecture, Art, and Sufism in Ottoman Turkey* for *Journal of the Society of Architectural Historians* 52.3 (1993), pp. 368–9.

Marie Lukens Swietochowski and Sussan Babaie, *Persian Drawings in the Metropolitan Museum of Art* for *Ars Orientalis* 20 (1990), p. 200.

Jill S. Cowen, *Kalila wa Dimna: An Animal Allegory of the Mongol Court* for *Iranian Studies* 22.2–3 (1989), pp. 133–5.

Lisa Golombek and Donald Wilber, *The Timurid Architecture of Iran and Turan* and Bernard O'Kane, *Timurid Architecture in Khurasan* for *Iranian Studies* 22.1 (1989), pp. 74–7.

Mehrdad Shokoohy and Natalie H. Shokoohy, *Hisâr-i Fîrûza: Sultanate and Early Mughal Architecture in the District of Hisar, India* and Mehrdad Shokoohy, *Bhadresvar: The Oldest Islamic Monuments in India* for *Journal of the Society of Architectural Historians* 48.4 (1989), pp. 390–1.

Glenn D. Lowry (ed.), with Susan Nemazee, *A Jeweler's Eye: Arts of the Book from the Vever Collection* for *Fine Print: The Review for the Arts of the Book* 5.3 (July 1989), pp. 147–50.

Julian Raby (ed.), *The Art of Syria and the Jazîra 1100–1250*, Oxford Studies in Islamic Art 1, for *Bulletin of the Asia Institute* n.s. 3 (1989), pp. 127–8.

Mehdi Bahrami, *Gurgan Faiences* for *MESA Bulletin* 22.2 (December 1988), p. 249.

Oliver Watson, *Persian Lustre Ware* for *Ars Orientalis* 16 (1986), pp. 176–7.

Sherban Cantacuzino (ed.), *Architecture in Continuity: Building in the Islamic World Today* for *Middle East Journal* 40.3 (1986), p. 547.

Erica Dodd and Shereen Khairallah, *The Image of the Word: A Study of Quranic Verses in Islamic Architecture* for *Arabica* 31.3 (November 1984), pp. 337–42.

Hayat Salam-Leibich, *The Architecture of the Mamluk City of Tripoli* for *Middle East Journal* 38.3 (1984), pp. 535–6.

James Allan, *Nishapur: Metalwork of the Early Islamic Period* for *MESA Bulletin* 17.1 (July 1983), pp. 77–9.

Work in press, submitted or in preparation

'Sultan Öljeitü's Baghdad Qur'an: a life history', in *The Word Illuminated: Form and Function of Qur'anic Manuscripts*, Massumeh Farhad and Simon Rettig (eds), papers from a conference held at the Smithsonian Institution, December 2017 (Washington, DC: Smithsonian Scholarly Press, in press).

'The Arabic inscriptions on the Norman palaces of Palermo in a broader context', in *Il Palazzo Disveluto/The Palace Unveiled*, Maria Andaloro and Ruggero Longo (eds) [special issue of *Bolletino d'arte*] (submitted).

'From manuscript to shrine: Qur'an illumination and luster mihrabs from medieval Iran', in *Art and Culture of Books in the Islamic World: Festschrift Prof. Dr. Zeren Tanındı*, Aslıhan Erkmen and S¸ebnem Tamcan (eds) (Istanbul: Lale Yayincilik) (submitted).

'Intersecting networks: the Gunbad-i 'Ali at Abarquh', in *The Architecture of the Greater Iranian World 1000–1250*, Robert Hillenbrand (ed.) (Edinburgh: Edinburgh University Press, accepted).

'Religious architecture in Iran under the Ilkhanids and their successors', in *Cambridge World History of Religious Architecture*, vol. 1, Kathryn Moore and Hasan-Uddin Khan (eds) (Turnhout: Brepols, in preparation).

'The art and architecture of the Ilkhanids', in *The Mongol World*, Timothy May and Michael Hope (eds), Routledge Worlds (London: Routledge, in press).

'Artists' signatures', in *Geschichte der Vier Erdtelle /Art History of the Four Continents*, Matteo Burioni and Ulrich Pfisterer (eds) (Munich: Wissenschaftliche Buchgesellschaft, submitted).

with Shane McCausland, 'The visual world' in *The Cambridge History of the Mongol Empire*, Michal Biran and Kim Hodong (eds) (Cambridge: Cambridge University Press, in press).

'Three ways of looking at a frontispiece: the face of the Cairo Bustan', Festschrift for Barbara Brend on her 80th Birthday, a special issue of The Journal of the Royal Asiatic Society (submitted).

Jonathan M. Bloom

Books

The Architecture of Western Islam: North Africa and the Iberian Peninsula 700–1800 (New Haven and London: Yale University Press, 2020).

The Minaret (Edinburgh: Edinburgh University Press, 2013).

Arts of the City Victorious: Islamic Art and Architecture in Fatimid North Africa and Egypt (London and New Haven: Institute of Ismaili Studies in Association with Yale University Press, 2007).

ed., trans. and introduction, *Early Islamic Art and Architecture* [The Forming of the Classical Islamic World: 600–950] (Aldershot: Ashgate, 2002).

Paper Before Print: The History and Impact of Paper in the Islamic Lands (New Haven and London: Yale University Press, 2001; R 2013); Turkish translation by Zülal Kılıç as *Kâğit İşlenen Uygarlık: Kâğıdın Tarihi ve İslam Dünyasına Etkisi* (Istanbul: Kitap Publishing, 2003); Arabic translation in preparation.

with Ahmed Toufiq, Stefano Carboni, Jack Soultanian, Antoine M. Wilmering, Mark D. Minor, Andrew Zawacki, and El Mostafa Hbibi, *The Minbar from the Kutubiyya Mosque* (New York: The Metropolitan Museum of Art, 1998).

Minaret: Symbol of Islam [Oxford Studies in Islamic Art VII] (Oxford: Oxford University Press, 1989).

Chapters in books

'Egypt (Arab conquest to Mamluk dynasty), 641–1517', in *Sir Banister Fletcher's A History of Architecture*, 21st ed., Tom Dyckhoff (ed.) (London: Bloomsbury and the Royal Institute of British Architects, 2019), pp. 267–91.

'The transformative role of paper in the literary culture of the Islamic lands', in *Books and Readers in the Premodern World: Essays in Honor of Harry Gamble*, Karl Shuve (ed.) (Atlanta: SBL Press, 2018), pp. 33–46.

'The marble mihrab panels of the Great Mosque of Kairouan', in *The Aghlabids and their Neighbours: Art and Material Culture in Ninth-Century North Africa*, Glaire D. Anderson, Corisande Fenwick and Mariam Rosser-Owen (eds) with Sihem Lamine (Leiden: E. J. Brill, 2017), pp. 190–206.

'How paper changed Islamic literary and visual culture', in *By the Pen and What They Write, Writing in Islamic Art and Civilization*, Sheila Blair and Jonathan Bloom (eds) (London: Yale University Press, 2017), pp. 105–27.

'The historical geography of paper', in *Mobilities of Knowledge*, Heike Jöns, Peter Meusburger and M. Hefferman (eds) [Knowledge and Space, vol. 10] (Dordrecht: Springer, 2016), pp. 51–66.

'Arthur Upham Pope: his life and times', in *Arthur Upham Pope and his Legacy*, Yuka Kadoi (ed.) (Leiden: E. J. Brill, 2015), pp. 75–93.

'Art and architecture', in *The Shi'i World: Pathways in Muslim Tradition and Modernity*, Farhad Daftary, Shainool Jiwa and Amyn Sajoo (eds) (London: Institute of Ismaili Studies and I. B. Tauris, 2015), pp. 228–56.

'Erasure and memory: Aghlabid and Fatimid inscriptions in North Africa', in *Viewing Inscriptions in the Late Antique and Medieval World*, Antony Eastmond (ed.) (Cambridge: Cambridge University Press, 2015), pp. 61–75.

'The Muslim community of Fustat', in *A Cosmopolitan City: Muslims, Christians and Jews in Old Cairo*, Tasha Vorderstrasse and Tanya Treptow (ed.) (Chicago: Oriental Institute of the University of Chicago, 2015), pp. 21–6.

'Evanescent meaning: the role of Shi'ism in Fatimid mosques', in *People of the Prophet's House: Art, Architecture and Shi'ism in the Islamic World*, Fahmida Suleiman (ed.) (London: I. B. Tauris in association with the Institute of Ismaili Studies, 2015), pp. 63–71.

'Kutubiyya Minbar', 'Qarawiyyin Minbar', 'Qasba Minbar', in *Le Maroc médiéval: un empire de l'Afrique à l'Espagne*, Yannick Lintz, Claire Délery and Bulle Tuil Leonetti (eds) (Paris: Musée du Louvre, 2014), pp. 192, 198–9, 369–70.

'Nasir-i Khusraw in Jerusalem', in *'No Tapping Around Philology:' A Festschrift in Honor and Celebration of Wheeler McIntosh Jr's 70th Birthday*, Alireza Korangy and Daniel J. Sheffield (eds) (Wiesbaden: Harrassowitz Verlag, 2014), pp. 395–406.

'Architectural "influence" and the Hajj', in *Hajj: Collected Essays*, Venetia Porter (ed.) (London: British Museum Research Papers, 2013), pp. 136–42.

'A cultural history of the material world of Islam', in *Cultural Histories of the Material World*, Peter N. Miller (ed.) (Ann Arbor: University of Michigan Press, 2013), pp. 240–8.

'The painted ivory box made for the Fatimid Caliph al-Mu'izz', in *Siculo-Arabic Ivories and Islamic Painting, 1100–1300: Proceedings of the International Conference, Berlin, 6–8 July 2007*, David Knipp (ed) [Römische Forschungen der Bibliotheca Hertziana, 36] (Munich: Hirmer Verlag, 2012), pp. 141–50.

'Silk Road or Paper Road?' in *The Silk Road: Key Papers*, Valerie Hansen (ed.) (Leiden: E. J. Brill, 2011), pp. 563–73.

'Fatimid gifts', in *Gifts of the Sultans: The Art of Giving at the Islamic Courts*, Linda Komaroff (ed.) (Los Angeles: Los Angeles County Museum of Art, 2011), pp. 95–109.

'Moving words', in *A Companion to Muslim Cultures*, Amyn Sajoo (ed.) (London: I. B. Tauris in association with the Institute of Ismaili Studies, 2011), pp. 137–64.

'The Islamic sources of the Cappella Palatina pavement', in *Die Cappella Palatina in Palermo: Geschichte, Kunst, Funktionen*, Thomas Dittelbach (ed.) (Künzelsau: Wuerth Stiftung, 2011), pp. 177–98, 551–9.

'Literary and oral cultures', in *Islamic Cultures and Societies to the End of the 18th Century*, Robert Irwin (ed.) [*The New Cambridge History of Islam, 4*] (Cambridge: Cambridge University Press, 2010), pp. 668–81.

'Woodwork in Syria, Palestine, and Egypt during the 12th and 13th centuries', in *Ayyubid Jerusalem: The Holy City in Context 1187–1250*, Robert Hillenbrand and Sylvia Auld (eds) (London: Altajir World of Islam Trust, 2009), pp. 129–46.

'Lost in translation: gridded plans and maps along the Silk Road', in *The Journey of Maps and Images on the Silk Road* Philippe Fôret and Andreas Kaplony (eds) (Leiden: E. J. Brill, 2008), pp. 83–96.

'Paper in Sudanic Africa', in *The Meanings of Timbuktu*, Shamil Jeppie and Souleymane Bachir Diagne (eds) (Cape Town: HSRC Press, 2007), pp. 44–57.

'Ceremonial and sacred space in early Fatimid Cairo', in *Cities in the Pre-Modern Islamic World: the Urban Impact of Religion, State and Society*, A. K. Benison and A. Gascoigne (eds) (London: Routledge, 2007), pp. 96–114.

'Paper: the transformative medium in Ilkhanid art and architecture', in *Beyond the Legacy of Genghis Khan* Linda Komaroff (ed.) (Leiden: E. J. Brill, 2006), pp. 289–302.

'Preface', in Therese Weber, *The Language of Paper: A History of 2000 Years* (Hong Kong/Bangkok: Orchid Press, 2006), pp. xiv–xv.

'Almoravid geometrical designs in the pavement of the Cappella Palatina in Palermo' in *The Iconography of Islamic Art: Studies in Honour of Robert Hillenbrand*, Bernard O'Kane (ed.) (Edinburgh: Edinburgh University Press, 2005), pp. 61–80.

'The Great Mongol Shahnama in the Qajar period', in *Shahnama: The Visual Language of the Persian Book of Kings*, Robert Hillenbrand (ed.) (Aldershot: Ashgate, 2004), pp. 25–34.

'Epic images revisited: an Ilkhanid legacy in Safavid painting', in *Society and Culture in the Early Modern Middle East*, Andrew J. Newman (ed.) (Leiden: E. J. Brill: 2003), pp. 237–48.

'Minarets', in *The Splendour of Iran*, N. Pourjavady (ed.) (London: Booth-Clibborn, 2001), vol. 2, pp. 180–1.

'Walled cities in Islamic North Africa and Egypt with particular reference to the Fatimids (909–1171)', in *City Walls in Early Modern History*, James Tracy (ed.) (New York: Cambridge University Press, 2000), pp. 219–46.

'Paper in Fatimid Egypt', in *L'Égypte fatimide, son art et son histoire*, Marianne Barrucand (ed.) (Paris: Presses de l'Université de Paris-Sorbonne, 1999), pp. 395–401.

'The minbar in the Kutubiyya Mosque', in *The Minbar from the Kutubiyya Mosque*, by Jonathan M. Bloom, Ahmed Toufiq, Stefano Carboni, Jack Soultanian and Antoine M. Wilmering (New York: The Metropolitan Museum of Art, 1998), pp. 3–29.

'Ibn Marzuk on the architectural patronage of the Marinid Sultan Abu'l-Hasan Ali (r. 1331–1348)', in *Windows on the House of Islam: Muslim Sources on Spirituality and the Religious Life* John Renard (ed.) (Berkeley: University of California Press, 1998), pp. 250–61.

'Jerusalem in medieval Islamic literature', in *City of the Great King: Jerusalem from David to the Present* Nitza Rosovsky (ed.) (Cambridge, MA: Harvard University Press, 1996), pp. 205–17.

'The minaret before the Saljuqs', in *The Art of the Seljuqs in Iran and Anatolia*, Robert Hillenbrand (ed.) (Malibu: Undena, 1994), pp. 12–16.

'Minarets and church towers in medieval Spain', in *Künstlerischer Austausch/Artistic Exchange: Akten des XXVIII. Internationalen Kongresses für Kunstgeschichte Berlin, 15.–20. Juli 1992*, pp. 361–71.

'Five panels from a minbar made for the Mosque of the Andalusians, Fez' and 'Minbar from the Kutubiyya Mosque, Marrakesh', in *Al-Andalus: The Art of Islamic Spain*, Jerrilynn D. Dodds (ed.) (New York: The Metropolitan Museum of Art, 1992), pp. 249–51 and 362–7.

'The classical period (1050–1250)', in *Islamic Art and Patronage: Treasures from Kuwait*, Esin Atil (ed.) (New York: Rizzoli, 1990), pp. 95–109.

'The early Fatimid Blue Koran manuscript', in *Les Manuscrits du moyen-orient: essais de codicology et paléographie*, François Déroche (ed.) (Istanbul/Paris: Institut Français d'Études Anatoliennes d'Istanbul et de la Bibliothèque Nationale, 1989), pp. 95–9.

'The revival of early Islamic architecture by the Umayyads of Spain', in *The Medieval Mediterranean: Cross-Cultural Contacts*, Marilyn J. Chiat and Kathryn L. Reyerson (eds), Medieval Studies at Minnesota 3 (St Cloud, MN: North Star Press of St Cloud, Inc., 1988), pp. 35–41.

Journal articles

'Painting in the Fatimid period revisited', Festschrift for Barbara Brend on her 80th Birthday, a special issue of *The Journal of the Royal Asiatic Society* (accepted).

'The Blue Koran revisited', *Journal of Islamic Manuscripts* 6.2–3 (2015), pp. 196–218.

'Papermaking in the Islamic lands', *Hand Papermaking* (2012), pp. 3–11.

'Strapwork designs in Western Islamic art', *Beiträge zur Islamischen Kunst und Archäologie*, III, Lorenz Korn and Anja Heidenreich (eds) (Wiesbaden: Dr Ludwig Reichert Verlag, 2012), pp. 150–62.

'Islamic art and architecture in Sicily: how Fatimid is it?', *I Fatimidi e il Mediterraneo: Il sistema di relazioni nel mondo dell'Islam e nell'area del Mediterraneo nel periodo della da'wa fatimide (sec. X–XI), pp.istituzioni, società, cultura*, Palermo 3–6 dicembre 2008, *Alifabâ: Studi arabo-islamici e mediterranei* 22 (2008), pp. 29–43.

'The fake Fatimid doors of the Fakahani Mosque in Cairo', *Muqarnas* 25 [Essays in Honor of Oleg Grabar] (2008), pp. 231–42.

'The garden as paradise; the garden as garden', *The Arabist: Budapest Studies in Arabic* 28–9 [Proceedings of the Colloquium on Paradise and Hell in Islam, Keszthely, 7–14 July 2002], K. Dévényi and A. Fodor (eds) (2008), pp. 37–54.

'Silk Road or Paper Road', *The Silk Road*, December 2005, pp. 21–6; available online at <http://silkroadfoundation.org/toc/newsletter.html>.

'Ivory and wood: The minbar from the Kutubiyya Mosque and the ivories from Córdoba', *Colloquium on the Ivories of Muslim Spain*, Kjeld von Folsach and Joachim Meyer (eds), *Journal of the David Collection* 2 (2005), pp. 204–13.

'Fact and fantasy in Buyid art', *Kunst und Kunsthandwerk im frühen Islam, 2. Bamberger Symposium der Islamischen Kunst 25.–27. Juli 1996*, Barbara Finster, Christa Fragner and Herta Hafenrichter (eds), *Oriente Moderno* n.s. 23.2 (2004), pp. 387–400.

'The introduction of paper and the development of the illustrated manuscript in the Islamic lands', *Muqarnas* 17 (2000), pp. 17–23.

'Mamluk art and architecture: a review article', *Mamluk Studies Review* 3 (1999), pp. 31–58.

'L'Iconographie figurative dans les arts décoratifs' and 'Les techniques des arts décoratifs', *Dossiers d'archéologie* [L'âge d'or des Fatimides] 233 (May 1999), pp. 58–71.

'The Fatimids: their ideology and their art', *Islamische Textilkunst des Mittelalters: Riggisberger Berichte* 5 (1997), pp. 15–26.

'Coverage of Islamic art in reference works', *Arts and the Islamic World* 27–8 (1996), pp. 64 and 139–40.

'"The Qubbat al-Khadra" and the iconography of height in early Islamic architecture', *Ars Orientalis* 23 (1994), pp. 131–7.

'On the transmission of designs in early Islamic architecture', *Muqarnas* 10 (1993), pp. 21–8.

'Creswell and the origins of the minaret', *Muqarnas* 8 (1991), pp. 55–8.

'The early Fatimid Blue Koran manuscript', *Graeco-Arabica* 4 (1991), pp. 171–8.

'A Mamluk basin in the L.A. Mayer Memorial Institute', *Islamic Art* 2 (1987), pp. 19–26.

'Al-Ma'mûn's Blue Koran?' *Revue des études islamiques* 54 (1986) [Mélanges Dominique Sourdel], pp. 61–5.

'The introduction of the Muqarnas into Egypt', *Muqarnas* 5 (1989), pp. 21–8.

'The Mosque of the Qarafa in Cairo', *Muqarnas* 4 (1987), pp. 7–20.

'The origins of Fatimid art', *Muqarnas* 3 (1985), pp. 20–38.

'Five Fatimid minarets in Upper Egypt', *Journal of the Society of Architectural Historians* 43 (1984), pp. 162–7.

'The Mosque of al-Hakim in Cairo', *Muqarnas* 1 (1983), pp. 15–36.

'The Mosque of Baybars al-Bunduqdari in Cairo', *Annales islamologiques* 18 (1982), pp. 45–78.

Entries in encyclopedias

'Islamic art history', for *The Oxford Encyclopedia of Aesthetics*, Michael Kelly (ed.) (Oxford: Oxford University Press, 2013).

'Fatimid art and architecture' and 'Minaret', for *The Encyclopaedia of Islam*, 3rd edition (Leiden: E. J. Brill, 2007–).

'Minaret' for the *Oxford Encyclopedia of the Islamic World*, John Esposito (ed.) (Oxford: Oxford University Press, 2009).

'Calligraphy'; 'Carpets'; 'Mosque of Ibn Tulun, Cairo'; 'Paper manufacture' for *Medieval Islamic Civilization: An Encyclopedia* Josef Meri (ed.) (New York: Routledge, 2006).

'Mosque', *The Encyclopaedia of the Qur'an*, vol. 3, Jane McAuliffe (ed.) (Leiden: E. J. Brill, 2003).

'Fatimid'; 'Islamic art §II, 5(ii)(a) Architecture: Tunisia and eastern Algeria c. 900–c. 1250';'Islamic art §II, 5(ii)(c) Architecture: Egypt c. 900–c. 1250'; Islamic art §VII, 1 (i)(b) Woodwork: Egypt, Syria and Iraq, c. 1000–1250'; 'Islamic art §XI, 1. Collectors and collecting, Islamic lands'; 'Khanaqah'; 'Madrasa'; 'Maqsura'; 'Mihrab'; 'Minaret'; 'Palace §V. Islamic world'; for *The Dictionary of Art*, Jane Shoaf Turner (ed.) (London: Macmillan, 1996).

'Egypt §VI: Artistic relations with Persia in the Islamic period' and 'Paper', for the *Encyclopaedia Iranica*.

'Alhambra' and 'Art, Muslim' in *Medieval Iberia: An Encyclopedia*, E. Michael Gerli (ed.) (New York: Routledge, 2003).

'Ibn Tulun Mosque', in the *Encyclopedia of the Modern Middle East*, Reeva S. Simon, Philip Mattar and Richard W. Bulliet (eds) (New York, Macmillan Reference USA, 1996), vol. 2, pp. 840–1.

'Aghlabid art'; 'al-Azhar'; 'Badgir'; 'Badr al-Jamali'; 'Funduq'; 'Mashrabiya'; 'Mosque'; 'Musalla'; 'Qa'a' for *The Dictionary of the Middle Ages* (New York: Scribner, 1982–9).

'al-Munif', for *The Macmillan Encyclopedia of Architects* (New York: Free Press, 1982).

Online publications

'Minaret', *Oxford Islamic Studies Online* (2013), <http://www.oxfordislamicstudies.com.proxy.bc.edu/article/opr/t343/e0117>.

'Papyrus, parchment and paper in Islamic studies', *Oxford Bibliographies Online* (2019),

DOI: 10.1093/OBO/9780195390155-0265.

'Islamic art and architecture in North Africa and the Iberian Peninsula', *Oxford Bibliographies Online* (2018), DOI: 10.1093/OBO/9780199920105-0124.

Popular articles

'An American's Qur'an', *Sightings* (March 8, 2012), available at <http://divinity.uchicago.edu/martycenter/publications/sightings/archive_2012/0308.shtml>.

'Gifts of the Fatimids', *The Ismaili USA* (2011), pp. 44–7.

'The paper trail', *Hadeeth ad-Dar* 24 (2007), pp. 5–8.

'Hand sums: the ancient art of counting with your fingers', *Boston College Magazine* (2002), p. 6.

'The Mullah's murals', *(AI) Performance for the Planet* (2002), p. 42.

'The minaret: symbol of faith and power', *Saudi Aramco World Magazine* (March–April 2002), pp. 26–35.

'Patient restoration: the Kuwait National Museum', (with Lark Ellen Gould), *Saudi Aramco World Magazine* 51.5 (September–October 2000), pp. 10–20.

'Muqarnas: the rhythm of the honeycomb', *Aramco World Magazine* 51.3 (May–June 2000), pp. 10–11.

'Quest for the perfect loaf', *Yankee Magazine* (March 2000), pp. 88–95.

'Revolution by the ream: a history of paper', *Aramco World Magazine* 49.3 (June 1999), pp. 26–39.

'The masterpiece minbar', *Aramco World Magazine* 48.3 (May–June 1998), pp. 2–11.

Book reviews

Caroline Fowler, *The Art of Paper: From the Holy Land to the Americas* for *Choice* (2020).

Christiane Gruber (ed.), *The Image Debate: Figural Representation in Islam and Across the World* for *Choice* 57.7 (March 2020).

Felix Arnold, *Islamic Palace Architecture in the Western Mediterranean: A History* for *Journal of the Society of Architectural Historians* 77.4 (December 2018), pp. 474–6.

Sonia Rhie Quintanilla and Dominique DeLuca, *Mughal Paintings: Art and Stories* for *Choice* 54.8 (April 2017).

Heinz Gaube and Abdulrahman Al Salimi (eds), *Illuminated Qurans from Oman* for *Orientalische Literaturzeitung* 112.4–5 (November 2017), pp. 393–5.

Linda Komaroff *et al.*, *Beauty and Identity: Islamic Art from the Los Angeles County Museum of Art* for *Choice* 54.3 (November 2016).

Mark Kurlansky: *Paper: Paging through History* for *The Historian* 79.3 (2017), pp. 658–9.

Tarek Swelim, *The Mosque of Ibn Tulun* (Cairo: American University in Cairo Press, 2015) for *Choice* 53.10 (June 2016).

Arthur Millner, *Damascus Tiles: Mamluk and Ottoman Architectural Ceramics from Syria* for *Choice* (March 2016).

Naoko Sonoda, Claude Laroque, Jeong Hye-young and Chen Gang (eds), *Research on Paper and Papermaking, Proceedings of an International Workshop* for *Journal of Anthropological Research* 71 (2015), pp. 132–3.

Doris Behrens-Abouseif (ed.), *The Arts of the Mamluks in Egypt and Syria – Evolution and Impact* for *Mamluk Studies Review* 17 (2013), pp. 258–61.

Richard Brilliant and Dale Kinney (eds), *Reuse Value: Spolia and Appropriation in Art and Architecture from Constantine to Sherrie Levine* for *CAA Reviews Online* (31 January 2013).

William Dalrymple and Yuthika Sharma (eds), *Princes and Painters in Mughal Delhi, 1707–1857* for *Choice* (June 2012).

Andreas Birken, *Atlas of Islam: 1800–2000* for *Zeitschrift der deutschen morgenländischen Gesellschaft* 164.1 (2012), pp. 264–7.

Helga Rebhan, *Die Wunder der Schöpfung / The Wonders of Creation. Handschriften der Bayerischen Staatsbibliothek aus dem islamischen Kulturkreis. (Bayerische Staatsbibliothek München. Ausstellungskataloge, Nr. 83)* for *Bibliotheca Orientalis* 68.5–6 (2011), cols 628–32.

Richard Yeomans, *The Art and Architecture of Islamic Cairo* for *Journal of Near Eastern Studies* 70.1 (2011), pp. 175–7.

Adam Gacek, *Arabic Manuscripts: A Vademecum for Readers* for *Journal of the American Oriental Society* 130.2 (April–June 2010), pp. 300–1.

Oleg Grabar, *The Dome of the Rock* for *The Times Literary Supplement* (7 December 2007).

Bernard Heyberger and Silvia Naef (eds), *La Multiplication des images en pays d'Islam* for *Arabica* 53.4 (2006), pp. 531–4.

Jill Edwards (ed.), *Historians in Cairo, Essays in Honor of George Scanlon* for *Journal of Near Eastern Studies* 65.1 (January 2006), pp. 71–2.

Caroline Williams, *Islamic monuments in Cairo: The Practical Guide* for *Journal of Near Eastern Studies* 65.3 (July 2006), pp. 213–14.

Nelly Hanna, *In Praise of Books: A Cultural History of Cairo's Middle Class, Sixteenth to Eighteenth Century* for *The Times Literary Supplement* (24 and 31 December 2004), p. 9.

Klaus Kreiser, *The Beginnings of Printing in the Near and Middle East: Jews, Christians and Muslims* for *Journal of Islamic Studies* 15.2 (May 2004), pp. 238–40.

Barbara Finster, Christa Fragner and Herta Hafenrichter (eds), *Rezeption in der Islamischen Kunst* for the *Journal of the American Oriental Society* 122.3 (2002), pp. 657–8.

Anna Contadini, *Fatimid Art in the Victoria and Albert Museum* and Irene Bierman, *Writing Signs: The Fatimid Public Text* for *Journal of the American Oriental Society* 120.2 (2000), pp. 271–3.

Jay Gluck and Noël Siver (eds), *Surveyors of Persian Art: A Documentary Biography of Arthur Upham Pope & Phyllis Ackerman* for *Iranian Studies* 31.1 (1998), pp. 100–2.

Michael Meinecke, *Patterns of Stylistic Change in Islamic Architecture: Local Traditions versus Migrating Artists* [Hagop Kevorkian Series on Near Eastern Art] for *MESA Bulletin* 32.1 (1998), pp. 48–9.

Barbara Finster, *Frühe iranische Moscheen vom Beginn des Islam bis zur Zeit saljuqischer Herrschaft* for *Iranian Studies* 30.1–2 (1997), pp. 146–8.

Mohamed-Moain Sadek, *Die mamlukische Architektur der Stadt Gaza* for *Mamluk Studies Review* 1 (1997), pp. 178–9.

Nasser O. Rabbat, *The Citadel of Cairo: A New Interpretation of Royal Mamluk Architecture* for *Journal of the American Oriental Society* 117.2 (1997).

Muqarnas 9 for *Journal of the American Oriental Society* 117.2 (April–June 1997), pp. 381–2.

Michael Meinecke, *Die mamlukische Architektur in Ägypten und Syrien* for *Journal of the Society of Architectural Historians* 54 (March 1995), pp. 108–9.

Catherine Asher, *Architecture of Mughal India, Ars Orientalis* 24 (1994), pp. 154–5.

George Michell and Richard Eaton, *Firuzabad: Palace City of the Deccan* for *American Journal of Archaeology* 98.1 (January 1994), pp. 181–2.

Gülru Necipoglu, *Architecture, Ceremonial, and Power: The Topkapı Palace in the Fifteenth and Sixteenth Centuries* for *Journal of the Society of Architectural Historians* 52.3 (September 1993), pp. 365–7.

Nezar Alsayyad, *Cities and Caliphs: On the Genesis of Arab Muslim Urbanism* for *Journal of the Society of Architectural Historians* 52.3 (1993), p. 371.

Doris Behrens-Abouseif, *Islamic Architecture in Cairo: An Introduction* for *Journal of the Society of Architectural Historians* 50.4 (December 1991), p. 470.

Myriam Rosen-Ayalon, *The Early Islamic Monuments of al-Haram al-Sharif: An Iconographical Study* for *American Journal of Archaeology* 95 (1991), pp. 188–9.

K. Archibald C. Creswell, *A Short Account of Early Muslim Architecture, revised and ed. James W. Allan* for *Journal of the Society of Architectural Historians* 49.3 (September 1990), pp. 330–1.

Priscilla Soucek (ed)., *Content and Context of Visual Arts in the Islamic World, A Symposium in Memory of Richard Ettinghausen* for *Iranian Studies* 22.2–3 (1990), pp. 135–6.

Lisa Golombek and Donald Wilber, *The Timurid Architecture of Iran and Turan* for *Journal of the Society of Architectural Historians* 48.3 (September 1989), pp. 303–4.

Stephen Urice, *Qasr Kharanah in the Transjordan* for *Journal of the American Research Center in Egypt* 26 (1988), pp. 254–5.

Susan Downey, *Mesopotamian Religious Architecture* for *American Journal of Archaeology* 93.4 (October 1989), p. 612.

Hasan Mohammed el-Hawary and Gaston Wiet, *Matériaux pour un Corpus Inscriptionum Arabicarum. Quatrième Partie: Arabie. Inscriptions et Monuments de la Mecque: Haram et Ka'ba. Tome I (fascicule 1).* Revised and edited by Nikita Elisséeff for *Journal of the American Research Center in Egypt* 28 (1991), pp. 240–1.

Lionel Bier, *Sarvistan: A Study in Early Iranian Architecture* for *American Journal of Archaeology* 91 (1987), p. 639.

Richard Parker, Robin Sabin and Caroline Williams, *Monuments of Islamic Cairo, A Practical Guide* for *Journal of the American Research Center in Egypt* 23 (1986), pp. 217–18.

Duncan Haldane, *Islamic Bookbindings in the Victoria and Albert Museum* for *MESA Bulletin* 19.1 (July 1985), pp. 100–1.

Abbas Daneshvari (ed.), *Essays in Islamic Art and Architecture in Honor of Katharina Otto-Dorn* for *Design Book Review* (November 1983).

Yanni Petsopoulos (ed.), *Tulips, Turbans and Arabesques* for *MESA Bulletin* 17.1 (1983), pp. 85–6.

Richard Parker, *A Practical Guide to Islamic Monuments in Morocco* for *Middle East Journal* 63.4 (Autumn 1982), pp. 622–3.

Work in press, submitted or in preparation

'The Norman palace in context: Islamic palaces in the Mediterranean', in *Il Palazzo Disveluto/The Palace Unveiled*, Maria Andaloro and Ruggero Longo (eds) [special issue of *Bolletino d'arte*], (submitted).

'Mediterranean technologies and thought: paper production', in *Mapping the Medieval Mediterranean*, Julian Deahl and Amity Nichols Law (eds) (Leiden: E. J. Brill, in preparation).

'Fatimid mosques' in *Cambridge World History of Religious Architecture*, vol. 1, Kathryn Moore and Hasan-Uddin Khan (eds) (Turnhout: Brepols, in preparation).

'The minaret during the Seljuk era', in *The Architecture of the Greater Iranian World 1000–1250*, Robert Hillenbrand (ed.) (Edinburgh: Edinburgh University Press, accepted).

Sheila S. Blair and Jonathan M. Bloom
Jonathan M. Bloom and Sheila S. Blair

Joint books

(eds), *Islamic Art: Past, Present, Future*, The Seventh Hamad bin Khalifa Symposium on Islamic Art and Civilization (London: Yale University Press, 2019).

(eds), *By the Pen and What They Write: Writing in Islamic Art and Civilization*, The Sixth Hamad bin Khalifa Symposium on Islamic Art and Civilization (London: Yale University Press, 2017).

with Kent Severson, *Waterscapes: Islamic Architecture & Art from Doris Duke's Shangri La*, Margot Nishimura (ed.) (Newport, RI: Newport Restoration Fund, 2016).

(eds), *God is the Light of the Heavens and the Earth: Light in Islamic Art and Civilization*, The Fifth Hamad bin Khalifa Symposium on Islamic Art and Civilization (London: Yale University Press, 2015).

(eds), *God is Beautiful and Loves Beauty: The Object in Islamic Art and Civilization*, The Fourth Hamad bin Khalifa Symposium on Islamic Art and Civilization (London: Yale University Press, 2013).

(eds), *Diverse are their Hues: Color in Islamic Art and Civilization*, The Third Hamad bin Khalifa Symposium on Islamic Art and Civilization (London: Yale University Press, 2011).

(eds and introduction), *Prisse d'Avennes: Arab Art* (Munich: Taschen, 2010); republished in smaller format as *Oriental Art* (Munich: Taschen: 2016).

(eds), *The Grove Encyclopedia of Islamic Art and Architecture*, 3 vols (New York: Oxford University Press, 2009).

(eds), *Rivers of Paradise: Water in Islamic Art and Civilization*, The Second Hamad bin Khalifa Symposium on Islamic Art and Civilization (London: Yale University Press, 2009).

Cosmophilia: Islamic Art from the David Collection, Copenhagen (Chestnut Hill, MA: McMullen Museum, 2006).

Islam: A Thousand Years of Power and Faith (New York: TV Books, 2000; reprinted in paperback by Yale University Press, 2002); also published in the UK as *Islam: Empire of Faith* (London: BBC Books, 2001); Spanish translation as *Islam: Mil años de ciencia y poder* (Barcelona: Paidos, 2003); Russian translation as Ислам: Тысяча Лет Веры и Могушества (Moscow: Dilya, 2009).

Islamic Arts (London: Phaidon, 1997); Greek translation (Athens: Kastaniotis, 1999); Japanese translation by T. Masuya (Tokyo: Iwanami Shoten, 2001); Korean translation by Ju Hun Kang (Seoul: Hangil, 2003).

The Art and Architecture of Islam: 1250–1800, The Yale University Press Pelican History of Art (London: Yale University Press, 1994); Spanish translation by María Condor as *Arte y arquitectura del Islam: 1250–1800* (Madrid: Ediciones Cátedra, 1999); Arabic translation by Wafaa 'Abd al-Latif Zayn al-'Abidin as *al-Fann wa'l-mi'mara al-islamiyya* (Abu Dhabi, ADACH, 2012); Polish translation by Jolanta Kozłowska, Ivonna Nowicka and Katarzyna Pachniak as *Sztuka i Architektura Islamu 1250–1800* (Warsaw: Wydawnictwo Akademickie/DIALOG, 2012). Yale University Press A&AePortal, available at <https://www.aaeportal.com/?id=-15655>.

(eds), *Images of Paradise in Islamic Art* (Hanover, NH, 1991).

Joint chapters in books

'From Iran to the Deccan: architectural transmission and the madrasa of Mahmud Gavan at Bidar', in *Iran and the Deccan: Persianate Art, Culture, and Talent in Circulation, ca. 1400–1700*, Keelan Overton (ed.) (Bloomington: Indiana University Press, 2020), pp. 175–202.

'The Islamic book', in *The Oxford Illustrated History of the Book* James Raven (ed.) (Oxford: Oxford University Press, 2020), pp. 195–220.

'Ten (or eleven) years of the Biennial Hamad bin Khalifa Symposium on Islamic Art and Culture', in *By the Pen and What They Write, Writing in Islamic Art and Civilization* Sheila Blair and Jonathan Bloom (eds) (London: Yale University Press, 2017), pp. 1–13.

'Introduction', 'Shangri-La and the role of water in the architecture of the Islamic lands', and 'The inside scoop: water in interior spaces and daily life in the Islamic lands', *Waterscapes: Islamic Architecture and Art from Doris Duke's Shangri-La*, Margot Nishimura (ed.) (Newport, RI: Newport Restoration Foundation, 2016), pp. 9–13, 15–35, and 39–61.

'Marvels of things created and miraculous aspects of existing things (mid-1200s), al-Qazwini' in *Hidden Treasure: The National Library of Medicine*, Michael Sappol (ed.) (Bethesda, MD: National Library of Medicine, 2012), p. 78.

'Syria and the Middle Euphrates after Dura', in *Dura Europos: Crossroads of Antiquity*, Lisa Brody and Gail Hoffman (eds) (Chestnut Hill, MA: McMullan Museum of Art, Boston College, 2011), pp. 19–29.

42 entries on Islamic Art for *30,000 Years of Art*, D. Fortenberry (ed.) (London: Phaidon, 2007).

'Christian art in Muslim contexts', in *The Lion Companion to Christian Art*, Michelle Brown (ed.) (Oxford, Lion Hudson, 2007), pp. 102–4.

'Inscriptions in art and architecture', in *A Cambridge Companion to the Qur'an*, Jane Dammen McAuliffe (ed.) (Cambridge: Cambridge University Press, 2006), pp. 163–78.

'The visual arts of Iran during the Islamic period', in *Persia: Fragments from Paradise: Treasures from the National Museums of Iran* (Mexico: Instituto Nacional de Antropología e Historia, 2007), pp. 123–50.

'From secular to sacred, Islamic art in Christian contexts', *Sacred/ Secular*, N. Netzer (ed.) (Chestnut Hill, MA: Boston College, 2006), pp. 115–19.

'Timur's Qur'an, a reappraisal', in *Shifting Sands, Reading Signs: Studies in Honour of Professor Géza Fehérvári*, Barbara Brend and Patricia L. Baker (eds) (London: Furnace, 2006), pp. 5–14.

'North Africa: 600–1500'; 'West Asia: 600–1000'; 'West Asia: 1000–1500'; 'Central Asia: 600–1500'; 'North Africa: 1500–1800'; 'Asia: 1500–1900'; 'West Asia: 1500–1800'; 'Central Asia: 1500–1800'; 'West Asia' 1800–1900'; 'Central Asia: 1800–1900'; 'Asia: 1900–2000'; for *The Atlas of World Art*, John Onians (ed.) (New York: Oxford University Press, 2004).

'Preface to the English edition', in *Gardens of Iran: Ancient Wisdom, New Visions*, Faryar Javaherian (ed.) (Tehran: Iranian Institute for Promotion of Visual Arts, 2004), p. 10.

'Art'; 'Calligraphy'; 'Dome of the Rock'; 'Manar/Manara'; 'Mihrab', *Encyclopedia of Islam and the Muslim World*, Richard C. Martin (ed.) (New York: Macmillan, 2003).

'Iraq, Iran and Egypt: the Abbasids'; 'Ornament'; 'Early empires of the East: Ghaznavids and Ghurids'; 'Central Asia and Asia Minor: the Great Seljuks, the Anatolian Seljuks and the Khwarazmshahs: architecture, decorative arts of the Great Seljuks'; 'Tiles as architectural decoration'; 'Iran: Safavids and Qajars: architecture'; and 'Islamic aarpets' in *Islam: Kunst und Architektur*, Marcus Hattstein and Peter Delius (eds) (Berlin: Könemann, 2000), English translation as *Islam: Art and Architecture*; French translation as *Arts &*

civilisations de l'Islam, pp. 88–124, 328–45, 368–9, 382–405, 448–9, 504–19 and 530–3.

'Art and architecture: themes and variations', *The Oxford History of the Islamic World*, John Esposito (ed.) (New York: Oxford University Press, 2000), pp. 215–68.

'Décors', in *Céramiques du monde musulman: collections de l'Institut du monde arabe et de J.P. et F. Croisier*, J. Mouliérac (ed.) (Paris: Institut du Monde Arabe, 1999), pp. 58–74.

'By the pen: the art of writing in Islamic art', *First Under Heaven: The Art of Asia* [The Fourth HALI Annual] (London: Hali, 1997), pp. 108–25.

Joint journal articles

'Reflections on the study of Islamic architecture', *International Journal of Islamic Architecture* 10.1 (2020).

'Hidden treasures: Qur'an manuscripts in the Museum of Fine Arts, Boston', *Codicological Studies* 1.1 [Festschrift in Honor of Iraj Afshar] (2017), pp. 9–18.

'Cosmophilia and its critics: an overview of Islamic ornament', *Beiträge zur islamischen Kunst und Archäologie*, III, Lorenz Korn and Anja Heidenreich (eds) (Wiesbaden: Dr Ludwig Reichert Verlag, 2012), pp. 39–54.

'Introduction: art, religion, and politics in South Asia', *Religion and the Arts* 8.1 (2004), pp. 1–4.

'The mirage of Islamic art: reflections on the study of an unwieldy field', *The Art Bulletin* 85.1 (March 2003), pp. 152–84.

'Epic images and contemporary history: the legacy of the Great Mongol Shah-nama', *Islamic Art* 5 (2001), pp. 41–52.

'Signatures on works of Islamic art', *Damaszener Mitteilungen* 11 (1999), [*Festschrift für Michael Meinecke*, Marianne Barrucand (ed.)], pp. 49–66.

'Islamic art and architecture in *The Encyclopaedia of Islam*, 2nd edition', *MESA Bulletin* 28 (1994), pp. 158–62.

with Anne E. Wardwell, 'Reevaluating the date of the 'Buyid' silks by epigraphic and radiocarbon analysis', *Ars Orientalis* 22 (1993), pp. 1–42.

Joint entries in encyclopedias

'Inscriptions in art and architecture' in *The Cambridge Companion to the Qur'an* Jane McAuliffe (ed.) (Cambridge: Cambridge University Press, 2006), pp. 163–78.

'Ornamentation and illumination', *The Encyclopaedia of the Qur'an*, vol. 3, Jane McAuliffe (ed.) (Leiden: E. J. Brill, 2003), pp. 593–603.

'Art'; 'Calligraphy'; 'Dome of the Rock'; 'Mihrab'; and 'Minaret' in the *Encyclopedia of Islam and the Muslim World*, Richard Martin (ed.) (New York: Macmillan Reference, 2003).

'Yashm', *The Encyclopaedia of Islam*, 2nd edition, vol. 11 (Leiden: E. J. Brill, 2002), cols 296b–98b.

'Tessuti, Islam', in *Enciclopedia dell'Arte Medievale*.

'Brick §II, 4. Islamic lands'; 'Colour §IV, Islamic world'; 'Islamic art §II, 1. Architecture: Introduction'; 'Islamic art, §II, 5(i)(a), Architecture: Iran and western Central Asia, c. 900–c. 1050'; 'Islamic art §II. 9(i)(a) Architectural decoration: non-figural sculpture'; 'Islamic art §III, 1. Arts of the Book, Introduction'; 'Islamic art §III. 4(i) Arts of the Book: Painted Illustration: Introduction, Subject-matter'; 'Islamic art §III. 4(ii)(b), Arts of the Book: Painted Illustration, belles-lettres'; 'Islamic art §IV. 2(ii) Metalware Gold and Silver before c. 1100'; 'Islamic art §V. 1 Ceramics: Introduction'; 'Islamic Art §V, 5(iii) Ceramics, after 1500, North Africa'; 'Islamic art §VI, 2. Textiles, Fabrics'; 'Islamic art §VI, 2, (iii)(e) Textiles: Indian subcontinent'; 'Islamic art §VI, 4(iv) (c) Carpets and flatweaves, c. 1700 and after: Iran', and about 100 unsigned articles, all for *The Dictionary of Art*, Jane Shoaf Turner (ed.) (London: Macmillan, 1996), 34 vols.

Joint popular articles

with Nancy Steinhardt, 'The back-roads historic mosques of China', *Aramco World* 65.6 (November–December 2014), available at <https://www.saudiaramcoworld.com/issue/201406/the.back-road. historic.mosques.of.china.htm>.

'Domes', *Saudi Aramco World Calendar*, 2014.

'A display of intelligence', [on the new installation of Islamic Art in the Louvre Museum] *Halı* 174 (2013), pp. 46–9.

'The scholars' view', [on the new galleries of Islamic art at the Metropolitan Museum of Art] *Halı* 170 (2011), pp. 50–9.

'From Aladdin's Cave: the reinstallation [of the David Collection], *Halı* 161 (Autumn 2009), pp. 74–89.

'A global guide to Islamic art', *Saudi Aramco World Magazine* 60.1 (January–February 2009).

'Why veiling', introductory essay to accompany a selection of photographs by Rania Mata, *Post Road Magazine* 17 (2009), pp. 33–4.

'Color in Islamic ceramics', *Studio Potter* 35.1 (December 2006).

'Through Islamic eyes, five manifestations of the Muslim vision', *Boston College Magazine* (2003).

'The splendors of Islamic art', *Humanities* 11.3 (1990), pp. 35–7.

Joint book reviews

Finbarr Barry Flood, *Objects of Translation: Material Culture and Medieval 'Hindu-Muslim' Encounter* for *The Art Bulletin* 93.1 (March 2011), pp. 108–10.

The Nasser D. Khalili Collection of Islamic Art, *Persica* 15 (1993–5), pp. 77–90.

Joint obituary

Oleg Grabar for *Society of Architectural Historians Newsletter* (March 2012).

Joint podcast

'The history of paper', for *Eavesdrop on Experts*; recorded March 2019; available at <https://podcasts.apple.com/sc/podcast/eavesdrop-on-experts/id1228445283>

Index

Note: *f* following an entry indicates a page that includes a figure